The Diaries of
Randolph Schwabe

British Art 1930-48

Edited by
Gill Clarke

Sansom &
Company

First published in 2016 by Sansom & Co
A publishing imprint of Redcliffe Press Ltd.,
81g Pembroke Road, Bristol BS8 3EA
www.sansomandcompany.co.uk
info@sansomandcompany.co.uk

Sansom & Co

www.twitter.com/SansomandCo

©Randolph Schwabe as Diarist: The Power of a Line: Gill Clarke
©Biographical Notes and Footnotes: Gill Clarke
©The Diaries: Collection of Janet and Di Barnes

Published to coincide with the exhibition at the
Otter Gallery, 6 February – 19 April, 2016
University of Chichester, College Lane, Chichester PO19 6PE
www.chi.ac.uk/ottergallery

Published with the support of the Marc Fitch Fund

ISBN 978-1-908326-87-4

Text design and typesetting by Stephen Morris, www.stephen-morris.com
Set in Joanna 10.5/12
Cover and plate section design by Ian Parfitt
Printed by Hobbs the Printers Ltd, Totton

CONTENTS

4 **Randolph Schwabe as Diarist**

The Power of a Line

The Diaries 1930-48

The Art of Writing

The Content of a Lived Life

10 **Editorial Note**

Annotations Used

Abbreviations Used in the Text and Notes

Abbreviations of Names Used in the Text and Notes

13 **The Diaries 1930-48**

545 Biographical Notes

556 Selected References

558 List of Illustrations and Credits

561 Index

572 Acknowledgements

RANDOLPH SCHWABE AS DIARIST

THE POWER OF A LINE

The distinguished artist and influential teacher Randolph Schwabe (1885-1948) kept a detailed diary for nearly two decades, providing a unique window into a remarkably rich period in British art in the 1930s and 1940s, including his tenure as Principal of the Slade School of Art. Schwabe commenced his diary in 1930 with the lead up to his 'great interview with the Advisory Board ([for the] Slade Chair)' on Monday 27 January. He vividly records his nervous tension, the interview and ultimately his appointment as Principal and Professor of the Slade succeeding Henry Tonks, from 1 August on an annual salary of £1200. A former prize-winning student at the Slade, Schwabe was well qualified to follow Tonks and maintain the reputation of the School and its tradition for good draughtsmanship, having taught at both Camberwell and Westminster Schools of Art from 1919 and later at the Royal College of Art (R.C.A.) as Drawing Master under William Rothenstein. As his diaries reveal, the Slade appointment was a turning point in his career and life; a life which was devoted to art until his untimely death in post in September 1948 at the age of 63. During his tenure he successfully steered the Slade through a period of great social and cultural change within the context of the movement from peace to war to austerity; most notably he oversaw its evacuation to Oxford to share premises with the Ruskin School of Drawing for the duration of the Second World War and its return and reopening on 1 October 1945 in its old and over-crowded site in Gower Street, London.

THE DIARIES 1930-48

Schwabe's diary of choice was a Royal Diary printed by Collins, being 'Full cloth, stiff, lettered black' and in 1930 priced at 2/6d. These red octavo volumes had one day to each page with space for 23 lines of text, until wartime paper shortages in 1944 led to changes in style condensing two days to each page and a reduction to 14 lines per entry. In 1946 Schwabe switched to using a Datada Diary printed by T.J. & J. Smith; which was also octavo in size and bound in red cloth with two days to a page but the cost had risen to 3/9d plus Purchase Tax. The following year he returned to using a Collins Two Day Royal Diary, which was 'Quarter bound, [with] paper sides, cut flush'. In 1948 he used a Letts Desk Diary, which took the format of one day per page with 28 lines with paper board covers.

THE ART OF WRITING

Known as a scholarly artist, Schwabe found writing relatively easy, having gained much experience as an art critic for the *Saturday Review* and through his contributions to a number of art periodicals including *The Burlington Magazine*, *The Studio* and *The Print Collector's Quarterly* and from autumn 1930 as editor of *Artwork*. As in his art, Schwabe strove for accuracy and authenticity in his writing. Despite his being notorious for his inconsistent spelling of names and places, the diaries are nonetheless well punctuated with few errors, crossings-out or little obvious sign of revision or repetition. He was able to communicate not only what he was engaged in or what was recounted to him but also to convey what he felt. The content is accessible and like his personality devoid

of malice or scheming. The entries are considered, without moral generalisations or bitterness, being on occasion moving, yet also witty and amusing. He maintains discretion throughout, only once in August 1943 believing that he has overstepped, whereupon he crossed out the entry. The indiscretion was more on the part of the teller, Lalla Vandervelde, former wife of the Belgium ambassador and good friend of Roger Fry. She had regaled Schwabe with 'some old scandal' which he thought she should not have told him so he crossed it out stating that 'the best thing I can do is to forget it.' It remains indecipherable.

The entries naturally vary in length ranging from a few words or a paragraph to more usually a whole page which sometimes spills over into the margin or the following page, the 'average' entry being around 200 words. Schwabe wrote these in the evening at his home in Church Row, Hampstead, most often using the pale brown ink mixed especially for him by Stephens.[1] It is notable that during holiday periods Schwabe wrote little, sometimes leaving it for a week or more without making an entry, being occupied with drawing and/or busy seeking a suitable pitch to sketch from. The diaries are not illustrated save for the odd end paper where Schwabe has used the available space to record a quick sketch, and unlike his scrapbooks they do not contain an index. One has, however, been supplied for this volume.

An immediacy to his chronicling is evident and he clearly felt compelled to record in his largely legible sloping script much that daily captured his attention. His writing had of necessity improved following the difficulties his young daughter Alice had reading the letters he wrote to her when she was a boarder at Bedales School, Steep near Petersfield, in Hampshire in the 1920s.

THE CONTENT OF A LIVED LIFE

While conservative rather than revolutionary in his work and ideals, Schwabe was much respected by fellow artists from diverse and rival factions. His diary-keeping spanned a formative period for a number of talented British painters and sculptors; some, but by no means all, were Slade students, who were influenced and informed by new ideas and developments in painting coming from Europe and who after the Second World War were to gain international recognition.

Visiting exhibitions and attending Private Views gave Schwabe much pleasure and provided a respite from the demands of running and teaching at the Slade. These exhibitions were often recorded in great detail. In the process he singled out artists and/or specific works for comment be it positive or critical and from these statements his own attitudes to art emerge. Although Schwabe missed the ground-breaking International Surrealist Exhibition which ran for three weeks at the New Burlington Galleries in London from June 1936 and attracted over 30,000 visitors, many of whom came to mock, he did in the course of the following month visit Salvador Dali's one-man show at Lefevre's. He noted that he did not really like him at all while admitting, perhaps a little grudgingly, that 'he is a sort of virtuoso.'

1 Schwabe's niece Margaret de Villiers (née Cobbe) also suggested that he may even on occasion have written his daily entries at the Slade School. Pers. comm. 12 July 2014.

Schwabe's wide interests also afforded him pleasure. His love of the ballet is apparent and he reminisces about the golden age of the Russian Ballet and the Theatre Movement in the first two decades of the century when he and Birdie, his wife, would attend performances at the Alhambra and other venues in London. They were fortunate too in having the Everyman Theatre in Hampstead which was well known in the 1920s for its productions although it fell into disuse in 1931. It reopened as a repertory cinema on Boxing Day 1933 and the Schwabe family were frequently in the audience, taking the opportunity to see some of the best films available from international studios at that time. They shared their interest in films with their friend, Dr. Joseph Bramhall Ellison, known as Ginger, who was closely involved with promoting the film *The Robber Symphony*, and visited the film studios with him and met the film's hero Hans Feher a number of times. The film was described in *The Times* in May 1936 as a 'film fantasy to music', it was later shown at the International Film Festival in Venice. Schwabe provides fascinating insights in his diary into the film's genesis and Ginger's investment in it.

Immensely sociable and 'many-sided in his conversation'[2] Schwabe regularly visited his contemporaries and acquaintances and they too would drop into 20 Church Row. Hampstead at that time was aptly described by the critic and writer Herbert Read as 'A Nest of Gentle Artists'. These meetings with 'Gentle Artists' form a significant part of Schwabe's diary, be they poets, painters, sculptors, dramatists, actors or actresses from across the spectrum of social, cultural and professional worlds. It is from these encounters and chance meetings on the Tube, and with other friends that he gleaned lively anecdotes that pepper his diary. These add an entertaining and illuminating dimension to his writing and offer access to other artists and literary figures most of whom were of a similar or older generation, and at events that he was not always party to.

Schwabe captures in his diary vignettes of his wide circle of friends, including Charles Rennie Mackintosh and his wife Margaret Macdonald whom he knew from the time when he lived in Chelsea in Cheyne Walk and with whom he and Birdie holidayed in Dorset in the 1920s. His daughter was a great favourite of Toshie's. He later records great regret at not taking the opportunity to draw Mackintosh. Other key friendships with notable artists, architects and writers emerge, for instance with Francis Dodd, Muirhead Bone, Albert Rutherston, Maxwell Ayrton and his son Tony, and Francis Kelly with whom he wrote and illustrated several books, including *A Short History of Costume and Armour* (1931) which received favourable reviews. He later recorded Kelly's ill health and eventual death. In the following year, 1945, after some 15 years of keeping his diary, he reflects that there 'is a lot of death in it'. His lifelong friendship with Rutherston, the Ruskin Master of Drawing, did much to foster and enable the smooth running of the Slade-Ruskin between 1939 and 1945 when the Slade was evacuated to Oxford.

Throughout the war years Schwabe was much occupied with administrative matters but in 1941 he reluctantly agreed to serve on the War Artists' Advisory Committee (W.A.A.C.) as the art schools' representative. Over the next few years he regularly attended meetings in London under the chairmanship of Sir Kenneth Clark, frequently travelling

2 Charles Tennyson (1951:6) Introduction in *Randolph Schwabe Memorial Exhibition*, The Arts Council.

up by train from Oxford with Muirhead Bone. He details the time and place of meetings, lists those present and outlines the business covered. Schwabe himself was commissioned by the W.A.A.C. to produce a series of portraits of home-front heroes. His diaries are enriched by conversations with his sitters. His draughtsmanship and painstaking attention to detail made him an ideal choice to record bomb damage in Coventry in 1940 (some days after John Piper had visited) and in London the following year and again in 1945. Schwabe's interest in the past and in architecture, particularly historic buildings, make his descriptions of bomb damage visually and verbally acute and accurate. His work on the W.A.A.C. together with his Slade duties and the problems of daily life during wartime would have left him little spare time to keep his diary, but it is likely a mark of its importance to him that he continued to do so. It is notable but perhaps not uncommon that there are few in-depth musings regarding the course of the war and wider issues, the focus largely being on turning points in the war including the sinking of well-known German battleships and the fear of Japan entering the war. Pre-war, Schwabe recorded details about Jewish academics who had fled Nazi Germany and noted the disturbing emergence and occurrence of meetings held by Fascist groups.

Given Schwabe's expertise in matters of art, he was much in demand to serve on juries and national committees, including the New English Art Club (he had been a member since 1917) and the London Group (from 1915), and for many years he was an examiner for the Board of Education and a judge for the prestigious Prix de Rome. From his insider vantage point he sheds new light on the inner workings of these groups and organisations and the dynamics of the inter-relationships and tensions within.

Alongside documenting these various duties and roles he provides unique insights into the running of the Slade, but this is not the mainstay of his diary, rather it forms a minor yet especially important part as during the war years there were no committee minutes kept.[3] Nonetheless, his aspirations and lifelong dedication to the Slade are much in evidence. While his diary is not confessional *per se* there are illuminating passages when he shares his private fears and concerns about speaking in public due to his stammer and whether it was ground for resigning, and he wonders what the students think of him. Naturally left-handed, he was made to write and draw with the right; the pressure allegedly led to his slight stammer. Some of Schwabe's earliest diary entries also offer revealing accounts of his difficulties over staffing following Tonks's retirement and his desire to have his good friend and R.C.A. colleague Allan Gwynne-Jones teach painting. He strongly believed that 'the assumed ill effects of his [Gwynne-Jones] being appointed were very much exaggerated.'

Schwabe was a sympathetic and kindly teacher who was well liked by colleagues and students who appreciated his genuine interest and encouragement and the time he took to help them advance their careers. The younger generation of up-and-coming artists

3 Pers. comm. to Alice Barnes from Stephen Chaplin, Leverhulme Research Fellow & Slade Archivist, 30 June 1997. See also Chaplin's (1998) *A Slade School of Fine Art archive reader: a compendium of documents, 1868-1975, contextualized with an historical and critical commentary, augmented with material from diaries and interviews.*

frequently turned to Schwabe for advice and testimonials when seeking employment. He records with a degree of modesty several instances of praise from esteemed fellow artists, though these in themselves do not suggest conceit on his part but rather reveal his own insecurities. The latter also become apparent at the end of the Second World War when he worries where he and his wife will live following the sale of their house which had become uninhabitable through dry rot. Prior to this he wrote about his concerns with regard to the cost of the upkeep of the house and expressed worries about his tax liabilities. He also voices his anxieties about being elected to The Athenaeum in 1934 and whether he could afford it and if he would 'fit' within such a London club. His anxieties were unfounded and as his later diary entries show he found it an oasis of calm, where he rubbed shoulders with many celebrated figures of the day including leading artistic, literary and scientific figures and patrons of the arts and sciences. Schwabe became a member of the Club's Artistic Committee and later donated work to the Athenaeum Collection as had such artists as Philip Wilson Steer, Henry Tonks, William Rothenstein and Max Beerbohm.

Schwabe's visual acuity and interest in all that surrounded him, including the taken-for-granted nature of everyday domestic life, made him an ideal and interesting diarist with much to say. Seldom without a sketch book and sharp pencil poised, he was also clearly making mental notes about daily events both great and small. Thus he reveals the difficulty of getting domestic help and servants including those experienced by fellow artist Wyndham Tryon, who had a notice on the door stating – 'As Mr. W. Tryon has no servant, he cannot always answer the bell as quickly as he would wish' (10 February 1930). His reference to this could stand proxy for a whole society in the process of change and there are many other apposite examples which are interspersed with details about the weather, the removal of dining cars from trains during the war, and walking his dog on Hampstead Heath on a Sunday with artist friend Karl Hagedorn. It is these elements from the paraphernalia and minutiae of life coupled with his wry observations that punctuate his diary that make for intriguing glimpses into the social *mores* and customs of an age gone by.

On occasion Schwabe refers to earlier diary entries and reflects on what he has written with regard, for instance, to individual artists and his assessment of them, acknowledging in some cases that he may have misjudged their work. There are moments too of nostalgia when he recalls his childhood in Hemel Hempstead where his father opened a business as a letter-press printer and stationer and his education at Heath Brow School, a private grammar school in nearby Boxmoor where he was a day boy. Schwabe's talent for drawing was apparent from an early age and evidenced in numerous illustrations for the weekly school magazine *Heath Brow Chronicle* which was edited from the outset by his brother Eric. In his diary he recalled his schoolboy drawings appearing in the *Hemel Hempstead Gazette* when the town was granted a royal charter by Queen Victoria in 1898 making it a municipal borough. He also points out that, while living there, during the school holidays he amused himself by making brass rubbings. Such amusements foreshadow much of Schwabe's later artwork and his enduring interest in historic buildings and costumes. His diary descriptions of both are accomplished with effect and his

wide appreciation and understanding of these enabled him to undertake book illustrations in particular with profound understanding and sensitivity. His approach was one of thoroughness and, whether his subjects were imaginative decorations or costumes, all were tackled with intense concentration and much fidelity. Schwabe also frequently details the time spent on specific drawings including for instance the many hours he spent on depicting the Radcliffe Observatory in Oxford in the bitterly cold winter of 1942 while also noting the strange and often amusing things that people say to artists.

Like the rural clergyman Kilvert who kept a diary from 1874-79 and whose art criticisms Schwabe includes verbatim in 1946, Schwabe rarely writes about his motives for keeping a diary. Both Schwabe and Kilvert shared a curiosity and wonderment about life. Kilvert felt it would be a pity 'that even such a humble and uneventful life as [his] should pass altogether away without some such records as this, and partly too because I think the record may amuse and interest some who come after me.' It is likely that Schwabe felt similar sentiments, given his sense of humour and his ceaseless delight and interest in all that surrounded him. In February 1939 Schwabe wrote 'who but an egotist would keep a diary anyway?' Kilvert asks 'Why do I keep this voluminous journal?' He says 'I can hardly tell.' Schwabe acknowledges after suffering a major heart attack nearly a decade later in March 1948 that it was 'a resource to keep this Diary going'. It is a rich resource that is worthy of analysis.

No diarist tells all. A degree of selection is invariably exercised and fragments of a lived life with all its complexities and vagaries omitted. Regardless, Randolph Schwabe's diaries, written without the benefit of hindsight, like Kilvert's, serve to 'amuse and interest' and provide an evocative and unparalleled portrait of artistic life over two important decades for British art. His centrality to some of the 'most adventurous circles of artistic and literary society between the wars' is apparent and it is evident that he was 'at the height of his powers during the Second World War'.[4] Taken together these factors serve to confirm that Schwabe was ideally placed to sustain meaningful comment in his diaries and as such he might deservedly be regarded as the Pepys of the art world.

4 John Russell Taylor (2013) Teacher, Etcher and Charmer, *The Times*, 2 March, p.91.

Editorial Note

In editing Schwabe's diaries the intention has been to retain the original character and richness of the entries and the breadth of writing across these but for reasons of scale and economy approximately half has been cut to reduce the text to *circa* 250,000 words. To maintain coherence and narrative flow passages that offer little insight into Schwabe's artistic and literary circles, his personality and his varied endeavours have been omitted as have the shorter, unconnected, inconsequential and enigmatic entries. Further, lists of people attending meetings and exhibition hangings have been pruned on the grounds that these can be found in other readily available sources.

Matters relating to Schwabe's immediate family and his relatives are touched upon but these too have in the main been excised as they are not always relevant and moreover they are largely covered in his biography which I completed in 2012. Rare passages of repetition including repeated anecdotes have also been cut, as have most details of the films and plays he saw, the restaurants he dined at and painting trips he undertook, as they reveal little that is new or particularly interesting and do not advance understanding of him or his world.

Schwabe's inconsistent spelling of names and places has been mentioned; as a consequence these errors and stylistic oddities have been silently corrected for accuracy and in the case of style minimal adjustments have been made to facilitate ease of reading. Where Schwabe used contractions such as Bd. these have been retained and italics used for book and journal titles and newspapers in place of his underlining. A list of names used by Schwabe is provided to avoid confusion (and abbreviations used) as he used a variety of names (and spellings) for his friends.

Brief footnotes accompany the text for clarification with regard to the identity of individuals, places and events so as to aid full appreciation of the diaries. These necessarily are more numerous in the early years of his diary writing and in particular in 1930, Schwabe's most lengthy volume.

Biographical notes of more prominent individuals in Schwabe's life and networks, are contained in a separate section after the edited diaries; these are noted by an asterisk in the text against their name. This occurs in the main when they are first mentioned unless this is in passing when it is indicated later at a more appropriate point and indicated with an asterisk against their name in the Index.

ANNOTATIONS USED
When Schwabe has not made an entry for a week or longer, this is noted in italics in the relevant month, where he has not made entries for several days this is not noted.

...	indicate that text has been cut
[]	show where text/dates have been added for clarity
*	appears alongside an individual's name in the text to indicate an entry in the Biographical Notes; this convention is marked in the Index to facilitate cross-referencing
	books, journals, newspaper titles and foreign words are italicized
	names are standardised and a preferred way determined: i.e. Gywnne-Jones or G.J.

ABBREVIATIONS USED IN THE TEXT AND NOTES

A.G.B.I.	Artists' General Benevolent Institution
A.R.P.	Air Raid Precautions
A.T.S.	Auxilliary Territorial Service
B.E.F.	British Expeditionary Force
B.M.	British Museum
C.E.M.A.	Council for the Encouragement of Music and the Arts
C.I.A.D.	Central Institute of Art and Design
D.N.B.	Dictionary of National Biography
L.C.C.	London County Council
M.o.I.	Ministry of Information
N.E.A.C.	New English Art Club
N.P.G.	National Portrait Gallery
O.M.	Order of Merit
P.C.Q.	Print Collector's Quarterly
P.R.A.	President Royal Academy
R.A.	Royal Academy
R.B.A.	Royal Society of British Artists
R.C.A.	Royal College of Art
R.E.	Royal Engineers
R.I.B.A.	Royal Institute of British Architects
R.N.V.R.	Royal Naval Volunteer Reserve
R.O.I.	Royal Institute of Oil Painters
R.W.S.	Royal Society of Painters in Watercolours
S.K.	South Kensington
S.O.E.	Special Operations Executive
V.&A.	Victoria and Albert Museum
U.C.L.	University College, London
W.A.A.C.	War Artists' Advisory Committee
W.R.N.S.	Women's Royal Naval Service
W.V.S.	Women's Voluntary Service

ABBREVIATIONS OF NAMES USED IN THE TEXT AND NOTES

Albert R.	Albert Rutherston
A.G.J./G.J./Gwynne	Allan Gwynne-Jones
Birdie	Gwendolyn [Birdie] Schwabe
Bysshe or Bish	Harry Jefferson Barnes
D.S.M.	Dugald Sutherland MacColl
H.M.	Henry Moore
N.S.	Ralph Nuttall-Smith
R.A.W.	Rainforth Armitage Walker
Rush	Henry Rushbury
Will R./W.R.	William Rothenstein

1930

1930 marked a turning point in Randolph Schwabe's career as while teaching part-time at the Royal College of Art, Westminster and Camberwell he applied for, and was successful in obtaining, the post of Principal of the Slade School of Art. The diary commences when Schwabe is 44 and he and his wife Gwendolyn, known as 'Birdie' and their daughter Alice, aged 15, are living in Hampstead at 20 Church Row, having previously lived in Cheyne Walk, Chelsea. He records the politics of staff appointments before taking up the post as successor to Henry Tonks and over the next 19 years until his untimely death in September 1948 he reveals much about the artistic and literary circles that he was a respected member of and where his friendship and critical advice was sought.

JANUARY

Wednesday 1
D.S.M. [Dugald Sutherland MacColl]*[1] advised me [to] write to secretary of University College [London]. He also wrote out and presented me with a poem of his composition *'La Derelitta' To the Botticelli of Walter Pater*[2] as a New Year's greeting. He described Sickert's* appearance at the Italian Exhibition at the R.A. (I think on Press Day) in a baggy old brown suit and a rusty tall hat − almost the only one there. Saw [Cyril] Beaumont* about his Taglioni article[3]…Discussed the cover decorations for *Noverre*[4]…

Thursday 2
…Dickey[5] came in the evening…He was full of the Italian exhibition: talked about Stefano da Zevio [c.1375-1451] and Cosimo Tura's [c.1431-95] drawings in relation to his paintings also about the Francis Townes [1739-1816] at the Burlington Fine Arts Club, and various Newcastle affairs. [Donald] Towner* has apparently done very well as a teacher at the School…Dickey likes Towner's paintings as I do…

Friday 3
Revised back of *Noverre*, making top and bottom ornament heavier and simpler…Beaumont, who liked it…paid cash 15/-…

Saturday 4
Went with Alice* to buy a photograph album, and took her to the *Daily Mirror* Dolls' House at the Grafton Galleries…To S.K. [South Kensington] Library to find dates of [Walter] Crane picture books. Konody's[6] book on Crane has a dated list…Saw [Francis]

1 Painter, art critic and lecturer.
2 Pater (1839-94), literary scholar, author of influential essays on Italian Renaissance art, including Botticelli. See diary entry 25 Feb.
3 Some Portraits of Marie Taglioni, *Artwork*, Summer 1930, pp.125-29. Taglioni (1804-84), was one of the great Romantic ballerinas.
4 Jean-Georges Noverre (1727−1810), French dancer and balletmaster.
5 E.M. O'Rourke Dickey (1894-1977), Professor of Fine Art and Director, King Edward VII School of Art, Armstrong College, Newcastle upon Tyne (1926-31).
6 Art critic, *The Observer* and *Daily Mail*.

Kelly* in the Library. He has found some excellent new costume material for our book…

Sunday 5
Walk on the Heath with Alice, [Karl] Hagedorn,* [William] Grimmond* & dogs…H. says Geoffrey Nelson is a Manchester man – he knew him as a boy: likes his pictures, but not him. Objects to Rowley Smart, another Manchester man. Was reminded of Ian Strang's story of meeting R.S. in Paris, at the [Café du] Dôme…and walking with him to the Café de la Paix, where the waiter refused to serve them on grounds that 'Monsieur (R.S.) n'est pas en tenue': his costume being a dirty pair of linen trousers and a shirt open to his navel…In the evening at Hagedorn's saw some excellent photographs of sculpture, 13th-14th century…at Freiburg-im Breisgau, whence Hag. comes.

Monday 6
Tea with Albert & Margery Rutherston,* 11 New Square, Lincoln's Inn. They are in the same dilemma as regards housing as everyone else seems to be. They are going to sell Nash End Cottage. Albert working on a book of a specially Jewish character[7]…It is to be very expensive (£35 a copy). His pen drawings extremely well reproduced. In Sandland Street, Red Lion St., met Malcolm Osborne[8] buying a book in second hand shop. Lent him 2/6d because he had no change. Albert told me that Morton Sands[9] used to support Euphemia Lamb[10] in the [J.D.] Innes days.

Tuesday 7
At R.C.A. [Royal College of Art]…Margaret Barker[11] interrupted me, up from her school near Birmingham…with some very nice work done last summer. Lithograph of [Elizabeth] Vellacott, and another of some people in an arbour in a garden…Met Oliver Brown[12] in the Tube. Story about Joe Duveen[13] commissioning a picture from [James] Pryde,[14] and then backing out when he found it was £800, Pryde's usual price. Had never heard of Pryde till Manson[15] told him that he ought to buy one of his works. O. Brown was asked to referee price, but his decision was disregarded. He supported Pryde. 10p.m. at Windsor Castle[16] with Walter Bayes* formulated Board of Education Exam. papers.

Wednesday 8
…Bought [R.L.] Stevenson's *Familiar Studies of Men and Books* [1901] and read a good deal of it. Interesting that such a self conscious and careful stylist should fail to correct one or two blunders in English…

7 *The Haggadah*. A New Critical Edition with English Translation, Introduction, and Notes Literary, Historical, and Archaeological by Cecil Roth. With Drawings by Albert Rutherston. Curwen Press.
8 (1880-1963), Head of Etching and Engraving, R.C.A.
9 Collector and patron, brother of the wealthy artist Ethel Sands.
10 An artists' model. Born Nina Forrest, she married Henry Lamb in 1906 (divorced 1927). He called her Euphemia because she looked like the female in the Italian Renaissance artist Andrea Mantegna's painting of St. Euphemia.
11 R.C.A. (1925-29), Schwabe encouraged her to send *Any Morning* (*c.*1929) to the N.E.A.C., it was bought by the Chantrey Bequest for £40.
12 (1885-1966), art dealer.
13 See *Duveen. The Story of the Most Spectacular Art Dealer of All Time* by S.N. Behrman, 1951. Duveen (1869-1939) had galleries in Paris, New York and London.
14 (1866-1941), painter architectural fantasies and interiors, lithographer and designer of posters.
15 James Bolivar Manson (1879-1945) painter, Director Tate Gallery (1930-38).
16 Public house.

Thursday 9

Worked on two water-colours which needed amendment. [William/Willy] Clause* advised on one. Telephoned Miss [Ethel] Sands[17] asking to see her Sickerts for *Artwork*... Dinner at Burlington House with Academy Club, F. [Francis] Dodd* my host: his other guests were Stephen Bone, Stanley Anderson and [Harold] Isherwood Kay.[18] Speeches. Toast of 'Honour and Glory to the next exhibition'...Excellent dinner...The Italian pictures wonderful. Dodd knows them very well, and has interesting views. Many pictures new to me, and drawings – so much more subtle than any reproductions of them...

Friday 10

...Arranged for Miss Dickenson and Hayes at R.C.A. to work as assistants under Percy Smith on some decoration paintings. Will R. [Rothenstein]* told me that Wellington* is competing for Slade Professorship and that Maclagan, Holmes and MacColl are on the advisory board. He has told Wellington that he has spoken to Gregory Foster in my favour. Lunch with Wellington, Harding, G.J. [Allan Gwynne-Jones*], W.G. Newton, Durst* & H. Moore...Tea with Mahoney* & [Percy] Horton, also very well informed about the Italian pictures. Agreed in most of our judgements. Horton is painting Ishbel MacDonald.[19]...With Bayes at Windsor Castle. He is reviewing Hill's [1905] book on Pisanello's [c.1395-1455] drawings for the *Saturday Review*. Shall try to buy the book from him when he has done it. Wellington said that Duveen promised more money for Morley College decorations. Mahoney says his [*The Pleasures of Life*] is nearing completion.[20]

Saturday 11

...Ethel Sands has some really excellent Sickerts...made notes of some which would reproduce...A good new Duncan Grant, still life of a mantel-piece, colour and quality delightful: same subject has been painted by [Roger] Fry, Miss Sands herself and others. The mantle-piece is at Miss Sands's house in the country...D.G. and Vanessa [Bell] are going to decorate the ground floor back room with an architectural treatment on the walls where pictures cannot be hung. Four drawings in pen and wash by [Henry] Tonks* of George Moore's amours, to illustrate *Confessions of a Young Man* [1886]. Very amusing...Called on T. Monnington & Jane* [Winifred Knights' nickname]...The Big Bank picture[21] very well advanced, the principal part underpainted in a red monochrome. The distant part, which is to be red, underpainted in green. Extreme realism of drawing in coats and trousers – have never seen the like. It is good, intelligent drawing, though, and the whole thing will be better than [his] *Queen Anne*.[22] I think the actuality gives him an advantage...Jane says Lady Pansy Lamb[23] has been fined at Salisbury for running into the Butter Cross, or some trivial offence with her car. The Lambs at Coombe Bissett and Monnington's doctor cousin in Salisbury have struck up a friendship.

17 (1873-1962), painter, founder member London Group (1913), friend and correspondent to Sickert.

18 (1893-1938), National Gallery (1919-38), Keeper and Secretary (1934-38).

19 (1903-82), daughter Prime Minister, Ramsay MacDonald and his wife Margaret MacDonald (née Gladstone).

20 The Refreshment Room was decorated by Edward Bawden and Eric Ravilious.

21 Monnington was one of a number of artists commissioned to undertake a series of murals to show working life in the Bank of England; these were hung in the Bank's new building. He married Knights in Rome, 23 April 1924.

22 *The Parliamentary Union of England and Scotland, 1707*, c.1925-27. (The English and Scottish Commissioners present the Articles of Agreement to Queen Anne at St. James's Palace.)

23 She married Henry Lamb in 1928, in 1931 under her maiden name, Pansy Pakenham, published a novel, *August* based on the world of Garsington, Oxford.

Sunday 12
...In the Tube met Grimmond going for a walk with his Sunday Ramble club. Founded by Leslie Stephen – its 50th anniversary today. Back in Hampstead met Towner...Went up to his studio in Heath Street. He is painting a landscape, as it is too cold to work out of doors, from an oak log, dead leaves and other material which he has collected and arranged on a table. The oak log about four feet long. He poured water over it to give an effect of a pond, but most of the water was on the floor. Walked with Hagedorn on the Heath. He regretted his lack of academic training, as E.[McKnight] Kauffer[24] once did to me...Towner came in after supper. His father was a naturalist and he (Towner) used to make highly finished drawings of his father's specimens when a child (beetles etc.)[25]

Monday 13
Albert R. wrote that his name was also on the list for the Slade, and that, having heard of it, he had not withdrawn it. A very decent frank letter. Replied cordially at once. A strong competitor Birdie* and I agree...

Tuesday 14
...V. & A. about Walter Crane again. Kelly in Library as usual. R.C.A. 1.30...

Wednesday 15
Meeting at 3 King St. [Covent Garden]. D.S.M. rather pleased with a poem he had written on the Syon House-Sewage Works affair.[26] *The Times* refused the poem, but it will appear in *Sat. Review*. Meeting with Hugh Dent[27]... He presented me with a copy of [Edward] Bawden's *Peter Wilkins*,[28] and asked me to make a portrait drawing of him...I asked £15.15.0...

Thursday 16
...[Charles] Vyse* at Camberwell. Arranged to go to his studio with Birdie to select a pot as his Christmas gift to us...

Friday 17
Bayes at Westminster talked of the early days of the Camden Town Group; and said that later Wyndham Lewis suggested to him that he should do some Cubist pictures (or Vorticist) such as W.L. was then working at: to which Bayes replied that he might do them when they were out of fashion, but he would be dammed if he would because they were the fashion. 11.30 wrote Margaret Morris[29] postponing Alice joining her classes, indefinitely, as she can't fit them in.

24 Edward McKnight Kauffer (1890-1954), born Montana, USA, influential poster artist and graphic designer. Produced some 140 posters for London Underground.
25 Towner's father was the nephew of John Chisholm Towner who left money to form an art gallery for Eastbourne. The old Manor House in the Old Town was bought and became the Towner Gallery.
26 '...a Committee of the Middlesex County Council wants to turn Syon Park, on the opposite side of the Thames to Kew Gardens, into a sewage farm. The Duke of Northumberland, the owner of Syon Park, objects to the proposal...,' *The Spectator*, January 11,1930.
27 Dent joined the firm in 1909, and was an editor for Everyman's Library.
28 *The Life and Adventure of Peter Wilkins* by Robert Paltock, illustrated by Bawden (1928 Dent) – his first book.
29 Morris (1891-1980), teacher of dance, trained teachers in her system of 'Margaret Morris movement', partner Scottish painter John Duncan Fergusson (1874-1961). The Schwabes knew them from their Chelsea days.

Saturday 18
…*Artwork* letters…Walked across Heath…back to Clause's, and saw his picture of Birdie and the dog. It is going on well, but he rounds the features too much. It is less like than it was.

Sunday 19
Jean Inglis* came in…Says Howard Hannay[30] has left Winnie (whom Birdie went to see the other day in Thurlow Road)…

Monday 20
Took Kenneth Clark's photographs to R.A.W.[31] to be sent to block maker. Clark seems to have been rather hurt at his reception when he brought them to the office – Miss Jones was perfectly civil, but I suppose he heard R.A.W. roaring that he didn't want to see anybody. Letter from U.C.L. [University College London] fixing interview for Monday next. Painful business.

Tuesday 21
Will R. very full of a theory that he was the first painter in England to appreciate the value of solidity in design and the treatment of *planes* as surfaces reflecting light: in fact that he was on the way to the Cézanne idea, without being touched by Cézanne, as early as about 1900-1904 when he abandoned the Whistler tactics. Tonks and Steer* did not understand what he was driving at. He feels he ought to have some credit for anticipating artists who are just now being written up – [Harold] Gilman, [Spencer] Gore etc. He is sensitive about such things. He says he appreciated Courbet (I asked him if there was an influence here), but thinks his change was his own spontaneous development; and that he was ahead of Roger Fry by some years. Preferred to say nothing about Sickert's connection with the stage as the little he remembers, or that his wife remembers, is too vague, and it may be thought a delicate subject by Sickert.

Thursday 23
Got Vyse's pot, a very nice one. This makes three he has given us.

Friday 24
Lunch at The Clan with Wellington, Harding, H. Moore, Durst, Gwynne [-Jones] (who has just come from criticising the Eton students' drawings). Bayes, at the Windsor Castle wished me luck with the Slade. [Philip] Connard is supposed to be another candidate, and, Bayes thought, a powerful competitor…He himself is too old for this or the L.C.C. [London County Council] Central School job, which is £1400 a year…He is very youthful in mind and energetic, in spite of a hard life. I read his article in the *Saturday* about the Camden Town Group. I only went there once, to Fitzroy St., when Gore was acting as showman, and asked me if I would like to see some work by Walter Bayes. I asked 'Who is Walter Bayes?' and Gore repeated my question with great scorn. Bayes got me my first teaching job at Camberwell, and later got me to the Westminster. We had only met once or twice before those days. He was apparently struck by a decoration I did for

30 Author *Roger Fry and Other Essays*, 1937.
31 R.A. Walker, sub-editor and manager *Artwork*, Schwabe succeeded D.S.M. as editor from the Autumn issue. Clark contributed Postscript to the Italian Exhibition, *Artwork*, Spring 1930.

an Arts and Crafts show at Burlington House [1916], where he was doing some large panels too: the same show that Augustus John did his big *Galway Peasants* for.

Saturday 25
Called on Arthur Watts.[32] Looked in at Kenwood [House] in the course of a walk. Saw... the Turner (which is very fine) the Crome, which though I like it so much, always looks so much poorer in that light than it did at Burlington House...

Sunday 26
Met [Charles] Ginner[33] issuing from the passage lined with dustbins which leads to the door of his rooms (where the Unwins used to be) above Gaze's shop on High St. One often sees him from Flask Walk through the window, painting steadily. He is getting fatter. After lunch, a tremendous telephone harangue from Wyndham Tryon explaining his reasons for resigning from the N.E.A.C. [New English Art Club]. The Orpens[34] at the last show were his greatest pretext. I didn't like them either, but have not resigned on that account. He objects to Nevinson as a member – 'a poster artist' – thinks Rushbury should put his drawings in the waste paper basket: says that we (not especially me) are almost all Victorian, sentimental, anecdotal, and don't know what plastic art means. He excepts Ethel Walker.* Has quarrelled with [Alfred] Thornton.[35] I said I flatly disagreed with some of his opinions, but would like to talk them over with him some day. His reasons for resigning I rather respect and think, in justice to him, that he was not so much moved by the fact that what he considers his best drawing was excluded (it was one that Duncan Grant likes and now has hanging in his studio) as by his feeling against 'Academy' painting.

Monday 27
The great interview with the Advisory Board (Slade Chair)...arrived...20 minutes too early. Allowed to smoke in waiting room. Read Stevenson's *Charles of Orleans* [1876] but mostly inattentively. Rodney Burn arrived 2.55, in state of high nervous tension...I knew nothing of his candidature, till five minutes before I arrived on the doorstep. I met Wellington in the street, and asked him if he were coming to the interview. He flushed and said he had not been asked. Awkward and surprising. It seems from later gossip that Daniel of the N.G. [National Gallery] had put him up a week before (at Tonks's instance?) and had been coaching him on how to behave before a Committee...I in a state of nervous tension too, but not so bad as Burn. He went in first, and was there half an hour. I kicked my heels, practising little steps on the carpet, at length summoned, put a good face on it. Recognised only Gregory Foster, [Eric] Maclagan, [Sir Charles] Holmes and D.S.M. Various questions – Had I ever had to deal cases of insubordination? (Gregory Foster – 'certainly not, never had any') Had I a good constitution? Told them about my weak heart, discharge from Army, and total disbelief in cardiac affection. By the way missed a good chance of reply to Gregory Foster, on insubordination. Might have reminded him that he threatened to expel me from the Slade on that score years ago – breaking windows was the last offence. 'Difference between art teaching at the R.C.A.

32 Illustrator and artist, his work appeared regularly in *Punch*.
33 Ginner (1878-1952), founder member London Group, Camden Town Group. Lived 61 High Street, Hampstead.
34 William Orpen exhibited *Armistice Night (Amiens)*, *The Mad Woman of Douai* and *Changing Billets*.
35 Thornton (1863-1939), wrote *The Diary of an Art Student* (1938), studied Slade and Westminster.

and Slade'? – Reply, 'considering that the R.C.A. Staff was half ex-Slade men, there couldn't be much'; but commented on weak charm of the lesser sort of Slade drawing, and urged that the Design side should be strengthened. Thought I saw approval from Holmes. 'Where was I educated?' – 'At a small private school in Hertfordshire' (Burn in Harrow). Other questions as to literary work and lectures. Said I *had* given three lectures at R.C.A. (Design School – on Costume) but that it was not my métier…

Tuesday 28

…at R.C.A. Rothenstein sent for me to ask if I had heard anything. Said he had heard that the Board, had decided unanimously, but that their decision would not be announced for some time. Telephone from Evelyn Shaw to go over and see him at once at Lowther Gardens. Found Monnington there; both very solemn. Shaw asked me very earnestly and confidentially whether I would like to have Monnington at the Slade in case I got the job. Repeated what I had said to M. months before that I would like to ask him but did not know how far my hands might be tied. The explanation of this question was that M. had had a caller early this morning who had asked him whether he would work with Burn if B. was appointed. After a short interview with Anonymous Important Person M. said 'yes'; but reflected afterwards that he didn't want to – or at least not so much as he wanted to work there with me; because he thinks B. has no experience and would be incapable of the work (this he said deliberately, as a friend of Burn's, and knowing him better than I) so that M. would have to do the job of Professor himself and supply B.'s want of experience. This he does not wish. He had turned down the idea of being Slade Professor himself: they had got so far as to ask him to come up for interview on Monday. He is too busy, and does not sufficiently like doing that sort of thing. The Anonymous Important Person told him that it would make the greatest difference to Burn's chances of being appointed if it were known that Monnington and Burn would work together. Therefore as Shaw and Monnington both say they want me to be at the Slade, they put it to me that it was of the utmost importance to my chances if it could be known that M. would work with me. Then followed a more remarkable revelation. Shaw this morning has also been visited by an Anon Imp. Person (whether the same or not I don't know), who had said if Schwabe goes to the Slade, he will take Gwynne-Jones with him, and he (G.J.) will clear out half his students from the School!: and that this must not be allowed. Followed some instances of G.J.'s tactlessness and indiscretion, from Shaw and Monnington; and they ended by asking me if I would undertake not to press for G.J.'s appointment. I replied that I could not go back on what I had said. It had been my intention to ask G.J. to teach painting, as I honestly thought that he taught it very well, as was evident at the Royal College of Art, and I thought that the assumed ill effects of his being appointed were very much exaggerated. 'Very well' said Shaw. 'You destroy your own chances': and continued to explain that there was an impression that G.J. would run the Slade through me. I held my ground: and it then occurred to me that, after all, all appointments suggested by the Slade Professor have to be ratified by the Senate, or who ever it is, and there would be plenty of opportunity for Anonymous Important Persons to make their objections felt, and quash unwelcome aspirants, when such suggestions had been put forward in a formal way. 'Would you resign if Gwynne-Jones were not appointed?' asked Shaw: and I replied 'certainly not'. So it was settled that Shaw was to explain the position to the person concerned, on those lines. I thought it extremely friendly of Shaw and Monnington (and said so to them) that they should

give me their support: but it occurred to me on the door-step that Shaw has an axe to grind, charming and friendly though he is in many genuine ways. Tommy has nothing, personally, to make out of it. He hates intrigue as much as I do. But Shaw is in a difficult position with the School at Rome now that Lord Esher is dead.[36] His committee, except Esher, never was very interested in the Arts, and would cheerfully give up much that Shaw has been working for. Shaw wants the support of the artists, and feels that the Slade, if well run and sympathetic, would give him strong backing. Having worked with me on the Imperial Gallery, he finds, I gather from Monnington that my interests, in sculpture, painting and architecture combined, are wide enough for his purposes…

Wednesday 29
D.S.M. in good form: peace with Walker. He actually hummed a tune…He permitted himself to say that I 'impressed the Committee very favourably'…Pleasant to hear, as one never knows what impression one makes on other people. They might have thought me a damned fool.

FEBRUARY

Sunday 2
Recollection of Hervey Fisher's account of Watts's marriage with Ellen Terry – the Fisher family being intimate with the Little Holland House circle, the legend may be authentic – Ellen Terry being very young was mightily impressed by G.F. Watts, and put down her school girlish thoughts and emotions about him daily in her Diary. Her elder sister Kate… used to read this…and could think of nothing better to do than to take the Diary and hide it under Watts's pillows. He woke in the night…and found the book and read it. He was stirred, and felt that having caused this commotion in the young girl's breast only one course was open to him as a man of honour. The next morning he drove over to the Terry's house in a gig, to propose to Ellen; but by this time Kate Terry had become alarmed at the possible consequences of her action, and seeing Watts drive up gave instructions to the servant that they were not at home. Watts prepared to drive away, but just outside the house had some breakdown with his gig, returned, and was admitted. Ellen rushed into his arms as the novelists would say, and the affair was settled. A year after she had left him, he rang the bell in his studio, and absent mindedly asked his maid to tell Mrs. Watts that he wished to see her.

Monday 3
Called on [Charles] Tennyson* at Dunlop's. Very swagger offices, pompous and efficient commissionaires, well dressed young and old men of business…Went to the Goupil Gallery to arrange about exhibition of drawings. Open April 3rd: 30 to 35 works of mixed character. [Elliott] Seabrooke was there, overhauling the exhibition of his oils, not yet open to the public…Extraordinary how he turns out such masses of pictures and yet keeps to his work on the stage. Most of them are a bit casual and empty. Noticed that Dorothy Cheston is acting in *Milestones* at the Criterion. Judging by her photographs outside she has lost some of the prettiness she had…before she got off with Arnold Bennett. I believe I designed a dress for her in some play. Burn and Horton at R.C.A. helped

36 The British School at Rome was founded in 1901 and received its first Royal Charter in 1912. Scholarships are awarded annually to students in Architecture, Painting, Printmaking, Sculpture and Classical Studies.

to select some of my drawings for exhibition.

Tuesday 4
At 11 Bedford Street started to learn business of make up on our next number [of *Artwork*] with R.A.W.'s assistance. L.D. [Lowes Dalbiac] Luard came in by appointment…A very pleasant fellow, but is going to give me…trouble over his illustrations.

Wednesday 5
Lunch at Stone's. They have altered the character of the place by putting the waiters into silly costumes, apparently intended to be 17th century…Letter at home (11 o'clock) from F. Dodd congratulating me on Slade Professorship. Didn't look on it as anything but rumour. Later Birdie told me that Randall Davies had telephoned and [Henry] Rushbury telegraphed to the same effect: but the thing evidently may be traced to Dodd. Got little sleep, either of us…

Thursday 6
Telephoned Dodd thanking him…also asked for his sources of information…Prof. Adshead is on the Senate of University, and reported details of meeting to his son-in-law Stephen Bone. It seems that Tonks made a long speech, quite out of order, and too long for their patience, and finished by saying nice things about his successor…Shall not spread news about Slade appointment before official announcement…Back to R.C.A.: met Codrington. I didn't realize he wrote plays. It seems he has had one or two running in his time. Burn at the R.C.A. He is almost painfully anxious and bothered, but I didn't like to report what I had heard about the Slade…started design for [Edmund] Blunden's[37] poem, as Beaumont is worrying. Called at his shop…but it was locked up.

Friday 7
…R.C.A.…Angela Culme Seymour came to see me. She might be a hopeful student: was at Bedales[38] with Alice and had a letter of introduction from Meo.[39] Advised her to start at Westminster as she is not prepared to join the College as a full time student…W.R. brought in Gilbert Spencer,[40] whom he was showing round as a prospective addition to the Staff, in place of Alston, who retires at the end of the summer; an ugly cheerful boyish fellow, whom I was surprised to see with some grey hair already, having always looked on him as a youngster. I hear that Bawden is coming on the Staff of the Design School too. Mahoney had tea with [Stanley] Baldwin[41] at the unveiling ceremony at Morley College yesterday. Everyone says that W.R. spoke much better than Baldwin, and I remember him completely outshining professional speakers at a Staff Dinner…D.S.M. liked Bawden and Ravilious, but thought Mahoney's colour was bad. W.R., on the other hand, says that Mahoney must be recognized as someone who will count in British Art.

37 *A Summer's Fancy* (1922).
38 Founded Steep, Petersfield, Hampshire in 1893 by John Haden Badley to educate 'head, hand and heart'; in 1898 became fully co-educational.
39 Head of Painting and Drawing at Bedales (1923-40). Known affectionately as 'Gigi', studied Slade (1905-08).
40 Professor of Painting R.C.A. (1932-48), Head of Painting Glasgow School of Art (1948-50) and Camberwell (1950-57), brother of Stanley Spencer.
41 M.P. and former Prime Minister.

Saturday 8
...A reporter from the *Evening News* asked to see me, but I sent him away...His movements are traceable to a paragraph in *The Manchester Guardian* of today, of which Hagedorn informed us by telephone, and which Alice bought for me, announcing it was pretty generally assumed...that I was to be Tonks's successor...

Sunday 9
Walked with Hagedorn, Mr. and Mrs. Grimmond on the Heath, to Kenwood and Highgate. Looked at Cromwell's House, and the two houses on the Grove now knocked into one for Gladys Cooper[42]...Doctored Collins Baker's English in a review of Burgundian Art.[43] He must have been in a hurry when he wrote it...

Monday 10
Returned a water-colour, which was originally borrowed by [Edward] Lintott for his book on *Watercolour* to Wyndham Tryon, now living at 21 Ampthill Square. Notice on the door – 'As Mr. W. Tryon has no servant, he cannot always answer the bell as quickly as he would wish'...He put on two records, Bach, and a Jewish singer. He seems in an unsettled excited state of mind: gave me a stiff whiskey & soda (10.30 a.m.) and told me about the new sub-conscious phase of his pictures, most of them based on 'visualizations' of music...Called on Beaumont 6.15, giving him draught [sic] illustration for Edmund Blunden. Camberwell as usual 7-9.30...

Tuesday 11
At R.C.A....John Young of Macquarie Galleries came with invoice forms to clear my drawings and prints through the Customs at Sydney, where they are held up...Telephone S.O.S. from Walker...Trouble about Kenneth Clark's article. He has written a sour letter, unnecessarily so, about the arrangement of his illustrations. Quick lunch and back to College, 1.30. Recommended B.E. Allen of College staff to the Arts League of Service as a silversmith, in response to their enquiry. Heard at home...that 30 inhabitants of South End Road have written jointly protesting against G.J.'s proposed additions to Bath Cottage...They even offer to buy it back from him to stop him doing it. 11.15p.m. met Towner in Tube station. He is going to Ivinghoe for week to paint. He was there at this time last year, so won't waste time looking for subject matter. Ivinghoe always brings back my school days, when we used to go there on 'long walks' from Hemel Hempstead. Beautiful country, and I believe quite unspoiled except around Tring.

Wednesday 12
At 3 King St....MacColl and Leonard Elton waiting. Elton is to be considered in the light of a possible assistant-ed. if I succeed D.S.M. as editor. Violet Hunt's article on 'Stunners', and one from Martin Hardie on Edwin Lear. V.H. diffuse and toshy, but amusing things in it. Took D.S.M. to the Duncannon Arms...stood him a sherry and bitter and showed him A.R. Thomson's Pickwick decorations, which he had not seen except in photographs. He liked them...16 students at Camberwell, men and women, Vyse may chuck it...Sorry if he does. I enjoy his company on Thursdays...

42 Dame Gladys Constance Cooper (1888-1971), actress.
43 Painter, art historian, Keeper National Gallery. The review of Les Richesses d'Art de la France. La Bourgogne, la Peintre et les Tapisseries. Par Louis Réau (1929) appeared *Artwork*, Summer 1930.

Thursday 13
...College...Long conversation with W.R.: gave him what news I could about the Slade...
He says he was one of my sponsors. Spoke highly of Mahoney, and I agreed. He wanted
me to demonstrate specially to a new Indian student, which I did...Tea with Mahoney.
He remarked on the obvious weakness of the critics at the Morley College opening day
– going round asking everybody what everybody else had said – afraid to voice positive
opinions of their own. Regarding the recently founded Young Painters Society, was
amused at the rejection of their overtures by the London Group, in the following terms:
The Committee were of the opinion that as a free society run by artists the principles of
the Group were opposed to those of a subsidized society controlled by critics and art
dealers (Eddie Marsh, Marriott, Tatlock & Co). A very proper spirit anyhow. The N.E.A.C.
has turned the thing down too. W.R. rather critical of Violet Hunt.[44] They are neighbours
but the Rothensteins don't encourage too much intercourse. She brings everything round
to the subject of sex – a mania with her. Her allusions to the beautiful Miss Herbert and
Edward VII's love letters, though funny, do not strike R.A.W. as printable.

Friday 14
...Long of the V.&A. called with a letter from Lord Biddulph, asking him to recommend
a young artist to make a drawing of his Lord B.'s daughter. I suggested Horton...

Saturday 15
I recall that Miss Creswell Clark, who studied under Bourdelle in Paris, and comes to
Camberwell on Thursdays, described Bourdelle [1861-1929] to me as wearing the
peculiar coat seen in his photographs (a sort of frock coat without collar or revers, and
buttoned at the neck) over his sculptor's blouse, so that he was ready for work in a
moment, on removing the coat which was grey velvet, and was worn out of doors with
a wide grey hat: no collar or tie. Clause came in and talked about Stanley Spencer who
visited his studio last year. S.S. painted the *Resurrection* in a narrow room, in which he
had little space to get away from his work. He had some peculiar system of judging the
tone of it by enclosing passages in a white cardboard mount and moving the mount
about all over the canvas. He explained this system to Clause...I don't quite see the good
of it myself. Walked with Birdie...and looked at Bath Cottage. Cannot see that the
architectural beauties of the row are such that they will be greatly damaged by a little
addition to the sky-line, which is pretty irregular as it is. The protest of the inhabitants
must be based on sentimental grounds. George Kennedy is too good an architect to make
a thorough mess of it...

Sunday 16
Walked on the Heath, with the Grimmonds. Met Horace Taylor near Wilde's Farm, push-
ing one infant in a pram and leading another...Odd how no one within a mile and a
half of the Heath seems to resist it. In Chelsea no one ever walked at all, except perhaps
Ethel Walker, because she had two dogs. Birdie told me that Clause doesn't expect her
nor any of his sitters, to sit rigid...as it worries him if he feels the model is strained or
tired or uncomfortable, and it puts him off his stroke. As an illustration of a different
attitude, Mrs. Gwynne told her that Allan [G.J.] used to keep Rogers the Guardsman with-
out a rest till, though a strong man in the best of training, he went green with faintness;

44 Isobel Violet Hunt (1862-1942), author, literary hostess.

and then exhorted him to stick it 'just ten minutes longer', with promises of half-crowns, and playing on Rogers's respect for him as an ex-Guards officer... I have heard...stories of models being hardly used by Ingres [1780-1867] and Meissonier [1815-91]. [John] Tweed flies into rages and swears at them. Manzi told me he said to Tweed: 'Mr Tweed, I am very good model: if you speak to me like that I go'...

Monday 17
... Met Violet Hunt...She looks nearly 60 and has the relics of a charming manner, but is diffuse and muddle-headed. She referred to her numerous quarrels, with May Morris among others: rather inconvenient in this case, as we want to find a good photograph of Mrs. William Morris, and May would have one. It appears that Walker's father was a parson near Kelmscott, and abused May Morris, from the pulpit for marrying a carpenter. Don't know what it had to do with him. Walker as a boy was caught climbing a tree in Kelmscott Manor grounds by Mrs. Morris, after some semi-domesticated pigeons: was called down, left his shoe at the top, and had to climb up again to get it under her embarrassing eye. V.H. produced a photograph of Rosa Corder, from a portrait painted by R.C. herself. Interesting, and probably very like. It is at St. Albans, in the possession of one of Rosa's illegitimate daughters, of whom she had two by Howell. She was Whistler's mistress also (according to V.H.) At 5 at the Grafton Galleries. Meeting to found a new Society of Artists' about 50 present, a very mixed bag...Elected a working Committee... I was suggested, but declined, too busy...I wrote yesterday congratulating [Gerald] Kelly on being made a full R.A.

Tuesday 18
Clause came to discuss the new society. Went to S.K. [South Kensington]. Kennedy of the Circulations Department, V.&A. wanted see me, so I went down and he showed me some drawings of Harry Watson's[45] which we selected from. Much better drawings than by Labouchère and other modern Frenchmen...In fact, rather good, rather slick, life studies. Suggested asking Walter Bayes for some of his, which are entirely different in approach, and did so later on, in the evening at Westminster. I approached him also about the new Grafton affair – he had already been approached. He says he can not afford six guineas. In the course of the afternoon Burn told me that he had been privately informed that he was out of the running for the Slade...to save him worrying. So now it depends on the Senate...Civil speeches on either side...Criticized Connie Rowe's and [Archie] Utin's work in the Staff Room, and wrote two testimonials...

Wednesday 19
Letter from Southport Gallery saying that they have decided to buy etching of *Piccadilly Circus*. Hagedorn arranged this – the 2nd print he has been instrumental in selling for me.

Thursday 20
Vyse said that [John] Revel had wanted me to be his successor at Chelsea Polytechnic rather than Jowett. In fact I should have been chosen if Jowett had not had such a flattering testimonial from W. Rothenstein...and if I had not conveyed the impression to the Committee that I was rather indifferent whether I got the job...whereas Jowett was keen. I was really rather relieved when I didn't get it. It is a great pity that Vyse is leaving

45 Landscape and portrait artist born Scarborough 1871.

Camberwell. He had a regular row with [Stanley] Thorogood[46] accusing Thorogood of not supporting him. I was present at one part of their argument, and backed Vyse up, but not offensively. Thorogood is the old fashioned type of art master who is not interested in art, but merely in running the school, and is, as Vyse says 'sitting on a cushion and waiting for a pension'. Vyse has the loyal support of his few students, and is one of the keenest, most valuable and disinterested teachers the place has had.

Friday 21
Went to Mary Adshead's show at the Goupil. She is very accomplished and has an amusing Rex-Whistlerian-Slade sense of decoration. There is a whole new school of the lighter sort of decorations now. Bayes told me how well Sickert lectured when he delivered the first of his series on painting at the Westminster School the other day; so that Bayes, who is deaf on one side, and was unable to hear much that was said, was delighted and amused by the play of his voice, his tricks and gestures…Bayes repeated to me Sickert's account of his commencing actor, which early training now probably stands him in good stead. Sickert says his father was against him becoming a painter, but thought he might make a living on the stage; so he called on Godwin the architect (who had theatrical connections) to ask him to use his influence for him. Godwin worked away at his drawing board, letting Sickert talk and saying nothing; then opened a cupboard and took out a pearl grey frock coat and tall hat, which he put on in place of his working clothes, descended the stairs, still silent, and hailed a passing hansom. They drove to a manager, to whom Godwin introduced Sickert as a young amateur actor of great talent, and whom he then asked to give Sickert a job. A touring engagement at £2 a week was immediately offered and accepted. Two pounds was quite a possible living wage in those days…

Saturday 22
Letter from Beaumont, who wanted urgently the copy of Blunden's poem…to make a new typescript from, as Blunden has lost his copy, and cannot get on with the revision. Went to Charing Cross Road, and wasted much time in second hand bookshops; bought F.G. Stephens [1894] on [Dante Gabriel] Rossetti and Francesco de Holanda (which interests me very much). A conversation with Mahoney the other day suggested Holanda[47] to me…Beaumont wanted to discuss a synopsis of illustrations for Blunden, whom he will see on Monday at the *Nation* office…Saw Blunden's letter approving in general of my rough design for the first illustration…Coming away from there (as Mrs. Beaumont was bringing the lunch into the bookshop…) was accosted by…Robin Guthrie. He asked whether he was to congratulate me on the Slade…He has an ineffectual appearance, a weak moustache and rather whining voice – characteristics which I remember in his brother at Dunhurst [Bedales Preparatory School]…I have reconsidered my opinion of him as an ineffectual painter and a sloppy and inconclusive draughtsman since I saw the picture of a pond that he had in the Imperial Gallery last year. This I thought one of the best pictures there, and now took the opportunity to tell him so…I always forget how young he is, and that he has time to develop.

46 Potter and Principal Camberwell (1920-38).
47 Originally Francisco d'Olanda (*c.*1517-85), Portuguese humanist and painter.

Sunday 23
...Mahoney came to supper...[he] met Rex Whistler at [Charles] Aitken's on Friday night: thinks he looks very like his work, and speaks so – a good deal of manner and not much behind. Albert [Rutherston] had been seeing him too, and his work, which A.R. thinks is so much *pastiche* that he doesn't find much to say about it. Thinks his book illustrations very clever. He has very great facility, too much probably...

Monday 24
Posted to R.A.W. [Lionel] Pearson article,[48] Mackintosh photograph & drawing...Wrote Elton proposing about 600 words on Bagaria[49] with one or two pages of illustrations...

Tuesday 25
Mahoney quotes Aitken,[50] whom he went to see in Church Row last Friday, as saying in disparagement that *La Derelitta*...is a Victorian work. Mahoney is annoyed by this, as he admires the picture: does not care over much if it is by Botticelli or not, but thinks it good. So do I. The sense of spacing, the drawing, and the general conception, are not common and not Victorian. I don't think Aitken knows much about pictures, though he is a fine public servant. He takes advice too easily to have very profound views of his own. Tonks was one of his moral supporters; and I remember him choosing a picture by Spencer Gore for the Tate from a show at Paterson's on the advice of John Hope-Johnstone, who also has few opinions of his own, but was that time primed by Roger Fry. A.B. Clifton wondered at Aitken's selection, and asked me as I happened to drop in after Aitken had left, which I thought the best picture in the room. I pointed to two or three which I thought were of about equal merit, and he concurred: then asked me whether I would choose 'this' indicating the one Aitken had said he was going to have, but not telling me that. I said 'no', and he explained his reason for asking, telling me that J.H.J. had been in the room when A. was there. The thing was unfinished, with the squaring-up still showing and couldn't have represented Gore's real intention. It was the last picture he painted I believe.

Wednesday 26
...Coming home from Camberwell, was met inside the door of no. 20 by Gwynne [Jones], with congratulations. Birdie waiting upstairs with *news* rightly furious at his tactlessness in not waiting for her to get it in first...It was on the wireless, and Ginger[51] telephoned to tell her.

Thursday 27
Congratulations from various sources – Anna Airy, Pocock, the Walkers, the Tennysons; Clause, of course. Went to *Illustrated London News* office, where Alick Schepeler[52] helped me in the search for the portrait of Madeleine Smith[53] that Violet Hunt wanted. Looked through the entire volume of 1857 without success...Alick had been to a cocktail

48 Mechanism and Craft in Architecture.
49 Lluis Bagaria i Bou (1882-1940) one of most important Spanish caricaturists in the first half of the twentieth century.
50 Director Tate Gallery (1911-30).
51 Joseph Bramhall Ellison, physician.
52 She met Augustus John in 1906 when a secretary at the *ILN*, for a number of years was his favourite model next to 'Dorelia' (Dorothy McNeill).
53 Smith (1835-1928), Glasgow socialite, defendant in a sensational murder trial in Scotland in 1857.

party at Viva Booth's, now Viva King, with Augustus [John], Poppet & Vivien,[54] King is in the British Museum ('in the China and Glass department,' according to Vivien). Party finished at Eiffel Tower. Jean Inglis at lunch told us that when she was at the Slade she showed some of her drawings to Tonks in the Staff Room, Brown* and Steer also present, and got such a terrible bullying from Tonks that the others were obviously most uncomfortable. Brown took one of the drawings to the window and said, 'But Tonks, this is rather a good drawing.' Steer said nothing, but took her hand and stroked it. About six months afterwards...T. broke out – 'Look here, I was a beast to you'...[Alexander] Stuart-Hill is painting [Edward] Wadsworth's daughter. Mrs. Wadsworth explains that if she went to a 'modernist' she wouldn't get a likeness: she might go to John, but he would make advances to her daughter whereas Stuart is quite safe in both respects. I got to the College at 4. Will [Rothenstein] came to my room and congratulated me...When I went into Q. Room, all the students clapped their hands: and in the 5 o'clock rest about 40 of the girls from downstairs were ushered into the Staff Room by Grant, the Common Room Secretary, and cheered...Official letter at home, and one from F. Brown. Told Will about G.J.– That he might want to go to the Slade with me. Took this well.

Friday 28
G.J. drove me to the College. Fuss more or less subsided... Letters from Tonks, Connard and others. Glad to get one from Tonks. Must go and see him...Tea with Mahoney and Horton. Chat about careers of past students. Lionel Ellis, Griffiths, Dawson and others. Ellis was apparently engaged to be married to a young lady from Devonshire, with an income. On the wedding day he ran away, or rather he watched from a house close by the wedding party leave the church after waiting fruitlessly for him. He went back to Jeanne Bellon the model, whom he has now married. They knock each other about, but they like that sort of thing – suits their temperaments...Ellis now working for the Fanfrolico Press with Jack Lindsay. Much obscene literature goes through their hands...

MARCH

Saturday 1
Went to Daly's with Birdie to see *The Way of Paradise* after [Aldous] Huxley's novel *Point Counter Point* Mrs. Ayrton sent us tickets, Max Ayrton* having designed one of the settings...

Sunday 2
Hagedorn said Jackson the picture dealer of Manchester was among the early buyers of Sickert, when he (W.S.) was very hard up. Jackson sold one of Sickert's pictures to Stephenson, who is connected with the press in Manchester and has something to do with the Atkinson Art Gallery in Southport for £12 and Stephenson later sold it for £80. Hagedorn goes to Sickert's lectures...About 75 or 80 come...Sickert tells them very little about painting, but chatters on easily and wittily without any notes or preparation. He now wears a well cut suit of checks...

Monday 3
...Artwork...Violet Hunt's information is obviously most unreliable. She has made mis-

54 Vivien (1915-94) and Poppet (1912-97), daughters with his second wife, Dorelia.

takes in nearly all her facts that I have had occasion to check...

Tuesday 4
...at Westminster recommended Clause to Bayes as a possible successor to myself, but not very successfully. In the first place he wants someone more important if possible, and means to try to get Wyndham Lewis, of all people, though he knows he will have all sorts of difficulties with him. I see his point in this. W.L. would be a great draw...In the second place, he wants to keep the place open for a bit, so that Meninsky* may have, temporarily, some extra work. Meninsky has had heavy expenses with his parents whom he supports or helps to support, and is very hard up. His mother had to have an operation. He can not take it on permanently...as he would then be doing more work than his status of part-time teacher is supposed to stand for by the L.C.C....

Wednesday 5
Went to Witt Library about an illustration for Luard. Met Lady Witt, and passed some affable back-chat. One of the secretaries told me that they now have over 350,000 specimens...Went on to see the Provost...says that my continuing with *Artwork* shall have his strong recommendation with the College Committee: advised me to see Tonks about questions of staff, Steer having not yet officially resigned. At lunch, Mrs. Leicester's, Philip Alexander talked very interestingly. He was at Oxford with Aitken, whom he describes as Bohemian in his tastes, and remaining unchanged therein by prosperity. Alex. was a convinced admirer of J. Ruskin when at Oxford: went to hear him lecture, and describes the beauty of his voice: remembers seeing him walking in the Broad, looking at the Moon, under the walls of Balliol...

Friday 7
W.R. lectured on the R.C.A. Sketch Club: subject, *Wuthering Heights*. He spoke very well about the atmosphere of that book...and about dramatic illustration generally...I saw Kennedy about some more drawings, by [Eric] Kennington this time, which he was choosing for the *Circulations*. Very remarkable...but I am unsympathetic about them. There was a hulking head of a General Currie, and another of a soldier – very good character in both, but strange empty passages: and some women's portraits, one rather cheap and flashy. However they are 'something'...

Saturday 8
...went to the Athenaeum in Gwynne's Morris-Oxford. Complimentary dinner to me. Present D.S.M., W.R., George Kennedy, Wellington, Albert, Clause and G.J., MacColl and W.R. talked reminiscences...Clause talked about de Conchy and the Renoir family at Cagnes...Albert spoke of the treasures of the Ruskin School, and how they had been neglected by [Sydney] Carline, who wasn't interested in that sort of thing, and by Carline's predecessor, who had been assistant to Ruskin and had lived somehow till not long ago...Carline did not get on well at Oxford: thought Oxford would be hostile to an artist, so assumed a hostile attitude himself. Albert has got one of the Colleges to let the Ruskin School undertake some decorative work in a College room...D.S.M. & W.R. spoke of Legros at the Slade. He was unhappily married, 'by' his landlady, a dull woman, who wouldn't let him have models and was altogether quite unsuited to him. I had the impression from them of a rather squalid ménage...D.S.M. said that when he was at his

busiest as a journalist, formerly, he never made more than £250 year by it.

Monday 10
...to S.K. to meet Kelly about choice of fresh line illustrations for the new book...Kelly is growing a beard and looks most disreputable...Sickert told Bayes that [William] Stott of Oldham was publicly kicked by Whistler in his Club. Whistler made a pretext of 'Maud', whom he wanted to get rid of (as he was about to marry Mrs. Godwin) having had too much to do with Stott, for whom she had been sitting. Maud had stuck to Whistler through his hard times. She wished to come back to Whistler, but he seized the opportunity of making a public demonstration – having organized the situation between Stott and her, in order to get rid of her. Stott should have knocked him down. He was a big man, much bigger than Whistler, but lacked physical courage. So 'honours' remained with Whistler, who behaved like a cad. Sickert thinks Maud is still alive. She was a model.

Tuesday 11
Rothenstein says that Arthur Symons[55] did not know Toulouse-Lautrec, or hardly at all: yet he talks as if they had been intimates...

Thursday 13
Monnington came see me in the afternoon at R.C.A., about the Imperial Gallery show. It seems we shall be short of pictures...He wanted my sanction to invite some more of the Rome scholars, [Edward] Halliday and [Robert] Lyon, poor artists both in my opinion (and in his), but he feels a responsibility towards them...

Friday 14
...Met [Boris] Anrep at Charing Cross Tube station about 11 o'clock, and travelled with him to Hampstead...Discussed Witt, Courtauld and Daniel. Witt he thinks does not know much nor care much, genuinely, about pictures, but uses Art for social purposes. Courtauld he likes. Says Mrs. Courtauld also has social aspirations, which her husband does his best to gratify. The new National Gallery people may not be so interested in Anrep's mosaics as in the past.[56] He is awaiting a decision from the Board...

Saturday 15
...Did two drawings for Beaumont's Rameau book[57] (he gave me a copy of *Noverre* in the morning, with a few little designs of mine in it and on the cover)...

Sunday 16
Birdie went to the Film Society with Alick Schepeler. I went to tea with the Vyses...to meet Guy St. Bernard, art critic of the *Daily News* and lecturer...I think we got on all right...as that was the kindly Vyse's reason for bringing us together – largely with a view to my coming exhibition of drawings...Birdie could not make head nor tail of one of the 'high-brow' films; neither could Alick, who is more high-brow. It is called *The Sea Shell and the Clergyman* and was rejected by the British Board of Film Censors on the

55 (1865-1945), poet, critic, magazine editor, became member of staff Athenaeum in 1891 and *Saturday Review* 1894.
56 Anrep created four mosaic marble floors for the entrance hall (1926-52). Born Russia settled in London.
57 *The Dancing Master*, P. Rameau; Cyril Beaumont (trans. 1931).

grounds that 'it is so cryptic as to be almost meaningless. If there is a meaning it is doubt-less objectionable'...[58]

Monday 17
...Did a small drawing for the costume book. The Marquis of Hartington came to see me about portrait drawings for Grillion's Club,[59] of which he is secretary...He was apolo-getic about the price offered £15-15-0. I told him that Trinity College Cambridge paid £20,[60] but that I would do, and did sometimes (!) do, them for less...The trouble about maintaining a sequence of portraits of members of the club is that so many of them were put off by the works of Sir F.[Frank] Dicksee, who was lately 'artist-in-ordinary', and did not give much satisfaction. Earlier drawings were done by [George] Richmond. Owen Seaman is now on the Committee, and the dinners are at the Cecil. He said (Hart-ington) that they were disappointed at Ramsay MacD. not being a member, as all other premiers had been: but R.M. excused himself on the grounds that it would cause trouble if it were known that he dined in that way with members of the Opposition...I showed Hartington a photograph of my drawing of Birrell,[61] whom he knows, of course. I always think that one came off well...

Tuesday 18
At Imperial Gallery all day to hang pictures. Monnington, Evelyn Shaw & Vera Ross... Duveen has clearly announced he won't go on financing the exhibition. His decision timed shortly after Lord Esher's death, as he had hoped by working with Esher to get nearer to what he wants – a peerage, with succession to his daughter...Vera Ross will be penniless when her job finishes. Her father died, leaving her nothing, and she was given notice from Duveen, at about the same moment I asked Monnington about the Slade, and the subject of our momentous interview of Jan. 28: he said that he thought a good deal of that had been hot air, but that it was not by any means altogether nonsense; but he had no new light. Vera Ross has a very elaborate painting, not at all bad, in the show, and I saw a meticulous pencil study of plants for it. Tonks has a charming picture of some children in a garden: there is an early Steer, blackish and difficult to hang; some awful pictures from the Dominions; an Adrian Stokes hangs side by side with a Porter, and a Duncan Grant looks less distinguished in queer surroundings than one might expect.

Wednesday 19
Went on hanging...Monnington's picture of a wine press in Italy looks well in a new gilt frame...I thought the Clause (Birdie & the greyhound) looked rather chalky. ...

Thursday 20
Tonks at Gallery...had a private conversation about the Slade, and he gave me much advice and information: advised me on no account to allow myself to be seduced into

58 Considered by many to be the first surrealist film, directed by Germaine Dulac, from an original scenario by Antonin Artaud, premiered Paris, February 1928.
59 London dining club and meeting place for political members founded 1812, took its name from the Gril-lion's Hotel where members met from 1813. A resolution passed in 1826 established the tradition of commissioning an engraved portrait of each member.
60 In 1926 they inaugurated a series of portrait drawings of distinguished Fellows and Hon. Fellows.
61 Completed 1927. Birrell (1850-1933), Chief Secretary for Ireland (1907-16), resigned in the immediate aftermath of the Easter Rising.

too much organizing work, but on the other hand never to consent to the appointment of someone else as 'manager': to remain, as Brown and he always were, teachers in the school and practising artists outside it: to be on good terms with the carpenters and odd job men, and a sort of clerk of the works named Voysey. He spoke well of his staff said 'they were very good to teach the beginners'…especially [Alfred Horace] Gerrard, whom he describes as a good fellow, who will take on any work he is wanted to do, and not think of extra pay: said that Steer has definitely resigned. I thereupon said something about G.J. taking on the work that Steer did, and mentioned my desire to have Monnington. Tonks was silent about G.J.: but said that Steer only got £200 a year (for about one day's teaching); and as to the question of appointments it was my duty to see the Provost at once. He describes the Slade as run in a 'ramshackle' old fashioned way, and would not have it otherwise: not a typewriter in the place, and bad accommodation for the staff. [Koe] Child[62] will almost certainly be unable to come back, but Mrs. Green can now do most of what he did. Tonks puts in 3 days and a morning at the N.G.: sets aside from about 1.30 till 3 for personal interviews with students; usually brings his lunch with him and eats it in his room, as there is not much time to go out (12.45-1.30). He has no regular 'deputy'…Tonks approved in the main of our hanging but made us 'nurse' the Steer a little more: not a word of his own picture. He admires the Steer water-colour as much as almost any that Steer has done: describes how a cloud was out of tone originally and spoilt it, but [Steer] applied a damp cloth to it and reduced it without damage to its freshness…

Friday 21
College…The Queen came. I did not see her, but Durst and Mahoney did…

Sunday 23
…To my surprise Stuart Gray[63] called in the afternoon. I opened the door to him, and saw the Ayrtons' servants goggling at him from behind their curtains. I suppose he is a strange apparition in Church Row. Shabby and shaggy as usual, with untidy parcels of papers under his arm. He still looks a very fine man, big and handsome at 68. Talked a lot of nonsense as usual about publishing poems and lino-cuts, but he has far too good manners to press this with me when he saw that I was unenthusiastic. He is now settled in a freehold cottage on Wallasea Island [Essex], with a wife and a few hens and geese. The wife has £40 a year, and is a descendant of the Barrymores. She is a 'scimple-lifer' [sic] and has lived in Arabia. He stayed to tea and then went off to Hyde Park to find an audience. John (Augustus) has been generous to him, as usual, so that he does not like to approach John about his immediate necessity, which is to raise £40 to pay off an overdraft…

Monday 24
…collected my drawings and took them to the Goupil: which gave me a chance to see Medworth's exhibition. Some of his drawings I liked …felt tempted to buy one £5-5-0… Did a few things at the office. Saw Beaumont, who gave me some material from Blunden for the illustrations…picture postcards, annotated…of Yalding in Kent, the scene of the poem, and books with pictures of the district…To R.C.A. to make up some of the time I missed last week over the Imperial Gallery. Burn had been there, and met Clause warming

62 Senior assistant to Tonks.
63 Ex-lawyer, artist, led a hunger-march, campaigner against unemployment.

up his picture with golden ochre. I told [Rowland Wright] Alston how well Tonks had spoken of his picture of the threshing machine. Saw a drawing of a head by Horton. Ishbel MacDonald has bought it. It is well drawn and like the girl, Miss Angus. I have advised Horton to cultivate the art of portrait drawing, for which he seems cut out…He seems fired by this idea…Posted some photographs of portrait drawings to Lord Hartington, at his request, to impress the Grillion Club, who are hesitating at his choice of me…

Tuesday 25
Appointment 10.15 County Hall with Gater, Education officer… Wanted my opinion of Dickey (suggestion made by Davies of the Board of Education), which I gave verbally, and afterwards put in writing…It was apropos the Central School job, for which Dickey has applied. I do think he would be a better man than Revel, as representing a higher standard of taste and scholarship. This I said, more or less, and that I had noticed at the Bd. of Education exams last year how relatively vulgar the Glasgow students painting was compared to the Newcastle people. Saw W.R. later in the morning, and told him…He agreed with me: but Bayes, whom I sounded as to his views later on, without saying that I had been consulted, disagreed…Gater read me a confidential letter from W.G. Constable, who had also been asked his opinion, and was non-committal, but on the whole had my views. He doesn't like Dickey's painting but respects his intentions and likes him person-ally: calls Revel's painting 'slick' and says he has not justified early promise…

Wednesday 26
…sat in Golders Hill Park reading Merezhowski's *Michael Angelo* (for review) – a poor book, but published by Dent, so abuse won't do…

Thursday 27
…Saw Provost…Debated question of Gwynne-Jones and Monnington and went into questions of salary. Provost dissuaded me from sacking any of present staff: pointed out that I should know better where I was with regards them individually after I had worked with them. Steer's salary £200 for one day a week. Child's £500 a year. Porter's (lecturer on perspective now over 70 and about to retire) £125. Provost's idea is that these amounts will all be available, but a substitute must be found for Child. Mrs. Green may do for a temporary stop gap, but not permanently. Told him I wanted G.J. two days and Monnington one, and that I should see Child on Sunday…

Friday 28
…Went to Goupil Gallery to hang show of drawings…Leaves me with 2½ hours to make up at R.C.A.. Found Neville Lewis hanging his painting in his shirt-sleeves…a good look-ing, confident fellow. His paintings are confident too, but shallow and sometimes vulgar. However, he is very cheery and good natured, at least to me. Yockney has died suddenly, in five minutes, last Wednesday, of heart failure. I am sorry, but it was almost painless, and it is a good way of dying. With Mrs. Marchant's advice, and assistance from her and the commissionaire hung the drawings in about 35 minutes…Eddie Marsh came in too, but I didn't see much of him. He has theories about the 'tempo' of good drawings, and prefers the more spontaneous. I remember disagreeing with him over an Ingres, which he thought laboured and 'studentish'. But if it is one's nature to be 'dull' (in my own case, I mean) it is better to be dull than to try for something that it is not in one's nature

to be…F. Brown has sent in his MS. R.A.W. thinks it long and dull…

Saturday 29
Spent the morning addressing Private View cards for my shows. Got rid of over 100…

Sunday 30
Went to see Koe Child at Harvard Court (one of three awful blocks of 1890 flats out of West End Lane). He is very hopeful of returning to the Slade, in fact was going there on Monday, though he can only walk slowly, with two sticks…He agrees with me about the present staff, particularly Franklin White and Wilkie…They are not a very efficient lot to run the show with. He says he has told Tonks he ought to get rid of some of them. Suggests now cutting down the number of days that they work, so that there may be money enough for Monnington & G.J. Porter, the lecturer on Perspective might, I thought, be replaced by Walter Bayes, who would come for less…It seems that Tonks has no private room whatever, and 'the boys' as Child calls the junior staff are on top of him and each other at all times in what is known as 'the Professor's room'…I expressed my strong desire for a relative privacy…

APRIL

Tuesday 1
…Westminster. Asked Bayes about the possibility of him taking on more lecturing on perspective. He is not unwilling, being short of money. The R.A. pays £50 for 12 lectures.

Wednesday 2
…D.S.M.…As we had nothing much to discuss we talked of Seurat. Oddly, he used the same expression as Mahoney the other day, in talking of Seurat's types – 'common'. Certainly they remind one of the common illustrations to comic journals of the period, the moustachio'd gentleman in *La Cirque* and *Le Chahut* particularly. The other evening Bayes and I talked of Seurat. Everyone agrees in liking the big picture (*Baignade*) in the Tate, up to a point, beyond which individual taste differs greatly. Somewhere or other Fry…has written with admiration of Seurat's great discovery of making the dark side of an object relieved by an arbitrary light patch in the background, and vice versa: talks about the whip lash in *La Cirque*: the only effect of this treatment here is to make the whip lash firmly embed itself in the floor of the arena, as far as I can see. To office…Wrote a testimonial for Douglas Percy Bliss, who is applying with D.Y. Cameron's support, for Professor Baldwin Brown's Chair in Edinburgh…D.S.M. suggested tackling Ricketts for *Modern Vasari*: says he is sure Ricketts keeps a Diary, in the de Goncourt[64] manner, probably very acid.

Thursday 3
Private View of show at Goupil's. Ernest Mann and Francis Berry the first to come in… Berry bought a drawing of *Chelsea Old Church* for £21. Plenty of people came but no more sales occurred…Reminds me of J.D. Fergusson's show in Glasgow, which he told me was 'a *terrific* success': I said I was very glad to hear it, and had he sold well? 'Oh no, I didn't sell anything, but it was a *terrific* success.'…

64 The Goncourt brothers published journals (1851-96), contain revelatory autobiography and provide a history of social and literary life in nineteenth-century Paris.

Friday 4

Going to R.C.A. travelled with Guy Robson, Thorpe of the V.&A., and Wellington. Saw Tristram[65] and spoke to him about the students' lack of principle and structural knowledge in pattern designing. Most of them repeat the same basis over and over again. He said that for years he used to put them through a couple of questions about geometric bases etc, but had finally dropped it as being a bore for everybody; but agreed that it was time that some such thing was revived: allowed me to requisition two books, Amor Fenn and Christie, to save me trouble of verbal explanations to students. Weekley asked me to his father's house on Sunday to meet the Provost in private life. Good idea. Went over to Block C to look at [Arthur John] Ensor's designs of shipping for the Science Museum...

Sunday 6

Tom Cobbe* came in...Birdie, Tom and Alice went to the Albert Hall, and I to 49 Harvard Road, Chiswick. Young Weekley, his married sister and her husband, Prof. Weekley and some women. Very scholastic atmosphere, but pleasant. A horrible house outside. Prof. W. bought it during the war for £400...Provost arrived with wife and daughter on bicycles from Notting Hill. She was at Cheltenham School...her daughter now at Girton. Provost was friendly, but didn't have much to do with him; made headway instead with Mrs. Mawer, a thoroughly sensible agreeable woman. They have been much in the provinces – Liverpool and Newcastle. She knows Rosamund Willis and Dickey. Young Weekley was a runner at Oxford, and has several pots that he won, and a photograph of himself in a group with Abrahams[66] and other well-known sportsmen...

Monday 7

...looked in at the Goupil: nothing doing. Morgan, the man at the desk very gloomy. Burn says he always is. Burn had a show there some years ago with Stephen Bone, his work on one side...Stephen's on the other, the sofa between; a large crowd on the Bone side, and none for Burn. As soon as they overflowed to Burn, they were shepherded back by Muirhead [Bone]* at the one end and Stephen at the other. Amusing picture, probably exaggerated.

Tuesday 8

Told G.J. about the financial position at the Slade, and that there is at most £200...for extra staff. Much depends on Child going or staying. He has been active at the Slade lately, so Burn tells me. G.J. says he will apply for my job at Camberwell. I don't consider he would do much good as a teacher of drawing...Bayes says he has been critical about one of my drawings in his paper *The Week-end Review*, there was a good notice...in *The Times* to-day.

Wednesday 9

...Lunch at Mrs. Leicester's. Mrs. Wellington talking over her old Fitzroy Street days, and how much more sociable we all were then. They used to meet people on Saturdays at a restaurant called (by them) 'The Mix' and have a 'gin crawl' afterwards. About the same era that Birdie and I frequented the Crab Tree Club, which went smash early in the War. Told her about Augustus John and Flanagan having an altercation at the Crab Tree, in

65 Professor of Design at R.C.A. from 1926.
66 Harold Maurice Abrahams, CBE (1899-1978), Olympic champion 100 metres 1924.

the course of which Flanagan was called a 'bloody fool'. He protested and said that after all he 'might call John a bloody fool.' 'Yes' said John, 'but you wouldn't do it with the same conviction'. I remember the dismal effect of Lilian Shelley singing *Genevieve*, over bacon and eggs at 5a.m., for the fifteenth time.

Thursday 10
Received from a touting press-cutting agency an unfavourable notice of show from *Morning Post*...Birdie and Alice and I went to look at the show. Two more slight draw- ings sold. This makes 40 guineas in all...

Friday 11
To R.C.A. in G.J.'s car...Dickey came see me about a temp. teacher of painting. I suggested Le Bas. Towner won't go again. Mahoney told me privately that Towner is going to take on two days a week teaching at Bishop's Stortford, which Horton is giving up...he would like extra money, having little, and selling less. Dickey tells me how well Rosamund Willis is doing at Armstrong College: adds that he doesn't like her personally...Lunch with Wellington, Durst, Thorpe. Apparently Worthington's lecture on Antonio San Gallo the younger [c.1483-1546] was not very good: too breezy and sketchy...The facetiousness of Worthington, so successful at the College, was probably not suited to a grave audience. Supper with Bayes & his wife in the Windsor Castle Dive. Never met her before. Strang always told me how pretty she was, and she still is very pretty. Once when she was a little girl she went away with Tonks and his sister in the summer. Tonks was very fond of children. I have been told that Mrs. Bayes was a model...

Saturday 12
...Wrote to Hartington about the Grillion Club they have accepted me as artist-in-ordinary...

Sunday 13
...Met Oliver Brown in Church Row as I went out to get some cigarettes. He is going on a motor-trip to Yorkshire for Easter, staying at Lincoln. Says he hasn't been to Yorkshire since he was a boy when he went to Whitby with his father. Remembers meeting George Du Maurier on the sands, with two Dandy Dinmonts, which figure in his pictures; remembers the dogs more clearly than Du Maurier, of whom he has a vague 'French' impression...Dickey has seen Towner's *Fisherman* and likes it. He also thinks that Towner may come to something. He has much in his favour − a small independence being not the least of his assets. A man refused one of his pictures for £15, saying that he never gave less than £20, in principle. This is the picture that started life as a still life of a tree trunk.

Monday 14
Examined Blunden's poem with a view to illustrations...decided it would be better to use the Easter Holiday to go to Yalding from Dover, and look over the terrain. Went to Beaumont to tell him this. Having noticed one or two changes in the verses...I asked him about them...he told me privately that Blunden's wife, to whom the poem was obviously in some parts addressed, has been 'carrying on' with another man while her husband was in Japan, and that Blunden is much broken up by it. The wife and her lover expect Blunden to support them, too, which, as Beaumont says, is a novel idea. Saw

Thorogood at Camberwell, who asked me if I could do a drawing of the Georgian houses about to be demolished in the Peckham Road, for [William Bower] Dalton[67] and his Committee of the S. London Art Gallery; and if so, how much would I want. I suggested £15...Discussed my possible successor. I mentioned Ian Strang, Clause and Medworth, stressing them in that order...

Tuesday 15
Hardly any students working at College: last afternoon of term. [Edgar] Ainsworth came and asked me to go over to the Imperial Institute to see a lunette he is doing of Malaya. It is in a monochrome stage and doesn't look bad. He has interesting and unusual material to compose with. Odd little, common man...with something in him that I like...

Wednesday 16
Walked over to D.S.M....He has had bad news about [David Thomas] Muirhead who has developed cancer, and is a lost man. He was away with Steer in the summer, and had a slight affection of the nose then, which developed into a polypus and was operated on later; but it seems that cancer is the real trouble. I hope they don't prolong his agonies like they did Mackintosh's. D.S.M. says Muirhead has had a hard time, and that when they were at Westminster he always thought Muirhead was half starved. Said he was 'a thrifty Scot'. D.S.M. was at Tonks's on Sunday. Tonks enjoys the retrospect of the Slade 'rag' and is none the worse. He met Steer...and told him that Brown was writing about the early days of the N.E.A.C. '*He'll* put his foot in it – and stir it round' said Steer... Camberwell. Model Giovanni Marcantonio – excellent fellow. His family comes from the same village as Pasquale Tullio. Thorogood asked me to choose a shape of a bowl and a vase, which the school will make for me and present to me on leaving...

Thursday 17
Left for Dover...Margaret Cobbe[68] a very pretty baby.

Friday 18
A Colonel and Mrs. Campbell (R.A.M.C.) came in after dinner...Campbell talked about the Aldershot Tattoo, and what a wonderful affair it is (he is stationed at Aldershot). They made £23,000 out of it for Army charitys [sic] last time. The Labour Government disapproves of soldiers giving so much of their time to this show...They are representing the Battle of Dettinger [1743] this year, but are forbidden to do a battle of the Great War.

Sunday 20
...The East Harbour at Dover has been cleared of the heaps of scrap iron, and looks quite business like, with the overhead haulage system from the coal mines. The [HMS] *Glatton* still there. Shargate Street is half pulled down, on the side towards the basin. I think I have drawn all the houses on the quay at one time or another...

Wednesday 23
Note that in a book on Dover, by Jones, it says that the Waterloo Crescent homes were

67 Potter and Head of Camberwell School of Arts and Crafts (1899-1920), simultaneously curator of the South London Art Gallery.
68 Daughter of Tom and Dora.

built about 1834. I should have thought them rather earlier. There is much excellent work of the 30s in Dover. The sense of proportion seems to have been lost shortly after that.

Friday 25
Noticed an Etty, rather bad, in a junk shop in Last Lane. Went in to ask about it…Took train to Yalding…Made some notes which will be useful for the Blunden illustrations…

Monday 28
Left Dover…

Tuesday 29
…Called at Goupil: no more sales. Met Eric Kennington hanging his show…It ranges over ten or twelve years…To *Artwork* Office…R.A.W.…has been corresponding with Blunden, as B. is projecting a book on John Armitage Brown, the friend of Keats, who was Walker's great uncle on his mother's side…

Wednesday 30
Walked to D.S.M.'s…He spoke with feeling about Muirhead's death and brought out an old drawing of M. by himself (by D.S.M.), which he wants to reproduce in *Artwork*… Rosalind Ord came to see me about her pictures – very respectable, honest work and improving in colour and other ways…

MAY

Thursday 1
…R.C.A. Mahoney and Horton have been to Paris in the holiday, and…Chartres…[and] brought me some photographs of drawings by Ingres, which I had asked them to do… The Grillion Club is beginning to be active…Kestelman called at the R.C.A. to ask if it was any use his putting in for the Camberwell job. I said 'not much'. A decent shy fellow, and a promising artist, but he would not fit in with Thorogood's idea of someone with a reputation…Birdie & I met Arthur Watts. We discussed the cost of living, and whether we could afford to go on at 20 Church Row with the whole house on our hands. A.W. says his outgoings are about £1350, including car, holidays, and everything.

Friday 2
Talked to Daniel of the N.G. in the Tube. He says he thinks Manson will succeed Aitken. Took Sr. Benito Martin[69] over the College, introducing him to every body – Newton, Osborne, Durst and others. Occupied him the whole morning; he talks nothing but French, and mine was even less fluent than usual. As a relief introduced him to Kelly, whose French is a great contrast to Newton's and mine…Ainsworth appeared, also after my Camberwell job…I wrote to John Rothenstein who wants my backing for the Edinburgh chair. Tea with Mahoney and Horton. Lionel Ellis, they say is to get divorced, Jeanne Bellon having gone off with one of the Lindsays of the Fanfrolico Press. Ellis has done a number of wood-cuts for them, partly of an erotic nature. Mahoney says Ellis has great ease and control in his graving work. A facile fellow. Talked to Bayes about the Perspective Lectureship: sug-

69 Argentinian painter (1890-1977).

gested £75. Bayes, Mrs. B. and Sandy B. had supper at the Windsor Castle. They had been to the P.V. of the R.A. Mrs. Bayes annoyed with Laura Knight for dressing up for the occasion in a vivid red costume with coat trimmed with white, like a bandsman's, a very short skirt and a very wide hat. If L.K. wanted to be noticed, she was successful. The papers single her out as a figure to gossip about. Mrs. Bayes used to work in a dress business in Saville Row...

Sunday 4
...Discussed gardening with Eleanor Farjeon[70] over the garden wall...Worked a little on Blunden. Rushbury rang up to remind me of the...Exhibition at the Grafton.

Monday 5
...Collected 5 drawings from Goupil, to send to the Grafton... Found William T. Wood at the Grafton in the thick of hanging, and felt a beastly nuisance for not having brought in my things in time; but he and Bernard Adams were very civil and good-natured about it. Mercer, Vyse, Frank Dobson, and Maresco Pearce were also present, busy hanging pictures or arranging sculpture, pottery etc...

Tuesday 6
...Met Le Bas, with beard: there are more of them about again. Westminster. Bayes will write review of perspective books. Rupert Lee says the London Group has elected all the sculptors proposed except [Eric] Schilsky. Does not think much of Barbara Skeaping[71] but more highly of [John] Skeaping and Maurice Lambert. He is carving some work out of doors on a building in Walworth. G.J. came back from hanging the [Biennale] show in Venice. Bayes says that Earle Welby – 'Stet' of the *Saturday Review*, and now of *The Week-End Review* – is a very learned and scholarly fellow, which is obvious from his writings; but he also has another side, or thinks he has, and fancies himself as a Bohemian...He persuaded Bayes to become a member of a night-club which he was running. Bayes never went there, though he was pressed to do so. Finally he said he would, on a certain night, but didn't after all: and that night the Club was raided by the Police, and went on no more.

Wednesday 7
...Telephoned David Strang to ask if he would like W.P. Robins to review his book on *Etching*. D.S. replied that he once threatened legal action against Robins for recovery of a debt, so that they are not exactly 'simpatico'...

Friday 9
Clause came in after breakfast – remembered my birthday...At Westminster Mervyn Lawrence told me how when he was a student at the R.C.A. he saw Legros make a demonstration drawing of a head. Whether this took place at the Slade or in the R.C.A. modelling school I am not clear: Lawrence said he visited the Slade when Legros was there: anyhow, Lawrence stood behind him to sharpen his pencils, of which he had five to start with, and which he silently handed to Lawrence one by one as they were blunted. The drawing was so faint to begin with that it was almost indistinguishable, but was built up gradually, without rubbing out, of course...

70 Farjeon lived 20 Perrin's Walk.
71 Née Hepworth (1903-75). Married Skeaping 1925, divorced 1933.

Saturday 10
Went on with Blunden drawing and finished it. It now reminds me of [Myles] Birket Foster[72]...It was built up from my own material, with a slight suggestion from a Corot composition, using the 'median sector'.

Sunday 11
Made some slight revisions of tone to Blunden...I hope the wood engraver will be able to follow the drawing. I get too minute, without really giving as much difference of tone as I want. Went to Rickmansworth (all of us) to Camilla Doyle...we walked along the canal to Springwell...Camilla rather eccentric, and negligent about the ugly little house, but very interested in the garden, and provided a good lunch. She read some poems after tea...Clause and Towner came in to no. 20 about 9.30, Clause to show me a portfolio of his drawings which he wants to take to Thorogood as evidence of his capacity as a figure draughtsman when he applies for the Camberwell job. They were pretty good evidence...

Monday 12
A tiring day judging pictures for Duveen's Hull exhibition with Adrian Stokes, who is old and gets more easily tired, Connard, Collins Baker and the Hull Curator (Galloway – he does not vote...). About 2000 things...We dismissed 900, accepting some 200 between 10-5...rejected two works by Vanessa Bell, and others by members of London Group and London Artists' Association. I had the V.B.s up again at the end, and Stokes agreed to vote with me for a flower piece, which was accordingly included; but nothing would make them vote for a figure piece of hers...Collins Baker discussed with me...the disadvantages of carrying on with Tonks's staff. He advises a firm line, without going too slow over it. I told him my difficulty with the Provost, who won't hear of immediate resignations.

Tuesday 13
Birdie told me about her evening with the Sturge Moores[73] yesterday. A poetry reading, Richard the third, with everybody except Birdie reading a part in turn. Mrs. Grant Watson took her and Peter Watson was there and Jean Farquarson's brother, who was the best performer of the evening; and Yvonne G.J.[74] and Riette. Birdie was very interested, and says S.M. has improved in impressiveness, and is a fine figure of an old man. He offered criticisms or connections, very pleasurably...to the various readers. Mrs. Sturge M. makes the tea and it is handed round with a tray of cakes. No servants appear...

Wednesday 14
...R.A.W. & I interviewed Hugh Dent, partly about the future of the magazine, my editorship, and the possible engagement of Leonard Elton as assistant: partly about the scheme proposed by D.S.M. last year for employing young artists at a small fee (paid by Dent) to make portrait drawings of celebrities, with the object of benefiting artists and ultimately the N.P.G....

Thursday 15
Clause came in...to tell me of his interview with Thorogood. He fears that at one moment

72 Victorian illustrator and water-colour artist.
73 Thomas Sturge Moore poet, author and artist.
74 Sister of Allan Gywnne-Jones, member WLA WWI, painted by R.S., married Innes Meo.

he may have made a bad impression owing to a lapse of memory. Must find out whether he did, and put it right if possible. Towner also came about the Camberwell job...I described the position...laying stress on the already large numbers of applicants, and the fact that a...specialist in figure drawing was demanded. He decided not to apply. Went to see...the Provost. Difficult position here. 'An important person' (who?) has told Mawer his opinion that Gwynne-Jones will seriously hamper the running of the Slade, and that from the nature of his temperament he is thoroughly undesirable. I said I knew he was indiscreet, but that his indiscretions were controllable, and not of a nature to do the harm anticipated: that in any case he was a good teacher of painting of a kind that Monnington was not so much a master of. Mawer had mentioned Monnington as more desirable and of more prestige than G.J. I repeated that I wanted T.M. on the staff but that I thought he was underestimating G.J. as an artist. He is of course a different kind. I am to make my case to an advisory sub-committee...but there is no doubt there is strong opposition to be met with. After lunch wrote to Mawer suggesting that if it should be possible to appoint both, T.M. would be the one I would prefer as Assistant Professor as more prudent and valuable in other directions than painting. If he were Asst. Prof. one objection to G.J.'s supposed pernicious effect would be removed, as G.J. is being thought of as a sort of second in command...Apparently G.J. has succeeded in spreading in many circles an impression that he will run the Slade through me. Wellington & Monnington have said as much. Damn all this indirect work.

Monday 19
Drew Lord Fitzalan [Howard],[75] S.K.A dull first drawing [plate 1]. He said he looked 'ferocious': I replied it was not ferocity but dignity...Saw Beaumont about the Blunden drawings. He likes the one I have done. He always does, or nearly...which is lucky...

Tuesday 20
Lord Fitzalan again...Rather a better drawing to-day, but still unexciting (Mahoney doesn't think much of it). I will send it him, however, as I don't think he is a subject I should ever do well. He is not without character, but the form is obscure and baggy, and confused with colour, rather patchily. W.R. is going to get a 'purse' for Alston on leaving, and he is to have a dinner...Moore thinks one of the Westminster Angels is re-worked and none of the surface original...

Wednesday 21
...Lord Cromer[76] at 4. Drew him by 5.15 with a rest between. A youngish middle-aged man. Said he didn't like his full face, so did his profile. A dull drawing again, but like [plate 2]. He recognised Fitzalan at once...Talked about his office of licensing plays, and the trouble it was to please all sides: either he fell foul of the Church or the stage...

Thursday 22
Morning with R.A.W. We may have Leonard Elton as assistant Ed. Dent has seen him, and has also asked Leman Hare [Ed.] of *Apollo*, whether he knows of anyone. L.H. could only suggest his brother Loftus Hare, and Granville Fell. Rather bad policy to employ

75 Edmund Bernard Fitzalan-Howard, 1st Viscount of Derwent (1855-1947). Politician, Conservative whip 1905-21, Lord Lieutenant of Ireland 1921-22.
76 Rowland Thomas Baring, 2nd Earl of Cromer (1877-1953), courtier, Lord Chamberlain 1922-38.

Leman Hare's brother as a rival concern, and G.F. isn't the right sort...Met the Provost, Lords Chelmsford and a man (Chambers? – Dean of Faculty?) and put my case as strongly as I could for G.J. Atmosphere of tacit opposition. I pointed out the awkwardness of dealing with anonymous suggestion as to his unfitness, and the impossibility of altering my clear-cut point of view, based on long knowledge of G.J. and eight years of him as a colleague: that Monnington and I had worked with him without any hitch as far as the College was concerned: that...W.R. had shown his confidence in him by making him Professor: that he represented a type of painting that was not Monnington's specialized branch: and that his eccentricities, such as they were, could certainly be controlled: that Tommy in any case probably would not want to do more than one day a week. The Provost did most of the talking...Lord Chelmsford said that they were particularly anxious about the Slade, as artists were such difficult people, and the Art School so sensitive to the currents of change: had it been the Engineering School they would not have bothered their heads, Engineering being more solid fellows. Provost said that being so, they were particularly anxious not to cripple me, or have me cripple myself, before I was 'in the saddle' by the appointment of a man who, he was informed authoritatively (but anonymously?) was sure to cause trouble with the Staff...

Saturday 24

...Saw Monnington about the Slade...He is not keen to come, but will, I think, as it seems for the Slade's interest...Jibbed at being Assistant Prof., in fact flatly refused to be over the head of G.J. I put my request on the grounds largely of friendship for me, and his being of real service to me in a difficult job...Didn't want to hear about the salary. I said I would see Tonks...to ask his advice about the staffing of the Slade. He thought I said stuffing – was rather stuffy himself, then thawed when I explained. Said at first 'you must make up your own mind – what's the good of coming and asking me?' Said he had been deeply hurt and annoyed by G.J. and the talk about him and round him...I explained that G.J. had a good side, and was a good teacher, but couldn't deny indiscretion. Repeated that I *must* be 'captain of my own ship!' Told me there was no occasion to have an Assistant P. at all, which I was glad of as it clears the ground for Monnington. Asked him to use his influence there, as I thought M. was so desirable at the Slade, in fact I couldn't think of anyone who had his precise qualifications. 'A very remarkable man' said H.T. He dreads Speech Day at the Slade, and asked me not to think it unfriendly if he did not come...

Sunday 25

Painful interview with Gwynne[-Jones]. Told him that his appointment had been strongly opposed, that Tonks is deeply annoyed, that he has been indiscreet, and that he must be more careful in the future. He does not see that he has been indiscreet. Says he never supposed that malicious tongues would make anything out of what he may have said, and puts much of it down to Tonks's present excessively high opinion of Monnington. Also told him that his proposed appointment was anticipated from me before I was interviewed, and that I was at that stage told that his name being coupled with mine was a serious bar to my being chosen as Professor. Thanked me mildly for backing him, but did not appear very conscious of his tactical...errors. Went to Richmond to F. Brown tea with him, his sister, niece and dog. A beautiful and roomy house with beautiful unpretentious things in it and good pictures...Showed me an early self portrait by his

father. Might be about 1840. Well done for an untrained artist. Also a butterfly painted in water-colour, in an album by him, almost deceptively realistic. I started to turn over the pages. He said 'there's nothing much in there – a lot of newspaper cuttings at the end. My father used to keep them – about my pictures.' He *was* proud of you, Fred', said the sister. Saw a little oil sketch of F.B.'s old blind brother, who lived with him a long time. They have seen in the paper an announcement that Chelmsford is to have an art gallery, in a house bought by the Corporation, and he and his sister think of making a pilgrimage there, and if they like the place, leaving them a collection of pictures…

Monday 26
Interview with Gwynne…Home truths…Mrs. Wellington, at lunch, says that W. is very worried and in a nervous state about the probability of his getting the Central School. He has been approached. He doesn't want to do it, but wants the money. Started drawing Lord Newton[77] at 3p.m. Clever old man, and amusing…but to show what different worlds we move in he had never heard of Rothenstein, the Slade or the N.E.A.C. He sat very badly and the drawing was a failure. His wife was painted by Sargent in Sargent's young days in Paris, for 4000 fr. Sargent took a lot of trouble over it, about 40 sittings, but N. says it is not like. Thorogood consulted me at Camberwell about the applicants for my job. Poor little Margaret Barker has applied but they would not consider a young girl. [Albert] Houthuesen[78] and Coxon[79] I recommended, but do honestly think Clause would be a better and more successful teacher, with his extreme enthusiasm and simple sincerity, also his sound drawing…

Tuesday 27
Upset by getting note from Monnington saying that he refuses to come to the Slade as a teacher. He has seen Tonks, but has concluded not to come. Birdie explained the position about A.G.J. to him forcibly and clearly. He took me into his room at the R.C.A. and said he was ashamed, that he had made a fool of himself, and that perhaps he ought to chuck it up. I did not encourage him to resign: but was glad he had the grace to make the suggestion, however half heartedly…I still believe he will teach well, and be useful: but he must clear his mind of ambitious plans.

Wednesday 28
Lord Newton again…did a new head, better in every way…He expressed himself as indifferent about his own portrait: was doing it because it had to be done for the club. Told me about the Committee on the Westminster Sacristy. Archbishop Davidson asked him to sit, 'as representing the man in the street' – a product of our age, as Newton said, of all the things most disgusting; nevertheless he was tickled, and, liking the Archbishop, consented to serve. Says that Mr. Tapper and the Dean wanted to seize the chance of immortalizing themselves. He, Newton was against it, and told the King, who pleaded for the Dean's view of it as a necessity, that it would look like a sort of public lavatory… An amazing talker, and clever. Spoke of the Chantrey Commission on which he also served. R.A.W., 3 o'c. Letter from Clausen saying that La Thangue has left a most interesting journal of his, which we ought to see, and possibly publish. Wrote to Mrs. La Thangue.

77 Thomas Wodehouse Legh (1857-1942). Diplomat and Conservative politician. Paymaster-General during First World War.
78 Born Amsterdam 1903, naturalized 1922, R.C.A. scholarship 1924, died 1979.
79 (1896-1997), R.C.A. 1921-25.

Thursday 29
10.30 Lord Fitzalan, rather on his dignity. Said he should not have recognized himself in the drawings. 11 o'c. Lady Fitzalan arrived: said she thought both drawings horrible. Might have expressed herself with less force…She said the new drawing I was doing was distinctly better…Visited the Grillion Clubroom at Grosvenor House Hotel to look at the portraits: observed one rather poor thing by Legros and a lot of Dicksees (all reproductions on a small scale)…Met Thorpe of the V.&A. asked him to write something for *Artwork*. He would like to write on [Katharine] Pleydell-Bouverie[80] and [Norah] Braden,[81] so asked him to do 2000 words. Went to their show, and to Hind's show of drawings at Agnews'…

Friday 30
Board of Education Exam, Delaware Road. Maida Hill. Premises used to be an old Skating Rink. Bayes stood a couple of bottles of Burgundy for lunch – Harry Watson, Travis, the B. of Ed. man and myself. Hard work on life drawings – more of them than last year…

Saturday 31
Lunch with Monnington to discuss the Slade…Used every argument in my power, friendship, the interests of the School, the advantage of M. getting away for one day a week from his decorative work, the universal feeling that he ought to be at the Slade, Tonks's wishes-no good. Don't think any worse of him for sticking to his work, about which he feels a great responsibility; but am really sorry, I counted on his coming. Perhaps he may yet, in the future. He doesn't care much about not being elected to the R.A. when Lawrence was. Doesn't like the R.A.s much. Has been to several Academy Club dinners, and thinks they get too drunk. Stokes and Munnings behave badly when drunk. Stokes interrupted speeches rudely, belched frequently and put his head on the table. Munnings, after they had adjourned to the Arts Club, made an offensive speech about Konody, a guest…

JUNE

Sunday 1
Finished abbreviating part 1 of Brown's MS….

Tuesday 3
…Provost wrote that he had seen Monnington, and that M.'s decision was final – for a year at least.

Thursday 5
…interviewed Loftus Hare…as a possible assistant editor: an elderly man with much experience of journalism and the printing trade: is editing the *Town Planning Magazine*, but could work this in with it. Thought it over…decided that I preferred Elton, and wrote to Dent accordingly…

Friday 6
R.C.A. Benito Quinquela Martin came again, to see about introducing a possible student…

80 Potter (1895-1985).
81 Potter and teacher (1901-2001). In 1928 joined Katharine Pleydell-Bouverie as a partner at Coleshill where they carried out experimentation with ash glazes, taught Bishop Otter College, Chichester 1942-66, now University of Chichester

from Buenos Ayres. Introduced him to W.R. Lunch with Durst, G.J.s, Wellington & Harding. Went over to see Durst's students in the School of Sculpture. A hot day, and very hot in the tin shanties...

Saturday 7
Mrs. G.J. says Stanley Spencer tells her he makes about £400 a year...G.J. has official letter from Provost announcing his appointment.

Sunday 8
Did a head-and-tail-piece for Beaumont. Supper with Arthur Watts, Margaret and Jimmy Horsnell. H. writes dramatic criticism...for *Punch*...10.30, saw the Ayrtons were still up, so called having been asked to do so by Grimmond, to ask him whether would support any movement to preserve no. 9 Well Walk, which is to be sold, and will probably be pulled down to build flats. Ayrton not very hopeful about the value of the protest, but sympathetic, clear and knowledgeable about the legal position in such cases. Said he would if necessary speak to Clough Williams Ellis who specializes in preserving amenities. Also I wanted to know whether Ayrton's assessment had been put up. Mine has, from £104 to 140, and I seem to be the only one. Ayrton, didn't know about his yet.

Monday 9
Did a vignette for Beaumont. Birdie and I walked to the Spaniards to have lunch... – a charming eighteenth century house with delightful ramshackle rooms, panelled...Everything almost unchanged from original state – except the furniture...Imagined Morland or Hogarth visiting the house – they probably did. Walked on to Golders Green and beyond. Saw new buildings – South Square...which I had not before seen. Much to admire, but a little too much pastiche of Queen Anne and other modes...

Tuesday 10
Reviewed David Strang's book and Wilenski's *Miniature History*. Went in to Grimmond after lunch. They have been to Woodbridge and Southwold in the holiday, and saw... the Wellingtons who are staying with them. Mrs. W. in a rush hat from Woolworth's, and W. in a large straw and a blue shirt. Relapse into Bohemianism in the security of the country. Discussed no. 9 Well Walk. E.V. Knox is interested: says that Mr. Benson, who has bought Burgh House and the adjoining old barracks (Wetherall House) and who is very rich may buy no. 9 as well and so preserve it. He is going to construct a flight of steps and an approach for cars from Well Walk to Burgh House...

Wednesday 11
...Went to Leicester Galleries. Van Gogh show, representing all periods of his work, very interesting and alive. [Frank] Dobson's *Truth* [1930] also, and a lot of mixed work, Sickert, Friesz[82]...Lithographs by Lautrec, Derain, Matisse etc. A landscape by F. Brown, which Oliver Brown told me the old man had seemed rather satisfied with on seeing it in the Gallery. Will try to reproduce it in *Artwork*...

82 Othon Friesz (1879-1949), French painter, graphic artist and designer.

Thursday 12
Lunch at The Clan. Wellington, Newton, Henry Moore. H.M.'s views about Dobson's *Truth* are that it is so good that he would defend it warmly to any outsider, as a fine thing…but thinks that as a woman's figure it is too strained. Agrees with me that the sections are too alike and the transitions from section to section, though managed better than usual, might be more subtle. Spoke of his enthusiasm for the Greek sculpture in the B.M. when first he came to the R.C.A. (later I remember him, in an extremist mood, abusing the Elgin Marbles.) Tea with Mahoney, who again developed his theory that design should be more or less unconscious, not too imposed, but coming about through the nature of the subject to be expressed.

Saturday 14
Started B. of Ed. Exam. papers, 71 to do. Saw Elton in morning and started him off. Tea with Pocock and Anna Airy. Old Slade and War gossip. She has been in correspondence with Tonks who seems to grow quite tearful about the Slade in the course of it. They see something of Walter Russell. Wish I could like Anna Airy's pictures. Saw Guthrie's car standing outside (he has another of the Parkhill Studios). Thought he was too hard up to have such a luxury. Anna Airy is on the Artists' Benevolent Society: says they constantly have to turn down applications from youngish people, about 30 years of age, who have been bitten with the modern movement and have neglected to make themselves ordinarily efficient and practical artists. She is against supporting them: advises them to turn to some other mode of life.

Sunday 15
…Birdie, Alice and I went by train to Colchester (12.30-1.40; 4/- return excursion)… Owen[83] met us with the Singer and drove us to Dedham, Dorothy and Elizabeth well…A conservative village, old ladies go there to die. You can not hire a boat on Sunday, nor can [a] charabanc remain for more than 20 minutes. Owen drove me round by Manningtree to Flatford and E. Bergholt. Plenty of boats on this part of the river, and an ice cream man with a bicycle. ('Stop me and buy one'), not to speak of sweet stalls and picture postcards at Flatford Mill. Beautiful place. Went into the room with round leaded windows. The studios seemed deserted. Willie Lott's house looked just like Constable's picture, but the elm trees are smaller, and of course a black blue sky did not look like Constable…

Monday 16
…To Camberwell to fix a viewpoint for the drawing of 1770 block of houses in Peckham Road. These and the later (Regency or thereabouts) houses opposite may be demolished any moment now…Dalton came with me. Said he wanted to tell me how in inspecting various S. London schools he had found the drawing much superior when Slade people were employed to teach.…Old Niccolo Marcantonio [model] showing off his trick of keeping his arms extended by the hour, in the Life Class. Only man I know who can do it.

Wednesday 18
Judging painting, Board of Education Exams…[Gerald] Gardiner is having a very good effect on the Cheltenham School. One gets to recognize the work of different schools quite easily: Sheffield (Anthony Betts), Newcastle; etc. Some like Liverpool have an old

83 One of Birdie's brothers, he and Dorothy, his wife, and daughter Elizabeth emigrated to Australia.

fashioned dull R.O.I. sort of standard, while Sheffield is affectedly modern, and all the students have all the same tricks.

Thursday 19
Provost's lunch, to meet Slade staff. Sat on the Provost's right, next to Prof. Richardson. Tonks on Mawer's left. Borenius* was there and told me that More Adey[84] goes out of his mind from time to time, and that in one of his fits he threw his sister down stairs. Richardson, a great talker, full of a scheme for buying Temple Bar, which can be had very cheap, to be re-erected as the Gower St. entrance to the College...Wilkie made up to me in a tiresome way: followed me into the room used in the Design Class where there was a show going on, and asked me to come and see him. I put him off. Gerrard, it seems, flew a bombing plane during the war. Saw John's portrait of [George] Carey Foster[85] which I did the replica of when at the Slade. Wilkins was not the architect of the Slade wing. This was altered and improved by another man later than Wilkins...Finished Exam. papers.

Friday 20
Busy at the R.C.A. selecting and preparing students' drawings for an exhibition. ... Westminster. Bayes & Mrs. Bayes, supper at Windsor Castle; saw Cosmo Clark[86] there too. Mrs. Bayes amusing about Selfridge's, and the many ingenious plans for shop lifting, fraud and robbery that they have to deal with. Miss English at the Westminster School told me that John Rothenstein has had his first novel accepted, and it may be out in the autumn...

Saturday 21
Went to Chelsea and borrowed Steer's painting of Havard Thomas[87] from no. 18 Glebe Place. Saw one or two interesting drawings, presumably by Havard Thomas, in the front ground floor room whence the Steer was removed...Started to read Burty's *Lettres de Delacroix* [1878], which I have been hunting for a long time...

Sunday 22
Started an illustration, a Fair scene, for the Blunden poem...[Millicent] Russell* came to supper. Has been to yet another specialist...who is very damping about her future. She will never, he thinks, be much better, and will have to continue dieting etc. for the rest of her life...Has been staying at Pont Audemer, where there is a notable old auberge, a half timbered building round a large court...She showed me some photographs of this, and of Dijon, where there is much interesting architecture.

Monday 23
...College...Wrote a testimonial for [Henry] Bird, who has been given the Travelling Scholarship. He has done some remarkable drawings, but his sense of colour is beastly ...Bought a paper while having tea at Hill's and an article caught my eye about the tutor

84 (1858-1942), art critic, editor and aesthete.
85 (1835-1919), chemist and physicist.
86 (1897-1967), 1922 visiting teacher life painting Camberwell, 1924 married fellow artist Jean Manson Wymer (1902-99), 1938 Head Hackney School of Art, 1939 Air Ministry, Camouflage Directorate; later Deputy Chief Camouflage Officer, Ministry of Home Security,1942-63 Director Rural Industries Bureau.
87 (1854-1921), first Professor of Sculpture at the Slade where he had taught from 1911.

who was recently murdered at Cambridge. I had read nothing about it but the headlines before, and to my surprise found it was Wollaston[88] who was the victim. Must be dreadful for his wife. They seemed so perfectly happy when I stayed with them at Uley [Gloucs.] two years ago. Both extremely pleasant people, whom everyone liked. I have one or two drawings of her – a handsome woman, and I did one of them as a little present…

Tuesday 24

Met Aitken in the Tube lift as I came out of the station late last night. He tells me that he, Daniel & Tonks, who are buying for Jo'burg Gallery have decided to have my drawing of *St. Martin's Church*, from Chandos Street…R.C.A.…Went in the lunch hour with Wellington, Moore and Harding to a show at the Lefevre Gallery. Travelled to Piccadilly in the Tube with W.R. who was going to lunch and rest as usual at the Athenaeum. We had sandwiches at the Cafeteria in Leicester Square. I admired a large seated nude made by Renoir greatly (in a squarish canvas, with red objects in the background), but [*added in margin* Composition very obvious] not so much a group of bathers of a later period. They say in the catalogue it was painted in the eighties. I should have thought the 'nineties at the earliest…All the Cézannes, Matisses, and Renoirs emphatically the work of painters, and almost all good in colour. One or two Renoirs, like *Mlle R allaitant son enfant* very high in key and of a flattish kind of paint, like a tea-tray…I admire him, on the whole, enormously…One of the pictures is priced at £20,000, which is a damned scandal…Wellington had seen Miss Alexander since she had tea with [Edward] Johnston on Monday. He won't come to the Slade to see the work of her Class. Says he has only enough energy to get from Ditchling to the College and back. He wrote her out a little alphabet, because he says his textbook is out of date – and that it was so even when it was published. Saw Burn later at R.C.A. We talked about Charles Keene, and Miss Bowers who used to draw the sporting subjects in *Punch* in the 70s. Burn and Monnington had been to another lecture by Sickert who had praised Bowers as a remarkable artist. What nonsense he does talk. I showed Burn some examples. Tea with Mahoney & Horton: all of us are full of enthusiasm for Delacroix, who seems rather in the air just now…

Wednesday 25

Saw David Jones at *Artwork* office…chose some of his work for reproduction. I like him. He has a certain mild conceit, but it is not unpleasant…went to the Goupil Gallery an interesting mixed exhibition. Was once more struck by the relatively poor appearance Duncan Grant makes among other painters not of his kind. Its true his picture wasn't a very good specimen…6.30 attended farewell function to [John] Linehan[89] on his leaving Camberwell after 31 years. Presented with pieces of pottery and a table made in the School. Not too affecting an affair fortunately. Always remember L.'s speech on my asking him if he liked Epstein: 'No: In my opinion, there are three sculptors whom I would call dirty sculptors. One is Rodin; the other is Epstein, and the third is a foreigner, whose name I forgot.' I suggested [Ivan] Mĕstrović.[90] 'Yes, Mĕstrović. Now I remember in the old days I went to a show at the New Gallery and there was a piece of Rodin's sculpture there. I was looking at this, when two people came up, a man and wife, obviously of the upper classes; and she turned to him and said "there, my dear. There is a man who

88 (1875-1930), former hon. sec Royal Geographical Society, murdered by an undergraduate.
89 Taught carving.
90 Sculptor (1883-1962), born Vrpolje, Croatia; he became an American citizen in 1954.

might have been great." And I never forgot those words.' Students shook hands with me and wished me well, my last Wednesday there...

Thursday 26
B. of Ed. Exams. Davis's successor, ~~Eden~~, Eaton or Eton? [sic], put in an appearance, with Francis Douglas. Last evening of Camberwell. 11 students: we wished each other well and parted.

Friday 27
R.C.A....Invited by Ceri Richards to go and see his work at 99 Fulham Rd. He is still working part time with the London Press Exchange, but is permanently active on his own. His wife (née Clayton) has sat literally for hundreds of drawings, paintings, playing the 'cello, in bed, in the bath, and in every kind of posture. They haven't been married long, and seem very content with each other. He and she both paint. He has so much facility and fluency that he may come to something, if not of the first rank...The drawings are in the modern Picasso trend: always very like the sitter in an exaggerated way. Last night at Westminster. Finish of ten years in the L.C.C. schools...

Monday 30
B. of E. Exams...W.R., G.J. and Rodney Burn came to represent the College. Douglas very worried at the inconsistency of our marking and our choice of students for scholarships...Then to New Burlington Galleries to see Quinquela Martin's show. Met him there, and struggled through a French conversation. Pictures full of vitality, but shallow. Some in a high key of colour, sunshine at Buenos Ayres [sic], better than others...

JULY

Tuesday 1
R.C.A. Ba Zaw[91] worried me for advice on his paintings – a nice little chap. Tea, Mahoney & Horton. Thought I would try Horton out as a reviewer, and gave him two little books, on Modigliani and Severini. He once took on Bliss's job for *The Scotsman*, and did the Dutch Show at the R.A. Mahoney shows an eager curiosity about all pictures that are new to him, and Horton says Mahoney is a tireless sight-seer (like me)...

Wednesday 2
Wrote letters...one to Lord Cromer declining, with thanks, an invitation to the King's Garden Party. I haven't any clothes for such occasions. ...Telephoned Mary Adshead. She says her *Homage to Mozart* was designed as an over mantel for a music room...

Thursday 3
Went to see Campbell Dodgson at B.M. about an article he proposes to write on the work of a girl called Purvis. He showed me my own etching of *The Quadrant* in the cases of recent acquisitions through the Contemporary Art Society; also a beautiful Dürer drawing of a head, a woman smiling, which he said was a 'noble thing' and quite unique in Dürer's work...7p.m. dinner at Cheshire Cheese with Camberwell staff. Complimentary speech

91 Saya U Ba Zaw (1891-1942).

from Thorogood, my health drunk, and two pots made in the School presented to me, one of which was afterwards filled with cold punch. Much roaring of songs ('Community singing'), George Holland at the piano…

Friday 4
King's Cross 10 o'c., Newcastle 3.40. Mrs. Dickey, met me and drove me to her house. Dickey came in after tea and took me to the [Armstrong] College, where I started Exam. work…Dinner, and afterwards called on Major Robert Temperley. He is 73 years old or thereabouts. Has a very superior radio-gramophone, and has just bought a drawing by Evelyn Cheston[92] but it has not been sent home yet. He was going through Musbury in a car, so called on Charles, whom he found busily engaged on Evelyn's *Memoir* [Faber & Faber, 1931] and there he selected his water-colour. He is still enthusiastic about A.K. [Alfred Kingsley] Lawrence and *Persephone*, and is anxious to have that picture back from Pittsburgh. I do not share his enthusiasm, but spoke well of Lawrence to him on other grounds…

Saturday 5
Work at Armstrong College all morning. Showed specimens of illustration, all rather modern in style – Bawden, Laboureur, Albert Rutherston tendency – by students of the R.C.A., at Dickey's request, to Hislop, who teaches that subject. He seemed rather shocked, but civil…

Sunday 6
…Left Newcastle after lunch…Dickey is disappointed in Daniel since he went to the National Gallery. Says he has got a bit above himself, and makes things difficult for W.G. Constable, who grumbles privately to Dickey….Cheque from Lord Fitzalan £15.15.0 with a civil note.

Monday 7
Birdie tells me she has been discussing Lionel Pearson with Mrs. Wellington, and he appears to be an active but carefully connected philanthropist: he has done all sorts of generous and thoughtful things for his friends…He has this year asked Thomas Derrick and his entire family to his place in the country, where they will probably be left by themselves. He sent the Wellingtons a cheque for £25 so that 'they would see a few more towns' in Germany, when they went there some time ago, and the cheque arrived just before their departure, so that there should be no discussion or verbal thanks…Went to U.C.L.. Provost and [Charles] Douie[93] inspected the Women's Cloakrooms etc. of Slade. The Professor's Room is going to be cleared…

Tuesday 8
…met Albert R. and his fellow examiners, Townsend & Barnes besides Burrows the rather foolish B. of Ed. Inspector and Mrs. Crompton. Douglas came in and later Tristram & Reco Capey…I had not…met Townsend: an intelligent, shrewd man…

92 Née Davy, m. Charles Cheston 1904.
93 Secretary U.C.L. (1927-38).

Wednesday 9

Artwork with Elton. R.A.W. full of his trip to Sweden with the D.I.A. [Design & Industries Association]. Impressed by the general absence of ugliness and the courageous nature of Swedish architecture and craft work...Supper with the John Copleys and their two boys...Copley talked about many people, Pennell and the Orchardson's whom he had known: says he learnt a great deal from Pennell, who learnt from Whistler, but bettered his instruction...Manson has had an accident and has injured his head and face falling into a cucumber frame-after dinner. He has a rather well known tendency to enjoy his dinner and his wine, and the affair is the occasion of many jokes at his expense.

Thursday 10

...Clausen told me that La Thangue MS has been offered to other publishers and that Dent was the only firm that had made any thing approaching an offer for it...

Friday 11

R.C.A....Freedman and Gilbert Spencer came to see W.R., to fix up for next term, when they will be on the staff. Spencer has an extraordinary trick of turning round and round while talking, which Barney was very amused at...Bought a mask from Clarksons, and after supper went to Pearson's 'Victorian' fancy dress affair, not dressed except for an antique Victorian waistcoat instead of an ordinary white one...Talked of the woes of portrait painters, including Glynn Philpot, whose portraits are not always considered like (but whose are?); and of the Connards giving dancing lessons in the old house in Cheyne Walk to keep the pot boiling in his young days.

Saturday 12

Farewell dinner to Alston at the Florence Restaurant. The old man bore all the complimentary speeches very well, and replied well and with spirit. Speeches from Anning Bell, Moira, Leon Underwood, Revel, W.R., Jowett, Horton, Grant (for the present students), G.J. and others...I sat between Mrs. W.R. and Moira. Moira is amusing, and Mrs. W.R. has a scathing tongue. She told me an anecdote of Mrs. Roger Fry walking with her on Hampstead Heath and saying 'How wonderful Hampstead would be without the Heath!': told me also about W.R.'s activities with the Indian Society, his discovery of Rabindranath Tagore, and his example in buying Indian drawings being followed by Colvin...

Tuesday 15

Burn says he has asked his father once why he was knighted, and his father said he didn't know, unless it was once during the War, when there was a campaign for selling war Bonds, he and George Robey made speeches from a cart in Holborn. Monnington is going to the King's garden party. He was going to get the necessary clothes from Moss Brothers but finally decided to borrow Evelyn Shaw's.

Wednesday 16

After supper Birdie fetched me out onto the Heath to look at the country dancers on the Athletic Ground: about three or four hundred of them, the men in white flannels and the girls in all colours a very beautiful and paintable spectacle...

Friday 17

Last day R.C.A....College photograph taken in the Fountain Court of the V.&A....The students had got up a rag in honour of [George] Lansbury[94] and about twenty of them were in bathing costumes and dresses thought suitable for 'Lansbury's Lido'...The staff assembled in the College, with many guests. Met...Max Beerbohm (who was looking very like W.R.'s last drawing of him, but a little softer, pinker and older than the drawing suggests) and Walter Russell (who has a more distinguished appearance with advancing age). Mrs. W.R. introduced me to Max, with an allusion to his prophecy at the Athenaeum that I should be Slade Professor, because W.R. had said so. We went down to the Lecture Theatre when Lansbury arrived. He made a good speech...He stood the presentation to him of a bathing costume by Archie Utin (dressed in bathing drawers) very good naturedly. The students had made a Robot, also in a bathing costume, which worked effectively at the back of the theatre. Much noise, controlled by McCrum, looking an heroic figure with very little clothes on...In the evening went to the College Social really to make valedictory speeches to W.R. who was very kind, and said agreeable things as he so well knows how to do...

Saturday 19

Began drawing of Hugh Dent, in coloured chalks; did something I could work into next time. Had only an hour...

Sunday 20

...I notice that the L.C.C. has prohibited the building of a group of houses on the side adjoining Jack Straw's, facing White Stone Pond. An appeal is being lodged. The existing houses are quite pleasant, and it would be a pity if the place was made uglier still than it will be when the new block of flats by Gangmoor is erected...

Wednesday 23

...Dipped into Edith Sitwell's [*Alexander*] *Pope* in the evening, and thought her approval of Pope's letter to Lord Hervey absurd. It is clever and scores well in places, but what a labour to write (and to read) and what an undignified thing to take such endless troubles over a mere vindictive retort...

Thursday 24

Started drawing at Camberwell...met A.E. Wade (Grimsby Art Master) at R.C.A. by appointment to discuss the affairs of his student Palmer, whom he warmly supports, and hopes to try to get some money for his support for a year from the Grimsby people... He had something to do with starting Barney [Barnett] Freedman off, some years ago, before going to Grimsby...

Monday 28

Finished drawing Hugh Dent. 3rd sitting. Mrs. Dent was there. Approved the drawing, and she will sit to me herself...Tried to encourage Dent to buy one of [Stanley] Badmin's drawings, a very pleasant view of Burford Street.

94 Serpentine Lido Pavilion was built in 1930 to provide mixed bathing and sunbathing facilities. As the First Commissioner of Works, in the Depression, Lansbury was keen to improve recreational facilities and appealed for funds.

Tuesday 29
Called on Macbeth at 17 Fleet Street about the collotypes for the Grillion Club. An interesting man in an interesting interior. Visited Prince Henry's Room, and liked the 18th century staircase. To Camberwell, and went on with my drawing of The Terrace, that is what the centre block of three houses is called, on a contemporary tablet with the date 1774. This is the third day on the drawing. Didn't get more than 2½ hours work on it: was driven off by the thundershowers...Went to see Batsford...Enjoyed my day, in spite of accidents of weather. London looked lovely, especially on the river...Noticed the new Oxo tower opposite Blackfriars, and the new Corbusier-like building of the Crawford Agency in High Holborn. Rather dull, the latter...Kennedy of the V.&.A rang up: wants to buy my lithograph *Peeling Potatoes* for the Museum. Paid £3.3.0...

Wednesday 30
...David Jones came in to collect his drawings...I went on to the Wellington Club to have dinner with Mr. & Mrs. L. H. Walters and Penelope Eyre of no. 19 Church Row...Walters has bought a drawing by Henry Moore, whom he knew nothing about. It is a semi-nude lady who looks as if she had had an operation in the stomach, and Mrs. W. has hung it in the bedroom where it will not be so much in the public eye. I thought my drawing of Mrs. [Henry] Rushbury that they have was very like her, on seeing it again.

Thursday 31
Drew for over five hours in the Peckham Road. One more good day should finish that drawing. Some of the figures I shall put in at home, as they want rather careful arrangement with such a flat parallel view...

AUGUST

Friday 1
...Met Griffiths at lunch-time in a new yellow tweed suit, looking much smarter than I do, and apparently affluent enough to be going to France in a few days...Jean Inglis came in after dinner, full of gossip. She seems to know everyone, nearly, in Church Row. The Bells who live next to Ayrton, are Clayton and Bell, the stained glass people. Bell is the son of the head of the firm, and has to be very discreet in doing any work which is not in the firm's antiquated manner. He does some on his own account, of which his father would strongly disapprove: an old martinet. Egan Mew* who also lives on the north side, is a friend of Max Beerbohm's, and goes to stay with him. She reminded me of what I had forgotten, that young Weekley's mother is the 'Frieda' of D.H. Lawrence; she ran away from Prof. Weekley's and got married to Lawrence eventually. Young W. is fond of his mother, and used to see her in spite of his father's wishes. Now he has a lot of business on hand winding up Lawrence's affairs for her. Colin Gill told me the other day that Lawrence stayed with him for a little time in Italy – I suppose at Anticoli. Gill says there was nothing morbid about the man as a companion; he was light-hearted and cheerful; which agrees with Middleton Murry's account which I have been reading in *The New Adelphi*. Jean Inglis says he was friendly with the Radfords in Hampstead. To continue with Jean's reminiscences. Once when she was hard up she sat to Walter Sickert as a model in Mornington Crescent, where he had a School. Gore came in and drew her once, too. On one occasion Sickert posed her leaning up against a mantelpiece

[plate 5], with her head screwed round in a rather defiant way. Then he arranged a big mirror, and to her surprise put on a tall hat and commenced to draw. When he had finished she realized that he had been drawing himself and herself as a composition, in the mirror: He proposed to call the drawing *Go to your beastly club, then.*[95] This system of drawing from a mirror, and drawing everything together, figures and surroundings, has been inherited by Walter Bayes, who is always encouraging the students to do it at the Westminster, where there is a long mirror for the purpose, which can be adjusted anywhere and at any angle. An aftermath of the Camden Town Group...

Saturday 2
Worked at home...on Peckham Road, putting in figures from sketch book – road repairs, etc; and pulled the thing together a bit. Faked the lighting, as the houses face north. Might look like that at 5a.m. The old Greswick paper (1818-20) always works beautifully...Pottered about looking for my next subject, think I have found a good pitch...Walked up the Grove. Had never been up to the top of it before...Considerable architectural features of a minor order...One in...[Camberwell] Grove where Joe [Joseph] Chamberlain lived. The Mary Datchelor School [founded in 1877] looks very raw in its old fashioned surroundings. I remember what it was like before the new building. Astonishing what a lot of late 18th – early 19th century building there is in London. Pleasant names in Camberwell Love Walk, Mazzard Row, Bullace Row. Must have been a nice sort of suburb before it got so slummy...The Fair all set out on the Heath, and a feeble attempt made to start it going...Seabrooke, I hear, has married 'Phienka' a Dutch lady [Adolphine Christina] who has a hat and dress shop under that name in [95] Heath Street. I remember how he introduced me to some woman as his wife the last time I met him, I think at Maresco Pearce's. Since the original Mrs. Seabrooke there have been so many of them, Dolly Steven; Mrs. Green (if that was her name, who lived in Cheyne Row); the Countess, something or other...

Sunday 3
Meo came in, and I went to their flat in Willow Road and looked at his drawings, mostly of his Bedalians. Very slight costumes some girls wear. Apparently there were protests recently in Steep about some of them appearing in public on a Sunday in their shirts and knickers only...

Tuesday 5
... on the way to Chelsea Hospital to draw Sir Neville Lyttelton.[96] [Plate 3]. Met Sylvia Baker who was rather malicious about the Rothensteins; said she admired William but could hardly bear to go to the house because the whole family had such an obvious attitude – 'Isn't Father wonderful?' 11.30 Lyttelton's butler said that his master was in bed. I said I had an appointment with him, and perhaps Lady Lyttelton would tell me 'how things stood'. Was shown into the Board Room, which was in an untidy state...Lady Lyttelton came in after a short time and explained that she had really forgotten about my coming...three of her maids being down with ptomaine [food] poisoning, and the General having poured some boiling water on his foot. I offered to go, but she said it was all en train...L. came in, in a uniform frock, rather worried because his two stars

95 See *The Mantelpiece*, 1907.
96 (1845-1931), Governor Chelsea Hospital 1912 until his death there. Former Army officer, 1908 Commander in Chief, Ireland.

had not been stuck on it. He is a distinguished looking gentleman...What he says is sensible and amusing, but he is getting old and says the same things several times...Thoughts of old age and mortality were not dispelled by his information that on an average 70 of the old pensioners die annually...Lunch...Lady L. objects to Amy Johnson's cockney accent (on the wireless)...

Wednesday 6
What a contrast between the sane and balanced judgement of [Walter] Bagehot, on Pope and Lady Mary, and Edith Sitwell's account of that affair. The Sitwells have no historical sense. ...

Thursday 7
...went to L. Underwood's show of drawings at St. George's Gallery. Able, but rather empty. Some of the Sur-réalistes work there too: nonsense, occasionally in pretty colours, and here and there the expression of a dramatic idea – not abstract...

Friday 8
Lyttelton again, a new drawing. More like...

Saturday 9
Called to collect drawings from the Lytteltons. Lady L. wanted some minor alterations... She is not a bad critic, and didn't want her husband, she said, to look a conventional soldier ('England's going to the dogs, damn it'). He sat again for a short time. The drawing lost freshness, but got more like...

Monday 11
...Miss Scott Thompson called at Church Row, in the Duke of Bedford's car, about the job of doing a reconstructive drawing of Woburn in the 17th century. Followed this up by going to see Harry Batsford to see if he, with his great knowledge of topographical prints, could help me to find a contemporary view...Heard from Eric* [97] first time for nearly a year.

Tuesday 12
...Saw Macbeth about Grillion reproductions, and gave him the drawing of Lyttelton to work from...Hugh Dent said the drawing of himself was more like him than any he had had done, and Mrs. Dent is pleased with it. She finds a certain vivacity in it.

Wednesday 13
...With Prof. Richardson to know whether he can help me to find a view of Woburn in the 17th century. Slade in the afternoon: saw two men [Roger] Pettiward[98] and Barclay Russell. Pettiward has been working under Angelo Janck in Munich. Influence very strong, downright, energetic, competent and rather cheap sort of work. The Alstons came to supper, and George Kennedy, who had been up to see G.J. came in. He has been having a row with the Dean of Salisbury about a memorial tablet in the Cathedral... Alston had been staying for a week with Le Bas and Carter, the cripple. And someone is

97 Schwabe's brother who was working in China.
98 (1906-42), cartoonist, aka Paul Crum.

giving him and his wife a fortnight's holiday in Lucerne. He has a small job at the Ealing School of Art, which will help him out.

Thursday 14
Started on a drawing for the Blunden book, urged by a letter from Beaumont...

Friday 15
...worked on Blunden drawing of the weir. Drew Mrs. Dent...Couldn't get [her] mouth right. It's like her, but rather grim, unlike what I wanted...

Saturday 16
...Went to Hoop & Toy to get lunch. They don't serve it on Saturdays...Kelly came in... Went with him to the Museum. Drew two helmets in Bailey's room. He got them down for me...Went to Everyman Theatre with Birdie. *Prunella* by Gran[ville] Barker. Very good acting and good voices...Muriel Pratt produced it. Should have liked to see her again. Reminds me of *The Loving Heart* [1918] which I designed dresses for a long time ago with her in it – Bridges Adams producing. A rotten play it was too...

Sunday 17
...went to the Hagedorns's after supper to look at his recent water-colours, which I like better than others he did before...

Monday 18
Started the second drawing in the Peckham Road worked for two hours, and then had lunch and got to Bedford Street by 3 o'c. to draw Mrs. Dent. Improved that. Dent wasn't at the office, having gone to the Oval to see the Test Match (it took me a quarter of an hour longer to get to Camberwell by bus on account of the crowds at Kennington), so I don't know what his opinion will be...She has known Noël Gilford (Adeney)[99] since she was a child. Says Adeney's mother was a Hampton, of the family that has the furnishing business, and is well off. Lucky for Adeney and his children. The Dents took the Adeney's cottage at Wittering [Sussex] one year, and liked the place so much that they built a cottage for themselves there. Macdonald Gill was the architect.

Tuesday 19
...Miss Scott Thompson at 3 o'c. A voluble lady: was a tutor at Oxford, and is full of her Duke. I showed her A.E. Richardson's letter. He has evidently taken a good deal of trouble to get information about 17th century Woburn for me, which is very good of him. Mrs. Lucien Pissarro came to tea, to see Russell. I made a drawing of them both while they were talking. After supper Birdie and I walked over to see West House, North End, which is for sale. The people in it are friends of Russell's. He is a novelist, Victor Bridges,[100] full of talk and historical information...His books are not selling so well just now in the great slump.

Wednesday 20
Took the drawing of Mrs. Dent down to Bedford St. Met Collins Baker at Strand Station. He was very emphatic in his advice to me to chuck *Artwork*...with that and the Slade, I

99 Painter and writer, married fellow painter and textile designer Bernard Adeney.
100 Real name Victor George de Freyne, a prolific British author of detective and fantasy fiction, also a playwright and occasional poet.

might cease to be a creative artist, which he seemed to think was the only thing worth doing; and he has done very little painting lately himself, so he spoke with feeling about officialdom. It is like Wellington's case over again. Baker, like most men over a certain age, is a pessimist. I am getting like that. However, as Bayes says when he speaks of the value to himself of the young people's company at the Westminster, 'God defend me from the company of men of my own age'...Baker has been to California, and looks bronzed and healthier. He enjoyed it, only regretted not being able to do any painting. Jean Orage* came to supper. She says Cicely Hamilton[101] made every penny she has, until a short time ago when she and Evie inherited a little money and bought houses with it. They haven't much now, but the houses may bring in £4 a week. Cicely H. sold *Diana of Dobson's* [written 1908] for £100, and Lena Ashwell gave her about £400 more, out of the profits. She does a lot of journalism now.

Friday 22
Reviewed F. Brown's 2nd part. Went to Camberwell and worked for 2½ hours, the sun coming out just at the right time for me to note the shadows. Saw [Carl] Bregazzi at his window and went in to see him. His photographing business is almost defunct, and he has a house of ten rooms for himself his wife and a small boy...

Saturday 23
Finished Camberwell drawing at home...My drawings always look hopeful until they are finished...

Sunday 24
In the afternoon went to see Said House, Chiswick Mall, which is up for sale, the present occupant, an old lady artist, having lost her husband and being hard up. She wants £3000...Next door is Bedford House where Euphemia Lamb and Turton used to live... Drew a little 1775 lady for the book. When I have done one of these, I feel like the mills of God: I grind slowly, but I grind exceedingly small. Very minute work.

Monday 25
Saw Russ[ell] off to Little Barn...Captain and Mrs. St. John came to see us in the afternoon. He was born in India, his father a soldier, and was educated at the United Services College[102] at Westward Ho. Remembers Kipling and Dunsterville Ma. and Mi. Kipling used to be made to eat odd things by the elder boys. Whether he actually did or not St. John doesn't know, but he seemed to do so. St. John was a handsome dashing soldier once, but retired on some crank or other, and devoted himself to penal reform and vegetarianism. Birdie remembers him about 30 years ago riding up to the door of 5 Mandeville Place, and his horse being walked up and down outside. Now a gentle, rather dismal, faded old man.

Wednesday 27
Westminster Abbey. Funeral of Duke of Northumberland going on...Cheston...came and stayed to supper. He showed us many photographs of Evelyn's work, which looks

101 Actress, writer, journalist, suffragist, lesbian and feminist. The play *Diana of Dobson's* was set in an Edwardian department store.
102 U.S.C. provided the setting for his schoolboy stories *Stalky and Co.* (1899).

extremely well in reproductions, and they should enhance her reputation when they appear in a book. She is very little known, and deserves a much higher place than she has ever been given...

Friday 29
Worked a little on costume drawings. In the afternoon left for Dedham in the car...

Sunday 31
Walked to Flatford by the water meadows. Artists sketching, boys bathing, fishermen, punts, canoes and gramophones...In the evening started to draw a corner of the Church Yard, just a note in a sketch book. Futile thing to do, but enjoyed doing it. I should like to work for months in this place.

SEPTEMBER

Monday 1
Walked towards Flatford on the Dedham side...The day more like a Constable day, with big clouds and sun. Everything as damned English as could be...left for London...Found, among letters at home, proof of new wood block, the weir, from Beaumont. Very well cut...I bought some albums of old paper from the antique shop in Dedham. They belonged to an artist called [Arthur] Glennie about 1830: a Dedham man...History will repeat itself in some junk shop in 2030 A.D.

Tuesday 2
...started on last Blunden drawing. Met Towner in the afternoon. Saw his recent pictures of Buckinghamshire – one or two very good, with more 'bite' in them than before...

Wednesday 3
...Went to the War Museum to cultivate an atmosphere, and procure facts, for the Blunden illustration...

Thursday 4
...Batsford and his nephew Cook (from Repton) came to see about Cook joining the Slade. He seems rather gifted, and I shall make no difficulty about admitting him...

Sunday 7 – Saturday 13: no diary entries

Sunday 14
Worked on Blunden book-cover. Ginner came in to coffee after lunch. Had been trying on his old army belt, and found it would by no means meet in front. Had been reading Wyndham Lewis's new book[103] in which he identifies Mrs. Wadsworth and other of Lewis's acquaintance, whose private lives are gone into with Lewis's usual malice. Suggested that Guntier should write about Lewis's private life, his illegitimate children, his habit of not paying his models, nor anybody else if he can help it, the book costs £3-3-0, and was lent to Ginner by Oliver Brown...Clause came to supper. Story (from Thornton)

103 *The Apes of God*, satirical novel of London's contemporary literary and artistic scene.

of how Thornton and Brown (Fred) were once, years ago, together in Monte Carlo, and Brown got so drunk that they wouldn't admit him into the Casino: after which Brown recovered and was very ashamed of himself, read Thornton a lecture on the crime of swamping man's noble powers of reason with alcohol, and insisted on a four-mile walk to get rid of the effects. 'So I had to walk four bloody miles' said Thornton. Ginner says Sickert asked George Belcher to let him paint Belcher's portrait. Belcher was asked to sit down and have a cocktail, and while he was so engaged, a photographer prowled round the studio, photographing him. After lunch, the same procedure: Belcher inquired when he was to begin to sit 'Oh, I've got all I want' said Sickert.

Saturday 20
...Met D.P. Bliss, who tells me he is considered too young for Baldwin Brown's job in Edinburgh. To the Library, after making a sketch of a helmet, and meeting Bill Bailey, cordial as usual...Worked on various drawings...Kelly...is full of the happiness of his married life: talked also of the Strong Man of Chelsea, one Spink, who, when a taxi driver refused to go somewhere for him, in the opposite direction; turned the cab round by main force; and when he was refused more drink in the Six Bells, gripped the mahogany counter so hard that he carried a large piece of it away. Birdie has been seeing a lot of Pamela de Bayon and Helen Fletcher (Pyramus and Thisbe) who know the second generation of all our old friends like the Macnamaras. They dislike Nicolette Macnamara, who has a habit of borrowing money and not returning it. She is at the Slade now. Francis [Macnamara] they dislike too, and it seems he wants to get away from Edie McNeill and go back to Yvonne, who won't have him. Rough on Edie. They have awful scandals probably quite untrue, about John, Romilly and Romilly's wife. They hear hard things of John from the Nettleships, who grumble that John has never given a penny to the support of Henry. But as Birdie says, that is only the Nettleship side: John complained to her years ago, that the Nettleships had snatched the child from him.

Sunday 21
Party at the Ayrtons', 7 o'clock. The studio decorated as a comic café, with posters, and notices in comic French. Tony Ayrton and Adrian Waterlow disguised as waiters with false beards. The Lee Hankeys, the Nevinsons, the Bells from the next door house...I was careless and drank too much, with the result that I was rather tired next morning, but otherwise none the worse.

Monday 22
Read Cantinelli [1930] on [*Jacques Louis*] *David* [1748-1825] and went to the office... Randall Davies came in, and will write for us...Went to Rule's for lunch. Fine atmosphere of the 1880-90s, but too expensive really...

Wednesday 24
Lunch with Randall Davies and Mrs. Davies. Looked at his collection of drawings with a view to an article for *Artwork*. Liked a great many of them – Wilkie, Rowlandson, Guys, Doré (he shares my liking for Doré in his more genial aspects) Romney, Girton, Robert Adam, Gertler* and lists of others...went out to...meet Albert R., who had telephoned that he wanted to see me about Diana Brinton and Thornton and N.E.A.C.. He was arranging his *Haggadah* drawings and the books for a show on Thursday...Russell Flint and

Sturge Moore came in to the upstairs rooms. Was introduced to Flint…At home, Jean Inglis to supper and Janina Bloch. Wellington came in afterwards, to borrow some books on Delacroix to prepare for his lecture at Newcastle. He is full of the Delacroix show at the Louvre, having been over for the week-end to Paris specially for that.

Thursday 25
Spent the evening clearing out more stuff from the studio at R.C.A… Lunch, Esther Salamar. Talked about the *Haggadah*. She can read Hebrew…to A.R.'s crush. Met the Nevinsons (Mrs. Nevinson says she was drunk at the Ayrtons' party, and had a headache next day). T. Lowinsky* (who has been buying Gainsborough drawings for 25/- each, and is just back from Urbino and Ferrara). Percy Smith, Humbert Wolfe, the Dodds, W.R. and Alice R. and the girls, Ravilious etc.

Friday 26
Worked on two sheets of colour blocks for cover of Blunden, Beaumont having sent blueprints of first block…R.A.W. is writing an article on Ian Strang for the *P.C.Q.* [*Print Collector's Quarterly*] Went to a General Meeting of the London Group at Allinson's studio in Clifton Hill, a converted coach-house with the upper floor taken out and a gallery put in. It makes a fine studio. Met young Lambert the sculptor for the first time: talked to Adeney, John Farleigh, Keith Baynes and others. K.B. is glad he went to the Slade. He was there three years, with Gertler. Said it was the only place in England then where anything could be learned about painting (from Brown and Steer): did not get on well with Tonks, as he was not so interested in drawing…Adeney spoke of a walking-tour he went on with Arnold and Clifford Bax some years ago, from Horn Head [peninsula in Donegal, N.W. Ireland] to Burnton Port and thereabouts. Knows Errigal, Falcarragh and parts of George Kennedy's district [County Donegal].

Saturday 27
…Durst telephoned, and he and Clare came in about 6 o'c., and dined with us at Jack Straw's. They are back in town from Selbourne. He managed to finish all the work he had set out to do for his show at the Leicester Galleries…Mrs. Durst says she remembers her sister living in the top flat at Burgh House, New End, when the house was let out in flats; and she paid 10/- a week.

Sunday 28
Put the finishing touches to the Blunden cover. That is the end of that job: it has been going on a long time. Clause and I walked to Kenwood, and met Gertler in Well Walk on our way home…

Monday 29
Watts came in the evening. He knows A.P. [Sir Alan Patrick] Herbert, and has been on the Grand Junction Canal with him. So *The Water Gypsies* [1930] is based on real knowledge of bargees…

Tuesday 30
Lunch at University Coll. – opening of room paid for by Sir J. Duveen, for exhibition of drawings & prints. Sat next to Mrs. MacColl, who was very catty about the Duveen's:

said that 'Zis Sir Joseph he has a face like a disease'…

OCTOBER

Thursday 2
Tea in Provost's room to meet new members of Academic Staff. Most…are much younger than I am…

Friday 3
Interviews at Slade. Turned a good many down…

Saturday 4
…Mrs. Green went over to see Douie about her position and salary. I foresee trouble here. They want me, I think to be my own Secretary and will save the salary. Didn't give her any hope of a rise on her £100 a year. …Went on to Evelyn Shaw's in Gilston Road for the wedding reception of Weekley & Vera Ross. Tonks & Steer, I was told, turned up at the church. Arrived too late, the bride & bridegroom had left. Saw Prof. Weekley, Monnington and Jane, and of course Shaw. Went to Durst's Private View (which was Nevinson's as well at the Leicester Galleries)…The Cochran Revue[104] very good…Oliver Messel's scenery excellent, and Zinkeisen and Rex Whistler good too: also Christopher Wood who killed himself a short time ago…

Thursday 9
…Met Gertler. He is recently married, and moving into a flat. I said what a trouble moving was, and he said seriously that he had already given up ten days to do it – an awful sacrifice for him, as he has had a landlady always who did everything for him and made him comfortable without his having to worry over domestic details. May do him good… He has always been terribly self-centred. Of course he has his illness, which accounts for much…

Friday 10
Lord Tweeddale brought his daughter to the Slade and I admitted her. She has learnt something about drawing at the Byam Shaw School. Trouble about our prize winner, [Evan] Charlton (the other Charlton) as he has not been at the School long enough to be eligible in the ordinary way. Douie thinks he can get over this, as the Melville Nettleship Prize has no conditions attached to it…We have a Scholarship girl called [Linda M.] Carmen at the Slade. One of the staff looked at her work and said 'I see Carmen has been very Bizet lately'…

Saturday 11
…Called on Beaumont about a proof of the war drawing for Blunden (well engraved… the engraver gets about £8 for doing each one). He paid me last week for the job. I only asked him £12 in all, and he thanked me for letting him off lightly. In the back shop today was Sachy Sitwell, looking more robust than he used to be, and more confident in manner-more like Osbert. A man of his size nearly fills the back-shop. He has just returned from Bavaria. He professed a kindly interest in Beaumont's ('this creature's')

104 Annual events at the London Pavilion in 1920s and 1930s 'produced' by Charles B. Cochran (Cockie), he never called himself a producer or impressario.

health and that he had been really worried about him in the summer. Beaumont said he thought Blunden looked very ill at work, and that his work as Literary Editor of *The Nation* was too much for him.

Sunday 12

...Supper with Hagedorn. He showed us some of his textiles again which are very striking. Mrs. Hagedorn is doing some sort of welfare work at Wormwood Scrubs.

Monday 13

Slade...Richardson & I went over to the Slade and got the Rex Whistler carried over to adorn the Staff Common Room, where it looks very well. We will have the Edna Clarke Hall later, too...*Artwork* till 6 o'c. took some Delacroix photographs to Wellington (he wanted them for slides for his Charlton Lecture)...

Thursday 16

Clausen criticized the Summer compositions at the Slade. It was rather a fiasco, as he was long – perhaps over conscientious – and owing to bad organization of the room, which entailed the students shuffling round after him, partly inaudible. A bad beginning. Wish I was a more able speaker myself.

Saturday 18 October – Wednesday 12 November: no diary entries

NOVEMBER

Thursday 13

Met Eaton and Douglas at the Board of Education offices. They wanted to discuss the Examinerships, and suggested that I should succeed Bayes as Chief Examiner in Art, Bayes being on their list for retirement, having served eight years. I argued that he should be kept on as long as possible, and mentioned G. Charlton* as a useful successor to Thompson as examiner in Anatomy. Douglas asked questions about Jowett, A.G.J, A.K. Lawrence, and John Platt: also Harry Watson. A confidential conversation. I thought that Watson's virtues were mostly of a negative order, that Lawrence...would be perfunctory as an examiner, that Platt is an extremely honest decent fellow, Jowett a very good man for the job, and A.G.J too; but an objection was raised to having too many Slade men. I might have thought of Wellington...

Friday 14

Made up time at the Slade missed by hanging the N.E.A.C. last week. Professor Prior came to see me, a handsome old bearded man with a pleasant voice and manners. He wishes to have a mutual understanding between the Slade Professors at Oxford, Cambridge and London, and would like his postgraduate students to attend the Slade School. Oddly, I had been reading an article of his on medieval sculpture, in the Walpole Society's publications, the day before. Dined with Professor Watson in Frognal Lane. Douie was there, and his sister. Douie said they had to spend an afternoon with Orpen when Gregory Foster's portrait was being discussed (Orpen did it for much less than his usual price) and was surprised at Orpen's apparent childishness in playing most of the time with mechanical woolly animals which raced each other across the floor. I should

not have been so surprised, knowing something of Orpen's buffoonery...

Thursday 20

Gleadowe called on me at the Slade in the afternoon: not so offensively 'Wykehamist' as I had been led to expect. Nicolette Macnamara also called. Her work shows the influence of Rodrigo Moynihan: I wonder if it was he she got engaged to?[105] Francis Macnamara treated the matter so lightly that it is supposed to have died from lack of opposition...

Wednesday 26

G.J. criticized the sketch-club at the Slade. Supper with Clausen in Carlton Hill...[he] smokes as many cigarettes as I do. Studio in garden...His big portrait for the Bank of England is hung up, metaphorically because he is so annoyed at the sitter saying it is unlike. The study looks most convincing as a likeness, though I don't know the man... Said again that Jane Kelly was the best model he ever had. She was about 16 when she sat for *Primavera* [1914]...[106]

DECEMBER

Thursday 4

...Visited the Zwemmer Gallery (with Bob Wellington in charge). A show of drawings by Epstein, H. Moore and Dobson, and a few others. Gaudier and so on. H. Moore as usual too cranky for my taste. Some of his conventionalized forms appear to me hideous...then to a meeting of the Imperial Gallery Exhibition Committee...Evelyn Shaw, Genl. Furse, D.Y. Cameron, Constable, Ledward, Monnington, Austin, Vera Ross. Furse got Duveen to go on for at least one more year. Shaw has his cheque for about £700. Congratulated Constable on his coming Professorship in the University of London. He wants to send such people as he may get to the Slade for at least a little practical acquaintance with drawing...He says no good critic has ever been entirely unversed in the practical side of art, and that [Jacob] Burckhardt [1818-97][107] was very good at it, though little known as an artist.

Saturday 6

Train from St. Pancras 8.25 to Ampthill...where met Hanslip Fletcher on the platform, going to spend week-end with Richardson...Fletcher ...show[ed] me the Alameda and Richardson war memorial...Richardson lives in a house in the main street. It was built by Holland about 1790 for a brewer: has 22 rooms and 5½ acres of garden...The house is a regular museum, the objects keeping as nearly as possible to the date of the house... Some good Rowlandson drawings, a Wilson painting and a Zoffany of the Indian period. Specimens of Hobby horses, velocipedes, costumes, toys, razors, mail bags, toll-gate tickets – all about the same date...Fletcher, Richardson & I went by car (a Crossley, which did 75 m.p.h. at moments, to Fletcher's annoyance and alarm) to a village...where R is repairing the Church tower. Norman work in it. We climbed up, and got very dirty... Then onto another church [St. Mary's], Eaton Sokon [sic] destroyed by fire and now being rebuilt for £15,000 by Richardson. The tower nearly finished, and a very good

105 Married Anthony Devas, artist. See *Two Flamboyant Fathers* (1966) by N. Devas.
106 Slashed by a suffragette at the Royal Academy.
107 Cultural historian, first professor art history in Switzerland.

job they have made of it, patching, pointing, using old material where possible; good lead roof (to which R. and I ascended leaving Fletcher to make a hasty drawing in the churchyard)…Most of the work on this was done by a man who was a local plumber. All the stones are being cut in the churchyard…The church will be a fine thing again. It is bonded all round the roof level of the side aisles with ferro-concrete. From the top of the tower one sees how very irregular the alignment of the nave and chancel must always have been, walls being slightly curved on plan…After lunch went to the object of my journey, Bushmead Priory, a Georgian house (Issac Ware [1704-66], according to R.) defaced in front by Victorian additions, lying in a rough neglected park of great beauty for timber and vistas. The people, Wade-Gery, are farming the place themselves, being hard hit and hard put to keep it going…The son of the house was there, but his father was out shooting, and had the key of the room in the monastic 14th century refectory where the books are kept: so that the copy of Lysons, with the extra illustration of Woburn that I wanted, was inaccessible. A long journey wasted, but enjoyed for its incident…They had a great affray on this estate a short time ago with 14 gypsy poachers. The Gerys and neighbouring farmers rounded them up in a wood and defeated them, afterwards giving them their chance of clearing out of the neighbourhood, where they had been living practically as banditti, or going to gaol. They cleared. Strange goings-on for 1930. In this neighbourhood too, a road-mender recently got two months for having burnt the body of his daughter's still-born child in the furnace of his engine. He was the father of it…Richardson is very anxious to get the job to build the new university buildings for the Faculty of Fine Arts – Lord Lee's and Courtauld's scheme. Says the Slade and the Architectural School ought to be called upon to work together on this. Fletcher is interested in this plot, and says he is willing to approach Lord Beauchamp, the Vice Chancellor of the University, about it…R. seems to me a bit of a plotter, professionally, and is ambitious for a big job, and to get into the R.A., which he abuses, as he does Lutyens, Tapper, Baker and other architects…

Sunday 7 – Thursday 25: no diary entries

Friday 26
At Shiplake (since Wednesday) [24th]…C. Tennyson wanted to go to see Aldworth where his grandmother Selwood came from…Drew some elm trees after lunch, and read D.H. Lawrence till surfeited with him…

Saturday 27
Drove with the Bruno and [Nellie] Kohns to Childery…A good place to paint in, and pretty unknown…Pantomine at Reading in the evening – Robinson Crusoe. Pen [Penrose], Dooley [Julian Tennyson] & Alice. Fine old-fashioned principal boy and the usual vulgar jokes. More like review than a pantomime.

Tuesday 30
Went to look at Newcastle House, was being remodelled by Lutyens. Scaffold still up…

Wednesday 31
Jean Inglis at lunch…described Gilbert Spencer's wedding and the party which preceded it on Monday evening. Lots of people at the party, Philip and Lady Ottoline Morrell,

Gertler and his wife, Stanley Spencer and his, Eddie Marsh and others but not the Behrends. G.S. actually *bought* himself a suit (no: hired from Moss Bros.) and tall hat. The wedding a proper affair in a Kensington Church, with bridesmaids. John Nash best man, in Tweeds, very nervous.

1931

Schwabe in his new role as Slade professor remains somewhat beset with staffing issues and in-fighting and worries about his stammer and ability to speak in public. He is much occupied with Artwork and trying to keep the quarterly magazine afloat but, as he records, it is moribund and he notes that people are panicky about money. Given Schwabe's expertise and varied interests he serves on a number of committees which take much of his time. Nonetheless, he finds opportunities to regularly visit exhibitions commenting insightfully and on occasions pointedly about the artists and their work. Alongside these commitments he continues avidly with his own work and meeting with his wide circle of friends.

JANUARY

Restarts Saturday 24
…Lunch with Lady Lyttelton at the Royal Hospital. She objects very strongly to the reproductions of the General's portrait for Grillion's by Macbeth, whose printed edition differs considerably from the proof he sent me. The edition is all over inked…To the V.&A. to look up Petrus Christus [1444-75/6] and brass rubbings. Met all sorts of people, students and others. Haynes among them, who told me the R.C.A. is disappointed about the Prix de Rome decision. An Academy student has got it, unjustly it is thought. I wish Miss [Ithell] Colquhoun had got it for the honour of the Slade. Looked casually at a lot of odd drawings…But so many people do good work it hardly seems worth trying to do it…

Sunday 25
Walked to MacColl's, to see about illustrations for his proposed article; and looked at Donald Maclaren's[1] drawings, with a view to a notice of them in *Artwork*…Wellington rang up at 12.10, to ask me if I would go with him to see [Ruskin] Spear's new window in the studio at Belsize Park Gardens. Did so, Spear a clever craftsman and a vigorous designer…

Thursday 29
Meeting of Accommodation Committee I put my case for extending the Slade into the present Zoology department, which would give us a large life room and a Staff Room… Saw the things submitted for the Rome Prizes, at the Imperial Gallery. Thought that the prizes had all gone to wrong people. Would have given the painting prize to Baker of the R.C.A., the engraving to Harrison (R.C.A.), the sculpture to Miss North of the Slade, and a mention to Miss Colquhoun…Moore agrees about the sculpture the R.A. man's work being common.

Friday 30
The Mayor of Fulham came to see me at the Slade, to explain his competition scheme for mural decorations. Told me at great length about Richard Jack's [1866-1952] portrait of the King, which the Mayor commissioned, but the King liked it so much he kept it, and Fulham has only a replica…

1 (1886-1917), portrait and landscape painter, nephew of MacColl.

Saturday 31
...Batsford rang up. Wants to know if I will have a show at his new Gallery in North Audley Street. Asked him for some money, pointing out that I have not had any during the last fourteen years...

FEBRUARY

Starts Saturday 7
Persian Exhibition in the morning. Rum punch party at 73 Wimbledon Hill.[2] Couldn't get out of being driven there by A.G.J. Very foggy in patches, ran up on the kerb several times and had to walk part of the way...Berry has two Tonks drawings I had not seen before, one a scene on the life of George Moore, some women playing cards at the bed-side of a dying woman. The Muirhead Bone interior of Berry's shop an astonishing performance. My own drawing of Moustiers obscurely hung, and the two others not visible. A thoroughly good sort Berry − I like his qualities of kindliness honesty and independence, no humbug. The punch prepared from an authentic old recipe supplied by O.[Oswald] Barrow. Milk and tea enter into its composition. Berry has some beautiful furniture and glass. He made a good facetious speech prior to presenting Ernest [Eddie] Marsh[3] with a bowl specially made by Vyse, with symbolic decoration alluding to Marsh's acquisitive instructs as a pot collector, 'Inaugural Meeting of the Anti-Marsh Society.'

Thursday 12
Costume drawing no. 102. Kelly came and took away the others I have done, of which he approves...

Friday 13
Went with Durst to see Ivon Hitchens in Adelaide Road: his work very agreeable in colour, but without guts. Some of his flower pieces would make admirable decorations for light modern rooms. He was at Bedales and has that slightly morbid character that a lot of Bedales men seem to get: was a member of the London Artists' Association for a year, but was removed by some intrigue of which I do not know the details, but which hurt him very much...A.D. [Alan Durst] has been very busy over a possible commission to do two life-size stone figures for the portal of the Academy of Dramatic Art in Gower Street. The architect has a 'ghost' who does all the work, and he has no hold over his Committee. Bernard Shaw and Henry Ainley are on the Committee and came to see Durst at his studio... Shaw cracked jokes the whole time, but was human: seemed to have a wish for Kennington to do the job, and made various impossible suggestions. Durst does not think [Jacob] Epstein's new *Genesis*[4] is well carved − that Epstein has in some cases cut away more than he intended to, and has not concealed his mistakes, noticeably in the hand resting on the thigh: also that he has destroyed the surface quality of the marble by cutting or hammering the wrong way, so that it looks like a plaster cast.

2 Home of Francis Berry, connoisseur of glass as much as of wine (Berry Bros.).
3 (1872-1953), civil servant, private secretary to Winston Churchill over twenty years, patron of the arts, in particular to John Currie, Mark Gertler, the Nashes, Spencer and other literary protégés, including Rupert Brooke.
4 A later depiction of maternity.

Saturday 14
Converted a study of a model into a water-colour — a beach scene. Clause came in, and likes it. Promised to go and see his new picture tomorrow…The Wellingtons spent the evening with us…W. told me that Spencer Gore knew Derain in London, before the war and before D. was so famous; that Derain painted some pictures of the Thames.

Wednesday 18
Mrs. John da Costa[5] called on me at the Slade with her step-daughter who wants to be a student there. They said they had had some opposition from da Costa, who wanted the girl to go to the R.A. schools, which Miss da Costa said were now full of Bolshevist Jews. The opposition was partly on account of the dreadful reputation the Slade had just after the war, for vice and immorality. I said there was always a rotten set in any big school, especially an art school, and that there maybe something of that sort now, but it is not so noticeable, so far as I can judge…Curiously, I had been talking to [Peter] Brooker[6] about the Slade era of 'Stripes', Eve Kirk, and others in Monnington's time. There was a good deal of promiscuity, from all accounts. Moynihan, by the way looks a dissipated young man. Unfortunately, in some cases the hardest livers seem to be the best artists — but by no means always. Great vitality — I suppose. Brooker repeated a story of Clara Klinghoffer, and the two pairs of boots outside her bedroom door, which is typical of what is being said.

Friday 20
Lunch with Lord Hartington, 85 Eaton Square…I mentioned in conversation that the Epstein child was at one time almost wild, and used to crawl under the table and bite people's legs; to which Lord H. replied that he was afraid his children did that too, and one of them, a little boy, saw a Tramp lying asleep in the park and, with the idea of playing at lions, stalked him and bit him…Fixed up something about the Macbeth reproductions for Lady Lyttelton. *Artwork*. Photographs of work by an Edinburgh artist-etcher and sculptor named William Lamb. Did not like them very much…

Monday 23
I hear that G.J. has taken Miss Colquhoun into Bath Cottage as a paying guest. Seems a very odd and unsuitable step to take – a Slade student living in the same house as a member of staff. Must ask Douie about this. Sine MacKinnon[7] is really married, and G.J. very upset thereby. *Artwork*. Was asked to pronounce on a MS for Dent, by old Voysey. Reported that it might be interesting to a few searchers in the byways of the Arts & Crafts Movement, but would have to be entirely re-written…

Thursday 26
…Duveen Committee — for Japan Exbn. Adrian Stokes, Collins Baker, Eddie Duveen and staff…

Friday 27
Artwork. New number out…Long talk with Monnington in his studio. Accused him of

5 John da Costa, well-known painter in oils, died May 1931.
6 Taught drawing at the Slade.
7 Married to Rupert Granville-Fordham, also a painter.

letting me down by going to the R.A. Schools, and asked his reason for refusing to come
to the Slade. He said he supposed I knew − it was G.J....He does not want to be Slade
Professor in the future: likes teaching, but does not want responsibility − finds letter-
writing difficult...I spoke to him freely about my stammering, and the fear it caused
me. He told me...about his morbid terror of Tubes and Cinemas...He, Jane, the Clifford
Allens and Bertrand Russell had taken seats for the first night of the Charlie Chaplin film,
but he had backed out, so I asked him to spend the evening with me, which he did.
Burn and Guthrie, he says, are going to America, where jobs have been offered them...
M.'s altar-piece is going on, entirely in black and white monochrome so far. It is to be
glazed. He has done a very good study of his own head for Christ-not like himself, but
very suitable for the purpose.

Saturday 28
...Adrian Kent and his wife came to tea. Birdie was out to tea with the Monningtons. I
was in the middle of sending out the invitations for the 'private' complimentary dinner
to Rothenstein, to his 'intimate' friends, ranging on Albert's list from the P.M. to H.G.
Wells – all the most distinguished men in London, about 70 in number. Wellington and
myself and Tristram are anomalies in this collection. Something damned silly and annoy-
ing in the whole business to my mind. Birdie came home late...This Monnington
business upset us both, and we talked of almost nothing else...

MARCH

Sunday 1
I went out to see the crowds on the Heath in the snow. Got snowballed, met Pocock,
and was agreeably distracted and amused. Had a cocktail with Ayrton over the way, and
saw one of Tony's new paintings. Behaved normally, but have a sinking in the pit of my
stomach very often...Got outwardly cheerful in the afternoon and sang absurd songs...

Monday 2
Dined with C. Koe Child and explained my difficulties to him. He said is an example of
Tonks's sensitiveness that recently when two young men called on him and went away,
having got what they wanted, he was hurt because they had never asked to look at his
work. I suppose the two were Burn and Guthrie. Child says Steer would never make a
speech, nor Russell either. Did not think my inability a ground for resigning. He had
discussed it with Gregory Foster last year...

Wednesday 4
Talked openly to Brooker & G.J. about my difficulties. Brooker urged me to make an
effort, and promised to cover my tracks at the dinner by speaking if I fail badly.

Thursday 5
Looked in at the Slade, and then lunch at Athenaeum with D.S.M., Max, Albert and
Thornton. Max made no effort to be witty all the time, but was occasionally amusing.
Said the Athenaeum was a good club in that it was large enough to get away from the
'jolly good fellows' who infested smaller clubs. I am up for election, seconded by him.
Don't feel confident that it is my true place. Albert and I went to Kettner's to look over

the ground and Alb. arranged menu. Went to Walter Bayes's Private View. Connard there, Ginner, Mrs. Bayes, an awful woman called Belle Cramer,[8] who was having a show in the small room, Medworth and his wife, Miss Strickland, whose book has at last been published by Blackwell, some B. of Ed. people, and Meninsky. Nothing of Bayes's sold, and in a rash moment I bought a small drawing…Meninsky & I went together to the Lefevre to see de la Fresnoye's work…Made some notes which I wrote up for *Artwork*…

Friday 6
So cold that I went for a sharp walk to shake off chill & depression…*Artwork*: corrected a rotten review by A.R. Powys. Mrs. Wellington at lunch. Says Mrs. Bayes is a bitch — will never ask women to her house, but asks their husbands without them. Spencer Gore a case. Used to be a regular once-a-week visitor, but had to give it up when he married. Ginner is apparently really hard up. Some years ago he had a legacy from an uncle, but it nearly all went on nursing homes and surgeon's fees. He was very hospitable while the money was there, and was proud of having drinks in the house, to give his friends…

Saturday 7
Small party at Alma Oakes's 32 Holland Park. Ledward, Orovida Pissarro, Claude Flight, Macnab, some Bedalians etc. Ledward is modelling key-stones for workmen to carve on the next Lever building at Blackfriars. McNab says that the Slade student (Westby) whom the Provost kicked out for the Clausen business[9] is working at his School. Thinks him harmless but not much good. I didn't object to him personally but he had to go, of course…

Sunday 8
Walked with Hagedorn to Parliament Hill and back by Kenwood…Called on Ayrton and drank some of his sherry…Tony is translating a brochure from the French, about Dr. Gachet[10] of Auvers. He knows Gachet fils and has much curious information about Gachet and his circle. Suggested that he might let us (*Artwork*) see anything that he writes on these matters…

Monday 9
Slade. Trouble about snowballing. Young [Stephen] Gilbert fined 5/-, which was collected and paid for him by the students. He disobeyed the instructions of the Senior Tutor who told him to stop. Long talk with Gerrard at tea. No love between him and Wilkie, I can see. He refused to stand as candidate for the Professorship when Tonks mentioned it to him…

Tuesday 10
Hanging Imperial Gallery…Told Tonks about Stephen Gilbert and asked his opinion… Tonks backs him strongly, and said that as he himself had been doing very well lately, he would promise to assist if S.G. got into too great financial straits…D.Y. [Cameron] remarked how impossible it is to hang any show, even this small one, without letting

8 Born New York City 1883; 1906 married and moved to Edinburgh, attended the School of Art. Returned USA 1939 having lived in London since outbreak World War I.
9 See R.S. Diary entry 16/10/30. The students wrote an open letter to Clausen about his reactionary views on art, which was published in the *Daily Mail*. Clausen having been invited by R.S. to criticise their Summer Compositions.
10 Painted by Vincent van Gogh 1890.

personal consideration creep it, and hanging MacColl, for instance, with special care because he is so sensitive about the place of his pictures; and how the R.A. is always criticised for this form of partiality, which, since we are all human, is inevitable. We all feel that Steer must hang in a place of honour, or that Roger Fry looks almost indecent above the line and so on...Tonks observed, apropos of E. Constable Alston, whom he always thinks well of as an artist, how important a genuine feeling for humanity is to artists as an impetus. He talked of Gerald Kelly and his acquaintance with Cézanne: and how he himself has difficulty in making lines vertical (some form of slight astigmatism?). Ledward's recumbent female figure strikes me as rather a fine thing: but people usually disregard his powers as a sculptor, and damn him for the Guards memorial, which he probably hates himself.

Wednesday 11
...spoke to Tonks about the Slade Dinner. He said he could not face it...might burst into tears. Asked him also if we could have a drawing of his for the U.C.L. Exhibition Room Collection. Got no further with this, but shifting the ground he declared himself willing to subscribe £5 towards getting a Steer water-colour, and promised to interest others, such as Aitken. I said I would subscribe too. 9.0. Party at Jean Inglis's and Miss Fulleylove's rooms in High St. Gilbert Spencer, and his wife, Oliver Brown, Hardinge (Papillon), Mrs. Sydney Carline etc.

Saturday 14
Walked over to MacColl's to consult him about arrangements for the Rothenstein dinner...Steer has recently presented him with the sketch for Mrs. MacColl's portrait – the one which is hung downstairs – and he has it on an easel in the studio, but is going to hand it over to the René MacColls...very like, as one can still see, though...done some years ago. It seems...Steer does give things away. I remember his saying to me apropos of a drawing I gave Lousada – 'What did you give it to him for? – I never give away my drawings'. Cheston came. We had dinner at the 'Refectory' at Golders Green, and came home afterwards. Cheston read about ¾ of his typescript memoir of Evelyn. I suggested a few textual changes, but it is no use tampering with a thing like that. They were a very devoted couple. Rushbury has many humorous stories of them – rather malicious. Cheston has little humour. When Evelyn was alive her neurotic state must have made life very difficult. She was much more genuinely ill than we ever supposed, though.

Monday 16
Young Di Luca, the model whom Monnington used a good deal for his St. Stephen's Hall decoration, told me that Tonks dressed him up in a loose suit of large check tweeds, stuffed him out with a cushion, and painted the figure of Sickert, in the piece of Sickert & Steer which was in the N.E.A.C. last time, from him. I wondered how it had been done, as Sickert didn't pose for Tonks. Diana Brinton called at the Slade and poured out her grievances about the N.E.A.C. 23 members have indicated that they wish her to resign, in a document reflecting on her business ability and salesmanship.

Tuesday 17
Letter from Rupert Lee, partly of a private nature, declaring his love for Diana, and putting a case for her against the injustice of the N.E.A.C. They wish to get married, but I believe

he is not divorced yet — after 17 years...

Wednesday 18
Basil Burdett[11] came...Made farewells. He...is going back to Australia sooner than he wished, as things there are even worse than he thought...and talks as if he is completely ruined. Asked me to exchange a drawing with John Moore, which I did with pleasure. Tasmanian water-colour in return for one of Welcombe. Burdett has visited Spencer's chapel at Burghclere, Eric Gill near Wycombe, and Gibbings at Waltham (Berks). Was amused at the Gibbings' insistence on the fact that they bathe naked together in the pond, and expect their guests to do the same. Burdett was also much impressed by the House collection in Bedford Square. A Leonardo and Italian primitives. Never heard of this before.

Thursday 19
...Artwork...R.A.W. showed me the balance sheet: loss, this year, £1460...Last year it was £200 more. Don't know how long Dent will stand this...

Friday 20
...Dinner at Athenaeum, Albert R. and Thornton. Talking of ragging at the Slade, Albert said he had all of his clothes stripped off him when he was there. Settled business of Rothenstein dinner...[including] Seating Plan...

Saturday 21
Dinner at Kettner's...D.S.M. spoke from the chair, read a letter from Max, alluding to W.R.'s early Paris days and gaucheries de la Rive Gauche; [H.A.L.] Fisher continued, rather pompous and dourish, W.R. responded: other speakers A.R.C. Carter (old Bradford School fellow, who alluded to W.R. as a 'typical Yorkshire' man) Humbert Wolfe, who ironically claimed to be one too, and made perhaps the best speech of all, F. Dodd, Howells, Newbolt and Chatterjee. Chatterjee a very intelligent man: talked about Indian art. Evan Charteris, on my left, said to me that though he speaks at the Bar daily, he does not like speaking at dinners: declined to do so here. Michel Salaman invited some of us to the Gargoyle Club in Dean Street afterwards...John was looking very ill and had drunk too much as usual. Lowinsky could not stop him making rude remarks about Rothenstein's memoirs...

Thursday 26
N.E.A.C. Executive Meeting, chiefly to discuss Diana Brinton, present MacColl, Connard, Thornton, Clause, Rushbury and Dorothy Coke.

Friday 27
Slade Dinner. Was in a state of extreme apprehension all day about speaking after dinner, but with the help of excitement and Burgundy managed to lose self-consciousness enough to say a few things without disaster. MacColl spoke well, and Thornton. Steer as usual declined. His health was drunk. Tonks and Brown were not forgotten, nor Child. Gladney, the American student, was amusing, and an old student named Reynolds... Steer was on my left and I talked to him about getting a Tonks for the Exhibition Room.

11 Journalist, art dealer, critic, 1925 with John Young established Macquarie Galleries, Sydney.

He responded generously, and I having said that I would give £5, he promised the rest of the price of one of the drawings now at Agnew's…

Saturday 28
…Got up early, and went to Agnew's about 9.15 to see about the Tonks. The drawing of Scarborough that Steer liked was already sold, so I bought the other one of Archangel. The show was naturally not open…but I managed to get hold of a man to deal with. Price, £21. Coming away, after ordering a suit of clothes from John Walls (they have come down to £10-10-0 from £12-12-0), met Francis and Mrs. Dodd in Cranbourn Street…they are having a new kitchen range put into their house at Blackheath. And while the workmen are there they are staying at Garland's Hotel. Went to Dodd's studio in Charles Street and looked at his work. Two portraits, one of Carmen Watson the little model who has been sitting at the Slade, the other of a man sitting at a desk: these for the R.A. Another genre piece of Blackheath, and a portrait I had seen before of 'Susan' Dacre,[12] who is now 87, blind and deaf and very bored with life…At Agnew's there was a very remarkable show of [Thomas] Girtins [1775-1802]…mostly from private collections. Almost all had his usual quality of dignity, which seems to increase as the colour tends to monochrome. *The Old Ouse Bridge York* [c.1797] is a very fine one, and of two *Durhams* one, with less colour in it, was very much better than the other. *St. Paul's Cathedral* [c.1795] – disappointing. His treatment of Yorkshire mountain and river scenery extremely fine, with great control over tone, which is where he scores over second-rate artists. *Rue St. Denis* [1802] very good, but some of the architectural subjects have a slight woolliness of drawing. The collection gave one an idea of the enormous amount he must have done in the short time he had to do it in…[Frieda] Blockie[13] came…[she] spoke of Arnold Bennett, who died yesterday of typhoid (Dorothy Bennett thinks because he drank the water when they were abroad recently) and of his great kindness to her. She was almost unknown to him, but he had heard of her difficulties and asked her about herself, making her promise that if she was in difficulties she would come to him at once. Blockie also agreed about his utter simplicity and absence of side, in spite of his great successes…I remember being struck by Arnold B.'s pleasantly bound- erish appearance, and his patent leather boots with cloth-uppers. He was an amusing talker on the three occasions when I met him – once at the Arts Theatre Club, once at Alick Schepeler's rooms on the top floor of 266 King's Road – I forget the other occasion. Alick has just lost a good friend…

12 Artist, feminist and suffragette, known as Isabel.
13 Frederica Bloch entered the Slade 1898, a great friend of Alick, at one stage they lived together at 29 Stanley Gardens, Chelsea. It was through her that Alick got to know Augustus John.

APRIL

Friday 3
Went to Dover. Commenced a drawing, a small schooner at the Quayside...

Monday 6
Drew the Basin from a top bedroom window in Cambridge Terrace.[14] This was a better drawing...

Tuesday 7
Drew for an hour or so on the quay Francis Berry and Vyse appeared, wandering about Dover. Berry is to retire from the wine trade. Back to Church Row by a late train...

Saturday 11
Went to Lewis about mounts...He complimented me on my new lot of drawings, which he thinks are 'better'...Went to *Sous Les Toits de Paris*[15] a well acted, well photographed film, at an awkward time, 7.50, and had supper (grilled steaks) at Lyons's palazzo in Coventry Street at 9.45...Can't go anywhere without seeing someone I know − South Ken. student, Andrews, at Lyons...

Sunday 12
...Dickey came to see me in the afternoon. Announced in confidence that he has been appointed Chief Government Inspector of Art Schools and is chucking Armstrong College. Asked me if I could think of a suitable successor, and I mentioned Wellington. Dickey said W. had been the first man he thought of; but we neither of us supposed that W. could be tempted to go to Newcastle. The money is not much more than he gets at the R.C.A. D. spoke of the increasing difficulty of artists living by the sale of their pictures: that he had been driven into teaching by having a wife and child to support...I said that Rushbury, Brockhurst and Cundall were among the few I could think of who had no private means but made a living without teaching. Dickey's staff at Newcastle is a difficult one. Bullock is in an abnormal mental state and Merian (? the sculptor) suffers from persecution mania, intensified, it seems, since a statue of his − an awful thing − was tarred and feathered at the Newcastle exhibition last year. Tea with Clause, who has been very energetic in trying to collect votes for Robin Guthrie, for the N.E.A.C. Does not think much of the other candidates, Sir Montagu Pollock, Lady Patricia Ramsey, etc. Jimmy Grant he thinks possible, doubts Tom Nash, and backs Mrs. Granger Taylor, whose work I don't know.

Monday 13
Slade began again.

Wednesday 15
...Spencer Pryse[16] (Walker and Grimmond told me this) related the history of his posters for the Wembley Exhibition to the Art Workers' Guild last week. Some responsible person called Winter, having resigned, Pryse had to get the approval of a certain Lord Stephenson,

14 Home of Tom and Dora Cobbe.
15 Trans. *Under the Roofs of Paris* (1930), directed René Clair.
16 See Hardie, M. (1925) 'The British Empire Lithographs', *Apollo*, Oct.

who succeeded him. Stephenson condemned the posters as obscene. Pryse, who had friends at Court, had arranged that they should be submitted to the Queen one day at the Duke of Connaught's house. The Queen sent off a set to adorn the walls of the girls' school at Sandringham.

Saturday 18
...Ethel Walker's show at the Lefevre Galleries. Introduction to the catalogue by Fred Brown. A very good lot of paintings...Went to get one to reproduce for *Artwork*...Film, *Morocco*, Marlene Dietrich and [Adolphe] Menjou. Not as good as *Blue Angel*[17] but well acted, and she is a beautiful woman.

Sunday 19
...Cheston came to supper...The show he is arranging, of Evelyn's work, is going to cost him a lot of money...He mentioned a sum of £700 but I am not clear whether that includes the cost of his book as well...

Wednesday 22
...Finished reviewing Rümann's book on *Illustrated Books*.[18] Am pleased to find that my little book of *Fables* engraved by the Brothers Dalziel, which I picked up on it's merits from a stall for 3d, is by way of being a German children's classic and has recently been re-issued by the Insel-Verlag, with the pictures reproduced from Speckter's original lithographs. Illustration appeals so much to me that I don't think I can be a very 'pure' artist.

Monday 27
Jury, [High Court] King's Bench, Court IV. My jury was in reserve while a case was tried, brought by some superior working-class people, to recover damages for the death of their son killed in a street accident. He, going along the Brixton Road on a motor-cycle, with the road clear, ran into a taxi-cab which turned sharply into a side street...the jury found for the plaintiff – £120. Exemplary young man, who had contributed half his wages to the support of his parents...McCardie a very good judge, and human...

Tuesday 28
Jury again. Case of the manager of a Cinema, in Ealing, dismissed from his job, suing for breach of contract. Legal arguments; during part of which I went to sleep. McCardie down on the defendants...

Wednesday 29
Case settled out of court...Received £1 for jury service...

MAY

Friday 1
Saw the Provost about increases in salaries: decided nothing was to be done. Private View of the Royal Academy. I went to meet Prior, Gardiner and Gleadowe – a conference of Slade Professors, but couldn't find them at first. A very New English Academy – the

17 The film made Dietrich a star.
18 See *Artwork*, Winter 1931, pp.vii-viii.

Slade well represented, and the College of Art too…Connard particularly asked me to tell G.J. how much he Connard liked G.J.'s picture (*Week Green Farm*, which he has been working on for four or five years). Towner has a picture. Later met Gardiner and the Slade professors and went up to the rooms above. Talk about nothing practical. John's *D'Abernon* is all out of tone, but vigorous. Don't like it much. Orpen's subject pictures not good. He is said to be very ill, and does not live carefully. Art Workers' Guild in the evening, taken by Grimmond, to hear a paper on Beardsley by R.A. Walker. Sullivan, Master, in the Chair…Frank Emanuel spoke, and Rackham, and Low the cartoonist. Met Townsend and Henry Wilson[19] (very shaky) who recognised me, though I have not seen him since that Arts and Crafts Show at Burlington House.

Saturday 2
Hung show at Batsford's. Cheston came, and we went out to dinner and a Cinema at Golders Green. He does not get on well with Dorothy Bennett. Described how she received him in a darkened room posing as a statue of grief on a sofa ('never saw such a theatrical exhibition in my life'). Then she got up and he heard her briskly telephoning in the next room…

Sunday 3
Blockie came to put in some plants. She has also been seeing Dorothy Cheston, who wants her to look after the child [Virginia], and to go to the South of France with her. D.C. is going to be with the Aldous Huxleys, and proposed that Blockie and the little girl should stay in an hotel…Dobson calls Epstein's *Genesis* 'Guinnesses'.

Thursday 7
Dinner with the Maufes in Church Street…Afterwards we went to the Vyses in Fulham Road, where Bernard Leach and Ernest Marsh also were. B. Leach a mild fanatic and a pleasant character. He showed a portfolio of collotypes of drawings by Tomimoto [Kenkichi], very slight but expressive, most of them, and largely designs for painting on pots. When Leach was with Tomimoto in Japan, they both agreed that it was no good harking back to traditional patterns for their decoration, and they used to make such rapid notes as these from anything that suggested itself on their walks abroad. The drawings partly done from memory I think, with the utmost possible swiftness and freedom. E.[Edward] Maufe is competing for Guildford Cathedral. He tells me he suggested me, among others, for the Trin. Coll. Cambridge drawings.

Friday 8
Slade again…making up for last week. After lunch to North Audley Street for my Private View. No-one there at 2.30. A few had been in the morning…R.A.W. bought a small drawing of a nude when I wasn't looking…

Saturday 9
Long talk with Clause about the ruin of his finances and his chance of joining the Slade staff which he would like to do…Willie has £400 a year left and must sell 16 New End Square…

19 Architect, metal worker, jeweller and teacher.

Sunday 10
Tea with Fairlie Harmar,[20] 126 Cheyne Walk to look at her Girtin, of Dovedale. Beatrice
Bland there; she spoke of the opening of Ethel Walker's show by Sickert. When the peo-
ple were arranged in a circle round the room, with Ethel Walker in a conspicuous
position, Sickert entered with George Moore.[21] E.W. rather put off by this, as she quar-
relled with G.M. 40 years ago over Clara Christian.[22] Sickert spoke, omitting all reference
to Ethel until quite at the end, when he said (indicating himself with one hand and Fred
Brown with the other) 'as to Miss Walker, of course she has been very well taught'.
E.W., annoyed, wrote to Sickert afterwards, assuming that it was that 'serpent' George
Moore who was at the bottom of this. No reply from Sickert. Jean Orage at supper with
us. Questioned her about orgies in Chelsea reported by the Marquis of Donegal in the
Sunday papers. The scene, it seems was Church Street next door to her shop, and Grims-
dale, the antique dealer, was the source of information for the press. A man fell out of a
second-floor window, injuring his spine, in the course of a 'bottle-party'. Jean says she
saw a young gentleman sitting in a car, with a vanity bag, powdering his nose.

Tuesday 12
Slade. Conferred with Gerrard and White about recommendations for scholarships. We
are all in agreement about the first 3 [Olga] Lehmann, Neil Cook and [Roger] Hilton.
Went to Leach's lecture on Tomimoto. L. described his introduction to pottery in Japan,
at a party in the house of a Master of Ki (or some word like that, meaning Aesthetics):
he the only European present. The guests were required either to do a drawing or a poem
on an unglazed pot, brushes and paints being provided. The pots were afterwards fired,
quickly. This roused Leach's interest in the craft and he arranged to have lessons from
the 6th Kenzan, an old man, a pure craftsman, without intellectual qualifications, whose
photograph he showed through the epidiascope. Later he met Tomimoto, and they
worked together towards something beyond purely traditional craft. Leach spoke very
highly of the way in which he was received and treated by cultured Japanese, who seem
free from the vices of the commercialized Eastern. One gentleman built Leach a kiln on
his estate, at his own expense, when Leach's previous place had been burned down...

Thursday 14
...Saw W.R.'s show at the Goupil...A drawing of Miss Wilstrop a model whom I have
drawn a lot myself, very like her, but curiously deficient in the realization of any feminine
quality she has, and she has a good deal...Went to Muirhead Bone's show. Whatever one
may think in other ways, no man living or dead could do these astounding things, and
keep a tedious thing lively. James Bone and a sailor brother were in the gallery. James
Bone said it was lucky for Muirhead that with his appetite (for work) he didn't drink...

Friday 15
...Birmingham, to award scholarships at the Art School. [Harold] Holden[23] received me

20 Artist, on marriage Viscountess Harberton.

21 Irish novelist, went to Paris to become a painter but returned to London in 1882 to write.

22 Amongst the characters in George Moore's *Hail and Farewell* is 'Stella' (Clara Christian), who settled in
Dublin and was his mistress for a number of years, later married Charles McCarthy, an architect, died 1906
in childbirth.

23 (1885-1977), formerly Principal Cheltenham School of Arts and Crafts, later returned Leeds College of
Art, where he had been a student (and Skipton School of Art), to become its Principal, 1922-28.

there. Devilish keen on their job heads of art schools seem to be nowadays. He knew the work and the students intimately. A lively place and some surprisingly good stuff done there. Drawings done on an odd system, some very direct and forcible. They proceed by putting a piece of semi-transparent paper over another, and redrawing on top if the thing goes wrong, often doing several drawings in this way before the final result is reached. Memory is still trained highly, as one might expect in the home of Catterson Smith and their constructive ideas are good. A hopeful sculptor called Bridgewater got the drawing prize. Gollins, a member of the staff, explained that the designers do their rough drafts by memorising and drawing with their eyes shut (they may open them again if they feel they are losing their way on the paper). They may retain feeling and expressiveness by this process. Painting frightful in colour, but Stubbington, who is responsible for this side – an odd little man, very keen, with flowing red hair and beard – doesn't know much abut painting. We reasoned together on these subjects. Saw the [Joseph] Southall decoration in the Art Gallery, rather interesting. Holden says that they can practically guarantee some sort of industrial job to any student who completes their course. The City seems to support the School handsomely so long as they don't try to turn out mere artists. The painting and drawing classes were knocked on the head for 15 years, and design and industry concentrated on. Holden is changing this, but has to go carefully. Train back...Dined at Roche's. C.J. Holmes[24] there and Lady Holmes and their eldest son. The other two were going to the opera, but Holmes and I stayed and chatted for an hour. Comparing notes I find that he has known Roche's for 35 years, since he was an 'office boy', patronised by Ricketts, and I for 25 years. He was amazed at my description of Wyndham Lewis poking a black whiskered face into the door of the English tea-shop in the B'aíd. Montparnasse (about 1908) and saying in a sepulchral voice to the waitress – 'avez vous des buns??' He talked of his difficulty in writing a testimonial for Sickert when Walter Richard was applying for a job at the Westminster School, knowing as he did Sickert's lurid past and his career in Dieppe with the fish-wife: finally described him as 'a man of the world'. Then he spent an evening with Asquith, then P.M., Sickert and others. Sickert said loudly to Asquith, whom he had never met before – 'if you ever want a testimonial, Holmes, over there, is the man to do it for you!' Saw some remarkable children's drawings, done in the school where Margaret Barker teaches. Pamela de Bayon and Helen Fletcher later in the evening. They both think that St. John [Greer] Ervine was a cad about Mrs. Edward Thomas's book, though they don't like it very much. Pamela says she owes a £1000. She had the story about [Alexander] Stuart-Hill and the girl all wrong.[25] We were able to correct her and give it its true – and better – aspect.

Saturday 16
N.E.A.C. Executive meeting...Discussed case of Diana Brinton, and Chisman as a possible Secretary for the future...I have a strongly expressed letter from Rupert Lee about Diana, the injustice with which she is treated, Thornton's 'dishonesty'. Thornton is not dishonest...

Thursday 21
B. of Ed. Exams. Travis talking about Job Nixon, with whom he was a fellow student. Nixon's income rose for one or two years to £1600, mostly from etchings sold through

24 Sir Charles, painter, etcher, art historian. Director N.P.G. (1906-16), National Gallery (1916-28).
25 Scottish painter, who was secretly engaged to Princess Louise of Battenberg, the future Queen Consort of Sweden and brother Louis, Lord Mountbatten.

Colnaghi's. Now he is hardly making anything, and has saved nothing. He is going to get married again, apparently none too soon for the lady's reputation.

Friday 22 May – Thursday 25 June: no diary entries

JUNE

Friday 26
Slade finished. Managed to offer a few platitudes at the Prize giving, and gave Charlton, G.J., Thomas and [Frank] Ormrod a nominal 5 minutes each to speak on the work of their departments....Thomas, almost as nervous as myself, but brief, natural and amusing. ...10-12.45 Last of Bd. of Ed. Exams. Farewell to Bayes & Watson. We have been an argumentative trio, but parsimonious and friendly...

Saturday 27
...went to see Hardinge-Papillion[26] in the house he has made for himself out of the stables behind no. 9 Well Walk...He attended the sale of Pavlova's effects at Ivy Lodge the other day. Much room for moralising in this matter: all her trophies and things done up in lots and sold for nothing. I suppose she was one of the greatest dancers – with Karsavina in the Taglioni class...

Tuesday 30
R.A. Walker back from his holiday in Belgium. He spent an afternoon with Ensor in Ostend...[who] also played for Walker, on the organ, selections from his Opera, or Ballet, which ever it is, *La Gamme d'Amour*. His father was an Englishman, but he cannot speak a word of English...They have good pictures of Ensor's in the Ostend Art Gallery. R.A.W. came back from Brussels by air-plane – a 2 hour journey.

JULY

Sunday 5
Note, that Bayes's story of the modern artist who went off with another man's wife 'because he thought it would improve his painting' refers to Roger Fry. Bayes has put it in his new 'Turner' book, but mentions no names.

Monday 6
Drew Lady Perdita [Rose Mary Jolliffe], one fairly complete drawing + one slight. She is a grand-daughter of Asquith (otherwise I have no idea who she is – Eddie Marsh was responsible for recommending me to the Jolliffes...) and knows William Nicholson well, who once painted her when she was about 16 but it was a failure and he burnt it. Lunch at the Blue Cockatoo – just the same after 3 years. How Miss Watson supports herself, 3 children, Hetty, Blake, and Udall is beyond me. Met Elsie Robertson in Cheyne Walk, and Adrian Kent coming out of The Six Bells (his fingernails were very dirty): he has some prospect of a job at a new school in Devonshire, and has been down to Bedales to confer with Meo on the art education of the young...

26 Antique dealer.

Wednesday 8

...lunch with Birdie and Margaret Mackintosh at Mrs. Leicester's. Margaret had been to look at a studio in the Vale of Health Hotel, but didn't like Mrs. Gray's squalor...Went on to Cooling's Gallery where were some French pictures...and water-colours by London Artists' Association. Noticed...some Robertses (still going on with the same Robot mode), a poor Roger Fry, some flagrant cribs of Matisse by Teddy Wolfe, who seemed to have no personality, and other things. Reflection – if this is the best they can do it's not a great a deal, though decent enough...Dinner with Gertler, 22 Kempley Road 7.30. Mrs. G. not there. Flat furnished with gilt furniture, and floor painted white (uneconomical). Walter Taylor[27] and a Mrs. Turner, wife of a dramatic critic at dinner. Much talk about Garsington, which they all seem to know. Gertler full of reminiscences of his youth. Described his unrequited passion for Carrington as contemporaneous with Fred Brown's unrequited passion for Dorothy Brett. All four used to go out for lunch together, Gertler, at that stage, rather in awe of Brown. Must have been a queer party. Brown came down to Garsington when Brett was there. He stayed in the village, she at the house... Eddie Marsh gave Gertler £12 a month at the beginning of the War, and invited him to stay in his rooms. But G. gave it up abruptly, as he couldn't bear Marsh's attitude about the War. Marsh was very hurt. Dorothy Brett made Gertler an allowance at the same time, and they shared a house together, either then or later. She is now in Mexico on a ranch, and Mrs. D.H. Lawrence, Frieda, is on her way to join her there. G. also described being taken to see Sargent by the Wertheimers, on a Sunday morning, when he held a sort of reception. Looked at Gertler's work, and thought it would be good for his appreciation of light and colour to go to Italy. Gertler didn't want to go to Italy – was in love with the Slade and his East End, so quarrelled with his Jewish backers over that. There is also a coolness between G. and W.R. – why? G. does not know. Gilbert Spencer came in after dinner, also full of reminiscences of Garsington...Walter Taylor says he never drinks anything now, except when he has lunch with Sickert.

Friday 10 – Thursday 16: no diary entries

Friday 17

Bought some maps of Charing [Kent] district at Stanford's, and saw Bernard Shaw also buying maps. How easily recognizable he is – one of the few public characters whom one really knows in the street from their portrait. Lord Ribblesdale was another, and A.J. Balfour both of whom I saw in this way...

Saturday 18

The Kohns took Birdie down to Charing in the car...I went with them as far as Kensington...dropped into the R.C.A. to see the School Show. Clack & a Miss [Evelyn] Dunbar very good...Met Alick in the Brompton Road, and to make amends for what she considers our neglect of her, gave her lunch at an Italian place in Greek Street. Much chat about Dorothy Cheston Bennett, John Hope-Johnstone, Poppet John and other old acquaintances. Alick doesn't admire Romilly John's book of poems, just out, so it must have gone round that they are not good...

27 Patron Camden Town Group, frequently entertained Sickert and Gore (godfather to his son Frederick) at his homes in London and Brighton.

Sunday 19
…Mid-day dinner with Willie & Lucy…Saw some of Willie's pictures. They seem rather stuck at the moment, and his funny clumsiness is often apparent in them. I liked some landscapes, fresher than the rest…Clause is strongly against sending Alice to the Margaret Morris Summer School at Antibes. He knew it well a few years ago, and there seem to be usually a good many rather viciously inclined young women, who collect a rotten set of Dago men around them.

Monday 20
…N.E.A.C. Committee…Holmes did most of the talking, Clause made notes for the minutes, Coke said nothing. Decided to have Chisman for Gallery Secretary – turning down an application from John Rothenstein, and a suggestion from me about Willie Cave as an alternative in case Chisman was not wanted. Travelled back to Hampstead with D.S.M. who talked rather indignantly about Bayes's book on Turner, saw there was no genuine foundation for all this stuff about Turner's mistresses, and that the reason Turner went to Wapping was to collect rents. I think Bayes *has* been rather too careless, and trusts his memory too much, having a horror of historical research and indeed (it seems to me) of facts of any kind: Theory is what interests him…

Tuesday 21
…Train to Charing…

Thursday 23
Broke my arm (left) falling off the back of Hugh's [Jones]* motorcycle coming back from Ashford just near the house. Telephoned Dr. Johnson in Charing, who took me into Ashford hospital to be x rayed. Hung about there for 2½ hours, talking to W. Dulhunty part of the time, who was in a private ward. He had been picked up unconscious on Biddenden Heath, and referred to himself as 'the Biddenden Heath mystery'. Engineer, concerned in the Morden Tube extension and the Underground bldg. St. James's Park. Chloroform. Arm set by Dr. Scott…

Friday 24
Woke up in Ashford hospital. Found W. Dulhunty again later. He was ruined in the Hatry crash. Seems quite content – says he has had everything out of life: his wife dead: his brother murdered: doesn't want to work any more – having had important jobs, cannot now be underdog…

AUGUST

Monday 3 August – Wednesday 19 & Sunday 23 August – Friday 11 September: no diary entries
[Dover – staying with the Cobbes]

SEPTEMBER

Saturday 12
Left Charing.

Tuesday 15
...Started an illustration, a duelling scene, for one of Blunden's poems...

Friday 18
Alice and I left Liverpool St. 10 o'c. for Flushing. Fare £2 each, first class on boat, return.
Arrived Flushing 5.30...Alma Oakes met us. Tram to Middleburg and taxi to Veere. Alice
slept in Schotche Huis with Alma O. and Mandy Stuart. I in a pension in the Market Place...

Saturday 19
Visited the Church before breakfast, being shown over by an English-speaking one-armed
custodian...Now being restored...Lunch in Veere. Started two drawings...There are 16
resident artists in Veere...

Monday 21
Went to make notes for a drawing...Veere looks well from the top of the tower, and the
fishing boats were putting out to sea one by one, looking nothing but Dutch – [Jan] van
Goyen [1596-1656] this time...Bus 12.15 to Middleburg, and taxi to Flushing. A rough
passage...Home about 11.30.

Tuesday 22–Monday 28: no diary entries

Tuesday 29
Went to deliver two drawings to the Leicester Galleries, and called on Beaumont to show
him a 'rough' of the cover for the new Blunden book, based on emblems of the law.
Beaumont approved, as he usually does...which makes him very pleasant to work for. He
presented me with a copy of *Flash Back* a book of reminiscences of his childhood, with an
introduction by Sashy Sitwell. Looked at a lot of good illustrated books on Beaumont's
shelves. Many artists doing this sort of thing now and doing it well. Noticed Stephen
Gooden, Vera Willoughby, George Charlton and Tommy Lowinsky. At *Artwork* office
R.A.W. showed me a letter from Gosling of Colnaghis offering to sell *Apollo* for £1500 to
Dent; which Dent has refused. There seems to be no hope of amalgamation, and both
magazines will cease shortly...R.A.W. says that the drawing of Beardsley's, *Tristan & Isolde*,
two women seated with a man standing, back to spectator, which belongs to Morton Sands,
was originally bought by Sands's brother in America for £100. The brother is a hunting
man and got so sick of being laughed at by his friends for having the drawing on his walls
that he sold it to Morton S. for what it cost him. Dickey's book, an illustrated history of
English art, with well chosen illustrations, is out, and is at the office for review.

OCTOBER

Thursday 1
Bought *The Times* to read about Orpen's death...

Friday 2
...*Artwork*. Memo. from Dent to say we must definitely look forward to giving it up after the next issue. Back to the Slade to meet Dickey, who wanted to discuss the question of the new examinations for the Board of Education Art exams...Dickey has been to Leeds where Leach was instructing a class for a fortnight in pottery. They built a kiln for him and he fired it with wood, an awful bother but everybody worked enthusiastically. Just as we were discussing Leach Ernest Marsh came in, and gave us more news of Leach, Hamada and Vyse. The latter two are having shows this autumn. A bad season it will be I'm afraid. None of the Camille Pissarros sold at the Leicester Galleries, and most people are panicky about money...

Saturday 3
Rang up Mrs. Pissarro to inquire about Lucien P. who is recovering from an operation in University Coll. Hospital...Durst came in 11.15: he has been working in London all the summer in a stone-mason's yard in Fulham on the figures for the Acad. of Dramatic Art in Gower St. He seems to have undergone a sort of revolution in his views on art, and spent a whole day in the British Museum trying to see sculpture, from the Ethnological exhibits to the Greeks, with a fresh eye. He feels the absurdity of trying to be naïve and primitive when you are essentially neither, and this has been brought home to him by R.P. Bedford and Henry Moore, who both seem to him to admire Ben Nicholson and the like out of all measure...Went with Clause to the Orpen memorial service at St. James's Piccadilly...Not everyone was wearing a tall hat and black-coat, though most were...the Church more than half full. Someone told me that Tonks and Brown were at the funeral very upset. I developed a tendency to moralise on Orpen's career and death, but on going to the National Gallery for an hour with Willie, looking at Turner, Wilson, Hobbema, Constable, Gainsborough and Ruysdael, became less gloomy. Tea with Winifred Hannay. Oppé and Jack Squire there. Squire's blue serge suit very shiny – I gather he is rather hard up. We were rather rude to each other the only other time we ever met, years ago, at the Behrends, but not today. Winnie Hannay has a portrait of Gertler by himself (oil) on the wall...

Monday 5
Slade term began...Olga Lehmann and Carmen lost no time in producing vast quantities of paintings done in the summer for my inspection...Supper at the Scotch House, where was Ginner. Talk of Sickert's habit of keeping taxis waiting, Ginner said that Sickert did so all the time he was lunching with Winston Churchill, when Churchill was having lessons from him...

Wednesday 7
Slade...Dined at the Everyman [Theatre] surrounded by the works of Ginner and Ethelbert White. Went on with Pamela de Bayon, Helen Fletcher and Warburg to P.'s flat in Branch Hill. Mrs. Hepburn (Anna Wickham), as she used to be called, the hostess, was

there with her son. She looks very little changed since I used to see her before the war at the Café Royal. A 'Hampstead type'.

Thursday 8
Went to the University to see about the drawing exams, for which I am now acting as Moderator…Wasted time in the afternoon trying to see Lucien Pissarro in…Hospital… Mrs. Pissarro was there…She told me the news of Ricketts's sudden death. Dined with Koe Child, and discussed the Slade. He agrees that feeling is strongly in favour of having the Summer Compositions judged internally and not by an outsider, such as Clausen or Roger Fry. Talked of the departure of Burn & Guthrie for America in the summer…They find James of Boston very kind and helpful, but had not yet begun work at the school when Child had Burn's letter.

Friday 9
…Dinner at the Everyman Grill again. Mrs. Filmer there, rather depressed about the prospects of the Theatre: offered us seats. Kathleen Dillon has been divorced by her husband the lawyer, and she is now going to marry Angus Morrison, who used to play at Margaret Morris's. Another Margaret Morris girl, Irma Minchin has 'gone gay.' They seem rather disposed to do that…

Saturday 10
Walked over to see MacColl. Saw Mrs. MacColl at the door, who spoke about Ricketts and Shannon. She sat for Shannon when she was young…Met Mrs. Watts on the Heath looking after offspring…She says Herbert Griffith has himself to blame, largely, for losing a £1500 a year job as critic for the *Observer* and *Evening Standard*. He got too well-known for coming in just for the last act of a play, and for letting anybody do his book reviews for him…started a drawing in Judge's Walk. In the evening Birdie, Alice, I and Margaret Mackintosh went to the Grafton to see *East Lynne*…this strange piece seemed to get hold of an irreverent audience in the end, though there was a good deal of laughter at the sentiment…

Thursday 15
Brooker did the Sketch Club at the Slade. G.J. and I and Wilkie judged the Summer Compositions in private…

Tuesday 20
The Bartlett School of Architecture has just had some rooms re-painted at great expense, and one of the rooms has been chosen by the students for a rag. They got in in the night, worked all night long, and accomplished a large painting, allegorical in nature, of Prof. Richardson and his staff supporting architecture. As it is rather well done, for architectural students, Richardson rather likes it, and has said nothing about it.

Wednesday 21
Miss Scott Thompson called at the Slade to see the drawing of Woburn, which she approved after I had explained all my reasons for doing it as I have done. I mentioned £21 as a price. She said not enough, suggested £30. I compromised at £25… Brooker told me…that Wyndham Tryon has been in a mental home since the last 6 months. He thinks he is John the Baptist. I thought he was in a queer morbid state when

I saw him last year...

Thursday 22
...Went to Batsford's to try and put the matter of the contract right for Kelly...Asked when I might expect some money – money is tight with them just now. Went into the Gallery to see Voysey's exhibition...Some of the textiles good...

Friday 23
The Criticism of the Summer Compositions went off smoothly. I managed a few introductory words, and G.J. and Charlton did the rest...to U.C.L., 7 o'c., met Jowett, who was a guest of Baker's at the Professors' Dining Club... Got into a group of scientific men who discussed Marie Stopes. They admire her, and praise her courage and ability at hostile meetings...

Monday 26
At the Slade spoke to Gladney about his summer composition. He seems to be very disappointed at not getting 1st prize, and was no doubt puzzled at the choice of Miss Rowntree to share the prize with Miss [Elizabeth] Brown...went...to see Zwemmer's show of film stills, which Bob Wellington is running. They belong to Paul Rotha, whom we were introduced to. A young man something between artist and journalist. Was anticipating something more exciting than Rotha actually was, but there was some excellent photography. Probably Flaherty is the best of them all so far...

Wednesday 28
...Filmer rang up in the evening to borrow £2. The Everyman Theatre is going broke again. Neither he nor Westlake had a shilling between them after paying the workmen. He says that unless a providential millionaire comes along they will have to close down next Wednesday.

Thursday 29
Slade. Lunch with Durst after viewing his two big figures on the A.D.A. in Gower Street. He knows how to cut stone, but to my mind suffers from having started too late as an artist, and from not knowing his form well enough. He ought to have been allowed by his Father to have become an artist, instead of Herbert, who has never done anything much since he left the Slade; it would have saved the time wasted in the Marines. ...He calls the A.D.A. the 'Academy of Dramatic Tarts' and describes the young ladies who frequent it with some zest, but no approval...Supper at the Everyman Grill...Met Egan Mew there, who invited us in afterwards to see his house in Church Row. Tiny, and crowded with amusing curios and antiques. He...says that Max [Beerbohm] and his wife were staying at Jack Straw's for a time when they were in London this year, which perhaps explains why Virginia Parsons was boarded out there when Viola was in America. Max came over to England with a commission to do 5 caricatures of sporting persons for £600. They included the Duke of Richmond, with whom he lunched at Goodwood for the purposes of his drawing. He subsequently got another commission for 5 other drawings at the same price, and then another for the *Spectator* series, which were not paid so well. But he seems to have done very well on the whole. Mew described a drawing of Max's of King George falling off his horse, with the legend *Our Sailor King*. The same

incident, I remember, inspired Osbert Sitwell to a humorous poem.

Friday 30
…Went to Slade for a short time in the morning about Carmen's affairs, and her British Institution Scholarship papers: then *Artwork*, and to Cooper's in Rose and Crown Yard to get a proper photograph of my *Langham Place* drawing (for reproduction in *Artwork*). [William] McCance has sent a beautifully produced book – [John Milton's] *Comus*, with illustrations by [Blair] Hughes-Stanton – for review from the Gregynog Press together with some…engravings by Mrs. McCance [Agnes Miller Parker] – excellent work, and very well printed.

NOVEMBER

Sunday 1
The German maid came: can't speak a word of English, very difficult…Went to tea with Gilbert Ledward in Pembroke Walk, Earls Court…[his] work is a little disappointing to expectations formed from looking at photographs of it, rather less sensitive than I thought. He does some good working drawings. He is working on some keystones… Ledward has also been working on the Lever building, keystones and panels…

Monday 2
…At Arthur Watts's in the evening…Looked at some of his sketch-books…He has a clever linear handling in these pencil drawings, and they are amusing documents. He rarely does a drawing without using studies, so naturally has a profusion of them…

Tuesday 3
N.E.A.C. Jury…1,200 outsiders' pictures to wade through, besides the members…Beer-bohm thinks very highly of D.S.M. as a stylist in criticism. It will be worth while reading his forthcoming book of republished papers…Chisman was once secretary of the Herkomer School in Bushey, and used to drive the Herkomer sons…from Boxmoor Station in a fly to Golden Parsonage School near Great Gaddesden. We exchanged reminiscences of Hemel Hempstead…

Wednesday 4
N.E.A.C. hanging… Jowett and I concentrated on the water-colours and drawings…Ethel Walker has the wildest partialities for her friends' work, but is otherwise useless on a hanging committee. She spent most of the afternoon slopping water-colour very freely on a composition of hers (Jesus wept, or some such subject). Yesterday she had a scarlet waistcoat, today a yellow one, both with brass buttons; and today David the dog came with her. Nevinson is getting fat; he laughs too much, but is good company, full of amusing anecdote about Nancy Cunard, John, himself and others. Ethel Walker describes Arthur Symons in his young days as unattractive and 'smelly', yet always boasting of the women who had loved him…[her] reminiscences are also violently coloured by her personal partialities.

Thursday 5

N.E.A.C. Finished drawing etc. by lunchtime and then Connard and I re-hung one wall of the big room…The retrospective show of Orpen's paintings looks very well…Connard said he liked my drawing of *Charing Church*…He is a generous admirer of other men's work, and especially of Steer, with whom he has recently been away: describes how Steer will sit down and work in front of a subject in which Connard can see nothing whatever paintable, splashing about with a broad water-colour brush (no drawing), and nearly always doing something beautiful…

Friday 6

…A man from the V.&A. library talked to me about some reminiscences he has been collecting from [John Melhuish] Strudwick, aged over 80, the last living man who remembers all about the P.R.B.s [Pre-Raphaelite Brotherhood], thought they would do for *Artwork* but I told him *Artwork* was moribund. Strudwick's recollections, of Lily Langtry in particular, who sat to him, are not all printable. She used to retire after dinner with a male guest to the drawing-room, W. Langtry (£800 a year and a yacht) remaining tactfully downstairs. 'You had better say good-night to W. Langtry', she would say on her guest's departure…

Sunday 8–Wednesday 18: no diary entries

Thursday 19

Finished fiddling with a gouache drawing of a dance rehearsal, based on notes made at Drury Lane when Fokine came over from America to direct a ballet in the pantomime. I made two drawings of him on that occasion, after waiting while he directed the rehearsal from 11-5.30. Beaumont had arranged the sitting and was there with me. In the afternoon started a design for the Sydney Press, a job brought to me by Prof. Richardson. Got a photograph of Sydney's portrait from the N.P.G. Went to Barnett Freedman's show of drawings, largely illustrations to Sassoon's new book. The drawings lose a lot in reproduction…I like some of the big pen and wash drawings – landscapes mostly. Bought Herbert Read's *The Meaning of Art* 3/6d.

Friday 20

Went on with Sydney design, adapting cartouche work from Lukas Kilian [1579-1637] etc., in *Les Grandes Illustrateurs*. Finished it in the course of the day…to Camberwell, to help arrange the pictures for the South London Group show. Tea in the school, with Cosmo Clark, Guy Miller and Laird. Holmes cannot come to open the show, being made an hon. fellow of his College on that day. So we wrote to Constable to ask him to open it. I was much struck by some of Badmin's work, and assume a little credit to myself for having directed his beginnings at the Camberwell School and at the R.C.A. Miller showed me my own two drawings of the Peckham Road, now hung in the Gallery… Guy Miller's records of the street, before the recent 'improvements', not bad. Some good sketch-book pages of Boyd Houghton's…

Saturday 21

…to Bletchley…Met at the station…and driven to Woburn…Was shown into Miss Scott Thompson's sitting room, hung with Dutch pictures…Miss S.T. showed me the rest of

the pictures, the Rembrandts (I remember the self-portrait the Duke paid £19 for...), the Canaletto room...the Sir Joshuas and Gainsboroughs...and interesting family portraits... (some extremely useful for costume)...Like a branch of the National Gallery running into the National Portrait Gallery...The Duke came in about one o'c. and showed me the outside of the house...Walked round the stables and tennis-court – later work than Flitcroft, at least the tennis-court is...All this makes me wish it had been possible to get going with the book which Harding and I once projected on the less familiar architects of the 18th century (text by Harding, drawings by me) – Flitcroft, Taylor, Leverton, Archer etc. Luncheon at which the Duchess does not appear, being stone deaf. I washed my hands in a bedroom on the first floor, a can of hot water being brought by a servant: no hot water laid on, and no proper lavatory. The Duke says there wasn't a bathroom in the house when Queen Victoria stayed in it...He is an oldish man, and wore a grey flannel suit and cloth cap... Miss S.T. did most of the talking. Smoking is not allowed in the house, but on leaving a servant brought a box of cigarettes on a tray, and a lighted candle...I asked what the cigarettes were – Virginian or Turkish? The man replied 'Virginian, Benson and 'Edges, sir'. Home by 4.45. Blockie working in the garden. Dined at Roche's, with Ginger, who took us to *Cavalcade*. The obviousness of Noel Coward's melodrama is rather inartistic...but the scenic affects are extremely clever, like all Cochran's work. The piece stirred up memories of the war, as it is evidently intended to do, and I thought of myself going round Chelsea with Hervey Fisher when the Jutland battle was in progress, and no-one knew what had happened; going to old Ionides in Glebe Place to find out if he heard anything from his nephew...and then hearing the news that Charles Fisher had gone to the bottom with his ship [HMS *Invincible*]; and old Mrs. Fisher's comment 'If only we had won!' (This was at a moment when the Admiralty's published list of our losses gave a worse impression of the affair than was actually the case).

Wednesday 25
Went to Gerald Kelly's 'Anthology of English Painting' show at the French Gallery... Kelly was very enthusiastic about Mrs. Swynnerton's portrait of Count Zouboff – ...She was over 60 when she did it. He was a sort of 'lounge lizard', as Kelly puts it, and he supposes that Mrs. S. was vaguely, unconsciously, stirred by him to a kind of lyricism, just as the landscape outside the window evidently stirred her. For Kelly, this landscape expresses all the feeling for the South [of France] and its light and colour that he remembers to have had as a young man, when, after some hideously uncomfortable journey in a 3rd class carriage, and feeling that nothing on earth was worth that, the beauty of the South made him feel it was worth while after all. I said to him that Steer's *Children Paddling*, which belongs to Daniel, was in the French Impressionist vein, but better than most Monet's, and he quite agreed. John's *Head of a Girl*, the over life-size head and shoulders picture which I once half seriously wanted to form a syndicate to buy, when it was in Knewstubb's hands for £80, looks as magnificent as ever, and Tonks's little *Head of a Girl* more beautiful than it did at the N.E.A.C., when Konody or somebody said the drawing of the ear was unworthy of a Slade Professor, or words to that effect. A very good show: Walter Russell's *Music Hall* among his best things, and some of Alan Beeton's very bad.

Thursday 26
Collected a water-colour from Prof. Brown's house at Richmond, for the University

College Collection...I saw only Miss Brown. She says he is very well, but getting forget-ful...They went down to Chelmsford some while back to see the municipal Art Gallery, with the idea that it might be a good place to leave his pictures to, but they didn't think it was a good enough gallery. In the evening got out an old drawing of Heyshott Mill, a failure, but I thought it had something in it, so started to redraw it and re-compose it.

Friday 27
Started a drawing of Hollybush Hill. Rather cold work...Jean Orage and Alma Oakes came to supper. Jean has some scurrilous story about Alice Rothenstein and Grein – how Grein looked through the keyhole of her residence in the early hours of the morning, saw W.R.'s hat and stick, and realised that all was over for him. No wonder Jean thinks [Rothenstein's] *Men and Memories* not amusing enough...

Sunday 29
Meo came in on us for a Sunday dinner. He is up in town to see Yvonne in the Pond Street Hospital. She has had another operation. He was cursing Bedales as usual and 'its pathological atmosphere', its crankiness...

DECEMBER

Friday 4
...N.E.A.C. General Meeting...Rushbury made a speech about the inadvisability of having 'Professors' on the Executive, and wanted a clean sweep, with none but young men to carry on the Club's affairs. In spite of which he himself got more votes than anyone, and I got the next largest number. Albert, Nevinson, Lowinsky, Rushbury, Thornton & I went to the Café Royal. Epstein was there, with Mrs. Epstein, Peggy Jean in a little green sleeveless frock, a blackhaired beauty and a musician. Nevinson also pointed out Barney Seale the sculptor, sitting with some journalists & a lovely lady. Viva Booth appeared; in fact the Café seems much like it used to be: somebody got thrown out as usual. Nevinson's stories can't be very reliable. He has too many of them and obviously loves embroidery. We talked of Blanche Denton and the 'Savoyard'. He says that after she went blind from drinking wood alcohol and came back from America with her husband, she ran away with a chauffeur. He admitted having 'relations' with her, but denied that he was the father of the child she tried to make him responsible for. She tried to make about a dozen other people responsible first, including Nevinson's father, who, I suppose, had never had anything to do with her. Tommy Lowinsky is very charming to the person he is talking to, but too fond of making unpleasant remarks about others to inspire much confidence. Nevinson says he is difficult to talk to, as he doesn't listen. There is something petty about him, as there is in his work. He reminds one, by his carping spirit, of the wits in 18th century comedy, but is not exactly witty. He told me of his labours in settling up the Ricketts and Shannon affair, he being a trustee for Shannon's estate now that Shannon is declared insane.

Saturday 5
Bought Redgrave's *Century of Painters* in Charing Cross Road, 2 vols. 6/-, on my way to Beaumont to sign the sheets of Blunden's new book...Beaumont has altered my cover design, printing the background in yellow instead of red...Opening of the South London Group...Dalton referred civilly to my services to the exhibition, which isn't a bad one.

Tea in the Gallery Bayes, Thorogood, Medworth and others.

Wednesday 9
After dinner went round to Watts, who had Jimmy Horsnell there, and Mrs. Watts went with us to Gluck's new studio behind Volta House on Windmill Hill, built by Maufe. Maufe was there too. A good studio, well designed...Gluck sang. An odd woman, dressed like a man, except for a short skirt. She has sung professionally, at the Christian Science Church in Mayfair, and divides her ambition between painting and singing. Her painting is hard and dexterous...

Thursday 10
Worked at the little design for the Sydney Press, which Richardson wanted some additions to. Sent it off to Ampthill.

Friday 11
Went to the Bank, and to call on Wellington at the R.C.A., Richardson having asked me to suggest someone as head of the Royal School of Needlework. Wellington suggested one or two people, but each had some objection when Mrs. Christie and Mary Hogarth were among his suggestions. Some people from the National Gallery came in, Booker the photographer among them, and we adjourned to the Lecture Theatre with Tristram to witness a demonstration of slides from National Gallery pictures. Was pleased to see Tristram again...Dinner with the Wellingtons, Aitken the other guest. A. was at school at Clifton with Roger Fry...Louis Behrend gave £250 towards the Tate Gallery mosaic, the first one, by Anrep. He is now worried about money...Aitken was a schoolmaster at Colet Court, and seems also to have a lot to do with Toynbee Hall...

Saturday 12
...did some little revised drawings (4) for Beaumont's new edition of the *Manual of Classical Ballet.*

Sunday 13 – Tuesday 22: no diary entries

Wednesday 23
Clause had another sitting from Birdie for the big portrait of her with the greyhound... At 5.30 went to a cocktail party at Nevinson's...The usual incredible collection of people. I got heavily engaged with Lady Drogheda, whom I had not met before. She reminded me that she was the first woman in London to have a room decorated in the 'modern' style (by Wyndham Lewis). I remember hearing all about it, nearly 20 years ago. She asked me if I were very modern. I assured her I was 17th century. She was interested to know who [Leon] Underwood was because he wore a raw-sienna coloured jersey... Ashley Dukes said that he probably killed Ricketts, as the worry over the production of *Elizabeth of England*[28] gave him sleepless nights and upset him terribly...

28 Performed The Cambridge Theatre, London, September 1931-January 1932; settings, dresses and properties by Charles Ricketts.

Thursday 24

Train 9.25 to Bedford. A.E. Richardson met me and drove to the *Bedford Independent* offices where I delivered my rebus...to an understupper for the Sydney Press...Richardson wanted me to say that his latest acquisition, a little girl's portrait in an oval, bought for £9, is a Hogarth, but I hedged. The chin is weakly drawn, and the paint not robust nor vigorous like the National Gallery examples...We all went to see an old lady, Mrs. or Miss More, aged 95: a beautiful head, and quite sane. She is learning to use a typewriter. Her father was a naval man, and his silk topper still hangs in the hall as it has done since 1850 or earlier, as he said burglars would think there was a man in the house if they saw it there...Miss More remembers clearly going up to London by coach as a little girl...She remembers the coming of the railways being discussed by the gentlemen of a tennis party, and their opinion that they would never do. Had a glass of sherry with the Wingfields at Ampthill Park: an elderly gentleman, his son and daughter-in-law (cousins): she a grand-daughter of Sir Francis Grant, P.R.A. whose pictures she knows well – the [*Melton*] *Hunt Breakfast* [1834] and so forth. Dinner with the Richardsons, and train 8.43 to London. Richardson was going to finish the day by dressing up and going round the town to make calls in Georgian costume, after interviewing two builders on business, and showing me all his own sketches of the summer: really, this shows considerable energy. The train was abominably late, and I arrived home at 11.30: to find Mdlle. Brion waiting with Birdie and Alice to drink a bottle of champagne as a small Christmas Eve festival. She having bored them stiff by her endless prattle, went off to Mass.

Friday 25 – Thursday 31: no diary entries

1932

Schwabe continues with his committee work, including the N.E.A.C. and the South London Jury and reveals in his diary the politics and power struggles within. He records the deaths of Lytton Strachey and Dora Carrington and comments on her relationship with Mark Gertler. Walter Bayes sets up a subscription for ailing fellow artist Bernard Meninsky supported by Schwabe whose good friend Hubert Wellington leaves London to take up the post of Head of Edinburgh School of Art. Schwabe completes a number of portrait commissions. Sales in general for artists are 'bad' and commissions scarce.

JANUARY

Starts Sunday 3
Back from Dover (went on the 26 Dec.)

Monday 4
Ran Colin Gill (whom I wanted to see about B. of Ed. Exam. business) to earth at the Imperial Institute, after looking for him in Tite Street, where Betty was, in a pyjama suit. All the Bank of England paintings were being assembled at the Imperial Inst. Monnington's, of the declaration of the Bank Rate (an appallingly dull subject) far the most distinguished looking. A K. Lawrence's very bad, getting below the Herkomer level. Clausen and W.R. adequate and not without dignity in the two big portraits; Gill has a knack of filling space, ingeniously. He was warm in praise of Monnington, but points out a defective drawn hand and other slight peculiarities.

Wednesday 6
French exhibition at Burlington House with Thorogood, after a show of students' posters at Alpine Club. Met Lionel Pearson and the pretty girl he is engaged to…

Monday 11
Slade began.

Tuesday 12
[George] Spencer Watson brought his daughter to the Slade.[1]

Thursday 14
Started on the composition of a Board of Education Exam. paper…After lunch…Birdie, Alice and I went to do some shopping…and to come to some arrangement with the Margaret Morris School about a possible reduction of fees…met F.[Fred] Stratton in the King's Road, Chelsea, he asked us to tea in his studio in Glebe Place. I am always rather embarrassed by his pictures, which I do not like; but he has evidently a gift for likenesses and knows a good deal about glazing. One head of an old man very skilful, and one water-colour fresh and true. He showed me a reproduction of a decoration he has done

1 Well-known portrait artist, Mary Spencer Watson (1913-2006) became a sculptor.

for the Duchess of Hamilton, a religious subject. The Duchess is a very good friend to him and indeed I don't know what he would do without her. He has recently had a portrait rejected by the R.A. and another badly hung…

Friday 15
…Went to the Imperial Institute to review Prix de Rome works. Slade students – [Edward] Scroggie, [Ithell] Colquhoun, [Jocelyn] Chewett, [Mary] Jameson, [Helen] McKean. The painters of this bunch have no chance of success in the competition because they, none of them, specialize in the kind of mural decoration that is asked for. A high level on the whole, but the decision will be very difficult. Chewett and Colquhoun are now living in the Rue de la Grande Chaumière, and other Slade students are in Paris. [F.E.] McWilliam has just come back, and [R.] Hilton is still there. Colquhoun seems to go on as before, on her own way, the only difference being that she now draws the male figure without any concealment…

Saturday 16
Spent entire day tidying up drawings and paintings which I have got out of store – the large canvas of the apple-gatherers among them. Destroyed some hundreds of drawings and a few paintings. Alick Schepeler came to supper. News of the John family. Romilly and his wife are said to live on a barge on the Thames, both of them rather dirty and Romilly (who does the domestic work, his wife being the bread-winner) with long hair. He writes an occasional poem. Edie McNeill and John Hope-Johnstone[2] take a very unfavourable view of the ménage. Alick says that Francis Macnamara[3] was strongly in favour of his daughter accepting an engagement at the Folies Bergère on the grounds that 'after all it was the classic brothel'. She danced at a party where Alick saw her kicking up her legs and revealing a very short pair of trunks at the top of her thighs. Alick disapproved and thinks that Augustus J. would disapprove of his daughter going on like that. Wellington told me the other day that it was Johnnie Granger who was responsible for the meeting of John and the McNeill family. Dodo [Dorelia] was in an office – a typist or something in the city…

Sunday 17
…Went to see Towner's water-colours in his studio. Talked of Constable's letters, and how modern he seems – at any rate, gulfs apart from the 18th century attitude of Sir Joshua, and the 18th-century reliance on reason and distrust of emotion…

Tuesday 19
…Went on to French Exhibition again…Why is Poussin such a fine colourist at times, and yet at times his colour is so beastly? It may be something to do with his methods of glazing. Some of his pictures are glazed all over and left, so that all the tones are hot together, without cool half tones. Sometimes he has plenty of cool colour as well, perhaps from painting into the glazes…

Wednesday 20
Faculty of the School at Rome. Imperial Institute…General agreement on four candidates

2 Briefly tutor to John's children at Alderney.
3 Poet, philosopher, economist, close friend of Augustus John, married his sister-in-law, Edie McNeill 1928.

being above the other 29, and Connie Rowe elected by a majority of votes. I voted for Baker (R.C.A.) on the grounds that he was likely to go further than Miss Rowe, but he hasn't specialized in mural decoration as she has, and that is what scholarship is given for, so the decision was not unreasonable. Miss Colquhoun was well thought of, particularly by Rothenstein & Russell, but was out of it for the same sort of reason. Baker got an honourable mention, together with a Glasgow man, and a man from the Byam Shaw School, whom Jackson had very insistently told us all was the best of the lot... Clausen talked about the French Exhibition being evidently biased, in the selection of the pictures by dealers' manoeuvres. Of the moderns only the most saleable are in evidence...Jean Inglis came in in the evening talked of the mad Margaret Radford and of the old Slade set – [Ian] Strang and [William] Bagshawe,[4] and how she and two other girls painted their Slade summer compositions in one room at 71 High Street which she now owns; how they paid 3/- a week for it, and how full it was with 3 girls, 3 four-foot canvases and Tullio the model.

Thursday 21
...Put in an afternoon at the Slade, making up for yesterday. Gerrard has very kindly been working on my little plaster lady, making the base fit for the casting in lead. He didn't know it was my work, had thought vaguely that it was something Victorian of the School of Lanteri.[5] I'm afraid it is an amateurish thing. He said he was up till 3 in the morning tinkering with it, sawing through wires in the plaster with a fretsaw...Read of the death of Nicholas Hannen's son Peter – I remember hearing of his birth when [Francis] Unwin was in Great Ormond Street and Hannen was an architect with a very pretty wife. They separated afterwards, and I believe he lived with Athene Seyler,[6] or still does. Mrs. 'Beau' Hannen was extravagant, spoiled, charming and hopeless. I tried to do her portrait at Howley Place, and did a very bad dry-point of him in a tall hat. Lytton Strachey's death is announced on the same page. My chief recollections of him are concerned with Lordswood when he stayed with Mrs. Sargant-Florence,[7] and of him at Wilfred Gough's party in Queen's Gate during the War – his long, lean arm shooting out and smacking Barbara Hyles on the bottom as she slid down the bannisters. I remember him also dressed as a pirate, with bare feet, at one of John's parties in Mallord Street: and George Kennedy's story about him, when Kennedy and another architect went down to the country to see about planning a cottage for Strachey: how the architect was puzzled by Strachey, particularly when it came to a question of sanitation, and it was explained by the architect that since there could be no water laid on, earth would have to be used, but that no inconvenience or unpleasant mess need result, provided that a separate receptacle was used for each operation, and the two operations were not as usual performed simultaneously. 'But that's half the pleasure!' said S. in his high, thin voice...

Friday 22
Painted in the morning and went to...see Barnett Freedman in Scarsdale Villas off Earls

4 Slade (1904-08), taught etching by William Strang.
5 Lanteri taught National Art Training School (later renamed R.C.A.), South Kensington, 1901 became first Professor of Sculpture and Modelling.
6 Actress (1889-1990), changed her name by deed poll to Hannen 1928, they married 1960, after the death of his first wife, who had refused a divorce. She made her debut in *The Truants* in 1909.
7 A painter, she designed her house, Lordswood at Marlow, Buckinghamshire, where she lived until 1940 and hoped to found an artists' colony.

Court Road...The Freedman's have everything very neat and pretty, Claudia having a nose for little antiques – she haunts the Caledonian Market. They have some Sicilian Puppets. He is painting one as a still-life. Her exquisite and pernickety penmanship is like her exquisite and pernickety manner – Birdie thinks she is much too charming, and that she overdoes it terribly: a great contrast to Barnett. I think it was wrong to chuck out his big painting of the Sicilian bag-piper from N.E.A.C. They keep in touch with Mahoney, Horton, Towner and [Albert] Houthuesen and the Jones's, each of whom has much of the good artist about him. *The Bagpiper* doesn't look nearly so black and low in tone as it did at the Gallery – curiously different in fact...Freedman doesn't think Connie Rowe a good artist, and agrees in preferring Baker. He disapproves of the whole Prix de Rome system of training for mural decoration.

Saturday 23
Bayes is getting up a subscription for Meninsky, who is suffering from a nervous breakdown in Liverpool, caused partly by worry because a doctor told him that a sore tongue that he had was cancer. Apparently it isn't. He has appealed to Bayes in a letter in which he says he will soon be quite destitute. Bayes has drafted a circular letter which I will get typed. In it he says 'we belong to a profession in which nearly all of us at sometime are in the greatest difficulties, but not all at the same time'. He is hard up himself. Gertler is going to sign the letter as well as Bayes and myself and Thornton has been approached. I wrote privately to Bayes, not doubting that Meninsky is up against it, but remembering certain moments in Meninsky's career (supported by Charlotte Wellington) which show a disposition to swing the lead. I am sure Bayes himself would not have written that letter (Meninsky's), and I told him so. If Meninsky can't work it means his income from the L.C.C. schools is cut off – that much is obviously true... Called on Kennedy...Went round with George to his office in the Chenil Galleries to see what he has been doing: designs for St. Katherines, for Balliol, and for a swimming bath in private grounds at Andover. He is also doing a small job for Euphemia Lamb. He has difficulties with her, her regard for truth is so slight...Tea with the family...they are shortly going to have as a paying guest the son of Musgrave Dyne, now aged 18, and they rather dread that he may be visited by Aminta [Dyne]. We agreed jokingly that the thing to do would be to hand her over to the police, if she comes. I believe she is still 'wanted' for the 'francs' case.[8]...

Thursday 28
...went to Camberwell to advise on a picture to be recommended to the Borough Council for purchase from the S. London Group show. Dalton and Thorogood were there. We agreed on two to suggest, both in regard to their merits and the artist's services to the group Medworth + Cosmo Clark.

Friday 29
...Professor's Dining Club, U.C.L. Solomon, Prof. Butler and his son whom we use to know in Marlow during the war (his mother cut us dead), Esdaile from the British Museum, Brady, Salisbury and others. Esdaile and I found much in common to talk about. Brady assured me that this ink won't last more than fifty years. He knows it's chemical

8 She was sued for £39,000 by a London bank over losses in a currency speculation, the trial was known as the 'Francs Case'. See Diary entry 23/1/40 re Aminta and Albert Rutherston.

constituents, and says the only permanent ink is Indian ink. Provost said he had had a letter of complaint that Miss Colquhoun's picture of *Judith with the Head of Holofernes* [1929] in the Staff Common Room was a disturbing influence at Committee meetings, and that it ought to be removed (the picture was at the R.A. about two years ago). He declined any action about it, and seemed amused.

FEBRUARY

Wednesday 3
[Vladimir] Polunin[9] took a party of students to see Curtis Moffat's museum at 4 Fitzroy Square. Moffat is Iris Tree's [plate 6] husband and a sort of antique dealer for American millionaires...Birdie called at the Slade 4.30, meeting W. Bayes & Mrs. Green and we went on to Tippy Griffith's lecture on Russia at the American Women's Club in Grosvenor Street. One third of the lecture was devoted to an exposure of the dishonesty of English journalism as practised by the *Daily Express* and other papers. They won't publish his articles on Russia, though they have paid for them, because, although the tone of the articles must be moderate enough to judge by the tone of the lecture, it would not suit the *Daily Express* to print anything at all favourable to Russia...

Thursday 4
Meninsky fund now stands at £59-10-0. The response has been very good...Painted and went to the British Museum Library after lunch to look into the history of fashion plates for an article to be in the *Print Collector's Quarterly*. Cocktail party at Nina Griffith's, 75 Marsham Street – a house very like 20 Church Row...Margaret (Griffith) Pidcock knows Gleadowe in Winchester. Described how he sent some pictures to the school show last year, studies of his wife (used to be a dancer with Mdlle. Rambert) getting in and out of the bath, which pictures he was asked to remove, as they [caused] outrage. This year he only sent a study of a crab, which is quite unobjectionable.

Friday 5
...Joan Manning Sanders[10] and her mother came to tea. Joan wants to come to the Slade, as...she wants to know more about drawing...I told her she couldn't come before Easter, as we were full ...Called on the Towners afterwards. [Samuel] Rabinovitch there. He has been modelling a head of Towner. Talked about Nina Hamnett, whom he likes and who is writing her memoirs. She is still doing plenty of drawings...She lives in Maple St., in a room smaller than any of Towner's rooms in Holly Hill, according to Rabinovitch; her latest 'boyfriend' is a boxer.

Saturday 6
...Rum punch party at 71 Wimbledon Hill...Some talk about the sculptor [Cecil Atri] Brown, the Prix de Rome [1928] man (I thought he looked an ass when he was at the R.C.A) who has a piece of bent wire called *Bravura* at the National Society which he has sold for £5. He has been working as Dobson's assistant. Dobson thinks him very useful and a good craftsman.

9 Polunin born in Moscow, teacher stage design.
10 Laura Knight in her autobiography *Oil Paint and Grease Paint* (1936) describes the teenage Joan's drawings as having 'remarkable quality'.

Monday 8
Symons at the First Edition Club, Bedford Square. He is selling his library and moving the Club to another house...Symons foresees a return to illustration as distinguished from book-decoration pure and simple: also a revival of interest in book-binding. Interesting to see an actual Sandys-Dalziel[11] block...I said if Symons didn't sell his *Oxford Characters* by W.R., now priced at £4-4-0 he might let me know as I should like to have it...

Tuesday 9
Meninsky Fund £95-16-0 not bad for about 10 days actual effort. Went to Westminster at 9.15 to meet Bayes and Gertler to talk over the affair. Decide to send £30 a month to Meninsky...We had some discussion as to whether we hadn't got the subscriptions – very generous ones – on false pretences – as Meninsky is now getting £2 a week from the Artists' Benevolent, and we appealed on the plea of destitution: but didn't see how we could send any money back, it being given really to Meninsky and not to us. Besides he may want all of it, if he is ill for long...

Wednesday 10
Lecture on Delacroix, U.C.L., by R.[René] Huyghe[12] ... Borenius hates Delacroix, and abused the lecture heartily. Daniel is lukewarm also: says Delacroix is a good painter when you look at bits, and quotes Steer to the effect that D. is a better man to talk about and to read about than to see. I was irritated by the lecture myself because Huyghe seemed to like Delacroix too much for sentimental and literary reasons, and talked a lot of rhetorical clap-trap such as only the French can... All Delacroix's searching for subjects on literature, though characteristic of his time, seems to me a weakness...I like the *Femmes D'Alger* [1834] more now than when I used to see it in the Louvre.

Thursday 11
...to the Goupil...Found Gilbert Spencer's show going on. Some very good drawings, obviously influenced by Lamb...He has good colour in his small pieces...Arthur Watts came in the evening to return a book by Ozenfant, and started a long argument about modern illustrators, holding that there isn't one among the artists of today whom the critics dare to mention who could illustrate a book by Michael Arlen – naturalistically, with motor cars, pretty girls and all modern accompaniments – if he tried. So that a return to the type of illustration done in the 60s, or at least done with similar motives, is hopeless, and largely, he thinks, from artistic snobbery.

Friday 12
On the way to the B.M. looked in at Cradock & Barnard's[13] because they have some Corot drawings – mostly a kind of Gouache and oil on paper. I was told it was a kind of wall-paper that he used. The pink roses sometimes come through. Another time he worked on paper out of ledgers. The drawings were pretty slight things, very good colour and occasionally making one think of Constable...some landscapes, trees and houses in pencil or chalk that I should have liked to have the pick of – only I can't afford £25...Dinner

11 In correspondence with the Dalziel Brothers, the Pre-Raphaelite painter Sandys (1832-1904) gives detailed instructions as to how he wishes the block for the print *Until her Death* to be cut.
12 Writer on history, psychology and philosophy of art, curator Louvre's Department of Paintings.
13 Print selling firm, established 1915.

with Birdie at Roche's, and afterwards at the Vyses, 433 Fulham Road. James McBey and his wife came. He has a large rugged head that would have made a good subject for David Octavius Hill...

Saturday 13
...There is a new Dance Club in Hampstead, which Bob Wellington, Stephen Bone, Margaret Alexander, Oliver Simon and the Carringtons and others belong to...Tea with Miss Eyre, a lot of talk about Patrick Geddes, whom she knows, and many friends of his. It is a pity for Alice's sake that the Margaret Morris place in Montpellier is being given up. I don't know whether Geddes is giving up Montpellier too. I remember I met him once at some meeting in Chelsea where Margaret Morris was. He had just arrived in England: said he was so glad to have the opportunity of being present, as it wouldn't occur again for some time – he was off to India the next day...

Sunday 14
...After lunch Clause, Birdie and I took the train to Richmond to see Prof. Brown...His pictures always worth seeing again...His John drawing is a good one. He says there is nothing in the legend that John suddenly became the artist that he is after getting concussion of the brain through diving: that he was a brilliant draughtsman after his first year at the Slade. Roberts was sent away from the Slade because he was too subversive for the tradition of the place – in his work that is. Brown said that they parted on friendly terms as far as he was concerned, and at the strawberry tea at the end of the summer term he asked Roberts why he was going so contrary to the early promise of his drawing. 'If I went on as you want me to I should only become a Royal Academician', said Roberts. A surly ill-conditioned youth. Brown's two portraits of himself that he still worked on have good passages of painting in them, and hold together in true and richness of matter like very few paintings that we see in exhibitions now...Most of the artists whose work he has purchased have delicacy & charm from Tonks to Milly Fisher Prout. He spoke of his admiration for Shackleton, in which I cannot altogether follow him. Frank Potter, Gwen John (done just after she left the Slade – he believes she studied for a while in Paris under Whistler), an early Steer of paddlers, Ethel Walker's in profusion, Clara Klinghoffer, Vernon Wethered...

Monday 15
...I went out to have a glass of port with Egan Mew. He has a different version of the Whistler-Stott of Oldham episode. The row between them occurred at the Hogarth Club. Stott of Oldham, according to Mew, was a very big man, and remained unmoved when Whistler, a little fellow, struck him feebly with a cane.

Thursday 18
...Went to National Society's exhibition in Piccadilly. Met Ernest Marsh & [William] Staite Murray. Murray has sold a pot for £30 at the 'Seven & Five' show. Hagedorn has sold a drawing at the National. But sales are very bad. Murray and I went to have a cocktail at the American Bar at Lyon's Popular Cafe, where a negro mixes the drinks. Murray says Barbara Hepworth (Skeaping) is Ben Nicholson's 'latest'...Pictures at the National – Teddy [Edward] Wolfe still imitating Matisse without much conviction, various imitations of Picasso, and some of Cézanne & Chirico. Good drawings by Cheston & Job

Nixon. College of Art staff dinner at Stewart's. G.J. and I being guests...Durst says that professional jealousy between husbands and wives, as artists, is at the bottom of the split between the Skeapings and the Ben Nicholson's. Ben Nicholson dislikes Winifred's painting and Barbara Hepworth has been beaten by her husband at her own game. Seems a pity and rather paltry too.

Friday 19
...Mrs. Meninsky came to see me at my suggestion – a pretty girl, has been on the stage. She did not stress the unpleasant side of things, and indeed seemed very sporting about her own position. She is going to look for a job. She must have had a devil of a job with Meninsky, who has been suffering the utmost agonies of mind for months past. He is afraid of death, and has other fixed ideas he can't shake off. I am sorry for him, as I know a little myself now how one can be terrorised by such things. They went to Cornwall at Christmas but the climate seemed to make him worse – too relaxing. He was utterly miserable on the journey home. He used to burst into tears and kneel at her feet, and she would try to console him, but thinks such consolation bad for him: a more bracing, less sympathetic treatment might do good. He seems to be like a child about money. She has cheques from him, but he can't have much left.

Sunday 21
...Wrote to Penhurst Hospital about Meninsky...

Thursday 25
Went to the Slade and on to the Nat. Gall. to see some students who have gone there to copy...

Saturday 27
...Went to Blackheath in the afternoon to see Dodd. Rushbury was there. Dodd is drawing George Moore, and gave us many samples of Moore's conversations, collected during the sittings (I think they take place at Ebury St.). G.M. expresses his dislike for Th. Hardy as usual – says a schoolboy would be whipped for bad grammar like Hardy's: goes on about his own friendship for Manet, and how he has been pressed to write his reminiscences of their friendship, of which he told Dodd to judge the intimacy by the fact that he and Manet used to 'womanise' together...Dodd's big portrait for the Bank is well advanced. Unusual in treatment, with the use he has made of the Bank buildings as a background...The sort of thing that may become very interesting in 200 years time. The colour at the moment is horrid, but it is hardly more than an underpainting...He has had a studio built by Harding, which has cost him endless worries and rages, and has tacked it onto the Regency cottage, with pleasant cast-iron balconies, where Miss Dacre and her attendant used to live. He pays £50 for this cottage, and its large garden, which adjoins his own garden...Rush. wants Spencer and Colin Gill to be brought into the Academy, and complains of the stupidity of the older members – excepting Clausen, Kelly and others, of course. Old David Murray wanted to put up Matania, the *Illustrated London News* illustrator, for election – incredible. R. has much to say about Oriana ('Stripes') who has left Helps, and refuses to move from Cassis, where she goes about with nothing but a pair of little shorts...At one of Nevinson's parties Oriana appeared in a striking red velvet dress, and another woman happened to wear one exactly similar.

This latter lady, at a certain stage of the proceedings went up to Mark Hambourg[14] and pinched his bottom. He was angry, fumed for some time, and later went up to Stripes, thinking she was the other girl, seized hold of her breasts, and as Rushbury says 'twirled' them. Where upon there was much abusive and highly coloured language from Stripes; Helps was just prevented from knocking Hambourg down: and explanations followed... Rushbury was trying to get a teaching job in the Central School, but the L.C.C. economised the class away. But for this Rushbury might have joined the great army of teachers. He is going to broadcast with Stanley Casson in a talk on Etching. Dobson is doing something similar on Sculpture, and Albert R. on something else. Fee £15-15-0...

Sunday 28
Alma Oakes & Jean Orage came to supper. Jean is still wearing designs by Kauffer & Marion Dorn: says that Ronnie [Ronald] Simpson makes £3000 a year as a designer and organiser for Morton Sundour.[15]

MARCH

Tuesday 1
Have just remembered that Dodd has Ian Strang's portrait of Innes in his dining room. He bought it for £20. I remarked on it's being like, and Rush. spoke of the drawing I did of Innes, late one night after I had spent the evening with him, while I was still vividly impressed with his appearance – one of the few occasions on which I have done a good likeness from memory. Rush agreed...I sold it through the Redfern Gallery to an unknown purchaser, and don't know where it is now.[16] John appreciated it too.

Friday 4
Margaret Morris show in evening...Fergusson was there. He is having a show at Lefevre's and has sold four pictures: this was the first day...

Saturday 5
Charlotte Wellington tells me that the Goupil Gallery is closing down. Mrs Marchant has not a penny. Gilbert Spencer has sold his picture [*A Cotswold Farm*] to the Chantrey Bequest – if he hadn't, he says, he would have had the bailiffs in...

Sunday 6
Grimmond, Hagedorn and I, in the course of a walk, saw Towner working in front of Admiral's House. The picture promises to be very good – good colour it seems out of doors. Collected some old drawings together in response to an invitation from the Fine Art Society to send 'some small inexpensive Drawings & Water-colour Notes at prices from 5-10 guineas'. They go on – 'Many artists have by them numbers of slight sketches and drawings not quite satisfactory in themselves but out of which might be cut acceptable pieces making quite good compositions and representative of their work'.

14 Concert pianist.
15 Sundour fabrics launched 1906 by Alexander Morton and his son James. In 1914 a new company was created – Morton Sundour.
16 Cecil Higgins Art Gallery and Museum, Bedford.

Tuesday 8
Impromptu party, with the new E.M.G. Gramophone. Durst and Clare, Ginner, Hubert and Charlotte Wellington, and Bob, and Kenneth Morrison and his wife. Mrs. Morrison is an American, and wants to do an article on the interior of 20 Church Row: so does Kate Syrett, and I told Mrs. Morrison so…

Wednesday 9
Visitation at the Slade from Deller and the Court of the University…A man I met at tea in the refectory, who seems to have moved in the Fitzroy St. and Slade set just after the war, told me about Nina Hamnett – how she is to be seen at the Fitzroy tavern, how she is far too often drunk, and how wretched she appears to be when drinking her solitary whiskeys. Another set which includes artists of a kind, who think of little else than drinking, is the Savage Club. John Hassall and Jimmy Pryde are ornaments of it, and very amusing, no doubt. My informant described a party to which he once went, where all the men dressed as women, and the women as men, exchanging clothes together in the only available dressing-room. Meninsky came, and refused to take part in this disguising…He then left – the only moralist – and was set upon by a hostile crowd outside the premises, who were offended by what they were able to divine of the proceedings within, and were waiting for a victim.

Saturday 12
…Alice's 18th at Pamela de Bayon's. The Gertler's came, Max & Tony Ayrton, the Hepburn's, two Warburg Cousins, Helen Fletcher and three Margaret Morris girls and Bob Wellington and Ginger. Towner wouldn't come because his dress clothes were not in order…

Thursday 17
…Mrs. Wellington has a theory that Carrington, who was found dead with a shot wound, shot herself. She had been in a state of mind since Lytton Strachey died. Whether she lived with Strachey I don't know, nor if she did so, what her husband thought about it, but that is the current idea. Albert R. does not believe she did. She was in the habit of shooting rabbits from her window – rabbits which overran the garden. Philip Alexander went down to the country, much distressed, to see about the affair. The Carrington's in Downshire Hill give out that it was an accident. Curious how I may have misjudged her – I suppose she was capable of real feeling…John Hope-Johnstone thought her an 'arty' snob. Gertler will be concerned about this. By the way he told me the other evening, when talking of Meninsky's breakdown, that he had a sort of breakdown himself about 2 years ago but conquered it by force of will. The sight of his picture made him cry. Meninsky has not, I should think, been able to make any such effort as Gertler's.

Saturday 19
…Dinner with the Copley's, 10 Hampstead Square…the important guests have got 'flu, and only Charles Marriott and myself remain, so I need not dress…Got embroiled in an argument about modern sculpture, Henry Moore, and the amount that the material should dictate to the artist. Mrs. Copley [Ethel Gabain] said very reasonably that in any case H. Moore's forms sometimes look like dough, not stone at all.

Tuesday 22
Slade dinner. The miracle, which I can hardly believe in beforehand, though I ought to be getting used to it, happened, and I managed to say a few words when I had to, only stammering badly once (somebody laughed, which I think rather stimulated me than otherwise)…Was glad the Monnington's came…

Wednesday 23
Slade…a string of students brought their work, most of them anxious about Diplomas. Alice finished her term, very pleased having passed her Exam and been specially noted by Margaret Morris…

Thursday 24
With L.A. Legros at Colnaghis. He looks rather French, with a neat, white beard. Arranged to have the plaster-casts and bronzes conveyed to the Slade, and got him to promise half a dozen etchings to the U.C. Exhibition Room. Colnaghis and the Fine Art Society both hold stocks of the Legros etchings and don't seem able to sell them. They are looked upon as dull. L.A. Legros, I believe, is a Fellow of University College. Has travelled a good deal in the course of his engineering work. In the afternoon called on W. Carl or Carroll, who wanted to see me about the Mussolini[17] play on Napoleon…at the New Theatre. Agreed to overlook the designs for the play, for a fee of 10 gns. when I come back from Dover. Explained to him that I did not wish to interfere with Sheringham, who is quite capable of looking after the job: but he thought a final critical eye on the whole thing was worth paying for.

Friday 25
Called on C.W. Beaumont, at his flat…where he has…many treasures connected with the ballet. He bought some of the things at Pavlova's sale. Borrowed a mass of documentary stuff for the illustration of the *Hundred Days*. Napoleon is one of C.W.B.'s liveliest interests...

Saturday 26
To Dover.

Monday 28
…Birdie brought down a letter from Meninsky, now in the Cassel Hospital at Penshurst. He is optimistic, and has faith in his doctor there.

APRIL

Friday 1
Francis Macnamara passed me while I was drawing on Custom House Quay. He had a girl with him, to whom he introduced me. He is at present in the harbour on his boat the *Mary Ann* of Galway. Miss O'Callaghan, the 'crew' or 'cabin boy', is a school friend of his daughter Nicolette. … Poor Edie McNeill. I had tea with them on board when I had finished drawing…He talked about John, and his present difficulty in finishing any

17 *Napoleon: The Hundred Days*, a play by Benito Mussolini and Giovacchino Forzano; adapted from the Italian for the English Stage, by John Drinkwater, ran New Theatre April 1932.

work he undertakes: he (John) has spent a lot of time in bed this year, and the drink really seems to be telling on him...Birdie did not want to go and call on Macnamara and his crew, so I saw them no more.

Tuesday 5
Canterbury. Drew the Dominican Priory...

Monday 11
Slade began. It seems that Collins Baker resigned from the Nat. Gall., as Holmes did, because he disagreed with the Board of Trustees about something. Two good men got rid of, I am sure through some folly on the part of the Trustees.

Wednesday 13
...Show at Zwemmer's – Room and Book – got up by Bob Wellington. Enid Marx has improved very much since she left the R.C.A., where she was a rather difficult student, full of theories and modernisms – often the best sort. Noted a perfectly beastly picture by Wadsworth, another by him rather interesting, two precious tasteful absurdities by Ben Nicholson, another by John Armstrong and some really excellent work by the Curwen Press. All the paintings and other objects look extremely well together, and that sort of picture certainly suits the modern interior. I find it difficult to really appreciate metal tubing as ordinary living room furniture, but the chairs are certainly practical and comfortable.

Friday 15
...New Theatre, Dress Parade of Mussolini. Philip Guedalla,[18] Sheringham, Mrs. Sheringham, Sydney Carroll and I sat in the stalls and criticised the costumes. I complained that Hortense had her dress too much off the shoulders for an Empire frock, and consequently looked 1860. 'You have beautiful shoulders, my dear, but we are seeing too much of them' roars Carroll. 'Sir', says the stage manager from the stage 'I am in a position to notice that this lady's legs are clearly visible through her frock, when the light is behind her, as it will be in the scene'. 'Turn on the light behind' orders Carroll. 'But' I observe 'they did that sort of thing at the period'. 'The experts say' shouts the producer 'that ladies at this period of history exhibited their legs to attract the men. In the cause of art, my dear, anything is permissible. Next. Please'. Guedalla murmuring from time to time – 'I don't know what I'm here for. I know about Wellington, but nothing about Napoleon'. But he was witty and made useful, pertinent comments. Four hours of this. A Major somebody 'vetted' the military equipment.

Sunday 17
... Met [Frank] Rutter in the tube and thanked him for introducing my name to Sydney Carroll. He (R.) and Hanslip Fletcher were at Merchant Taylor's together, and H.F. was doing drawings of London even then.

Monday 18
The David [D'Angers] bust [of Jeremy Bentham] was brought round, I offered the man Green £10. He suggested £15, so I will try to get £15 from the College...A very good piece of modelling...and dignified.

18 Barrister, historical and travel writer and biographer.

Wednesday 20
Dined at Major Temperley's invitation...at the Old Water Colour Society Club...Adrian
Stokes asked me why I didn't join the R.W.S....

Thursday 21
Painted: after lunch went to Griffiths' show in the Welsh Hall at Mecklenburgh Square.
He has improved very much too, and has sold quite a lot. Max Ayrton has helped him a
good deal, and W. Rothenstein made a speech at the opening of the show urging Wales
to bag its native artists...went into the Lefevre gallery to see Christopher Wood, good
colour and quality of paint, like all that school, but quality sometimes sought for a little
too obviously...

Saturday 23
...Evening with the Tomalin's in Belsize Park Gardens. Mrs. Tomalin has recently been
painted by Stephen Bone. He lets himself off rather lightly as a portrait artist, like I used
to do when I was his age. I could do her better now...Grimmond who came in to supper,
repeated a remark of Lethaby's, quoted at the Art Workers' Guild, that the old fashioned
art school training was 'like learning to swim in a thousand lessons, without any water'...

Sunday 24
...Campbell Dodgson, whom I drew for the second time (a better drawing) says that
when William Strang did his engraving of him (C.D.) he only made the slightest sketch
of him in chalk (lithographic chalk?) on the bare copper, and then drew straight away
with the burin. Rather a feat and it came very well too He is evidently very interested
in Unwin's work; talked of [Ettore] Cosomati's influence on him...

Monday 25
..Slade. Gladney came back again, and again made complimentary remarks on my
pictures. Extraordinary how one takes a simple pleasure in appreciation from a student.
It's not worth much in itself, but it is satisfying to feel that students don't think you a
complete fool...

Tuesday 26
...Committee at R.I.B.A. Street Frontage Medal. Kennedy's Geographical Society building
was favourably spoken of, but not in the running, not being quite what the medal is
offered for. Beresford Pite's Burlington Arcade frontispiece laughed at...

Wednesday 27
Dinner with Vyse at Chelsea Arts Club...I defended Ledward's sculpture to Dobson. Vyse
is inclined to sneer at Ledward, but grants him intelligence. I don't think him a really
great man, of course, but a good craftsman, and an honest artist...

Friday 29
Painted. Meo came in and gave me some quite useful criticism. In the afternoon to the
P.V. of the R.A. Previously Gustave Schwabe had telephoned suggesting I should join the
Arts Club. I replied that I had put my name down for another club. He asked me to tea...
At the R.A. I looked for some of my friend's pictures – Ayrton's and Richardson's

drawings in the Architectural Room among them. Noted Lutyen's designs for the Liverpool Cathedral, which should be a very fine thing…Wheatley's portrait of Smuts, which I think beastly in colour, though Pocock who was in S. Africa as a C.I.V. says things look like that there. (So much the worst for S. Africa): Ethel Walker: The Bank pictures, which look simply beastly in that light and on a red wall…a fine work by Sickert, and some stupid things by Philpot: fell to wondering whether my own picture was any better than the Procter's: decided it was no worse…Orpen's Slade picture, cleaned, varnished and handsomely framed, looks incomparably finer than it used to do on the Slade walls…Went on to tea with G. Schwabe at the Arts Club. Never met him before, don't suppose he wanted to know me in the earlier stages of my career, but he knows Nellie…Rather awkward talking to Fred Terry about Nellie. I know she was his mistress years ago…

Saturday 30
Tom Cobbe drove us to Hindhead…Saw Miss Sathery Pope about Katherine Mayer, and later saw Katherine herself. Birdie is very anxious to help her…to come back to London and start working again: but Miss Pope's report was discouraging. A tragic business and I don't know what can come of it except the workhouse or the madhouse. At present a Colonel Burden, whom she painted some portraits for, is finding the money for her keep. She has a breakdown about every month or 5 weeks. She is 50 now: looks very well.

MAY

Sunday 1
…Birdie & I went to Doctor Lower in Fitzjohn's Avenue, to make inquiries for accommodation for Kath. Mayer…Also called on Joan Fulleylove & Jean Inglis to ask advice. Had tea with them on Fulleylove's little roof garden at the back of the High Street house. Jean Inglis told us a disgraceful story of Hobson or Hudson (of *Country Life*) trying to do her down from £10-10-0 to £5-5-0 for a copy of a portrait. She was introduced to him by Collins Baker. Apparently he often behaves like this. Rendall of the Imperial Arts League had to County Court him some years ago, and Jean has put her matter in his hands to deal with.

Monday 2
After the Slade visited Kenneth Hobson's book-binding place in Upper Rathbone Place. He does some very interesting work. Left two books to be bound…Met Max Ayrton in the tube, really enthusiastic about Lutyens and his Liverpool Cathedral. Told me he was with Lutyens when L. was starting.

Thursday 5
Meo came in to make his farewell before going back Bedales. He did not return the 30/- he borrowed…but left his drawings in pawn…Mrs. C. Dodgson came after tea to look at the second drawing of Dodgson, which she approved…She was at the Slade about the time that I was first there, which makes it easier to discuss drawings with her…

Wednesday 11
…Lunch at Claridges to view the new wing decorated in the alleged modern style – not

bad. Artists – O.P., Milne, Marion Dorn, Sherringham and a girl called Lee from the R.C.A., to whom I believe we refused a diploma...[Wilfrid] Cave[19] and Blockie in the evening. Glad to see them, and vaguely proud that I made a friend of Cave all those years ago. I still admire him.

Saturday 14
Alphamstone [Suffolk] (by train...).

Sunday 15
...Admired the country intensely, and wish I could realise the beauties of this late spring in the drawings which I do. (I did two pen drawings this weekend, with some hope of adding tone or possibly colour to them afterwards)...

Thursday 19
Alice and her Margaret Morris girls have been doing a little sun-bathing at the back of St. Barnabas Hall. They are occasionally interrupted by the arrival of men bearing a dead body – there being a mortuary at the end of the passage.

Friday 20
Towner came in with information about a studio to let near Fittleworth – it had belonged to Glyn Philpot...I went round with him to Heath Street to see a portrait he is doing of W. Leon Jones, which I thought to have very good passages – I liked it, but criticised the drawing of the head. Talking to him, I pointed out that Corot never seems to get as much credit as Constable for being an innovator in landscape, yet there is almost more of a break between Corot's early work and the French landscape that preceded him than there is between Constable and the Norwich School. I am sure Corot had not seen Constable's work at the time he was painting his admirable naturalistic studies of colour and atmosphere in Italy and elsewhere...

Saturday 21
...Bought in the Fulham Road a few more fashion plates of men 1850–1860. Price going up but got a reduction of 1/- each from 3/6d – 2/6d. In the afternoon went to the Royal Academy with Alice, Mrs. Carr and Allan Carr: also to the R.W.S. There is really much decent work in these much abused shows...James Gunn's group of Chesterton, Belloc and Baring [*Conversation Piece*] – remarkable from the point of view of accomplishment. Adrian Stokes's landscapes are very like the river bed that you pass along in the train from Sisteron to Manosque...

Sunday 22
Began to draw Prof. D.S.M. Watson F.R.S....I showed Watson the bust of Jeremy Bentham by David D'Angers. He agreed that as it cannot be bought out of College funds, we might raise £15 by subscription to the Common Room...Meo returned the 30/- he borrowed on his drawings, and I kept one, giving him 10/- with the understanding that if he could sell it for more, or if I could, it will not remain in my hands...

19 Slade 1901-03.

Monday 23
Board of Education Exams...Something over 480 drawings to examine & mark. Colin Gill, Woolway, Travis & Dickey...

Tuesday 24
...The Wellingtons came in in the evening. H.W. was at the Slade when Orpen's *Hamlet* [1899] was painted, and remembers Orpen making large numbers of studies at the Sadler's Wells Theatre during the summer, going there at nights. Also talked about one of the models whom Orpen used, whom John drew at the same time – a street musician. I bought W.R.'s second volume[20] to-day, and among other matters turned up his references to [Ernest] Debenham and Macdonald Gill and the Afpuddle estate. He does not mention the scheme which he got going to decorate the Village Hall there, in which scheme John Nash and I (and Carrington and MacNaught, as far as I remember) were concerned. We were to do it for nothing, except our expenses. I went down to Afpuddle...for a fortnight or three weeks and made a lot of drawings of rural life. I recollect W.R. convening his chosen artists in Albert's studio in Thurlow Square, and haranguing us on the propositions adapted from Eric Gill, I should say, that an artist should be content to work for a workman's wage, even as the mediaeval craftsman did. It all came to nothing. The Hall, so far as I know, never got built. The War came, and stopped all that.

Wednesday 25
...John Guthrie, Miss Farjeon & W. Earle in the evening. Guthrie has been busy with theatrical scenery work for the Phoenix and for the Coliseum, where they are doing Erik Charell's *Casanova* with costumes by Ernst Stern. He says that Rex Whistler complains that Oliver Messel has stolen his ideas for the decoration of *Helen*. As it occurred to me before I heard this that the decoration was like Rex Whistler's only not so good, there may be something in this complaint. Travis spoke of Job Nixon today, how hard up he is and how the Procters and Laura Knight are helping him. I think they have got him a cottage in Cornwall, and they try to sell his pictures. He said some while back that he had sold none for two years.

Thursday 26
...Colin Gill says he met La Goulue [The Glutton][21] in Paris not so long ago, very pathetic and appealing for money or help. She danced in the studio of a friend of his, to show she could still do it: and she applied for a job at a Theatre where they were putting on a review incorporating impersonations of famous dancers of past years, thinking that she could appear as her old self...There is a new Society being formed, so Hagedorn informs me, of young artists mostly from the College of Art. Hagedorn went to a meeting where there were about 20 of them – Ososki, Finney, Poulter, Betts, Kestelman, Michael Rothenstein...etc. Freedman won't have anything to do with Betts, and Towner doesn't want to send to the proposed exhibition, which is to be in Oxford Street.

20 *Men and Memories. Recollections of William Rothenstein 1900-1922.*
21 Stage name for Louise Weber (1866-1929) the famed cancan dancer of Le Moulin Rouge, immortalized by Toulouse-Lautrec.

Friday 27
Slade. Charlton has done all the tedious work of arranging the Diploma stuff and the drawings for competition. Met Towner in the evening in Hampstead, who tells me that Sydney Schiff is backing another group of seven lesser known artists, who include Towner, and are to have a show at the Leicester Galleries: Mahoney, Horton, Rhoades, Freedman, Houthuesen and another. ...

Saturday 28
...Egan Mew told me an anecdote of E. Knobloch, to whom one of the Dolly sisters said that if her fourth marriage was unsuccessful she would retire to a convent: 'The Convent of the Sacred Tart, I suppose' said Knobloch. And another, probably very well known of Oscar Wilde and Lewis Morris: the latter complained that there was a conspiracy of silence with regard to his work (he had had no reviews) and what was he to do about it? 'Join in the conspiracy' said Oscar.

Sunday 29
M. Russell arrived from Marseilles, and stayed the night.

Monday 30
...After the Slade came home and read Delacroix. I suppose the depressions of middle age were worse in his case than most others because he was ill. I got pretty depressed myself afterwards at a New English general meeting, at the R.W.S., having allowed myself to be put in the Chair...Manson had refused and Tonks & Steer & Jowett. I did it so badly, and was completely inarticulate at moments...We elected Stephen Bone & Vernon Wethered to the N.E.A.C. Delacroix is like Bernard Shaw's Julius Caesar – he seems to revive after food and wine. There are several passages where he refers to the differences in a man before dinner & after...

Tuesday 31
Slade: gradually collecting the £15 for David's bust of Bentham...Committee at R.I.B.A., London Street Frontage medal...Bone was lamenting the fact that no politicians, at least not in the H. of Commons are interested in architecture. Conway and Crawford are, but they are in the Lords. Rendle said that most of their people are suspicious of architecture, and that it was an error of judgement even to have mentioned that Waterloo Bridge was rather a fine thing. If its preservation has been asked for on purely practical grounds, as of value to the traffic problem, it might have been saved...I observe that the architects don't like Baker's India House, in Aldwych: nor do I, but his Martin's Bank in Lombard St. was well thought of, though not, in the end, put on the list of buildings we are to visit.

JUNE

Wednesday 1
It was Holden that I saw at the R.I.B.A. yesterday. We met this morning in the Tube, and talked about Clara Unwin, and Richardson & Gill's building for Sanderson's, which Holden & James Bone went to look at after the meeting. Holden spoke very well of it – the use of coloured material, and the way the rear façade is considered as well as the front...

Thursday 2
…Visited the Central School show of students' work, where I met Jowett and Spear. I think that the type of drawing produced under Roberts, Meninsky and Grant, though much of it is capable, is not as good as now at The Slade. Charlton, who went to the show before me, said the same, but in stronger terms. Some paintings in the Matthew Smith manner.

Friday 3
Exhibition of Burlington Fine Arts Club. One very good Farington drawing, which confirms my view that he is better than a lot of people think: a painting of the *Bay of Naples* by Marlow, which I would have sworn was a Richard Wilson…

Saturday 4
Katherine Mayer turned up. Her 'protector' as she called him – Col.Burden – has established somewhere in Belsize neighbourhood. We shall probably have some trouble with her. She seems much as she used to be before her break-down, but nervous & excitable (she always was…). We told her to use the studio to do some work in, to get into the swing again, before she starts some portrait commission she has, one for a Mrs. Lutyens…

Monday 6
The Provost rang me to know if I would take Prof. MacMurray's place at the dinner after Ogden's[22] Jeremy Bentham lecture…The David Bust was placed in the Exhibition Room where we dined, and looks well on its pedestal. The College has another portrait of Bentham after all, an 18th century anonymous painting…I talked to Prof. Chambers and G.I.H. Lloyd at dinner…interesting meeting Ogden again, whom we knew in Marlow, during the War, when he was editing the pacifist *Cambridge Magazine*. Everyone tells me his lecture was exceptionally good…O. says that Bentham was a very great man, and a forerunner of all sorts of people. O. himself is working with a man called Richards, I think, in Cambridge, at something that J.B. originated, which may help us to form a proper terminology of aesthetics.

Tuesday 7
…the Wellingtons came. They seem settled about going to Edinburgh. They had been to a cocktail party given before Nina Hamnett's show at Zwemmers…She told Zwemmer in the morning that she had been giving her young man a bath, which she described as an annual affair. This is the sort of thing she says. I forget who it was that told me once that she described herself as the most successful unpaid prostitute in Paris. Her later paintings according, to Bob Wellington, have gone off, and don't compare well with the older ones, which I used to like.

Thursday 9
B. of Ed. Exams again. The one Slade student, Miss [Rhona] Robertson, looked very well as a painter among all the others, in spite of having had to leave the Exam. less than half way through because of the death of her father…

Sunday 12
Finished D.S.M. Watson's drawing for University College…

22 Charles Kay Ogden, writer, psychologist, linguist, founder Basic English.

Saturday 18

...Went on to the R.I.B.A. Final meeting...Fletcher, Davis, Bradshaw, Holden and Norman, who used to be Chairman of the L.C.C. Drove to Dorchester House, which was well thought of, then to Cropthorne Court, Sanderson's in Well Street, the *Daily Telegraph* building (in front of which the *Daily Express* building, being well in view, came in for a good deal of unpleasant comment), Lloyds Bank in Cornhill and no. 52 Cornhill, and finally to Hay's Wharf. Something very lively about Hay's Wharf, with Dobson's sculptures, Gill's mosaic, and the general light and cheerful air of the whole place, but more like a cocktail bar or a night-club than a warehouse, as Charlton Bradshaw says...We all finally agreed that the sober unashamed distinction of Richardson's building deserved the medal, good use of colour, refined detail, and fitness for it's purpose. Supper with Charlotte and Bob Wellington (Hubert has gone up to Edinburgh). He went on to the Gertlers, and the rest of us to see Fay Compton and Ranalow in *Autumn Crocus* at Golders Green. A play of the third or fourth order, a good professional standard of acting, and plenty of sentiment. Returned to Church Row, picking up Joan Fulleylove. She is rather worried about Jean Inglis, who has had all her teeth out and quarrelled with Hester Radford, the combined effects of these two incidents leaving her a wreck.

Sunday 19

Jean Orage and Jean Inglis came. J.O. has been to Veere to see Alma Oakes.

Monday 20

...Gill tells me that Rushbury and Connard are going to run an etching class and are looking out for pupils – a sign of the times, money and commissions being scarce. After supper Alice & I called on the Copleys to deliver Alan Sims's book *Phoenix* to Peter. Found...Sturge Moore with John Copley. Sturge Moore thinks most of W.R.'s portrait drawings are bad – only about 1 in 20 good – and that the 'Einstein' looks like a charlatan. I defended them. S.M. went on to characterise the Ricketts & Shannon as 'pretty' and his own portrait as a failure (it was done in Church Row he says)...

Tuesday 21

...Great alarms and excursions over Wellington going to Edinburgh. He does not really want to go, and Birdie feels it is a sort of tragedy, and that he is only doing it to for the money and from a sense of duty. He does not want the money for himself, but thinks it is up to him to get the extra few hundred a year for Charlotte's sake...

Wednesday 22

...the Slade show...Roger Pettiward, Miss Berry and Miss Brown particularly noted. I wonder what will happen to them and the irrepressibly energetic Olga Lehmann? Pettiward has gone off on an expedition up the Amazon – the 'River of Death', *The Times* calls the place they have gone to – as a surveyor. He said good-bye to me the other day at the Slade, but said nothing of this...

Friday 24

Slade Prize Giving & Strawberry Tea...

Saturday 25
Tony Ayrton came in…Rothenstein has turned him down for his Diploma, an odd thing, as he is more talented than many who get it…In the evening at the Camargo Ballet[23] at the Savoy Theatre. Drop curtains by Roberts & Kauffer, and a travesty of Inigo's Jones's designs in *The Origin of Design*…Lopokova danced in this, with her accustomed liveliness & charm, and [Anton] Dolin was a very good dancing partner…Constant Lambert, who has grown very fat, conducted…

Monday 27
…Slade Committee, passed off harmlessly: Sir John Bradford, Ashmole and the others… Tea in Southampton Row. There met Porter and Mrs. Porter. They tell me that at last Diana Brinton is marrying Rupert Lee…The London Group will have to give them a wedding present…

Tuesday 28
…John Guthrie came to supper. He is designing some costumes for a masque and wanted information on Charles I costume.

Wednesday 29
…(I haven't noted it before) Lutyens describes the exhibition of the Bank pictures as 'Sir Herbert's Bakerloo'.

Thursday 30
Last week, it seems, the Prime Minster's secretary called at the R.C.A., and after seeing W.R., asked Wellington if he would take Collins Baker's job at the National Gallery. After seeing Baker & Constable, and thinking over it for the week-end, H.W. decided against it. He was told the P.M. would make it all right about Edinburgh…but he does not think it is his métier to sit in an office at the N.G.…Constable told him frankly he had trained up Isherwood Kay with a view to K.'s succeeding Baker. Camargo Ballet with M. Russell. *Mercury*; music by Satie, which struck me as very similar to an ordinary music-hall orchestra. Russell didn't like it anymore than I did, and with better reason, being a musician. All the snobs in London thought of Eric Satie as the very last word in music about 10 years ago. The ballet was silly. It was followed by *Giselle*, long but not boring: corps de ballet good, beautiful dancing by Spessiva, a good display by the leading man, whom I believe was Dolin, but I lost the programme. I also appear to have lost £5 in notes, which bothers me having only £40 in the bank (but more coming in next month). Saw Keith Baynes, Mrs. Matthias, and several art students whom I know. I believe it is a very limited public that likes the ballet, you always see the same people, or others just like them. But it is an enthusiastic audience, just as it used to be for the Diaghilev shows.

JULY

Friday 1
…Margaret Morris show in evening…Margaret did several turns: Bach, Negro Spirituals, a Spanish dance (not good) and Dvorak's *Humoresque* again (by special request from Alice). I think she is a born dancer and has a lovely figure. Her arm movements are quite

23 Founded London 1930 to further the development of British ballet.

remarkable…

Saturday 2
…Mrs. Filmer, it seems, ran off with the manager after the Everyman season…I remember suspecting that something had happened when we met Filmer at Roche's on June 25. I said 'how is Mrs. Filmer?', and he replied 'As far as I know, she is quite well'.

Sunday 3
Looked at Willie Clause's pictures that he has brought back from Cagnes. His actual painting is becoming more masterly, in the portrait heads especially, and I liked some of the water-colour drawings…

Tuesday 5
Awards Committee, Board of Education, Maida Hill. Eaton, Wallace, Rothenstein, G. Spencer, Horton, Wellington, Dickey, Woolway, Travis, Gill. No friction with W.R., as there was at the Industrial design Exam. Gill took me to lunch at the Arts Club. We talked about Bellini. He has seen Bellini's *The Feast of the Gods* [1514] in the Widener Collection, and admires it greatly…Widener has a portrait of himself by John, which he dislikes, though Gill says it is one of the best John's he has seen. Widener says it makes him look as if he hadn't shaved (it is a little blue round the chin) and prefers another portrait by Oswald Birley. Gill says that America is more abandoned than Paris in it's behaviour, and describes the atmosphere of Harlem café's, with 'high yaller' girls who dance without a stitch on, as making Paris seem jaded by comparison: also described sitting at dinner with two middle aged ladies, both of whom pressing his knees hard from opposite sides. We went to the Nat. Gall. to continue with Bellini and in the Venetian Room met Jane Monnington. Had tea together. Jane was amused at Gill's account of Oriana's latest adventures in the South of France. She was in a boat in a bathing costume, when a yacht passed with some people she knew in it. They asked her to come on board, which she did: she returned three weeks afterwards, still in her bathing costume. The proprietor of the yacht was fined by the authorities in St. Tropez for exposing his backside through a porthole. Dined with the Dickeys in Greville Road, Richmond, where was Tom Balston the publisher, who annoyed me by abusing Charles Tennyson…But he spoke up loyally enough about Gertler, only saying that Gertler's worries have increased since his marriage, his wife developing a habit of staying in bed for four days at a time, and letting everything slide: whereas what Gertler really wants is a wife to 'mother' and look after him. Earlier in the day I had met [Bernard] Adeney in High Street Hampstead, where he had been to take his boy to school. He was very sleepy, having been up late with Henry Moore the night before. Gertler was also with them. Adeney thinks as I do about H.M. – roughly that he is a better artist than his work sometimes shows.

Wednesday 6
Visited Miss Unwin at 16 Eaton Rd., to get material for an article on Unwin for *P.C.Q.* The same house where he lived when I first knew him at the Slade. He lived then with his mother who has died only recently. The house is now divided into two, and Miss Unwin lives in half of it. Walls and staircase lined with Unwin's prints: they are pretty unsaleable now: I see them advertised for small prices, from about half a guinea

upwards…My own are apparently worth a guinea at the moment…

Friday 8
…Drawing of Hutchinson's house on Church Row. He came and looked at it: so did Egan Mew, who brought up Lady Tree as well. She was attending Beerbohm Tree's grave alongside in the Churchyard…Mew was very amusing about his accident: he slipped on some grease outside Smith the butcher's shop in Heath Street, and hurt himself. The butcher's boys came and rubbed his back with their greasy hands – well meant, but destructive to his well kept clothes. He likened himself to the nightingale, which sings on though wounded…

Saturday 9
Finished the drawing…Mew tells me that Norman Evill also did a drawing of the house, in his architect's manner, which Mrs. Hutchinson wanted to have to give to her husband. He sent it in, with a bill for £20, which rather staggered her. It is more than I should have asked anyhow. I have just accepted an offer of twenty guineas for 2 drawings of Dover. One, of *Alexander House*, very elaborate; an offer made by Kidderminster Art Gallery.[24]

Sunday 10
Dinner with the Wellingtons – the last we shall have with them in Downshire Hill. His portrait is in several of the papers as the new head of the Edinburgh School of Art. Charlotte is very proud of this. I'm glad she didn't see my 'figure' in *Homes & Gardens*.

Tuesday 12
Occupied with article on Unwin. I shall not touch on his unfortunate marriage to Clara, nor his tragi-comic side – his lack of humour, his easy abandonment of himself to the guidance of others like that fool of a doctor who first treated him (for gastric catarrh) and Homer Lane [1875-1925] the quack psycho-analyst, who bolstered him up with vain hope of recovery. What a mess it all was; and his theories of sex, about which he understood nothing…Meeting at the Bartlett School, to discuss management of supporting British craftsmanship – Richardson's idea…Lutyens, Blow[25] and Richardson did most of the talking…Lutyens cracks jokes most of the time, and I often didn't know whether Blow was trying to be funny or not: he has a grave leg-pulling manner: so I reserved my hilarity with caution.

Thursday 14 – Sunday 21 August: no diary entries

AUGUST

Starts Monday 22
…Plymouth…Called at Laboratory 12 o'c. and fixed sitting with Dr. Allen. Began at 3 o'c. and worked till 4.30… He is a genial old gentleman, with something boyish and simple about him occasionally. Could not make much of Ogden's [Williams & Woods] *Foundations of Aesthetics* [1922] which I reserved for a bonne bouche after dinner…

24 The Kidderminster Collection was acquired by Bewdley Museum in 1990 following closure of Kidderminster Museum and Art Gallery.
25 The architect Detmar Blow (1867-1939) as a young man accompanied John Ruskin on his last journey abroad.

Tuesday 23
Went on with Dr. Allen's portrait. Saw Epstein's *Genesis* which is being exhibited at an artists' colourman's shop: 1/- in the morning, 6d in the afternoon. I thought that there were inconsistent conventions in *Genesis* as in other of Epstein's works; also that he somewhat resembles B.R. Haydon[26] in a misconception of his own power. He has plenty of power, of course, especially as a modeller...

Wednesday 24
Revised the portrait. A Miss Bidder...of Allen's staff criticised it frankly and unfavourably. She was probably right. Started another in the afternoon...

Thursday 25 – Tuesday 6 September: no diary entries

SEPTEMBER

Starts Wednesday 7
Began to draw Sir William Bragg[27] at the Royal Institution...

Thursday 8
2nd version of Bragg...He is not a bad amateur water-colourist. I really quite liked a drawing of his of the Australian bush... His daughter Gwendy is an artist, also not too bad. She was under Bayes at Westminster. She is marrying Caroe the younger of the architect's family, and is going to live in Markham Square. I told Sir William that the Square had a very unsavoury reputation 30 years ago, ladies of easy virtue being accessible there...

Tuesday 13
Met R.P. Bedford in the Tube. I told him I was going to see Durst's sculptures on the New Merchant Taylor's Building at Northwood. He said he hoped they were better than the ones in Gower Street. I asked him what he thought was wrong with those, which seemed to me to look well across the street, and to be well cut, and therefore more agreeable than most London sculpture. He grudgingly admitted the cutting, but said they were 'dull', 'wanting in humour' and 'not beautiful women any way'. The last criticism surprised me, from Bedford an apostle of the abstract. He went on to talk with malicious enjoyment of Wilenski's new book on Sculpture, in which W. drops several bricks, as I knew he would, in his account of Greek art... We went up a 40ft ladder to look at Durst's carvings of Dante, Shakespeare etc. Birdie was rather scared but did not show it, and said nothing about it until she got home. Durst is dissatisfied that his work should be so high up, but as a matter of fact it reads fairly well from the ground. Still I can understand his feeling...

Thursday 15
Ivon Hitchens is apparently very ill in Somerset...His landlady in Adelaide Road, Mrs. Lund (widow of Niels M. Lund[28]...) is very agitated. She is about 80 and drinks too much

26 History painter, teacher, diarist, born Plymouth 1786, ambitious, opinionated took his own life 1846.
27 Joint winner (with his son Sir Lawrence Bragg) Nobel Prize Physics 1915 for his research on the determination of crystal structures. Knighted 1920. Director of the Royal Institution.
28 Danish artist (1863-1916).

whiskey, but is anxious to go down at once…P.S. This turned out to be a false alarm…

Saturday 17
…Supper with the Hagedorns. His designing job in Manchester gone. He is getting a year's salary, and will get his money out of the business (£1500). The business is closing down. He says that Schwabes and 2 other firms are still the backbone of the Calico-printers Association. It is lucky that Nelly Hagedorn has a job now, at Wormwood Scrubs Prison, and will be chief of her department next year. Russell went to see the Pissarros. They have let their house for 4½ gns. a week, and are living in the studio. He sold only one picture last year, and Orovida only one. They are spending capital…

Monday 19
Dinner with Koe Child. He is no better…told me that it is really true that Steer is so careful about chills that in the winter he puts on an overcoat when passing from one room in his house to another. He also told me something about Edwin Long,[29] whom he used to know when Long lived in Fitzjohn's Avenue, where he had a fine studio and did very well. Odd that I cannot ever remember seeing a picture by Long…One sold at the time it was painted for £7000, and another sold at Christie's not long ago for the price of the frame…

Saturday 24
Drew a man model's head in the afternoon with an idea of getting more out of this kind of thing than I have been doing recently in commissioned portraits. (More *out* of it, not more *into* it). It may take some time to develop this, but a course of trials will be made…

Sunday 25
Made two drawings of Towner. Not much development in these so far. I was moved to do these things partly by looking at a Rubens' drawing which has intense vitality and largeness of vision. Wilenski's new book has possibly caused me some dissatisfaction with what I have been doing, which is an attribute that such books have. He is interesting about sculpture but forces his point unfairly, if amusingly. I still feel that finer relations of form can be discovered in actual representation than he has any notion of…

Monday 26
M.A. [Ayrton] has been to the South of France, round about Nice. Tony was in Kent (Alice suggests, near Evelyn Dunbar?) and is going off to Edinburgh on Friday…

Tuesday 27
Slade…Ithel Colquhoun came to see me with some of her work. She is going back to Paris again soon…Her studio in Montparnasse costs her £40 a year. I mentioned Brancusi. She says his studio or studios is really impressive with all these huge 'abstractions' about the place, and she has a great respect for him…Alice teaching a class – her first experience outside the School – in Tooting today.

29 Victorian painter (1829-91).

Wednesday 28
Bought a setter (4½ months) with Hagedorn's help, at the Army & Navy Stores: £8-8-0…W.G. Constable…says Monnington is painting a portrait of Stanley Baldwin, and that he is very sensible not to ask high prices: will do a head and shoulders for about 25–50 gns and a whole length for £100. Talked about Nina Hamnett's *Laughing Torso* [1932]. The publishers have been served with an injunction at Aleister Crowley's instance.[30] Constable thinks that Crowley is an unscrupulous blackguard, who extracts money from young men, and that Cambridge University was quite right to set their faces against him…

Thursday 29
…went to Buckhurst Hill in the afternoon to see my father and Jess. Have not been there, it seems, for about 3 years. Found him much changed…He is full of thoughts of money and schemes about absurd patents. Jess has been having a bad time of it. She says they could get along if he didn't waste money on these schemes. I sympathized, knowing what my Mother went through, and how this mania has persisted for 40 years. I told her she might think me not very dutiful, but it stuck in my throat that he never wrote but when he wanted money…Cheston came in while I was out and told Birdie the astonishing news of his approaching marriage to a French lady of 45 who lets lodgings in Cambridge. She has no money and he forfeits Evelyn's money if he marries again. Has been speculating with his own money, it seems with Steer's advice, and has improved his position so that he should have several hundred a year.

OCTOBER

Saturday 1
London Group…selecting jury. Met Bob Wellington beforehand taking in Hubert's pictures…He says Brodsky has been contemplating a book on Gaudier for the last fifteen years. Took my picture in with a glass over it: found out that this is very unpopular with the L.G., and not done. Felt very out of it…I used to be very active on the London Group: now a lot of people don't know me, nor I them. I saw Morrison, Porter, Baynes, Noël Adeney, Farleigh, Lee of course and Diana, Allinson, Carline, Brodsky, Henry Moore, Dickey – and I think that is all I recognised out of 18. No – Vera Cunningham, Seabrooke, and W. Bevan. Very instructive to see what they like and don't like (mostly the latter). Colquhoun was chucked. Moynihan and Bellingham-Smith provisionally accepted. Nina Hamnett was nearly chucked, but was given a D (doubtful)…

Tuesday 4
After the Provost's address, visits from Randall Davies and Borenius, and other amusements, tea with Walter Bayes. He is not thoroughly satisfied with Gertler as a member of his Staff: complaints – lack of humour, sense of his own greatness, and snobbery…But this complaint to be balanced by some appreciation…

Wednesday 12
Went to Walter Bayes's Private View at the Fine Art Society. …Bought Bayes's new book, *An Artist's Baggage*…Ernest Thesiger was having a show of water-colours in another room (I did not like them) and he was there himself. We shook hands on the strength

30 Crowley sued, unsuccessfully, for libel over allegations that he practised 'black magic'.

of having been at the Slade together.

Friday 14
Went to Roland Pym's show, Bloomsbury Gallery, on my way to the Slade for the criticism of the summer pictures…Jo Jones was hanging a little show in the next room to Pym's. Haven't seen her for years. She stayed with the John's in the summer, but didn't see as much of them as she would have done if she had not been ill: she thought you had to be very fit to stand their hard drinking habits. She admires Vivien John. Pym has sold 27 drawings and paintings, mostly small things. Slade ordeal over – stammered a bit in introducing G.J. and Charlton, who did the criticisms. Went to Gertler's show at the Leicester Galleries, where Klinghoffer was having a show as well. Gertler has got clearer & harder in his work, and his colour has improved: there is not so much of the stuffy anti macassar feeling in them. There is a portrait of T. Balston,[31] very like in a way, but suggesting a different sort of personality to my own conception of him. Clara Klinghoffer's picture of Lucien Pissaro is like in every way…I liked it better than any of her other things. Great competence, not much meaning it seems to me.

Saturday 15
Went to see Miss Wilcocks, 26 Sussex Place…Her house is a fine one, where the Galsworthy's used to live a generation ago. It is the background of the Forsyte books… Unwin's things certainly look at their best in such surroundings, and I was glad to see 5 prints of my own…Dinner with the Copleys: Ethel Copley's sister, Alan Sims, of *Phoinix* [1928], looking more like William Morris than ever, and two Russians a man and his wife (some name like [Elena] Miranova – she acted in *Grand Hotel*)…Mrs. Copley is going to paint her. John Copley knew Ford Madox Brown: said how very hard-up he was in his latter years, and worried to know what his wife would do about money if he were to die first. I observed that Rossetti behaved abominably to F.M.B., judging by the P.R.B. Diaries: but Copley says that F.M.B. always spoke enthusiastically about Rossetti.

Sunday 16
Walked with Hagedorn…[he] has two posters to do for Shell-Mex, £20 each.

Thursday 20
…Lady Rothenstein telephoned that she wanted to come and see me, which she did: it was all about a notice of W.R.'s show at Agnew's in *The Times*, which said among other things that 'he was not a very good draughtsman', and that he could not make a head look solid, and that he had a weak response to form…W. was really very upset by this, looking on it as likely to damage him at the College and to prejudice his sales…He puts it down to hostility on Marriott's part, dating from the time of McEvoy's death, when W.R. wrote a strongly worded letter condemning Marriott for not seeing how good an artist MacEvoy was, and slighting him in his notice published by the paper. The upshot was that Alice R. after…over enthusiastic praise of my pictures, asked me to write to *The Times* expressing a contrary view to Marriott's. This I agreed to do, as I quite honestly like very many of W.R.'s drawings, and think that Marriott is wrong: but Marriott may be quite honest too – many people dislike Will's drawings…I don't like writing to *The Times*, but W.R. would certainly do it for me, and I owe it to him to inconvenience

31 A supporter of Gertler. Now in the Ashmolean Museum, Oxford.

myself a little…

Friday 21
…After lunch in the Refectory was taken by Gregory to see the Observatory out at Hendon…Admired…its compactness & efficiency, and felt how ignorant most of us are about science…

Thursday 27
…Arranged my drawings at Barbizon House…and visited the students' show at the R.A. Most of the work is lacking in what the Slade usually has too much of – 'taste'; but there were some good landscapes.

Friday 28
…Zwemmer's have a show of 'Nineteen'– young men and women mostly from the College of Art. I liked Davenport, Diana Murphy, some drawings by Holland, and some work of Barbers. Did not like Anthony Betts. Boswell is coming on. Kestelman imitates the Cézanne-Lhote school.

Saturday 29
…Dinner of the Old Bradfordians at the Savoy. I was Rothenstein's guest…I told E. [Ellis] Roberts about my letter to *The Times*, which has not appeared. He confided to me that he had also written, and had not been printed: Alice R. had telephoned him, asking him to…He has something about Rothenstein in *The New Statesman*, though, concocted by himself and Earp. Agrees that Marriott is quite wrong, and thinks him a better novelist than art critic.

NOVEMBER

Tuesday 1
N.E.A.C. Jury…Holmes confided to me after lunch…that years ago when he was a clerk he took offence at W.R.'s manner to him, and threatened to punch W.R.'s head in public: the only occasion, he thinks, (except the case of Herbert Horne, who swindled him over a picture) when he was driven to use threats of violence. The Jury made the usual errors: chucked out Gilbert Spencer & then reinstated him. Towner's pictures were well received, so were Hagedorn's, and Will Grimmond was accepted without difficulty. Ethel Copley had her two (which I chose for her) accepted…I don't think I noted that she wrote me a note, rather touching about being always being fired out of the N.E.A.C.…

Wednesday 2
Conference, Board of Education…It all ended in nothing except expressions of good-will and co-operation from Llewellyn, Jowett, Rothenstein and University College; but the[y]…can now say that they have contacted the most eminent educational authorities on the over-lapping of art-education…N.E.A.C. hanging. G.J. knocked a hole in Gilbert Spencer's picture…Connard jeered, resenting G.J.'s running the show too much: a not uncommon feeling…

Saturday 5
...Met Ethelbert White, who is annoyed having one of his pictures thrown out...I'm sure it would not have been rejected had it been properly and carefully considered by the Jury. Wrote Ethelbert, taking one twelfth of the blame...

Monday 7
N.E.A.C. General Meeting...Maresco is annoyed at having his one and only picture hung in a corner...

Wednesday 9
Went to Gluck's show at the Fine Art Society, to see what her portrait of Margaret Watts is like. She is getting a good deal of réclame, having fitted up the whole gallery with a lining of three ply-wood, like a built scene on the stage: it is painted white, the pictures are let into it, and heavy strips of wood give a kind of pilaster effect at intervals. A good piece of showmanship...

Thursday 10
To Barbizon House to see about my Private View. Ernest Marsh came first...lunch with R.A Walker to discuss the possibility of writing a book on English Illustration: the suggestion came from him, and appeals to me, though I have just refused a suggestion from another firm of publishers that I should do a book on *Art in my Time* – 50,000 words for £150. My refusal being on the grounds that I prefer to spend my time making pictures. But Walker's proposition could be tackled at my own time...

Friday 11
...Passed Piccadilly Circus at exactly 11 o'clock, when the silence began...My taxi stopped, of course, and the only sounds I could hear were the ticking of the taximeter and the barking of a dog – sounds one never hears in London...

Saturday 12
Went to Camberwell to hang the South London Group...Some good things by Francis Dodd, and prints very remarkable technically by Washington, whom I have not noticed before...

Sunday 13
Lunch, Hagedorns, Belsize Park Gardens. He and I walked afterwards from the Borough Station by devious ways to Blackfriars, noticing much of professional interest...Hagedorn remarked on the civility of Londoners – how much in contrast to the residents of Ancoats or any Manchester slum, who dislike strangers; also the relative well-being of them (of course, they all had their Sunday clothes on, which are probably 'popped' on Monday morning), as compared with the barefoot inhabitants of Manchester 30 years ago. Supper with the Hagedorn's. Ginger came. He has written something on measles[32] that was well reviewed, to the extent of half a column in the *Morning Post*...Rutter has given me a very good one for the Apple picture in *The Sunday Times* of the 13th under a sub-title *Homage to the Slade* and side by side with a piece about Fred Brown's self portrait. I am glad, or rather relieved, about this, because it is good that one's connection with the Slade should not be made a reason for abuse, and it is good for the school to be well spoken of.

32 Discovered providing vitamin A to children with measles reduced mortality by nearly 60 per cent.

Thursday 17
Opening of the show at the Romano-Santi Restaurant 50 Greek Street. Chesterton made a speech introducing Eric Gill…Gill was serious with sparks of wit, and rather lengthy…

Friday 18
Started a drawing of sheep dipping. Visited Margaret Mackintosh, Chelsea Manor Studios. She is cheerful but hardly able to get up with her heart…

Saturday 19
…Ivy Tennyson and Charles came to tea: the first time they have visited us here. She is going to take over the house at Farringford and run it for the Tennyson family…insistent that we should go to Aldeburgh for Christmas.

Monday 21
After the Slade went to Cooper's to see about the reproductions of Dr. Allen's portrait (I have the cheque for it, too, an enormous sum, even for two drawings – 75gns)…

Tuesday 22
Scandal about Margaret Morris, from Margaret Mackintosh, informed by Alick Schepeler & Lois Hutton. I always looked upon the irregular union of M. Morris and Fergusson as one which was not to be harshly criticised, because it was consistent in its ideals, though based on theories which are not mine. Now it appears that Margaret Morris also lived with Goossens for a time, and that Fergusson lived with one of the students. The latter affair apparently upset Margaret Morris a good deal. It is referred to by Lois Hutton as 'The Dust-up'. Having been reading Goethe's (in a translation) *Dichtung und Wahrheit*, I am reminded of what he calls 'the strange labyrinths by which civil society is undermined'. There is a lot about this somewhere in the 7th book. Margaret Mackintosh very informative and amusing (to Birdie) about Toshie's methods of work: how he shut himself up in his studio to model a bird – a design for a tombstone…which he could not get right by drawing. He spent the night with several bottles and a heap of a day, making strange noises, and was found in the morning quite drunk. The bird finished, the bottles empty, and clay in every possible part of his studio where it could be trodden or thrown. She says he never drank except when he was bothered about something, but that he drank from an early age, before they were married, appearing at dinner with her family…so drunk that they disapproved of him violently. Only her mother had a weakness for Toshie. He was handsome when young and a fine looking elderly man.

Thursday 24
…Interview with Dent about the proposed book on English Illustrations. He wants me to make a rough synopsis…Lady Rothenstein's At Home…Plunkett Greene singing…I went to a downstairs room, where Francis Dodd, quite spontaneous, without any self-consciousness…told funny stories in a Lancashire accent, first to Essil Rutherston, and then, standing up, to everybody in the room. I talked to Lowinsky, who says he is doing some drawings, mildly indecent, for a book by Jimmy Laver…

Friday 25
…went round the R.C.A. Sketch club show, and I awarded a prize to some drawings of Evelyn Dunbar's…

Saturday 26
Durst's *Mare and Foal* in Siena Marble, which we have on the exchange-loan principle, looks very well on our mantelpiece and everyone who comes to the house likes it… Philip Alexander also called on us about 6'o clock. He has been reading D.H. Lawrence's letters, which he finds very painful. Durst is reading them too, and…has revised his opinion of Lawrence in consequence. He now thinks Lawrence unbalanced and morbid, particularly in his sex obsession, as in *Lady Chatterley's Lover*…

Sunday 27
Medworth's picture of his wife in her bath had to be removed from the show at the South London Art Gallery owing to the protests of an Alderman…

Wednesday 30
Went to Vyse's show…At Walker's Gallery…it being now the third day of the show, over 80 pieces are sold out of about 200. I bought a bowl for £3-3-0, wishing to help Vyse. There is a general sympathy for him in his great trouble about his wife, who is still in hospital…In the evening called on Towner, who has hurt his leg. Mahoney was there…He (M.) is loyal to Rothenstein, and says the 'old boy' is becoming more brilliant than ever, saying remarkable things, and making most excellent extempore speeches, full of matter; but that he does not understand 'student psychology'. They don't understand what he says…On a previous occasion, Mahoney says there was almost a riot in one of the life-rooms after W.R. had been round. Mahoney…found a student standing on a chair haranguing the others. He quietened them down, explaining Rothenstein's meaning, and pointing out that the business of a Principal was different from that of the teaching staff… Mahoney is a devoted admirer of Charles Keene, and knows a lot about that period of illustration with which I may be concerned if I take on the book for Dent. He will lend me books. He also admires his friend Rhoades's work…A man named Lang called on Towner, and I left with him, bringing him back to Church Row to show him *A Short History of Costume and Armour*, in which he was interested…Lang remembers me, and Kelly too, year ago, working in the Library at S. Kensington, and wondered then what we were working at.

DECEMBER

Saturday 3
Went to the New English, it being the last day. Looked at the press notices, many of which insist on the dullness and retrograde nature of the show. I noticed a good drawing by Heber Thompson. Sales better than usual – about £600, and double the number sold last year, but mostly small things. Brown's Chantrey picture accounts for £300…Went on to Ethelbert White's Private View at the Leicester Galleries. Very full, there being two other shows on at the same time – Peter Arno's and Kapps, the caricaturist: did not care for either…but thought E.W., much improved – broader, more sense of depth, and better painting …

Monday 5
Tea in the Exhibition Room, U.C.L. on the occasion of the presentation of a portrait by
László to Lord Cecil of Chelwood, in the Great Hall, lent for the occasion…László knew
Legros, but…knew next to nothing about the Slade…We move in closely confined
circles…Baldwin spoke, and then Lord Cecil, with the Archbishop of Canterbury to
finish…I thought László's an emasculated version of a fine face…

Tuesday 6
Lunch with Heal, 46 Fitzroy St., and Arthur Watts, to discuss procedure in collecting a
fund for Blockie's old age, or other emergencies. Heal says he is 60 himself…Charlton
feels that that Slade students are 'getting very slack'. This and an article (stupid though
it was) in the College Magazine about the Slade were cause for depression. Must be
prepared for criticism, and some of it must be stupid…

Wednesday 7
…Mrs. Hannay at Home…Was introduced to Algernon Newton without catching his
name…I should have known all about his pictures…he is tall, thin, with a white beard
and moustache, something like Cunningham Graham, but not so picturesque…Newton
says he only makes notes on the spot for his pictures, and often uses photographs, but
freely, of course. He uses a car to draw from – dislikes the business of drawing in the street.

Wednesday 14
Committee meeting, Whitechapel Art Gallery…Saw the show E. London Academy
afterwards in the Gallery with Aitken and Duddington. East London people exhibiting,
largely Jews. An extraordinary piece of work by a working class woman (Mrs. Gill)
whose husband is dying of t.b. and who has a paralysed son, but who seems to go on
placidly working at her enormous designs. This one was called *Reincarnation*, and was
about 9ft. long on calico, drawn with a fine brush line in indian ink…Ososki, Weisman,
& Klaska, the fellow who made the row at the R.C.A. 5.30 Maroger[33] lecture at Courtauld
Institute. Met Rothenstein on the doorstep & sat with him. Fry read the lecture, Maroger
not having enough English, but he was there to prompt Fry…Rothenstein spoke with
reference to the recent death of his friend Anquetin,[34] who had experimented along the
lines of Maroger. Maroger replied freely admitting his debt to Anquetin, whom he had
known and worked with…Am not convinced of the soundness of the Maroger
emulsion…but everyone who has experimented with the stuff says it is pleasant to work
with and does produce the quality claimed for it.

Friday 16
Slade Dance went off without incident…Miss Blake of the Refectory said that our three
hundred odd people drank as much as she commonly allows for a thousand…Richardson
came disguised as Sir William Chambers in real 18th century clothes. He looked
magnificent…Some of the girls' costumes excellent, some as near naked as they can
(how we have changed our standards of indecency!)…

33 Painter (1884-1962) and technical director Louvre Museum's laboratory Paris, devoted his life to
understanding oil-based media of the Old Masters.
34 French painter (1861-1932).

Sunday 18
Revised an old painting of Lords Wood, done 13 years ago. One discovers possibilities by messing about with unsatisfactory paintings…

Monday 19
…Went onto see Margaret Mackintosh, who is faced with the problem of living in a studio which is practically one room, and not being able to do much for herself, yet hating the presence of the servant whom she has to employ. She has an attitude about the 'lower classes' which is going out of date: she is kind, but can't bear to be intimate with them…

Tuesday 20
Meeting at Central School to discuss criticisms of draft Syllabus, Higher School Art Examinations. Dickey & Noel Rooke. Rooke says he was partly responsible for the choice of Farleigh to illustrate Bernard Shaw's *Black Girl*. Farleigh was very hard up at the time. They wanted some artist relatively unknown but good. Shaw wrote to Farleigh asking him to submit a design, apologising for being too old to have heard of him, and enclosing £5 in case it all came to nothing. The first edition was very large, about 25,000, so it was no wonder that the publishers could afford to sell such a remarkable little book for 2/6d. Many people are buying it for the sake of book production and Farleigh's designs, more than for Shaw's text. The cover sells the book to some extent. It is great good fortune for Farleigh to be associated with a thing that has such a wide circulation. The first edition was sold within a few days.

Friday 23
Drove to Aldeburgh, to the Tennysons, with the Kohns…

Wednesday 28
Left Aldeburgh for Dover…

1933

Schwabe is deeply moved by the death of good friend Margaret Mackintosh and does much to promote the reputation of her husband Charles Rennie Mackintosh 'Toshie' in Glasgow. The racial politics of the Nazis are reflected with reports of Jewish academics being dismissed from posts in Germany. Albert Einstein leaves for the USA, Slade students attend a demonstration in his favour at the Albert Hall. Schwabe is once again involved in judging the Prix de Rome. He and Birdie attend the Russian Ballet and reflect on their enjoyment of the early visits of the Ballets Russes. The controversy generated over the proposed sale of an alleged Holbein calls on Schwabe's expertise viz. costume and drawing.

JANUARY

Sunday 1
Dover.

Saturday 7
Received a postcard from Aunt Agatha saying there had been a telephone message that Margaret Mackintosh was seriously ill, in a nursing home…We went straight to Chelsea, to Margaret's studio and were told that she died at 4 o'clock this morning in the Nursing Home, 39 Royal Avenue. Birdie blames herself very much for going away when Margaret was obviously so ill, without anyone to look after her; but we had been reassured by her doctor, to whom I telephoned some time back, and who told me that he thought she had 'a good life'. She died unconscious, with none of her friends or relatives to do anything for her. She was heroic about that all along, not wishing to cause any trouble to anyone, and keeping as quiet as possible about her condition. She had made up her mind that she would die soon. Will Kennedy and I believe, Ann Dallas, had called at the Nursing Home on Friday, but she was almost unconscious by then. Her cousin, Hardeman, has been telegraphed for. We met the Wellingtons at the Café Royal, where we dined. They were cheerful, and evidently Edinburgh has many interests for them…Having broached the subject of Margaret's death, he told me that Barber, a very promising artist, who had just started, for the first time in his life, on a settled job under Williamson at the Chelsea Polytechnic, has committed suicide. A verdict of accidental death was brought in as he had one of his side pockets full of aspirin and the other of poison, and it was assumed that he had confused the two and taken the poison by mistake; but no one who knew him believes that. Gilbert Spencer thought he would have gone out of his mind anyhow. We talked of Meninsky, who has apparently recovered sufficiently, to get back to work: he and his wife have agreed to live apart for a year – a good thing, I think. We had other more cheerful topics, too; but after all, the question of death is one that all middle-aged people must think of, naturally and not necessarily with too much gloom…

Sunday 8
Hardeman telephoned that he is making all arrangements for Margaret's cremation, and

is winding up her affairs. Her brothers are too ill to come to London.

Tuesday 10
Stayed away from the Slade to go to Margaret Mackintosh's cremation service with Birdie: 11.30 at Golders Green. Hardeman and a woman unknown to us were there. The ceremony is dignified enough. The parson had a good voice and manner and was impressive. The coffin slides noiselessly on its bronze slab through the door in the sidewall of the chapel. There was a thick damp mist outside. Hardeman was evidently affected. We looked at the garden where the ashes are strewn but could see little...Jean Inglis came in after supper at the Scotch House. She is leaving to copy the Vandyke of a member of the Herrick family, at Beau Manor, Leicestershire, which is wanted by an American Herrick.

Wednesday 11
Went after the Slade to 5 Fitzroy Square, where Birdie was having tea with Le Bas and Clara Unwin; they have rooms, and he has a studio in two houses which formed part of Curtis Moffat's place. C.M.[1] has gone bankrupt. This was the first time we have seen Clara for years. I don't profess to understand the position with Le Bas. One would suppose they were living together, but perhaps they aren't...

Thursday 12
Slade...I have just had an assessment for two years' income tax, 1930-1932, which I was perfectly innocent about, thinking that I had satisfied all demands: I shall now be some £400 in debt. Everything is very depressing and worrying...

Friday 13
Started work on Board of Ed. Exam. papers. Sent synopsis of proposed book to Dent. Attended Committee, R.C.A., to discuss further interaction and overlapping of Schools of Art...I also saw the R.B.A. in the afternoon, largely to look at [Thomas] Falcon's[2] work. He knows all about rocks, but not enough about tone and colour. I should like to admire his pictures because I like him, but in spite of his knowledge I get little satisfaction from them. He has been writing words about his old friend Colin Phillip, son of Spanish Phillip, who is now dead. His widow doesn't know what to do with his pictures. Nobody seems to want them...

Sunday 15
...Alma Oakes and Mardy Stuart came to supper. A.O. talked about the Millet forgeries, done by a member of the Millet family whom she knew, a scoundrel who was known by his relatives to do these things...The same scoundrel sold many drawings, signed by himself ('Millet') but purporting to be by the elder artist, to Americans at Barbizon...

Tuesday 17
...Courtauld Institute, lst meeting of Board of Studies on the History of Art. Only Mann and Constable present, so it was lucky that I turned up. I was put on the Board of Exam-

1 Born New York 1887, married English actress and poet Iris Tree in 1929 (divorced 1932), opened an interior design company and gallery. Known particularly for his abstract photographs, innovative colour still lifes and glamorous society portraits, died Martha's Vineyard 1949.
2 (1872-1944), landscape painter and silversmith, 1901 married Julie Alice Schwabe. Lived Braunton, Devon.

iners as knowing about the History of Costume, a subject which candidates may be examined in. Constable told me that he had been consulted as to the choice of an artist for Lord Chelwood's portrait, which later fell to László. He always finds this question of a suitable portrait-painter a very difficult one: so does Mann. We ran through the possible people – Kelly, Lamb, Birley, Le Bas, Dugdale – none of them wholly satisfactory to recommend, from the sitters' point of view and from the artist's point of view as well. The young man whom Constable recommended to the League of Nations turned out something that was thought much too caricatural, so they had László after all. Birley goes down well because he is a sportsman, and can talk to sportsmen about hunting and shooting. He has been chosen to do the King for that reason. I remember first hearing of Gerald Kelly through Robert Gregory. Kelly had painted Lady Gregory, and Robert thought the painting very good. Hugh Lane did a lot for a man whom he considered a rising painter, and Kelly speaks gratefully of this.

Wednesday 18
Dinner as Grimmond's guest at the Café Royal, the Double Crown Club, to hear John Farleigh read a paper on *Book Illustration*, with special reference to his most successful *Black Girl*. A lot of publishers there, Tom Balston in the chair: De la Mare, of Faber & Faber, and Holbrook Jackson almost the only ones I identified (I forgot Flower). Ravilious was there too. Farleigh was a little conceited...because, after all, other books as good as his have been done and have not had the immense sale that Shaw's name guaranteed. Agnes Miller Parker's illustrations to *Aesop*, for instance, are just as good, but she has not had the luck to work for a cheap edition of a best seller. Still Farleigh was interesting and intelligent, even witty. Maxwell, the printer, spoke. I got into a long argument with Noel Rooke after it was all over, on the subject of the place of the reproductive wood-engraver in book illustration, Rooke being for the artist-engraver almost entirely. Grimmond and I went later into the Café, where we found Rushbury and Ethelbert and Betty White. The Whites have a new car, a Morris Minor. They have only had it a fortnight, and he can hardly drive. They garage it in Heath Street for 6/6d a week. We came home, four of us, to Hampstead: a tight squeeze: arrived without mishap, except that White ran off the road by mistake into a stable yard at Chalk Farm. Willie Clause brought round Preston, the director of the Bradford Gallery, to see me. He liked my work, earmarked several water-colours for the Bradford show and wants *Fructidor* to go there.

Thursday 19
Judging for the Prix de Rome, painting. W.R. Clausen, Cameron, Dermot O'Brien, Jackson, Lawrence, Monnington, Russell, and the new Director. Gave the Prize to one Barnard of Farnham, with great misgiving on my part...His drawing is vile, but he has apparently enormous energy, imaginative power and ease in composing – a remarkable young man, and should come to something if he will discipline himself...

Friday 20
...Dinner at U.C.L., Professors' Dining Club. The Provost had asked me to come to meet his guest, Glasgow, the new keeper of the National Gallery: he is an ex-official of the Board of Education...

Sunday 22

...walked with Hagedorn on the Heath...told me that George Moore is dead. I never had any personal contact with him, though I heard much of him from Robert Gregory, and I saw him at the Café Royal, and at a Slade Dance one year: on this occasion Albert took Birdie into the Professors' Room and introduced her to Moore, who, she says, behaved with charming frivolity to her, equalling Albert's, who was very gay and amusing in those days...Max Beerbohm was present at the same dance...We have the greatest admiration for Moore as writer; he is probably the greatest who was left among us. Child rang me up in the afternoon to tell me that Moore was the first student ever registered at the Slade School, in Poynter's time: at least so he always told Tonks...

Monday 23

...Dined with Sir Andrew Taylor (who, I am told, is over 80), his two nieces and Hanslip Fletcher, and went on to hear Fletcher's lecture *Changing London* at Stanfield House. Fletcher completely unselfconscious, naïf and amusing...he has been doing London drawings since 1892: must be nearly 60...

Saturday 28

...Got a nurse in.[3] Miss Muirhead, oddly enough one of the former Mandeville Place[4] nurses, who, of course, knows the Jones family, and its history. Curiously, too, she was a relief nurse when little Ann Hagedorn died...of meningitis.

Monday 30

...I like this verse, quoted by [T.] Earle Welby[5]

> Many scarlet bricks there were
> In its walls, and old grey stone;
> Over which red apples shone
> At the right time of the year.

It expresses so much of what I appreciate in country buildings and gardens. The mere place-names will sometimes do to recall or suggest the same sensations, and I am sure William Morris would have enjoyed the sound of 'Great Graces', 'Little Sir Hugh's', and 'Paternoster' – all three in the Danbury district. Lying in bed, with leisure to think, as one seldom has, one's thoughts are not all unpleasant. It is easy to dream oneself into recollections and imaginings...those little scenes of agriculture or sheep-farming, with water-mills and villages and castles, which make one believe for a little that there was a calm beauty in the past – that it was not all squalor and cruelty; and that people left this life full of confidence in their religion, and were, as far as may be, happy. The telephone is out of order; I am running up an enormous bill for doctoring; I cannot pay my income tax...We must sell the dog: he is too unmanageable under our present conditions...Sentimentalizing over William Morris soon fades into a more habitual state of mind.

3 The Schwabes had 'flu.
4 Birdie grew up in Mandeville Place.
5 Known for his literary criticism, particularly under the pseudonym 'Stet' in *Saturday Review* and *Week-end Review*.

FEBRUARY

Wednesday 1
Slade…Then to Hams Studios to meet the lawyer's man from Glasgow, and to go through papers and drawings, etc., belonging to Toshie and Margaret – a great many of his plans which we put on one side for preservation, but what is to be done with them the family must decide. I wonder if the R.I.B.A. Library could do with some of them. A gloomy business, going through a dead artist's things. I remember what it was like when Tonks took one to Sargent's studios in the Fulham Road. A dirty business too: the lawyer's man and I stayed till 9 o'clock in Glebe Place, and got very black from handling the stuff. It is better to destroy most of one's work as Brown has done.

Thursday 2
…Saw two shows in Bond Street, with the idea of looking at the work of Claude Rogers and Robin Darwin for our Slade show. They were at Cooling's and the Redfern. I liked some of Rogers's things, and Darwin may come on…There were some old Innes-like landscapes by Lees at the Redfern, which I liked. Did not care much for some Epstein drawings. Most modern young people's work is still very slight.

Friday 3
…Slade: and afterwards to the R.A. exhibition. The dead men – Orpen, Muirhead, Sims, Dicksee, Greiffenhagen, La Thangue, Tuke, Lambert – several whom I had known personally. What an artist Orpen was when he began, and what a lift he got on the shoulders of John in those days! There were some beautiful early paintings and drawings of his, and some sensitive, charming works by Muirhead. Orpen made me feel very small and sad: so many associations are wrapped up, for me, in his work – a little shock of remembrance, for instance, on seeing, so recognizably, the portrait of Michael Carr in *The Fracture* [1901], an early drawing of Albert R.; the *Café Royal* [1911] with John and Pryde; *The Homage à Manet* [1909],[6] with Steer and MacColl and George Moore and the others all so much younger. I recollect so many of the pictures when they were first shown at the N.E.A.C.: however, the pathetic badness of some of George Lambert's, Dicksee's – the poster-like painting of Greiffenhagen, the unsatisfying Sims' (mostly I don't like them, but there were one or two which gave me pleasure) made for enjoyment of Orpen in a way. I went down to Buckhurst Hill to see my Father – more depression. He is much worse, and a dying man. I could wish this miserable condition well over for him. I can do nothing. Gave Jess an extra pound, and told her to get some nursing help if she can…Read *The Apes of God*[7] [1930] in bed – a tiring, boring book, with moments of unhealthy excitement (these are well managed in their beastly way); very clever, very formless and disorganized…I should record the extreme kindness and decent behaviour of Mary Matthews and her mother (whom she called in to help us and who would hardly consent to take a few shillings). We forget the virtues of servants too easily, or take them as a matter of course.

6 An ardent admirer of Orpen, Carr was a Slade student when *A Mere Fracture* was undertaken. The room depicted in *Homage to Manet* is in Sir Hugh Lane's house in South Bolton Gardens, which was later acquired by Orpen and used as a studio.
7 Many of the characters are based on real-life figures.

Saturday 4
...Called on Mahoney in Willoughby Road, and saw his work. Queer, some of it. I think he is a little starved mentally from having been so poor, but he has feeling. He is doing a...series of decorations, for a school in Brockley. He is not getting paid, and can't afford models for the figures. He has a passion for the little bit of country he knows best, in Kent – orchards and hop gardens...Sidelights on the advertisement business, Grimmond has been helping to take photographs of nude ladies in their baths, for Reckitt's Bath Cubes. Great difficulties in getting the right model, the right poses and lighting, in preserving the decencies...

Monday 6
Augustus John brought Vivien to the Slade as a new student. She appears to have some talent, and is a smartly-dressed young woman. I haven't seen her since we stayed with the Johns at Alderney (must have been towards the end of the War – one Christmas). John spoke of that visit, and asked very kindly, as he always does, after Birdie and Alice. He doesn't like the Orpens at the R.A., and didn't seem at all warmly disposed, even, to the early ones: it's true he seemed to except the interiors. He said the Slade had an air of prosperity – different from what it was in his time there...

Tuesday 7
...went to the Dursts...[he] says little and is honest in his admirations and dislikes. Another set which I hardly know, the Seven & Five Group, worships Ben Nicholson, who has a great hold over the others. 'What he says goes', and it is agreed among them that the Seven & Five is the only show in England that really counts for anything. Durst is going to lecture for Wellington in Edinburgh on Modern Sculpture. He told me some of his ideas on the subject of distortion and how far it is allowable. He thinks you must preserve the *characteristics* of what you represent. If you use the human figure it must have the characteristic structure and attributes of a figure; you may exaggerate that if needed: but deliberate distortion, away from the characteristic, is absurd.

Wednesday 8
...Supper with the Patersons whom we met at Aldeburgh at Christmas...Several artists there-the Pipers, whom I knew as students at the College of Art and a woman called MacGuinness, also Penrose Tennyson...Getting home at 11 o'clock, a telephone from Buckhurst Hill to say that my Father would probably not last through the night. Curious how little I am really moved by this – perhaps because I feel it will be a good thing when it is over. Read *Brave New World* in bed: don't like it much.

Thursday 9
...Train to Buckhurst Hill. My Father died at 9.30. I was affected when I saw him. He was a good Father in many ways when we were boys, but his mania about money was his and our undoing. His affairs in an awful mess. Had to leave £6 for Jess, who is practically penniless there with the funeral and her rates to pay, too, and I am surety for a loan which now falls on me. Arranged for the funeral to be local: too complicated and expensive to open my Mother's grave at Great Gaddesden. Train back to Liverpool Street, very bothered and gloomy. Made a little scribble in Paternoster Square to distract my mind, on the back of a catalogue...Dinner with Charles and Penrose Tennyson, 33 Eccle-

ston Square. Talked about Shakespeare and films. John is supposed to be painting Aug. [Augustine] Birrell, but has only turned up once to do it. C.T. likes my drawing of his stepfather [done in 1927] – thinks the resemblance is good.

Friday 10
Meeting at University College Medical School to discuss Sir Buckston Browne's pictures and the new room they are to go in…The architect, Ripley, knew my brother in Hankow…A reporter from the *Glasgow Evening News* called to get information about C.R. Mackintosh…

Saturday 11
John McDonnell of the Macquarie Galleries in Sydney called. He wanted a portrait drawing done…He is a very intelligent man, with no colonial peculiarities and came over with some idea of taking a degree at the Courtauld Institute…I spent the evening with the Grimmonds. The scheme for advertising Reckitt's Bath Cubes has been turned down. After mature consideration, the Directors decided that drawings might be used, but photographs of actual people might strike conservative customers as indelicate.

Sunday 12
Started drawing John McDonnell – a good head to draw – better than Sir W. Bragg. Philip Alexander called. He told a curious story of the making of Lord Leverhulme's garden in Hampstead: Alexander had it from the architect. Hundreds of tons of earth were required to level the garden up and to make the terraces. At that time, the Tube was being built, and the contractor for that work had to dump the soil removed somewhere in South London, at a cost of 1/6d a load. Leverhulme offered him his garden as a dump, at 1/- a load. The contractor saved 6d a load, Leverhulme got his garden made, and was several thousand pounds in pocket. He was also in treaty with the Hampstead Borough Council to close up the lane which runs between the two halves of the garden, and which is now bridged over. He died, however, before this could be done…

Monday 13
…Slade…Left at 12 for Buckhurst Hill, to bury my father. Jess and her old cousin the only other people. Was relieved to find the graveyard a pretty place, with willow trees and a pond, and a view over the country beyond. I have always had that much sentiment about these things, which was why we selected Great Gaddesden as a burial-place for my Mother – instead of a hideous modern cemetery…

Thursday 16
Called on the Grimmonds, who had much to say about Ceri Richards and his wife. Richards does scores of drawings of her nude, which she blandly hands round: 'This is one', she says, 'the last stages of pregnancy'. They seem to be in a queer set, and very solemn and 'advanced'. Len Lye[8] is supposed to live with two negresses at once…

Friday 17
Slade. Gerrard wants to be made Professor of Sculpture as Havard Thomas was. Difficult,

8 Born Christchurch, New Zealand 1901; 1926 moved to London, joined Seven and Five Society, established an international reputation in experimental filmmaking, moved to New York 1944 where he died in 1980.

with Thomas's son a colleague of Gerrard's. Went to the Seven & Five Exhibition. Nearly all the artists have a good sense of colour, whatever nonsense they may do. 'Squiggles' by Len Lye. Oliver Brown has never heard of the negresses. It was a white woman who received him and gave him cocktails in Len Lye's studio. Fine pots by Murray. Some alleged sculpture by Barbara Skeaping. It must be fun to experiment in this irresponsible way...

Sunday 19
Drew John McDonnell...He thinks his family would prefer the one done last Thursday, so I am giving him the other, the final one, as well, as it seems to me a better drawing...

Monday 20
Miss [Rosemary] Allan's work at the Slade strikes me as very good. Dickey came to see me about another proposed Committee to be set up by the Board to discuss the relations between Art and Industry. He wanted names of useful people. Doesn't want Fry himself. I suggested Ormrod, Holmes (C.J.) and Kenneth Hobson...to the Grimmonds...talked of the great days of the Russian Ballet and the Theatre Movement about 1912-1920: how we lived through it and were rich without realizing how exciting and interesting it really was: though, goodness knows, Birdie and I were excited enough about the first Ballet season the Russians gave in London. I wish I had kept a diary then. It costs one an effort now to remember even the names of some of the dancers whom I drew portraits of.

Tuesday 21
After the Slade, went to the Elizabethan Exhibition in Grosvenor Gardens...Noticed that *A Short History of Costume and Armour* is quoted in the Catalogue. I see in the *Manchester Guardian* that Isabel Dacre is dead. She was blind and deaf and 90 years old. Her going must be a relief to the Dodds. A distinguished woman to meet and converse with, as I did a few years back.

Wednesday 22
Bought Richardson's book on *London Houses*...I have long thought I should like a copy, as I remember it so well from the time that Unwin had it in Great Ormond Street...

Thursday 23
Began to draw Dr. Carter, K.C...Made my first version in an hour and a quarter, at which he was relieved, as he does not like sitting...

Friday 24
Received more cuttings (the second batch) from the *Glasgow Evening News* about C.R. Mackintosh. Glasgow is beginning to take an interest in him as a result of the newspaper propaganda...

Saturday 25
Drew Dr. Carter, the third and last time...He entertained me with *The Cuckoo and the Nightingale* and *Land of Hope and Glory*, on the gramophone...

Sunday 26
…In the evening, Ginger and the Charltons. Birdie and I were much struck by Mrs. Charlton's beautiful expressive face. I should like to do a portrait of her. She becomes quite unselfconscious when listening to music and her face gains in interest…

Monday 27
Very much annoyed about being made Chairman of Board of Examiners in History of Art. Went to see Constable at the Courtauld Institute. He says I am chosen as being the senior appointed teacher on the Board…Another panic for me, I suppose, but I must put up with it.

MARCH

Thursday 2
…Saw Hugh Dent, and arranged to get on with the book on Illustration. I am to have £100 when the MS is completed and another £100 when 525 copies are sold. It will take a long time to do. Talked reminiscently about John with Birdie – how civil he has always been to us, and how rude he can be…It was a pity Birdie did not hold him to his suggestion – an extraordinary one – of exchanging one of his drawings for one of hers. He meant it at the time. He found her working on a little drawing when he came in once to 43A [Cheyne Walk]. But it seemed a shame to take anything from him – so many people did…

Friday 3
Drew Mrs. Railton…Her husband is the designer of Sir Malcolm Campbell's 'Blue Bird' car, the 273 m.p.h. one, and they live at Brooklands. She says that all these stunt aviators and racing motorists are unpleasant people: Seagrave was a liar, Campbell is a liar, Mollison drinks: but she backs up Amy Johnson, and admits that they are all very remarkable in their way. Her husband thinks it silly to want cars like the 'Blue Bird', but designs them because they are wanted…

Saturday 4
Started reading Jan Gordon's book, *A Step-ladder to Painting* in typescript for Faber & Faber…Hagedorn came in…He told us that he, as a German, like a good many other Germans, has a liking for being as English as possible, and has no love for his native land: as a boy he wanted to get away and come to England.

Monday 6
Went to the Law Courts, being called to serve on a special jury…We were told we were not wanted till tomorrow. Went to the Slade. Attended a Committee at U.C. Medical School. I wonder if students like [Henry] Eveleigh and [Edward] Eade will become artists? They might. Both have something in them. O'Keefe, I think is an unstable man. Eveleigh seems devoted to Miss Beazley, the model…

Tuesday 7
King's Bench again: Maxwell Ayrton there, and Leslie Moore, and Norman Evill, half the inhabitants of Church Row. I was dismissed till tomorrow…

Wednesday 8
Slade till 4.30…Bought a bottle of whiskey to entertain W. Davidson of Glasgow, who announced that he is coming to see me about M. Mackintosh's affairs. He came, with his wife, a very deaf lady. They are elderly, in their sixties. They bought Mackintosh's house in Glasgow and took over some of the furniture. Davidson also had a house built by Toshie. He told me of the jealousies in Glasgow about the Art School Building: Keppie (I think the name is) is a Governor of the School and a former partner of Toshie's. He has a theory that the designs for the building should not have been put forward in Toshie's own name, but in the name of the firm (Honeyman, Keppie and Mackintosh) though they were all Toshie's own; more than that, he put them forward at one time in his own name. He is jealous of Toshie's reputation, and therefore not likely to further an exhibition of T.'s work at the Art School, which is what Davidson would like. Mac-Nair, it seems, has come to grief, partly through drink. He has no money, and is in a bad way, having gone down a lot since he left his professorship in Liverpool.

Thursday 9
…Spent the day looking through the Mackintosh's drawings, in company with Mrs. Davidson. Destroyed a large number of worn stencils, tracings…and…early life-studies. Discovered a whole portfolio of Toshie's textile designs, [plates 7 and 8] which I like… Mahoney came to supper…He has a vast admiration for John, and slight suspicions about the single-mindedness of Stanley Spencer; believes Spencer's oddities are thought out – yet considers him an admirable artist. Believes in Henry Moore, but not in the Skeapings. Admires Bawden.

Friday 10
Wasted all day at the Law Courts…Sat and sketched surreptitiously, or went to sleep during the hearing of a long case, which is still unfinished. Patrick Hastings and Beyfus were the two counsel, typical of their unpleasant profession…In the late afternoon wandered round Covent Garden…Made a note of a horse and cart, the sort of thing that might be useful in a street drawing…

Saturday 11
…spent the whole day clearing up the Mackintoshes drawings…in Chelsea Manor Studios. I destroyed many that…were…either so damaged as to be beyond hope, or juvenilia which it was a kindness to tear up. I do not like the work of Margaret and Frances MacNair, though I realize that someone else may…

Sunday 12
Michael Ross, nephew of Sir Denison Ross of the School of Oriental Studies, came with Morris Kestelman to know whether I would act as judge in a proposed undertaking to decorate some Museum in Baghdad with paintings illustrative of Moslem history. Kestelman and Ross are to try their hands if it comes off, and I suggested Mahoney…

Tuesday 14
Slade. Board of Studies in Fine Art…A sign of the times that Moira and Heywood, late of S. Kensington staff, have applied to be put on the panel of assistant examiners for the University. Hard, ungrateful work. Moira would not want it if he was doing well…

Saturday 18
Drew all day…Clause came in…said he thought Cheston second only to Steer as a water-colourist…on thinking it over, I don't think he is far wrong…Yet Cheston can't sell enough to live on…Clause is still practising with the Maroger medium. He says (via G.J. I suppose) that G. Kelly keeps his linseed oil a long time before he uses it. He does not put it in the sun, but lets it go dark; the theory being that it can't go any darker and your painting is keyed up to suit it, thereby avoiding yellowing afterwards.

Monday 20
Richardson's lecture on *The Restoration of Bedfordshire Churches*, at the Hampstead Antiquarian Society…

Thursday 23
Went to a show of Coldstream and Du Plessis at Cooling's. Duplessis is a good artist. Coldstream rather empty, in the London Artists' manner…Met Ernest Jackson, who shared my views on Coldstream and Du Plessis…

Friday 24
…Visited Robin Darwin's show at the Bloomsbury Gallery. He has improved a good deal: some of the stuff is no longer of the very thin, slight kind affected by Coldstream, Devas and others…

Saturday 25
…Supper with the Charltons, 40 New End Square. They have some very pretty things about the house, and the pseudo-Georgian mantelpiece which Charlton has constructed is very well done. His taste runs, as mine does, to the 18th century…

Sunday 26
Hagedorn came to see me, largely to talk about the young man Barnett who is coming to the Slade and is a pupil of Freedman's. His father is rich and has paid F. £50 for a course of lessons, which seem to be very irregularly given. Freedman telephoned me in some agitation, thinking, I believe, that his guinea-pig had been taken away from him: but young Barnett is only coming to the Slade for 3 days a week, so he can still work with Freedman…

Wednesday 29
Mahoney came in in the evening. He has strong likes and dislikes and a personal taste for illustrative art of the 19th century – Bewick, Keene, Cruikshank and the like; contrasts their unaffected, lively work with moderns like Farleigh, Hughes-Stanton and Miller Parker. He believes in the 'subject' in art; did not like some of my drawings which have little or no apparent subject; yet others would say I am too much an illustrator.

Thursday 30
R.I.B.A. Street Frontage Medal Committee…The choice narrowed down to Lutyens's new building in Pall Mall, Unilever House, Moon's Garage in the Bayswater Road, Lilley & Skinner's in Stratford Place, St. Mary's Hospital, Dorchester House (again), Faraday Building, and Yardley House, Bond Street. Shell Mex and others were cut out…

Friday 31
…Tony Ayrton is home again for a brief holiday, bringing a new girl with him from Edinburgh…Charlotte W. has no patience with Tony. She champions Evelyn Dunbar, who apparently gave Tony the push. The Wellingtons are up for the vacation, and are staying in the Carringtons' house in South End Road, a charming little place.

APRIL

Saturday 1
Went to the *Studio* offices about Mackintosh and afterwards to Charing Cross Road…looking at second-hand bookshops…I met [McKnight] Kauffer, who said I had not grown older in appearance. Certainly, I could retaliate that he looked much the same as when I first met him in Chelsea, about 1914, when he and his odd little American wife were driven away from Paris by war conditions and he was painting in the manner of Van Gogh…

Sunday 2
Started to combine my notes on Bewick and did so to the extent of some 500 words… Willy and G.J. are painting Bobby Jones together. I saw the two works in Willy's studio. Neither has made the best of Bobby…

Monday 3
[Herbert] Palliser came in the evening and showed me some good landscape drawings, of trees and ponds and streams, mostly near Clavering, where he has bought a cottage for £350. He talked about his work on the Vintners' building, and the big pediment which he did on the new block in Bloomsbury Square. To do these he took a studio in St. John's Wood at £280 a year…He knew Eric Gill before he began carving figures – Gill was doing only lettering at that time. One day Gill took up a piece of stone and began to carve a figure out of it: Rothenstein, for whom he was doing some other work, saw it and bought it for £20, so Palliser says. Palliser feels the lack of knowledge and early training of the academic kind in Gill's work. He himself is fond of animals and is at present interested in modelling a spider monkey, from observation at the Zoo. He has become an F.R.G.S. in order to get facilities for working there, and studies the skeletons at the Natural History Museum. He has a great admiration for Havard Thomas: says he (H.T.) was consistently chucked out of the Royal Academy for years…

Wednesday 5
Party at Cheston's…[Ronald] Gray talked a good deal about old times. He remembers Chelsea when there were fields about Elm Park Garden…[and] when Trafalgar Square had a gate to keep the traffic out, and Clausen and others lived in houses where the Polytechnic now stands. He also talked of Admiral's House, when the Hammersleys had it and Tonks, Steer, George Moore, Max Beerbohm, John, MacColl and himself – used to foregather there…

Friday 7
…Slade…later dined with Mahoney, Towner, Horton and Rhoades, at their expense, in Charlotte Street…Horton has taken a cottage, cheap, in Dulwich Village, which he shares with Fitton the painter. They are practically in the country: at least in the private estate

of the College with trees and rusticity all round for a long way. Horton is going to take a party of R.C.A. students in the summer to see Stanley Spencer's Chapel. He says that there are twice as many at the R.C.A. as there were when he was a student: sometimes 60 in a life-room. I feel that the Slade cannot compete with this.

Monday 10
...Dined at Durst's invitation at Romano-Santi in Greek Street – all of us, including Alice...Durst was treating us because we sold his *Deer and Young*. He has lent us another carving, a white marble head of a horse. He has written to *The Times* protesting against a silly letter making fun of Gill's sculpture on the B.B.C. building...

Thursday 13
To Hastings with Hagedorn. [Plate 9].

Tuesday 18
Left the Wilberforce Hotel, Hastings, for the Royal Marine, Ventnor.

Sunday 2
Left Ventnor with the Hagedorns.

Tuesday 25
After the Slade, went to a Private View of pictures at the French Gallery, 11 Berkeley Square – Horace Walpole's house...A very good show. Towner's *Admiral's House* looked particularly well, and there was a small head of a boy by Horton, only £12-12-0, which I should have liked to buy if I had the money to spend. It seemed to me just as good as an early Henry Lamb, and rather similar in feeling...

Wednesday 26
Street Frontage Committee, R.I.B.A....Went in cars belonging to Rendel[9] and Davis to see Unilever House, Lloyd's Bank in Lombard Street, Faraday Building, Lilley and Skinner's...Claridges' new wing (proposed by Holden), Moon's Garage in Kensington: also considered, but ruled out, Dorchester Hotel, Curtis Green having had the medal already. Finally, decided on Lloyd's Bank: traditional but good of its kind...

MAY

Monday 1
A visit to Epstein's new show at the Leicester Galleries, after the Slade (where, by the way, Miss Goodyear, following up a discussion with the Provost, explained the official view on girls wearing no stockings, and on Slade students wearing trousers instead of skirts – bare legs are not approved in Academic circles, but no notice will be posted about it, private remonstrance being the milder course recommended. It is the display on the lawns that is objected to, and it is not only Slade girls who are concerned. But it is such a prevalent habit now, the stockingless one, that not much notice can be taken). Oliver Brown told me what a generous supporter of Henry Moore and Matthew Smith Epstein has been – a little contrary to my previous view of him. *The Sun God*, on the

9 Slade Professor of Fine Art, Oxford (1933-36).

rear face of the great slab – *Primitive Gods* – has been cut back about a couple of inches deeper than it was at first (it is an old work of E's), quite recently. Some of the shapes are awkward near to, but one cannot help being impressed by Epstein's vitality, even if it leads him to inconsistencies and bad form (in the aesthetic sense): over dramatization is better, I suppose, than debility. I liked the bronze *Madonna* with the Child between her knees very much. It is more in the line of sculpture, such as 12th century Gothic, which gives me real satisfaction. Other bronzes are fine, too.

Tuesday 2
Exhibition at Cooling's. Claude Rogers and John Dodgson. Rogers the better of the two …

Saturday 6
…started a drawing in St. James's Lane [Dover]. The town was full of miners, who were having a demonstration. One of them criticized my drawing as being done from the wrong point of view. I asked him what he knew about it and he said he had been a pavement artist. He only wanted a tip, really…

Monday 8
Private View, William Michael Rothenstein, at the Brook St. Gallery. He has sold a good number. I met a Mrs. Morse, a neighbour of the Rothensteins in Airlie Gardens, and an old friend of Holman Hunt's, some of whose pictures she has, together with some Blake drawings. She has bought one of Billy's works. She is the mother of Enid Morse to whom we let the top studio in Cheyne Walk, and who set fire to it, which destruction ultimately caused the condemnation of the house, and our removal…

Thursday 11
Small cocktail party at Egan Mew's. Amusing talk from Mew and Gertrude Knobloch… Was astonished at Mew's memory. He told a story which I had told him, practically verbatim – a long history of our visit to Ethel Walker at Cholesbury, when she fell off a cherry tree and broke a rib. Not one ludicrous circumstance did he forget…

Saturday 13
Towner is off on Monday to the Lacock neighbourhood. When he comes back he has a commission to paint a lady with a cello. She says that what she wants is something like John's *[Madame] Suggia*.[10] Met Rutter on the doorstep, and introduced Towner to him; and observed Gracie Fields for the first time in the street – a loud, cheery woman, not good-looking…Dinner at Jack Straw's: Bob Wellington…talked animatedly but depressingly of the prospects of our younger painters – [Raymond] Coxon, [William] Coldstream and others. They are all, according to him, so busy with the business of living, domestic cares, pushing perambulators, or cleaning studios, that they have not enough time to produce sufficient painting for their own developments. Birdie says that artists shouldn't marry artists. If they do, one of them must give it up. Bob excepted Henry Moore. B.W. has no background for his views on art…

Sunday 14
Hagedorn and I met Rutter on the Heath…Rutter has not heard B. Wellington's report

10 Portuguese cello soloist, lived in London from 1914.

that Stanley Spencer has declined to join the R.A....Rutter is full of views on the impotence of provincial gallery curators to do anything good. Stupid committees and snobbish parochial intrigue are rife. They never elected Sir. M. Sadler to the Gallery Committee in Leeds in Rutter's time. Election was sought for social reasons, largely, and aldermen and others would eagerly bring their wives on the platform when Rutter got some Lord or other to open a show; but when Sir. C. Holmes came scarcely anyone would put in an appearance, as Holmes was not a social draw. The Dursts came to supper. We discussed Epstein, negro carving and kindred matters; agreeing in great – very great – admiration of Epstein, but not as a carver. Mrs. Durst doubted whether the *Sun God* was actually carved by E.: it is so unlike other specimens of his hand. She repeated what I have heard before, that the marble in *Genesis* is 'stunned' all over, till it has lost the marble quality and looks like a plaster. She probably was told this by Durst. It is true that it looks like plaster. We all agreed that the *Madonna and Child* and the *Christ* are very fine things. I told them (possibly for the second time) how E. assured me, years ago, in his studio in Cheyne Walk when he was showing the *Oscar Wilde*, that he cut it all himself, but I found later that an Italian workman assisted him...Clement Game and John Fothergill claim to have been among the first to take up E. in England. He arrived here with a parcel of drawings and much self-confidence. Birdie remembers how handsome he was and what an impression his personality made on her in Chelsea. He learnt something about carving from E. Gill. They are not on good terms now.

Monday 15
Stephen Gooden has notice to do the Newfoundland stamps. He writes prompt and business-like letters. Introduced the affair to Olga Lehmann, who should do what these people want very well...

Thursday 18
...Colin Gill told me a lot about Goodhart Rendel, for whom he is working. Rendel, he says, is very nearly a great architect, very nearly a great musician, and an excellent lecturer. They are doing a ballet together now.

Friday 19
Rutter's article on me came out in *The Studio* – very bad editing. 'Cheyne Walk' is described as 'North Sydmonton House' because that address, the address of the man who owns the drawing, was written on the back of the photograph, and the article, written two years ago, is not brought up to date, but speaks of 'this year' meaning 1931. In the same issue is a fairly well illustrated article on C.R. Mackintosh. I always wish I had drawn his portrait as I meant to do...

Monday 22
...Daryl Lindsay and his wife, with an introduction from Basil Burdett in Melbourne, came to supper with us...

Wednesday 24
Slade. Esther Salaman came to supper, an extremely handsome girl now, and very pleasant. She is studying singing.

Friday 26
Hanging Slade students' Exhibition with Tomas Harris. At lunch met Mrs. Brooks who used to live in Margaretta Terrace, Chelsea; her conversation about herself; how she thought she was going to marry Lionel Pearson years ago, and how Nevinson chased her round a room because she wouldn't go to Paris with him. Tintoretto's *Cornaro Family* was duly removed to make room for Elizabeth Brown, Coldstream, Rogers, Robin Darwin, Rosemary Allan, Ann Tooth, Rex Whistler…Makes up a pretty good show.

JUNE

Tuesday 6
Diploma Examination at the Slade – Walter Russell, Pegram, Borenius, Bayes, [Hector] Corfiato, Ormrod. Borenius explained to me mysteriously that he would have to slip away, as he was commanded to Buckingham Palace…

Thursday 8
Opening of Slade Show at Harris's…I think the honours go to Elizabeth Brown. Claude Rogers's paintings look better here than they did at the Cooling Gallery, where by the way, he did not sell a thing…

Saturday 10
…In the evening Cheston came in his car, full of his news…that he and 'Jenny' are not going to get married…but will live in sin together. Evelyn's sisters have been quite uncompromising about the money (about £250 p.a.) which, under the Davy will, he gives up if he gets married…

Thursday 15
Darryl's Private View…the pictures better than I expected. I quite liked some of his water-colours…Walter Bayes and his wife and Mahoney came to supper. Mrs. Bayes behaved herself very well…quite unlike what we have been told to expect from Charlotte Wellington, who said that Mrs. Bayes was so rude to women. Perhaps she was, to Charlotte.

Friday 16
…'At Home', the Provost and Mrs. Mawer, 12 Dawson Place. Parlour games, in this nature of intelligence tests, and a female impersonator on the lines of Ruth Draper. As one of the parlour games depended largely on general knowledge of London, I got a prize for it…

Saturday 17
…Marked Exam. papers for the Courtauld Institute, my co-examiner in this case being Holmes. I rang him up and told him how bad they were. He quite agrees.

Monday 19
…Called on J.G. Mann…at the Courtd Inst.…Compared notes…about Exam. papers. Pleased to hear that *Kelly and Schwabe* is the students' textbook…

Tuesday 20

...Imperial Institute til 6.30. Taxi to Hampstead to dress and fetch Birdie to the Blue Cockatoo, to dine with Flick and go to Philipowski's concert in the Glebe Place Studio. Stuart-Hill looking more wonderful than ever....At Stuart-Hill's our friends, Katie Letch-more (who told me how she sat to E. Gill for the figure, and how he was 'very obscene' on that occasion: she says she ended the sitting by putting on his girdle which had been blessed by the Pope, over her nakedness, and dancing a cakewalk)...

Thursday 22

Lunch at the Athenaeum, as Constable's guest, to meet Cecil Hunt, a very pleasant, good-looking elderly man, who stammers worse than I do, but doesn't appear to mind (perhaps he does really)...Hunt volunteered to put me up for election to the R.W.S. next winter – he said he got his two nominees in last time. Ethelbert White and Charles Knight...Hunt is the Vice President. He explained to me the system of submitting work to the Jury of electors...Hunt says that being an old Society they are inclined to be rather stuffy if people do not submit work...Slade picnic...A good deal of bathing in the Lea... after tea Wilkie and I followed suit in borrowed bathing costumes...Kitty Gordon, Daphne Charlton and Olga Lehmann did the rowing, annoying the local anglers by their heavy going with the oars...The fairground...at Rye House [is] all neglected and rotting, but it still makes a good amusement park...

Saturday 24

A parcel from Albert Rutherston – an old drawing of Birdie which he did about 1909 – not a flattering portrait, but I am very pleased to have it...In the afternoon with Jean Inglis by train to Beaconsfield, to the Heals' – a party, as Toddy Heal put it in her invitation of 'our oldest friends'...Most of the guests were in the Slade set in my time, 1900-1905, and I haven't seen some of them for years. There were present Wilfrid Walter, Dolly (Phil Morris), Keiller, Berta Ruck, Goosie (Mrs. Gillespie) and her husband, Dominy (Mrs. Moody), Noel Rooke and his wife, Alick, Jean Inglis, Jane Hare and Maurice H., Herbert Alexander and his daughter Camilla, Amy Drucker, and a few others. Wilfrid Walter told me that he first taught George Charlton drawing, at a school in Old Street, and was more or less answerable for G.C.'s going to the Slade. Charlton's father presented Walter with a shaving brush of his own manufacture, as a token of his esteem. Walter has written some plays lately. He speaks slightingly of his own drawings (water-colours done in leisure moments). He hasn't come to much, after his promise as an art-student...

Monday 26

At the Slade with Elton and Mrs. Green, about the taking over of secretarial duties...The foundation stone of the new University building was being laid in the afternoon, and most people were in morning dress...Richardson wasn't, nor were any of the Bartlett School: they were not going to the ceremony and were suffering from pique. Though not ill natured about Holden: still, they have the natural feeling that Richardson, Adshead and the University architects have been slighted...5.30 Meeting of Rome School Faculty in Painting...Connie [Constance Mary] Rowe is very religious, and may become a nun.[11] That is the effect that Rome has had on her...Dinner at U.C.L. Sat between [Sir William]

11 She entered the community of the Dominican Nuns of the Perpetual Rosary, also known as the Blue Chapel, in Union City, New Jersey in 1938, known as Sister Mary of Compassion.

Reid Dick and Mrs. Douie. Dick says the King is quite easy to talk to, a 'chatterbox' himself in fact; has a taste for an anecdote…Dick was very reluctant to wear the insignia of the Society of Sculptors, a large gold badge on a chain, with a naked lady in ivory done by Garbe…

Wednesday 28
…party at Sir Augustus Daniel's, 2 Hampstead Hill Gardens…Met Gertler, The Rodney Burns…and others. Lady Daniel said she was sorry Birdie had not come, as she wanted to meet her. They have a mutual old friend in Octavia Davenport. Lady Daniel went, as we did, to see Octavia and Mr. D. when they were in Minehead, and has seen them since in Bath. She spoke of 'Robin' Davenport's new book. Gertler says he has painted over many of his paintings which he does not like, but has kept in store his big picture of the *Merry-go-round*, which represents something to him. He never sold it. 7.45 The Douies dined with me at Romano-Santi's, Greek St., and we went on to the Academy Soirée. Douie told me stories of G.J. in the war…Amusing anecdote of how the Welsh Guards entertained the Scots Guards in a devastated area, where food of any kind was difficult to come by, G.J. was deputed to see to it, and with the help of two Welsh ex-poachers in his regiment, secured two fine hens, which were served up for dinner to the surprise of the Scotsmen. Their surprise was probably greater next morning when it was discovered that two of the hens which had been jealously guarded throughout the war, to provide fresh eggs for the S.G.'s Officers' Mess, were missing…

Thursday 29
Called on C.J. Holmes, at his office…about Exam. papers…Went to the National Gallery to look at the new Rembrandt which Randall Davies[12] has bought for Melbourne: extraordinarily broadly painted and authoritative. Gertler was very enthusiastic about it when I met him yesterday…

JULY

Saturday 1
…Clause, at whose house we dined in the evening…reported, through G.J. (they have been painting Bobby Griffith together) that Kelly (G.F.) gives his sitters a choice of 18 sittings direct from life, or six with the help of a photograph. Almost all choose the latter alternative. Kelly has found that even if they don't their interest wanes after about six sessions and he has had a lot of trouble through that. He takes the photographs himself. Clause has had a picture bought for the Bradford Gallery. They have also bought two of my drawings for the price of one…

Sunday 2
…Cheston criticised some of my drawings. He argued that you should not *draw* the tiles on a roof – you should *suggest* them. He also advised me not to send architectural drawings if I submit some to the R.W.S., but landscape and figure things…

Monday 3
Elton telephoned about buying a typewriter for the Slade. We have never had one yet.

12 Davies was London adviser to the Felton Bequest 1930-34 in consultation with Holmes.

Thursday 6
...Constable still very worried about allegations of unfairness in the Exam. papers...Went on to the Matisse show at Tooth's...many of which I liked...Dined with the Daryl Lindsays...[he] has sold 11 or 12 things...He is going to see Lowinsky's collection of [Charles] Keene drawings and has a lot of them himself. He says it is a lie that C.K. committed suicide – he died of cancer of the stomach. He knew the Hipkins family, who were friends of Keene...

Friday 7
Final meeting of Board of Education Examiners, and the College of Art Representatives, at the Imperial Institute to settle awards. It went off well, without serious disagreement. W.R. is very prejudiced about Anthony Betts' pupils...but Gilbert Spencer won him over to our view...Cooper and Baker at Wimbledon seem to have a remarkably good influence. Their people got a very large proportion of the awards...

Monday 10
By charabanc with the Bartlett School people to Ampthill, via St. Albans and Luton (2 hours). Picked up Richardson at his house...says he has no architectural work coming in, and has all the running expenses of his London offices on his hands...In London by 6.30. Dressed, and went at Ginger's invitation to the first night of the Russian Ballet at the Alhambra. Mrs. Jennings had had Birdie and Alice to dinner at her flat in St. James's Court...They say the Alhambra is to be turned into an Amusement Park. Mrs. Jennings told me about her house in Roland Gardens being turned into one-room 'flatlets', a sign of the times...The Ballet was very good. Could not identify the dancers except Woizekowsky, but Massine danced also, and some ladies, new to me: Baronova (I believe) very charming. Programme – *Les Sylphides* (never again to be quite as good as it was once). *Scuola di Ballo* (Goldoni with Boccherini's music) and *Jeux d'Enfants*, one of the best of the modernist shows I have ever seen...

Friday 14
In the evening, meeting of the Hampstead Heath Protection Society Committee, Hutchinson secretary...

Sunday 17
Went to Chelsea to take away, on approval, some of Jean Orage's rugs, as she has offered me one in exchange for a drawing; found later that the colour does not go with our furniture. Meeting of the Board of Trustees of the Whitechapel Gallery. Campbell Taylor is added to the Board. Sir Andrew Taylor was in the Chair...

Tuesday 18
9.30 left with Towner and Mahoney for Hilly Fields, to see the decorations which are being done at the Brockley L.C.C. School. Evelyn Dunbar was working hard at a lunette of some poultry, dressed in a pair of workmen's blue trousers. I liked her work and Mahoneys. Two big arched spaces in the body of the hall are half-finished. Met the headmaster, dressed in his gown, and the art masters, both pleasant intelligent fellows.

Saturday 22 – Friday 28: no diary entries

AUGUST

Tuesday 1 – Thursday 10: no diary entries

Friday 11
Returned finally to London from Kilton…The Hagedorns left with us, but spent the week-end in Bath. We have all been devoured by fleas.

Friday 18
In the evening went to Eynsford for the week-end, to Saddler's Hall, where Hagedorn was staying…

Tuesday 22
Home again…

Wednesday 30
Started pastel head of Alice, 10-12.30.

Thursday 31
Went on with Alice's head for an hour, but my eyes went green, so I gave it up…

SEPTEMBER

Friday 1
…Finished drawing of Alice…dinner at Scotch House, where we met Jean Inglis (she has got the job of copying Lord Mount Stephen's portrait…) News of Clara Unwin's sudden death.

Saturday 2
At 9 o'clock left with Ayrton in a car borrowed from Adlard Bros. to Adlard's Wharf, Bermondsey, to do some sketching. Ayrton has dealings with the firm and uses their roof tiles a great deal. Mr Pinion, of the firm, and all the staff, treated us very well, letting us use the office for lunch, and assisting us in every way – placing ladders for us to get onto otherwise inaccessible barges…The views up and down the river are very fine… Ayrton and I both selected the up river view. Had some of the firm's sherry, and Ayrton's sandwiches, for lunch. Ayrton had whiskey, as he suffers from rheumatic gout. After lunch we went to sleep on a barge, but woke and did a second drawing with re-doubled energy. It takes time to get used to drawing on a wobbling, bumping barge…Adlard's chauffeur drove us home. Birdie had been to 5 Fitzroy Square to see Nellie Schwabe and Le Bas about Clara. She died in the London Hospital of some affection of the lungs (not T.B.) which the doctors know nothing about…Bob Wellington came to Jack Straw's with us, and home afterwards. He talked very intelligently about Germany and the Nazis.

Tuesday 5
Clara's funeral service at Golders Green Crematorium…

Saturday 9
Willie Clause thinks he is dying of heart disease. He is in bed. This is getting serious for Lucy.

Saturday 16
Park Lane [drawing] in the morning...Dined with the Wellingtons at the Barcelona Restaurant (Spanish)...Epstein was there with a lady who looked like one of his sculptures – probably a model.

Wednesday 20
After attending to some business at the Slade...I went at C.K. Ogden's invitation to his business premises at 54 Frith Street...He introduced me to an American teacher, Miss Shaw, who has invented a new process by which children produce most remarkable designs in colour. The paints are water-paints, mixed to the consistency of thick mud, and worked on wet paper which is of a specially prepared surface. The fingers only are used...She showed me how it was done, and I experimented myself, producing intricate spirals and delicate gradations with great ease. The method would obviously be of value for purposes such as marbled end-papers...

Saturday 23
Went into Hardinge's shop in Heath Street, to inquire about a good carved frame which he has on a Dutch picture, but of course, he won't sell one without the other...

Tuesday 26
First night of *The Man with a Load of Mischief*, at the Westminster Theatre...It was Filmer's production, and he gave us the seats...Met Mahoney and Rhoades, back from the country. There is some talk of Mahoney being engaged to Evelyn Dunbar which seems to me a doubtful adventure.

Friday 29
Interviewed new students at the Slade...A charming young girl, Polunin's daughter, with her hair in plaits, was among them. Claude Rogers called, wanting a job...

OCTOBER

Monday 2
The Slade began. Many people to interview, but possible to do some teaching in the course of the day. Joan Manning-Sanders joined, and Virginia Parsons. Rather more men than usual...Elton came in the evening...He brought a print to show me which had been given him by a painter in Westcliffe near Southend; it was designed and cut on wood by Derwent Wood. It was no. 10 of a series from the book of Job, was done after the war, and struck me (and Elton) as very unusual, imaginative and altogether exceptional in its kind. No one seems to have heard of D.W. doing these wood-cuts. His widow has the small edition that was painted but has not published it...We always liked Derwent Wood, though I have seen him behave abominably to others. He was a pleasant companion at lunch, at the Eight Bells. Gin was the end of him, and sclerosis of the liver.

Tuesday 3
Provost's inaugural address in the Refectory. Announced the retirement of Flinders Petrie and Karl Pearson...I never had anything to do with either, beyond sitting on a Board with Petrie, who went to sleep...His successor Glenville looks young and insignificant by comparison. Was told about Professor Freundlich, a colloidal chemist, whom I saw at lunch, apparently a person of great distinction who has been kicked out of Germany as a Jew by the Nazis...He and several others are working at University College. There is a great meeting this night at the Albert Hall, a demonstration in favour of Einstein. Slade students were invited to attend.

Wednesday 4
Conversation at lunch about the Einstein meeting...Einstein read something in English – very difficult to understand, or to hear...A man came to the Slade, sent over by A.E. Richardson, with 13 Burne-Jones panels on canvas which he wanted to sell. Said he got them in Winchester, and that they came from a chapel, now destroyed. I have no proof that they are by B-J, but am pretty sure of it. I do not like them much. They are so weakly drawn...But when the man said he wanted £4-10-0...I offered him £4, which he accepted. Anyhow it is only about 3/9d each; but what I am going to do with them I don't know.

Friday 6
Hung the Whitechapel Art Gallery...It was the East London Academy exhibition. Ososki, Norman Jones, Weedman, R. Horton and others whom I know were showing. A lot of bad stuff, some of which we (Duddington and I) chucked out...The Whitechapel Gallery...was offered two sculptures by Henry Moore and Maurice Lambert, which they refused, on the grounds that they could not form a permanent collection; but the fact is that Sir Andrew Taylor and others did not like them, and Duddington could perfectly well have placed them in the vestibule.

Monday 9
At Mrs. Lillian Bayliss's invitation, Birdie and I went to a dress rehearsal at Sadler's Wells, of a Russian Opera, *Tsar Saltan* by Rimsky-Korsakov with Polunin's costumes and decorations. The actual painting on both was done by his scene-painting class at the Slade, and the execution is most professional. I was asked in recognition of my having let them use the Slade Life Rooms to paint the scenery in...

Tuesday 10
Judging pictures for the prizes at the Slade, Rosemary Allan's is the best.

Wednesday 11
...first night of *Tsar Saltan*...Met a number of friends...Elsie McNaught, who is now making a living doing fashion-drawing (she was told 'not to draw like an art-student' when she began doing the work)...Polunin went on the stage at the end with the producer, Clive Carey, and the conductor.

Thursday 12
...R.A. Walker's office. He wanted to see me about a scheme for circulating a portrait of C. Dodgson, by his wife, in honour of the 21st birthday of *P.C.Q.* Campbell D. had writ-

ten me a private note about this, as he seemed to think it might hurt my feelings if a second portrait drawing of him were circulated in the same way that my drawing had been…of course I don't mind. F.L. Griggs was in the office. I had not met him before… He said he bought the *Madrigals and Chronicles* of John Clare from Beaumont for the sake of my illustrations. He is going to lecture on etching, chiefly with the object of supporting the claims to attention of etchers like Haden, Frank Short and Robins, whom he thinks are undeservedly looked down upon. He said I ought to join the Arts Club. Manson is joining. As a matter of fact I have now definitely committed myself to standing for the Athenaeum next year…

Monday 16
…Executive Meeting of the N.E.A.C.…Discussed having a retrospective exhibition of the Club, on its 50th Birthday in 1935; also the writing of a history of its 50 years…Neither Holmes nor D.S.M would undertake this…Rutter was suggested…Lowinsky threatens to resign because the only picture he sent has been hung on the top row. He wanted to take it away, but Thornton wouldn't let him…

Tuesday 17
After the Slade, went to a show at Fred Mayor's gallery in Cork Street. Was annoyed to see that Lyons' have cut into the ground floor of an old house in Clifford Street with one of their beastly tea-shops. The show included Picasso, Braque, Kandinsky, Leger, Lurçat, Herbin, Arp (a nonsensical piece of flat decoration and on glass in a frame, with a hole cut in the middle of the surface) Paul Klee…and various English exhibitors including Ben Nicholson, Wadsworth, Hitchens, Paul Nash, Burra, Hepworth and Moore. Most of the pictures were abstract or semi-abstract, and most of them had good colour and decorative quality. Usually I think this sort of painting more suitable for the applied arts. I do not get the excitement which some persons apparently feel when confronted with the ingenious experiments in design that their 'advanced' artists are doing (and have been doing for 20 years past). I liked Braque and thought Ozenfant silly. Adeney, whom I met, was not warmly in favour of the general mass of the work. He excepts Picasso and Braque…but thinks a picture of two nudes by Souverbie (the only piece of representational painting in the place) sentimental and art-schoolish. Herbert Read[13] has had something to do with this show. Paul Nash looked very thin (his work, I mean).

Thursday 19
Drew Sir John Beale…it does not suggest his 'presence'. He is a tall striking-looking man. He is very willing to talk about his work during the war, and his many Directorships – L.M.S. Ry., Guest, Keen and Nettlefold…A self confident, capable man…He is a connection of Mrs. Sargant-Florence's, she being related to the Beale family of whom Mary Beale the painter was one.

Sunday 22
Clause brought young de Saumarez to see me. He wants to come into the Slade. His work is very promising. He has been working at Willesden under Heber Thompson who seems to have had a very good influence on him. He was at Christ's Hospital before that, and is now 18 years old; a member of the Saumarez family that was in the Navy in Nelson's

13 *A Survey of Contemporary Art arranged in conjunction with Art Now* by Herbert Read.

time; which reminds me that Jean Inglis yesterday – Trafalgar Day – began to copy a picture of the battle of Trafalgar which belongs to the Fremantles. The copy is to hang in the ward-room of a new ship which is to have the same name as Fremantle's ship at Trafalgar, and is to be commanded by the present Fremantle. She says the painting is by Sartorius [1759-1828] but I did not think he did sea-pieces.

Monday 23
Went to Bawden's show at the Zwemmer Gallery. I liked his water-colours very much. He sold practically all of them…He does them on non-absorbent lettering paper, the colour in some cases put on rather thick, so that it looks like gouache. I…asked him about this. He says he doesn't use gouache. The catalogue was amusing. Instead of ordinary titles for the pictures there were quotations from Wordsworth, Goldsmith…very aptly chosen, with a sense of the comic. I can only remember one – 'Christ, I have been a many times to church' – for a picture of a village church. Bawden himself struck me as too elaborately artificial and humorous in conversation. Egan Mew came in…He talked about his friend Max B., and Dorothy Brett's strange book about D.H. Lawrence…

Thursday 26
College of Art Staff Dinner, on the occasion of the resignation of Professor William [Godfrey] Newton.[14] Knapp Fisher takes his place…After dinner, the Newtons, Durst, Harding, Palliser and I had a few more drinks…Palliser drove us home – that is Durst, Harding and myself. We called in at Wychcombe Studios on the way. A.K. Lawrence is very exercised in his mind about the question of the R.A. and painting from photographs. He is against the use of photographs, not only in the case of [Reginald Grenville] Eves… I explained Gerald Kelly's way of using them to him. Monnington apparently doesn't object to a reasonable use of them…

Saturday 28
Letter from Gerald Kelly about the Castle Howard Holbein. He wants me to write to *The Times*…I went down to Spink's…but they wouldn't show it to me – said the exhibition was closed…Kelly rang me up in the afternoon. He says the Holbein business is a ramp. Geoffrey Howard, the owner, is very hard up, and wants the nation to buy it. László's letter in *The Times* urging its purchase was inspired. He is very sure that it is a dud, and that László ought to know that it isn't worth buying as a Holbein; but he is a friend of Howard's. Steer went to Spink's this morning, too…[15]

Sunday 29
Letter from Allinson…asking if I would let him have the *Park Lane* drawing at the N.E.A.C. for what he can afford to give for it, if it is not sold for the full price…I have replied yes…I would rather find another home for it than a drawer in my studio…Hagedorn complains of Barnett Freedman's insincerity – how he abuses everyone, but is civil to their faces. He thinks he is living beyond his income, and will spoil himself as an artist if he has to do too much commercial work to make money…

14 Professor of Architecture, R.C.A. (1928-33).

15 Schwabe's book of *Newspaper Cuttings* contains *The Times* articles pertaining to Henry VIII's portrait attributed to Holbein, including Kelly's letter (26.10.33) captioned 'A Portrait Painter's Doubt'. Schwabe is quoted as saying 'As one whose chief interest is in the practice of drawing and painting, I do not recognize in the "Henry VIII" the great qualities I admire in "The Ambassadors"…'.

NOVEMBER

Thursday 2
Wasted most of the day on this Holbein business. Went to Spink's, by appointment, at
10 o'c., and saw both the Castle Howard picture and Lord Bate's version. My impression
was that the Howard picture was not so bad as I had been led to expect, but when I went
to the Nat. Gall. afterwards, with this impression quite fresh in my mind, I could have
no doubt of the enormous superiority of *The Ambassadors* [1533] and *Christina* [*of
Denmark, Duchess of Milan*] [1538]. Even the 'De la Warr' which is not a Holbein, is
better than Spink's picture. Came home and wrote a letter to that effect, which I took
round to Kelly in Gloucester Place in the afternoon. One can always tell his house by the
pink marbling of the painted columns by the door and the yellow and black paint on
the door itself. Kelly took me up to his untidy drawing room and showed me a repro-
duction of the drawing of Henry VIII, which seems to be the basis of the Howard and
Bate and Warwick pictures, and which even [Paul] Ganz[16] disowns as a genuine
Holbein...He is working on three or four portraits in the studio; one...an important
person in the League of Nations. He was very much bothered about the composition of
this last one. I saw the full-sized enlargement of a photograph that was being used as a
basis for this last picture. Kelly pointed out how much he had had to alter from the
photograph to the painting.

Friday 3
...Miss Beale of E. Grinstead, sister of Sir John came to see me, with another sister. On
the whole they approved the beginning of Sir John's drawing. They talked...about the
Slade, where Miss B. was in my time, and slightly before, with Edna Clarke Hall, John,
Orpen, Albert R. and Ernest Thesiger...

Sunday 5
At tea with the Grimmonds met Keith Henderson and his wife. He is having a show at
the Beaux Arts Gallery, for which he is paying...He is doing badly, having sold only five
pictures so far. His last show was a great success. He and his wife spend part of the year
in a little cottage they have on the slopes of Ben Nevis...

Monday 6
Interviewed Rosemary Allan at the Slade about the Frognal School job...I want her to
get this job...Audrey Haig is leaving because she has become such a crank. Her interest
in the 'Oxford Movement'[17] makes her quite impossible. She is in an hysterical state, and
makes the children hysterical. One of them couldn't sleep at night after a lesson from
Audrey, who worries them too much...

Tuesday 7
Changed my day at the Slade to draw Sir John Beale...or rather to go on with the drawing
already begun. Finished it...but asked for another sitting to make sure. I think it suggests

16 Director of the Picture Gallery, Basle (1902-19); Professor Ordinarius at Basle in 1928.
17 Started in 1833 by a group of young men in Oxford led by John Keble. 'It was a revival of faith and
loyalty to the great doctrines of our religion--such doctrines as the Incarnation, the Atonement, Baptism
and the Holy Communion--reinforced by a restored faith in the Church of England as a vital and necessary
part of the Holy Catholic Church.' http://anglicanhistory.org/england/misc/bell_oxford1933.html.

his 'presence' now...5.30 at Tryon's 21 Ampthill Square. Tryon has a beard now, which gives him an Elizabethan appearance. He was wearing Spanish-looking clothes – light fawn-coloured trousers of peculiar cut and a yellow sleeved waistcoat. He talked incessantly and nervously about his pictures and about abstract art, until he put the gramophone on, when he was silent. His voice trembles when he gets excited about aesthetic questions. He does not approve of people doing abstractions on theory, such as Paul Nash, but claims that they are as real to him, and as really visualized, as his work from nature, to which he returns from time to time. He showed me during other things, a number of ink drawings done with an orange stick, of Spanish buildings. These had a certain Piranesi-like grandeur in the conception; he said someone had been reminded of Mantegna by them. I genuinely admired some of them and he gave me one...I think his work has developed a good deal since his collapse. It has advanced in colour and design. He admires Paul Klee, whom Wadsworth has been to see in Dusseldorf; he says that black and white reproductions lose much of Klee's virtue, which is largely colour. Rupert Lee, who came in, says there is a whole wall of 'abstractions' at the London Group and that the Adeneys have both 'gone abstract'. Darsie Japp's old picture of a Spanish woman in a black shawl, which Tryon has, wears very well. He also has a pleasant Duncan Grant. He thinks Fry has diverted Grant from his natural best, and into theoretical.

Thursday 9
Called on Ginner...I saw him at his window as I was coming down Flask Walk...Ginner says Sickert has the bailiffs in again.

Friday 10
Elton tells me that MacColl is reviewing Herbert Read's *Art Now* for the '19th Century'. Going over a few pages of *The Meaning of Art* with W. Grimmond in the evening we found considerable misunderstanding and doubtful information about pictures and schools of painting – not a good foundation for a work of criticism. There is no doubt that Read is helping on a wave of untraditional work. It may be a good thing in the long run, but some of the present manifestations are rather distressing. All the young people seem to swallow his last book eagerly. It is a sign of the way things are going that semi-abstract and distortionist artists are teaching in important schools like the Chelsea Polytechnic – Henry Moore and Williamson, for example. I don't know how they teach, but judging by examples of Chelsea students' work that I have seen there is among them a cult of the slight, the spontaneous and the would-be naïf, and now, I expect, of the pure abstraction, without much solid backing of craftsmanship and study as a preparation. Ben Nicholson says he can do several pictures in a day, and this sort of thing has a fascination for students.

Saturday 11
Dinner with the Wellingtons...up for the week-end from Edinburgh. They had been to the London Group in the afternoon – Private View...Moore has sold three pieces of sculpture to Sir Michael Sadler. Tatlock has left the *Burlington Magazine*...Herbert Read is taking [it] on...

Wednesday 15
After the Slade went with Elton to an excellent show of paintings by Derain at Tooth's. The

man really is a painter, and is not applying a few formulas to everything he does…Met David Jones…there…[he] has been ill, a sort of nervous break-down, and hasn't done much work…There were reminiscences of Corot in some of the Derains. Probably that is why Bob Wellington, who is a bit priggish about modern pictures, doesn't like them…

Thursday 16
…After an interview with Marion Dorn…we went to Bob Wellington's gallery in Litch-field Street to make quite sure we were not doing him out of a commission or out of some kudos with Zwemmer if we get some Dorn rugs…A show of etchings for Ovid etc., by Picasso and Matisse, is going on…

Friday 17
…Miss Margaret Beale came…to look at Sir John's portrait. She approved of the likeness, but was not quite happy about the expression. I altered a passage which was out of tone, and this appeared to reduce what looked like a sneer before…Bought Read's *ART NOW* – 12/6d, nearly bought a Picasso for £5-5-0…I have sold a drawing of *Pont* in Liverpool for £10-10-0.

Saturday 18
Letters in *The Times* about the Holbein – Fry and Herbert Read; got these sent on from U.C.L.. At Marion Dorn's for the second time about carpets for the room downstairs. She says Kauffer now has a photographic studio in Bedford Square, and that he is doing a lot of commercial work in which photography (plus drawings) plays a part, as in the dust-cover of *Art Now*…She and Kauffer have prints by Picasso and Matisse, and she has bought an African carving of a head from Reid & Lefevre (it came from the Guillaume collection) which she is paying for in instalments.

Sunday 19
Tea with the Keith Hendersons…I liked his painting of *Famagusta*…

Monday 20
Took the afternoon to revise Sir John Beale's drawing…Took it down to Cooper's to be photographed…Went to the London Group. They have sold badly so far, Diana Brinton was there, also Maresco Pearce, Ginner, Porter, R.P. Bedford and Teddy Wolfe. I do not like Wolfe's pictures much, but am coming round to some of the 'abstracts' – they are such pleasant colours, for instance one of Ivon Hitchens….

Tuesday 21
Story of Sickert and his taxi-cabs – he was dining with Oliver Brown, and kept a taxi ticking up the shillings all the time. Brown, who is rather careful, asked if it was really necessary? Sickert said – 'If, at my age, I can't afford to keep a taxi waiting, what the devil have you fellows been doing for me all these years?'…

Wednesday 22
After the Slade went to Cheston's Private View of water-colours at Agnew's…as a whole charming and distinguished work. Charlton came with me. Cheston had left the Gallery. Agnew's man said it was a mistake for artists to attend their own Private Views – they

spoiled the chances of selling. Not much was sold. We went upstairs to see the Sickert retrospective show…Huge portrait of Charles Bradlaugh…Charlton liked the Brighton scenes – he knows Brighton well, and has a particular admiration for one of some Piers with fading daylight and electric lamps: the one we reproduced in *Artwork*, from Morton Sands's collection. The man is an admirable painter…

Friday 24
…Jean Orage has given us a handsome specimen of her hand-woven rugs…we have placed it in front of the studio fire. I am to give her a drawing in exchange, in the same way that Allinson is going to swap one of his pots for my *Park Lane* drawing.

Saturday 25
Selected and helped to hang the South London Group show in the Art Gallery, Peckham Road with Medworth, Guy Miller and Russell Reeve. Kelly has sent five pictures…

Sunday 26
Lunch with the Bruno Kohns…Their niece from Nuremberg is with them, kicked out of Germany without a penny by the Nazis. Her brother is interned. Her father has been put in prison for a time…

Thursday 30
In the [V.&A.] Museum met R.P. Bedford, who talked at great length about Henry Moore, whom he considered a good academic artist, not an abstract one, and he agreed with me that H.M. will probably return to normality, like Derain has done. We also discussed Wilenski's book on Ruskin, which R.P.B. says is good. Wilenski told him he had read through all Ruskin's works. If this is so, he must be the only man living who has done so…Looked at the Raphael Cartoons again. I am always impressed by these…

DECEMBER

Saturday 2
…removed my two drawings from the London Group. While there met the Ethelbert Whites on the same errand. They said they had sent out 1000 appeals for the Artists' Benevolent Fund (he being a steward this year). Later met Hagedorn and we took our pictures and ourselves to the Café Royal…Went to a little show that Rhys Griffiths is having at a studio, lent to him, in Pilgrims Lane. Did not like his work, except about two paintings, but bought a drawing for £2-2-0 to help them on. They are always hard up, and Bobby is still working hard as a model and the three children are farmed out somewhere with his parents in Wales…supper at the Durst's…He says the London Group has sold very badly, only £150 in all, while John Cooper alone has sold £200 worth of his paintings in the East London Group, and his wife has sold some more besides. Letter from MacColl in *The Times* yesterday driving the last nail, I hope, in the coffin of the Howard 'Holbein'.

Monday 4
Went with Elton, after the Slade, to Cooling's Gallery and to Vyse's show. I bought a sheet of life-studies by Orpen at Cooling's for £3-3-0, thinking it might go well with

the others we have at the Slade. Elton came home to supper…We talked about [Augustus] John, and his early days in Liverpool. His conduct there was unusual in one holding a university appointment. Mrs. Elton…remembered him coming down the street one evening in riotous mood with a girl, whom he had picked up. [The Hon.] Mrs. [Mary] Chaloner Dowdall,[18] who liked him very much, invited him to her country cottage; at about 2 in the morning there was an alarm, because he had, in the dark, attempted to get into bed with the governess. No harm was done. Mrs. Dowdall was inclined to laugh at the affair…

Tuesday 5
Funeral of George Havard Thomas…Clausen drew me aside afterwards and talked to me of Mrs. Thomas's financial affairs. She had…applied to the Artists' Benevolent Fund, as there was no money in the house a few days before Thomas's death…

Wednesday 6
Dinner, as Grimmond's guest, at the Café Royal; the Double Crown Club. Francis Meynell read a paper on the origins of the Nonesuch Press. He has a charming personality, and read nervously, but amusingly and well…All of us were presented with copies of Donne's *Valedictory Sermon*, printed by the Nonesuch Press, and a little book by John Johnson, the Dent Memorial Lecture.

Thursday 7
Tea with Fairlie Harmar, 101 Cheyne Walk. She says it was part of Lindsay House, being connected by doors now blocked up, and that her studio, the first floor front room, was Whistler's where he painted the *Symphony in White* now in the National Gallery. She points out that the mantelpiece is the same. Her husband, Lord Harberton, was present…an extraordinary looking old man with a grey beard and a nose with a large swelling on the end of it like Ghirlandaio's portrait in the Louvre. He was covered with rugs in his chair and was drinking hot gin and water…He is apparently a writer, or at least has literary tastes, and makes facetiously rude remarks to everyone…

Friday 8
…Hagedorn tells me that Clause has been appointed to a job at the Blackheath Art School.

Saturday 9
Went to Allinson's, 87 Clifton Hill, to take him my drawing of *Park Lane* and to select a piece of pottery in exchange. I took a figure, *Eve*, which looks well in our house but is a little difficult to place…Reflections, after a conversation with Birdie, on the case of Wyndham Tryon – If you have to listen to music before painting a picture, you are translating the art into another – an art which is already complete in itself; and there is something second-hand about it. Surely it is on a level with looking for literary inspiration before you decide what to paint. The composer, too, would probably deny all relation between his work and the pictorial interpretation of it. Still, Tryon is perfectly sincere. Birdie likes him, but thinks him a case of a monstrously selfish person, what I call an egomaniac, who dramatises himself and his conceit; and a weak artist, because

18 Barrister, Lord Mayor of Liverpool (1908-09), friend of Augustus John, subject of one of his most controversial portraits.

he does not rely on his own impressions of nature. I think the egomania, with other circumstances, amounts to madness. She does not.

Sunday 10
Lunch with Lowinsky…He has been painting portraits, and presented me with his book *Modern Nymphs*, of which he has bought up the remainders…He is pining for appreciation of his work, and evidently feels what he calls his 'rebuffs' from the New English & Tonks, very deeply. He is almost spiteful about other artists – Teddy Wolfe and Keith Baynes who are friends of his. He advised Baynes to try portrait painting as a discipline, and says that Baynes was very upset to discover his incompetence in this direction.

Monday 11
Vandyck the photographer called to see me at the Slade, about getting students to work for him at painting portraits from photographs. He produced a photograph of Lord D'Abernon in exactly the same pose and with the same accessories as in John's portrait of him at the Academy a year or two back. He gave me to understand that he had done this for John, and that John had had this photograph enlarged onto his canvas by the magic lantern, and then drawn round as a basis to work on. I explained Vandyck's proposition to young Godfrey who said he would rather starve than take it up. Other students are going to look into this matter. Olga Lehmann among them. It is part time work. V. says he has a staff of 80 people working for him and that he has 300 commissions a year. Whether he meant for paintings or for ordinary photographs I am not clear.

Tuesday 12
After dinner at Noel Rooke's invitation to the Arts & Crafts Society, Queen Square. Papers on the relations of handicraft and machine work, by Farleigh, Rooke, Mason the printer…Frank Pick replied forcibly…I was called on to say something, but declined…

Wednesday 13
Was invited by Corfiato to attend the dinner of the Architecture School in College. Richardson spent most of the time in silence, thinking out points and jokes for his speech, which all came pouring out in fine style…Corfiato also spoke well and easily, and Hanslip Fletcher not so well…

Thursday 14
Very good decorations for the Slade Dance by Polunin's people and others; Rosemary Allan, Olga Lehmann, Eveleigh, and Mrs. Granger-Taylor…

Friday 15
Board of Trustees, Whitechapel Art Gallery. Don't know who half of them are. Aitken was there. Discussed successor to Lord Burnham as Chairman. Lord Lee of Fareham's name was vetoed…Lord Bearsted is to be approached instead. Discussed possibility of a William Morris centenary show…Noticed, almost as an oddity, what used to be commonplace in London streets – the uniformed boys with pans and brushes sweeping up horse-dung in the mists of the traffic; this was in Newgate Street…

Tuesday 19
Bought Christmas presents…Received a horrible Christmas card from Nevinson, painted in colours, representing in an Italian futurist fashion his own head, his wife's (not in the least like her), a cat and various unrelated fragments of things, with the legend 'Nothing to lose not even chains' which is incomprehensible to me. I remember seeing the picture, and disliking it, at the Leicester Galleries. The three-coloured reproduction adds vulgarity to it. I am sorry, but I suppose he likes that kind of thing.

Friday 22
Left Euston for Edinburgh…

Saturday 23
Visited the College of Art. There is an interesting nude there by John, done in his Liverpool time. It doesn't belong to the College but they are trying to avoid giving it up to some crazy lady who owns it…

Monday 25
Birdie went to Church. Went on with drawing in the Grassmarket…Edinburgh is beginning to take more notice of Christmas than it used to…The principal monuments in the town are flood-lit, and there are one or two gorgeously illuminated trams and buses.

Tuesday 26
Went to the National Gallery with Wellington and Bob. Cursitor, the Curator took me round…The Scots are annoyed at Kenneth Clark's depreciation of Raeburn in *The Listener*. 'Vulgarity of Lawrence without his skill'…'Occasionally rise to the height of D.O. Hill's photographs'.[19] Rather too sweeping for a National Gallery expert. One cannot deny Raeburn skill. Clark is equally absurd about Richard Wilson's 'weaknesses', we like Wilson in spite of his weakness, it seems. There are too many critics who do not know what it is to paint a picture…

Wednesday 27
Returned to London…

Friday 29
…Went to Heal's. Exhibition of metal furniture…

19 David Octavius Hill and Robert Adamson, helped pioneer photography, creating a record of Victorian Scotland in 1843-47.

1934

Schwabe's brother Eric, returned from China to England for a short stay after an absence of 13 years, his journey across Europe interrupted by riots in Paris. Alice, his niece, accompanied him on his return in June. Schwabe recalls his studies in Paris as a young art student. He is elected to the Athenaeum but not the R.W.S. The round of exhibitions and Private Views is as numerous as ever, including attending 'Objective Abstractions' at the Zwemmer Gallery. A reflection of the changing social and political climate, he is asked to judge posters for the Anti-Nazi League.

JANUARY

Monday 1
Major Longden has bought the drawing of the Thames from Adlard's Wharf. Ayrton had a hand in this. They chose between me and Claude Muncaster. I asked £15-15-0.

Tuesday 2
Finished drawing of Edinburgh at home. Jean Inglis came in in the evening, in a great dither about the way she is treated at Frognal School – her suggestions (with regard to the appointment of Rosemary Allan, for instance) overridden and herself apparently ignored. I said I would talk to Maxwell Ayrton about it, and rang him up (he is on the School Council)…

Thursday 4
Lunch with A.E. Maude, 100 Leigham Court Road, Streatham. Mrs. Maude was there, very dignified and charming as usual. We reminded each other that it is now about 25 years since our acquaintance began in Paris. It was, I think, at the Cercle International des Arts, a sort of Art School in the Bd. Raspail, run by a M. Bornet. Robert Gregory worked there too. Maude says we met in 1909. I apparently criticized his drawings. This was after I had given up going to Julian's and about the time that Gregory, George Kennedy, Lamb and I used to haunt Gertrude Stein's Saturday evenings. I read her new book in Edinburgh, which deals with those days and mentions Lamb and John. She first heard of John through Gregory, who showed her some photographs of John's work. She was rather contemptuous of them: 'Good stoodent's work' (pronounced in the Bowery style) she said. The Maudes drove me up to London, and I went to Albert Rutherston's Private View at the Leicester Galleries. A very good show…

Saturday 6
…Dinner with the Clauses at New End Square, to meet John Platt, Clause's new Principal at Blackheath, and his wife. I knew Platt when he was studying engraving at the R.C.A., and liked him then. Before that I had seen his drawings in exhibitions such as the N.E.A.C., and they always annoyed me because he used to sign them 'John Platt, A.R.C.A.' He was then teaching at Leicester. He now specializes in coloured wood-cuts, as Morley Fletcher did…His colour prints are better…than Morley Fletcher's.

Sunday 7
… After supper, to the Hagedorns, chiefly because he wanted to show me his new picture of the Bernard Baron settlement[1] in the East End.

Monday 8
Slade began…

Wednesday 10
…Richardson told me he had had to buy the house next to his in Ampthill Street, because a Cinema company wanted the property to build a cinema on. He raised £500 and now owns what he calls a Tudor cottage, which he is willing to let at £50 a year. The 'cottage' seems to be a large enough place, with plenty of rooms and a garage. Met Evelyn Dunbar at the De Vere. She says she still has 40ft. of wall to get on with at the Brockley school – unpainted as yet. She hopes to finish this year. She has lost some of her attractiveness…

Thursday 11
Went to the Imperial Institute to review the work of candidates for the Rome Scholarship in mural painting. Was struck by the work of a youngster of 17 from the Farnham School; also by the work of Brenda Stanley-Creek,[2] who is also described as being at the Farnham School, but I believe she was at the Slade before that. She had a picture in the N.E.A.C. last time. Met Mrs. Sargant-Florence, looking exactly the same as ever, and very sensible in her judgment. She was also making a preliminary inspection of the work, as she is on the Faculty for the first time this year…Bought Albert R.'s *Sixteen Designs for the Theatre* from the Oxford University Press, priced at £4-14-6, remaindered at 7/6d.

Friday 12
At the request of Doctor Grant, of University College Medical School, went to his laboratory to try to mix some standard specimens of human blood in test tubes, using oil and water-colours. Got very near it, but had to give it up. Artists' colours failed in redness or darkness – if red was achieved it was too light, and as a darker tone was approached it lost redness. Lunch with Elton…Franklin White has been having trouble with his eyes. He was hit in the eye by a cricket ball in a match at Shoreham during the summer…

Saturday 13
Met Barger by appointment…at Burlington House [Royal Academy] and went round the pictures till 12.15. It is a muddled show[3] – too many pictures…in places there are three rows one above the other…As I was going out I was greeted by Neville Lewis and his new wife, back from S. Africa…[He] said he was glad I got the Slade job, as he was afraid someone else was going to get it (probably meaning Wheatley)…Has had trouble with his portrait commissions – people dying before he could paint them…Back to Hampstead and then by taxi to Chelsea to have dinner with Alick Schepeler…She has been seeing the Johns – says 'Dodo' has allowed her hair to go white now; and she lent us Romilly's *Seventh Child* to read. Contrasts the manners of the John family favourably

1 Named after Bernard Baron who donated £65,000 for the purchase of the building which was equipped for welfare work and recreation for Jewish boys and girls.
2 In *The NEAC Exhibitors 1886-2001* she is listed as Briada Stanley-Creek and exhibited 1931 and 1932.
3 *Exhibition of British Art c.1000-1860.*

with those of the Macnamara girls…Stories from Alick of the meanness and rudeness of Bruce Ingram [Editor] of *The Illustrated London News*…

Tuesday 16
Busy at the Slade, getting things together for Students' Sketch Club Show at Whitechapel …Prix de Rome Faculty meeting…gave the Prize to one of Jackson's young men from the Byam Shaw School…Clausen told me the chestnut about Munnings, attributing the repartee to Mrs. Swinnerton – 'There are some damned fools who say I can't paint' – 'There are some damned fools who say that you can, Mr. Munnings.' Went to Mrs. Copley's show, Arlington Galleries. She has sold 3 pictures, totalling about £60, which may help to pay some of the expenses of Christopher's operation and illness. Met…Lowry, who was also showing some pictures. Had not met him before. He comes from Manchester, as so many of us do…

Wednesday 17
…Lecture on English Mediaeval Art at U.C., by Borenius, the Finnish Minister in the Chair: he spoke and looked like an Etonian, with hardly a trace of accent – much better than Borenius…

Thursday 18
…Walked past St. Giles's-in-the-Fields, where were some rather tedious strong men, awful looking scoundrels, performing in the gutter. (They stopped the show and stood to attention while a funeral passed). I encouraged them to the tune of 10d., because I wanted to make mental notes for pictorial purposes…to the R.A. show…The porter, who takes in my walking-stick, always greets it as an old friend…Tea at the Kardomah. John Cooper, Underwood and Ivon Hitchens were there and I had tea with them. They had come from Skeaping's Private View – the big wooden horse, etc.. Did not seem very enthusiastic, nor about Alan Durst, whom I mentioned; but Hitchens thought that A.D.'s last figure showed a waking-up, and they all admitted his craftsmanship…

Saturday 20
…Read a little of Romilly John's book: all our old acquaintances are in it:- Cole, Macnamara, John Hope-Johnstone, the Icelander (little humbug), Trelawney Reed, Edie McNeill and so on. (I still have a mental picture of F. Macnamara and Edie spending the afternoon asleep in each other's arms on a sofa in the dining room, during our Christmas visit to Alderney during the War.) I remember hearing about the incident of Cole being kicked down the stairs out of the Mallord Street house at the time, when we were living in Chelsea. Cole used to resent his practical jokes being turned against himself. He was annoyed, when (having locked Ian Strang in a room in his Cheyne Row house, with a girl – Billie Shelley, as far I recollect) Ian broke the door down. I remember hearing about all the stages in Romilly's career from Alick and others: 'Romilly is going to be a poet'; 'Romilly is going to be an engineer': 'Romilly is going to Cambridge': at least he has now written an interesting book, but I believe his wife is the bread-winner…

Monday 22
Charlton and I went to Whitechapel to arrange the Slade pictures. Found they had not allotted us enough room for the pictures we had sent, about 40…Attended a meeting of

professors in the Council Room, at which representations were made about professorial salaries: the flat rate of £1000 a year to start with being held…to be insufficient to attract good men from provincial universities. On account of the expenses of living in London…Am pleased to hear that Jan Gordon is writing for the *Observer*. If he succeeds Konody as a regular thing it will set him up, and he will be a fairly broad-minded and well-informed critic: much better than Konody was.

Tuesday 23
Charlton told me, yesterday, something about his father's business in the neighbourhood of Old Street. It was to do with the preparation of badger fur, and a special process was employed, invented by the grandfather, and which was…almost a monopoly of theirs… the business having collapsed owing to tariffs and foreign competition…

Wednesday 24
Lecture by Pevsner on English Art, in the Great Hall…

Thursday 25
…meeting of the Council of the National Society (I have been put on the Council) at the R.I. Galleries in Piccadilly. Many people I did not know. Nevinson in the chair. I voted against Percy Smith being a member. He sent up a lot of etchings which I don't like much. He is better at lettering. Stafford Leake wanted him. I voted for Evan Walters, who did not get in either. (A mistake – he did, by one vote, and sent in an enormous picture of the Annunciation, apparently based on Jim Mollison, Amy Johnson and El Greco)… We voted Lowry in, and some others…

Friday 26
…Rutter…agrees with me that [Alfred] Stevens [1823-1906] was the best painter of his time in England. He also talked about Gilman, and how, if Gilman had not been steadily rejected by the N.E.A.C., there would never have been a London Group. Gilman was the fighting spirit – the others of the Camden Town Group more apathetic. They used to meet at the Café Royal and Gilman would urge them to action, whether by capturing the N.E.A.C. committee or otherwise…Rutter says he wrote the book on *Thirty Years of British Art*, which appeared under Duveen's name and got £150 for it.

Saturday 27
…Bob Wellington is having a show of a man called [David Francis] Butterfield, a Bradford operative, discovered by Sir Michael Sadler. He does abstract paintings like Braque, without ever having seen Braque; he has hardly even been to London (but I expect he has seen Sadler's collection, and probably, in that way, some pictures by Braque, too)…

Sunday 28
…Clause told me yesterday that Ian Strang has married, or been married by a woman with money, rather older than himself, and that old Mrs.William Strang, of whom I have so many kindly memories from the time when I lived in Howley Place and used to frequent her house, died in Hampstead General Hospital a day or two after the wedding: she had advised Ian's wife not to marry him, because of his drinking habits…

FEBRUARY

Monday 1
...At the Slade was informed by Brooker that young Swiney was posing in a pair of bathing drawers to some of the girls in the stone carving room. Told Elton to go down and stop him...With Iain Macnab, hung the water-colours at the National Society. Was astonished, after meeting Cecil Brown the other day and thinking what a nice unassuming fellow he was, to see his sculpture: one piece is an enormous phallic symbol, about 15ft. high, and another, *Ballerina*, very suggestive (but I rather liked it). Another piece of 'sculpture' is by that girl who does abstract designs – is it Agar? – it is coloured gorily, and covered with bits of imitation lace made of paper. Retired with Kirkland Jamieson, a tall striking looking Scot, and Iain Macnab, to Prince's Brasserie. McNab knows Wm. Davidson of Glasgow well – in fact comes from the same village where C.R. Mackintosh built David-son a country house. Kirkland J. teaches in a training college for secondary school teachers in Shoreditch...Gill has sold his big decoration of *Colonists* that he did when he was at the College of Art with me, in the Mural Decoration Room upstairs, to Johannesburg...

Sunday 4
Grimmond told me of a meeting at the Art Workers' Guild, at which Sturge Moore read a paper on his friend Charles Ricketts. Bernard Shaw contributed his praise for Ricketts as a theatrical designer. C.R., of course, did several jobs with Bernard Shaw...

Monday 5
...Bob Wellington came to supper. Much conversation about Butterfield of Bradford, and Coldstream and Devas, who are having a show after Butterfield, and have been for-mulating artistic creeds for themselves. Their idea seems to be to follow on the discoveries of Turner's later works – a co-ordination of tones and colour without concrete form, quite away from the geometrical or cubist schools of late years. What a muddle men's minds are in: but something will come out of it all, I hope, and be made clear...

Tuesday 6
...Took Charlton to Zwemmer's Gallery. We saw Butterfield's pictures, and I was intro-duced to Butterfield (met Coldstream there, too), a typical fair, broad-faced young Yorkshireman, with pleasant manners and an underlying Yorkshire accent. His pictures have some feeling – a good deal probably, but I am not sensitive myself about that type of picture – an instinct for drawing, as could be seen in one or two little studies, and pretty colour, which most of the abstractionists seem to get. They enjoy messing about with surfaces and textures of paint. Completed an orgy of modernism by visiting Paul Klee's show. Two pictures were sold. One drawing, in particular, struck me as silly, being a deliberate imitation of all the characteristics of a child's drawing. Very pleasant colour, and design which I should appreciate very much in applied art. His researches into texture and quality of surface seem based on a liking for antique objects such as ikons.

Wednesday 7
Postcard, marked urgent, from the National Society – Council meeting this afternoon. Couldn't go. Rang up Bill Adams to tell him so, and to inquire what it is all about. It is Cecil Brown's phallus. He has poured red paint over it, which suggests blood, and calls

it *Christ*. Suggested, on the telephone, that they might ask him to remove it…8.30 another lecture, by Francis Dodd, in Campbell Taylor's studio, to the Hampstead Soc[ty] of Artists, on *Wall-painting*…presented in Dodd's highly personal style of combined emotion and humour, comic, parsonic occasionally, and informal. Everybody liked it…Met…Ernest Blaikley of the Imperial War Museum, who reminded me how I once [as a student] sat him in a basin of water at the Slade. He said he supposed he deserved it…

Friday 9
Saw some musicians [plate 10] who suggested a composition which I started to do… Jean Orage…came to supper…Should like to ask her about her early life with [Alfred Richard] Orage in Leeds, before he came to London and started the *New Age*.[4] She used to send him money…from Leeds, out of her earnings…

Saturday 10
…Wire from Eric[5] arriving Victoria 3.10. Haven't seen him for 13 years. Train one hour late. He had come overland from Venice via Paris. Owing to the rioting in Paris there were no taxis at the stations, but he and four other men got a butcher's cart to convey them to the Gare du Nord for 50 francs…Telephone and telegraphed various message to the Kings – his regiment had not yet sailed. Much chat about the world and things in general. When E. came home in 1921 there were some premonitions of a slump in the East. He went to see old Reiss, one of the partners in Reiss Bros. to discuss this. The old man told him, with tears streaming down his face, that he knew (though nobody would believe him) that it was going to be the greatest slump in history: he was old enough to remember the Franco-Prussian war and its consequences, and, of course, the Boer War: he had read up what happened after 1815: and he knew what was coming. But his partners would take no notice. The firm had been doing very well, and they were proud of themselves. S.J. David saw what was coming, and closed down his East Indian trade completely…He is still a rich man. Reiss's failed for half a million, after about a hundred years' successful and honourable trading…

Thursday 15
Went to Wyndham Tryon's Private View at the Adams Gallery in Pall Mall Place: the abstract paintings. They looked more frigid away from his own studio, and I was disappointed in the colour of most of them…

Friday 16
Appointment with Colin Gill at the Slade. More about his experiences in Paris. He walked there, from Dieppe…with a brother, to join Betty, who has been in Paris some time writing a novel…They went out to see the shooting round about the Place de la Concorde – statues and kiosks uprooted, buses overturned and in flames. They saw twenty corpses carried into a café – more than one would guess from the newspaper reports…There was much looting by blackguards in the wake of the communist demonstrators. Lunch with Eric, a real Indian mulligatawny and curry, with mangoes (tinned) in [Veeraswamy's] Swallow Street. A well-spoken handsome Indian waiter in turban…

4 Orage edited *New Age* 1907-22, died suddenly 1934, buried Hampstead, gravestone carved by Eric Gill, with whom he had had a long association.
5 Schwabe's brother.

Saturday 17
Eric says he is going to call on Goff, late Consul General in Hankow. Everybody in Shang-hai cut him after the evacuation. He did some kindness to Eric and his wife at some time, and Eric does not blame him for what happened, even if he was lacking in dignity and perhaps in courage. He had warned the Foreign Office that what happened would happen, and this a year before it did. Eric has it on his conscience to make a demonstra-tion of not joining in the ostracism...

Tuesday 20
Eric told me how the German ships at Shanghai, August 1914, all scuttled away to Tsing Tao 3 days before war was declared, many of them with English cargoes aboard. Eric was sent up to Tsing Tao in December to try to get Reiss's property back from these ships. He had the greatest difficulty on the way: the Japanese were very pro-German and obstructive, trains ran, if at all, very irregularly, and were unwarmed and all their win-dows smashed – this in the depth of winter. He and some English travelling companions were obliged to stay in a German hotel at some place en route, because the trains ran no further, and there was no other hotel. There were 300 German blue jackets, disguised as Red-Cross personnel, in the place. Elsewhere only a Chinese inn was possible. In the end he never got to Tsing Tao...He wired to the firm to say that nothing could be done, and was recalled. The Japanese dropped their insolence and obstructive tactics as soon as they knew he was returning to Shanghai. A mutiny of Indian troops in Rangoon was engi-neered from Shanghai by a German agent who passed as a Russian. It was stopped by an improvised volunteer corps with machine guns, who surrounded the barracks in the early morning, only half an hour before the mutiny was arranged to break out.

Wednesday 21
Mann came to see me about Courtauld Exam papers. When we had finished these, we got on to common ground about our early interest in the historic costume question being roused by the illustrators of our boyhood – Paul Hardy, Seymour Lucas, Gordon Browne... There are no magazine or story-book illustrators of that kind now, and Mann thought that the modern boy must lose something that we had as food for the historic imagination...

Thursday 22
Lunch at the Whitgift School, Croydon, by invitation of the Headmaster. Potter met me at the station, and Gurney, the Headmaster, showed me round the new buildings. Her-bert Durst[6] was there, acting as assistant (unpaid) to Potter in the art classes...

Monday 26
After the Slade, to 17 Cavendish Square. Conferred with Holmes...about exam papers... He does his drawings in a sketch book, a practice I myself cannot abide for water-colours...He said in confidence that Ganz might have been dishonest over the Holbein, or that he is getting old and losing his perception: that Ganz ruined another Holbein by over-cleaning – all the crisp linear touches, mostly in soft browns, being blurred when had finished with it...

6 Brother of sculptor Alan Durst.

Tuesday 27
...Executive Committee N.E.A.C....Arrears of subscriptions. Alfred Hayward can't pay. Arranged to suspend him, not to get rid of him – so that his arrears won't mount up, and he can automatically rejoin when he has the money. Ginner in arrears, too...

MARCH

Thursday 1
...Committee of the Hampstead Heath Protection Society. Scarlett, of the Bartlett School, has prepared some very dull and inappropriate designs for a block of flats on the site of the School at the top of Heath Street, backing on to the Grove.

Friday 2
Wrote all day, extending my first chapter on Illustration.

Saturday 3
...In the evening Alice...went to the Everyman with Jean Inglis...[she] was full of her reception on the new cruiser *Neptune* at Portsmouth, where she and Joan Fulleylove were treated with naval courtesy and honours on the occasion of her copy of the Sartorius *Battle of Trafalgar* presented by the Fremantles being hung in the ward-room...

Tuesday 6
When Grimmond met Eric the other day, he inquired whether Eric knew Maurice Beck,[7] the photographer, who had been in Shanghai. Eric said he knew him, but was uncommunicative...I thought he had more to say...It appears that Maurice Beck had an affair with the wife of ...Eric's taipan when he was with Reiss Brothers...

Wednesday 7
Went to a Margaret Morris demonstration at St. Barnabas Hall, Pimlico, with Eric, Birdie, Towner, Ruth and Hugh: Alice was in it, and came out very well. The exercises and movements always look well, the dancing and inventive work is less interesting...

Thursday 8
B.M. Reading-Room. A.M. Hind[8] saw me there, and came up to tell me that I had been elected to the Athenaeum, also to say that he would like to ask me to give some drawings to the Print Room. Am rather worried about the expense of the Athenaeum...£15-15-0 a year and 30 gns. entrance, on what is a doubtful advantage...

Friday 9
Took my work down to the R.W.S. Galleries for the election...I had also been to the Leicester Galleries, to see Gilbert Spencer's pictures, which are largely good ones, especially some landscapes. He has a freshness of impression which makes me rather envious...The Seven & Five show was going on at the same time in another room. Ben Nicholson's *Two Circles*, cut out in wood, painted a uniform whitey-grey and stuck in a frame, will probably get him some attention from the Press. He is now imitating Paul

7 Chief photographer British *Vogue* with Helen MacGregor.
8 Keeper, Department of Prints (1933-45).

Klee and Arp, and John Piper still sticks to the old-fashioned trick of gumming newspaper on his canvases. I remember that being done about 20 years ago. I liked Ivon Hitchens, Winifred Nicholson, and (not so much) Frances Hodgkins. Colour and quality and decorative value are their assets...

Sunday 11
Walked to the Bull & Bush. Eric remarked again on the change in such places since he left England first. Women never went to them then, now they do, and cultivated women too...I met Alan Sims and asked him in...He talked learnedly about the Hemel Hempstead country, which Eric and I know so well. We told him how the High Bailiff of that town, when we were boys, was dissatisfied with his title (also a unique one) and petitioned to be made a Mayor, which was done...

Monday 12
...Eric told me the other day that our grandfather Anthony Ermen was very much respected as an employer in Patricroft. When Eric was in Manchester for a time before going out to China, about 1908, he found that the old gentleman's photograph was still piously preserved in many of the mill-workers' cottages, and his memory kept alive: he died in the 1880s.

Tuesday 13
Removed my works from the R.W.S. Galleries...I was not elected – they chose Albert Rutherston and Ronald Gray...Holmes, whom I met later on at the Courtauld Institute, after a Board of Examiners, told me that some of the older members...did not like my figure composition...thought it was not academic enough...The subject was a ballet rehearsal at Drury Lane. It would be too academic for the London Group...

Sunday 18
The Kohns came to tea. Bruno is just back from Germany. He had no trouble with the Nazis himself, but relates that when an aunt of his died – the chatelaine of Pretzfeld – and a kindly obituary was published in a Nuremberg paper, other papers lavished filthy abuse on the lady and the author of the notice. Apparently, it is improper to say a good word of a Jewess. Nevertheless, the newspaper justified itself in a second article, and pleaded for fair play...

Tuesday 20
After judging some posters for the Anti-Nazi League, Old Cavendish Street, with Jowett and W. Rothenstein, had tea with Jowett in Oxford Street...Jowett was very communicative about his own early training at the R.C.A., after he left Leeds with a scholarship. He wishes he could have gone to the Slade: says it would have saved him ten years floundering in art. He was taught to do large imperial sheet drawings in charcoal, and never drew with the point till after he had seen John's and Orpen's drawings at the Chenil Gallery, and had studied old masters at the British Museum. When he put his new discoveries into practice in the life-class he was looked upon as a revolutionary, and was called up before Augustus Spencer to explain why he disobeyed Mr. Hayward, the teacher of alleged drawing (and Spencer's brother-in-law). But Jowett was obstinate, and won his point in the end; and other students followed his example. It is to Hayward's credit

that he got up a little show of such drawings by Jowett, before Jowett left the College; and Jowett got his first press notice for it. Poor Hayward was hopelessly incompetent as a draughtsman himself. No one had ever seen him try to draw. He merely fussed about, kept discipline, and taught anatomy. One of Augustus Spencer's favourite remarks was – 'We don't want any clever fellows here.' Such 'clever fellows' as he had under him got very dispirited for lack of proper direction. Jowett is very fond of old Alston, though. He was always on the side of decent work, though he had not much influence. Moira, who was at loggerheads with Spencer, was popular with the students: he was young, energetic and friendly, but, looking back, Jowett doesn't think he taught them much. He wishes he had known enough about Lethaby at the time to go and work under him. He insists on the measure of good work that the Central School has done in the last quarter of a century, particularly for trades like goldsmithing and book production...Jowett also objects to Lutyens's behaviour. They are serving together on a Committee for next year's Burlington House show. Lutyens never listens to anything, but scribbles in a sketch book the whole time, and passes it over from time to time, with – 'There, what do you think of that?' Some of the drawings are architectural, some obscene...

Wednesday 21
Saw the show of Ruskin School students' work at the Warren Gallery in Maddox Street... I liked the work of a young man called [Kenneth] Rowntree, whom I talked to. He is a connection of the Rowntree girl whom we gave a prize to at the Slade.

Friday 23
...Meeting of the Worshipful Company of Craftsmen at Richardson & Gills, in Russell Square. It cost me a pound, which was demanded of the 'Foundation Committee' to cover expenses...Slade Dinner. Richardson spoke, and Albert and Walter Bayes (my guests). I got through, after less than my usual doubts whether I ever should...

Saturday 24
Letters at the Slade, and drew a model who was doing nothing. Made my first appearance at the Athenaeum, as a member: with Albert R....he showed me over the place, explaining the customs of it. Met A.M. Hind and Daniel. Albert and I went to the R.W.S. together, and afterwards to Gilbert Spencer's show. Was again very much struck by one or two of the landscapes, but unfavourably impressed by the large figure composition of some people carrying fruit and flowers down a village street – a harvest festival...

Monday 26
Wrote a report for Routledge's on [Adolfo] Best Maugard's book *A Method for Creative Design*...From Meatyard in Museum Street I bought what he had left of my own early etchings. *S. Nicholas du Chardonnet* and *The Conciergerie*. I paid 10/- each for them, preferring to do so than to see them advertised in his catalogue for 12/6. Birdie, Alice and I went to the Charlton's 8.30-11.30. The Grimmonds were there too. Grimmond told me about the new show of Abstractionists at Zwemmer's: Coldstream, Ceri Richards...[he] has a large repulsive nude of his wife, done when she was going to have a baby, and emphasizing her condition, besides being distorted a good deal. She seems to like sitting for the figure. When the baby was born they wanted some photographs of it, and got a photographer in, a friend of theirs. She held the baby, in a pose which

he liked. 'That will do,' he said. 'Now take off all your clothes and we will photograph you'. Which was done. I remember her as a student of the R.C.A. of Blakean tendencies.

Tuesday 27
Slade letters and others…One from Eric enclosing £50 towards Alice's outfit for her China trip…

Friday 30
Left for Dover.

APRIL

Wednesday 4
Finished the work on the Harbour Board offices, as far as I could in the street. Fifth day of it.

Monday 9
Slade began again.

Friday 13
Went to Lewis's about mounts for my Dover drawings, and met H.C. Game on his doorstep. Game is still in the Censor's office…Drew the gateway of Bart's Hospital for four hours…

Saturday 14
Smithfield again. Little Britain is the headquarters of a body of Greenshirts, who came forth, very martial, with drums, and paraded about in the afternoon. Most passers-by smiled: one asked a Greenshirt the way to St. Bartholomew's, which upset the Green-shirt's military demeanour. Bob gave a carefully reasoned explanation of what he considers to be the motives of the painters of 'Objective Abstractions'. [Rodrigo] Moyni-han, [Geoffrey] Tibble, Ceri Richards and the others. Considering how we disagree on matters of art we get on very well. I know he has no interest whatsoever in what I do, and I think much of the stuff he puts up is futile. I admit to some suppressed irritation at times, but I think he is doing very well at the Zwemmer Gallery, and doing what ought to be done for the younger artists…

Sunday 15
…Eric Gill has been staying with the Wellingtons in Edinburgh. He was lecturing to the College. He wore a robe, cut Magyar-fashion…He is…doing some work for buildings in Palestine.

Thursday 19
Jury at Bloomsbury County Court. All Church Row seemed to be called up – Maxwell Ayrton, Shepherd the builder, Frank Rutter and Leslie Moore (but he got off on some pretext). Rutter was talking about Fry's book on the English School, how he runs down Reynolds and compares Hogarth unfavourably with Jan Steen [c.1625-79] as a composer. He says it is true that Monet had a great admiration for the later Turners, and that he

used to have a large framed photograph of Hogarth's *Shrimp Girl* [c.1740-5] in his stu-
dio…Further points from Rutter's conversation: he said that he has seen Sickert recently
at his house in N. London and it is quite true about all his creditors coming down on
him, and his having the brokers in. I said perhaps he didn't mind much, that it was in
the Whistler Bohemian tradition he has always lived up to, but Rutter was not so sure…
said he was rather pathetic about 'keeping a roof over his head.'…All his pictures are
more or less in pawn…and the show at Agnew's did him no good…though it brought
him credit as a painter most of the work was borrowed for the show. About Orpen, too:
the reason he could not go to court for a long time after he was knighted, so that there
was some trouble with the Lord Chamberlain, was that he was terrified of such things:
he could never be got to make a speech either…

Friday 20
Committee Meeting, R.C.A., about Mural Painting Workshops. Rothenstein in the chair:
Dickey, Russell, Constable, Jowett, Dowling, Athole Hay. Something may be done, per-
haps, if the Board of Works or somebody will lend a building…and if some endorsement
can be procured…Dickey says that after his tour of the Continental schools he finds no
teaching of traditional academic drawing to compare with the Slade and the other English
schools where the Slade influence has spread.

Monday 23
…Hampstead Antiquarian Society Lecture. I went because Sir Andrew Taylor sent me a
postcard asking me to go. He wanted as large an audience as possible for Reynolds
Stephens. I was introduced to him (R.S.) and to F.O. Salisbury – queer company. R.S.
seemed a pleasant old boy with a hearty contempt for modern sculpture. His paper, or
what I heard of it when I was not in a doze, was not very brilliant…

Tuesday 24
My fourteen Burne-Jones panels are all framed and glazed now by Trollope at the Slade…
Nobody likes them much…

Thursday 26
…In Leicester Square…I was hailed by Francis Dodd, on his way to the varnishing of
the Royal Academy. We went together to a small show of old Johns and Steers at the
little gallery in Pall Mall Place…most…very good…Dodd has been doing some portrait
drawings. He says he takes three mornings over such things: prepares the drawing, from
a constructional point of view, but vague as to definition of features…in the first sitting,
and traces the placing of everything on to a fresh piece of paper for the second day…Ian
Strang called…I had not seen him for a long time…Tells me that Rowley Smart is dead.

Saturday 28
Francis Dodd came to tea. He was annoyed about Dod Procter's election. Munnings seems
to have an influence in these affairs. George Belcher is a disappointment to those who
elected him. Sickert wanted the Academy to be officially represented on the occasion of
his being made an LL.D of Manchester University, and offered to take the representatives
down in a specially reserved saloon carriage. Of course, Llewellyn declined. Sickert had
the saloon all the same, for his wife and friends. …Dodd…described the miserable end

of Isabel Dacre, who didn't die of cancer (which she had) but of pneumonia after influenza. The Dodds were paying £6-6-0 a week, for the nursing home for a long time...

Sunday 29
...Rutter called...Faber and Faber's will do the book if the N.E.A.C. will guarantee 750 copies at a guinea each, which is of course absurd. Rutter approves of Jan Gordon, but did not like Konody. He said in the old days the band of art critics was much more friendly – MacColl, Claude Phillips, Lewis Hind...

Monday 30
After the Slade went to Zwemmer's Gallery and bought a wood-cut of John Farleigh's, from the *Black Girl* for 1½ gns. Some of his water-colours are good...

MAY

Tuesday 1
First of Doctor Pevsner's lectures on the Venetian School, U.C.L....

Thursday 3
Went out with Eric in the morning. Chinese visa business. An office in the basement of a house in Portland Place...Looked at the B.B.C. building, and bought some photographs of it, as Eric thought they might be a good thing to show to the architect in Hong Kong, who is going to build an office block for the David firm...

Friday 4
Took a bus with Eric to revisit the scenes of our youth at Hemel Hempstead; singularly unchanged, although there are miles of new buildings between London and King's Langley...In many cases the same names are still over the same shops. Talked about our worthy schoolmaster, old Dowling, and what we owed to him...Dressed and went to Kettner's for the London dinner of the Manchester Academy of Fine Arts... Chettle the president spoke...

Saturday 5
...Academy Private View...Much discussion about Stanley Spencer's pictures – artists may like them, but not many other people do. Lutyens's big model for Liverpool Cathedral is there. The architects are mostly enthusiastic...at least Richardson and Guy Dawber (to whom Richardson introduced me) were, though Adrian Waterlow thought it wanted a good deal of modification. Richardson calls it 'plastic', which, he says is what good architecture ought to be. Some people don't like the shape of the dome, and assume that he will purify away all sorts of mistakes in working it out, but the general reception is that given to something quite exceptional. Richardson has a pretty model of his Jockey Club building there, which I intend to make a drawing of. He wants me to do one in the Rowlandson style, with crowds of appropriate figures, himself and the King included; he is very full of having taken the King round the building the other day, and having made him laugh, with some jokes that I have forgotten...Coming away from the Arts Club...I saw Professor Brown, very bent and aged now, negotiating the escalator at Green Park Station...He says he is 'as well as he can expect to be': had been having tea with

Clause after going round the Academy: and thinks Stanley Spencer must be mad. Connard, who was partly responsible for getting him (S.S.) in to the R.A., has doubts of his consistency and sincerity now: says the reason he (S.S.) didn't send last year was that he thought he would get more réclame from a one-man show...Monnington's portrait of Baldwin drawn with the greatest care and skill, a remarkable piece of craftsmanship, but I did not like the colour of the head, and it seems to lack life...

Thursday 10
Went to Witham [Essex] and drew the Spread Eagle as a frontispiece for A.E. Richardson's book on *English Inns*. I believe he wanted me to do the White Hart, but it has been restored and has lost its character...

Saturday 12
Ayrton called...and proposed, as it was a fine day, that we should go out together and draw something. We went to Bankside, and he did three sketches while I painfully did one drawing of Cannon Street Station across the river...

Monday 14
...Eric, Alice and I went to the Everyman film – *Le Loup-Garou*...Epstein appeared on the News Film, and made a little speech about exaggeration and emphasis in art, in front of his bust of Ramsay MacDonald...

Tuesday 15
Batsford and Fry appeared in the Common Room with Richardson after lunch at U.C.. They approved of the drawing of the Spread Eagle...but want it coloured. ...Settled about the Slade Scholarships for the year...The new ones are [William Ian] Brinkworth, Jeremy, [Mary] Fedden, [Margaret] Shaw and [Karin] Lowenadler...

Wednesday 16
...Slade...Ithell Colquhoun called. Colquhoun is now 'done up' in the fashionable manner, no longer the typical art student. She has a studio in Hammersmith. She, like so many others, wants advice on how to make some money by art.

Friday 18
Lunch with the Douies, in Gordon Place. Richardson was the other guest. Conversation about Adrian Stokes and his recent rudeness to Ramsay MacDonald led to Richardson's story of Leonard Stokes, with whom Richardson worked as a young man. L.S. was a Catholic, and an ill-tempered man. One day, after he had been cursing and swearing at his entire office staff, a large piece of plaster fell from the ceiling, narrowly missing his head: he crossed himself, retired to his inner room to pray, and handed out £3 apiece to the members of the staff...

Saturday 26
8.30 at the Bartlett School, for the Architectural students' tour of Beds. and N'hants.... Met Richardson at Luton (he was expecting the Queen at Ampthill next Monday, but had a message that she was indisposed: Mrs. Richardson polished the floors in vain, and a Beechey picture of George III will go back to the shop it came from in London): also

the Cambridge contingent under Geoffrey Webb, in a beard and plus-fours: among them was Heal's son…

Monday 28
Board's Exams: 500 candidates in the drawing section: that means 2500 drawings to be carefully marked…

JUNE

Friday 1
Professors' Dining Club: Ambrose Heal, Solomon, Prof. Neale, Norman and others my immediate neighbours. Neale's book on Queen Elizabeth is apparently selling very well. Rosemary Allan is going to do two panels for his house in Lyndhurst Road, which Corfiato has been working on…The rest of the family had been to the Everyman cinema, and brought the Charltons back with them, who had been there too. Eric cannot see that Mrs. Charlton is a beauty. I tried to explain that she had all the elements of the Peter Lely[9] type: he admitted she was attractive, but I suppose it is another case of the artist admiring types which are not generally recognised as beautiful.

Sunday 3
Went over the street to look at Tony Ayrton's work which he has collected for his A.R.C.A. Diploma test. He has improved a good deal under Wellington at Edinburgh. … to the Kohns, who had a tennis party…Kohn's brother was there, too, from Germany: very bitter about the Nazis…

Tuesday 5
…Jean [Inglis] talked about a model whom I know, and a bullying she got from Willie Clause, which so upset her that she came for consolation to Jean and stayed till 2 in the morning. She has been sitting to Oliver Lodge, Jr., in the country: while there, she saw a naked lady dancing about in the garden, who was Mrs. Oliver Lodge, and who came in and sat down naked to lunch…Mrs. Lodge usually goes about naked…She receives the tradesmen in that condition: they are assiduous in calling. Lodge himself is a bit of a nudist, but he was ill at the time.

Thursday 7
Board's Exams. My opinion of Anthony Betts, who is said to put such 'kick' into his students…is that it is a kick up the backside, which sends them vertically but not forward.

Friday 8
…Talk with the Provost about Meldrum's appointment to the staff of the sculpture school. He is to have £125 a year for two days' attendance…He is worried about how he is to make a living, as his capital is running low…

Saturday 9
Departure of Eric and Alice for China. They left by the 11 o'clock train from Victoria, and will be in Paris about 24 hours. They hope to have two days in Venice, and then by

9 Portrait painter (1618-80), particularly at the Court of Charles II.

Lloyd-Triestino to Hong Kong and Shanghai. Their going makes a great gap: but what a pleasure it should be for a young person…Alick Schepeler came to dine with us at Jack Straw's. There is a report that Wadsworth has killed a man while driving his Rolls-Royce home from a cocktail party. He is sure to be accused of being drunk, and may get a heavy sentence. It is a dreadful position to be in. The Wadsworths are enthusiastic about everything German now: the daughter, a nice intelligent girl, for whom the Wadsworth money is held in trust, is married to a Bethmann-Hollweg.

Sunday 10
…An anti-Fascist demonstration was going on about 10 o'clock in Hampstead – some shouting, but no breach of the peace. We went up to the White Stone Pond to see what happened, but the men were dispersing by then, and the police moving them quietly on. One man shouting for his 'comrades' of the Hampstead I.L.P. was shut up by a constable's hand on his shoulder.

Monday 11
Ormrod has had three months' notice from Clark, Coats & Co., who are closing down the London design studio…Merely a change of policy on the part of the directors – they are satisfied with his work. He loses…£800 a year, and has only his Slade job left till he works up his free-lance designing connections again. He is putting in for the Westminster School of Art – I'm sure he won't get it with Albert R. as a competitor…The Home Secretary has turned down Jean Inglis as a copyist of the portrait of Peel for the Police College. He thought her price too high. He won't get it as well done as she would do it if he won't pay a proper fee…Postcards from Alice in Paris. She went to the Café du Dome…I was also in that Arcadia – about 30 years ago.

Tuesday 12
Arranging the year's show of drawings, with Charlton…at the Slade. A very slight falling off…A.W. Lloyd of *Punch* came to show me the painted wooden caricatures he is doing, for a show at Cooling's in the autumn. He is employing [Olga] Lehmann as an assistant. She gets 3/- for laying in the colour on each figure. He does the heads.

Wednesday 13
…A.M. Hind came to look over the Slade, before attending the Slade Committee. He says that David Strang is now in a difficulty, having the house in Hamilton Terrace on his hands, and no work to do, as nobody is selling any etchings and consequently there is no demand for printing. D.S. thinks of lecturing…

Thursday 14
Slade…Dined at the Club…I shall begin to habituate myself to the Athenaeum, I expect. The hall porter is very friendly…Postcards from Alice, from Venice…takes me back to my stay…with Unwin…about 1908…

Saturday 16
Went to Ampthill to draw the shop that has been taken by Hawkins of the *Bedford Times* for his printing press…[later] went to see the Dursts…Adjoining Wychcombe Studios

is the house of Mr. and Mrs. [P.C.] Samuels,[10] who have something to do with a film company...Durst had told me about the swimming pool and rose garden at the back of the Samuel's house, constructed in the fine Hollywood style in a fortnight on a piece of waste ground, with flowers in bloom and sun-bathing shed all complete: and about the cinema beauties who bathe there....

Tuesday 19
Betty Gill is dead – suddenly, at the age of 32, after an operation supposed to be slight. I am sorry for Colin, and told him so on the telephone. When she was Codrington's wife, and Rothenstein painted her, she had great beauty.

Wednesday 20
Having occasion to ring up Gerald Kelly, he tells me that the response to the appeal for Sickert has been most generous, and that he will be got out of his difficulties...Met Augustus Daniel in the Tube. He says Tonks and MacColl are both painting at Christchurch (Hants) now, but three miles apart, for their mutual convenience. Not that they are quarrelling, but they work better separate.

Thursday 21
Board's Exams. Gill came. The funeral was yesterday. Worked too late to be able to get off for the Slade Picnic...at Rye House...

Friday 22
Prize-giving at the Slade. [Peter] McIntyre the leading figure, with [Henry Rowland] Eveleigh, Rosemary Allan and others. Strawberry tea, indoors, on account of the state of the lawns, which have suffered from the drought: the first time indoors for years...

Sunday 24
...Clough Williams Ellis is the architect of three houses which are now building on the garden of Norman Shaw's house; we can see the operations from the bathroom window...The owner of the Norman Shaw house wanted to pull it down...but he was prevented...on account of a sentiment that Shaw's own house, built for himself, should be preserved as a monument.[11]

Monday 25
...Tooth's to see the Vuillard show...almost all with a beautiful colour sense and painter-like quality. Some have no recession, which must be intentional, as he can get it admirably when he likes...Met F.H. Shepherd in Bond Street. He likes Vuillard too, as does Holmes, who says V. is the man who learnt most of all from Degas...Holmes disapproves of the influence 'Bloomsbury' has had on art and literature, and thinks Duncan Grant has been damaged as a painter by Roger Fry...

Tuesday 26
Hagedorn says he never had any real instruction in art when he was a young man. There was a Frenchman called Valette who taught at the Manchester Art School, and who said

10 Samuels was Studio Manager, Lime Grove of The Gaumont-British Picture Corporation Ltd.
11 Number 6 Ellerdale Road (now the Institute of St. Marcellina) built by Shaw (1874-76).

H. did not need instruction. It was through him that Hagedorn went to Paris, about 1912-13. Maurice Denis was teaching at La Palette somewhere off the Rue Notre Dame des Champs (…I remember going there, to a party, where Euphemia Lamb was, and a horrid American man dressed as a woman, who had to shave his back to wear a woman's evening dress). Hagedorn worked under Denis for only a month. Denis was one of those teachers who make everyone work alike. Hagedorn did not get on with him, and besides, being hard up, he wanted to save the money he spent on fees, so he left…

Wednesday 27
A message from Sloley of the U.C.H. Medical School, about a brass tablet for the Buckston Browne room…Designed the lettering in the afternoon, and sent in a bill for 10/6d…I would have given it to a student…but there wasn't one at hand. Anyhow, as the room is of a Queen Anne type, my more or less 17th century lettering probably suits the place better than a more modern sort…

Thursday 28
…Met Willie Clause on a bus…went on to Reid and Lefevre: exhibition – Renoir, Cézanne and their Contemporaries. Some excellent things. The early Degas, a portrait of his brother, extremely interesting…I agree with Towner in liking the Pissarro *Dulwich College* [1871] and the Monet *Deux Pêcheurs* [1882]. The latter emphasizes my point about M. being such an excellent painter when he had not got the Impressionist bee in his bonnet…

Friday 29
Courtauld Institute to see Constable and Mann and agree our marks to Exam. papers. No great difficulty.

Saturday 30
9.25 train to Ampthill. Met Benslyn the architect, at St. Pancras. Had not seen him for years. He was going to Bedford, where he is building a new theatre. Do all architects talk as much as he and Richardson? Ayrton, too, has a propensity of the kind. …Mrs. Richardson and her daughter saw me drawing in Ampthill street and invited me to lunch. Had a good look at the Rowlandsons while waiting in the house; and heard a lot about the Queen's visit, when the two ladies came in. Forty policemen in white gloves appeared suddenly in Ampthill on that memorable day…

JULY

Sunday 1
Drew Dr. Parkinson in the morning…

Monday 2
Mrs. Parkinson and her husband called…and took away the drawing…to consider it… He criticized the 'dreamy' look, but said he hadn't expected it to be as like as it was. Comparison with a photograph gave me, at any rate, some support…

Wednesday 4
…2nd day's outing with Hagedorn to Waltham…Drew the Abbey Farm…Party at Lady Witts in the evening…Must have been more than 200…Lady Rothenstein told me how she met an elderly man bathing, with two naked children, at Portmeirion in Wales. He recalled himself to her memory as Bertrand Russell. Presently he said to the children 'Come along and dress now, it's time for lunch.' There followed a prolonged struggle with buttons and braces and safety-pins: the buttons being off the sleeves of their shirts, safety-pins were being used instead. Alice R. remembering all about the Russell system of modern education, thought this was very funny and silly. She read Russell a lecture, and said she could take him to a shop where really simple practical clothes for children could be obtained – sleeveless vests and the minimum of fastenings. So much for her opinion of our reformers. She dislikes Badley at Bedales, and said John R. learnt little there.

Friday 6
…John Rodker called at Church Row, at 4 o'clock, about Frieda Bloch's affairs. He wants to raise more money for her support, so that she shall have a regular quarterly income, and be free from some of her worries about money. She only made £40 last year by her typing, but her brother helped her out…

Saturday 7
Cable from Alice and Uncle Bill: arrived in Shanghai…Dinner with the Whitworths in Ormonde Gate…Geoffrey W. arrived back from Oxford, where he had been doing an extension lecture. Talked about H.G. Wells's new mistress, aged 50. Phyllis W. doesn't see why he shouldn't have as many mistresses as he likes, which, I thought, was encouraging for Sancha (aged 19). G.W. is being painted by Roger Fry. Phyllis says Fry has made him look like a City Jew, coarse and heavy, but with hands like a skeleton. Fry, having asked her to say exactly what she thought about the portrait seemed rather hurt when she said this, but took a bit off the nose. He introduced her to 'my wife, Mrs. Anrep.'

Thursday 12
Tate Gallery in the afternoon, after fetching my long malacca from Smiths, with the new top made by Haussen in High Street, St. Giles's. Found my own drawing at the Tate… very obscurely hung. Odd to find nearly all the friends of one's youth now in the National collection – Innes, Lees, Albert, Lightfoot, Unwin, not to mention Spencer, John, Ethel Walker, McEvoy, Mrs. Florence, Ginner…So many pictures I remember being painted, and so many of the sitters too: McEvoy's *Euphemia* [1909], so exactly like the willfully 'gaga' expression she used to have (clever woman): John's *Barker* [1916] and Betty May…

Saturday 14
…Dr. Parkinson, about 2 o'c., bringing back the drawing…with criticisms and suggestions for alterations…He…bought my drawing of *Carn Freena* (Cashelnagore) for £8-8-0…

Sunday 15
…Parkinson again…Made some revisions to the coloured chalk drawing…and started another in black chalk…

Tuesday 17
...Tea with Jowett...told me about a visit of Mendelsohn, the German architect, to the Central School. Mendelsohn describes himself as a hundred per cent Jew, and cannot go back to Germany just now under the Nazi regime. In the School show he liked everything that was most English, and not, as Jowett expected, the work showing ultra-modern influences. M. said it was climatic conditions on the Mediterranean, for example, being different from our equable, temperate climate, and it was natural for different traditions in art to grow up here. Having dismissed the 'modern' furniture design in favour of more traditional things, M. went on to talk about Henry Moore, whom he respects, but says that Moore is trying to do something that Mendelsohn himself was trying to do twenty years ago...

Wednesday 18
Worked on preparation for a small painting of Donegal peasants, from an old etching in which I borrowed a Poussin composition. ...

Friday 20
...Diploma Day. College of Art. Ormsby-Gore spoke, without saying anything ridiculous, or being too long. The College show very good. [Henry] Bird, who has the Travelling Scholarship this year, received his Diploma in an academic gown, bare feet and sandals. He also has a beard...

Sunday 22 – Friday 3 August: no diary entries

AUGUST

Saturday 4
Went to Gravesend with Maxwell Ayrton. He had seen it from the river, and thought it would be a good place for our purposes. Although an interesting place... Plenty of dirty old streets, with weather-boarded house, many of them in process of clearance and demolition...the general view he had in mind did not exist. He found something to do in a boat-builder's shed, and I sat in a boat out in the river: but as the tide came in I was forced to move, and did not finish what I had begun...

Monday 6
Newmarket, about the drawing of Richardson's Jockey Club. Made a beginning...

Wednesday 8
Worked on the Newmarket drawing at home, filling in some obviously repetitive passages. Don't usually do much away from the spot – it makes the drawing dull and mechanical, but I can save a lot of time on this one, and check the detail more easily than when I am standing in the street. In the evening I was stopped in the street by a man whom I did not know, but who evidently knew me by sight. He said he was Beresford (who took some of the best photographic portraits in his day, including Tonks), and would I like to see an Alfred Stevens painting? I believe I was at the Slade when Beresford was there, with Albert R. and F.H. Shepherd; but he came before I did, in the days of John and Orpen. Now he looks old and shabby. He had the painting under his arm, in paper, and showed

it to me in the Tube station. It was a life-size head and shoulders of a girl, who, he said…
was Stevens's mistress. It is not as good as other Stevens paintings. MacColl had seen it,
and said it isn't a Stevens. It came from Orpen's sale.

Friday 10
…Tony Ayrton tells me he is going to work in a scene painter's studio. He got the job
through George Sheringham. Rowley Smart is really dead this time – it is in *The Times*,
circumstantially. The notice speaks well of his painting – I have not seen it for years, but
it wasn't always good. He was a 'Bohemian', like Dolores, who is also dead: that is, he
drank a good deal, and was quite unscrupulous about money and women. Dolores had
the most fantastic ideas about her beauty, and the 'romance' of her life. She signed her-
self, proudly, in Hetty's autograph book at the Blue Cockatoo, 'Dolores-Epstein's model',
and never lost a chance of letting it be known that she sat to Epstein, as a hundred other
girls have done…

Wednesday 15
Tony has started work as a scene-painter. The firm is executing some designs of Rex
Whistler's for C.B. Cochran. John Guthrie is one of Tony's fellow-workers. Whistler
seems very casual and autocratic, making changes in the work as it goes on.

Thursday 16
Newmarket. The sun just held out long enough to give the shadows I wanted on the
drawing.

Friday 17
Dinner with the Charltons: the Hagedorns there also. The Charltons' house in New End
Square is very charming and personal – George Charlton is chiefly responsible for that.
He has a great knack of picking up pleasant odds and ends…ridiculously cheap: a Car-
rington Bowles print for 4/-, a good landscape drawing by Skelton for 10/-, as examples.
He is always busy about the house, his activities extending even to model yachts, which
he is re-rigging in the basement, a regular work-shop.

Thursday 23
Went to Bermondsey with Hagedorn. He started on a painting from Horsleydown New
Stairs and I on a drawing of a house in George Row…The children in Bermondsey area
extraordinarily dirty, and so are the streets…Perhaps the clearance of old slums which
is going on, and the building of fine new tenement houses which, some of them, are
now finished, may make a difference…

Friday 31
Went with Hagedorn to Langley to stay the weekend with his brother-in-law, Aron.
Train to Macclesfield…

SEPTEMBER

Sunday 2
Aron is a very well-informed man…He has a Jewish exterior, and a hectoring manner at times, which reminds one of Willie Clause or of R.A. Walker, and may be left over from his days of service in the Army, 1914-18, when he apparently did rather well as an officer…Went on drawing…Aron has a picture by Derwent Lees, of Edith, called by some fancy title. He bought it for round about £80 in Australia. It is in the Innes-John style. How well I remember him doing that sort of picture, and Innes going off on a more modern tack at Collioure, about the time I let him my rooms in Howley Place (for which he never paid me). I damaged one of Innes' oils by using it to blow up the fire afterwards, when he had left and had left a lot of pictures behind. He was quite indifferent…

Tuesday 4
Home by train from Wilmslow…

Thursday 6
Dinner with the Wellingtons…Talk about Epstein in his young days – trivial things such as one remembers: how he broke two Louis XV chairs at Walter Taylor's, one after another, merely by sitting on them. He was heavy even then. And how Birdie and I visited him in Cheyne Walk when he had just carved the Oscar Wilde memorial, and how he never paid Ford, the Cheyne Walk tobacconist: and the white canvas shoes he used to go about in…

Friday 14
Began to draw Dr. R. Hutchison[12]…He is a very tall man, in a grey tail-coat, who vaguely reminds me of Tonks (whom he does not know personally). He has some works by Brabazon, whom he calls 'Brabby', and by Francis James, both…his patients…Francis James never paid him anything, but used to give him a picture now and then in return for Hutchison's professional services. H. says that theatrical people, too – Lady Tree among others – always seem surprised at any suggestion of payment to their specialist…

Monday 17
…Met Evelyn Gibbs, former Rome Scholar and A.R.C.A., who has written a book on the teaching of art to children – a job she has been conversant with these last few years…

Tuesday 18
Began a drawing in St. Thomas's Street, going down to London Bridge with Hagedorn. Got permission from the Superintendant of Guy's to stand within his premises. Barbara Nicholson greeted me over the railing (Sir Charles Nicholson, the architect's daughter), reminding me of the R.C.A. She is working at Guy's, doing diagrams of animals' intestines…The Wellingtons have been staying for the weekend with Philip Alexander at Walberswick. Last night they dined with Herbert Read and his new lady, and heard about Roger Fry's death. He fell and fractured his pelvis, and was in great pain. The hospital people were treating him for a broken leg, and accused him of making an unnecessary fuss, not realizing that his pelvis was broken too. Fry said 'he had had enough of being an English gentleman' and screamed.

12 Friend of Dr. Parkinson.

Friday 21
Final sitting from Dr. R. Hutchison. He appears pleased with the first and third drawings. He is a student of Boswell and Johnson…

Saturday 22
…Tryon came in the evening and talked music and painting enthusiastically. He has become more handsome and striking…I think that insomnia must be his chief trouble. Colour he loves, and says the English School, with few exceptions (Cotman is one) does not appeal to him, because they work on a monochrome basis and not for colour as a primary consideration.

Sunday 23
…I had taken the opportunity of meeting Rutter in the street to talk to him about Hagedorn's coming show. Rutter was quite willing to be interested…said he looked upon Hagedorn as one of his own discoveries, having given him his first show at a gallery that he used to run years ago.

Monday 24
Went to see Wyndham Tryon after supper, in Ampthill Square. He was less jumpy… and is now painting naturalistic pictures again. Some of them – oils and watercolours – I liked, and his experimenting with abstractions seems to have helped his handling of paint…Tryon was very cordial and invited me to call on his old father at Grove Mill… in the neighbourhood of Watford. He spoke in a kindly way of his father, contrary to what Rupert Lee had led me to expect, who said that it was Tryon's father who caused him to be certified as insane…

Tuesday 25
St. Thomas's Street again…Lunched with Barbara Nicholson…She showed me her meticulous drawings of guinea-pigs and diseased organs – very good for their purpose: they are in gouache, in colour…

Saturday 29
With Maxwell Ayrton to Limehouse…Ayrton has been talking to Giles Scott about his proposed new Waterloo Bridge. Scott is rather afraid of concrete – doesn't know what will happen to it in 80 years. Ayrton is in favour of it…

Sunday 30
Hagedorn and I called on the Grimmonds…he is about to lose his job at Hobson's, after having been with the London Press Exchange people for over 18 years…

OCTOBER

Monday 1
First day of the Slade. Interviews, and a little teaching squeezed in between. …Cundall asked me whether I was 'going to the meeting' – the New English Executive, which I had totally forgotten…Clause and I went to Stone's in Panton Street for a glass of sherry on our way home. Compared our memories of Innes, who…first introduced me to that

place: how drunk he got when staying with the Gregorys at Coole, coming back completely done up after three days or so at Galway when the races were on, and how he never seemed to pay the least attention to his consumption, which carried him off. His teeth had mostly gone, and he could hardly masticate anything finally.

Wednesday 3
Hagedorn's Private View at The Fine Art Society. He has sold four pictures – young Beddington was responsible for one sale, to his family – and three critics have been in – Jan Gordon, Sevier and Marriott…Birdie came, in a bright green costume; a great concession for her to make, as she hates Private Views…

Thursday 4
Slade – an extra day for me. Plenty to do, and very little time for teaching. Summer compositions, not bad. McIntyre, Eveleigh, Brinkworth, Paul Godfrey…the men have come out well this time. Saw Richardson and showed him my Jockey Club drawing. He thinks it might go to the R.A. next year, and has hopes of my making some money out of it, by the members of the Club buying reproductions. Very dubious. The Savile Club bought hardly any copies of my etching. Wilkie making himself unpopular by asking buckshee advice from all the architects about his new studio. He never pays for anything if he can help it…

Friday 5
Slade…Letters from China – Eric and Alice. Alice is still with the Handley-Derrys in Tsing Tao. Dinner, cocktail parties (she does not drink cocktails), bathing, swimming, sailing and picnics in the hills. They seem to keep it up very late in China: she talks about 3 – 6 a.m.: but they sleep in the middle of the day.

Saturday 6
Private Views at the Leicester Galleries…Nevinson, Gertler and Anthony Gross. I am told the last is a Slade man: Dufy-Laurencin influences. Nevinson's paintings in a dozen different styles, some good, some very bad. Gertler's with colour and design which are interesting up to a point, but negative by his quite childish following of a particular Picasso manner. But for Picasso they would never have been. Guitars (how sick I am of guitars) and grandiose pink women, completely and willfully unsubtle in shape…Told Nevinson (just to rag him) that the rig of his Thames barges is all wrong. It is, too; he gives them a gaff where there is none….

Sunday 7
Mrs. Randall Davies came to tea – the first time she has been to this house, or to Church Row at all. Randall is worried about money and the boy's education. He has lost his Felton bequest work for Melbourne, and has been selling a few of his collection of 3000 drawings…

Monday 8
Douie rang me up at the Slade about Elliott Smith, who was due to deliver the inaugural Anatomy Lecture this evening. Douie explained how ill he had been, and how students must be warned to be indulgent to a distinguished sick man. I did this, and attended the

lecture myself…Called on Arthur Watts…about Blockie's affairs, and to see a map or poster he is doing for the Underground. He wanted some advice on it…

Tuesday 9
Jury of the N.E.A.C.…Clause…roused Connard to an angry protest by recalling a rejected picture by Percy Horton and explaining that the artist was one of Will Rothenstein's young men. Connard said he didn't care whether he came from the College of Art, the Slade School or any other bloody school – it was nothing to do with the Jury and should not be mentioned. There was too much of that sort of thing, he said…I think our Jury, not being drawn this time from the oldest members of the Club, was more sympathetic and painstaking – consequently a little slower – than usual…

Wednesday 10
Hanging N.E.A.C.…At lunch Ethel W. became reminiscent, remembered Egan Mew, whom she likes; she says the drawing he has by her is of Lydia Russell. She says Steer was a very good dancer in his younger days, and came to her parties…Jowett and I concentrated chiefly on hanging the two water-colour rooms…There is only one Steer, a water-colour, and a small painting of a head by John. Burn and Guthrie have a lot of stuff. Why Burn, who is a good artist, lets himself off with such exceedingly sloppy drawings, is a mystery to me…

Thursday 11
…Bought a drawing by Gertler, a portrait of Dorothy Brett, from a junk shop in Whitcomb Street. It isn't a very good drawing really, but is typical of what he did at the Slade. A large painting by her, too, was offered to me for 25/-. Ethel Walker has a story about her, that she painted a picture of some women in the family way, and called it *War Widows*. Ethel complimented her on it, purposely miscalling it *Out at the Front.*

Sunday 14
Hagedorn's show has nearly touched the £100 level…Ethel Wardell and Jean Orage came to supper. Jean is threatened with cataract, but is told it may be arrested…Wardell has been living for six years with a man named Knox, in the south of France and in Brittany. She met him in Cassis. They are leaving France now because it is too expensive. Knox's wife having divorced him, he is going to marry Wardell and take her to South Africa… He is said to be a relation of Lord Lonsdale: Jean thinks him a selfish brute. A nice girl, Wardell, of whom we are all fond, but her man-hunting mania used to be a real nuisance… Now she should be more happy and settled.

Monday 15
Slade Summer pictures. G.J. and Charlton did the criticisms well. 1st Prize – Eveleigh. Mrs. John Copley is vexed because she was chucked from the N.E.A.C., and will no longer stand as a candidate for election…

Tuesday 16
Committee on Mural Decoration…R.C.A.…Tea with Constable, Jowett and Dickey at the A.B.C. in S. Kensington. Talk about Wilenski, whom everyone likes as a companion for a while, or just to meet, but nobody loves. He is under contract to write for Faber &

Faber, and has to write things that will sell. He took a good deal of information from Constable, in conversation, and used it in a book without any acknowledgment. He re-wrote a good deal of his book on the English School, at Constable's suggestion, having contacted Constable about it. C. respected him for taking so much trouble, but agrees with me that W.'s knowledge is not firmly or widely based, and that he is illogical...

Sunday 21
...Started a drawing of University College, for presentation to Prof. Coker. It will be paid for out of the balance of the sum raised on his retirement, which...amounts to £10... The Beadle, who didn't know me, made some difficulty about letting me in the quad. 'Only Professors are allowed in on Sunday.'

Tuesday 23
General Meeting of the N.E.A.C. Southall in the Chair, as none of our more distinguished older members, such as D.S.M. and Holmes, was present, and Southall is older than most of us...he did very well, better than he paints...

Wednesday 24
Chatted with Ashmole about the Skeapings and the news of Barbara Hepworth's and Ben Nicholson's triplets, which is being colporté everywhere, with the general opinion that it serves them right. At the Copleys in the evening...Copley, who prints his own litho-graphs very skillfully, says there is not a man in London now capable of printing as Whistler's were printed, and that Vincent Brooks ruined a stone of Ethel Gabain's.

Thursday 25
Clause rang up from the N.E.A.C. to say that Connard was there raising hell about the hanging of his picture, a little blue painting of his wife, which he complains is killed by a red flower-piece next to it. Advised Clause to carry out his own suggestion of shifting the flower-piece and exchanging it for another equally good, by nobody in particular, which suits Connard better. Quite unconstitutional...but no one will notice...

Wednesday 31
There is some dissension in the N.E.A.C. about the proposed brochure in honour of the 50th year of the Club. Stephen Bone and other younger people think that Rutter will emphasize the glorious past, to the disadvantage of the present day; or, as Nevinson puts it, people will be more than ever convinced that 'once the Club was in the van, now it is in the cart.'...

NOVEMBER

Thursday 1
Party at the Charltons...Talked to MacColl, Nevinson, the Ethelbert Whites...It was a more middle-aged party than the last one...There were a few Slade students, but carefully selected, Moynihan among them. Carline and his mother, and Mrs. Spencer (the daughter of Mrs. Carline), Bassett, and about forty more.

Saturday 3
Drew Mrs. Tyrwhitt Drake (introduced by Mrs. Ollivant)…She had driven up from
Amersham. She told me a lot about Shardeloes…The kitchens at Shardeloes are in a sep-
arate block, not even on the same level as the rest of the house…The Queen came to see
it, and to have lunch…An equerry came the day before to explain exactly how H.M. was
to be received, and to ask what other people were staying in the house, going into details
such as the sugar in her tea, and what you were supposed to wear…Mrs. Drake liked
H.M., though. She went all over the house twice, and shared much knowledge of periods
and furniture: she became quite human and amusing. It seems she smokes a cigarette
after lunch…Collins Baker has been recently to the house to look at the pictures. He
called when Mr. Drake was out, and was not admitted. He then telephoned from the inn
in the village, explaining that he was Keeper of the King's pictures…

Wednesday 7
After the Slade, Walter Bayes's Private View at the Leger Gallery. No pictures sold…
Bayes…says he is sorry he got Gertler to the Westminster as a teacher, thought Gertler's
last show was silly, and that he has nothing definite to teach. Thinks Spencer (Stanley)
is silly too, and a *faux naïf*, but does Gilbert S. justice as a landscapist…

Thursday 8
…9 o'c. A party at the Lee Hankeys, 24A Heath Street. It is a big flat with two studios…
Rather a dull party, and I am unsympathetic about the sort of work L.H. does – all too
obvious, though capable. Hers interests me a little more. Mrs. Gertler told me about
William Roberts, who is a neighbour of hers, and his enthusiasm for 'all-in' wrestling
matches. He sits enthralled, growing pinker and pinker with excitement, and silent, as
is his habit, at these barbarous displays. Gertler goes too. They went to see Rabinovitch
perform, who wrestles under the name of Rabin. There is strong feeling between Chris-
tians and Jews on these occasions. Gertler got quite worked up, too, and all Jewish,
screaming encouragement to his co-religionist.

Tuesday 13
Durst rang me up to say that W.R. has convened a meeting of his staff this day, and had
read to them a letter written to the Board of Education announcing his retirement at the
end of next June. This has spread a general gloom over the College staff…

Wednesday 14
Barnett Freedman's Private View at the Zwemmer Gallery…Oliver Simon (who informed
me that some designs I did of the seasons for the Curwen Press…are now being used
for Christmas cards at 2d each), Mahoney, Coxon, Ravilious, and of course Barney and
Claudia, who was as sweet and humbugging as ever, and invited me to come and see
her baby…Considering that Barney is in danger of becoming too commercialized owing
to his scale of living (he had to borrow £10 from Hagedorn the other day), the show
was surprisingly good. Colour a little heavy in some of the oil landscapes…

Friday 16
Went to the College of Art to award my prize in the Students Sketch Club. Noticed some
good paintings by a student called [Ruskin] Spear. Met Horton, Mahoney, and Freedman

(Barney is developing as a raconteur of the broader kind) with whom I had tea in the Museum, being joined later by John Nash, whom I had not seen for years. He looks much the same – a thin, rather unhealthy, intelligent, pleasant face. I am told he writes expert articles on gardening, illustrated with good drawings by himself. Most artists agree that he is a sounder man than Paul…

Tuesday 20
Committee at R.C.A…Mural Decoration…formed ourselves into a Society and Advisory Body. The next step, as always, is to get some money…

Saturday 24
British Museum. Lunch at the pub in Little Russell Street. Harvey Darton there. He is living at Cerne Abbas. He was full of sidelights on my subject of illustrators, and gave me some useful tips: says Howitt, the illustrator, worked for his firm, or his grandfather's rather – Harvey & Darton…He, like me, was working in the Reading Room. Ginger telephoned to say he is going to make a will, leaving all his money to Alice…'Merci pour le compliment', but as he and his mother are risking all their money backing films, and have…already lost the best part of £10,000, the increment may be small. Birdie, who took the telephone, protested, and asked 'what about his mother and his family?' He replied that his mother wanted him to do it…He doesn't want his brother, Commander Ellison, to have his money, and has no other relatives that he knows, so the only other alternative is a cat's home…A strange development from a chance acquaintance sprung up some fifteen years ago when Birdie was in St. George's Hospital, and Ginger was a medical student. He is only 16 years older than Alice…

Sunday 25
…The Hagedorns came to supper, and Ginger, bringing with him Hans Feher, the juvenile film star of *Le Loup-Garou*: a boy of 11 years, good-looking, pleasant-mannered, self-possessed, yet quite boyish enough in spite of his quick-witted intelligence and his four languages. He looks…a little girlish, partly owing to a German sailor suit he had on… and which was cut low in front: sailor collar and brass buttons. He is staying with his father at the Splendide in Piccadilly, whence he is going to see the Royal wedding procession on Thursday. Lunch and view from the window, £2-2-0 a head. They are thinking of sending the boy to Downside to be educated, ultimately as a doctor, perhaps. He doesn't want to remain a film star. His father has Jewish blood…and he, who shows no sign of the Jewish ancestry, which has caused his father to leave Germany, is brought up a Papist.

Tuesday 27
Evan Charlton's show of paintings, at Thomson's (The Palser) Gallery, King St., St. James's. He has improved a good deal, has the ability to get a likeness, and his landscapes are better in design…I am trying to get him a job under Milner at the Bristol Art School…

Friday 30
Mrs. Tyrwhitt Drake came a third time, and I finished my first drawing of her. It has taken something under six hours…went to…a farewell dinner with Ethell Wardell and her husband, Knox, before their departure for S. Africa tomorrow. Had not met Henry Knox before. He…was a naval air man in the War-lived at Cassis and knew Colin Gill,

Darsie Japp and Wyndham Tryon there: well-read and well informed, and considerate in his behavior to his wife. They were at the Cumberland Hotel, Lyons's newest, and of course successful, experiment with crowd psychology. Jean Orage came too. The Knox's are going to manufacture pâte de coing in the Paarl district. They describe the condition of France, where they have been, near St. Malo, as very bad…Everybody very depressed and expecting a war or revolution…

DECEMBER

Saturday 1
…as usual; took the dogs up to Judge's Walk and round the White Stone Pond, as usual: went to the British Museum. Asked the station master at Hampstead the reason for excavating the cement floor between the metals at all stations:- it is an anti-suicide scheme: they are making pits under the railway lines, so that intending suicides will be disappointed in their hopes of being run over. The reason is not humanitarian, but on account of traffic delays. They had forty suicides, or fatal accidents recently, in four months, on the whole Underground system…

Sunday 2
Went to lunch at Shardeloes, 12 o'c. train from Baker Street. A car met me at the station. Mrs. Tyrwhitt Drake had said it would be 'only themselves', but there were about five other people…The house is as fine as I thought; the rooms beautifully proportioned…but few interesting pictures. Except for some good Elizabethan costume-pieces, and one or two of the like, 17th and 18th century Drakes…J.H. Mortimer's conversation piece of Sir William Drake, his family, and the brothers Adam is one of the better specimens. The big lake at the foot of the hill shows signs of drying up, to the annoyance of Thomas Tyrwhitt Drake, who, poor man, was present in his wheeled chair, which he propels himself….

Wednesday 5
Cold bath, and exercised the dogs for twenty minutes as usual, before breakfast…Slade… Richardson…reminded me that there was a Board of Architectural Education…Sir Andrew Taylor in the Chair, who mounted to the top of the building afterwards to look at the work of the Atelier without showing any signs of his 84 years…

Saturday 8
Daphne Charlton came to take the dogs for a walk, and when she brought them back… we asked her and Charlton to lunch…Daphne, talking of costumes for the Slade Dance. Told us that Phyllis Bray, now the 2nd Mrs. John Cooper, once came in nothing but a rather shabby ill-fitting bathing costume, which, as she is rather a skinny girl, did not look too well…

Sunday 9
Hagedorn…says that Freedman has got his commission to design a postage stamp for £100…Mrs. Hutchinson called in the late afternoon to ask us to go over to her house. Hutchinson is interested in this week's *Country Life*, which has an article on Richardson's house at Ampthill.

Wednesday 12
A Miss Heinemann, who has something to do with the English-speaking Union, and is interested in art education, both here and in America, called at the Slade for some information...Great preparations for the Dance. Polunin and his people have done the decoration of the rooms very well. Olga Lehmann has a big panel on the stairs...

Thursday 13
Basil Burdett came to supper. He is on a year's leave from his Melbourne newspaper, and has been writing articles for them from Spain...As Burdett is hard up, Birdie thought he might be asked to occupy Alice's bedroom for a while. He gave us messages from the Daryl Lindsays.

Friday 14
Slade Dance...Douie and Mrs. Douie came, and Albert R. and his wife, James Laver, Viola Tree, Dr. Kirk, Borenius (for a short time, with his daughter), Corfiato and others...

Saturday 15
Went to Kenneth Hobson's show of water-colours. He draws very carefully and sometimes very well, but is not always happy in the design of his subjects, nor the colour. The show was at Lockett Thomson's, upstairs now at Barbizon House...

Monday 17
...Committee, Old Queen Street, about British Exhibitions under the auspices of the Department of Overseas Trade...[Rupert] Lee and I were appointed, with Manson, as a sub-committee to arrange a show of modern British paintings in Brussels, the work...to be entirely untraditional and personal. The N.E.A.C., whose representative I am supposed to be, won't like this, as it cuts all of us out...Dressed for dinner, and went with Birdie in a taxi to the Hotel Splendide...to meet Ginger, his mother, and the Feher family. Feher is theatrical, self-confident...lavish, coarse, and clever: showed us some really admirable 'stills' and costume designs for his new film. Hans was there, rather subdued, and his mother, a Russian Czech of opulent charm, very beautiful really, with remarkable red hair, which is perfectly genuine; but has passed the climax of her beauty...Dinner began with a dozen oysters each, and champagne...They have all been working at the new film, on the Mer de Glace, and at Banyuls-sur-Mer, and are shortly going to Ragusa...

Wednesday 19
Board of Trustees at Whitechapel Art Gallery, Lord Balniel in the chair – a pleasant, good-looking young man...

Thursday 20
...Packed to go away with the Kohns to Farringford.

Friday 21
Started at 10.15 to drive to Lymington...lunching in the New Forest, near Brockenhurst. Arrived at Farringford, leaving the Kohn's car on the mainland...

Sunday 23
Charles [Tennyson] asked me in the evening to make a drawing of him as a present to
Ivy, as his real Christmas gift to her has gone wrong. I am to draw him in a characteristic
Farringford interior, as a souvenir of the place, too...

Monday 24
Drew Charles in the morning, in Pen's bedroom, to preserve some secrecy...It got to be
pretty well like him...Looked through some amusing letters from Irving, Ellen Terry...
part of a vast collection in the house...These were about the performance of *The Cup*
[*A Tragedy*, 1884]. The Bard [Alfred Lord] Tennyson got £4 royalties on each perform-
ance, or about £100 in a month. Adam Carle playing on the flute...

Tuesday 25
The parson and his wife came to a Christmas Tree party with presents, in the afternoon...
He talked to me about Arthur Roby, whom he knew at St. John's College, and in Man-
chester, where he was before he came to Farringford. In the evening, Pen and the rest
of the boys performed a play...Prologue spoken by Pen, disguised as his great-grandfa-
ther, in the poet's authentic hat and cloak – making rude remarks about the local port.

Thursday 27
Left Farringford in the Kohn's car (from Lymington). We visited Beaulieu Abbey on the
way, in the rain...Dinner, bed and breakfast at The Old Ship, Brighton. Had never been
to Brighton before: I understand Charlton's liking for it – the Regency parts.

Friday 28
Arrived at Dover, about 6 o'clock...

1935

Schwabe is accorded the honour of an exhibition of his prints and drawings at the Museo Nacional de Arte Moderno in Madrid. He is also much involved with selecting works for British art exhibitions in Brussels and Bucharest. Basil Burdett returns from Australia and stays with the Schwabes; he and Schwabe visit Augustus John for Burdett to purchase artworks for his employer Sir Keith Murdoch. Schwabe is commissioned to undertake a number of portraits and to illustrate Of Human Bondage *by Somerset Maugham. The brutal actions of the Nazi party impact on his Jewish friends and he notes the presence of English Blackshirts.*

JANUARY

Wednesday 2
Visited Chartham by means of Tom's car, he having a patient in the Mental Hospital there. Found the [Sir Robert de] Septvans [d.1306] brass, with some difficulty, in the Church, under the carpet. Too wet to draw anything. Called in at The Artichoke…kept by some pleasant, poorish people, who did not know how much to charge for a gin and vermouth. I paid the usual price, 8d.

Sunday 6
…Left Dover by the 5.13 train, getting into a compartment…we found a young [Frederick] Gore, Spencer Gore's son, whom we met at Jean Inglis's. A young man of a pleasant personality, reminding one of his father in some ways. He was going up to London from Sandwich, where he lives, to resume his studies at the Westminster School of Art.

Monday 7
Slade began. Among other new students, a niece of Orpen's from Dublin. Francis Dodd called…Described his difficulties with his portraits, which he paints largely from drawings, photographs…on to his canvas. He is at present painting an officer of the Horse Guards Blue, in uniform, and also with an academic gown & hood, which he is entitled to wear, placed on a chair beside him. Instead of looking erect and martial all the time, as he does at the commencement of the sitting, he lapses into a shrunken old man…

Tuesday 8
After the Slade a cocktail party of Alma Oakes's, at the M.M. Club ('Mainly Musicians') in a basement, 14 Argyll Street, Oxford Circus …Dinner…Jack Straw's…I like the pleasant large warm room, in spite of the fake medieval panelling they have recently put up. Why they couldn't leave it alone – a perfectly good late Georgian house as it was…The waiters know us and our habits, and we can feel most of the advantages of a good inn…

Thursday 10
…Met Christopher Perkins,[1] who took me into Green & Stone's to see a portrait drawing

1 Perkins (1891-1968), trained Slade, later taught New Zealand, returned 1934, was a key figure in the development of NZ's art between the wars.

of his which has been bought by the Contemp. Art Society. He says he is getting a fair number of portrait drawings to do...Entertained Rosalind Ord at Jack Straw's. Her little firm of Packard and Ord (both Slade girls) is now established in Bath with the part-time assistance of one man, and his wife, who does the book-keeping. They got a good many orders for their tiles and have some exhibits at the R.A. Industrial Art show. Very creditable. Towner came in late, and renewed his acquaintance, a slight one, with Rosalind, who was at the R.C.A. when he was a student (she went there after having been at the Slade for a while).

Friday 11
Burdett came to occupy the bedroom at the top of the house. He has been seeing Steer again, and has bought a drawing from him for a man in Australia. I was really pleased to hear that Steer had spoken well of my work to Burdett, never having had any indication... that he liked it. Steer remembers seeing Charles Keene working at the window of his studio over what was (in my time) a tailor's shop at the corner of Bramerton Street and the King's Road. Keene had a house elsewhere, but worked at the studio. Burdett says that Louis Behrend offered the big portrait of Strachey by Lamb to the Tate Gallery, but it was refused: it is now back at Burghclere, after being exhibited at the Tate on loan...

Saturday 12
...Went on with my drawing of University College...Was very annoyed because I carelessly made a mistake in the perspective of the drum of the dome, and had to go to the trouble of scratching out a portion, and using an eraser on it, to do it again. It looked elliptical...In the Tube coming home met Rabinovitch...He is going to have a show of wrestling drawings, at least drawings of wrestlers and other material behind the scenes, done spontaneously on the spot. He says he does not feel any after effects the day after a wrestling match, though he may be tired immediately afterwards. He wrestles in the catch-as-catch-can style...

Monday 14
...Prof. Richardson is working with the Provost to get Abercrombie installed as successor to Adshead in the town-planning appointment...Richardson wants someone not too untraditional to work with him, and is very much against pure functionalism in architecture...

Tuesday 15
Ginner rang me up...to ask if I could lend him 5/- 'as he had forgotten to go to the Bank'. He came round for it, and...talked a good deal about his student days in Paris, much about same time as my own (he is 56). He was born and brought up in France, though his family comes from Hastings and his mother was Scotch. He studied painting at the Académie Vitti, in Montparnasse, under Henri Martin. Blanche also taught there. Martin was a bad tempered man. He was so annoyed once, on arriving at the School at 8 o'clock in the morning, to find Ginner the only student present, that, after abusing Ginner, he refused to give any lessons at all when the other students appeared, and put on his hat and went off. Ginner also attended lectures at the Beaux Arts, on perspective, the history of art, and anatomy, having gruesome recollections of the écorché that was used. He lived on 200 fr. a month, having a large room in the Rue de Vaugirard, facing the Luxembourg, for which accommodation he paid 35 fr. a month (I paid 30 fr. for

my room in the Hotel de l'Univers et du Portugal). Ginner related a story of a visit to the Ethelbert Whites, in their caravan. He and Bernadette Murphy went, on the Whites' invitation. For lunch appeared an enormous jelly, with carrots in the middle; after lunch, they went for a walk and returned for a fresh attack on the jelly. It appeared for supper, and there was practically nothing else. Neither G. nor Murphy are vegetarians, and suffered heavily, Ginner waking in the night with a stomach ache.

Wednesday 16
…Burdett went to see Tryon last night with Maurice Lambert. Tryon is painting abstract pictures again, with the gramophone accompaniment. Burdett failed to guess what pieces of music they were supposed to interpret, and preferred the naturalistic water-colours.

Thursday 17
…went to the Imperial Institute for a preliminary study of the work sent in for the Rome Scholarships. Not so good as last year. The mannerisms of the Farnham School, in painting are too annoying and obvious…Only one Slade student competed, in the sculpture section – Miss [Eileen] Mayo, and she sent in a silly thing, though she is rather good really… visit to the R.A. I liked a lot of our industrial art, but the show is not exciting nor impressive on thinking it over afterwards. Some vile furniture designed by Ambrose Heal, and I didn't like some of Gordon Russell's either. Betty Joel's[2] bedroom good.

Friday 18
…Award of Rome Scholarship in painting. Committee almost unanimous for Hooper, whom I remembered at the Slade (a nervous little man), but who seems to have developed a good deal since he went to the R.A. Schools. Usual Committee, plus Charlton Bradshaw. A.K. Lawrence arrived, characteristically, when the judging and voting were all over. To Department of Overseas Trade, about modern pictures for the Brussels Exhibition. Manson and Rupert Lee & Major Longden. Arranged a shortlist of 25 painters… attend[ed] a meeting of the National Society at the R.I. Galleries. Nevinson in the Chair… Ethel Walker (who showed me a letter full of most complimentary remarks on her present show of paintings, from W. Rothenstein…she said he had spread the butter on too thick, which is exactly what I always used to feel when he paid me compliments…)…

Saturday 19
Max. Ayrton came in…and started a drawing of Church Row from our first floor window. I drew him, during the morning…Burdett, Birdie and I…went on to Tryon's in Ampthill Square…new pictures by Tryon, who played the guitar – long Spanish pieces, with no apparent sequence: I don't know how he remembers them as well as he does without written music. He says himself he is forgetting them. I criticized mildly the colour of some of his new music pictures. He has done nineteen in a very short time – a week or a fortnight…I really liked a more normal picture of some ships in a harbour…

Monday 21
Tea and Lecture at University College – Dr. Weinburger, a 'Refujew', on 15th Cent[y.] German art…

2 Joel began designing furniture in Hayling Island in 1921, later having showrooms in Knightsbridge and a factory off the new Kingston bypass.

Tuesday 22

Slade...A purely formal Board of Studies...W. Bayes, thanked me for being instrumental in getting him re-appointed as Examiner in Perspective for the Board of Education...It is a help to him now he is retired from the Westminster. Wilfrid Cave and Frieda Bloch came to supper. They are both thinking of living in Richmond. Cave talked about the Eumorfopoulos collection, and what a great addition to the nation's treasures it will be.[3] He saw it about twenty years ago, when he was in the employ of Charles Rutherston, and when Eumo. lived in Redhill and elsewhere. Cave also spoke of Rodin's residence in Cheltenham at one time, for about two years; where he passed almost unnoticed, and apparently did no work, not having a studio.

Wednesday 23

A certain Denys Wells, R.B.A. called on me at the Slade to ask for a testimonial...He is applying for a teaching post with the L.C.C. I remembered him as being a student with me. He looked very shabby, and was unshaven. He is yet another who has given up hope of living by selling his pictures. He is older than I am, and a friend of F.H. Shepherd. I don't remember noticing his pictures...though he has exhibited...at the N.E.A.C. Went to Ethel Walker's show at the Lefevre Gallery. Not much sold, though everyone says it is so good. So it is, in spite of her obvious uncertainty about the placing of her forms. She has an underlying feeling for drawing, as well as a distinguished sense of colour and her very personal, feminine outlook on the world...

Thursday 24

...Dinner, in company with Mew...[He] spoke of Max Beerbohm's caricatures of the Royal family, exhibited after the War. Gerald Du Maurier bought one of the P. of W., thinking it very amusing; but when the storm broke and accusations of disloyalty and Boche bad taste were hurled against Max. Du M. said he had bought it only in order that it might be suppressed...

Friday 25

Looked out about 50 drawings and prints with Burdett to send out to Madrid, for a show there. In the afternoon, a meeting of the National Society Council, to elect new members. Dugdale presided, with Maurice Lambert as Vice. Bernard Adams secretary. Turned down a lot of people, including young Prinsepp the sculptor and Potter of the Whitgift School. (Jan and Cora Gordon also failed to get elected, after considerable discussion as to the advisability of such a refusal, he being a critic; but their pictures were not liked well enough.) Elected Wyndham Tryon, young Forward from the Slade and some others, most of whom I knew nothing about...

Thursday 31

Went with Burdett to a show – 'the past hundred years' – at the B.M. Print Room. Looked with most attention at drawings by Ingres & John, and wished that someone at the Slade now could put up a performance like the fine life drawing of John's Slade days...Drew some money from the Bank in Chelsea, sent £15 pocket money to Alice for her return journey from China and went back to the B.M. for research on obscure artists – Westall, R.K. Porter & Howitt...

3 In 1934 as a result of the Depression he sold part of it to the V.&A.

FEBRUARY

Friday 1
...Hanging at the National Society. [William Sidney] Causer and I arranged the water-colours. I had not met Causer before: he has very similar tastes, as an artist...and has drawn many of the same places that I have. We made a good centre on the longest wall with Wyndham Tryon's 'abstracts' and a Jowett flower-piece...In the other rooms a lot of very abstract sculpture, with the sculptors, Underwood, Lambert, Dobson etc. busy arranging it...Tea...I sat next to Allan Walton, who was evidently in a state of nerves because he had to go off at 4.30 and lecture, on *Art and Industry*, at the Royal Academy...

Monday 4
Slade...looking through General Schools Exam papers, as Moderator for the University. Bayes, as the new Examiner in the History of Art, much too complex and advanced. Took Charlton's advice on this and other matters, including the question, which Charlton raised in a letter to me, of giving more time to the teaching of painting in the Slade. It seems that the students have been agitating about it...but have not brought it to the notice of the Staff. Not that they are dissatisfied with G.J. but they want more lessons than he and I give. Charlton says there was more teaching of painting in his time, when McEvoy, Tonks, Russell & Steer all had a go at it. In my time...Brown & Steer alone did it – not Tonks, nor Russell...

Thursday 7
Called on Hutchinson.. I had hardly an opportunity to speak to him, as he was telephoning nearly all the time about the business of the Hampstead Protection Society. A new scheme is on foot to erect a block of flats in Willow Road, on the site now occupied by small cottages with long gardens in front, at the Well Walk end of the street. There will be opposition to this, and much more if the great plan of widening Heath Street, of which one hears, ever comes to anything...

Friday 8
...Dinner with the Copleys...I took occasion to ask Nevinson whether his estimate of Orage agreed with mine. N. knew Orage well, and I did not want to misrepresent him to Burdett. However, Nevinson entirely agreed with me. He said that Orage was thoroughly fraudulent and dishonest – that he signed his name to articles written for him by other people (one such man he knows, who now lives with Eileen Agar, and was victimized by O.): that he let down Mrs. Hastings as badly as he let down Jean, abandoning her in Paris for someone with money. Nevinson knew Modigliani well... The poor man died of pneumonia, and did not kill himself as has been said...He was not a Jew, though he spoke Yiddish among other languages. Nevinson agrees that 'modern movements' are mostly dealer's movements, not aesthetic movements at all... I was reminded of our early acquaintance with Nevinson before the War, in the days of the Petit Savoyard in Greek Street. Blanche Denton was living there with Ballantyne, having just ousted Billy Shelley from her place as Ballantyne's mistress. Blanche's baby, that there was so much fuss about, was supposed to be Nevinson's. Gertler, Allinson and I painted large panels on the walls. They cut a hole in mine to put a clock through it, and all the decorations disappeared when the place became rather smart during the War.

Nevinson says 'Bill' Hutchison is making a good job of the Glasgow School, which was very out of control in Revel's time…Nevinson read a paper to the students, without disaster. He admires Toshie's building.

Sunday 10

… I have sold 2 drawings at the National Society – the Anchor at Bankside, and some barges in the same place: 12 & 10 gns. respectively…Dickey rang up to ask if I would present a drawing to Martin Hardie's Department at the V.&A. Museum. They have no money to buy, and Hardie himself is shy of asking people to give things.

Monday 11

Allan Carr came to see me at the Slade. He will join next term. I have in no way persuaded him to this. Charlton, who saw one or two drawings & paintings that A.C. had brought, said…he was one of the best recruits we had ever had from a provincial school…

Tuesday 12

Drew a model, Miss Sallé…to get a pose for one of the figures in the Board of Education Exam…Colin Gill to supper, to discuss the Exam papers…He is going to America again as a juror for the Pittsburg Exhibition,[4] and will have a show of portrait drawings in New York…

Wednesday 13

…Saw in the paper that Mark Symons is dead. He was at the Slade with me, and with Birdie after I left. He painted her portrait, rather unsuccessfully. Sargent helped him and got him commissions. There was a period when he tried to enter a monastic order…He was always a devout Catholic. A queer mind – one might almost say stupid, but very sincere in everything…His father, W. Christian Symons's…illustrations, mostly of nautical life, used to give me pleasure when I was a boy.

Friday 15

Started on a round of visits to select pictures for the Brussels Exhibition, going first to Ginner…Nevinson was second. He and Mrs. Nevinson received us. Then Tryon, whose abstract pictures were much liked by Manson, and five were chosen – more than we have of anyone else's…Ivon Hitchens…has improved a good deal, and we selected 3 of his paintings…Gertler has moved to 53 Haverstock Hill, one of the nice old houses with long gardens in front. He has been doing a number of large pastels: the one we liked best was a large one, alleged to be a portrait of his wife, mostly red and orange, in a large hat, and with shoulders twice the size of life…Went to Tooth's, to look at paintings by Matthew Smith…then to Henry Lamb…he was out…A few pictures were shown to us by his sister-in-law, one of the Pakenham girls…Amusing contrast, for me, in this house in a Kensington square and these ladies, with my recollections of the ultra-bohemianism of Henry and Euphemia when I first knew them in Paris about 1907. Lamb walking to Dijon with only ten francs in the world, Euphemia, very picturesque and beautiful, usually wearing a long cloak, sleeping on the floor of [Charles Freegrove] Winzer's studio…We drove on to…Raymond Coxon…He had a frightful headache, and

4 Established annually in 1896 by Andrew Carnegie, renamed the Carnegie International, now held every 3-5 years.

looked so ill we advised him to go to bed, and we left…for Ethel Walker's…Clare Atwood was there, cleaning old canvases with potato. E.W. had just been painting a nude of Miss Sallé…

Sunday 17
Went to see Augustus John, with Burdett. Train from Waterloo – Salisbury [and]…bus to Fordingbridge. Arrived…about 4, looked at the church there and walked up to Fryern. We met John coming across the garden from his new studio (it has Modigliani heads in stone as terminals on the outside staircase. It is very modern, by an architect called Nicholson, very good, too), with brushes to wash in his hand. He had been painting Cedric Morris, and showed us the canvas, a head and shoulders, done in an hour and a half…there were many evidences of work going on…I think that what one has heard, about the short time that John is able to work now, must be exaggerated. John and Burdett got on very well, finding common interests not only in pictures but in Australian anthropology, the Pitt-Rivers collections…Burdett was pleased to find John so easy to talk to…he had been looking forward…to this meeting. We went over to the house when the tea-bell rang. It is a pleasant old place, with an old walled garden, and a small park around it. It has a…ramshackle appearance, the columns of the portico coming to pieces a little, and the interior comfortably untidy, but by no means squalid. Dorelia served tea on the same long refectory table that they had at Alderney, in a large dining room with three big sash windows, almost down to the floor: a late Georgian room, with a modern brick fireplace put in. A very good painting of a sailor man over the fireplace; it was painted recently in a pub in Cornwall. Cedric Morris was at tea. I apprehended some awkwardness, as I thought that he and I were not on speaking terms owing to my having said rude things about Lett-Haines years ago; but that seemed to be forgotten. Vivien came in late to tea with a bearded young man named Lambourne(?): they had been motoring on the Downs… John has been painting her, a pretty head, which Burdett was much taken with, and thought of as a possible purchase for his employer…John wants £460 for such things, and £40 for a drawing. After tea…John showed us a flower-piece, a recent one, which Burdett liked even better…Other pictures we noticed on the walls…a portrait of Adrian Daintrey, by John; an old painting, head and shoulders, of Alick Schepeler in a black hat, which John told me was painted from a drawing…He fetched his car round to take us all three (Morris as well) into Salisbury… but Vivien protested that there was not room…and drove us herself in another. We – Burdett, Cedric Morris and I – dined on the train and chatted all the way to Waterloo, Morris talking about Munnings, his neighbour in Suffolk…

Monday 18
In bed with a cold. It is humiliating, for another artist, to see John's work as I saw it yesterday. Its vitality is so enviable.

Wednesday 20
…Burdett has had a cable from Australia (from Sir Keith Murdoch) authorizing him to buy John's flower-piece and the head of Vivien… He has also had cables from Melbourne, from Daryl Lindsay and his own employer, that there is a chance of his being made buyer for the Felton Bequest. He would get a salary…sufficient to allow him to stay in England. The Bequest has £18,000 a year to spend on pictures.

Saturday 23
Drew Burdett in the morning, and made a second...after lunch... [this] agreed pretty closely with Arnold Mason's portrait, of which Burdett has a photograph: it was done four years ago.

Sunday 24
Burdett, at breakfast, talked about Orpen. He had visited him at his studio and at the little Georgian house in Kensington where Orpen kept his mistress...The annexe to one of the studios was fitted up as a chapel. There was a barrel organ...and Burdett and Orpen bawled out a hymn, *O, Star of the Sea* to the organ's accompaniment. Orpen's *Sowing New Seed* [1913] was bought for Adelaide, but aroused a storm of protest there on the grounds of its supposed impropriety. Orpen exchanged it for a bad portrait of Marshal Foch...Drew Hagedorn in the morning. Alma Oakes came to supper, rather worried about Jean Orage, who may have to give up the shop and retire to the country on account of her eyes. She has only £100 a year of her own...

Monday 25
...Visited various dealers...in search of the ultra-modern for the Brussels exhibition. Saw work by John Nash, Paul Nash, Ben Nicholson, Kynnersley Kirby (no use), John Aldridge, Frances Hodgkins, Skeaping, Underwood and others...

Tuesday 26
The newly-formed debating society in the Slade opened its proceedings with a talk from Eric Gill, on *Art and Industry*, with some reference to politics...Coldstream, who is now working on the films, as one of John Grierson's under directors, got Daphne Charlton and Moynihan to sit in the character of artists for some little B.B.C. film of the wireless. They were only at it for a minute and a half, without make up: no fee, only expenses...

MARCH

Friday 1
Robin and Vivien brought up John's flower-piece from Fordingbridge in the car. They did not stay long. Robin is a tall young man, with a good voice, inherited from his father. Vivien said the portrait of herself, which she thinks is the best John has done of her, is still unfinished. John was in a bad temper the last time she sat...Burdett brought a Mrs. Zander, an Australian, and Will Dyson to supper...We talked about John, and told funny stories about him, but always, I noticed, with the underlying respect which everyone has for John. Mrs. Zander knows the family of Derwent Lees in Australia. The father was well off. The mother died and the father married again; when he died in turn, he left everything to his second wife, and the daughters of the first marriage were totally unprovided for. They are now elderly women, leading miserable lives, earning a living as single women do – seamstresses, companions...There was no madness in the family: Derwent was quite unlike the others, who are sane and commonplace.

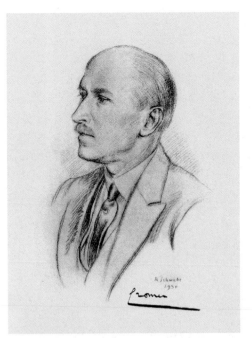

PLATE 1

RANDOLPH SCHWABE
**Edmund Bernard Fitzalan-Howard,
1st Viscount Fitzalan of Derwent**
1930 • collotype • 32.3 × 24.7 cm
© THE ARTIST'S ESTATE. COURTESY NATIONAL PORTRAIT GALLERY

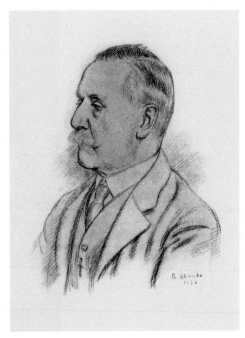

PLATE 2

RANDOLPH SCHWABE
Rowland Thomas Baring, 2nd Earl of Cromer
1930 • collotype • 32.1 × 25.1 cm
© THE ARTIST'S ESTATE. COURTESY NATIONAL PORTRAIT GALLERY

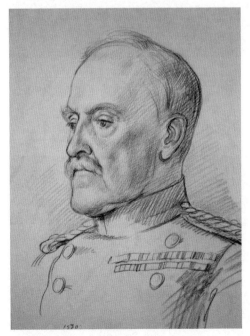

PLATE 3

RANDOLPH SCHWABE
General Sir Neville Lyttelton
1930 • pencil • 35 × 25.5 cm
© THE ARTIST'S ESTATE. COURTESY JANET AND DI BARNES

PLATE 4

RANDOLPH SCHWABE
Randall Robert Henry Davies
1939 • chalk • 35.9 × 29.2 cm
© THE ARTIST'S ESTATE. COURTESY NATIONAL PORTRAIT GALLERY

PLATE 5

WALTER SICKERT
The Mantelpiece
1907 • oil on canvas • 76.2 x 50.8 cm
COURTESY SOUTHAMPTON CITY ART GALLERY/
BRIDGEMAN IMAGES

PLATE 6

DORA CARRINGTON
Iris Tree on a Horse
c.1920s
oil, ink, silver foil and mixed media on glass
11 x 14 cm
COURTESY INGRAM COLLECTION

PLATE 7

CHARLES RENNIE MACKINTOSH
Textile design
c.1918 • pencil and watercolour on tracing paper • 30.1 x 23.8 cm
© VICTORIA AND ALBERT MUSEUM, LONDON

PLATE 8

CHARLES RENNIE MACKINTOSH
Textile design
c.1918
watercolour on backed tracing paper
13.3 x 13.3 cm
© VICTORIA AND ALBERT MUSEUM, LONDON

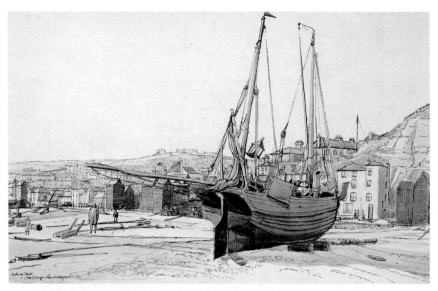

PLATE 9

KARL HAGEDORN
Beach Scene, Hastings
1933 • pen and ink, and watercolour • 34.8 x 50 cm
© PRIVATE COLLECTION. COURTESY CHRIS BEETLES GALLERY AND THE HAGEDORN FAMILY

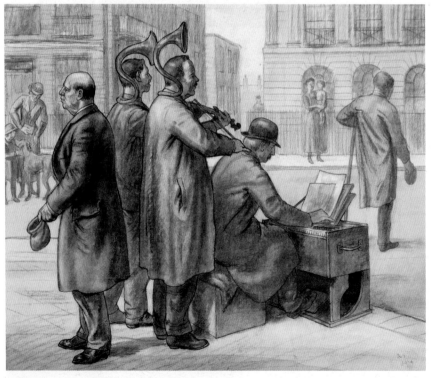

PLATE 10

RANDOLPH SCHWABE
Street Musicians
1934 • watercolour • 41 x 47 cm
© THE ARTIST'S ESTATE. COURTESY JANET AND DI BARNES

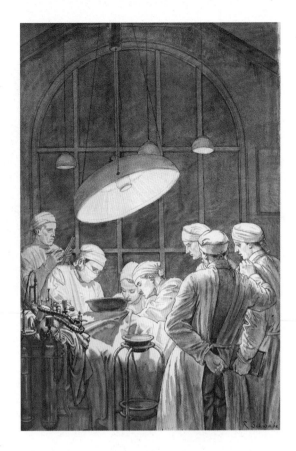

PLATE 11

RANDOLPH SCHWABE
**On certain afternoons in the week
there were operations**
Of Human Bondage, Somerset Maugham
1936 • collotype • 69.5 x 48 cm
© THE ARTIST'S ESTATE. COURTESY JANET AND DI BARNES

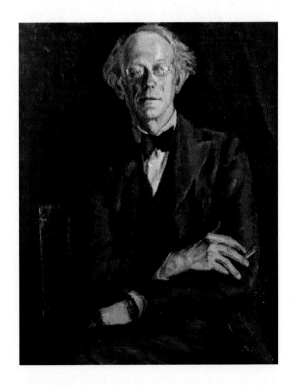

PLATE 12

JESSIE C. WOLFE
Professor Schwabe
1938 • oil on canvas • 71.1 x 55.9 cm
© UCL ART MUSEUM, UNIVERSITY COLLEGE LONDON

PLATE 13

RANDOLPH SCHWABE
The Round House, Dover
1938 • ink and watercolour • 32.9 x 39.2 cm
© THE ARTIST'S ESTATE. COURTESY MANCHESTER ART GALLERY

PLATE 14

HENRY LAMB
Portrait of Lady Ottoline Morrell
1910–11 • black chalk • 29.2 x 22.9 cm
© ESTATE OF HENRY LAMB. COURTESY INGRAM COLLECTION

PLATE 15

AUGUSTUS JOHN
Mrs Randolph Schwabe
c.1915–17 • oil on canvas • 61 × 40.6 cm
© THE ARTIST'S ESTATE. COURTESY UNIVERSITY HULL ART COLLECTION

PLATE 16

RANDOLPH SCHWABE
Sir John Rose Bradford
1938 • oil on canvas
101.7 × 76.2 cm
© UCL ART MUSEUM,
UNIVERSITY COLLEGE LONDON

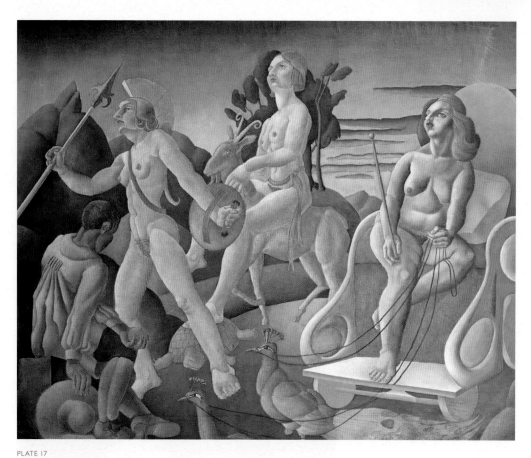

PLATE 17

ITHELL COLQUHOUN
The Judgement of Paris
1930 • oil on canvas • 62 x 75 cm

Tuesday 5
…Cremation. Golders Green, of C. Koe Child. He served the Slade for 37 years. His arthritis developed about 1927…Pneumonia was the actual cause of his death. There were about 25 people at the service…In the evening, dinner to Ethel Walker, in recognition of her distinction as an artist, at the Belgravia Hotel…Fred Brown was Chairman, and made a long speech…He calls Ethel's [*Decoration: The Excursion of*] *Nausicaa* [1920] a masterpiece. She was with him at the Westminster and afterwards at the Slade. He said she never went through any very steady course of drawing, but did exactly what she liked, which was painting, from the first. She began rather late, about 22…

Wednesday 6
Reception at the National Gallery, on the occasion of inaugurating the new system of artificial lighting…Many I saw as I had never seen them before, the Turner *Spithead* [1807-09] for instance, which had always seemed to me a dark picture, and now shows miles of high-pitched distance and sky… There were hundreds and hundreds of people (all in full dress, with orders etc.) including the Duchess of York, who was being taken round by Kenneth Clark and Sir Rob^t Witt. Talked to…Duncan Grant, Arthur Watts & Jim Ede & his wife, whom I met down in the Tube. I asked Mrs. Ede on the way whether there would be anything to eat or drink at this affair. She said 'Nothing will pass our lips except the nonsense that we utter'. It occurs to me that I don't get on well with Duncan Grant. I have known him off and on since I was in Paris about 1907, but never well. I suspect that his leg-pulling attitude to me implies something contemptuous. If so, it does not bother me much – just enough to make a note of it. Henry Lamb used to leave me with something like the same impression but he was friendly enough when last we met. I don't mind my leg being pulled, usually, and Grant is not definitely offensive. He is very often a very good painter, though I think he has allowed himself to give way, rather weakly, to certain influences which had nothing really to do with his own personality.

Friday 8
…In the afternoon, took three drawings in to the R.W.S. and went to a show of water colours by Edith Laurence and Claude Flight at the French Gallery in Berkeley Square, and then to see Epstein's *Thou Art the Man* at the Leicester Galleries…the gallery was very crowded, so much so that it was difficult to see the portrait busts…I disliked the stone figure. I sometimes wonder if Epstein is not going the same way as Haydon. There were some good busts, notably of Bernard Shaw and of a Siamese or Burmese woman.

Sunday 10
Did two portrait drawings of Burdett…One I think is one of my best drawings. Happens to have some quality which I used to have, and thought I had lost.

Monday 11
Alice's 21st birthday – it slipped my memory all day, she being away, and I having written her about it sometime ago. Tonks, who asked Burdett to dinner yesterday, told him in the course of the evening that he had been very much attracted by Edna Clarke Hall when she was young…Tonks might have asked her to marry him, but he didn't and now he thinks it was just as well. He thought she led Clarke Hall a devil of a life…He enjoyed the Ethel Walker dinner, and the company of Virginia Woolf, who was his

neighbour at dinner; and afterwards she, Vanessa and Duncan Grant were all very amiable to Tonks. 'D'you know why?' he said – 'because Fry is dead'. There had been little friendship between Tonks and that group for years. He prefers that there should be. He has liked pictures by Duncan and Vanessa, though not always in sympathy with what they do, and doesn't now see why artistic differences should imply hostility...

Tuesday 12
Removed my drawings from the R.W.S., having failed to get elected. Charles Cundall, Leonard Squirrell and Dorothy Coke were successful. Jowett also failed. Albert R. and Walter Bayes did all the log-rolling they could for me...I shall try once more. Birdie & I had dinner with the Tennysons...Maresco & Anna Pearce were there...Birdie is amused to think that she might have married Pearce when she was at the Slade. He didn't pursue the matter very far, having the sense to see that it was useless. He was looking about for somebody to marry, but was not very attractive to some women, though rich & handsome, and likeable in many ways.

Thursday 14
...Went to Lewis to make a list of the things he is mounting for Madrid. Saw some extraordinary drawings of Ian Strang's in his shop, waiting to be mounted. They are meticulous but somehow lifeless, with little recession or light, and they look like early Victorian lithographs. Called on Jean Orage, 49 Church St.. She is still busy weaving for Marion Dorn... Met Manson...to look at Gilbert Spencer's pictures for the Brussels Exhibition...selected four large ones, one an early portrait of a working man (about 1911) another of *The Sermon on the Mount*. G.S. says he has given up painting religious subjects, having become agnostic. He is very busy with the decorations he is doing in Oxford...

Friday 15
Reverting to yesterday – Gilbert Spencer says that his brother still paints a picture by beginning at the top left hand corner and continuing across and down till it is finished, so that the white canvas is left showing till the very end. I objected that you couldn't get any real truth of tone by doing this: it is what the Pre-Raphaelites did, and where they went wrong. G.S. agreed, and said that he does not paint in that way himself now, though he used to. Stanley looks upon Gil. as knowing more about 'tone' than himself. Jean Orage told me of Ethel Walker saying loudly to Epstein – 'Why are all you sculptors so derivative? Why don't you do something creative?' She goes in for home truths to her brother artists; saying to Dunlop that he was a mass of conceit and had a double chin, and being equally rude to Nevinson...

Saturday 16
Slade Business with Elton and Charlton...about the dinner, and the decoration of the bridge in Queen Victoria Street for the King's Jubilee. Rang up Polunin and the City Surveyor, and arrived at a rough estimate of over £80. Olga Lehmann will do most of it, under Polunin's supervision. He is to have a fee of £15. The College of Art is doing the Ludgate Hill Bridge for nothing, except the expense of materials...

Sunday 17
...Burdett brought young Beddington back to supper, a pleasant, well-mannered, diffident

young man, just back from Italy. Described all the regulations about motor-horns, jay-walking, and innumerable other matters, which now exist under the Mussolini regime. Muss. is not popular now in Florence: they venture to say things against him there. It seems as if the old, cheap, slip-shod Italy before the war was a pleasanter place to travel in than it is now…

Tuesday 19
Saw the Provost about W. Thomas Smith, who will have to retire, at the end of next year, from the Slade, on account of the age limit. He is 70 this July. He is to be given a year's notice…

Wednesday 20
Handed over my drawing of Univ. Coll. to Dr. Barlow for Professor Coker…To Colnaghi's, who wrote asking me to take away an old drawing…It is…of Katherine Mayer… During the day, Aug. John telephoned…[he] has finished the head of Vivien…

Thursday 21
…Zwemmer Gallery…the Hughes-Stanton show is over, but I saw a few of the things, expertly engraved, with a strong D.H. Lawrence obsession in most of them…(Cheque for £12-12-0 for Coker's drawing.)

Tuesday 26
Birdie and I had dinner with the Ayrtons, Guy Dawber and his wife…Dawber, who has done much excellent work for the Artists' General Benevolent Society…dislikes the R.I.B.A. building, and Mrs. Dawber was abusive about it, as befits an architect's wife. Architects all abuse each other. [She]…knew William Strang and his family well, and used to go to those Sunday suppers, and evenings in the studio, in Hamilton Terrace, to which, I, too, often went, and of which I have many pleasant recollections…

Wednesday 27
Urged by a postcard from Sir Andrew Taylor[5] went to the Athenaeum to vote for a man who was up for election – Booth, of Dulwich College. Met Evelyn Shaw there, and Mac-Coll, who informed me that Dodd was up for election too, so I voted for both men, hoping that I dropped my little bits of cork on the right side of the ballot boxes. Congratulated MacColl on his broadcast with Eric Newton, which I had heard much praised by various people, and subsequently bought *The Listener* to see what it was all about. Talked to Sir Andrew, who claims to have persuaded Holden to make many modifications and improvements in the new University building…Shaw has been with Monnington to see Hardiman's completed statue of Haig. Both of them liked it very much, especially the horse, which supplies a dignity that a mere portrait of Haig could not give…Shaw also talked about Jane Monnington's difficulty and slowness in getting down to work. An invitation to dinner is sufficient to put her off for a whole day. She has some big things commissioned by Courtauld and after a year has not even produced a sketch. Of course, she has had the baby in the meantime. Shaw persuaded M. not to send his new Bank picture – the last of his set to the R.A., where it is unlikely that it will look as well as it ought to do.

5 Architect, lecturer and Conservative party municipal councillor.

Friday 29
Slade Dinner, held, for the first time, in the Slade, instead of in the Refectory…

APRIL

Friday 5
Arrived in Venice…

Sunday 7
…Review of Fascists in the Piazza. Every column plastered with placards – 'Duce! Duce! Duce!' Did not stay to see the end of it…

Tuesday 9
Went alone to Padua…The Cathedral (outside) and most of the public buildings and then S. Antonio, followed up by the Arena Chapel…Was much interested in the colour of the Mantegnas, knowing them…in photographs only…

Friday 12
…Saw Alice off at Verona for Innsbruck & Kitzbühel…Spent the day in Verona with Birdie…What impresses me…as before, in Venice, is the enormous importance of Tintoretto. I think the average painter or critic does not do him justice. A marvellously inventive composer, with the power of ten men: dignified and broad in portraiture, excellent in colour – and alive.

Saturday 13
Pottered about Paris. *Golden Arrow*…Arrived Dover…

Saturday 20
Herne Bay with Tom and Dora…Home by the boat train, arriving about 10.30…

Monday 22
Left with Ayrton and Guy Dawber for Limehouse where we worked till 4.30. Dawber is singularly fit and untiring for a man of over seventy…Decorations going up all over London for the Jubilee. Photographs of Slade students doing their bit in the *Illustrated London News*.

Tuesday 23
Slade began…

Thursday 25
W. Clause came in…showed him some photographs of Tintoretto's paintings, and my own drawing of the Bianca Cappello palace in Venice, which he liked. I modified a shadow at his suggestion…Burdett…has bought the head of Vivien for Sir Keith Murdoch, offering, at Arnold Mason's suggestion, £300 instead of £400, on the grounds that exchange is so much against Australian money that, in paying £700 for the two paintings, Murdoch is really paying the full price. John accepted the offer…

Friday 26
...Talk about Stanley Spencer's resignation from the R.A., which is in all the papers. Everyone agrees that his attitude in wanting his pictures back from the show is absurd, and that he hasn't got a leg to stand on. He should have resigned with dignity, if he wanted to, and shut up about it...

Tuesday 30
Called on Gerald Kelly, at the Provost's request, to see how he was getting on with the portrait of the late Lord Chelmsford for the College... He was very bored with the painting of posthumous portraits...

MAY

Thursday 2
Going to Lewis in Pelham Street, I met Tonks just by South Kensington Station. He is afraid that Spencer has developed a taste for self advertisement, but thinks very highly of Spencer's *Resurrection* – of its 'spiritual' quality. He says 'old Brown' dislikes it...N.E.A.C. Executive...MacColl sat on me, good naturedly, for talking inaudibly with a cigarette in my mouth, and for not addressing the chair...

Monday 6
King's Jubilee. I remember the other Jubilee in 1897, but...only the High Bailiff's procession in Hemel Hempstead, and myself, at the age of 12, making little pen drawings, certainly very bad, of the doings, and having the drawings reproduced in the *Hemel Hempstead Gazette.* To-day we got up at 6.45 and Alice and I got to the Athenaeum by 8.30...though the crowd was thickening in Pall Mall. Later there must have been about a quarter of a million people in the length of the street. It was a perfect summer's day... though it must have been stuffy in the crowd, and I saw at least fifteen people who fainted or were ill and were removed by the St. John's Ambulance men, who had...a nursing station by the Duke of York's column...Dustmen cleared up every bit of paper on the sanded road, and when the King came, shortly after 11 o'clock, there was no doubt of the perfectly spontaneous enthusiasm of the cheering. Alice saw everything very well from her £2-2-0 seat on the Pall Mall side of the Club, and I saw it, but differently, with Albert R. from the top balcony...

Tuesday 7
Slade...Everyone seems to have been favourably impressed by the King's broadcast... The old gentleman was really moved himself, which moved others...

Wednesday 8
In the evening, Ginger, and Ruth and Hugh. Ginger is still busy with the film, and says that another £15,000 has had to be borrowed...

Friday 10
...1.15 started to draw the arch of Waterloo Bridge over the stairs to the water on the south side, working from a staging to which I climbed from the water level. I was nearly cut off by the tide about 5.30...The Kohns came to supper...He is very bitter about Germany,

most of his deep-seated Germanic feeling being turned to dislike of the country now. The Kohns have been bankers in the neighbourhood of Nuremberg since the early 18th century, at which period, though they conducted business in the city and were received socially by the notables, they were forbidden by law, being Jews, to sleep there: they were obliged to leave before the city gates closed at night.

Monday 13
Lunch with the Douies…to make arrangements about Mrs. Douie's portrait. They have been in Italy…About Mussolini – Douie, in one of his Committees, had to have some dealings with the Italian Government: having some experience of this, he wrote direct to Mussolini instead of to other officials, and got what he wanted in an immediate reply. He was much struck by the general increase in efficiency in Italy under the Mussolini regime. Trains run to time, hotels dare not overcharge because prompt action is taken when complaints are made by foreigners, cleanliness is on the increase, and so on. Looked at Mrs. D.'s wardrobe, and selected a dress for her to be painted in. The Towners came in to supper. John Rothenstein is doing an article on Towner's work for *The Studio*…

Thursday 16
Began a drawing of Mrs. Douie…Went to Richmond…to see Willie Cave…Another friend of my youth…Cave has 2 rooms and a bath on the second floor, for which he pays £60 a year. He cooked the meal himself…and supplied sherry and a bottle of hock…he does all his own house work. Talk about Conrad Dressler[6] and his curious establishment of Frenchmen and others at the pottery on Marlow Common, where Cave and Dyne worked 35 years ago; about Harry Schloesser, now become a lord, who shared rooms with Henry Game (Game was in St. Paul's at the Jubilee, in diplomatic uniform) in our Slade days; and about George Moore, whom Cave met at dinner at Will Rothenstein's, talking greatly and purposely shocking a woman guest to whom he took a dislike…

Sunday 19
…Asked the Burns…to supper, but Rodney was away, so Mrs. Burn came alone… The[y]…hated Boston. Latterly he was fighting the Governor of the School…which he did not enjoy, and they only stuck it out for three years out of pride…Burn sold about 8 pictures at his recent show, paying his expenses and getting a good press…Ethel Walker helped him to have the show with Reid & Lefevre.

Monday 20
Two items of news in the papers interested me – Lawrence of Arabia is dead, and there has been a serious fire at the Jockey Club at Newmarket. I met Lawrence twice, at Private Views. He was inconspicuous, and unassuming in conversation…The first was at the Alpine Club…at a show of John's paintings after the war. Once he was in a blue serge suit, on the other occasion in Air Force uniform. I had to look hard to realize how remarkable his head was, and how like John's portrait…

Tuesday 21
Richardson, seeing the announcement of the fire at the Jockey Club, dashed down to

6 The Medmenham Pottery specialised in architectural tiles and large wall panels, 1906 it changed into the Dressler Tunnel Ovens Ltd.

Newmarket…and got there while it was still burning. He was afraid it might have been caused by a defect in one of his flues, or by some fault in the construction, but a work-man had left a blow-lamp burning against the woodwork in his dinner hour, so no blame attaches to Richardson. The King telephoned to know about it…

Wednesday 22
Meeting of the Council of the National Society…Decided to propose membership to W.R. Sickert and Stanley Spencer, now that they have left the R.A.. Neither, of course, can be relied on to pay a subscription, but we might have them for a year or two. I have my own theory about Sickert's resignation over the Epstein affair. He says he is resigning because Llewellyn won't interfere on this question over the removal of the figures from the building in the Strand, now taken over by the Rhodesian Gov.^{t.} As a matter of fact, he (Sickert) was asked to withdraw one of his pictures from this year's show, like Spencer was; but, being cleverer than Spencer, did not resign then and there…He waited till he could find an opportunity of damaging the Academy, or at least having the appearance of right on his side.

Friday 24
Board's Exams…Gill went to a party in Gracie Fields's house – John's old house – in Mallord Street…Flanagan asked him. The length of the wall, in the studio, was lined with bottles. There are still some of John's pictures about. Gill says that Richard Wynd-ham's mother was painted by Sargent and that as soon as she died Wyndham took the portrait over to America and sold it for £20,000, when the Sargent boom was going on: he has lived principally on this money…

Saturday 25
Revised the 1st drawing of Mrs. Douie, and improved it. She seemed pleased with it…

Sunday 26
The Dursts came in the afternoon…Durst says that Llewellyn dined with Sickert the night before Sickert's resignation from the Academy was announced. The letter was actually in the post, but S. said nothing about it, leaving it as a pleasant surprise for Llewellyn the next morning…

Tuesday 28
…called on Gerald Kelly to leave some books I have illustrated, so that he could form some idea whether I was a suitable man to illustrate his friend Somerset Maugham's autobiographical novel, which I have not read. I took the John Clare book, and the Blun-dens, and the Arthur Symons and a Curwen Press calendar. I had recommended Clare Leighton to Kelly, on being asked about the work. G.J., who was also asked, recom-mended me. K. has Stephen Gooden in his mind too…

Wednesday 29
Julian Huxley came to see me at the Slade, to know if the Slade would be interested in a scheme that he has for the erection of a building in the Zoo where artists could have special facilities for the study of animals. Naturally, I thought it a very good idea. If it is carried out it will be the first thing of its kind…

Thursday 30
Jean Inglis came in the evening, and talked about Stanley Spencer: how he put up with a great deal in his married life. Hilda seeming almost incapable of doing anything, though not ill. When he was painting *The Resurrection* Spencer washed and fed the baby, took it out in the perambulator and did the shopping…Jean described him getting up on the table in the intervals of these occupations and doing a little more to the big picture. There are of course two children now. Spencer pays for their education. The eldest [Shirin] goes to King Alfred's School: she was looked after for sometime by a friend of Jean's named…Mrs. Harter. Dick Carline isn't a bad uncle, but Hilda remains totally incompetent. Her old mother makes the tea for her. It was left to Jas Wood to wipe the baby's nose at a party in the Carline house…

JUNE

Monday 3
Diploma Exam at the Slade. Russell would not pass some seven candidates, among them Roger Hilton. Congratulated Russell on his knighthood. Young Gilbert got through. He awoke to the fact that he had to prepare a subsidiary subject, Design or Sculpture, about a fortnight before the Exam. Knowing nothing about either, he elected to do sculpture. I pointed out that it was a little late in the day. He said that he had always understood that sculpture was rapid work, and that he had seen his grandfather do a head in about half an hour, so he thought he would try. Anyhow, he produced two heads which were not at all bad, and were passed at once by [Sir Henry Alfred] Pegram. Perhaps he ought to have been a sculptor.

Saturday 15
…[Dropped off] my lithograph of *The Bath* [1917] on Gerald Kelly, who might want it to show to Somerset Maugham in connection with the proposed illustrations to *Human Bondage* (Clare Leighton…wrote me to say that she had read the book and would not care to illustrate it)…

Sunday 16
…The Bassetts came in the evening to discuss leaving John with us one night when they are invited to a party…Birdie told them how we used to take Alice about with us when she was a baby: she used to sleep through a party, such as at John's or at the Summers's, being just put down on a bed somewhere out of the way. I don't remember Alice giving any trouble on these occasions. At the Johns' she used to be put with Poppet & Vivien, who were near the same age: sometimes people used to leave their coats and things in the same room…

Monday 17
The Slade was visited by Constable and Walter Lamb, and a Mrs. Lowe, all part of a committee on higher education in Fine Art, which has to do with the reconstitution of the R.C.A.…

Tuesday 18
Another visit to the Slade, from a second section of the same Committee, with the

chairman, Lord Hambledon, and Dickey…

Wednesday 19
Russell took her song and the beginnings of her quartet to Vaughan Williams, at the Col-
lege of Music. He was encouraging, and will help her to get the song published. He will
introduce her to a singer, who will include it in her programme. Publishers, he says,
won't look at songs unless they have had a public recital. Russell was a pupil of Vaughan
Williams, probably more than twenty years ago now. She went to him un-introduced,
when he was not famous, and asked for lessons in composition, because she liked what
she knew of his work, and because she was not getting on well at the College. He at first
seemed disinclined to do anything for her – asked her who sent her to him…She said
that nobody had sent her…However, he became interested and said he would give her
lessons if she wished. She asked him how much they would be, and he said half a guinea
an hour; but later on he never would take the money…

Saturday 22
Charlton came in in the morning, and Birdie asked him and Daphne to lunch in the garden.
It was the first hot day, and the current fashion for bare legs and sandals was very noticeable,
Daphne following it…Charlton went home about three, to work at a mass of Exam-papers,
and I asked Daphne to sit for me in the shady place near Miss Farjeon's wall…

Sunday 23
…Russell has gone to stay with Conch Andrews at Amersham. She went away in a crazy-
looking get up – a sleeveless dress of an old Provençal printed cotton, a large black cape
buttoned round her neck, Lucien Pissarro's old felt hat on her head (it was too big for
her), and some sennapods and other things in her hands…

Monday 24
Board of Education Exams. Adjusting results in the painting section. Dickey, Gill, Wool-
way, Travis. Dring has done well with his Southampton people…

Tuesday 25
Board of Education Exams. The best draughtsman, who has done some quite distin-
guished work, is a lad named David Bone, the son of a commercial traveller in
Beckenham: he is 17 years old, suffers from curvature of the spine, appears almost wholly
illiterate, and has failed in architecture & perspectives…

Friday 28
Slade Prizes. [Harry] Barnes comes out well…

JULY

Wednesday 3
Opening of School Show, after lunch to Press…Jan Gordon, Marriott, Rutter, Eric New-
ton, Grieg…Jowett talked…at lunch about his war experiences. He told me of a badly
wounded Scot, who passed a cage of German prisoners at the Front: he was carrying a
Mills bomb slung round him, which he seized as he went and hurled into the middle of

the prisoners, saying, 'take that, you b.....s'. Two...were killed. No one took much notice: an example of how decent instincts go under that sort of strain...

Friday 5
...Sherry party at Beatrice Bland's. On the way there called at Lewis's...He spoke of the slump in the print and etching market – how half his trade used to come from the etchers, and that he sometimes made 200 mounts a week for them. Now nobody buys prints, old or modern. It is not only money difficulties that account for this, but fashion. People don't really appreciate pictures for the pictures' own sake, and when fashion has gone elsewhere they are no longer interested...

Monday 8
...Finished up Board of Education Exams. Rothenstein, Jowett and Gilbert Spencer assisting...Two students from Blackheath and one from Southampton were given Royal Exhibitions, which pleases me, and pleases Willie Clause, because we can congratulate each other on the benefits of Slade influence. I swear to God the verdicts were quite impartial, and Jowett, Woolway and Rothenstein have as much to do with them as I or Gill...

Tuesday 9
At 4 o'clock met Guy Dawber at the Arts Club, and drove, in a car belonging to a friend of his to 23 Rotherhithe Street, a small early 18th century house...We sat out on a flat roof overhanging the river on piles, and made sketches till 8.30...The flat roof reminded me of Chelsea, where we used to look into the street from above Mrs. Cook's shop. There was a monkey on an adjoining balcony (there is a whole row of similar houses on the water front), boys bathing, and a great deal of traffic on the river...

Wednesday 10
...Tea with the Barnett Freedmans, Canning Place. Saw a big picture that he is working at – a crowded street scene: and his work on *Lavengro*[7] which is half finished. Among other work that he showed me was a title-page for *Of Human Bondage*, which he said had been discarded. I said nothing about the overtures that Gerald Kelly has been making about the same book. I presume he was approached, as Farleigh has been. The big picture looked very promising. He has just sold another, to Birmingham. Saw Vincent for the first time, a fine small boy...I may find this illustrating job rather interesting, if I get it.

Friday 12
...Called on Nelson Doubleday...about the illustrations to the Maugham book. He is a very large, fine-looking American of about 35-40 years of age: a most impressive physique, and pleasant withal...It appears I am to have the book to do, if the terms can be settled. Farleigh will be disappointed...

Saturday 13
Drew in Perrin's Court...The children there wear bathing costumes in this summer weather...Two other artists were working there – it is a popular pitch...Working men get their hair cut on Saturday mornings in Perrin's Court, and, judging by the sounds floating through the door (with a running accompaniment of wireless), the barber's

7 *Lavengro: the Scholar, the Gypsy, the Priest* by George Borrow, published 1851.

shop is a sort of club for political disputants and raconteurs…

Thursday 18
…R.C.A. Staff Dinner at the Belgravia Hotel – farewell to W.R.…there were to be no speeches, and Tristram from the Chair, enforced this in a few short words (rather an effort for him: he hates that sort of thing…nearly as much as I do): but Wellington very sensibly broke the ruling down, made a speech himself…Will made references to his old staff who had turned up, including myself – 'Schwabe, whom we all love' – an after-dinner utterance which pleased me, though I realize the little value of things said on such occasions: still, the other speakers told fewer lies than usual, and were for the most part quite sincere, and certainly meant to do well by Will, who deserves it…

Friday 19
Diploma Day at R.C.A. Oliver Stanley made a good speech…Jas [James] sent me his book *New World Vistas* [1926] with the story in it – *Influenza* – which is based on a visit to Birdie at 43A Cheyne Walk. Much of it…is truthful description. There are a lot of circumstances that are very recognizable…

Saturday 20
…News of Arthur Watts's death in an air-liner…The liner crashed in the Alps. Mrs. Watts, in Cornwall, has just had her third baby, and has not yet been told…A.W. was always worried about getting old or out of fashion, and so unable to keep up the considerable income that he made. I know it was more than I ever make – roundabout £1600-£2000…He worked very hard, and conscientiously. They saved some money, and bought houses, which they let off. I have known Watts since about 1901.

Sunday 21
…to the Kohns…usual tennis party…Bruno's nephew Dachau has died in Germany… murdered by the Nazis. The[y] say he committed suicide: anyhow he was driven to it.

Tuesday 23
…Committee at the Tate on Exhibition of Graphic Art at Budapest…

Wednesday 24
Committee, Whitechapel Art Gallery, Lord Balniel in the chair. As he is new to the job, it was a little unfortunate for him that a Trustee, one Davis, who represented some Jewish society which holds a Bazaar in the Gallery, chose to make a violent and incredibly lengthy, hectoring attack on Duddington, chiefly, as far as I could see, in the hope of getting out of paying a bill for hire of the Gallery, damage etc.…

Friday 26
…Students' demonstration at Margaret Morris School, Cromwell Road. Alice appeared in two dances, and got through very well. Jack Skinner & Kitty Clarke did very well also…

Saturday 27
Elton reported on the Committee on the Higher Fine Art Education (Lord Hambledon's) to which he and Ormrod went to give evidence yesterday, to present the Slade point of

view and an array of facts.

Sunday 28
Peasenhall. Julian was at home with the Tennysons, and Charles came for the weekend.

Tuesday 30
…Hallam also came home from Eton.

Wednesday 31
Drew the windmill at Peasenhall – 2 days at it.

AUGUST

Starts Thursday 8
Left for Alphamstone: having visited a good deal of Suffolk from Peasenhall…

Monday 12
Back at 20 Church Row…

Tuesday 13
Wrote letters and did odd jobs, preparatory to getting off to Dorset – Sydling – where we join the Wellingtons.

Wednesday 14 – Friday 23: no diary entries

Saturday 24
Corfe [Castle] full of charabancs, and people in beach costume: women in backless dress-es with very little front, and shorts. Lulworth, I am told, is worse – a parking place for innumerable cars, excursions from Lancashire, and the beach like Margate. A change from July 1914, when there was not a soul there except Gerald and Norah Summers and ourselves: and I believe Gerald Summers was the first man who ever drove a car down to Arish Mell, where there are now plenty.

Tuesday 27
Had an enjoyable day – Birdie enjoyed it too – going to Sherborne from Sydling, walking to Cerne Abbas…I drew a little picture of the house with the portico, which Birdie likes, at the corner of Abbey Street, while waiting for the bus in Cerne.

Wednesday 28
Left Sydling, by a little bus packed with people and produce, for Dorchester: train thence. Looked at the sights of Dorchester – the Museum, St. Peter's Church, the Kennington statue of Hardy…

Saturday 31
…Dinner at Roche's…met Paul Nash and his wife, whom I have not seen for years, also Barnett Freedman…and Pitchforth, who was dining with my old Slade acquaintance Edward Gregory. The last two seem to have struck up a friendship while painting in the

country. Chatted with P. Nash about Dorset, which county, of course, he likes. He has given up his house at Rye and thinks of building near Langton Matravers.

SEPTEMBER

Friday 6
Took a Green Line bus to Hatfield in the afternoon, to see whether there was anything that appeals to me from the drawing point of view…I was not lucky, or not clever, in finding a subject for a drawing, but made a note of something. I am sure, with more intimate knowledge of the place, there might be plenty to do there…

Saturday 7
Painted Mrs. Douie, perhaps the last sitting. I have been working on the accessories without her…Douie's brother has shot himself. He was in the Army, and suffered during the War, and in consequence developed insomnia. They had thought he was getting over it, but recently it came on again. His doctor gave him drugs. He went out to shoot rabbits alone, and, as the result of a momentary impulse (Douie is certain), probably under the influence of the drugs, of which he may have had an overdose, sat under a hedge and blew his brains out…

Tuesday 10
The Wellingtons came to supper. Wellington has been to see Henry Moore, who has moved…to Kingston, or near Kingston, in the neighbourhood of Canterbury. Oddly enough there are two other sculptors in Kingston, one a carver of architectural ornament, the other Ernest Cole, of whom I have heard nothing since he gave up teaching at the College of Art. It is odd how he has sunk into obscurity since his early fame, his encouragement (I think overdone) by Ricketts & Shannon, who praised, too highly, his Michelangelesque drawings, and his work on the County Hall and elsewhere. His big commissions have always been followed by some dispute, mostly about money. (I believe the County Hall work was finished by someone else.)…Wellington knew him well at the College, but has no answer to his letters now. Cole lives a very secluded life at Kingston…Mrs. Cole sent a message through the Vicar that Cole did not wish the other man to speak to him in the street.

Sunday 22
…Russell and Ginger to supper, and afterwards the Hagedorns. Ginger's great film is now being 'cut', about half being done already. It has cost £60,000. Feher is now busy with his 'talkie' version of *Dr. Caligari*. The other film is called *The Robber Symphony*.

Tuesday 24
Left for Boston with Hagedorn…Put up at the White Hart, a pleasant old-fashioned rambling inn, with views from the bedrooms over the Witham and the Stump. The food good as Hagedorn, who is fussy in such matters, agrees...

Wednesday 25
…Drew from a wharf in the afternoon…The premises belong to a firm which seems to have something to do with feathers, which (and dust) blow about in great quantities…

Saturday 28
Finished the second drawing…left at 7 for London…We travelled behind the *Silver Link*, the new stream-lined railway engine, the only one that has done as much as 112 m.p.h. on trials. There were little crowds at Peterborough & King's Cross to look at her…

OCTOBER

Tuesday 1
Did my first drawing of E.E. Sikes, of St. John's College…Constable arranged this commission. He is a genial little scholarly old gentleman. He has practised modelling a little as an aid to his lectures on Greek Sculpture: very sensible: even the slightest practical acquaintance with the arts is an assistance to talking about them, or criticizing…

Wednesday 2
Spencer Gore's son [Frederick] came to see me…seeking advice as to whether to go to the Slade…and…the value of a Diploma…An agreeable young man, who will have great difficulties to face, as he has very little money…Dined with Burdett, at the Spanish Restaurant…Met Ravilious, while waiting. He had gone to dine at the Café Royal, but found that he had made a mistake, and that his dinner was next week…Burdett has been seeing Despiau, J.D. Fergusson and other artists in Paris. Discussion still rages about Picasso. Fergusson thinks many of his works masterpieces. A Spanish painter (Ortiz?) disagrees, and Fergusson has no very convincing reasons to offer for his opinion. It is, of course, difficult to define one's reasons for liking a picture. Despiau appears to be a charming person, and has recently done a male figure which Burdett liked very much – somewhat in the attitude of *Le Penseur*, but not so big; he seemed anxious to show that he is not only a modeller of busts…The Spanish painter had known Modigliani, and said that John had befriended M. when he was very poor, and ill. John gave Modigliani 500fr. Probably the pieces of sculpture by M. at Fordingbridge were given in exchange for this generosity…John advised him to be a painter rather than a sculptor, and he seems to have followed this advice…

Friday 4
At the Slade in the morning, interviewing newcomers – about 30…Committee on Bucharest exhibition…Tate Gallery…

Saturday 5
…Went into Low's studio in Heath Street to borrow two drawings for the Bucharest exhibition. He consented willingly, and showed me some of his illustrated books, which I did not know: one on Russia. He will borrow a caricatured portrait of G.B. Shaw: does not want to send his *Evening Standard* cartoons, which he calls 'rush work'…

Monday 7
Slade began.

Thursday 10
Slade – an extra day, to look through the Summer compositions, which I did with Charlton. Allan Carr's first shot at this sort of thing is very hopeful and Brinkworth has some

good qualities. Rang up Lowinsky, to try to persuade him, on the part of Martin Hardie
and the Committee for the Bucharest exhibition, to lend some of his Charles Keenes and
Samuel Palmers. He refused, and finally gave his real reason for doing so: a detestation
of the nasty Nazi way the Roumanians have treated the Jews…

Friday 11
Called on Hind at the B.M. about borrowing Contemp. Art Society drawings for
Bucharest. Selected a MacColl, a Spencer, a Beatrice How, a John Nash and Vivian Forbes's
drawing of Matisse. Hind showed me Hagedorn's landscape, which has been given to
the Contemp. Art Society and which he likes…Roy Carr came to dinner (Jack Straw's)…
He says that there was cheering on the Stock Exchange when a newspaper report came
out that the Abyssinians had massacred 2500 Italians; and English blackshirts were hustled
and ragged by Stock Exchange members.

Monday 14
Slade…Dined with Somerset Maugham at the Café Royal, in the room which preserves
its old decoration. We discussed *Of Human Bondage*, I trying to get some lead from him
as to what his own wishes were; but he seems inclined to leave me a pretty free hand.
He is in favour of my asking a fairly good price from Nelson Doubleday. I suggested
£10 a drawing, which, if 24 drawings are wanted, won't be too bad…He seemed very
amiable, and we found much in common to talk about. He stammers much as I do, but
much more in ordinary conversation. It is this infliction, of course, transmuted into a
club foot, which makes him so sensitive in the autobiographical parts of the novel. Kelly
told me this. Kelly has been painting S.M. again…

Tuesday 15
Jury of the N.E.A.C.…Two of my things were given 'A', which was not too generally
done. Most were 'B'.

Wednesday 16
Hanging at the N.E.A.C. The invited works by older members stand up very well, and
one wall looks like a section of the Tate Gallery. There is Clausen's portrait of *Mark Fisher*,
John's *Oliver Elton*, three portraits (two recent) by Fred Brown, a Steer, a good Holmes,
a Rothenstein & a Dodd: besides a big Sickert, golden in colour and looking like a portion
of a vast work by Tintoretto. We have a large new Stanley Spencer, full of his usual excel-
lences, another, *The Lovers*, that was rejected from the Academy, a good but crazy work;
another Sickert, 3 more Johns, recent and not so good as they might be from him, and
the Nash's. Jowett is very enthusiastic about a Paul Nash oil. The hangers are Holmes,
Nevinson, Jowett, Cundall ('what do we do this for?' says he: 'we don't get anything
out of it. I suppose it gives us a sense of self-importance') Ethel Walker (perfectly useless,
and a nuisance, dear old thing), myself, and Thornton and Clause ex-officio.

Thursday 17
Hanging again. In the course of the afternoon disagreement between Holmes and myself
led to unseemly words…Holmes was overruled. Luckily he never bears malice. He is
67…and got tired and cross. I felt that he might think that the younger men hadn't given
him credit for what he had done, and for his really great skill in hanging: so on reaching

home I wrote him a note, expressing the general appreciation. I told Clause I was going to do this, and he agreed that it would be a good thing. Saturday, Holmes's reply was, of course, charming. He said something, in an exaggerated way, 'Of the madness which fell upon me and reduced me to the condition of a foul-mouthed, swollen-headed ___'.

Friday 18
Slade. Prize giving for summer compositions. [William] Brinkworth & [Lydia] Rogen-hagen shared the first prize. Not perfectly satisfactory, but the best we could do. Allan Carr was one of the seconds, and Mary Fedden, and Fairlie Harmar's niece Miss Pomeroy. Dinner with Rodney Burn, his wife and sister-in-law, both of whom sit to him a good deal and, I must say, are excellent models to paint. He talked about Stanley Spencer, and old Mrs. Carline's version of his engagement and marriage. After Stanley & Hilda had been engaged some time he announced one day that he wouldn't marry her till he had found God. Mrs. C. asked how long he thought that would take – a week, a month, a year? He didn't know. Apparently, a fortnight or so sufficed…Spencer supervised the details of the bride's costume, and decided that a veil would be wrong. At the last moment, on the steps of the altar, he had qualms about this, and thought the ceremony should be postponed till a veil could be procured. However, they got on without it. Then it appeared that Gil. would be lonely if Stan and Hilda went off on their honeymoon and left him behind, so he went with them. It was not a great success. The brothers squabbled and took little notice of Hilda. Stanley took on the housekeeping, because Hilda was so bad at it…

Saturday 19
A further recollection of Burn's gossip – John made himself unpopular in Boston. He painted the portrait of the Governor of Massachusetts, who thought John charged too much for it. No price was arranged beforehand, though John had been asked to name a figure. The two men did not get on well with each other, and finally John asked something like £70000 [sic], when the sittings had dragged to an end. It is also related that John threw a cigarette into a waste-paper basket in the studio that he occupied, and set it alight. He had gone out and slammed the door, without noticing the blaze…Someone noticed it, hurried after John, told him what had happened and asked for the key of the studio, so that the fire might be put out. John said – 'My work is no good – let it burn.' This anecdote annoys the Bostonians…

Sunday 20
…Lucilia Japp and Juanita came to tea. Had not seen them since Chelsea days. Darsie is with Wyndham Tryon in Spain: he, too, is now doing 'abstracts'. Mrs. Japp said that when Stanley Spencer got his £1000 cheque for *Resurrection* Louis Behrend, to pull his leg, sent the representative of the Rolls-Royce firm to call upon him. Spencer at first took this quite seriously, but Behrend was frightened that he could smell a rat and be annoyed: so he told Spencer that Darsie had done it, and told Lucilia, hoping that Japp wouldn't mind. He explained that Spencer would probably never finish the Chapel if he knew it was a little joke of Behrend's. Anyhow Spencer was annoyed over what seems a silly joke.

Tuesday 22
Prof. Fred Brown is apparently a little disappointed…that his large self-portrait at the

N.E.A.C. isn't as well hung as he would wish. He told Clause…Dined with Mrs. Hilda Guest in Belsize Park Gardens. Adrian Hill and his wife were there….Hill now teaches at the Westminster. I had not met him before. He says that he has used *Historic Costume* in his illustration classes…partly because of the costume, partly because of the technique of line drawing: very gratifying…but I don't know whether he is a good judge. The Westminster School is being firmly reorganized under Kirkland Jamieson. Smoking, which used to be general when I was there under Walter Bayes, is banned except for certain limited opportunities. Students don't smoke while they work. Three offences entail expulsion…

Thursday 24
…Called at Sir Stephen Gaselee's house near Gloucester Road (S.K.) to see two war drawings by W. Roberts, which he is willing to send to Bucharest…There was a show of pastels going on at Colnaghi's, by little Arnold Foster, a queer type who was at the Slade with me. I believe he did some very good administrative work on the blockade during the War. Fairbairn, the police chief in Shanghai, and his wife called on us in the evening. He is a great friend of Uncle Bill's, and taught Alice jujutsu out there. He spoke very highly of Uncle Bill as a friend and as an old member of his corps of snipers, and described with gusto the great day in 1932 when a small police force got the better of the Chinese mob, who were dangerous and numerous. They tore up rickshaws and shutters from shops to make weapons, and threw stones and other missiles. Altogether, throughout the city, there were at least 15000 rioters about. Fairbairn's men retreated at the double to convenient fighting ground, their retreat, of course, encouraging the hostile crowd. At a suitable point the policemen, professional and amateur, held their ground and charged again and again, laying about them with cudgels. 200 Chinamen were removed to hospital without a casualty on our side, Uncle Bill, so Fairbairn swears, laying out at least twenty. He says, moreover, in so many words, that Uncle B. is one of the finest revolver shots in the world at a moving target, and one of the quickest. Uncle B.'s ambition now is to sail home on the boat that Lentilhac and he have in Shanghai. Fairbairn gives him credit for having much to do with the bullet-identification system, and the invention of a real bullet-proof waistcoat, superior to that used by the U.S.A. police. We liked the Fairbairns. He, a fine type, not well educated, with a common accent: entirely self-reliant, courageous, quick-witted and honest: she, a middle-aged woman, a very fitting counterpart. He told me something of third-degree methods used by our police. The only thing, apparently, that frightens Mrs. Fairbairn is the escalator on the Tube railway.

Saturday 26
Went in the afternoon to Cambridge, at Sikes's invitation, to a feast in St. John's College…My drawing of the President was on show, but I had no comments on it except from Constable, who is paying for it (£20)…

Thursday 31
…At home Mr. Gurney of the Medici Society called…to look at some work…for reproduction on Christmas cards. The fee suggested was £3.3.0. He is a youngish man, an Etonian; I believe he has less sense of what the public wants than I have. He went away with a portfolio of drawings to think over…

NOVEMBER

Friday 1
Took a drawing into the London Group. I met Rupert Lee and Diana Brinton…

Saturday 2
…Birdie got away for her week-end in Edinburgh with Charlotte…Went to Kingston to stay with the Kohns…

Sunday 3
Bathed with Kohn in the lake at the Wilderness before breakfast, a performance which was repeated every morning of my stay. A large party of Jew refugees, about fourteen… was entertained during the day. I remember chiefly Franz Reizenstein the pianist (Kohn's nephew) and a cellist from Palestine named Chavivi…

Monday 4
Slade. Lecture, very confused, by Prof. Alexander, O.M., of Manchester on Beauty and Greatness in Art…

Thursday 7
…Went to Tooth's…to see some portrait drawings by Stanley Spencer. I was asked to do so by the Dept. of Overseas Trade. Tooth's had a show of them, unsuccessfully…they are now put away. I asked the price of one. It was £10; but they don't sell. Went on to the N.E.A.C. exhibition…Thornton's pamphlet on the Club's history says something very handsome of me as a draughtsman. Since MacColl had scrutinised, and practically re-written, the pamphlet, I was the more pleased that he let the sentence stand…Ethelbert White has resigned from the New English. He had a picture rejected. I voted for it when it came up, as I thought it good enough. As a matter of fact it was not rejected. He was asked to withdraw it, as he had sent one too many. I didn't get this clear at the time. His complaint was that he was only represented in the big room by two small sketches, which incidentally were very well placed and both sold. The whole thing is absurd. He sold two water-colours as well. He is touchy about such matters. Of the others by him that are hung, three have been sold. Twenty five works in all had been sold up to to-day…

Friday 8
…Worked in Hampstead all day on a 'rough' for *Human Bondage*. Birdie came home about 6…

Sunday 10
Went to see Walter Bayes in Parkhill Studios. Saw a lot of pictures done this summer at Boulogne. Ruskin says something, somewhere, of a derogatory nature, about artists who have a fondness for purple. Bayes uses purple too much. He says he used to use a lot of chrome, too, which I have always thought a dangerous colour…

Monday 11
This was the first time official Armistice proceedings in the Great Hall at the College were discontinued. Only the two minutes' silence was observed. Went to the Central

Telegraph Office in St. Martin's Le Grand to judge the works of their Art Society. They
have a class once a week, which about 30 employees attend. It is run by another employ-
ee, a water-colourist and carver in wood. Some of the work done in oil & water-colour
is above the usual amateur level. It seems that the Government realizes the uses of edu-
cation, probably as a means of keeping the working people out of mischief, and filling
their small leisure with satisfying employment; and Art for the People is much to the
fore. I don't suppose we shall sell any more pictures on that account.

Tuesday 12
Hung a lot of pictures at the Whitechapel Art Gallery, and had lunch with Duddington...
[He] went to Russia in 1914, before the War began, and was held up there for a con-
siderable time because he couldn't get a ship home. One that he might have gone on
was torpedoed off Newcastle on the outward voyage. The Russians were jealous of Eng-
land because they imagined we had designs on the Caucasus: a ridiculous idea, never
heard of over here, and probably, as Duddington suggests, fostered by German propa-
ganda. Conversely, no one in Russia had ever heard of Russian designs upon India, which
idea was a common English bogey before the War...

Wednesday 13
After the Slade, Executive Committee of N.E.A.C....Not sympathetic about Ethelbert
White. Sales are over £600, which is much better than usual...

Thursday 14
Went, after a morning at the Slade (letters, and doctoring Bayes's exam papers for the
University) to the N.E.A.C. with Birdie. She particularly liked Prof. Brown's things, & a
charming Milly Fisher Prout, and the John flower pieces, and W.R.'s old pictures of barns
at Oakridge. Dinner with the Dursts. He has done a font for a church near Manchester. I
think his manner is very suitable for the job, and it has come off very well...Durst is
definitely against abstractions of the Henry Moore-Hepworth-Nicholson kind.

Friday 15
...Visited London Group, where I met the Farleighs...An absurd Sickert, the older mem-
bers, Vanessa Bell, Thérèse Lessore and others, look tame beside the more demonstrative
younger ones – Hans Feibusch etc. Moynihan & Tibble reduce the painting of pictures
as near to nothingness as possible...Charlton who came in with Daphne after supper,
says that Tibble & Moynihan hardly see each other owing to some disagreement and
jealousy between their wives. This being so, it is the more remarkable that their 'pictures'
are so alike, in colour and nothingness. They work very hard and earnestly...Tibble, the
son of a wholesale provision dealer in Reading, with a handsome allowance from his
parents, is curiously mean, and a maniac about tidiness in his studio...

Saturday 16
Drew Dr. Bethune-Baker in the morning. He is a theologian, has preached in St. Paul's,
knows hardly anything of London after fifty years of Cambridge...Though abstemious,
he quotes with approval a saying that theology flourishes on red wine. He was dressed
un-clerically, and I asked him to wear a parson's collar next time...Cocktail party at Egan
Mew's...Max Beerbohm and his wife and Gertrude Knobloch. Max was amusing, taking

up whimsical ideas and playing with them; nothing much to remember, but entertaining at the time…

Sunday 17
Drew Dr. Bethune-Baker again. The portrait is destined for the Divinity Schools. In the evening went to the Ballet Club in Ladbroke Road, Notting Hill Gate…The Club…is run by Mrs. Ashley Dukes (Mlle. Rambert), now looking elderly…They put on a series of divertissements from *Aurora's Wedding* which I remembered, unfortunately for my evening's entertainment, being much more perfectly done by Diaghilev's company at the Alhambra…

Thursday 21
Birdie went to lunch with Margery & Albert Rutherston. Margery drove Birdie home to no. 20, and became very confidential about Albert, whose conduct worries her. He has a studio, but he seems afflicted with an inability to work. He goes to the studio, and, she supposes, falls asleep…He has a job…to design a tea-set…it just lies about the studio. He is not producing any other stuff of his own, and, she says, seems to live almost entirely on the past. He is absorbed, on the other hand, in the decoration and arrangement of the new flat, and sits about looking at it till she turns him out. I am sorry if there is serious cause for anxiety. Albert is a good artist and promised so well thirty years ago: but he never excelled the painting he did at the Slade. Went to the Lee Hankeys after supper: the Ethelbert Whites, Mrs. Copley…Ethelbert is still disgruntled about the N.E.A.C.; and both he and Lee Hankey appear to resent Job Nixon being made a full R.W.S. ahead of them. Lee Hankey despises water-colour artists, Ronald Gray and so on (me, too?) who don't use plenty of colour – 'strong' colour: and he says that Dudley Hardy was one of the best painters we ever had. White says that he taught Nixon how to use water-colours…All this sounded to me so petty and stupid, that, though L.H. is a kindly fellow in the main, I felt out of sympathy with him and his pictures…

Friday 22
Drew Dr. Bethune-Baker…he dislikes the second drawing I did…feeling…that it makes him look an old fool. I…consider he has a more distinguished appearance in the profile that he detests than in the full-face views…He talked a good deal about his friend Dean Inge, who told him that his income from journalism had at one moment reached five figures…

Sunday 24
…Dinner at Jack Straw's. Called on the Towner's afterwards. Blackshirt meeting by the White Stone Pond. About half a dozen policemen, with an inspector, stood by…Towner…thinks of going off to Harting if the weather remains fine, to finish a painting of a country house near there…John Nash's little son has been killed, falling from a motor-car driven by Christine Nash. Tragic – it was a child born late in their married life, after much forethought had been taken about it.

Thursday 28
Worked on an idea for an illustration till 12 o'c. Went to the Slade to collect some pictures together, two of which I took…to Mrs. Marchant in Berkeley Square, and six to

the Fine Art Society, who are going to have a show of inexpensive water colours, from 4-12 gns....continued down Bond Street to go to Ginner's show, dropping into Knoedler's in passing, where there was a collection of portraits by R.G. Eves. This is a more skilful fellow, and a better painter, than I had thought. He should get a lot of work to do. His drawings are the work of a man who doesn't spend much of his time in drawing. Ginner was alone in the Leger Gallery, and has only sold one drawing so far, for 11 gns. He is hopeful about the sale of an oil. The emptiness of these two last galleries was a contrast to the business of Sotheby's, and Agnew's, where I went to complete my surfeit of pictures with Derain. Here there were some excellent paintings of Gravelines, a good powerful still-life and some portraits, alternately woolly and emphatically characterized; one with reminiscences of Greco in it, which Rosemary Allan, who was there, described as 'rather an eye-full'...

Friday 29
Received a cheque from Douie for the two portraits, £85. As I have an unforeseen bill from my income tax expert (£37) it was very welcome...

DECEMBER

Sunday 1
...I gave Hagedorn a drawing of Waterloo Bridge, as I owe him one in exchange for the one he gave me. He has been elected an R.B.A....

Monday 2
Cunnington, a Slade student who left at the end of the summer term, has committed suicide. This is the fifth case in the 35 years I have known the Slade – Lightfoot, Currie, Frances Jennings, a foreigner whose name I forget, and now this poor fellow. He had a job as art-master in a good school at Rugby. A few days ago he disappeared without saying anything of his movements. The police were informed, and he was found in Bloomsbury with his head in a gas-oven. He was of a serious, neurotic, over-earnest type. He told Elton that the Slade was a depressing place...It was through the Slade that he got his job. It was not his first experience of art teaching – he had done it before, and it was his own choice of a career. Perhaps he had some reason we don't know for killing himself...

Tuesday 3
Cocktail party at the Maitland Davidson's[8]...Reginald Bell told us, of Adrian Stokes, whose death was announced this week, that he was at the Arts Club about 10 days ago, and drank the best part of a bottle of burgundy, with a triple brandy to follow: he said his doctor had told him that he would kill himself if he did not give up alcohol: he replied – 'I would rather kill myself than be killed by a bloody doctor'. He was about 83, and died of a chill...

Wednesday 4
Visited the Chinese Exhibition at Burlington House for an hour. Met Sachy Sitwell walking round with [Arthur] Waley, both damning it as a rotten show. Maresco Pearce was

8 Margery Maitland Davidson was a novelist.

inclined to do the same, but other artists whom I met were enthusiastic (Dugdale, Ratcliffe & Ed. Gregory). Gerrard, too, who took a party of Slade students yesterday, was very appreciative...

Thursday 5
Durst's show opened at the Leicester Galleries. The other rooms were given up to Rackham and Blampied. The latter is one of those artists whom I have always thought bad, or at least commonplace and second rate, but who surprises one by doing a good drawing now and then...Durst has an awkward ugliness in his treatment of human figures, to which I cannot reconcile myself. In his animals it is not apparent. He is a very good craftsman, though, with great understanding of various materials.

Sunday 8
...9 o'c. Polunin's cabaret party. Durham Wharf Studio, Chiswick Mall...He had asked 300 people and 450 came, the odd 150 being gate-crashers. The Studio is the workshop of a Mrs. [Julian] Trevelyan, who makes pots, and was borrowed for the occasion. It is right on the river. A theatre was set up in one part, and a bar, with kegs of beer and bowls of mulled claret, in another. A.P. Herbert's daughter looked very beautiful, I thought, behind this bar, where she served the drinks. Tatiana, too, looked well in an old Russian costume; so did the Slade girls in the performance – Annette Scott, Lehmann & Labouchere. Sokolova danced, but the stage was very small, and she had hardly room for more than arm-movements. I reminded her that I drew her and Woizikowski years ago in Lansdowne Place, an incident she had completely forgotten...

Monday 9
Called on Durst...after attending Dr. Kirk's Anatomy Lecture in order to make notes for an illustration...He told me of dissensions in the London Group. There is a feeling that Rupert Lee has been President long enough, and that Diana Brinton is a bad Secretary. Lee and Diana resent this feeling, and won't go gracefully. There is a movement to make Ginner President. It is true he is deaf and can't hear what is said at a meeting, but he is impartial and has no enemies...

Tuesday 10
...went to the Athenaeum where I met Max Beerbohm. He was full of talk about Yeats (whom he would like to be a member under Rule 2) and Blanche, and Thomas Hardy, and George Moore. Hardy was a rather shy man, with dignity and good manners. George Moore was not always such an egoist, nor had he always such a good opinion of himself, as was latterly the case: he used to look up to Yeats when he was young, and praised his poetry and his oratory. Max says Yeats is no orator: a pompous speaker...

Wednesday 11
After the Slade, a meeting...about the Abbey Scholarship & the Rome Scholarship running in double harness. Evelyn Shaw, Jackson, Russell, Monnington and myself. The Council of the Abbey School is dissatisfied with the working of their scheme. The programme for students who go to Italy with the Abbey money is extremely absurd – a sort of penitential course of study, almost impossible to get through...and very little use...to a

creative artist. All sorts of measured drawings and copies are recommended. Venice is to be visited solely for the sake of the Carpaccio room in the Accademia: not a word of Tintoretto, nor of anything else. A.K. Lawrence drew up this scheme.

Thursday 12
Dinner with the Constables. They have a flat...on top of the Courtauld Institute...The dining-room is modernistic. It appears to have been decorated by John Armstrong before the Constables came. ...

Monday 16
Cocktail party at Beatrice Bland's...The Shepherds, the Pearces, Edna Clarke Hall's son, Lady Carlisle, Mrs. Robertson, Allan Walton...Shepherd has a job to do a group of Sir Michael Sadler and fourteen colleagues at Oxford. Some younger artist had the commission first, but made a mess of it...Ginger came to supper, still enthusiastic about his film interests – *The Robber Symphony* and the talkie of *Dr. Caligari*.

Tuesday 17
...Slade. Doubts about Franklin White, who seems very irregular and slack in his attendance, and leaves too much on the hands of Brooker and Charlton...

Friday 20
Slade Dance, which went off without any contretemps...

Saturday 21
Went to the Slade to clear up...Charlton, Gerrard, Elton & I drank a left-over bottle of champagne. Tipped the Beadles. Went to...Batsford...He seems favourably disposed to my scheme of making a book of London drawings...Dinner at Roche's – Birdie, Alice and Ginger. We adjourned to the Hotel Splendide where we found Feher and Hans and a Greek gentleman who is apparently helping to finance the films. Feher behaved in his usual lavish way, supplying liqueurs, coffee and a bottle of champagne in his rooms afterwards, where we heard gramophone records and looked at stills of *The Robber Symphony*...

Tuesday 24
...Left for the Tennysons at Peasenhall...

Wednesday 25
A fairly quiet Christmas...

Saturday 28
Left the Tennysons for Alphamstone...

Monday 30
Left for Dover...

Tuesday 31
Went over to Whitstable...I wanted some ideas about 'Blackstable' for Somerset Maugh-

am's illustrations. Looked over the harbour, the town, and the old Vicarage where Maugham's uncle used to live…Back to Canterbury, and looked at the Kings School, again with a view to using it…for my illustrations (…Doubleday's now offer me £250, for 24 drawings)…Back to Dover.

1936

Schwabe is much occupied with completing illustrations for Somerset Maugham's Of Human Bondage, alongside undertaking various Slade duties and judging for the Prix de Rome Scholarship. As usual holidays are a time for daily drawing, in August Schwabe took the opportunity to visit Luxembourg with his good friend, the architect Max Ayrton. The previous month he visited the Salvador Dali exhibition at Lefevre's having missed the International Sur-réaliste exhibition which had all London talking. Notable events at home and abroad are recorded including the death of King George V, the Spanish Civil War, a Fascists' meeting in Oxford and the abdication of Edward VIII.

JANUARY

Saturday 4
Dr. Richardson showed us in the drawing room at 6 Cambridge Terrace [Dover] a film of his own making showing some operations at the hospital. One of them was a Caesarean – one saw the procedure very clearly. Another was the amputation of a leg, performed on a boy who had been run over. Tom [Cobbe] figured in the pictures. The operations were skilfully done, no doubt, otherwise the surgeons would not have liked to have the films shown. I see that the cinematograph camera may be of great use to the surgical and medical professions.

Monday 6
Slade began…

Wednesday 8
…after the Slade, drew Miss Sallé in one of the Life Rooms. She talked a lot about Nina Hamnett, whom she knows, and meets in Charlotte Street. Nina, she says, was living a little while ago with a 'tough guy' who knocked her about and blacked her eye…

Thursday 9
…Rosalind Ord…dined with us. Birdie has engaged a cook to come in for a week in the evenings. Rosalind is going to give up teaching at the Royal School, [Bath] and concentrate on the tile industry. Daphne Charlton came in in the morning to talk to me about the Moynihans' affairs. Sometimes they are literally down to their last sixpence, and they have the baby to support and to look after. Moynihan wants teaching work – suggests coming back to the Slade to do some ordinary representational drawings of the model, to show prospective employers, who may not like the other stuff he does. He even talks about giving up painting altogether and becoming a clerk…

Friday 10
Alice went to a party at the Savoy, on Allan Carr's birthday. Mary Fedden went too…As showing how inaccuracies creep into current anecdote, (no doubt this diary is full of them, though I am fairly careful), I, happening to mention a story which amused me in

Edmund Gosse's *Life*[1] [1931], about some actresses calling on Henry James at Rye, find from Mew, who was in Rye at the time and knew the ladies, that they weren't actresses at all – weren't even made up – and that James, for all that he was a judge of character, entirely misjudged them. He described one, according to Gosse, as having 'a certain cadaverous grace', but the point of the story completely goes when it turns out that they were quite a different sort of people from what he thought. One was Mrs. Clarence Rook,[2] the other, if I remember rightly, Mrs. James Welsh.

Saturday 11
...Ian Strang's Private View at the Leicester Galleries. His drawings looked better than I had anticipated. Guy Dawber liked them. Mrs. Lucien Pissarro, who was there, obviously dislikes them – says they are 'too careful'. Seven or eight were sold...Ian and I went off to the Café Royal, Mrs. Strang cautioning me cheerfully not to give him too much to drink...He told me much about Les Baux and the Olive Branson[3] murder there, and amusing stories about an ex-maquereau from Marseilles who is President of the Bouches-du-Rhone Department. A joke of Ian's addressed to a man who had drunk a good deal of white wine at dinner – 'You speak with a Graves accent'. 'Which is a grave accent?' asked the man, sloping right or sloping left?' 'It's the one with a list to Port', said Ian...

Sunday 12
Worked all day on an illustration...Durst called in the afternoon. There is now a proposal that Sickert should take Lee's place as President of the London Group...

Monday 13
At 3.30 attended at the offices of King Edward's Hospital Fund in Old Jewry to judge some posters for which a competition had been organized. Jowett and John Hassall were the other judges. Hassall seems a singularly well-preserved active man for his years, if the stories of his drinking are true. We went up on to the roof of the building, from which there is a fine view of roofs and steeples. At one point, St. Mary-le-Bow comes exactly central with St. Paul's dome, cutting through the middle of it. Had tea with Jowett, who is getting a little sick of conferences on art and industry. Nothing has been settled about the future of the College of Art. He describes Gilbert Spencer interviewing new students – 'Are you prepared to starve? – You must be, if you want to be a painter'...

Tuesday 14
Judging for the Rome Scholarship. As usual, I voted for a candidate who did not get it, but was no.2 on the list. Monnington and Jane, too, voted for either no. 2 or no. 3. Afterwards, a meeting...to discuss the running together of the Abbey and Rome Scholarships in Mural Painting. Cameron in the chair. A.K. Lawrence made a protracted but feeble defence of his absurd measures for regulating the Abbey major scholarship – an exhausting and inhuman programme of copying the Italian old masters. Nobody else

1 *The Life and Letters of Sir Edmund Gosse*: Schwabe is referring to Gosse's letter to Maurice Baring in which Gosse describes staying with James who had told him about the 'young actresses' coming over from Winchelsea to see him.
2 Rook was a writer and journalist, best known for *The Hooligan Nights* (1899). His wife Clara was a minor artist.
3 A wealthy English artist who 'sought what she called "the original man", and when she finally found him... he murdered her.' *Milwaukee Sentinel*, June 16, 1929, accessed 12/10/15.

liked it, not even Charlton Bradshaw, who is on both the Abbey and Rome councils. I was put on to a sub-committee which advises the scholars as to their plans on setting out. Evelyn Shaw, of course, got his own way entirely. It is he, more than Ernest Jackson, who drafted the new proposals. He puts himself forward as little as possible, but is the 'deus ex machina'...

Wednesday 15
...Cochran is having some scenery painted in Alick Johnson's studio from Ernst Stern's designs, and John (Augustus) has been doing some actual scene painting on a curtain there for some performance...

Thursday 16
After putting in a day at the Slade (Monnington came to the Slade, about a possible job for Ormrod), because I had missed much of my usual time this week, I went to Cooling's in New Bond Street to see the Group of Oxford Painters – including F. Gore, Rowntree, Waterfield...Rowntree is the most developed of them, and has learnt a lot, obviously, from Barnett Freedman. Waterfield is sensitive. Gore has not got very far yet...

Friday 17
Council of the National Society. Dugdale Chairman, Maurice Lambert, Vice. ...The selection of new members for the National Society was assisted by whiskey and sodas all round...

Saturday 18...
Called for Durst, and went with him to the General Meeting of the London Group at Vanessa Bell's studio...over the little iron bridge at the back of no. 8 Fitzroy Street. Over forty people came, and Sickert was almost unanimously chosen President. Bayes proposed that Rupert Lee should remain as Vice President, because Sickert will not have much grasp in the conduct of the Group's affairs. Durst proposed...that R.P. Bedford should be Vice. I voted for Lee, thinking he had in many ways done well in the past ten years; but a number of people dislike Lee and Diana Brinton, and the upshot was that Lee lost the election by a few votes; Diana going out too, her place being taken by some woman whose name is new to me. V. Bell was of the Lee Brinton faction. Farleigh was hostile, and there was an undercurrent of bitter feeling...

Monday 20
Slade...Letters...kept me busy when teaching didn't. At home, on the spur of the moment, and as the result of a conversation with Birdie about Burdett and his friends, rang up the Chelsea Arts Club and asked Arnold Mason to supper. He came, and was a pleasant guest. He began his training at the Macclesfield Art School, whence he got a scholarship to come to London...He described Aug. John at Martigues as doing nothing whatever for a whole month, sitting at a café most of the time. Very unusual, in my experience of John, who is a great worker.

Tuesday 21
...The King is dead. The regret is general and genuine. There are few men whom more would wish alive...

Wednesday 22
Elton and Margery Rutherston came to supper. Margery talked (a little too much, I thought) about Albert's dread of illness and death, and the innumerable bottles of tonic and other remedies in his medicine cupboard...

Tuesday 28
...It being the day of the King's Funeral the Slade was closed. I finished the third of the revised drawings for Doubleday. This leaves 21 more to do, if possible by July. The guns sounded for the two minutes' silence as Birdie and I were in the middle of lunch...All the shops in Hampstead were closed, though there was no order to that effect. Yesterday, I paid 1/3d to have a black band sewn on the sleeve of Birdie's coat. Several people we know who had seats to view the funeral procession – Hagedorns and Mrs. Russell of Church Row among them – came home without seeing anything, because the crowd was so dense that they could not get to their seats...Others who were in the crowd told me that there was some disorder and lack of reverence in places. People had to be told to be quiet when the coffin was passing...Grimmond, who saw the procession, said there were some unpleasant scenes – hysterical and fainting women, screams, and so on, in the crush that occurred about Marble Arch. The police do not seem to have expected such enormous crowds, and did not altogether keep the situation in hand.

FEBRUARY

Saturday 1
Set out to collect some pictures from the Slade and take them in to the National Society. In Gower Street met Max Beerbohm. As he came towards me I thought, without at first recognizing him, what a very 1890'ish figure he was, with spats, soft felt hat, turned up moustache, and a sort of 'flaneur' walk...He says he is 63 and Mew is ten years older...

Sunday 2
...Grimmond tells me that Tom Poulton has a contract from a firm to supply him with £1,500 worth of commercial work a year. £300 goes off in commission to the firm. McKnight Kauffer's vogue is less than it was, and his advertisements are not so much in demand. Hobson's firm is now doing press advertising for Whitbread. This is a good sign, as the Whitbread standard may improve. I have always thought it extraordinary that a man of Whitbread's culture should permit the abominable posters that his firm makes use of...Ginger came to supper. His film, *The Robber Symphony* will not be out till March.

Friday 7
...Slade, to rewrite Bayes's examination papers for the University General Schools. They were too difficult and complicated, and there have been complaints. ...Dinner...at the Belgravia Hotel, to say farewell to Eaton of the Board of Education. The dinner was given by the College of Art staff, Jowett in the chair. Talked with John Nash, Dinkel, Helps, Harding...and sat between Mrs. Ralph Hodgson and Mrs. Athole Hay. Mrs. Hodgson told me something of Evelyn Dunbar, rather in a sentimental vein. E.D. seems to be a difficult, moody, temperamental girl. Her wall decorations and Mahoney's at Brockley, by the way, are to be publicly unveiled next Friday. Mrs. Athole Hay (Silvia Baker) is still a very fine

looking woman, somewhat like Mrs. Cameron's photograph of Mrs. Leslie Stephen…

Saturday 8
Ginger called and took us in his mother's car to Boreham Wood, to the film studios, to see seven reels of Feher's *Robber Symphony* tried out. It was our first experience of that sort of Hollywood atmosphere. The open fields are stuck with huge 'sets', mostly in ruins: Moorish palaces, an old English village, a castle: and littered with incredible debris, broken hansom cabs, guns, boats and motor bodies. Elisabeth Bergner's company was rehearsing *As You Like it* indoors in one of the studios. I am told a vast forest of Arden has been built up, with real branches at the top and made-up trunks below…Most of the company, in costume, was in the canteen, and among them we found Elliott Seabrooke who has a small part. He says it is one way of finding money to pay for paints and canvases. As he did not appear much, he was not made up with the customary orange paint. Feher's film was most interesting, but most people of the small audience thought it was too long, and would have to be cut. Madame Feher was present, and an intelligent and eccentric German Jew named Kuh, who criticized the film afterwards volubly and learnedly in German. He has worked with Feher for twenty years. I could not help thinking of Elstree and its neighbourhood forty years ago, when it was real country: no arterial road, no 'Barn Club', and almost no houses between Hendon and Mill Hill, each of which was an isolated little place.

Sunday 9
Grimmond and Hagedorn in the morning. Grimmond had been to one of Sturge Moore's poetry readings, of Michael Field. He dislikes S.M.'s way of reading poetry, a high-pitched manner of intoning…

Friday 14
…Alice got her 'Mauve' Diploma from Margaret Morris…Had to attend a Committee, 3 o'c., at the University…to recommend an artist for the commission of painting Athlone, the Chancellor…The Vice-Chancellor has ascertained Athlone's own views about the portrait – Oswald Birley is the man he likes, and he would like to be done three quarter length, to show both his Chancellor's robes and his left knee with the Garter. [Sir Ernest] Pooley, Constable and I were all for Augustus John, though Constable was tactful about Birley, his point being that either you chose to have a work of art, with some risk as to the likeness, or you had a safe coloured photograph. I objected that, of the latter kind, Kelly was better than Birley; Constable doesn't really approve of Birley, but was trying not to antagonize anyone. The greybeard [Vice-Chancellor, Deller] objected to John, because John had painted the greybeard's old friend Hatton, and it was nothing like. Pooley related the history of that portrait. He said there was a first version of it which disappeared, and which was excellent…Probably John went on messing about with it, and ruined it. After an interval, John asked for further sittings and started a second picture. He liked Hatton as a sitter, but Pooley agreed that the likeness was a failure. Agreed, finally, to recommend, as first choice, John: if Athlone won't take the risk, Kelly next, and failing him Llewellyn. The University will pay only £500, but Constable thinks that any painter would drop his price to do this job. I said that if it came to the point I would undertake to negotiate with Augustus…

Wednesday 19
Egan Mew remembers Alice Rothenstein as Alice Knewstub, before she was married –
acting at Toole's Theatre. He remembers her beauty too. She was lucky enough to get an
important part because the leading lady retired, and Alice took her place. I think it was
Mrs. J.M. Barrie who retired…

Saturday 29
…Saw in the paper that Horace Cole is dead. There was about a column describing var-
ious practical jokes that he had played. From my knowledge of him, derived chiefly from
Gregory and Ian Strang (I did not know him personally at all well), he did not always
take jokes against himself in the spirit that he expected others to show when enduring
his. He was very angry when, having locked Ian and Lilian Shelley together in a room in
his house, Ian broke the door down: but he didn't mind smashing other people's things.
I was told that the Navy people were only prevented from flogging him, after the *Dread-
nought* hoax [1910], by his pleading a weak heart. He did, in fact, die of some such
thing. I remember he wrote some verses on Innes's death, which were published…in
the weekly paper that Orage edited. These verses were the only public notice that the
occasion called forth.

MARCH

Sunday 1
…Hagedorn in the morning…He has been to see the Spencer chapel at Burghclere…is
rather inclined to regret the eccentricities of the paintings, but agrees, as we all do, that
Spencer is a good artist. Alma Oakes came to supper. She is working on a book with
Muriel Clayton, on English printed cottons of the 18th century and earlier.[4] By good
luck, I was able to give her some information she had been looking for, by referring to
Ambrose Heal's book on tradesmen's cards.

Wednesday 4
Saw Ramsay MacDonald leaving his house in Frognal, when I took the dog out, a little
later than usual, at 9.15. The policeman who is nearly always on duty…and another man
whom I guess to be a private detective, were there to see that all was well. This seems to
take place every morning, but I usually see only the policeman, the chauffeur, the other
fellow and an Armstrong Siddeley car. After the Slade…dined with the Lowinskys…
Looked at a lot of James Ward's, and at Lowinsky's own paintings, endlessly elaborated
and slow as usual. He takes about a year over a portrait. He is now painting Billy Despard.

Saturday 7
…In the afternoon drew a model, Tiger King, the Aran Islander, who was in Flaherty's
film, *Man of Aran.* He complained that they were made to talk a stage Irish, such as no
one ever talks on Aran…and some of the facts about life on the Islands were misrepre-
sented for the sake of stage effect. He is a fine-looking fellow, a Galway man…over six
feet high. Has been a blacksmith among other things. I drew him in Corfiato's cap and
gown, for my illustrations…

4 Muriel Clayton and Alma Oakes (1954), 'Early Calico Printers around London', *Burlington Magazine*, 96,
614, May, pp.135-39.

Tuesday 10
…Albert R. rang up, deploring…that I had not put up this year…for the R.W.S. He thought I would have got in easily this time. Jowett did, and he only got two votes last time, against something like 17 for me…

Wednesday 11
In the Tube, coming home from the Slade, met Muirhead Bone, who is staying with Aitken in Church Row. He has been printing some etchings with Collins and Dear, who, he says, find it difficult to carry on, the market for etchings being so flat that hardly any-body does any. Bone has aged greatly since I saw him last, and has been having trouble with Gavin (now a Fellow of his College in Oxford), who developed T.B. and had to be treated at Mundesley [Hospital]; so the Bones took a little house in Norfolk, and the Oxford house has been shut up for nearly two years…

Thursday 12
Dinner with W. and Alice Rothenstein…W.R. has bought two pleasant little drawings of Evelyn Dunbar's [for Carlisle]. He thinks that John is the greatest artist now living in Europe – greater than Picasso or any Frenchman. John is quarrelling with him over the publication of part of a letter in W.R.'s *Men and Memories*: it was slipped in through a secretary's oversight: John had been consulted previously about what, of his and Ida's letters, was to be published…

Friday 20
After lunch (I had been hanging the Slade Dinner show…) went with Corfiato to the Greek Church in Moscow Road to look at some work he has been doing there, and at the two arches decorated by Anrep, and the work over the altar by Glyn Jones. We dis-cussed an alteration to the fittings with the Pope, a bearded Greek. Slade Dinner: Speaker, Richardson (new A.R.A.), Albert & Seton White…I managed my speaking with slightly less preliminary agony than usual…

Monday 23
Worked at a complicated drawing of a staircase, for my 13th illustration. Saw the College Play, with Allan Carr as Mr. Pepys in *And so to Bed*. He was good, and Annette Scott was good too. Phyllis Woodliffe, the other Slade student, a little disappointing as Mrs. Pepys…

Tuesday 24
…Leaving [Malcolm] Johnson [of Doubleday, Doran & Co.], I met Warburg in the street with his new partner, Senhouse (he has quarrelled with Routledge, left them, and trans-ferred his capital to Martin Secker). Going into their offices in John Street, which are smaller and not so elaborately decorated as Doubleday's, though there is again a good ceiling, I met Secker. Warburg said I should approach him if I wanted any more books to illustrate, and spoke of the great success of Rothenstein's memoirs. Boots bought up 800 copies in one day. Had to write to Deller about the John portrait of Athlone. I had not read his letter carefully. I had been asked, it appears, to try to get John to do it for less than 500 gns. and I had mentioned the maximum in writing to John. Too late to alter the offer now. Anyhow, it is cheap enough and a great reduction on John's usual price for a ¾ length.

Wednesday 25
Still engaged with the drawing of the staircase. Sent the previous drawing, of two lovers, off to Doubleday's, as they want to use one for advance advertisement.

APRIL

Wednesday 1
...Jean Inglis was at no. 20, when I came home...She is worried because there is a scheme to build a Woolworth shop in the High Street next to her old house, and some of the other 18th-century houses may go to make room for it...and what beauty the High Street still has would be lost. Hutchinson is being consulted about it.

Thursday 2
Telephoned for a man named Roussel, who sits at the Slade...and drew him for an hour: also drew Dora [Cobbe]...both for my next illustration. So far, I have regulated each one of these compositions, after the first designing of them, by the Section d'or. Hagedorn does this too...

Friday 3
...Called on Rutter, who...is still in a bad way...Most of his work for the *Sunday Times* has been done by ghosts lately...Tom, Dora, Margaret, Birdie and I went to Sadler's Wells to the Ballet...Harold Turner and Pearly Argyll very good in a pas de deux from *The Sleeping Princess* – Idzikowski and Lopokova's dance. *The Haunted Ball Room* excellent, and *Façade*, with its note of the English music-hall, very amusing. *Carnaval*, of course, is always spoiled for us by recollections of greater artists – Nijinsky, Karsavina, Bolm and the rest of them round about 1912. Nijinsky was a supreme harlequin, or Pierrot. When he did Pierrot his pathos was almost terrible. Austin, who took that part last night, can have no idea of what Nijinsky put into it. I suppose all these people now are too young to have seen the Russians at their best.

Saturday 4
...London full, it being Boat Race day, and also England v. Scotland at football: hundreds of Scots, noisy but otherwise orderly. Police numerous at Piccadilly Circus.

Friday 10
...finished another drawing and started my 18th, using Dora and myself as models...

Tuesday 14
Slade began.

Thursday 16
Went to 65 Gloucester Place (number now altered to something else [117]) to show the drawings for *Human Bondage* to Kelly and Maugham. Maugham was sitting for a portrait. There are two of him going on in the studio (as well as one of Monty James), both seated, with papers in the foregrounds. Very like indeed. K. and M. were very kind about the drawings, making only one or two small criticisms, and Kelly afterwards congratulated me handsomely, addressing me jocosely as 'cher maître', and saying that what

I had done was what he understood by 'illustration'. Maugham said they made him want
to read the book again. He had not opened it for 20 years. He recognized my background
of Whitstable, and Canterbury, and talked about the original of his character Thorpe
Athelney, a broken-down journalist who died recently in the eighties. His name, as I
remember was Huish. Maugham had promised to pay his rent for the rest of his life,
years ago, and did so, but had no idea, when he made the promise that the man would
live so long. He spoke also of Low's caricature of himself (Maugham). He sat to Low for
a morning, and Low did a number of things which he wouldn't show, but did not use
any of them. Later Low met M. at a dinner, and caught him in the act of stammering,
thus catching him on his most sensitive point. Maugham says Doubleday has only two
words in his vocabulary of praise and blame – 'swell', and 'lousy', and that therefore if
he only said my drawings were 'swell' I was to take it in the spirit it was meant. M. said
that they were 'crazy' about the drawing that was sent in advance to America…went to
the Charlie Chaplin film, *Modern Times*…There was a new Disney film too. He shows
little signs of flagging. He seems to me to have elements of Caran d'Ache, Caldecott, and
other humourous artists, and to be at least their equal…

Saturday 18
…Ginger's film was shown to the trade at the Queen's Hall last Thursday. There were
good notices in *The Times* and *Telegraph*. It has now cost £80,000 and will have to be
cut again.

Monday 20
…Coldstream, who came to see me at the Slade, held forth…quite intelligently, on what
he considers to be the course of modern art. He looks forward, having been a bit of a
modernist and having dallied with the cinema, to the revival of illustration and subject
matter.

Tuesday 21
After the Slade went with Charlton to Devas's show at Cooling's. Devas is another young
artist who is turning to a more naturalistic sort of painting than he attempted some years
back. It wasn't a bad little show. He gets very good likenesses of Nicolette (Macnamara)
his wife, and of Daphne Charlton…One study of Nicolette, semi-nude (there were two
of them) stuck in my mind for its pleasant colour. She has just had a second baby, and
they want money. Devas has sold eight pictures and…may, with luck, clear about £80-
£100. Norris, of Repton, was at the show. He is Devas's old art master. He has sent us
some good students to the Slade, and seems to be an inspiring teacher. Neil Cook and
Barnes came from Repton, and Norris's nephew, Rolt.

Wednesday 22
G. Kelly telephoned to the Slade, wanting a man to do some perspective for him, on an
early picture which he is revising. I rang up Forward at Gordon Jeeves's office and told
him to get in touch with Kelly. Kelly makes no claim to know anything about perspective.
He talked a long time on the phone about my drawings for the book. He is not satisfied
with some of the characters. Nora, for instance, whom he knew – at least, the original
of that character. She was very good to Maugham, and he treated her badly, as is set
forth in the book. K. thinks I have made her too distinguished: she was ugly, with a

pleasant ugliness. And Mildred was more like a Burne-Jones than I have made her. He says also that the Miss Chalice incident is lifted by Maugham from Kelly's experience, and was not a personal experience of Maugham's. He wants Eddie Marsh and some others to see the drawings, because they know the book well. He refrained from making criticisms in front of Maugham because Maugham was so pleased with the drawings as a whole. He, Kelly, had not realized that I was going to take such serious trouble over them, or he might have supplied me with information. Maugham said that he thought I could easily get more illustration to do, if I wanted it, on the strength of what I had done.

Friday 24
Drew a model, Latchford…for my 20th illustration. A smart, well groomed, intelligent young man, who has worked for the films.

Saturday 25
Adrian Kent came to see me…He is teaching at Dartington Hall, for which he gets £250 a year (I gather that he and his wife have some small resources besides this income). His wife has just had a baby. He wants to get a better, more congenial job. He has done some good drawings of animals, in line, or water-colour, which he showed me…

Monday 27
Saw Ethel Walker's new show at Barbizon House…Ethel had sent me a card asking me to go. Painting as charming as usual, but she cannot claim the gift of exact portraiture. I walked round the room without a catalogue, and never realized that two of the portraits were meant for Ithell Colquhoun and another for Basil Burdett.

Thursday 30
Ihlee and Clause dined with us…Ihlee has a 'pied-a-terre' with Hereford at Collioure, but spends eight months of the year 'on the road' in the car, pushing on from place to place and painting. He says he is very happy, with few possessions or impedimenta, and few responsibilities. Nevertheless he has been worried about Hereford, who suffers from depression and persecution mania, and has been very difficult. Ihlee said an odd thing about Innes, whom he knew very well and liked very much: it was that he had known Innes to eat glass, with the idea of hastening his end – He, Innes, knew he was a dying man then, and took the knowledge very hardly. Ihlee also mentioned the megalomania and extreme selfishness of Derwent Lees, which became very noticeable one summer when they were all at Chepstow together – Innes, Lees, Ihlee, Clause and…MacLaren.

MAY

Friday 1
Went to Hampton Court in search of material for an illustration. The tram lines from Hammersmith to Hampton have been filled up since last year, and trolley buses have replaced the trams…Made some notes in a sketch book, in the Park… Changed my clothes for the Manchester Academy of Fine Arts dinner at Kettner's… Ethel Gabain and Francis Dodd made very good speeches…

Saturday 2
Took back the photographs of my illustrations made by Cooper of Rose & Crown Yard, at Doubleday's expense; I thought them not good enough. It is the first time they have disappointed me. The old man has retired and the sons are carrying on the business. Made a brief note, for another illustration, of some details in Peter Robinson's shop window, and was asked rather offensively by the shop-worker, who came out, what I was doing. He was afraid that I was pirating some of their dress designs. I asked him what the hell that had to do with him, but explained, and we ended by being civil to each other. Spent 15/- in Wardour Street on fashion plates of the early 1900s, again with an eye to *Human Bondage*. Charlton called…in the afternoon to say that the Slade students are getting too slack and idle, and that something must be done about it, by me. I agree, and know he has the interests of the School at heart…

Thursday 7
Board of Studies at the Architecture School. Constable, who was there, has been writing to *The Times* about the new coinage and stamps, which, he thinks, should be examined by a competent body of artists and experts before the designs are passed. Otherwise he is afraid they will be very bad…

Saturday 9
Went to Cooper's about photographs, and visited a show, at Reid & Lefevre's, of [Archibald] McGlashan,[5] Lord Berners and Ed. Le Bas…Today being my 51st birthday, Alice sent me a book, on the *Parish Churches of England* (Batsford). A good choice, as it interests me.

Sunday 10
…went…to see Durst in Wychcombe Studios: he has a new font which he is working on, and wanted to show me. It is being done as a sample, in the hope of selling it or getting other commissions. His expenses are paid by the business in which Ledward has a share. I thought it was very good, and nearer to Durst's real interests in life and art than a lot of his work. His early years in a Cathedral close, his residence in Chartres before the war, and his real love for Romanesque work have done much to form the style he is now, in a sense, reverting to…

Friday 15
Started to correct my share of 106 exam papers in the History of Art (Bd. of Education), having passed 50…on to Rodney Burn, who has been appointed co-examiner. Colin Gill won't leave America, having been successful in getting portrait commissions there…He gets about £60 as Examiner, and no doubt is making far more than that out of his portraits.

Sunday 17
…Dodd called…he had an account of what Shannon told him about [Constantin] Meunier [1831-1905], apparently, having heard the facts from Meunier himself – that Rodin, who was designing some lamp posts in Brussels as a young man, went to study from the life for that purpose in the Art School of which Meunier (then a painter) was head.

5 Founding member Glasgow Society of Painters & Sculptors, member Royal Scottish Academy, exhibited with Society of Eight in Edinburgh.

Rodin was on the point of being turned away from the School, by a subordinate teacher, as a dangerous influence on the other students, because his work was like the model, instead of being cast in a Grecian mold [sic]. Meunier intervened and kept Rodin on. Not only did he think him a good influence, but he (M.) was moved by R.'s example to become a sculptor, at the age of about 45, and not only to drop painting, but the Art School as well, which meant a return to poverty. Surely a remarkable gesture of enthusiasm. Meunier said to Shannon 'You are lucky – you found your path in art in time. I found mine only as an old man.'

Thursday 28
Dinner with Gerald Kelly, to show my drawings for Somerset Maugham to Eddie Marsh and Charles Evans of Heinemann's...Evans was a little drunk, and repeated the same thing over and over, telling me that Doubleday's must use collotype, not half-tone, or the drawings would lose too much. Kelly told stories of Maugham and Arnold Bennett in Paris in their young days. Bennett seems to have been very accessible to flattery. There was some jealousy between him and Maugham. Kelly imitated them stuttering at each other, which, naturally, didn't appeal to my own sense of humour. Maugham spoke French well, and Bennett was teaching himself, and had a very English accent...

Saturday 30
Dined with Albert R....He told us that Jessie Wolfe's being in a nursing home has nothing to do with her being ill – she has retired there on account of the strained situation between her and Humbert, who has been caught out in one of his infidelities. They were engaged...in their teens, and when Humbert Wolfe was twenty-one he fell in love with another woman, but she persisted and married him just the same. Since then he and she have had many difficulties. Albert also told me of a Fascist meeting in Oxford, at which Mosley spoke. Mosley had brought down about thirty of his toughs from London, and said that any interruption of his meeting would be sternly suppressed. The hall was full of undergraduates and ordinary Oxford people. Albert was not there, but he was in The Randolph when a number of undergrads, many of them bleeding, came in when the meeting was over, and his chief informant was a Don who was there and took part in what happened. Gilbert Murray's son asked a question, and was snubbed by Mosley. Undeterred, he asked another. M. made a sign, and his myrmidons advanced into the hall. Young Murray was seized by the head and neck and jerked forcibly from his seat, whereupon the meeting rose and fell upon the Fascists, very properly, and a tussle took place in which Mosley's people were discomfited. Metal chairs were used as weapons, and some men were moved to hospital. Albert's informant, a very powerful man, got onto the platform and asked M. to call his people off, saying that he himself could control the undergrads, to whom he was well known. Before he had time to say more he was seized and hurled into the body of the hall, an example of the forcible and brutal methods practiced by the Mosleyites. I was glad to hear that they got the worst of it.

JUNE

Tuesday 2
W. Thomas Smith, at the Slade. Told me calmly and stoically, that he is a doomed man and has not more than a year to live. He has cancer. He says he has 'had a good innings', being 71 this July. I thought he was very brave about it, and hope I might behave so well in like circumstances.

Friday 12
Signed about 200 of the 751 sheets of the special limited edition of *Human Bondage*, a task like writing 'lines' at school. Went to the Slade at mid-day, to entertain Gilbert Spencer to lunch. Rosamund Willis, an old student of my time at the R.C.A., and now head of the Luton School of Arts and Crafts, called. Spencer had been asked, at the instance of the Slade Society, to criticize the Sketch Club. He went round the work very conscientiously...It may have disappointed some students who might have thought he was likely to have very modern views. He advised them in a grandfatherly way to stick to drawing... Told them very much what we always tell them about the advantages of the academic background. He had tea in my room, and John Alford came in (he is now Professor of Fine Art in Toronto). I dined with Rodney Burn, to complete the exchange of drawings. Monnington was dining with the Burns also...Burn and Monnington are very firm friends, and understand each other perfectly – like boys at school do... Monnington says that anyone who wishes to get into the ranks of the Academicians must have the support of either Kelly or Munnings, who have more influence than anybody else, but don't always agree...

Monday 15
Went with Walter Russell and Monnington to look at the designs for Holden's ceilings in the new University building. They are to be seen in a room in the basement of the Imp. Institute. Evelyn Dunbar has sent in some designs through the R.C.A., and the R.A. Schools come out well with two of their people; and Bartlett and other Slade competitors are not outshone. A lot of talent in every school...

Saturday 20
Dr. Pevsner called...with some exam papers from the Courtauld. Left home with Birdie for Kingston at 9.30, and had a delightful day with the Kohns, who drove us to Breamore, near Fordingbridge. The house...was open to inspection by members of the Nat. Art Collections Fund...The house is Elizabethan, much restored and changed...We met Louis and Mary Behrend going round...She asked if Birdie was my wife or my daughter, seeing so little change in her since their first meeting in Henry Game's studio about 24 years ago...

Thursday 25
Slade Picnic, at Burnham Beeches. Owing to some feud between the Slade Society and the Slade Scholars, very few students came. Some more declined because they had no money. So there were only 16 of us...including Connell, Elton, Ormrod, Charlton and myself...

Friday 26
Finished at the Slade. Allan Carr...got two Prizes, for life painting and figure drawing. Strawberry Tea, indoors, as it was wet...

Saturday 27
Charlton gave me a big drawing of New End, and I am to give him one in exchange. I
wish he had given me a choice, as I prefer other drawings he has done. Birdie, Charlton
and I called on Towner to look at his new pictures done at Tyneham – He gets the essence
of a particular place or scene, and has considerable mastery of tone and colour...

JULY

Wednesday 1
Discussed a draft of the new conditions for the Abbey Scholarship with Evelyn Shaw...
At 8 o'c. called on Sir Keith Murdoch at Queen Anne's Mansions, where I dined with
him and Lady Murdoch. She is an attractive, intelligent woman, who organizes Broad-
casting in Australia...They have commissioned John to paint their boy, and have been
to see him at Fordingbridge. They have bought a panel by John in a sale...for £6, and
have been acquiring other art treasures...After dinner, Murdoch rang up a Daimler hire
car and drove us to Hampstead, where he and Lady M. stayed with us for about an hour.
He is another man who hates making speeches. When he does, he is apt to be afflicted
with a stammer, like me.

Friday 3
Went to Reading University as External Examiner in Art. Was met at the station by Prof.
Anthony Betts...Betts seemed to be very pleased with his appointment. We talked of the
days at the College when Rothenstein refused him a Diploma, and of his being a student
demonstrator. He was sharing a studio with Henry Moore then...

Monday 6
Meeting of Examiners & R.C.A., S. Kensington, (Board's Exams.)...G. Spencer was very
amusing: related how he had stayed with Neville Lewis, and painted his wife. Rather to
his surprise, Lewis paid him £25 for the portrait, explaining that he had had a 'bumper
year' and made £1500. 'I never have a bumper year', said Spencer to me: 'It's just one
crash year after another.' He got £250 for the Balliol job, which took him two years.
After lunch, Burn took me to see Monnington, because he was anxious about a cartoon
of Monnington's ('printing notes at the Bank of England'), which the Bank has bought,
in addition to the painted decoration done from it, for £100. The cartoon had to be
stretched on a frame, and B. and M. had done this between them the night before, damp-
ing it and sticking it at the edges. They were afraid it might split with the tension when
it dried, but it set perfectly. Burn is doing a good picture, called *The Wedding Morning*,
or something similar, in M.'s studio. The four-poster bedstead comes into it...The three
of us went off in Burn's car to see Stanley Spencer's paintings at Tooth's. He has sold
about 17 pictures, totaling about £2000: so Hilda and Mrs. Harter should be able to get
some money out of him. I thought the pictures showed an unpleasant change: the colour
is good, except in the naturalistic landscapes of trees and flowers; these Burn says, bore
Stanley now, and he does them only because he thinks they will sell. But whereas
Spencer, to use his own words, used to 'walk with God', he now introduces a note of
viciousness, or at least of sensuality. There is a picture called *On the Landing*, representing
a little man overpowered by a much larger woman, which might be an allegory of
Spencer's present state, since he left Hilda and lived with the other lady [Patricia Preece],

in whom he finds inspiration. There is a portrait of her, a horrible thing, which gave me a sort of turn, it is such an evil-looking object (by the way, I liked Stanley's self-portrait very much). Monnington says she was at the Slade, and was an outrageous Lesbian then. Stanley met her on a kind of family boating party, of Spencers and Carlines. She tried to vamp Dick Carline, stroking his hair affectionately: old Mrs. Carline, observing this, rapped her over the knuckles with her umbrella. The girl then turned her attention to Gilbert, without much success, so she passed on to Stanley as a pis-aller.

Wednesday 8
Finished my twenty-second illustration, of Philip dressing the shop window…[went] to see the Cézanne water-colours and drawings at Agnew's where Robin Darwin was having a pretty good show, too…Cannot make much of Cézanne's water-colours – their power of suggestion is too elusive for me; but they have a certain vague charm…Went on, to give myself a thorough indigestion of art, to the Oppenheimer collection at Christie's, and to Salvador Dali at Lefevre's. Bought a number of *Minotaure*,[6] consecrated to the Sur-réaliste movement. I missed the exhibition, which has set all London talking of it. *Minotaure* seems to insist a good deal on the sadistic side. There is a dialogue, very lugubrious, between the Marquis de Sade, M. de Mesanges and Jack the Ripper; not at all unlike Dali in spirit. I don't like Dali's chrome-lithographic picture postcard technique: in fact, I don't really like him at all, though he is a sort of virtuoso. There is something niggling about his drawing. I suppose he is a recrudescence of the spirit that inspired Huysmans, Gustave Moreau and Odilon Redon, a spirit that never produced anything really first-rate.

Friday 10
Dinner at home. Towner, Geoffrey Egar, and Marshall of Hong Kong, a friend of Uncle Bill and Alice. Marshall told several amusing stories of Bill – how he laid out a giant Cornish wrestler unconscious, having been asked to give a little display of self-defence methods, and having reluctantly consented: stipulating, first, that the floor of the inn where this scene took place should be covered with mattresses ('in case I get hurt', as he put it)…and a characteristic anecdote of Bill receiving a man in his office, who sat down and faced Bill without removing his hat, which B. thought a breach of manners: so Bill rang the bell, ordered his boy to bring him his hat, and gravely put it on before resuming his conversation with his visitor…

Monday 13
Meeting of the Faculty of Painting, Rome School…Called on Margaret Barker…to see her work and write her a testimonial in connection with a job for which she is applying. She gets some remarkable work out of her pupils, but gets little time to develop herself, and what development there is is rather queer. Still, she is an artist…

Tuesday 14
Daphne Charlton to tea at home. George is in Brighton, doing some work for the picture postcard firm that applied to the Slade a fortnight back.

6 A Surréalist-oriented publication founded by Albert Skira, edited by André Breton & Pierre Mabille, published in Paris (1933-39).

Tuesday 21
…Lunch at the Athenaeum. Met Albert R. afterwards there, who drove me to see Athole Hay's and Miss Dunbar-Kilburn's new furnishing shop in Grosvenor Street. It is full of pleasant things: Foley china, with designs by Albert, Graham Sutherland and others: furniture by Ravilious: textiles by Marx…

Wednesday 22
…By arrangement with U.C. Hospital, I went at 3.30 to witness an operation, having the scene in mind for another illustration. C.W. Fleming operated: gall stones: one sees very little of the actual work, but the impression of the operating theatre, with all the oddly dressed figures, was very strong. I was there for about an hour, dressed like the others, in white overalls, mask and rubber boots…I was annoyed at losing a photograph of Tom Cobbe's operations, which I rely on for some of the information for my proposed illustration…

Thursday 23
…Slade in the morning. Albert R. called for me…and we went to lunch at the Athenaeum to discuss the possibilities of collaborating in the scenic production of a new play by Clifford Bax – *Jane Shore*…

Saturday 25
…Birdie and Hagedorn and I dined at Roche's…We went to the news film and saw something of the civil war in Spain: street fighting, women and men at the barricades and much serious destruction of life and property.

Monday 27
Left London for Bickington, where we joined the Wellingtons. The furnished cottage roomy, convenient and pleasantly situated.

Tuesday 28 July – Wednesday 12 August: no diary entries

AUGUST

Starts Thursday 13
About this time, Wellington went up to London from Bickington to attend Aitken's funeral. Aitken had been extremely generous to the Wellingtons when they were not well off, and had taken a lot of trouble about their affairs. He was kind and considerate in all sorts of unexpected ways – unexpected, that is, to those who did not know him well.

Thursday 20
Left for Braunton, to visit Tom Falcon…

Thursday 27
…visited Dartington Hall…Saw the weaving as well…The Ballet Jooss was at the Hall, and various foreign looking ladies about.

Monday 31
Returned from Bickington.

SEPTEMBER

Tuesday 1
Took the complete set of drawings for *Human Bondage* to Lewis for dispatch to America. (One is already there, but the 23 others have to go) I did the one of the hospital, from my notes and making some use of a photograph, at Bickington [plate 11].

Wednesday 2
Birdie and I went with Daphne Charlton (who is full of a recent visit – her first – to August John at Fordingbridge) to inspect a cottage that belongs to Viola Tree Parsons, and is to let for 10/- a week. We thought we might share it, and halve the rent. The cottage…is at Broxbourne, in the grounds of the old school house, a curious building of the 1860s, where the Parsons live…decided it was too gloomy and inconvenient: 3 floors, narrow winding stairs…no indoor water supply…

Thursday 3
…Went with Maxwell Ayrton to draw at Limehouse…He told me a lot about Orpen, whom he knew very well and liked very much – with one or two reservations. He thinks O.['s]…humour was sometimes cruel, though he was generally kind. During the War, when he was going back to France, Orpen was seen off at the Station by his wife: he had forgotten his watch, which was being repaired, and had asked her to fetch it and bring it to the station. She did so, and gave it to him, with an envelope containing a lock of hair. The watchmaker had found the hair in the back of the watch-case, and had put it in an envelope. Of course, as it wasn't Lady Orpen's hair, she came to the natural conclusion that it was some other woman's. This amused Orpen greatly, and he never explained. Actually, it was a German lad's hair, given to Orpen for transmission to the dead man's family. Orpen set about a report that Ayrton and Williams, an engineer and a member of the Arts Club, had improper relations together. Ayrton had to tell Orpen that if he heard any more of this he would have to thrash him, or do his best to, anyhow. Orpen took this very well, agreed that he was behaving like a ——, and they became friends again. The last months of Orpen's illness were pitiable: mad, incapable of feeding himself properly, he still lunched at the [Arts] Club, to the discomfort of other members. The same Williams, the engineer, was speaking at a dinner, at which Orpen presided, given at the Club to congratulate Max on having got the Richmond Bridge job. He took occasion to say that the word 'bridge' was not to be found in the Bible. At this moment, David Murray came in, heard the last words and said – 'Young man, ye must have been reading an "abridged" edition'.

Saturday 5
…dined at Roche's. Ginger came. Feher has bought the Villa Esterhazy, outside Vienna, for £80, but he does not know where money is to come from in future. *The Robber Symphony* has got a medal or prize, but no profits have accrued from the £90,000 outlay.

Sunday 6
...The [Lee] Hankeys told Birdie that Gertler had twice attempted to commit suicide lately, once by cutting his throat and again by opening an artery in his arm...I know no details, nor why he did it.

Monday 7
...Went...to see Hagedorn's paintings, of Portugal and of Hastings, done in the studio from drawings. Towner's are done on the spot...

Tuesday 8
Took some of my summer's drawings to Lewis to be mounted...Lewis tells me that Sargent's sister was killed in a bicycle mishap – she was knocked over and died from shock.

Thursday 10
Renewed Passport at Passport office. Went to Dover with Birdie and Owen...Alice is already there.

Tuesday 15
...Left Dover with Ayrton, whom I met on the boat, for Luxembourg. Spent two and a half hours between trains wandering about Ostend. A fine French three-masted schooner in one of the basins, a picturesque fishing fleet and other shipping: far more than there is, usually, at Dover.

Wednesday16 – Wednesday 23: no diary entries

Thursday 24
Esch-sur-Sûre. Spent the day, as usual, drawing for about 7 hours...Ayrton was amusing about the parties he used to go to at Walter Crane's in the late '90s. They were looked upon as outrageously Bohemian...something like the parties Nevinson gives now. The daughter used to get extremely drunk. This, in a woman, was almost unique at that period. Dame Crane used to get herself up, when dressed for the evening, somewhat in the manner of a Wagnerian soprano, with silver shields on her breasts, and a gold fillet in her hair. Supper was at a long table, with the Cranes seated, with their backs against the wall in the centre of its length, like a cenacolo. Ayrton has a view that Percy Adams,[7] Holden's deceased partner, was a real innovator, and Holden learnt what he knows, so far as it is good, from him, though Adams has never got the credit for it. Ayrton has been in the running for the London University job; and Lutyens put him up for the R.A. two or three years ago, when he was backed, as well, by Adrian Stokes and Orpen, and someone else, all three dead now, so Ayrton's chances of election have diminished, he thinks.

Friday 25
...Ayrton is an indefatigable draughtsman. We were leaving Esch tomorrow, but he wants to finish a drawing, so we will go on Sunday instead. He telephoned London to tell our families of our change of plan...Ayrton's conversation in the evening was chiefly about his experiences as a balloon pilot during the war. He enjoyed the sensation of flight, generally, but had a nasty moment on his first going up alone: having reached

7 Fellow architect, member R.A.

6,000 ft., all the creases expended suddenly out of the silk envelope, the net slipped over it and the car dropped with a crash – only a few inches…a thing an experienced man would expect, but A. thought the whole apparatus had come to bits. It seems that before the war ballooning was a fashionable pastime among the very rich…

Monday 28
Left Brussels 9.13, arriving at Victoria, rather late, something after 5. No incident of sickness…I left England on the 15th with £10 in Belgian money. I got back to Dover with 4/-…so my total expenses, exclusive of a rtn. ticket bought in advance, were £9-16-0…

Tuesday 29
American Consul's office, 2 Harley Street, to make affidavit about authorship of drawings sent – or not yet sent – to Doubleday…

OCTOBER

Friday 2
Slade…Interviewed over 30 applicants for admission…

Tuesday 6
At 4, left the Slade with Charlton and Daphne and took a taxi to the Tate to see Tonks's Private View. By chance, we picked up R. Guthrie on the way…Tonks was there himself…Everybody thought the show was a great success and a triumph for Tonks. Some of his paintings and drawings struck me as being much bigger in style – more in the 'grand manner' – than others, which have a certain littleness and lack of rhythm…his colour is sometimes beautiful…

Thursday 8
…John Howard came [to the Slade]…about someone to help him with his Shoreditch work, and I recommended Harry Barnes…Howard told me that Tryon is again under supervision in a mental home, The Priory, Roehampton, having apparently broken down under the strain of moving to new quarters in Highgate…

Friday 9
Slade. Corrected and amended General Schools Exam papers for the University with the assistance of Charlton, who had helped in setting the papers…

Saturday 10
…visited Mrs. Lee Hankey and Mrs. Copley, to look at the work they think of sending to the New English…knowing…that I am likely to be hanging…[and] shall know what is likely to be accepted. In return, from the Copleys, I got a glass of sherry and some exaggerated compliments on my drawings in the Rutherston collection, which they had seen in Manchester. Peter Copley is acting with a touring company in S. America. John Copley is painting a large picture of a string quartet. I told him, for fun, that the deltoid of his principal figure was much too short, which, incidentally was perfectly true. He seems unaware of such things. Ginger came in to see Alice and stayed…Ginger's film company owes £20,000, and its assets, as they stand, may be worth £8,000. Feher is in America, trying to sell the

film rights. Perhaps it may do well yet, or perhaps they may all go bankrupt…

Tuesday 13
Jury of N.E.A.C.….Connard was annoyed at the confident attitude of Mary Adshead (who has never been on a Jury before) in voting for what he considers all the wrong things… Received some compliments on my drawings of Bickington and Esch. I believe them – the compliments – to be genuine. Some were reported to me at second-hand by Willie Clause. We do not as a rule say much about each other's pictures.

Friday 16
…to the Suffolk Street Gallery, and, though the catalogue of the show had gone to press, revised the hanging with [Charles] Cundall, Clause, Pearce and Ethel Walker…Lunch… at the Comedy. Asked Cundall about his war experiences. He joined up in 1917, did not get a commission, was in the trenches on the Somme, and after a year was invalided out with a wound in his right wrist. His right hand is still in some measure incapacitated, and he gets a pension of £30 a year. He did not tell the War Office that he is ambidextrous, and uses his left hand with as much ease as, formerly, his right, so that his wound makes little difference to him, except that he has rheumatic pains in it. He also suffers from nerves. Went on to the Slade, and at 9p.m. to the Copleys, who were having an evening party (not dress)…[Adrian] Hill told me about the methods of teaching at the Westminster, which he is doubtful about, and they certainly seem to me, from what he says, largely unwise and unsound; but Kirkland Jamieson, from having at the beginning almost more staff than students, has filled the place to overflowing. The students, or a large party of them, are suspicious of the uses of anatomical or constructional information in drawing, and learn to paint still-life or the figure in a quite unnaturalistic way, under Gertler and another fellow. Hill teaches anatomy and drawing: Chadwick, engraving.

Wednesday 21
Slade Summer composition criticism. No first prizes, but 10 seconds, of £8 each. My embarrassment at having to say a few opening words still persists, but it is not…so bad as it used to be; though even now I have great discomfort for days beforehand, for fear I should stammer. Carr, Barnes, Brinkworth, [Dagmar] Saerchinger, Stephen, [Nora] Braham, Wardley, Joan Moore, Griffiths, among the winners. I wonder how many will ever be heard of as artists hereafter?…

Thursday 22
…Birdie went today to Chelsea, and lunched with Russell at the Blue Cockatoo, meeting Hetty and Blake, those well-trained servants, and Stuart-Hill and Philipowski, all of whom greeted her with the warmth of old Chelsea acquaintance…

Friday 23
…Woolworth's have now completely demolished the two 18th century houses in High Street, next to Jean Inglis. Her house has had to be shored up, and the side wall of her top flat rebuilt. She contemplates selling her site, if some other big firm like Marks & Spencer makes an offer for it; but she won't budge for less than £6,000. She and Joan Fulleylove (who, by the way, has given me a drawing by Lord Leighton) paid £2,000 when they bought the house.

Saturday 24

Drew in Sherwood Street…A brief lunch of sausage and mash at a bar. On returning to my pitch, I found my ink-bottle, which I had left inconspicuously on a window-sill, had been stolen…Bought Hone's *Life of George Moore*. I remember the Hones as friends of Robert Gregory: she was painted by Orpen. Gregory let his house at Burren to them one summer, and they all migrated to County Clare with children and nursemaids; but on arrival they found that the house was still in the builder's hands – it wasn't complete when we were there in 1915 – and had no roof yet. Gregory had forgotten to mention this circumstance…

Sunday 25

Rutter has a pleasant little notice of one of my Esch drawings in *The Sunday Times*. The Rutters have left Church Row now, and are in Golders Green…

Tuesday 27

After the Slade, went to Mrs. Campbell Dodgson's show of drawings at Colnaghi's. They are pretty and tasteful, with reminiscences of the 18th century, and there are some portrait heads which have real life in them…

Friday 30

Finished drawing in Sherwood Street…There are only four 18th century houses now left in Golden Square…What has replaced them is very untidy and careless, with no thought for the architectural appearance of the whole. Canaletto's house still stands in Beak Street…

NOVEMBER

Sunday 1

The usual walk on the Heath. Hagedorn stayed to lunch, and I went down to Belsize Park Gardens in the afternoon to look at his pictures. He has done two portraits, and is sending one to the London Group…

Tuesday 3

After the Slade, went to Mrs. Morrison's, in Alma Square, St. John's Wood, to select pictures for the London Group. F. Porter met me there, and we chose six which went well together. We talked a little about the days in Paris when both Porter and I used to frequent Gertrude Stein's Saturday evenings in the Rue de Fleuris…

Wednesday 4

…dined at the Athenaeum, having to go on to the soiree at the N.E.A.C. …Hind came and talked to me about buying one of my drawings through the Contemporary Art Society's funds…At the New English, Ethel Walker was acting as doyenne and hostess, Thornton being ill. Something over 100 people…

Thursday 5

Took drawings to the British Museum for Hind to select. Party at the Copleys 9 o'c.… Pamela de Bayon was very hot about the wrongs of the Spanish peasants, and how we ought to intervene if Franco gets control: he is at present bombing Madrid, and children

have been killed in dozens...Nevinson claims to have been a founder of the London Group. He and his wife arranged the publicity and Private View of the Group's first show. Roger Fry disapproved of N.'s methods, and held that it would be better to discourage people from looking at their pictures – at least, the sort of people whom Nevinson collected...There was a quarrel and Nevinson resigned. 'I told Fry that I, at least, had to sell my pictures – I had no cocoa behind me.'

Monday 9
Selected Prize winners in the Central Telegraph Office Employees' Art Exhibition. Mr. Smart took me round...It must mean a lot to these people. As Smart says, being a telegraph operator is a soul-destroying job...Orpen used to do what I did today, and Frank Emanuel[8] does the same for the Post Office, making his usual inflammatory speeches about 'modern art', which he is convinced is a vast, dishonest conspiracy. Evening with Egan Mew. He showed me a letter of farewell from Max Beerbohm, written on leaving for Italy again. Max refers to Egan as his 'brilliant friend'. George Street is dead, and there was an unsigned tribute to him by Max in *The Times*, which Mew had cut out. Mew knew Street very well in the nineties. I read an essay of his on Ouida, while Mew was preparing his supper of eggs & tomatoes. It seemed...carefully written and good, but I suppose all the authors of that date were a thought too careful & precious. Mew insists that Somerset Maugham is a better stylist than any of them because he has arrived at an apparent ease and directness, without the look of conscious effort. We agreed in liking Joe Hone's *Life of Moore* – a very good job of work. Albert R. (who has just moved to [2] Linden Gardens, Kensington) will feel the loss of his old friend, Street. It is of Street that the story is told that he went abroad with Albert, and they both returned attired somewhat fantastically; Albert in corduroy trousers and a general 'Vie de Boheme' get-up. They landed at Brighton or somewhere, and walked along the front. 'We seem to be attracting a lot of attention' said Street. 'Ah,' said Albert, 'but if they only knew who we were.'

Wednesday 11
...sold one of my Bickington drawings at the N.E.A.C.: the first time I have sold there for years...

Thursday 12
...chose a drawing for a prize at the R.C.A. Students' Sketch Club Show in the V.&A. Museum, and went on to Roy Beddington's Private View at Ackermann's. He has improved greatly...and works very hard...

Friday 13
Went to Matthew Smith's show at Tooth's. I like his painting better than I have done hitherto. He has got rid of most of the hot reds and purples, possibly because he now has a blonde mistress, whom he paints a good deal, but as he has almost no sense of form, her face and figure do not impress the average person, in the heads and nudes at Tooth's. The flower pieces are finely handled and very good in colour sometimes...

8 Painter, etcher, illustrator and writer. Published art criticism and topographical drawings in *Architectural Review, Manchester Guardian*.

Saturday 14
Received my cheque (£6-6-0 being half price) from Hind for a drawing of *Farm Carts at Lanteglos*, for the Contemp. Art Society's additions to the B.M. collection...

Sunday 15
Lunch with the Kohns...Franz and Lotte Reizenstein were there – he played the piano in the afternoon – his own compositions, Bach and Debussy. Among others who came in for tea were Mr. & Mrs. Dehn...Dehn was one of...Unwin's greatest friends, and has a collection of his prints. He shed a new light on Homer Lane, who psycho-analysed Unwin, and, I thought, did him a lot of harm; but Dehn had experience of him, and thought he was not a quack. Perhaps the truth is half way between the two of us. Certainly, Clara disliked the psycho-analysis and its results, and I fancy it had something to do with her parting with Unwin. Dehn points out that U.'s work changed entirely in character after he had been in Homer Lane's hands, but Dosimati, Hudler and John Nash had some effect on it too. Lane was deported from England, unfairly, Dehn thinks. He says, too, that Lane died shortly after in Paris, as it were of a broken heart. He sized Dehn up very exactly after two minutes' look at him, once when Unwin was psycho-analysing Dehn, who says he benefited greatly by the process, and was able to make an important decision, affecting his whole future, which he would never have had self-confidence enough to do without this extra impetus. It meant chucking a safe job, with a wife and young family on his hands, and branching out anew. He is a patent specialist...and doing well.

Monday 16
Benno Elkan, the German sculptor, called on me at the Slade, introduced by a letter from Jowett. I conclude that he is exiled from German on account of Jewish ancestry. One of his big monuments has been taken down by the Nazis. Towner is not elected to the N.E.A.C. Spencer, Kirkland Jamieson, R.O. Dunlop, Nadia Benois and Winifred Nicholson are.

Tuesday 17
After the Slade, went to see Elkan's show at Knoedler's and to meet him there. His work is very capable, his portrait busts and medallions good, and some of his candelabra, etc., for Buckfast Abbey inventive and interesting. Some large work, of which he showed me photographs, has a touch of megalomania, like much German sculpture. His portrait drawings did not appeal to me. They have very little of a good tradition of drawing, though Holbeinesque in intention: hard and insensitive. When he had shown me everything, the point of his seeking me out appeared. He would like a job at the Slade, as a sort of supernumerary teacher in the Sculpture School, specializing in the art of the medallion. He claims that he and half a dozen others...revived this art, which was thoroughly misunderstood in Germany before their doing so, so that in his native country there is now a flourishing school of medallion makers. He says...rightly, that there is nothing of the sort in England now.

Saturday 21
...to the Peckham Road...to help More and Russell Reeve to hang the South London Group pictures...there is also a special exhibit of Austin Spare. Some powerful men's heads in pastel are better than his imaginations. [Guy] Miller says he is a dirty man: he lives in Walworth, in squalid surroundings...

Thursday 26
Went to three shows – the Vyse's, Ethel Walker's, and the memorial exhibition of Kitty Clausen's work…Lunch at the Athenaeum. Met Sir Charles Peers, who is cleaning up the front of Westminster Abbey for the coronation…

Saturday 28
Dickey rang up, asking me to go down to Whitehall to look at some drawings by a young man from the Sidcup school, who wants to take the Board's Drawing Exam., but is under age, about a fortnight. Dickey thought him exceptionally good, and that the age restriction might be relaxed as a special privilege. I agreed, and it was done, Wallis agreeing too. (Candidates have to be 17 years old)…

Sunday 29
Train to Bedford…Richardson met me in an old Bentley which wanted decarbonizing. Lunch, Mrs. Richardson and Lord Sandwich. Richardson had hired a butler for the occasion (10/-) who has been trained at the Wingfields…Tea…An architect named Micklethwaite, and a local lady who had been at school, in Bedford, with Dora Carrington. The two girls had been great friends. Carrington was looked upon as a brilliant girl at school, but, according to this lady, who has only recently destroyed a bundle of early letters from her – somewhat incoherent and heart-broken outpourings about an early love affair – was always emotional, odd and temperamental. She once, when about 18, contemplated suicide – rather significant in view of what happened later – and gashed her wrist badly with a razor to test her nerve in the event of a more serious determination…

DECEMBER

Tuesday 1
It is all out now in the papers about Mrs. Simpson.

Friday 4
Drew Somerset Maugham. He has a very mobile face, and I had to ask him, at intervals, not to talk. He expressed himself as pleased with the drawing, using the word 'distinguished' (of his own appearance under my hands), and said that it made him look like a writer, not a stockbroker. He stammered very little indeed, but referred again to that subject. He says he knew Mrs. Simpson a long time ago: she used to come to his house on the Riviera to play bridge; and that since her connection with the King she has 'put on no frills', but seems just as simply pleased to see Maugham as she was in the old days when she was unknown. She has had a bad time over this affair with the King – her life has been threatened in numerous letters which she has received. On the whole Maugham seems in her favour…Maugham smiled a good deal to himself when sitting silent: he explained that he was thinking of some amusing dialogue between imaginary characters: though he is not actually working on a novel or play at the moment. Marie Laurencin[9] wrote recently and asked him to sit for her, which he did, and he now has the 'portrait', very pink, young, large-eyed and unlike. She told him that she was indifferent as to whether people thought her portraits like the sitters. Maugham has been much ragged over this one…

9 French painter and printmaker.

Wednesday 9
Competition for Prizes offered by the Tin Research Council, for Pewter objects, held in the Slade. Judges: myself, MacNaughton and Frank Pick (I should have mentioned the last first, as he was most important, in his own estimation and everyone else's). The work produced was, on the whole, disappointing…Pick said that certain modifications suggested by him in the design of Giles Scott's Waterloo Bridge have been adopted – e.g. the removal of the pylons and the alteration to the shape of the cut waters. …He is quick, intelligent, has a good eye and much information on craft questions and design generally. In spite of an authoritative manner, he is open-minded and willing to modify his opinions…

Thursday 10
Dined with Alice at the Savoy, as guests of Dr. Lynham, at the annual meeting of the Irish Medical Graduates' Association. Lynham is President this year… Lynham proposed 'The Royal Family' instead of 'The King, as Edward has announced his abdication this night…

Friday 11
Doubleday, Doran & Co., sent proofs of the Maugham illustrations…Bernard Stevenson of the Laing Art Gallery, Newcastle, wants to have my drawing of *Yeo Farm*, which is on show there, at a reduced price…I have suggested £6-6-0. My monthly bill for wine and beer is about £4-5.0, so it won't go far…

Sunday 13
…After lunch, went to Colin Gill…to begin concocting Bd. of Education Exam papers. He is painting a large portrait of a model whom I know, in a cool green dress, with a guitar. Well designed…not very sympathetically painted. He likes America and the Americans. He did many portrait drawings out there. I saw two, extremely able and better than the painting. He knows the members of the Doubleday, Doran firm (also Mrs. Simpson, to whom he has no objection)…

Monday 14
Gave a little dinner to Stuart-Hill and Dr. Campbell Duncan, our old Chelsea acquaintance, now of Rotorua, N.Z., whom we have not seen for years…Stuart-Hill told me he studied drawing in Matisse's school for six months just before the war, which brought his studies to an end. They were taught to draw there much as we do at the Slade – serious studies of form and light and shade, about sight size.

Friday 18
Slade Dance and Cabaret…excellent: A Dryden masque, in which Allan Carr was Mars looking well and speaking well, with just the right amount of the tongue-in-the-cheek: Betty Stephen as Venus…Portraits in the manner of famous artists, with girls' heads poked through the canvas, extremely well done. One girl was astonishingly like Botticelli's *Primavera*: Rosemary Allan made an excellent Renoir: Camilla Wybrants a Raphael: and good Goyas, Toulouse Lautrec, Cranach…Jimmy Laver came. At my Supper were the Provost and Mrs. Mawer, Douie, Viola Tree, Lady Bonham Carter…

Sunday 20
Tinkered with the first drawing of Miss Steel, according to instructions, with, perhaps,

some very small advantage to the likeness and none to the drawing. She was, as usual, very nice about it, and expressed herself once more as being perfectly satisfied. I gather that The Royal School [for Daughters of Officers of the Army] subscribers are to pay me £20 for this. My gross receipts from Jan. 1 till now, including my salary and everything, have been £1,134.

Wednesday 23
Alice went off in the Kohn's car to Peasenhall. We follow tomorrow. …Received cheque from Doubleday, Doran & Co. for £250…

Friday 25
…Christmas tree and distribution of gifts…Julian is engaged to a Miss [Yvonne] Le Cornu, whom he brought to see us in Hampstead…Pen…gets £15 a week now for his film work. Julian has had a poem accepted by the *Cornhill.*

Monday 28
Left Peasenhall for Dover.

1937

The death of Schwabe's predecessor Henry Tonks is reported in the national papers in early January. Some four months later King George VI is crowned at Westminster Abbey. Schwabe spends a considerable part of the summer drawing in one of his favourite places Cerne Abbas, Dorset. In October Schwabe saw news film of the bombing of Shanghai by the Japanese and notice of a meeting 'Japan must be stopped'. Such events are punctuated with Schwabe's usual round of visiting and hanging artworks for exhibitions.

JANUARY

Sunday 3
Finished my drawing in the dockyard, near the slipway…Left Dover.

Monday 4
Birdie and I dined at Jack Straw's, and sat with Egan Mew in his house afterwards. Some discussion of the pestilent inaccuracies, carelessness and want of real historical sense, in Sachy Sitwell's *Conversation Pieces.*

Thursday 7
…Albert rang up and asked me to dine with him in his new flat…opposite the Mall in Notting Hill Gate…[he] feel[s] that his work as a painter is finished, and that he must now do what jobs come his way to support his family. He reckons that he may have painted a score or so of good paintings in his lifetime of over fifty years…

Saturday 9
News of Tonks's death. I bought *The Times* and cut out the obituary. I also bought the *Evening News.* Alice, who did not know Tonks, looked at the portraits in these papers and said he had a 'frightening' head: it reminded her of Boris Karloff, the man who does Frankenstein and other horrors on the films…

Sunday 10
…I was rung up by George Sheringham, who asked me to come and see him. I have not seen him for some years…He is painting flower pieces and hopes to have a show…He was in a reminiscent mood, talking of the days when we were at the Slade together (but I did not know him then) and later on in Paris. We spoke of Wyndham Lewis, as we remembered him in Paris…Sheringham was 16 when he went to the Slade, and wore an Eton collar. When a female model saw him and Albert R., who looked very young, she got down off the throne, put on her kimono, and said she wasn't going to pose for a lot of schoolboys. She was persuaded to resume the sitting, until she saw a workman, who was mending the roof, looking in at the window; upon which she cleared off for the rest of the day. Sheringham worked with Jimmy Pryde on a production of *Othello.* He liked Pryde, who nevertheless left Sheringham to do most of the work and drank a good deal. He got £1000 for the job and gave Sheringham £250. Sheringham was paid

so much per hour for editing *Robes of Thespis* [*:Costume Designs by Modern Artists*] [1928]. He says he did not do very well out of it. Albert R. had been asked to do it, but demanded a fee of £2000, which was considered too much...

Monday 11
Gerrard at the Slade, was casting a death-mask of Tonks. He made the mould about 48 hours after death, when the features had regained some serenity. From certain aspects it is very like Tonks: only the mouth is a little sunken, probably due to the absence of his teeth, but the profile is fine. Tonks was not definitely ill before last Monday night...He disliked doctors, and wouldn't go near them. (Gerrard says he was afraid they might suggest an operation, when he injured himself by falling, on the occasion of Lord North-bourne's funeral.) Tonks said to his housekeeper after dinner – 'Gough, give me a glass of claret. Have some yourself...I shall never go up those studio stairs again.' He went to bed, and she heard him walking about in the night, which was unusual. She went up, and he ordered her away, but she concealed herself and watched, deciding that he was wandering in his mind. She went down and fetched Monnington, and between them they more or less forced him back to bed. He was never conscious again, but delirious at times.

Tuesday 12
...The funeral took place, 11.30. I went with Clause and the Charltons, and was driven to the Slade in Gerrard's car. I was introduced to Myles Tonks, the nephew, who practises painting. Tonks's brother is very like him. Daphne said she thought she had seen a ghost...Hung up a laurel wreath, and the press-cuttings, with the reproductions of Tonks's pictures in the Slade...

Wednesday 13
...I wrote a little piece about Tonks for the Annual Report of the College...My new model throne is now installed. I hope it will help me in drawing portrait heads, as I can now stand up and be on a level with the model's head, when the model sits in a chair.

Thursday 14
Could not go to Tonks's Memorial Service at Chelsea Old Church because the Slade was being inspected by the University – Professor Atkins of King's College, London, visited me. The Provost could not go either. He wrote to Osmond Tonks (brother), explaining this, and Wilkie represented the Slade officially at the service, G.J. and Charlton went...

Friday 15
Architectural Drawing show at the R.A., with Corfiato. Got in free with a Press ticket from Mrs. Zander, whom I happened to meet in the vestibule. She took me into her office in the Library. It appears that Basil Burdett is not to have the Felton Bequest. Cockerell of the Fitzwilliam has it. Looked at drawings by Inigo Jones, Adam, Chambers... and Corfiato's, and my own Jockey Club drawing...

Tuesday 19
After the Slade, went to Bob Wellington's exhibition of lithographs for Schools, at Curwen's offices, 108 Great Russell Street, upstairs on the top floor, where there were caviar

sandwiches and sherry for the visitors. I was early and only Curwen, Oliver Simon, Nan
Kivell, Bob and another man put in an appearance. There are ten lithographs, by Bawden,
Freedman, Ravilious, John and Paul Nash, Medley, Norah McGuinness, Graham Suther-
land, H.S. Williamson and Clive Gardiner. They are to be sold to schools at 17/6d each,
or £1-11-6 each to the general public...

Wednesday 20
Received cheque £10-10-0 from Somerset Maugham, for his portrait. He made a slip in
writing the figures – £10-0-0 instead of guineas, but I can't be bothered to send it back
to him at Cap Ferrat, and will claim the smaller sum from his bank.

Thursday 21
Received cheque (£21) with an appreciative letter from the Governors of the Royal
School for Daughters of Officers of the Army, for the portrait of Miss Steel...

Friday 22
...Went to see Hagedorn, about his new picture. He is painting it entirely in golden
ochre, Fr. Ultramarine and Venetian red. He likes a limited palette. With his tendency to
colour blindness it is perhaps a good thing...Darsie Japp and Lucilia came in also. It is
years since I saw him. They supplied Alice with her first cot, and he was the best man at
our wedding. They live now at a hamlet outside Bordeaux...We talked about Wyndham
Tryon. Japp is not allowed to visit him at the asylum at Roehampton. He is going to
spend a night next week with Tryon's father (aged 86) at Watford, to see if anything
can be done. Reports from the asylum are that Tryon is better.

Saturday 23
MacColl rang up about the possibility of getting Gerrard to do a bronze bust of Tonks for
the Slade. I am to make tentative inquiries about price...Tonks has left the drawings on
his staircase (by others than himself) to University College. There is a Rossetti among
them...Daphne told me that there was some considerable difficulty about getting the plas-
ter of the death mask away from Tonks's head. It became a matter of main force, Gerrard
tugging for all he was worth. Monnington lost his nerve. Gerrard has a wholesome mat-
ter-of-fact attitude about such things, as of one used to dead game in the country.

Monday 25
Gerrard says that Tonks was losing his hold over the students in his last three years at the
Slade. They stood up to him more, and were impressed less by his mannerisms. He
dreaded some sort of revolt, and complained that the modern young people...wouldn't
do what they were told. I have always thought it strange that a man who gave so much
of his life to positive abuse of other people's work should be so hypersensitive as to
withdraw from exhibiting his own on account of some adverse criticism. He did not
show at the N.E.A.C. for years, chiefly because of that.

Thursday 28
Went to Alfred Thornton's show at the Fine Art Society...On the way, passing Cooling's,
I went in to see the Oxford Group of Painters, being interested to see how those who
have been at the Slade have developed...Waterfield is sensitive, Rowntree capable, and

Gore improving. Thornton has sold six things, one to the Contemporary Art Society; and I hear that Ethel Walker bought one, or perhaps two. I find the degree of truth in Thornton's work unsatisfying. I noticed a room full of 'Warwick' Smith's water-colours...I was not previously acquainted with them. Lunching at the Athenaeum I met Thornton. He speaks of Tonks as narrow (referring to his taste for a peculiarly English art), but 'not so narrow as MacColl'. He talked a great deal about psychology and drawing, and told me some extraordinary stories about thought transference or mind-reading, things that had happened to himself in contact with a medium in Paris, a complete stranger to him...

FEBRUARY

Monday 1
Inaugurated the new scheme of painting a model at the Slade with a background of furniture arranged to look like an ordinary room. A screen is covered with wall-paper (design by Ed. Bawden) and pictures are hung on it. The model poses on a sofa of Victorian lodging – house pattern, which Brooker bought for 5/- (but it was expensively covered). The students like this, and evidently take much thought for the composition of their pictures.

Wednesday 3
Lunch with the Douies...Douie was amused at the idea that he, Richardson and I are the only men in the University without degrees: does not think we are inferior on that account. Gwynne-Jones having told me the rather astonishing news of his engagement to Rosemary Allan, and his hope that his salary would be increased, I passed these on to Douie, who was amused, but not hopeless about the salary...

Thursday 4
Board of Examiners at the Courtauld, myself, unluckily, in the Chair. Stammered, but not desperately, and managed to get the business done. Came back to Hampstead, 6.30, for a cocktail party at Egan Mew's. Present...Mrs. Rutter (who says Rutter is ill again with his asthma, and that she finds the Garden Suburb remote and suburban), a painter named Clement Scott (who lectures in Germany), and Robert Farquharson de la Condamine,[1] with whom I got on well on the strength of a mutual liking for Albert R. Condamine is amusing and has great charm of manner, of the kind that goes with his known proclivities...Both he and Scott stammer too (perhaps Mew brought us together on purpose?) but Condamine makes a joke of it. When asked his real name by someone who did not catch it, he said he called himself Farquharson because he never could get farther with the other than 'Con...damn...damn...'.

Friday 5
Neville Lewis rang...to ask me for a testimonial, explaining that, now Tonks is dead, he is driven into asking me. He is making an application, backed by Rushbury, and with the approval of the South African High Commissioner, for the Michaelis chair, to which the South Africans have failed to appoint any of the other candidates. He hates Wheatley, and says he got drunk when he (Lewis) heard that I had got the Slade Professorship. I said in my testimonial that he was the most distinguished artist that S. Africa had produced, which may not be high praise, since the only others I know of are Gwelo

1 Actor, used the name Farquharson.

Goodman and Jan Juta…He told me extraordinary stories about Wheatley. Wheatley got £1000 a year at the University of Cape Town, and had his wife appointed teacher of drawing at another £600 p.a. He then got the job of Curator of the Art Gallery, with additional salary, and also snaffled every portrait commission that was going in S. Africa. He took over the School with 50 students and left it with 7. When the Gallery was founded he came to Lewis and asked to buy one of Lewis's pictures. Wheatley approved of one and asked the price, which was £200: he said they couldn't afford that, and asked Lewis as a patriotic concession, to come down to £75, which was agreed upon. Lewis afterwards found out that Wheatley had sold one of his own pictures to the Gallery for £500. There was also a commission for ten portrait busts of distinguished S. Africans, at £300 or £600 each…Grace Wheatley got this, though she had never done any modeling in her life, and though there is a very good S. African sculptor whose name is unfamiliar to me. Lewis, furthermore, complains of Wheatley's obvious truckling to Steer in the Chelsea Arts Club, and to Russell, who might push him for the R.A. Both of them had pictures bought for Cape Town (not unreasonably, perhaps). I don't know how much of this is strictly true, but it is as Lewis told me…

Monday 8
Asphodel Fleischmann had a show of pictures at the Beaux Arts Gallery in Burton Place. She has improved a good deal since she left the Slade. Some of the paintings were done in and round New York…

Tuesday 9
Cocktails with Mr. & Mrs. Norman Janes…Burn was talking of Tonks, and his difficulty in literary expression. He wrote many lively and spontaneous letters, but more carefully composed literature was not his strong point…MacColl re-wrote much of Tonks's reminiscences in *Artwork*…*The Times* did the same with his articles. I wonder now whether his utterances in the *Life of George Moore* were not rather edited by Joe Hone.

Thursday 11
Went to see the painted ceilings in the new University, with Polunin, Miss Stephen and Miss Labouchere, who drove us there. Miss Stephen's work is tasteful but too careless-looking, the cult of spontaneity being carried too far. The Academy School's ceiling is bad, but there are others not bad at all – one by the Central School students, one…by the R.C.A.…

Friday 12
…worked a little on an old drawing. Often one can see faults of tone or composition after an interval of time.

Tuesday 16
Nevinson gave a party at his exhibition [at] the Redfern Gallery. The rooms were so full…[and he] was doing the showman rather crudely. I heard him say to one woman that she was so beautiful that she prevented his pictures being seen; but in spite of all this, not many…appear to be sold…

Wednesday 17
...went to the Old Vic to see *Hamlet* 'in its entirety'. It began at 7 and finished about 11.30. Laurence Olivier is a handsome Hamlet, rather like a good Cranach portrait of a young man, and he tore himself to pieces in a hysterical, but earnest and intelligent rendering of the part...I have seen Hamlet done three times, once by Forbes Robertson, once by Gielgud, and now this. Whole long passages come back to me word-perfect from my school days, when I used to illustrate my school copy of the play...

Sunday 21
...interview[ed] Rice-Oxley of Keble about a portrait drawing commission. He knows Henry Lamb, who painted a portrait for the College: likes him very much, though he is difficult because so highly strung...

Thursday 25
...Gave Tommy Lowinsky dinner at the Athenaeum. He had dined there with Albert R. not long ago. As they walked into the coffee room Albert apologized for the dullness of the place – 'there will only be a few bishops about' – but actually there were no bishops, only Robin [Robert] de la Condamine and a boyfriend of his. Lowinsky... would not go to Tonks's memorial service, feeling his breach with Tonks too much. He saw a lot of Tonks during the War, when he was in the Guards and Tonks, a surgeon. As usual he was carping to a fault, and kindly at the same moment.

Sunday 28
Began a drawing of Geoffrey Hutchinson. His family comes from Bury, Lancs, but does not appear to have had anything to do with the cotton industry, like the Schwabes and Ermens...I am doing my drawing, which is entirely for my own satisfaction...in black, white, and red chalk...He has not sat before to anyone but Norman Evill,[2] who did not apparently make a success of it.

MARCH

Wednesday 3
Tea with Sir Charles Peers and Thompson, the American lecturer at the Courtauld, at the Athenaeum, to concoct an Exam. paper.

Sunday 7
Finished drawing of Geoffrey Hutchinson. He likes it and would buy it, but I will not let him do that, as I have seen too many people inveigled into spending money on portraits that began by a simple request from the artist for sittings, for his own satisfaction...

Tuesday 9
Burn's Private View at the Beaux Arts Gallery...Walcot was having a show in another room. Some of his drawings of London were better than I usually find his work. Usually, I dislike it for a kind of facile slickness and apparent insincerity. Matthew Dawson, the architect, whom I met, says Walcot is not doing so well now as he used to in the days of the overdone boom in his etchings, when he was reported to make £5000 a year at

2 Architect, worked for Lutyens before working on his own, also drew and exhibited R.A.

least, and had studios and wives in most of the capitals of Europe: certainly, in Rome, Paris and London...Burn's work, though full of sensitive qualities, disappointing – a little – from its usually incomplete realization...

Thursday 11
...went to visit Willie Clause in the Temperance Hospital in the Hampstead Road...[he] has had his gall bladder removed...McClure, the surgeon, is the man who operated on Ginner and, some say, messed up his case and fleeced him of most of his little capital – but there may be another side to that story...

Saturday 13
Started a drawing of Corfiato, which I will give him in return for his good offices in selling the drawing of Hastings for me, to Ferner, the architect from S. Africa (£10-10-0). Corfiato was once taken to see Rodin, and assures me that he found him naked in his studio, with a red fez on his head and one or two naked models about: also that Rodin went to the Quatz' Arts ball similarly equipped, as regards his own costume.

Monday 15
...After dinner...went with Birdie to the Marsdens in the residential part of the British Museum, where they have a fine house, and where they were entertaining to supper a party of young people, including Alice, before their departure for the Albert Hall...He is Keeper of Printed Books...

Tuesday 16
Borenius hates Constable; 'nothing but contempt for his character,' 'a bad teacher', 'the Courtauld Institute a laughing stock'...All this and much more he said to me in an attempt to get me to decline my signature to the document which reached me from Mann on March 10. I told him that I had already signed it, from friendly feeling to Constable and trusting to the knowledge of affairs by Mann and Campbell Dodgson: that I could not withdraw my signature, and that...I regretted not having consulted him...

Friday 19
Slade Dinner...felt most uncomfortable...Still it isn't as bad as it used to be. Albert R. was nervous too: he made a much-needed speech about Tonks, which was well received...

Tuesday 23
...Went to see Jean Inglis, who was very worried about the commission that I got for her, through Borenius, to copy a portrait of the Princess Royal by Simon Elwes. She is really doing it very expertly, but was given strict injunctions not to use any medium, so the paint sinks in and looks cold.

Wednesday 24
Finished the drawing of Heath Street. The sun came out conveniently...allowing me to note the lighting....5.30 Went over to see Max and Tony's Coronation Procession, 100 ft. long, for the Lansdowne Bar...

Sunday 28
Finished, as far as I could, the drawing of the backs of Church Row from the roof of Max Ayrton's studio. He and I started together on Friday, but were driven off in the afternoon by snow. Mrs. Ayrton is very good, bringing out trays of hot coffee and gingerbread in the middle of the morning; and Adrian Waterlow very helpful erecting ladders to get on to the flat roof...Afterwards to Shawfield Street, Chelsea, to see Gertrude Knobloch's lead figure of a jester, a garden ornament, also destined for the R.A. There is a certain skill in it, but though not without a sense of design, the form is weak here and there...Mew was there and Edward Knobloch.[3] Knobloch was very disparaging about the cinema industry and its leading figures. He called on Douglas Fairbanks some time ago to show him the synopsis of a film drama, boiled down to its mere bones in five pages of type script. Fairbanks professed himself utterly unable to read it. 'You tell it to me. I have never read anything but my own press notices'...

APRIL

Friday 2
Left for Hastings with Hagedorn. Stayed at the Rendezvous, an Italian café on the St. Leonard's front: a hideous interior, but very good service and food...10/6d a day for everything.

Saturday 3
Started a drawing of Pelham Crescent...it is by Decimus Burton, and I am informed from local sources that Burton designed the symmetrical lay-out and features, in the Greek revival style of about 1830-40, on the front at St. Leonard's. Hagedorn went to the fishing town at Hastings...

Tuesday 6
Drew some boats on the beach. Returned to London...

Friday 9
Went to Ealing to meet Miss Winifred Mayer, and to go through some of Katherine Mayer's effects – drawings of all sorts...recalling many incidents of our Chelsea days. She was very near being an excellent artist, and the things she did not show are frequently much better than her commissioned portraits – I have known few painters with a better sense of character, particularly in children. There is going to be a memorial show of her work...I gather that her mental state did not improve. She died in February.

Thursday 15
Made a preliminary inspection of the Prix de Rome work...Some of it has considerable beauty and capacity. There are some particularly pleasing works by those competing for the engraving prize. I met Robert Austin and Gillick there...

Friday 16
Spent the morning with Collins Baker in Tonks's studio picking out...drawings for the Slade School...Collins B., very rightly, is destroying some of the work...The moral of

3 Dramatist and novelist.

all this is not to keep too many of one's own drawings, but, though I have a firm determination to destroy a few hundred of mine soon, I know there will be a ridiculous surplus of bad things...lunch at the Athenaeum...MacColl was...annoyed about Maynard Keynes backing Gertler, on his recent work, as one of the three most important artists now in England, the others being Sickert and Duncan Grant.

Tuesday 20
Meeting of the Rome Prize Painting Faculty to award the Scholarship. For once we were unanimous and selected an Australian student of the R.A. Schools named Bevington... Rutter's funeral was one day this week...Hagedorn went. He said there were very few people there. I...did not know of it in time...

Wednesday 28
Dermod O'Brien called upon me at the Slade, to inquire into the progress of Gerrard's bust of Tonks, which is not yet begun, though G. has accumulated material for it, notably some twenty or thirty photographs by Beresford...O'Brien once shared a house with Tonks in Cheyne Row. They did not quarrel, though Tonks was difficult, even in those days; and they remained firm friends to the end, Tonks visiting O'B. last year in Ireland...

Thursday 29
...Imperial Institute to see Albert R.'s decorative panels for the Paris Exhibition, together with the furniture of the room in which the screen is to go. Chairs by Ravilious out of Dunbar Hay, carpet and tea set by Albert [painted for Kenneth Clark]...

Friday 30
Wrote 400 words on Stanley Spencer for Will Rothenstein's forthcoming book of portrait drawings[4]...

MAY

Thursday 6
Went to see Lewis about framing my Tonks drawings, and Colin Gill about Exam. papers. Having a frame and 79 scripts to carry, and as there is a bus strike going on, I took a taxi. We were stopped in trying to cross the Park from Paddington by Stanhope Gate, because the Park is a military camp during the Coronation proceedings...London has 'gone gay' in the matter of decoration, especially the poorer streets (as opposed to the bigger private houses) which are smothered in bunting. The Royal Hospital in Chelsea is tastefully done with red and gold swags of drapery under the cornice...Gill was just beginning a huge canvas of Boadicea at Colchester: had some of the figures drawn in in monochrome. He is going to do it in a wax medium. He has just returned from his tour of mosaic research...

Friday 7
Geoffrey Egar to dinner. He has been in Paris, where he was taken to call upon Picasso, Leger, Brancusi and Cocteau. Picasso[5] and Brancusi struck him as simple and unaffected:

4 *Contemporaries: Portrait Drawings*, Faber & Faber.
5 May-June painted *Guernica* in his Paris studio for the Spanish Pavilion.

Leger self-satisfied and over-pleased with his work – he has been working on miles of decorations for the Paris Exhibition: Cocteau affects the manner of a more youthful man than he is: talks a lot about 'nous autres poetes', and is generally rather showy without saying much of interest. Brancusi's metal objects of art are shown off by revolving them slowly on electrically driven turntables.

Saturday 8
Coronation decorations are growing thicker all over London. Ayrton in Hampstead has put up his two wooden soldiers over his porch and arranged a flood-lighting for them. Even Mew is going to hang out a flag…Birdie has ordered a wreath of red, white and blue flowers to hang on the door-knocker.

Wednesday 12
Alice and I saw the Coronation procession from the Athenaeum…Many casualties visible in the street. St. John's Ambulance men dealing with them…I was too high up on my balcony to see into the covered coaches, but Mr. Baldwin and Princess Elizabeth were visible as they leant forward. The Indian troops and potentates looked very fine – so did our own army. The drum major of the Royal Marines was 'doing his stuff', throwing his staff high in the air and catching it as he marched…The wireless did its work well reporting everything…Birdie and I dined with the Wellingtons and Daphne at Jack Straw's. Listened to the King's speech – slow with awkward pauses, but clear…

Thursday 13
…to Greenwich to see the new Maritime Museum – very well done, and the Inigo Jones house looking very fine…All the Jamaica Road and Deptford and Bermondsey districts very profusely decorated with loyal signs. Working people must spend every halfpenny they can afford, and more, on these things…Went to a party at Mrs. Pomeroy's in Onslow Gardens…On the invitation, sent by Fairlie Harmer, it said 'Cocktails and Coronation Robes'. She received the guests with all the robes on, and a coronet. Lord Harberton (without robes) sat in a chair in a corner, rather silent, whether from an excess of gin or too little, I don't know. Noel Rooke was almost alone…in wearing a tall hat, in which he looks like a Baptist preacher…Dinner at De Hem's [they] have introduced a dance band, but the manager says they have done very badly over the Coronation, and so have most of the shops.

Thursday 20
Board of Education Exams…Story of Tom Balston visiting Robert Gibbings at White Waltham in Berkshire. He was introduced in the garden to the house party, Gibbings, Mrs. Gibbings and others, who were all practising their cult of nudism. Afraid that he might be a little shocked, or not knowing quite how he might react to such a situation, they came towards him holding some sort of drapery across their middles. He says he realized that only one course of action would regularize things: seeing a pond, he said: 'What a nice bathing pool you have here!' – stripped off his clothes, and plunged in, joining the others for lunch afterwards without dressing. He found it rather awkward at first to prevent his gaze dropping below the faces of the persons he was talking to…

Sunday 23

Walked with Grimmond…he related how last week he had, for advertisement purposes, to procure a photograph of a canary in a cage. He bought a birdcage and a canary, but found it impossible to get a good picture of the live bird, so decided to try a stuffed one. On inquiring at the shop where he got the birdcage he was told of a man in Camden Town who supplies such things. (I have always believed that somewhere in London it is possible to buy anything in the world that can be wanted). Grimmond went to a dull featureless street…and in a yard at the back of a house found his man…There was an elephant's head and a huge gorilla…A boy was ordered to 'bring out the canaries' – a large box full of them at 2/6d each, or 3 for 5/-. Grimmond said to the taxidermist, or naturalist, as he calls himself, that the birds were a little shabby. 'Oh, you can easy prink 'em up with a pin', the owner said, blowing off the preservative powder.

Monday 24

Board's Exams – 500 odd candidates…As they send in two [drawings] for today's test – Memory and Knowledge – that means over 1000…to be marked.

Sunday 30

Tom Cobbe drove us all – Dora, Birdie, Alice, Margaret and I – to our old cottage at Lower Wood End [Marlow], which Alice wanted to see: she hardly remembered it, but seeing it recalled a great deal to her, from the time when she was a very little girl there, with Mrs. Gwynne-Jones, Mrs. Orage and Mrs. Florence…It was a pleasant period for us. Birdie used to look so beautiful, too, in her blue Egyptian cotton dresses, always fresh and clean…and Alice's frocks, always kept spick and span…It must have been hard work…[and] driving with the coals in Mrs. Todd's car that we borrowed…There are buses now…and the roads are full of young men and girls on bicycles, in shorts, which would have been thought odd twenty years ago…We watched a German air-raid, thirty miles away over London, from there once. More curiously, we heard the guns in Flanders, from Chelsea, one quiet night with an east wind blowing…

Monday 31

Wilfred Walter called at the Slade. He is thinking of sending his boy…He was a Scholar in my student time, and I used to think him very brilliant. He taught drawing to George Charlton, in the City somewhere, when Charlton was a boy. Then he took to the stage. He was very good-looking, and he and Arthur Watts, another six-foot Adonis, used to have boxing contests after 5 o'c. in the Slade life-room.

JUNE

Thursday 3

Met Henry Moore coming home in the Tube…I told him that I used him, in talking to students, as an illustration of the fact that a backing of academic study, of drawing particularly, did no harm to a modern artist. He heartily agreed, and made much of the value of being trained to observe…

Friday 4

Tea, at Codrington's invitation, at the India Museum…There was an Indian manservant

waiting…Went off after a while with Athole Hay to the College of Art, where we met John Nash and Freedman…Hay says Nash is a great success at the College…

Tuesday 22
…went to the opening of a show of pictures by Isaac Rosenberg at Whitechapel…Eddie Marsh made the opening speech…He said nothing about the pictures, mentioning Rosenberg only as a poet. Mrs. Wynick, the artist's sister, travelled with me from Euston Square to Aldgate East. I thought that three at least of his drawings were very good and the paintings very promising. A Jew poet (practically all the audience of over 50 persons were Jews) named Leftwich spoke also, and did it much better than Marsh, whose voice and delivery are poor. Charlton said he remembers Rosenberg reading his poems in the Slade life-room. They were received in silence, and then, when Rosenberg had finished, with a roar of laughter. Now Edith Sitwell says he was 'one of the greatest poets we have had in this or the last generation'…

Wednesday 23
Examiners' Meeting, Board of Education at S. Ken., to reform syllabus. Charlton came, and the architects, Jarrett & Holmes, and Dickey, Travis and Wilson from the Board.

Thursday 24
…Slade picnic at Wraysbury…played cricket. The driver of the charabanc, and Connell the Beadle, and Adurka, the Bombay student, were far the best players, which does not speak well for our expensive schools. Daphne, who is entirely incompetent, and cannot throw a ball straight underarm, played for a while in her bathing costume, as did some of the others; but they dressed for tea…

Friday 25
Board of Education Exams. Jowett and G. Spencer came, and agreed with our marking, entirely independently…3.15 Speeches and Prize-giving. Thank God that's over…

Saturday 26
Birdie went to see a show at King Alfred's School, in the gardens, in aid of the suffering Abyssinians. Margaret Morris people, including Alice and Dorothy Gates, danced. Sylvia Pankhurst spoke, and the Emperor Haile Selassie, sitting on a kitchen chair, honoured the proceedings with his presence. I don't suppose he cares a tuppenny damn about the suffering Abyssinians, except himself. He ought to have stayed in Addis Ababa and taken the chances of war when the Italians got in. Sylvia Pankhurst was ill-mannered and offensive to the M.M. people, who were doing their stunt for nothing…

Tuesday 29
Went to the Tate in the afternoon, but it was shut, owing to the inauguration of the new Duveen Sculpture Galleries by the King and Queen…

JULY

Friday 2
Reading University...Betts and Ormrod...Betts is illustrating *Wuthering Heights* with 24 drawings. He knows Haworth and the country round intimately, having been born in those parts, and he appears to have a real feeling for it. Did not see Will Rothenstein's portrait of Austen Chamberlain – it is lent to Sheffield. There are two portraits in the common room by Morley Fletcher, whom we used to know in Marlow during the War, or just after; very competent, up to a point, but totally uninteresting.

Saturday 3
At 97 Cheyne Walk, hanging Katherine Mayer's pictures. The organizers have borrowed a lot of pretty bad commissioned portraits of children, and have left out the drawings and studies which I selected, which would have given an intelligent critic a much higher opinion of Katherine's power as an artist...One of the back rooms was Whistler's studio...There is a good 17th century staircase. Another one was put in by Lutyens for a previous occupant and is now masked with three-ply by George Kennedy, as his client did not like Lutyens's work...

Thursday 22 – Thursday 29: no diary entries

Friday 30
...Called on Ayrton. He is pleased because, after numerous disappointments, he has at last landed another big job. The Medical Research place in Branch Hill, to which he built an addition, is being moved by the Government to Mill Hill, and he is to do the new building.

Saturday 31
Left for Cerne Abbas...We stay at the Pitch Market, facing the Church door in Abbey Street. It is a half-timbered house, with a little 15th century carving left on it, and two 15th-century fireplaces. Mrs. Jarrett runs it as a 'guest-house'.

AUGUST

Sunday 1 – Saturday 7: no diary entries

Tuesday 10
Ginger came to Cerne.

Wednesday 11
We all...walked to Maiden Castle from Dorchester...saw a skeleton being uncovered... We were struck by the perfection of the skull that we saw brought to light...we supposed about 2,000 years old...A girl in shorts was cleaning the teeth of one head, with a toothbrush...This, and one other day when we drove to Goathorn and Studland...is the only time subtracted from the business of daily drawing...Ginger goes about in a Tyrolean costume of grey flannel with a green stripe down the trousers.

Thursday 12 – Monday 23: no diary entries

SEPTEMBER

Sunday 5
J.B. Clark, ex-teacher Royal Academy Schools, lives in Abbey Street, in a house that was one of the dozen inns of Cerne in past days…He seems to have been a skillful engraver and etcher…

Thursday 9
Hagedorn left Cerne.

Friday 10
…We are all, really, very depressed about going back to London. I stay on alone, to do some more drawings while Birdie gets the white elephant of a house in order…Read some of the cheerless and overdrawn work *The Death of a Hero* [1929].[6] P.S. I don't know that the war parts are overdrawn. Luckily, I have no first-hand experience of war, but can believe anything of it. I was thinking of the social satire in the book.

Monday 20
Minkie [Eunice] Pattison* and I climbed to the top of Cerne Church tower, and I had a final general view of the place that I like so much…she drove me to Dorchester and I took the 1.55 train…

Tuesday 21
Took my Cerne drawings to Lewis…He liked some…but not others, which, consequently, I did not have mounted. The same has happened with Steer, who apparently has been doing a few water-colours during the summer. He can see the landscape out of the corner of his eye, but can hardly see the paper…

Friday 24
Birdie, Alice and I called on the Dursts after a dinner in Belsize Park. He is having a show of his sculpture in Oxford, and has just finished writing his book for *The Studio*…

Sunday 26
…Saw Egan Mew and G. Hutchinson (M.P. now). H. has been in Germany. He thinks there is a boom on there, and that things are not so bad as our newspapers would have us think…

Tuesday 28
Started a drawing of the south door of Hampstead Church. Something about the body of the Church has always appealed to me, though I don't think Flitcroft succeeded so well with the tower…Party at 3 Onslow Square for Dooley [Tennyson] and Yvonne [Yve], who are getting married tomorrow. She looked charming and behaved with charm and dignity. Before going in, met Penrose in the street…just back from his film job.

6 Richard Aldington's first (partly autobiographical) novel set in the First World War.

OCTOBER

Friday 1
...Slade interviewing new students...

Saturday 2
...Did all I could to my drawing of the Church, except a few washes to be added at home...Dinner at Roche. News Film, including photographs of the bombing of Shanghai, and the interior (very interesting and admirable) of Washington's Mount Vernon. Got a cheque from *The Studio*, £5-5-0, for article on Book Illustration. It is out now...

Thursday 7
...House hunting. Looked at Stanfield House again. The caretaker, Davidson, has broken up Skeaping's plaster figure and laid it out in bits along the border of a flower bed in the garden, like a rockery. He says 'It looks much better filleted.' We have decided not to move till we sell this house, and to put it in Messrs. Potters' hands at the ridiculous price of £6000.

Friday 15
Slade Prize giving for summer compositions. [John] Innes is very promising (2nd prize)...4 o'c. First experience of Courtauld Management Committee, at the University. Formal business. Stormy petrel, Lord Lee, said nothing: neither did I. I note that Constable got £1500 a year, and the flat...

Saturday 16
...Towner is busy getting into no. 8 Church Row. His rates there are about £30. Ours are over £60, and his used to be £10 in Holly Hill. There seems to be a want of proportion about this. I see notices of a meeting to take place at the Town Hall: 'Japan must be stopped'...How can they stop Japan?

Tuesday 19
N.E.A.C. General Meeting...Dodd took the Chair. I was made a Trustee and put on the Executive again. Nevinson drove Charlton and me back to Hampstead...He is writing his memoirs. Doesn't like the new Picassos he saw in Paris. Knowing everyone, as he does, he had a good deal to say of his meetings with Salvador Dali.

Thursday 21
Began a drawing of Mrs. Noel Carrington, in black, white and red chalks, with a little pastel added. Her head is as beautiful as I thought it, and the drawing went well...3.00 At the National Gallery, to see a copy by an Indian student at the Slade, Gondhalekar[7]... Met Charles Weekley, going to see Epstein's *Consummatum Est.*[8] Nobody seems to like it much. It looks a hideous shape to me, in photographs.

7 Slade (1937-38), educator and administrator.
8 Exhibited as a curiosity at Tussaud's fairground in Blackpool. The idea for the sculpture came while he listening to Bach's B minor Mass and, looking at a large slab of alabaster in his studio, he saw it as a whole, in his head. 'Consummatum est' (It is finished) was uttered by Christ from the Cross.

Friday 22
Continued the drawing…The mouth looks wrong now, as I have worked the rest up to a different stage, and there are little things to adjust. She has sat to Gertler and Colin Gill. She and her sister, Margaret, were known as the beautiful Miss Alexanders. Her husband says I should have drawn her sixteen years ago, but I think she has worn wonderfully well. She was 19 when she married Carrington. She complains of her lack of education…

Monday 25
…On a sudden telephone invitation…(probably to replace a guest who failed) I dined with the Rothensteins…W.R.'s second drawing of Somerset Maugham is…very like and very sensitive, and much better than the reproduction of it in his new book of portraits…

Thursday 28
Finished the drawing of Catharine Carrington. She says it is the most like her that has been done. She talked about her friends and acquaintances at the Slade and in Pond Street, Gertler, Dorothy Brett (who is believed to be living a solitary life on her own ranch in America), the Anreps, who quarreled violently and pigged it in some disorder in the otherwise pleasant old Pond Street house, Middleton Murry, and Katherine Mansfield. Dorothy Brett spent a lot of money helping to support some of these persons.

Friday 29
…hung the East End Academy, with Duddington, at the Whitechapel Art Gallery. The new Underground Station is making changes in Aldgate and Whitehapel High Street… The Gallery used to collect dues (in common with the neighbouring shops) from the hay wagons that used the centre of the street opposite their premises. The dues fell off because the L.C.C. limited the number of standing places, and finally they were abolished altogether, without compensation…

Sunday 31
I see in the current catalogue of the London Group exhibition that that enterprising artist, Norman Dawson, has painted a picture with the attractive title 'Pre-Natal – Cacaform'. I hope nobody takes any notice of it, as I should like him to be disappointed in his new effort at publicity. Rodrigo Moynihan has practically confessed to Daphne Charlton that his extremely abstract ventures were simply done to make a sensation. He is now doing portraits, including Daphne's, because there is more money to be made that way. These people don't seem to paint pictures because they want to paint pictures but because they want to be talked about or rich. I don't think theirs is a good primary motive, and there must be a great deal of disappointment in the search for wealth through painting. Of course, we all like to be rich and successful, but not everyone puts such things first in starting on an artist's career. It will be interesting to see how rich and how successful these gentlemen become. Nevinson, somebody told me, discovered, on going through his accounts, that he had made £40,000 in 20 years.

NOVEMBER

Monday 1
Lunch at the Athenaeum with Evelyn Shaw, to discuss the affairs of William Morgan, once a Rome Scholar in engraving [1924], who has been living on a gentleman's estate (Owen Smith's of Hay's Wharf) and at Ardtornish in Argyllshire for some years, with his wife and child. It was Tonks who suggested that he should go there…This laird appears to be one of the old-fashioned patrons of art. Morgan thinks the time has come when he should get more in touch with the world again…Now he wants a teaching job. I wrote recommending him…to the Head of Malvern College, who wants somebody just now and will pay £400 a year.

Thursday 4
Began a drawing of Daphne Charlton. She is a difficult and distracting sitter. In the after-noon, Slade…Tea in the Provost's room to meet the Sitwells. They were all three there, Sachy, who was to lecture on George Cruikshank, arrayed in a perfect morning coat, with a flower in his button-hole – a very becoming costume to a man of his elegant, tall figure. The lecture went off very well, and the etchings from the *Comic Almanac*… showed up well on the screen. Edith S. (arrayed in black with a biretta-like hat, looking distinguished and rather Renaissance) says Sachy has never lectured at all before this bout, and was secretly horribly nervous, but he carried it off well…The lecture was free from affectation of any kind. So were the Sitwell family (Osbert, Sachy, Edith and Mrs. Sachy – they all kiss one another in public) when I dined with them later at the Douies… I ventured to suggest to Edith, next to whom I sat at dinner, that I might draw her por-trait. She received this idea favourably…She did not like sitting for Tommy Lowinsky. In the drawing room they egged each other on to tell funny stories: 'You tell that Edith', and so on. There is a strong family camaraderie among them.

Friday 5
Went on drawing D. Charlton, with some difficulty and frequent interruptions. Her set of young people seems to include some who toy with nudism. The Noel Carringtons make a practice of nude bathing. Daphne, Eleanor Moynihan and Rodrigo all took off their clothes one evening at the Moynihans' rooms. Maxwell Ayrton says he hears of 'strip-tease' parties, where a game of forfeits is played, each forfeit being followed by the removal of some article of clothing…

Tuesday 9
Dinner in College in honour of the Sitwells…Sachy was at my table, and I sat between Mrs. Sachy and Mrs. Douie…Edith S., instead of looking like a portrait by Holbein, as she did the other day, resembled a Victorian lady of the 'fifties, with a dress which showed her shoulders, cut straight all round, and her hair done appropriately…The Sitwells were as easy to get on with as before, almost shy in their modesty, and without the acid quality of some of their literary work.

Thursday 11
Finished drawing Daphne Charlton. She came late, at 11.15…when the two-minutes silence was past. She had been listening to the wireless, and described how Big Ben was

heard striking the hour, and then, instead of silence, an uproar. I went out to buy a paper, but at the moment of writing this I cannot get one – they are all sold out. I had a verbal description from the girl in the newsagent's shop of the scene at the Cenotaph. 4.15 Bought a paper with details of the incident that took place: a man just out of a mental home causing a disturbance...

Friday 12
...Did a round of exhibitions in the afternoon: Roy Beddington's water-colours... Hagedorn thinks him too facile: two shows of Degas, including some masterpieces (The Spanish beggar woman is fine, and his colour and general control, especially in the later works, most interesting), but, curiously enough, some occasional weak or empty pieces of drawing, which I found again when looking at some reproductions of early work by him, in the *Gazette des Beaux Arts*, which I picked up at the Club – he is not impeccable: a show at Tooth's, with some fine Pissarros, Boudins, Renoirs...and the Duncan Grant show at Agnew's, with the big decorations...for the 'Queen Mary'. Jowett...rather under-valued these, which I thought remarkable things, though the inconsistence or partial absence of planes is worrying. Cundall...agreed with me about their interest, and liked their colour. In Pall Mall met F. Kelly and Tom Heslewood,[9] a remarkable looking pair...

Sunday 14
...to The Flask at Highgate. Met Albert R. and Athole Hay, who had come up in a car. Some talk with Albert about Humphrey Waterfield going, or not going, to take up Robin Darwin's job at Eton. Waterfield declared his pacifist views, which he thought unsuitable, and would not bind himself to stay longer than three years. They have not found a more suitable man yet. The Daryl Lindsays came to supper...Much conversation about the Fel-ton Bequest job, about Burdett failing to get it, and about Cockerell's way of carrying it on. Lindsay criticized Cockerell severely for his way of spending the money, for his rude-ness when out in Australia, and for his self-important attitude...

Thursday 18
Sent some of Tonks's letters to Joe Hone, with the idea, suggested by MacColl, that Hone might use them in his *Life*...

Saturday 20
...Went to Camberwell to hang the South London Group...with Guy Miller, Russell Reeve, and [R.F.] More. They are going to show some thirty drawings of mine in the corridor gallery. Gerald Kelly has sent nine pictures, some done on his recent tour of the Far East...

Tuesday 23
Olga Lehmann's Private View at the Little Gallery in New Burlington Street, an under-ground cramped place...Olga is extraordinarily productive, and, besides her decorations in stick-bee paint, has done scores of drawings, some very lively and capable...

Thursday 25
Presentation of the Tonks Memorial Fund and bust at University College, in the Exhibi-tion Room. The bust is very much liked by those who knew Tonks well...MacColl...

9 Actor and costume designer.

made the principal speech…his address was beautifully balanced between real feeling and the lighter side. D.S.M. first met Tonks at the Westminster School of Art, in Brown's time – the old Architectural Association building. He sat on a seat to draw the model, and Tonks claimed that he had bagged that seat himself, and MacColl resigned it; from which trivial origin a life-long friendship began…

Friday 26
…Birdie reminded Towner and me of Augustus John's odd way of painting a head regardless of the background. When he painted the picture of her in a black hat, he did the head completely first on the bare canvas, and then said – 'What sort of a background shall we have? – bother the background.' The standing figure of Birdie was done with one of John's own paintings of a lake-side scene behind her. He made this look as if it was out of doors. In the case of Richard Gregory's portrait – done at Coole – he got it to a certain stage when everyone was quite pleased, with…a green background, and they came in one morning to find he had changed it to a bright blue, or at all events some other colour, without, apparently, considering its relation to the head at all.

DECEMBER

Wednesday 1
Cocktail party at the Blomfields, 51 Frognal: it seems hardly a suitable house for an important and successful architect: comfortable…but without architectural character and nondescript in the way of furnishing…The Constables have been in Venice, where he has been working at a book on Canaletto…

Thursday 2
Went to Tite Street to confer with Colin Gill about Board of Education Exam. papers. He is writing a novel, in partnership with a girl whose name I forget, but who was present at tea. Gill has been drawing a head of Q. Elizabeth at Buckingham Palace. He only had 1 hour's sitting, and is to do a painting from the drawing, and to have another hour's sitting when the picture is well advanced. He wants a model for the Queen's figure. I think I know of a shortish, plump person who would do, who sits at the Slade. When Gill arrived in the room, in which he was to draw Q. Elizabeth, there were several men-servants making up the two fires there, and a major domo holding up a thermometer, testing the temperature of the place…After an hour's work, in the course of which Gill kept up a running conversation and the Queen (unexpectedly) said she thought László's paintings were 'chocolate-boxy', Princess Elizabeth came in, saying 'Daddy says lunch is ready', and the proceedings came to an end…

Saturday 4
…Thorogood opened the South London Group Show with a sensible, considered speech. He referred to me and my part in the Exhibition, and George Holland has written a kindly notice of me in the catalogue. I was a little late, as I went to sleep in the Tube about Old Street, and got carried to Balham instead of the Oval…

Wednesday 8
Attended Sir Andrew Taylor's[10] funeral service at the Presbyterian Church in Frognal
Lane. After the Slade, the Athenaeum. Met Eric Gill there, being entertained to tea by an
Indian gentleman who was interested in getting a new alphabet for India…

Thursday 9
Went to see Bob Wellington about a commission to do a lithograph. His office is on the
2nd floor of no. 15 Soho Square, a house of about 1680…John Piper and Myfanwy Evans
came into the office. We discussed the nature of an architectural subject to be drawn,
and after dropping several alternatives, decided on Greenwich – the Royal Naval College.
The fee is £5 when the drawing is done, another £10…when the stone is finished, and
a possibility…of royalties which might bring the whole sum up to £60. I went off to
Greenwich…Pottered round, talking to policemen and naval men who look after the
building…

Friday 10
…Athenaeum. Met Gere, and later Francis Dodd, now busy with the work of hanging
the Winter Exhibition of 17th century art at the R.A. Dodd has made very little money
indeed these last three years…A bad case is Clausen's. He has not let the state of his affairs
be known, but Dodd ferreted things out, and will do his best to get a picture of his
bought by the R.A. for £200 out of the Stott bequest; also to get him and Lady Clausen
a Civil List pension. He sold one painting only last year, and had an annuity of £50 from
the A.G.B.I. That is all he has. He talks of having to sell his Gainsboroughs (drawings)…
but says 'at my time of life (86) I oughtn't to have to sell my Gainsboroughs.' He was
in tears when Dodd held out hope of honourable relief. His (four or five) children have,
I suppose, been helping him, but naturally he wouldn't like to be a drag on them. He
says he still paints, but only from habit now. Dodd is also in part responsible for a
movement to do honour to Fred Brown: he talked this over with MacColl, who wrote
out a draught of an address to be presented to the old man. Dodd innocently showed
this to Walter Russell at the R.A., who, not finding his name in it, flung it on the ground
in a rage: he thought, reasonably enough, that any account of Brown's teaching at the
Slade, and of his assistants there, should make some reference to himself. He said 'I have
worked for the place for thirty years, and they treat me like dirt.' 'They' apparently,
includes Steer and Tonks: though Charlton told me that they all always got on very well
together, and Russell hung Tonks's pictures at the Tate, and Tonks said to me, apprecia-
tively, how well it was done. Dodd tried to placate Russell by explaining that MacColl's
screed was not in its final form, and that Russell would certainly be mentioned: in fact
Dodd will make it his business to see that D.S.M. does something about it. I felt myself,
the other day at University College, when MacColl was making his speech about Tonks,
with Russell sitting in the front row listening, that some allusion to Russell was called
for; and was conscious of an awkwardness when I was referred to, and not he.

Wednesday 15
…I was guest at the R.B.A. Club Dinner, Park Lane Hotel. Curious to see Bertram Nicholls
& Clifford Bax[11] who were youngsters with me at the Slade now in places of honour.

10 By his will, the Sir Andrew Taylor Prizes in Fine Art and Architecture were funded at U.C.L.
11 Bax's *Inland Far* (1925) refers to his Slade days *c.*1904, later a critic, editor and playwright.

Bax used to be an effeminate youth with a receding chin and a red tie; now he is a dignified man with a grey beard, who makes a very good speech. Humbert Wolfe also made a typical oration, impassioned in parts & funny in others…Bax came and spoke to me when the dinner was over, and I talked to Bertram Nicholls too, also with [Denys George] Wells who was at the Slade in 1900…Hesketh Hubbard presided well.

Monday 20
…Christmas shopping in Hampstead, books for presents. Bought Agnes Miller Parker's *Down the River*…better than Clare Leighton.

Friday 24
…To Peasenhall, meeting Charles Tennyson, 3.10, at Liverpool Street. By car with him from Ipswich…Pen's job with Gaumont films has come to an end.

Saturday 25
A fine morning: walked with Bruno K. by Sibton and the Saxmundham road…Afternoon – Christmas presents…

Wednesday 29
…Left Peasenhall…

Friday 31
Started drawing at Greenwich…Towner described a Christmas morning service at Harting, where he and his mother have been staying. It was a very dark day, and a few candles were lighted…The parson, reading the lessons, would walk to the nearest candle to get a little light on his book: overhead, numbers of bats flew about and squeaked, occasionally flitting low over the congregation, who are used to them and take no notice. Old Gunning King, well over 80, still lives and paints at Harting, and is active enough. I don't think he is a good artist, but he has ability. He has sold well during his life… [although]…He told Towner…that he had not sold at the R.A. this year.

1938

Schwabe is elected to the R.W.S. on his third attempt. He notes the alarm in the newspapers about Hitler's Germany annexing Austria. The 'Cross-Section of English Painting' exhibition at Wildenstein & Co. is visited by Schwabe, a number of the exhibitors are members of the recently established Euston Road School, whose members work essentially in a realist tradition. Schwabe spends a few days on a painting holiday in France with Max and Tony Ayrton. Fear of war is apparent both in Europe and at home where anti-aircraft guns and trenches are in place in Hyde Park and barrage balloons are being tried out.

JANUARY

Sunday 2
Only achieved 2 hours and 20 minutes at Greenwich. Rain…Home by the tunnel to Poplar, and by Millwall, Commercial Road and Mile End to the Bank. I always admired the Wren and Inigo Jones building, but closer knowledge of them convinces me that they are among the finest things in Europe…There seems no dignity now in art to compare with the 17th century. Tea with Durst. He was trained at the Naval College, and agrees with my estimate of its architecture. He has done a well-lettered tombstone to his 16 year old cat, and a font cover for Goring Church, in wood.

Wednesday 5
17th Century Exhibition at R.A. Met Dodd there and went round with him, with great enjoyment.

Friday 7
A fine day – first sun since Christmas Day. 4¾ hours work at Greenwich.

Sunday 9
…Finished drawing at Greenwich by 2 o'c. The 9th day and my 10th visit. The Admiral-President, [Sir Sidney] Bailey, and his wife invited me in to have a glass of sherry and to look at their palatial and pleasantly furnished quarters…There is central heating, and open fires.

Thursday 13
Took my Greenwich drawing to Bob Wellington & [John] Piper in Soho Square, who passed it, and I went on to a commercial photographer in Chancery Lane to have it enlarged to the size of the stone, ready for tracing…

Friday 14
Met MacColl and Sir A.[Augustus] Daniel at Park House, Rutland Gate – Baron F. D'Erlanger's – to look at a [Jacques Louis] David [1748-1825] portrait about which there is to be a law suit. It is badly damaged in the right-hand bottom corner, by fire…The insurance money, £10,000, is being claimed, and refused because an alleged expert in

Paris says the picture is not a David. I see no reason to doubt its attribution and its genuineness. It is supposed to be of Mlle. Ducreux, daughter of the artist, and belonged to the artist's descendants. Borenius is going to testify that it is not a David. MacColl thinks he is a rogue, and that he is, among other machinations, trying to undermine Kenneth Clark at the National Gallery. Daniel's opinion of the picture was undecided: he does not claim to know enough about David to be positive, but he leaned to our view. 6.30 Party at Ian Strang's…Conversation turned on Fred Brown. Ian and Meninsky are both warm in his praises, and, of course, ready to sign the memorial which is to be presented on Brown's 87th birthday. Meninsky says he teaches drawing on exactly the same system that Brown taught him (though I should hardly have thought so) and remembers much of his actual teaching, but almost nothing of Tonks's…M. sees something of David John, who earns £800 a year playing the oboe in the B.B.C. orchestra: he asked Meninsky to tell him candidly whether he considered Augustus a good artist, and flushed with pleasure (though they are quarrelling now, he and his father) when M. was genuinely enthusiastic.

Saturday 15
Fetched my photographic enlargements of the Greenwich drawing (2 for 11/6d: 18 x 14) from Chancery Lane. Called on Bob Wellington again about lithographic details. Saw a drawing of Wadsworth's in the office – only average interesting…

Sunday 16
Rodrigo Moynihan called to get my signature for an application to the Artists' General Benevolent Institution. He is in debt. He and Elinor (Bellingham-Smith) have managed to get along for about six years, but have broken down now. She has a small allowance, some £50 p.a. from her father. R.M. appears to have no private income.

Tuesday 18
Board of Studies in Fine Art. Borenius, Holden, Bayes, Corfiato, Borenius, after the others had gone, talked at length about the absurdity of keeping to the Giorgione[1] label in the National Gallery, for the four disputed panels. He was not violent, in fact, carefully moderate, about his attitude to Kenneth Clark (K.C.B., by the way, is now currently said to mean 'Kenneth Clark's Bloomer'), but I felt we were treading on dangerous ground after what MacColl said the other day…

Wednesday 19
Professor Ernst Stern[2] called at the Slade with his daughter: a thick set, solid, rather Jewish man. He was principally interested in the Polunin class – naturally. Rodney Burn also called to get particulars of the Glasgow teaching job, which is advertised. He was turned down for the Central School, in favour of Job Nixon: odd, because Burn is a far more experienced figure draughtsman than Nixon, and it was figure drawing that was wanted…After lunch, the Provost showed me a portrait of [Thomas] Campbell, the founder of the College, by [Thomas] Phillips, R.A.; a romantic, theatrical view of the gentleman, slickly painted, but worth having…It is presented by Sir Thomas Barlow,

1 Little is known about Giorgione (c.1476/8-1510), it remains debatable as to what works can be firmly attributed to him.
2 German stage designer, settled in London 1934.

who paid Agnew £200 for it: as much too much as was the £14,000 for the 'Giorgiones' at the N.G.. 5 p.m. Meeting of Board of Examiners...Met Boase for the first time. Coming home met [William Staite] Murray the potter, who always irritates me with his high-falutin' talk and theories, though a good potter...

Thursday 20
11.15 Baynard Press, near Kennington Oval. Mr. Griffits, at the Press, very helpful. Sent me a stone and some materials in the course of the afternoon. The stone is a yard long and weighs two cwt. It was carried upstairs to the studio by a man called a 'stonee' – on his back...

Friday 21
Started tracing on my stone...Athenaeum Art Committee. W. Rothenstein, Hind, Charl-ton Bradshaw, St. John Hornby and one or two others. We visited the 'Senior' to inspect a new system of lighting pictures discovered by the Secretary of that club: also went to the Annexe in Carlton Gardens to consider the hanging of pictures there. I was asked to present a drawing of Rutherford to the Club.

Saturday 22
Finished tracing of lithograph and started work in chalk on the stone. Charlton came in, worried about the terms of the Brown memorial, because there is no reference to the continuance of the Brown tradition in the Slade today...

Monday 24
Saw the Provost about Elton...upshot is that [he] may be raised to £300 a year...

Wednesday 26
Letter saying that the Northern Counties Art Collections Fund had bought my drawing of *Sheep Dipping*, from the Newcastle show, for £15.15.0...a man from the Medici Society called at the Slade to pick out another drawing to reproduce as a Christmas card, as they did before with one of Sydling. He went off with five to make a final selection of one. 8.45 Alice and I at Sturge Moore's, in the house that was Constable's, in Well Walk. He read a paper on Watteau by Charles Ricketts, with slides. He read badly, and mispronounces French abominably, in spite of having a French wife; and he even makes mistakes in the pronunciation of English...But everybody...said how well he did it...I admired his entire unselfconsciousness and self-satisfaction...

FEBRUARY

Tuesday 1
Dined with Owen [Hugh] Smith, 39 Charles St., Berkeley Square. No one else there. He was a great friend of Monty James, and talked about him; and of Tonks, of course, and Sargent, who painted Smith's mother...

Sunday 6
Practically finished my stone – the first or key stone, but will revise it on Thursday, when I am at home from the Slade...

Tuesday 8
Meeting of the Rome Painting Faculty to consider the case of [Kenneth] Bebbington, who has gone out of his mind. I am sorry about this, as his work is the best among the Rome Scholars...

Thursday 10
Did a very little more to my stone and rang up the Baynard Press about it: they will fetch it tomorrow. Looked at a book of Samuel Prout's lithographs, which I find are too much in the nature of hack work – toneless and mannered, with the black accents often overdone. The drawings reproduced in Ruskin's *Notes on Samuel Prout and William Hunt* [1880] are better...but...David Roberts was sometimes better still. Ruskin says something about the difference between Prout's original drawings and his more commercial products.

Friday 11
The stone went away. The 'stonee' 'umpted' it, as he said, on his back downstairs...The Copleys' show at Colnaghi's. He has talent and feeling of an invalid kind, and technical expertness in lithography, his drawing is weak, ignorant and unconstructional: she has some charm, and draws better than he. Odilon Redon at Wildenstein's. Spent a few minutes there. He is the first and best Sur-réaliste, as I always thought. I suppose others have noticed it, which may explain his revival by the dealers. I like his copy of Delacroix's *Lion Hunt*, really more than his own inventions or flower pieces: but his colour is very delicate...

Saturday 12
Max Ayrton has received confirmation of his big Government job for the [National Institute for] Medical Research place. He is very relieved, and says he thinks he would have cried if it had slipped through his fingers, as so many other things have: he would have looked upon himself as really finished. He is luckier than A.E. Richardson this time, who had prepared plans for the remodeling of the civic amenities of Bedford, by the old bridge, and would have carried this out well. He is now made only assessor, and the job is up for competition. I gather he is doing the North London Collegiate School...

Sunday 13
Grimmond, who has been meeting Maurice Lambert at Heyshott, tells me that he (Lambert) is commissioned to do the George V statue, on horseback, for [Adelaide] Australia. They wrote to me about this from Australia, and I suggested that Gerrard might be asked to submit a design. I believe Daryl Lindsay has something to do with it...Lambert may do it well, and seems to have prepared something pretty free from eccentricity.

Thursday 17
Baynard Press...[they] have about 100 machines, some...very expensive, from £1500 to £2000...The lithographic stones are cleaned and re-surfaced, by rocking marbles over them in a tray which oscillates constantly by a simple mechanism: water is used to make the friction less. Got a proof of my stone...it 'rolls up well', as they say, and there are only two or three very minor places to mend, and these were done while I waited. Mr. Griffits (who worked for 33 years with Vincent Brooks & Co., before he got his present job...) has had much experience of lithographers, the Copleys and Spencer Pryse among

others. He didn't like Pryse much; thought he made use of him, without thanking him... Went on to Daryl Lindsay's Private View at Tooth's...The drawings are all of the Ballet. Thinking about the Ballet, by a coincidence, I met Cyril Beaumont and his wife in the Burlington Arcade. He has not changed much, and remains the same mixture of shrewdness, simplicity, enthusiasm and cockney accent...

Saturday 19
Received three huge zinc plates, rolled, from the Baynard Press, with the offsets on them for the colour work: am flattening them out with weights on the throne in the studio...

Tuesday 22
Athenaeum...About F. Brown's birthday party. MacColl's case, by the way, about the David, has been settled out of court, in his client's favour. The insurance company has paid up £13,000. D.S.M. wants to get Borenius sacked from University College!...

Thursday 24
...Sickert's show at the Leicester Galleries. Sickert came in, in a ginger overcoat and a full grey beard, with Thérèse. He said he could not remember when and where he did some of the pictures, and asked her, pointing to one of them – 'Who were those two people?' (I think they were done from a photograph, anyhow, and a lot of the others were from Victorian illustration by T.[Thomas] Morten, etc.)...there is a shrewd suspicion about that. Thérèse paints Sickert's pictures for him now. Certainly, the tonality is like hers rather than his. There were a few well observed paintings of good personal Sickertian quality...

Friday 25
...Athenaeum...Art Committee – Blomfield (recovering from the double break in his arm), St. John Hornby, Bradshaw, Hind. Discussed the placing of a portrait group by Olivier 1861, the loan of Watts' *Island of Cos*, the loan of some pictures by Sydney Lee and the indecency(!) of Tonks's caricatures presented by MacColl. My drawing of Rutherford was accepted by the Club...

Monday 28 February – Sunday 6 March: no diary entries

MARCH

Monday 7
Albert R., Keith Henderson, and Lee Hankey rang up to tell me that I have been elected to the R.W.S – Ginner too. Also Daryl Lindsay, Millie Fisher Prout, and someone called [Thomas] Hennell...I am quite pleased, though Charlton...said 'it wasn't much of a show to belong to'.

Friday 11
...Baynard Press. Finished proving the plates of the lithograph. Griffits will add a few small alterations. He says Wellington is pleased with the work, as far as he saw it. It looks better now, with slight colour added. Duncan Grant and Vanessa were at the Press also working on their lithographs for Bob. I said good-morning, but did not interrupt them.

I am struck by the contentment of the workers in the business…Griffits, too, says he thrives on his work…I asked him how he got on with Vanessa – she is usually so difficult to get a word from: but, admitting that she was practically dumb at first, he professes to get on very well with her now…

Saturday 12
Met Albert R. at the Athenaeum and went over with him to the R.W.S. 'Touching-up day' luncheon in the Gallery…The trend is all in the direction of the N.E.A.C. traditional type of water-colour, as against the old stuff of the 1880s, a little of which still remains. Henry Payne is an inferior artist. Austin seems to be going to pieces – or perhaps it is that he is really an engraver. The papers full of alarm about Hitler and Austria…

Sunday 13
Ballet Club. Dined with the Crallans before the show. Hugh Crallan, being an architect, is interested in the Victorian buildings in the Notting Hill neighbourhood and in Bayswater…Many…are coming down now, and they have considerable interest – the classic styles of 1830-1850…A very good little performance – a Degas Ballet and other things. We met MacNaught there, and Mme. Rambert. Veronica Crallan is studying ballet in the Rambert school.

Monday 14
Had my first hot bath for years, thinking it more suited to neuritis than a cold one. When I was demonstrating on students' drawings at the Slade the pain became a real nuisance… Gerrard drove the Charltons, [and MacColl] and myself down to Richmond to Fred Brown's 87th birthday party…About 100 people present. MacColl spoke, and Francis Bate was in the Chair. Brown's speech in reply was very long and slow and full of repetitions – allusions to his old friends Clausen, Steer, Russell, MacColl…He spoke of the 'fanatical' quality in himself, without which, he said, little in the way of revolutions or movements ever got accomplished…D.S.M.…insisted on calling on Dora Gordine, in her curious house with the beautifully lighted studio on the edge of the Park near Robin Hood's Gate. Saw a lot of her sculpture. Her husband [Hon. Richard Gilbert Hare] was there, a good-looking but small young man…Gerrard drove us all back to Hampstead…Put on a white waistcoat and tailcoat to dine with the Blomfields in the house in Frognal which he built, it seems, for himself 45 years ago. It was some sort of wedding anniversary…

Wednesday 16
Dined, as Albert's guest, with the Old Water Colour Society Club, at the Hotel Victoria, Northumberland Avenue. Pompous affair. Lord Blanesborough presided: Russell Flint spoke well, but at too great length. Other speakers included the Master of the Rolls, Morshead (the Windsor Librarian, who was excellent) and Sir James Jeans. Flint made one or two prejudiced allusions to 'modern art', which annoyed me – not that I am 'modern', but I like a little catholicity and tolerance, and then R. Flint is such a bad artist himself that I should have some shame about joining the Society over which he presides, if the other members were all like him…

Friday 25
…Slade all day, preparing for the Dinner…Guests collected in my room for sherry. W.

Rothenstein the chief figure. At dinner, he and Dickey spoke, both well and briefly...I said a few things. After 8 years I do not suffer the horrors of anticipation and doubt that I used to – at least not so acutely; but I still look forward to my duties at the Dinner with miserable misgivings for sometime beforehand...

Saturday 26
Went to Campbell-Taylor's studio, where he was showing his picture of the Coronation. It is an interesting record, but the subject is an impossible one. Perhaps Goya might have painted it well. The glare of electric light in the Abbey, which, Mann told me, was as strong as it could be, hasn't helped...and there is no unity in his picture. He must have been annoyed that a reproduction of Salisbury's version of the same scene came out in *The Times* this morning. Salisbury has sold his, and C.T. has not...he did it as a speculation. He got all the Bishops and Generals...to come to the studio and sit. Met Ralph Edwards and his wife, and the Dursts...Edwards was amusing about the Manson incident at the official luncheon in Paris[3] and the French Minister's tactful letter about it, in which the demonstration was put down to natural enthusiasm and warmth of heart, or something to that effect. Edward says Manson's cock crow was so realistic that people thought for a moment that some mechanical method of sound reproduction was being employed.

Sunday 27
In the course of a walk with Hagedorn and Grimmond and the dogs, met Aug. Daniel... he tells me it is pretty certain that Manson is resigning because of the incident in Paris. I hope, if he does, that he does not forfeit his pension. He is not due to retire yet. Campbell-Taylor came at 8.30p.m. to discuss arrangements for the Whitechapel show, and the list of invited artists. He says that he intends to tone down the left hand side of his Coronation picture...and this may pull it together a bit. He says, also, that if he doesn't sell it he will be bankrupt. I asked him about printsellers: it seems there is little demand for such subjects now.

Monday 28
...Called on old Mrs. Stiebel in the Tower House nursing home...We exchanged reminiscences of Buxton, which I remember well when we lived there...I was about 4 – 5 and my grandmother Ermen was alive, being pulled about in a bath chair by a boy in Buttons...Afterwards...to Wildenstein's, to see the Cross-Section of English Painting [Illustrating some Contrasting Tendencies] – E. Dunbar, Moynihan, Rowntree, Devas, Ginner, Pitchforth, Coldstream, Le Bas, Pasmore, Morland Lewis, Graham Bell, Daintrey.

Wednesday 30
Started sitting for my portrait to Mrs. [Jessie] Humbert Wolfe [plate 12]. She talks a lot about Humbert, among other things, says she saved him from bankruptcy and dismissal from the Civil Service not many years ago. The little flat in Mount Street makes a tolerable studio. 8.15 Physical fitness show at Albert Hall: the Margaret Morris troops, Prunella Stack's[4] forces, and the Folk Dancing crowd. The Queen was present, and Dorothy Gates had some speech with her. Alice was identifiable in the demonstrations...Margaret M.

3 Manson arrived drunk at the déjeuner given by the Minister of Beaux Arts. During the ceremony he made cat-calls and cock-a-doodle-doos.
4 Head of Women's League of Health and Beauty.

spoke into the microphone: Lord Aberdare made a speech. The Towners were there, and enjoyed it all…

APRIL

Friday 1
2.00 Mrs. Wolfe. She talks a lot about her husband and his perfidies. Two of his mistresses are Viola Garvin, of the *Observer* – Garvin's daughter – and Pamela Frankan, daughter of Gilbert Frankan. Mrs. Wolfe painted Pamela Frankan's portrait without knowing that there was anything going on between her husband and this lady: she and the Garvin girl seem to be pretty promiscuous. Wolfe (he is Umberto Wolff, born in Milan) gets £70 a month from the *Observer*. He quarrelled with Lloyd George during the war, or might, but for this, have been even higher in the Civil Service than he is. Mrs. Wolfe found out about the Frankan case by an odd accident: calling, by a complete mistake at a wrong number in Cliveden Place to get a nurse for her mother who was ill, one evening when Humbert had left her, as he said, to write at the Athenaeum, she saw him drive up in a taxi to the next-door house, where P.F. was looking out of the window. Humbert saw his Jessie, and dropped to the bottom of the cab, which drove on – he hoping that he had not been noticed…

Saturday 2
…Mrs. Wolfe again…After leaving Mrs. W., enjoyed pottering round Mayfair and all the old Georgian places which are disappearing so fast – Shepherd's Market, Pitt's Head Mews…Should like to draw some of these places…

Sunday 3
Mrs. Wolfe finished her portrait of me…It has some qualities, but is naturally not a very complete or final statement. Supper with Max and Tony Ayrton…Max says that Lewis Baumer has taken to grumbling at length about the way *Punch* is treating him: the Art Editor, Fougasse (Bird) now refuses his drawings, and he fears this very much. Max is not sympathetic. He thinks that Baumer has had a very good innings, that he is not a good artist, and that the fashion in humour is changing to a slicker, more American kind. Baumer is 68, and has done well always since he was a student, seldom making less than £2000 – £3000 a year…

Tuesday 5
To Dover…Birdie and Alice come on Saturday.

Sunday 17
Finished drawing of the Round House [plate 13], the second drawing I have struggled through while in Dover. The house is let off in flats, the ground floor to an odd little man, who calls himself Pastor Efemey and conducts holiness meetings in the rooms which have been added to the original structure. He gave me permission to sit in the garden and draw: he was sawing wood there.

Tuesday 19
(25th anniversary of our wedding) Returned to London…

Wednesday 20
...Bought 25 lilies to decorate the house and to remind us of yesterday's anniversary. Lady Ottoline Morrell [plate 14] died about this time. We were fortunate in our relations with her when we were young – round about 1914 – finding her of a genuinely kindly nature. Many of the people she took up, artists and writers, were ungrateful, and poked fun at her behind her back, or wrote satires on her. Birdie was taken to one of Lady Ottoline's parties in Bedford Square by Boris Anrep, who, after making a great fuss of her (Birdie), abandoned her for someone more important, and left her to get her own taxi and go home alone. 'Ottoline' was considerate and concerned about this, being always an excellent hostess. Her eccentric appearance, odd dress and exceptionally tall figure attracted attention. I sat behind her once on top of a bus in the King's Road, without recognizing her back, and made mental notes that only a charwoman, or something near it, would wear a string of enormous sham pearls with a shabby plush coat such as she had on: she turned round, and I realized who she was and that the pearls were genuine. I remember also Dorothy Warren,[5] then Mrs. Weymer [Jay] Mills, saying to John – 'Oh, John, I'm so depressed, everyone hates me: Ottoline says I'm a bloody bitch.' 'Nonsense', said John, 'she doesn't say things like that.' 'Oh, yes, she does, when she talks to me.'

Thursday 21
Saw a show of Philip Connard's at Lockett Thompsons and met Beatrice Bland there. Connard and Georgina [his wife] would not face the Private View. I liked many of the paintings which are now free from a certain 'chic' which they sometimes used to have...

Friday 22
...Athenaeum. MacColl...is collecting his poems to be published in a volume. He was very down on Wyndham Lewis for making a fuss in the papers about the rejection of his portrait of T.S. Eliot from the Royal Academy: said it was badly drawn, anyway. Fred Brown is painting another self-portrait. Steer is destroying much of his work preparatory to leaving this world...Visited the R.I.B.A. building – the first time I have been inside it. I liked the effect of the staircase hall. It was about the Prix de Rome business that I went there: the problem of the painter candidates was to decorate the R.I.B.A. reception room, and I wanted to see what it was like in actuality, before judging the work sent in. Called on Bob Wellington to see how the edition of my lithograph came out. It looks better in a frame. Some good stuff by other artists, Vanessa Bell among them. Duncan Grant has had difficulties with the medium and his print is not finished yet. Much that he put on the stone did not print at all.

Saturday 23
Went to have a preliminary look at the Prix de Rome work, at the Imperial Institute; here I met Maurice Lambert, looking at the sculpture exhibits, of which he is a judge. He agreed with me in disliking certain modernist pastiches of Henry Moore. In connection with his own equestrian figure for Australia, which is on the stocks, he has made a special visit to Italy, to look at Gattamelata and Colleoni. He infinitely prefers the former (which he says has a remarkable number of geometrical or mathematical concordances,

5 Niece of 'Ottoline', married to the American author Mills.

when analysed closely) to the Verrocchio, which he examined all over from a scaffold supplied by the Fascist government. Visited the Leicester Galleries to see George Shering-ham's pictures. A.J. Munnings was having a show too, and was present. I liked some of his landscapes, particularly those in snow, which are better by far than the Christmas number vulgarity of his other more usual stuff.

Monday 25
Chelsea Arts Club Annual Dinner, to which I went as James Bateman's guest and sat with him, Stanley Anderson and Vyse in the annexe; the speeches...coming through on a loud-speaker...Rushbury was in the Chair, drunk as an owl maudlin, illiterate and tedious. I heard someone say 'What a Chairman! What an R.A.!' and was sorry for it. Llewellyn, whom Rush soft-soaped, made a tactless speech about Wyndham Lewis, pretending not to know him as an artist: said he had looked him up in *Who's Who* and that he was described therein as an author: also that not one hand on the hanging committee was raised for W.L.'s picture – a circumstance that it would become the R.A. better to suppress. [Lord] Dunsany was good: [A.P.] Herbert not so funny as he ought to be. [Sir Roger] Keyes not bad. [Field Marshall] Milne exhorted artists to paint stirring battle-pieces, to rouse the martial spirit of the young, which, he said, was declining (a voice – 'Thank God'). Altogether a rather lamentable exhibition of our public men. Guy Dawber died yesterday.

Tuesday 26
Prix de Rome...I proposed that the prize be not awarded, but was out voted 5 – 3. Some good work though, and the two candidates selected for the Rome and Abbey Scholarships have some hope in them...A.K. Lawrence, like Bateman and Anderson last night, deplored the state of things in the Academy. John might have done more to reform it by staying in than by resigning...

Thursday 28
...Was interested, in the evening, at the Athenaeum, in the notebooks and drawings of Gerard Manley Hopkins. He had a Ruskinian or Da Vinci-like interest in the appearances of nature, appropriate to a period when Pre-Raphaelitism flourished. His notes on pictures at the R.A. are very curious.

Friday 29
Slade...Got out some of the drawings and paintings which were left to the College by Tonks, with a view to hanging them in the School. They were stored in a cupboard in the Provost's room. In the afternoon went to Eltham, because I had seen some pictures of it in a book, and thought it might be a good place to make some drawings...Dinner of the Manchester Academy at Kettner's [Soho]. Kenneth Clark the chief guest. A much more rational affair than the Chelsea Arts' Club one, though the weight of distinguished persons was far less...

MAY

Monday 2
Dinner of the Royal Academy Club at Painter Stainers' Hall. I was Dodd's guest, and sat between him and Guthrie, an architect. Speeches by Llewellyn, Eric Gill (intelligent, but a little long)...Dodd (very good), Guthrie, Kenyon and another. Dodd wrote out his speech, rehearsed it to his wife about three times...but he didn't look at it at all while speaking...

Thursday 5
Started correcting exam. papers – 140 to do, of which Gill does half...

Friday 6
Private View of Kenneth Morrison's pictures – a memorial show – at the Beaux Arts Gallery. Mrs. Morrison was there; so were F. Porter and Cora Gordon, both of whom were students with me in Paris about 1907-8. Morrison's colour (in which he was evidently very interested), being more or less arbitrary and not truthfully studied, causes his painting to diminish in interest after a time. Duncan Grant has written a foreword to the catalogue. I suppose Morrison may have been somewhat influenced by Grant's work, or at least come under the same influences...

Wednesday 11
...Cocktails at Mrs. F.H. Shepherd's, 19 Paultons Square. Sydney Lee and his wife, Beatrice Bland, Eric George...Colin Gill some years ago made a portrait drawing of Mussolini. The Duce was busy at his desk when the sitting commenced, and asked if he could go on working. Gill began drawing, leaning his drawing board on the opposite side of the desk, but could only see the top of his sitter's bent head most of the time, so he tore his paper in half to attract Mussolini's attention, and to make things clear, and make him sit upright. 'Very well', said M., 'you draw me, and I'll draw you' and he started scribbling on a piece of paper, keeping this up while Gill's drawing progressed. Gill thought it a successful drawing, and passed it over for Mussolini...saying 'Now may I see what you have done?' M. passed across to Gill a sheet of paper with nothing on it but 'Londra, Londra, Londra' written an infinite number of times. Gill thought he was a little mad.

Tuesday 17
Courtauld Board of Management at the University, at which MacColl's account of Constable's resignation and the reasons which led to it, which was published in the *Nineteenth Century*, was discussed and censured as inaccurate, and unfair to Courtauld, Lee and Witt. The two last were present. The Principal had prepared and circulated a type-written statement of the real facts, which was finally passed by the meeting.

Thursday 26
Board's Exams...Woolway likes Barry Craig as a member of his staff. The students are keen to learn from him.

Saturday 28
The Hagedorns left for Marseilles, meaning to go on, probably to La Ciotat. They have

cancelled their arrangements for Collioure because a little place nearby – I forget the name, but is about 20 minutes away by rail – has been bombed by Franco's aeroplanes...

JUNE

Wednesday 1
Was approached by the Provost about a posthumous portrait of Sir John Rose Bradford [plate 16]. I should like to do it...There is an excellent photograph, giving all the drawing, and I can get a model for the colour as I remember it in Sir John's face. The rest, robes, background, etc., will be an interesting still life. It is for the Medical School. There seems to be no lack of money, and I was advised by the Provost to suggest a good high fee. Learning that Kelly had got £350 for his posthumous *Lord Chelmsford*, I suggested £250...It will clear me of worry about how I am going to pay next year's Income Tax.

Thursday 2
Uncle Bill writes from Shanghai that things are bad, and his salary has been cut, so that he won't be able to leave the East, if at all, till 1941...

Sunday 5
My usual companions being away, I went for a walk with Tony Ayrton. He is copying a Van Dyck head in the National Gallery...

Monday 6
Lunch with Albert R. at the Athenaeum, and after by bus to Hammersmith Broadway, whence we walked by the Mall to Chiswick House. This district has become full of associations for us both...Albert has a pleasing child-like power of being entertained by such things as pumping-stations, cricket-matches, and shop-girls, such as we encountered on our walk...

Tuesday 7
Slade Diploma Exam. Ormrod had qualms about one or two Design students, but we passed all but one – Danziger, whose 'Design' was absurd. Russell, Borenius, Ledward, Gerrard, Ormrod, Bayes and myself examining. Carrington-Smith, an Australian or Tasmanian, called upon me at the suggestion of Owen Smith, his kinsman. O.S. mentioned him to me the other night at Mrs. Wolfe's. He has an Art Scholarship from Sydney for two years, and is studying at the R.A. Schools. Daphne Charlton knows him. He was at the annual dinner which Owen Smith gives to the descendants of Abel Smith, the founder of a bank and the family fortunes in the 18th century. This dinner is given in Fishmonger's Hall (O.S. being a Fishmonger) and was this time attended by some forty members of the clan, including the Smith-Dorriens. Carrington-Smith showed me some of his water-colours, not bad. He has a wife and baby. The baby was actually washed overboard in a gale on their way to England, but washed back again and grappled in the scuppers by an active sailor, being retrieved totally unhurt...

Wednesday 8
Attended at the R.W.S. to receive a Diploma of Associateship from the Council. Morley

in the Chair, and Rushbury present…Had a long talk with the… Commissionaire, who looks after the Galleries. He says that buyers now are all old stagers, and…there are no young people to take their places, consequently sales are steadily declining. A few years ago, Members of the Society would have been horrified if one of their number had sold a drawing for less than 20 guineas: Munnings got £250 for one: now 8 and 10 gns. is usual enough…The photographic exhibitions have a bigger gate than either the etchers or the painters…

Thursday 9
Imperial Institute [Examinations] again. Dickey, Woolway…Dickey and I saw John's pictures at Tooth's afterwards…there is no doubt whatever that John's work is the authentic stuff, of the masters. It is no good Clive Bell or anybody else writing disparaging things about them. When all the weaknesses are conceded, so much remains. *Bridget*, unachieved in some ways, is a fine thing. Birdie's old portrait [plate 15] was there, upstairs, and out of curiosity I inquired the price. The man thought about £360. It belongs to Tooth's. It looks very fresh. I suppose it was done about 1915-16…Gilbert Spencer, whom I met, appears to think that you can't teach much about painting. I believe I was taught too little. We do our best now – G.J. and the others – to teach it at the Slade; and in this connection I was pleased to find that the highest marked life-painting in the Board's Exams. turned out to be by a Slade man, Roebuck. I had not recognized it till I saw his 'testimony of study'. John D. Moore and his wife came to dinner with us: our first meeting with them. They see something of Basil Burdett sometimes in Sydney.

Friday 10
Finished Exams, at South Kensington. Jowett and Gilbert Spencer went round for about two hours carefully selecting students for Exhibitions and Studentships. They picked out Roebuck, and he is likely to be recommended for a Royal. The best man was from Beckenham. Evan Charlton's pupils at Bristol did well…News that Mew is ill – gall stone trouble. His niece, Miss Manners, whom we met, says he is 76…

Sunday 12
…Griggs, R.A., is dead, leaving a wife and four children and nothing else. He accused himself to Max [Ayrton] some time ago of being a most selfish man with regard to his family, having spent £14000 on his house, which is now mortgaged up to the hilt. Harold Knight, at whose house Griggs was taken ill, made himself responsible for the doctor's fees, and £50 is being produced by the A.G.B.I. for Mrs. G. to carry on with…

Tuesday 14
Committee on School Examinations at the University. Shurrock, Jenkins, Noel Rooke, Charlton, Ormrod, two head-masters and two-head mistresses: myself, unwillingly, in the Chair.

Wednesday 15
Dinner with John D. Moore[6] and his wife, in a service flat, part of a converted house, no. 4 Lowndes Street…Moore's watercolours, of which he does a great number, suffer from hardness and blackness, very often in the middle distance. He is skillful though,

6 Moore was appointed to Board of Architects of New South Wales (NSW) 1937. Deputy Director of camouflage for NSW (1942-45). Fellow of the Royal Australian Institute of Architects and an Associate of R.I.B.A.

and has done a good one of Kenwood. He seems, also, to be a good architect. He showed me some photographs of his buildings in Australia.

Thursday 16
Called on Prof. Elliott at U.C. Medical School about the portrait of Sir John Rose Bradford. The price is to be £200…I am to borrow the robes It may be an interesting job…Tea at Athenaeum. Will Rothenstein, polite as ever. He says John R. is going to have a difficult task at the Tate…

Friday 17
Dinner at Lowinsky's; excellent as usual. Raymond Mortimer[7] was there…I don't think Mortimer relished some remarks of mine about Picasso's lack of real conviction – a born artist, and an experimenter always, but always moving off to a new vantage point when the others catch up. Now that Picasso is over fifty one might expect him to settle down to an assured style…

Saturday 18
Drove with the Kohns on one of the National Art Collections expeditions to Ickworth, near Bury St. Edmunds…Amusing to see West's [1770] *Death of Wolfe*, which I had known from prints since I was 4…

Sunday 19
…After lunch called on Gondhalekar…He wanted me to look at his work. He has a bed-sitting room in Parliament Hill Fields…he works tremendously hard, and is overcoming to a slight degree the commonness of his Bombay outlook. A capable man…

Wednesday 29
Reading University…People going to Henley Regatta. Betts met me at the station with a taxi. Did the Examining business. Meeting with the Vice-Chancellor. 12.30 Saw W. Rothenstein's recent portrait of Austen Chamberlain. Lunch. Sat in the garden outside the common room, watching bowls. Train back 2.50. Egan Mew returned home from the nursing home…

JULY

Friday 1
Slade Prize giving. Innes and Rhoda Glass the most outstanding students…

Saturday 2 – Saturday 9: no diary entries

Sunday 10
Tea with the Lucien Pissarros at Brook House, Stamford Brook…I saw a lot of Lucien's pictures, some of which I liked very much, particularly one of a garden gate, with a vista of trees behind and a portrait, very sympathetic, of his mother; but when he showed me others in the studio there was an old view of a Normandy orchard in autumn, by

7 Mortimer wrote for *Vogue, Nation* and was literary editor of *New Statesman* (1935-47), chief reviewer *Sunday Times* (1948-52).

Camille, which seemed to give them all away – it was so much better. The paint was richer and easier in handling and the colour rich and warm; whereas Lucien's tend to cold blues, which sometimes get niggled and out of hand. They don't seem to me, in such cases, to have the truth of a good Camille. Getting rather bored with these excellent and hospitable people – the old man is 77 and almost impossible to understand when he talks – I declined to follow up a hearty tea...and compromised by going round to Orovida's studio and looking at her work. It is better than it has been. She is doing some panels of the seasons, which are European, not pseudo-Indo-Persian-Chinese. She does them without models...

Monday 11
Going to the Slade to discuss business with Elton, I met Rabinovitch, the sculptor and all-in wrestler, in the Tube. He has a great admiration for Despiau, who has a show now in London...I have always admired Despiau's work. Rabinovitch called upon him in Paris...and described him as a delightful, simple old man; when he spoke of Rodin he always raised his cap; a gesture which Rabinovitch approved. Ordered a 30 x 40 canvas for my posthumous portrait, and collected an enlargement of the photographs from which I am to work...it cost 19/- and the canvas 16/-...

Wednesday 13
Went on with pastel portrait of Alice in Tony Ayrton's studio, Jean Inglis and Tony working at the same time...Took Douie out to dinner...Afterwards Douie and I went to the Café Royal, where we met A.K. Lawrence, full of a new book on Shakespeare, which proves that the sonnets have been misinterpreted, and that Shakespeare was not guilty of what the Americans call 'moral obliquities'...

Thursday 14
Luigi Mancini sat in the President's Robes for Rose Bradford's portrait. Went on with the drawing I started on Tuesday.

Friday 15
Worked on Rose Bradford, in monochrome, from the photograph.

Thursday 21
Returned the Presidential robes to the College of Physicians, where they are wanted for a succession of functions. This rather holds up my portrait, as I want a model to sit in them...

Friday 22
Colin Gill came to see me, wanting a small job of lettering done, to go with a reproduction of his drawing of the Queen. He advises me to charge 2 or 3 guineas for it, though there are only 9 words. He himself has been in financial straits, being dunned for £1000 arrears of income tax. He has paid off all but £200 in the past few years and is now threatened with prosecution if he does not pay the balance. As luck will have it, he has a commission for a portrait in the South of France, which will pay his last instalment...

Wednesday 27
Drew Dr. Parkinson's carotid artery at no. 1 Devonshire Place, from an elderly woman who was not so mad as I anticipated. She keeps a boarding house and was anxious to get back and cook for her lodgers…

Thursday 28
Translated two drawings into ink line, for reproduction for Dr. Parkinson…Gill rang up to say that the inscription which I did under his drawing should have read 'Patroness', not 'Patron'. I suggested this to him at the time, but he wouldn't have it. His sister, Lady Allen, is very fussed about it. The drawing, with inscription, had to be bound up in the Royal copy of some book presented by the Plantation Committee.

Friday 29
With Parkinson…making corrections to diagram – trying to make a lump look like a pulsation instead of a tumour. He paid me £3-3-0…Lady Allen also sent £3-3-0 for the bit of lettering…Exercised mentally by the writings on art of modern German authors. One, Uhde, comparing Manet's *Olympia* with the *Mona Lisa*, says that the latter is only a smile, and that if the smile were removed it would be only a dirty bit of brown canvas, or words to that effect: whereas Manet has spatial relations, or God knows what, which make him ineffably superior. But I like *Mona Lisa* in just the same way that I like *Olympia*, and I don't care tuppence about the smile. The sense of form in Lisa's hands is superior to the sense of form in Olympia's legs, good though they are. And I would say that Manet's human emotions about his young woman were of the same class, if somewhat different, as Leonardo's. Another German, who uses the nom-de-plume Peter Thoene, has the following illuminating passage on Paul Klee – 'This shorelessness is the suspension of logic and causation: time and space are simultaneous in time and space.' Oh, for a stone-bow to hit him in the eye! Perhaps Herbert Read may make something of this, though I can't. Nevertheless, I suppose the Klees and their kind will have started a sort of art which may develop in the future through the cinema. It will be amusing to see whether Walt Disney may have unknowingly shown the way to the means of expression that these people want. Disney is sometimes as good as Caldecott, but is vulgar when he comes to humans. It is the animation of his pictures that I think may be developed by others – one or two artists like Anthony Gross are attempting it without much success so far. Job Nixon is dead…suddenly, on a caravan holiday in Norfolk, aged 47. He owed Lewis £10, a many-years-old debt. Hard on Lewis – I doubt if he will get it from the executors, and he is hard up. So was Nixon, usually, since he ceased to make his £1500 a year from etchings.

Saturday 30
Old Mallozi sat for Rose Bradford portrait, but though he was some use, he is the wrong colour. Paid him 7/6d for 3 hours and went on without him…

AUGUST

Tuesday 2
Drew J.M. Thompson of Magdalen, Oxford, a charming theologian, now retired at 60. The commission comes through Albert Rutherston. The price is to be £25...rather a lot for me. The drawing was, I thought a bit woolly and uncertain, but attained some likeness...Thompson, by the way, like so many Oxford men, is a mountain climber. He climbed the Cuillins, staying at Glenbrittle, and knowing Colin Phillip – all parallel to my own doings with the Falcons.

Sunday 7
Birdie and I left for Cerne Abbas – the Abbey Farm – with Ginger and Charlton. Alice joins us on Monday from Braunton.

Sunday 14 – Wednesday 24: no diary entries

Saturday 27
Party at the Pattisons...Mr. & Mrs. Hancock (she is Darsie Japp's niece), ...Jean Inglis and one or two more...P.[Paul] Oppé[8] turned up unexpectedly and made a long visit to us at the Abbey Farm. His conversation is intelligent, skilful and amusing...

Sunday 28
Birdie and I returned from Cerne...

SEPTEMBER

Friday 2
Left for Sisteron with Max and Tony Ayrton...from Victoria, via Newhaven-Dieppe. Met Oliver Brackett on the boat, very badly shaven – he looks as if he drinks... Brackett is now retired from the V.&A. Museum.

Thursday 8
Rain...Max A. did an interior of the Church, a fine building inside...I should have thought too dark to draw in, but he managed to get something done. I asked the Cure's permission for him, as he has not enough French to do so. It was cordially given...

Friday 9 – Thursday 15: no diary entries

Sunday 25
To Gap by car. Reserves being mobilized at the Barracks – very depressed they looked... Gap Museum is the worst I have ever seen, except for the Moustiers pottery. We went by the Route Napoleon, which is rather dull, and came back by Veynes, Laragne, Mison...a much more beautiful road...Some beautiful scenery along the two Buech rivers. Innes would have painted it well.

8 Drawings collector, art historian, Deputy Director V.&A. (1910-13), thence Bd. of Education.

Monday 26
Max A. and I left Sisteron…Arrived at Dijon about 6 o'c.…The war scare is developing. The
son of the house was getting married prior to joining up: rather tragic, as his sister said.

Tuesday 27
Explored Dijon, a town of most distinguished architecture…The Museum is full of good
things…I liked the Prud'hon [1758-1823] portrait of the man with a horse: his drawings
interested me too: their academicism is not always very happy. A Gainsborough, unlike
his usual work…

Wednesday 28
Left Dijon…for Dieppe, via Paris and Rouen. Crossing Paris in a taxi, the city, which is
supposed to be evacuating its women and children, seemed fuller of people than usual.
Changed at Rouen: Auto-Rail to Dieppe…Several English people going home. The war
scare more acute, but no visible panic. Porter with a handcart from station to hotel…
After dinner, in the hotel again, listened for war news on the wireless…Felt that we
ought to have made for home sooner – the war seemed so likely to break out.

Thursday 29
…At home, the war scare has been at its height. Anti-aircraft guns and trenches in Hyde
Park. People, notably Daphne Charlton, have been trying to persuade Birdie to leave
London. The Charltons have gone to Devizes. Birdie was busy with Russell's affairs, and
would not move. Alice, on her return from Dover, at once joined an A.R.P. unit and
helped to distribute gas masks…We have 3 gas masks in the house… Billy Kettlewell
has joined up with the auxiliary balloon defence force. It seems to be in an awful muddle.
His station is at Hook near Surbiton. He went to Hook near Basingstoke by mistake.

Friday 30
Peace now. I went to the Slade and interviewed people. Charlton had written a letter
suggesting that the Slade should be moved to Cardiff, to his brother's School. Nonsense,
of course: if there was a war all the young men would be in the Army and nobody would
go to Cardiff. There wouldn't be a Slade. Called on Egan Mew, who was sufficiently
worried about gas attacks to have contemplated taking a basement in Gardnor Mansions
and making it gas-proof. Max Beerbohm was with him. The threat of war has driven
him out of Italy, and he and his wife are now living in Inverness Terrace…

OCTOBER

Sunday 2
Hagedorn…has been helping with the gas mask business, at Hampstead Town Hall…
War talk…

Monday 3
…Slade. It is not opening this week as it should have done. Notices were sent out
postponing the opening till the 10th…

Tuesday 4
Painted on Rose Bradford...Will Rothenstein's Private View at the Leicester Galleries –
fifty years of his painting. All the Rothensteins were there; so was Wyndham Lewis...
and Max Beerbohm. In another room was the exhibition of Bob Wellington's contem-
porary lithographs: practically everyone, except mine, had sold several prints. The firm
is so broke that they can't pay me my fee...Lowinsky retired to the country with his
family and a lorry containing his pictures and collections...Durst reported at the Admiral-
ty and was sent to Chatham; but he was given leave when things slacked off. A Foreign
Office man told him that all German spies were recalled from England on Sept.15.

Saturday 8
Took some drawings to Lewis to be mounted...Met Ronald Gray. He abused Will Rothen-
stein's pictures...I disagreed with him. He is in the Charterhouse[9] now...and...has a
pleasant garden outlook to his room; but he says the Company is not good – failures, and
second rate artists & musicians. There are only about half a dozen men to whom he takes
any pleasure in talking. Saw a balloon being filled in Grosvenor Square, part of the anti-
aircraft barrage which is being tried out to-day. Later the sky was dotted with balloons.

Tuesday 11
Jury, N.E.A.C. Fred Brown has his latest self-portrait...and Steer has sent three of his
water-colours, not...done recently: they are very good ones...Connard was on the Jury
too...Steer's father was a painter. He used, so Connard says, to make his children repeat
– 'Turner is the greatest artist that ever lived.'

Friday 14
Professor Elliott, of U.C.H. Medical School, called and took me down, together with Rose
Bradford's portrait, in his car to University Street. He wants the portrait to be shown at
a gathering tonight. He expressed himself as satisfied with the resemblance and the
expression, but thought that Bradford should be pinker and the hands less dropsical...A
new suit of clothes came home, the first I have had since three years...Slade. There were
more students last session, so I have an automatic and, to me, unexpected, addition of
nearly £90 to my salary...

Sunday 16
Nelly Hagedorn has been reading Nevinson's book about himself, and Hagedorn, on
her report, thoroughly disapproves of it. There is some rumoured scandal in it about
Maxwell Ayrton, without the least foundation and unnecessary to call up again even if
there was such a rumour, particularly as Nev[sn] is a friend of Ayrton's. I glanced at two
or three pages of the book the other day and came across a reference to Nevinson's affair
with Blanche Denton, who unkindly ousted Betty Shelley from the more or less comfort-
able position of mistress to a man called Ballantyne, then living over the Petit Savoyard.
She had a baby which was supposed to be Nevinson's. He reports this, with the addition
that other people, including Tonks, were credited with the paternity. Now this is very
unfair. No one ever suggested to my knowledge that Tonks was the brat's father...the
truth was that Tonks was sorry for the girl and kind to her, and did what he could to help
her over the period of confinement. Surely this might have been mentioned, too, in the

9 A former Carthusian monastery in London, now an almshouse, known as Sutton's Hospital in Charterhouse.

book. Blanche went to Canada, drank herself blind with wood-alcohol, and died there. She had acquired a husband with some money. Some curious impulse makes Nevinson create the character of a cad for himself. I don't believe he is one, really, at bottom.

Monday 17
...dined in the Senate House. Sat opposite Codrington, who talks volubly and interestingly about the international situation, his war service, his eight minutes conversation with Hitler in Austria (Hitler sent one of his young men to show Codrington the way up a mountain, and expressed doubt as to the value of museums, at any rate English ones,) and himself generally...

Tuesday 18 – Wednesday 26: no diary entries

Friday 28 – Thursday 10 November: no diary entries

NOVEMBER

Friday 11
Trying to finish Rose Bradford's portrait. Difficulty with the hands...Lunch at the Athenaeum with Fougasse of *Punch*, to discuss a scheme for the encouragement of humourous talent among art students. His proprietors are willing to go so far as to give £100 a year as a scholarship. Albert R. joined us, and suggested a further meeting of our three selves and Max Beerbohm: he also did a little log-rolling for Barnett Freedman. After coffee, I went to Dora Gordine's show. She is a very able draughtsman and sculptor, and her bust of Fred Brown is very like, but, my God, what a pushing showman of her own works she is. She told me with great candour which of them were masterpieces (most of them appeared to be) and held out every inducement for me to bestir myself to raise funds to buy Fred Brown for the Slade. The only action I have taken, or will take, is to send her an appeal for a subscription to the Artists' General Benevolent Institution, for which, as Steward, I have now collected over £90. This is the result of 450 letters.

Saturday 12
...Called at the R.W.S. new gallery in Conduit Street to fetch a picture of *Sisteron* which was crowded out and which I thought would be useful for the Camberwell Show. It was what is rather ridiculously called 'Touching-up Day'. Nobody touches anything up... Saw something of Jowett, Ethelbert White, Hartrick, Morley, Dorothy Coke, Alan Sorrell (who was once a student under me at S.K.), Maxwell Armfield...and extracted cheques from Sorrell and Hartrick for the A.G.B.I. Taxi, with my drawing to Camberwell and helped to hang the South London Group pictures...Kelly has sent about 8...one a good, big landscape of China, and has consented to open the show...

Thursday 17
Did a little more work...on the Rose Bradford portrait. Took Birdie and Jean Inglis to see G.J.'s show at Wildenstein's. It is good painting, well framed, well hung and makes a very pleasant impression. There are faults here and there, as in the Alston portrait, where the ears seem out of drawing and out of tone, but there are good passages in that. The self-portrait is absurdly like. The little head of Rosie the model I thought was bad,

but somebody has bought it, and the sales on the whole are very good: at least fourteen pictures must have gone, including the big one of the Fair for £200. Sine Mackinnon's portrait looks as well as anything, and comes out very strong after all these years. Albert was in the Gallery, and I met a man whom Albert knew...who is going to buy my drawing of *The Round House, Dover* from the London Group for £10 (instead of £12-12-0). He appears to be connected with Huddersfield...dinner at Fishmonger's Hall... It was the occasion of the presentation to the winner of Doggett's coatland badge.[10] Much pageantry. Going up the stairs to dinner, we passed between files of former winners in the red Doggett livery, holding their oars aloft. When the Prime Warden made the presentation, there was a fanfare of trumpets from four guardsmen, introducing the procession of watermen...We used to see the race from our windows in Chelsea...

Friday 18
...Train to Oxford to do a drawing of Balliol, commissioned by the Tennysons...

Thursday 24
Oxford again...

Friday 25
...Met Muirhead Bone in a bookshop. He is doing another drawing for the *Oxford Calendar*. Bought Blomfield's *Studies in Architecture*, secondhand, 2/-; it passed the time agreeably, after dinner...

Saturday 26
Finished what I could do on the spot with my drawing of Balliol. Stood Hallam [Tennyson] lunch at the 'Mitre'. Geoffrey Whitworth[11] came to stay there too, and I saw him for a few minutes. He is conducting a meeting, with speeches about the drama from Masefield, Lillah MacCarthy, etc. Harold Nicholson spoke, mostly about politics, and anti-Chamberlain (to the approval of his audience), at the Balliol binge last night. Every-one seems to have been drunk except Hallam, and the chamber-pots were duly thrown, as custom requires...Home by 4.30...

Sunday 27
Worked on the drawing of Balliol – from notes. Charles and Ivy drove up to see it, and Ivy gave me a cheque for £17-17-0...She repeated, with Charles' concurrence, an extrav-agant statement about my draughtsmanship from Sir Michael Sadler – 'Finest draughtsman in Europe'...this is going rather too far. I didn't know that Sadler approved of my work, since he stopped buying it about 20 years ago. I thought he preferred Kandinsky 'et hoc genus'. A catholic-minded man.

Tuesday 29
To the Leicester Galleries, at Towner's request, to look at the hanging of his pictures... Oliver Messel[12] is showing some paintings in the inner [room]. I looked at them out of the corner of my eye, and thought them better than I had expected. Theatrical, decorative,

10 Doggett's Coat and Badge is prize and name for the oldest rowing race in the world – on the Thames.
11 Director British Drama League, lecturer and author.
12 One of the foremost stage designers of the twentieth century.

but some portraits seriously and well drawn. Charlton says he was a good student at the Slade.

DECEMBER

Thursday 1
Took Egan Mew to the Leicester Galleries...Private Views in full swing...Messel, with a smart crowd (I was introduced to him and he gave me a signed reproduction of one of his paintings)...Walt Disney...has a room full of coloured things for *Snow White*, practically all of which are sold. There are about 100 of them, bad bargains for the purchasers...Perhaps a simple line drawing by him would be worth having...Read Thornton's *Diary of an Art Student*...I have it for review from *The Burlington*...

Friday 2
...wrote 250 words on Thornton's book. Two illustrations in it, of Gauguin's work, confirming my impression that he was a good artist but a bad draughtsman. The head in charcoal of Pissarro (probably expressive, up to a point, as a likeness) compares unfavourably with Pissarro's drawing of Gauguin; and the picture of two little Breton girls, like the portrait sketch, shows merely ignorant bad drawing, not expressive, wilful distortion or simplification of form. I seem to remember reading a story of someone asking to see Gauguin's drawings and of his refusing to show them. Probably he knew they were bad!...

Friday 9
...wrote a stiff letter to Margaret Morris about Alice's work, which Margaret suggests she should give up, at least for the greater part, as far as the School is concerned. In other words, she has given Alice the sack, because she can't afford to pay her, and wants what money there is for Audrey Seed. She might have done that politely, but her method was abrupt, without any proper explanation...After dinner went to the Maurice Hares' flat, 2 Orsett Terrace, where there was a small party, including the Idzikowskis and Jenepher Hare, whom I had not seen for years, the Idzis since the great days of *The Sleeping Princess* and the Cecchetti book [1922][13] (they now have a dancing school in Great Portland Street), and Jenepher since she was a small child (in the interval she has been married and her husband has committed suicide). Idzikowski assured me that Picasso told him that he painted what Id. called his 'crazy stuff' in order to make money, and because people would not buy his other pictures.

Saturday 10
...I have a merely formal acknowledgment of the letter [M. Morris] this morning. It seems that Prunella Stack's 'Health and Beauty' movement is on the rocks too, in spite of magnificent publicity. Towner...has not sold one picture in his show so far. Most people think his paintings are too big, and many find them a little dull. Hagedorn likes them, and went twice to the show...Subscribed at £1-1-0 to an Artists' Refugee Fund for Czhecko-Slovakians [sic] or German Jews who are dispossessed in the troubles abroad...

13 *A Manual of Classical Theatrical Dancing According to the Method of Cav. E. Cecchetti*, Beaumont collaborated with Idzikowski, Schwabe undertook the drawings of the exercises as Lopokova and Cecchetti demonstrated.

Tuesday 13
Cocktail party at Nevinson's studio. Mrs. Nevinson officiated part of the time behind a bar. Maresco Pearce told me he was jotting down his recollections for the benefit of his family, and compared notes about what we did in Paris *c.*1907-8. We were both there as students...I gather that he was one of Euphemia Lamb's lovers. He speaks well of her, from his own point of view. Stanley Spencer was present at the party, and I talked to him a good deal, or rather he talked a good deal to me. He was unshaven, and his soft collar couldn't possibly have got as dirty as it was in less than three weeks. He is staying with the John Rothensteins, and arrived without any luggage.

Friday 16
Slade Dance...150-200 persons...The Decorations, by Dodie Glass, Angela Baynes... were better than usual...

Monday 19
Lunch at the Langham Hotel, with some people from the B.B.C., Connard, Jowett, Chisman...Afterwards we went across the road to Broadcasting House to select some drawings done for the *Radio Times* for public exhibition. Some of the drawings were very good...Among the artists represented are Nicholas Bentley, Ardizzone, Eric Fraser and Tom Poulton. Jowett and I adjourned to the Athenaeum. He agreed that Stanley Spencer is in a filthy state...Even Gilbert, who is very loyal to his brother, is worried...

Friday 23
Went round a few shops pricing drawings for presentation to Douie from the College on his retirement. There are plenty of Rowlandsons at Squires & Meatyard's for under £10; and...I may get a good painting of a head by G.F. Watts for £25. He is unfashionable...

Saturday 24
...the snow continues...A man in a Hampstead stationer's shop told me it has had a bad effect on Christmas sales. Selfridges...have sacked 2000 extra assistants...We leave for Peasenhall on the 3.10 train. A great business, packing Christmas presents for everybody at the Tennysons'...

Wednesday 28
Left Peasenhall, and through to Dover.

1939

The threat of war shows little sign of abating and it is proposed that should war break out, the Slade shift operations to Oxford to share premises with the Ruskin School. In June Schwabe visits Ithell Colquhoun and Roland Penrose's exhibition at the Mayor Gallery in Cork Street, in the same month an IRA bomb explodes in London and Gertler commits suicide. The Schwabes are on their customary summer holiday in Cerne Abbas when war with Germany is announced on 3 September by Prime Minister Neville Chamberlain. They relocate to Oxford for the duration of the conflict and on 16 October the Slade-Ruskin under Schwabe and Albert Rutherston opens. In November the War Artists' Advisory Committee is established under the chairmanship of Sir Kenneth Clark.

JANUARY

Monday 2
Alice and Birdie came home from Dover.

Saturday 7
Went to the Squire Gallery in Baker Street to get a Rowlandson drawing for presentation to Douie. It is called *The Legacy*. It is a half-finished drawing. The price is 9½gns…Met Tommy Lowinsky thinking of buying drawings by Thornhill and Richardson. He talked about Joe Hone, with whom he has been corresponding over *The Life of Tonks*. He says Hone is not publishing some of the unpleasant letters that Tonks wrote: and he told me a long story of Tonks's treatment of Col. Armstrong, who (like Lowinsky himself) suffered some rudeness at Tonks's hands. Armstrong and Tonks used to go for a walk together on Sundays, a habit which endured for over twenty years. A time came when Tonks avoided Armstrong, and when Armstrong said something, pleasantly enough, about it. Tonks replied with a cruel letter saying that Armstrong had bored him and irritated him for years, and that he couldn't bear with him any longer. Armstrong replied in a most Christian spirit – 'Dear Tonks, I know you don't mean a word you say'…and asked Tonks to lunch. The invitation was accepted.

Tuesday 10
Received cheque for £5-5-0 from the B.B.C. for looking at their drawings with Connard and Jowett…

Wednesday 11
Met Dodd at the Athenaeum. He thinks the R.A. had a narrow escape from having Sydney Lee as President, whom most people regard as an amiable nonentity; and further he thinks that if a few persons had not split the vote by voting for himself, Lutyens would not have got in. Contrary to my previous opinion, Lutyens seems to be very businesslike, attentive and useful in his conduct of R.A. affairs. He wanted, apparently, to be president, in spite of his being a somewhat inaudible and unsuccessful speaker. Anyhow, he is about the most distinguished man they could have got. Richardson, in the kindly way

that architects have in speaking of each other, told me various stories of Lutyens having ruined his clients...

Thursday 12
...R.A. show of Scottish Art, where Oppé introduced me to the works of Alexander Runciman and David Scott...Geddes, Ramsay and Raeburn all worth looking at. Raeburn is generally entirely deficient in cool half-tones. Others, Watson Gordon, McTaggart, John Brown...not uninteresting. McTaggart had an eye for the colour of a sky, but his little incidental figures are bad...

Saturday 14
Went to see Kelly, who has a project for a new book on costume...During the summer, having had an unexpected windfall of £60, they all went for a holiday to France, calling on old Maurice Leloir and on some ancient Catholic school-friends of Kelly's, and staying for a few days with the venerable M. Harmand, author of *The Costume of Jeanne d'Arc*, in his chateau of La Bazoche-Quelquechose. This last gentleman is a real enthusiast. At an advanced age he has learned tailoring, and with his own hands reconstructed the wardrobe of his heroine, doing every stitch himself except the eyelet-holes, and sometimes working a thing a dozen times before he is satisfied with it. He got his wife's daughter to wear Joan of Arc's drawers for a month to prove that they were practicable...He spent 25 years on his great book.

Sunday 15
...Grimmond tells me that John Piper was heavily crushed by Stephen Gooden in a debate at the Double Crown Club. Piper had said that Albert Dürer's treatment of form was out of date, and that his interest was chiefly in light and shade, or something to that effect. Gooden continued to make it appear that Piper had confused Dürer with Rembrandt...

Friday 20
Scottish Exhibition, a second time. Looked at Orchardson, particularly his wife and baby: the baby's features have lost their horizontal axis: otherwise there is a touch of distinction in this performance. But I really liked Geddes's *Mrs. Greatorex* [1840], a symphony in russet, and Wilkie's self-portrait: also many other things, some of the Raeburns, drawings by Ramsay...Should like to see more of John Brown, and of Robert Adam's monochrome compositions...

Saturday 21
...Dinner with Birdie at Jack Straw's...Looked with assumed reverence at three golden belts, deposited on show in the bar of the hotel by Len Harvey, the heavy-weight boxer, who won them by his prowess in the ring. Two of them have portraits of Lord Lonsdale in enamel. The rest is real gold and they are said to be worth £1500. Harvey sometimes stays at Jack Straw's when training.

Sunday 22
...Towner...is working out a composition with cows in it...lent him some studies of my own and a book of Rubens's drawings...this determination of his to do something less dependent on literal observation of an actual scene may be a good thing. It may

broaden the interest of his painting, which, he has been given to understand by the critics, is a little dull...Called on Mrs. George Sheringham...She has many troubles about the disposal of Sheringham's work. Provincial galleries have bought some, but neither Hind nor John Rothenstein will come to see her about it...

Monday 30
Inspecting the Chelsea Polytechnic for the Board of Education...Met members of the Staff, Williamson, Finney, Medley, Coxon, Ceri Richards, Henry Moore...The work taught is mostly good, traditional stuff. They are not taught to be 'modern' first. Williamson has done some excellent posters. He makes a very conscientious Head of a School, and has a good eye for selecting the best of his students' work. Fortunately, there is little for me to do in the way of adverse criticism. The fee for this job is £15...

FEBRUARY

Tuesday 7
Called on Elton...to see how his 'flu is getting on...His being away from the Slade makes it impossible for me to go to E. Constable Alston's funeral, which is tomorrow. Alston was connected with John Constable's family: a Suffolk man, from Dennington, where his father was vicar. He might perhaps have been a very good artist, but his long years of teaching at the R.C.A. left him little time and little incentive...I well remember one or two little pictures of a simple, personal quality. Some of us got him to send to the New English, which he would never have done without persuasion, and he was hung to his great pleasure. Lecture at U.C.L. Someone called Markham, M.P., on Museums. Lively comments on the propaganda museums of Germany and Russia. Pro-Nazi or Pro-Soviet exhibits very effective in moving the public mind.

Friday 10
Dinner with Professor Flugel, Merton Rise, Adelaide Road. Clive Gregory was there, and showed me some photographs of water-colour drawings by a man in an advanced stage of schizophrenia – not an artist. The drawings were pure sur-réalism, just as interesting as the ones done by followers of Dali...

Monday 13
Eddie Marsh has bought a drawing of mine – *Les Deux Andronnes* at Sisteron – from the National Society, which I rejoined following on a pathetic and flattering letter from Bernard Adams. It seems...flattering, also, to have another picture bought by Eddie Marsh after all these years. He says somewhere in an article that his purchases are made largely by following the judgment of painters whose opinion he respects...he went round the National Society with Fairlie Harmar, so she tells me, and I believe her unconscious log-rolling (bless her!) must have influenced him. I know she told him my drawings were very cheap. About these same Sisteron drawings, Heber Thompson, when sending his cheque for the A.G.B.I. to me, was also very complimentary: said...that he thought them in the best English tradition and that 'they deserve to take their place among the truly great'. This is frightfully kind of Thompson, who is sincere and honest as the day, but I wish I could swallow the last bit. Compliments were rarer when I was young. I have had several recently, to roll over on the tongue and savour privately. But too much of this

sort of thing is bad…Eric Gill once introduced me to a man thus – 'This is Randolph Schwabe, a fine draughtsman'. I don't suppose I shall forget that easily…

Thursday 16
Played about with a design for a banner for the Cerne Women's Institute, which I am doing out of friendship for Mrs. Pattison. A previous design, done last summer, wouldn't do on account of the impropriety of the giant's figure. Shows of paintings, Leicester Galleries. Nevinson and Gilbert Spencer. G. Spencer has a much more distinguished vision than Nevinson. Nev. has abandoned any abstract forms of painting that he ever practiced, and paints like an ordinary traditional artist now.

Friday 17
…Went to a meeting of the Bloomsbury Protection Society, to which I have been asked to belong by Sir Ernest Pooley, who lives in Mecklenburgh Square. The south side of the square is threatened by the extension of Sir H. Baker's London House, which will absorb, also some of the old frontages in Caroline Place…all very keen to preserve what seems worth preserving of Georgian London, and the Square itself certainly seems to come in that category.

Saturday 18
…Took [John] Howard to lunch at the Athenaeum. He has been active about Wyndham Tryon, and is trying to get the Head of Bedlam to go down to see him at Roehampton, in order to find out if the best is being done for Tryon's mental state. The family…won't move in the matter. Howard, however, fears that Tryon is really worse: he talked of homosexual complexes and masturbation, etc. He does drawings which the Roehampton mental specialists look upon as strong evidence of an insane condition. They are obscene, but that does not prove them insane…

Saturday 25
Began a drawing on Windmill Hill, of Romney's House. Clough Williams-Ellis's daughter, who runs in and out of the house, is pretty and intelligent: I met her at the Chelsea Polytechnic, where she studies art. Egged on by Maresco Pearce, wrote to the Town Clerk at Oxford imploring him to preserve Ship Street. Why this should be supposed to move a hard-hearted Town Council, I don't know.

Tuesday 28
I suppose it is a matter of common observation that young people decline to take seriously, or to themselves at all, the complaints of the middle-aged and old on the evils of life. Crabbe Robinson with his 'ennui', Delacroix's complaints about the insupportable ills which he must put a good face on, Hickey ('now that we are old and miserable'…) or George Du Maurier with his regrets for the temps jadis – each and all leave the youthful reader quite unmoved, or at most anxious to explain that the complainants are neurotic, dyspeptic or sentimental. When my Father said that 'Life wasn't worth living for', a remark which he made often and dramatically enough, I thought he was play-acting, and was more interested in his reasons for adding the unnecessary 'for' than in the gist of the sentence. I could at that time only with difficulty understand the reasons for people committing suicide. My own death seemed a matter far too remote to bother about. I

suppose that most of the time in my 20s and 30s I must have been gloriously happy (and quite unsympathetic) without knowing it. It is rather an honour to the middle-aged and old that they do so little to impress their unhappiness on their juniors. Perhaps we are silent from kindness; but also we know we shall get no sympathy and little belief. I have, as a matter of fact, managed to recapture a state of contentment at moments, lately, which is comparable to the state I describe as being mine between 20 and 30; but it is purely selfish, I am afraid, and there is bound to be a relapse. Others round me have far more reasons for unhappiness than I have. Who but an egoist would keep a Diary, anyway?

MARCH

Friday 3
...past days in bed [flu], have read *Art in England•* by R.S. Lambert, and René MacColl's new book *Flying Start* – largely about Van Lear Black, the flying millionaire, very amusingly yet feelingly written; have re-read Maurois' *Ariel*; and read most of Virginia Woolf's *Common Reader••* Have also worked out a few features for a dust-cover of a novel, in the rough. The book is *Lost Heritage*, by Douie.

•A pebble by the silver sea
A simple pebble is to me:
To Henry, something Moore.

••After reading Virginia Woolf on the Elizabethans, and remembering my own exploration of them (there is a long row of 'Mermaids' on the shelves downstairs), it is suggested to me that they are like a vast, steamy sloppy ill-set Christmas pudding, in which one may fish with a spoon for six pences and three penny bits. Depression – not so bad as anticipated. Have been extraordinarily well looked after, yet unfussily, by Birdie. I dread her getting this plague again...

Sunday 5
Ship Street, Oxford, has been reprieved and the S.P.A.B. [Society for the Protection of Ancient Buildings] are being consulted, so C.M. Pearce tells me...he thinks my letter carried a lot of weight. I think of another letter, received by me once from Bell of the Ashmolean, after I had written an article on something that he conceived to be his province without reading his own article on the same subject (Lely and Van Dyck, it was). 'Unparallelled pomposity and ignorance' was the best phrase in it. I have striven to live up to that...

Monday 6
...Spent most of the morning writing a recommendation of Rodney Burn, to facilitate Wellington getting him employed as a teacher of drawing in Edinburgh. There has been some sort of separation between Mrs. Burn and R., for which I am very sorry: and he is now, apparently, free to go to Scotland, if they will have him, as Wellington wishes...

Thursday 9
Called on Willie Clause, at Hutchison's request, to make sure that he sent one of his best pictures to the show of the New English which is being organized by the R.S.A. Some

further talk with Willie on the subject of Thornton's successor as Secretary of the N.E.A.C....

Sunday 12
...Visited Alan Durst, to vet the costume of a statuette of Shakespeare that he is doing. Finished book jacket, as far as I can...It wants a little medallion or something on the spine, but I can't do that till they send me the sheets of the book, so that I may see what the characters are like.

Monday 13
Election to R.W.S. – Associates. Hagedorn, Norman James and Charles Bathurst were the candidates...none...got in, though James nearly did. Instead, Wildman, Vincent Lines, Miss Hudson(?), Dinkel, who has no sense of tone whatever, and Mrs. Averil Burleigh, who is thoroughly meretricious, were elected...

Sunday 19
Czecho-Slovakian crisis. People are more used to the idea of imminent war now, and there is less excitement than in Sept. and less depression...

Tuesday 21
Provost...announced at the Professorial Board, that in case of war and evacuation of the College, the Slade would to go Oxford, to the Ruskin School...

Wednesday 22
Lunch at Athenaeum with Albert. Will and John R. were there too, with O.[Oliver] St. John Gogarty, whom I have not seen since he visited us many years ago with Augustus John in Chelsea – a circumstance he has no doubt forgotten. Talked over the possible successors to Thornton as Secretary of the N.E.A.C. Albert sees the objections to Lowinsky, and is not against F.H. Shepherd...

Friday 24
Slade Dinner...My anticipations and forebodings not worse than usual. Will Rothenstein and John R. came. The latter was pleased that he could get out of making a speech...and leave it to his father. Will was very good, light and amusing and quite impromptu. Four minutes before he got up he said to me: 'Now, what shall I talk about?' I said at random – 'Oh, about the old Slade of your time', and he did so...

Saturday 25
Charlton, at the Slade, told me that latterly Tonks and Brown did not really get on well together (but there was no disagreement between Tonks and Steer). They disagreed about many things, and there were times when Tonks was positively rude. When Brown had retired he came back to attend one of Tonks's public criticisms of the school work. Brown was in the hall when Tonks saw him, on his way upstairs to the room...where the criticism was to be. He said to Brown 'If you go up there, I shan't' and Brown did not go. Charlton thinks it was all this that F.B. was referring to in his speech a year ago – 'There has been much to forgive, and much has been forgiven.' Tonks, according to Charlton, was radically eccentric, and his attitude to any given subject could not be

forecast, even by C. Koe Child, who knew him so well. Charlton thinks that Tonks had a great deal of jealousy in his nature – of Will R., for instance, particularly when Will became head of the College of Art...

Sunday 26
Hagedorn, Grimmond and I called on the Lee Hankeys, it being what in the old days was known as 'Show Sunday', before the Academy. I doubt if either Lee Hankey or Mrs. Lee Hankey will be hung in the R.A.. Tastes have changed, and they have not too much taste anyhow, amicable people as they are. L.H. has painted the Catholic priest of Holly Place. This is his best effort.

Wednesday 29
...A fuss in the papers about John signing one of Robin Guthrie's drawings by mistake. A Bond Street dealer has promptly put some of Guthrie's drawing in his window, hoping to get the advantage of the publicity...

Thursday 30
Finished the little medallion on the back of Douie's book jacket...Ethel Walker's Private View at Reid & Lefevre's. A great many pictures of distinction, the product, or part of the product, of two years. Her energy, for a women of over 70, is remarkable...Miss Sallé, the model, who sits for most of Ethel's nudes, and whom I met in the crowd, told me, as an instance of Ethel's generosity, that she had given her (Sallé) a painting of herself (Sallé) and some drawings...Ethel was being called for at 6 in Chelsea by the Television people, who wanted her to do a little piece for them...

Friday 31
...Tea with the Euston Road Art School (Pasmore, Coldstream and Rogers), who had invited me to see their exhibition. Mrs. Anrep was there, very friendly, and amused, apparently, to talk of old times in Paris and Siouville, about 30 years ago. The hostility from her to me, which had been put into my head by somebody, seems entirely imaginary...The painting done in the School is of a good kind, quite representational, with regard for colour and tone: the drawings I thought rather weak...The studios are large, and typical of the sort of thing one used to know – no pretence at superlative cleanliness, just bare rooms cleared for the occasion. They are on the second floor, over a sort of 'amusement park' at 314 Euston Road.

APRIL

Saturday 1
11a.m. Saw the Boat Race, at Ralph Edward's[1] invitation, from Suffolk House, Chiswick Mall. Cambridge obviously the better crew...The crowds not so great...perhaps because it was Saturday morning, and not everyone can leave his work, perhaps because interest in the Boat Race (particularly in this time of crisis) is declining. Hammersmith Bridge was closed, having been damaged by an Irish bomb. Heal's shop, too, has suffered damage from the same cause. This is the second time only that I have seen the Race. The first was years ago, from Francis Macnamara's house in Hammersmith Terrace, when

1 Keeper Furniture and Woodwork V.&A., author *Dictionary of English Furniture.*

John, Innes, Dora Carrington and Ian Strang were present, sitting on the roof…

Sunday 2
Yesterday Mrs. Lowinsky, who is more jingo than her husband, said that Tommy was thinking of putting his name down for some camouflage work in case of war; but he learned that camouflage nowadays is done largely by testing it from the air, and he doesn't like the idea of flying, so he didn't put his name down after all.

Tuesday 4
…Saw Tanner at the College, about air-raid precautions, and various points in connection with a possible evacuation of the Slade to Oxford in case of war…Meeting of the N.E.A.C. to discuss the appointment of Thornton's successor. Finally, Shepherd was unanimously recommended, much to my satisfaction, as I suggested him in the first place. I did not directly favour him at the meeting, beginning by putting forward Muirhead Bone, who was not adopted as a possible candidate; and Willie Clause tactfully avoided saying that Shepherd's name had been brought forward by me…

Thursday 6
Dover.

Thursday 13
Finished drawing of Camden Crescent.

Thursday 20
…Drove up from Dover with Tom Cobbe…Breakfast…Euston station. I shall be sorry when the great portico is pulled down. Went to Albert R.'s show at the Gallery in St. James's Place, where Roland Pym is having a show as well…He is a good-looking young man, and a clever decorator. He seems to have done a lot of work, theatrical and other. Albert had sold a good few drawings, but he had marked them down to about 4 guineas each, because of the crisis, which is on everyone's mind just now, making pictures seem trifling.

Friday 21
Lunch with Albert R. at the Athenaeum to talk over one or two details of the proposal to shift the Slade to Oxford if a war comes. … Afterwards spent a very pleasant afternoon loafing about St. James's & Bond St. with Albert. He is an excellent *flaneur*, interested in all sorts of trifles. We looked into his exhibition…and into another exhibition of drawings (including a very good Samuel Palmer) in the same street; and we looked at Samuel Rogers's house, and the back of White's Club, and other pleasant buildings in that neighbourhood; and then to the Building Centre in Bond Street, which is the old Grafton Gallery transformed, with an entrance in Bond Street instead of Grafton Street. There we met Ernst Stern, who was having a show of theatre designs – very alive and professional work, working drawings with little care for a picture-maker's finesse. There were some water-colours of his, too, views of Paris mostly. Our last act was to investigate the two fine 18th century houses on the north side of Clifford Street…

Saturday 22
Daphne Charlton is childishly pleased because there is a photograph of her in *Picture*

Post, talking to Stanley Spencer in Nevinson's studio. Albert R. is annoyed with Nevinson because he wrote Nevinson a letter on his election to the R.A. – a letter which Albert himself described as very witty – and Nevinson made no acknowledgment of it... Gwynne-Jones...has been put on the Committee of the Tate Gallery. David Low, whom I met, has been building himself a bomb-proof shelter in his garden at Golders Green. Harry Barnes has been similarly occupied making one for his parents in Sheffield.

Thursday 27
Royal Academy Dinner. I sat with Bradbury of *Punch*, an old facetious man, and a typical supporter of the Arts Club, whom I had met before at Maxwell Ayrton's. Near me were John Rothenstein and Martin Hardie...

MAY

Wednesday 3
A.G.B.I. Dinner at the Mayfair Hotel...My collection of £181 seemed small beside Oswald Birley's £1500, but better than Allinson's £47.

Thursday 4
N.E.A.C. General Meeting...Shepherd was unanimously elected Hon. Sec..

Sunday 7
Went on drawing on Windmill Hill...At home, Ginger and Jean Inglis...the Charltons, Caroline Gabriel, and [Stanley] Spencer came in about 10.30 and stayed till 11.45. Stanley Spencer is a very little man, but looks tough and is full of vitality. He says he did very heavy work when he was in the army.

Monday 8 – Sunday 14: no diary entries

Wednesday 17
Gossip concerning the Spencers – Jean Inglis has been staying with Gil and Ursula near Pangbourne. They have a small daughter, very rampageous, aged about two, who smeared her mother's rouge all over the white cat. Gilbert has also an illegitimate son, whom he supports dutifully and sends to school. The boy does not live with his father, but they correspond. I suppose Mrs. Tom Nash to have been the mother of this boy (Yes, she is). Gilbert, who faces up to his responsibilities, gets a little irritated at Stanley's successful evasion of anything like family ties; though from the monetary point of view it seems not so successful, as Stan has to live on 30/- a week, and this in spite of making some £3000 a year just now. Both Jean and Daphne Charlton agree about this figure. Tooth's arrange his money for him. He has to support Hilda and the children, and his second wife has run him into enormous debts – £1000 for clothes in one year...They are not together now. She won't live with Stanley. I notice that the erotic phase of Stanley's work is over. Mrs. Behrend bought some examples of it, but doesn't like them.

Thursday 18
Wrote my review of Hone's *Life of Tonks* for the *Observer*, from notes made while reading the book at the Slade yesterday. MacColl put the *Observer* on to me. ...They

published it with a silly headline, *English Eccentric*...

Tuesday 23
Met Will Rothenstein for a few moments at the Athenaeum. He was up in town...to do a Television discussion on modern art with Wyndham Lewis and others...

Wednesday 24
...The Slade students got up a Derby Sweep, with tickets at 6d. Polunin won the first prize and I the second (19/-)! Gilbert Spencer met his wife when he was drawing her father (Bradshaw). He hesitated for a little time about proposing to her, and used to rub out Mr. Bradshaw's mouth, or an eye...so that the sittings could go on, and so that he might have more chance of making a determination.

JUNE

Thursday 1
Allinson called to get my signature to a document...he [also] wrote to congratulate Nevinson on his election to the R.A., telling him his candid opinion of his work – how good he thought it at times, how vulgar at others. To this he received no reply and is now wondering if Nevinson was hurt. Nevinson had been abusing the R.A. violently to A. shortly before the election. Charlotte Wellington came, and said the appointment to the Glasgow Art Gallery will probably go to Honeyman, of Reid & Lefevre, in preference to Hendy, a much better man. Hendy is not on the short list given in *The Scotsman*. The chief reasons for appointing Honeyman, if he is appointed, will be that his politics are Labour, he has a rich wife, and is a Glasgow man himself.

Monday 5
Slade Diploma Exam. Russell, Borenius, Corfiato, Ledward and Ormrod. 34 candidates, of whom 33 passed.

Wednesday 7
The Russell Cotes Museum in Bournemouth is going to buy my drawing of *Perrin's Court* for £12 gns. Willie Clause is furious about the selection of British artists by the British Council for the New York Exhibition. He wanted someone, himself, or me, or MacColl, to write to *The Times*...I declined. He points out that Tonks, Brown, Gwynne-Jones and myself(!) are not represented, though Gertler and a number of painters, whom he detests, are. Well-well: is this Kenneth Clark's doing? It doesn't matter much...As far as I am concerned, the same British Council did invite me to send to their exhibitions in the Northern Capitals of Europe, and they borrowed some pictures by Tonks, too.

Thursday 8
Birdie reminded me of her curious experience with Augustus John, once when she went to Mallord Street at the time she was sitting for her portrait. John met her in a quite excited state, and dragged her in, saying – 'Come – I've got something to show you.' Birdie was a little uneasy, knowing John's eccentricities; but when he flung open a door, the sight she was to see proved to be Dorelia, sitting by the fire-side with her hands on

her knee in the attitude of the *Smiling Woman*[2] which seems to be unselfconscious and habitual with her. She had a pile of children's garments in her lap, having been airing them by the fire; and Birdie thought she really looked very lovely, and that John's enthusiasm was not misplaced. Blockie came to tea, in the garden. She says Heal & Son lost £12000 last year, the first time in their long history that such a thing has happened; and that is why Ambrose and Teddy are moving to the flat in Bath, and selling Baylins Farm.

Friday 9
Went to a show of sur-réalist paintings and 'objects' by Ithell Colquhoun [plate 17] and Roland Penrose at the Mayor Gallery in Cork Street. Ithell C. has excellent draughtsmanship, craftsmanship and colour, and the slightly morbid turn that she always had finds expression in the most recent fashion in painting (though it isn't very new). There were dilapidated corpse-like figures, odd symbolic motives, and a very naked man, more or less naturalistic; also more naturalistic interior and some flowers. Mr. Penrose is not so efficient as Colquhoun. He scores by having labels stuck on the wall – 'I know why I am alive, but I don't know why I eat' – 'Le monde est bleu, comme un orange' – 'These pictures are painted in oil and vinegar'…Showmanship is evidently the most important side of his art, and the sillier the better, I suppose. Met Colquhoun in the Gallery and told her in mild terms what I thought of the show, giving her praise for what she has, but jibbing at the literature. She has, I am told, in the catalogue, which I did not see, photographs of herself nude. 7 o'c. Left, with Birdie, Alice and Bobby, the cocker spaniel, for Tuff's Hard, Bosham, where David Renwick lives. Renwick drove us down…

Saturday 10
Renwick's house is one of a block of three on a little building estate that Chesterton the architect is developing. He invented the name 'Tuff's Hard'. At present there are about six houses built…They go very well into the landscape and are well designed. The Chestertons go down every week-end and put up in two gypsy caravans…Renwick ran me over to Bosham, where I drew all day…It is about half-an-hour's walk from the house to Bosham. Bosham looks a little unreal. It is very carefully kept up, and seems to be run exclusively for visitors and the gentry who are interested in boat sailing…

Sunday 11
Another day's drawing at Bosham…Chesterton took me out for a short sail over towards Itchenor, in his small dinghy…

Tuesday 13
Stanley Spencer lectured to the Slade Society. It went off very well…He was a little nervous, and says he once had to give up a similar talk because he couldn't face it, but on this occasion he was pretty fluent for an hour and a half, including the answering of questions from the students. He has a great feeling for the Slade. He told me he spent his four years there almost entirely in life drawing. He did not attend any lectures on anatomy, but had some knowledge of perspective, acquired at Cookham or Maidenhead before he came to the Slade. Now, he says, he is more interested in rendering the planes of the ground, and in similar perspective problems…He remembers starting one life painting, which he gave up half way through, and a painting of a head, but that was

2 See *Woman Smiling* (1908-09), Tate.

about all the painting he did in the School; so that his *Nativity* [1912] prize picture was done with very little preparation. He painted this in the three months' vacation after he left the School. Before that he had painted one or two small compositions – Schiff bought one, he thinks – and had made a start on *The Apple Gatherers*, which went on a long time before it was finished. He had found, at that time, that a wash drawing was all he needed to express his ideas.

Wednesday 14
Spencer is staying with the Charltons in New End...before he goes off to tackle the decoration of a Chapel for Father D'Arcy (at Campion Hall?). I dined with the Charltons and him. John Rothenstein was there too, and Clause came in after supper. R. flung out an idea of having a show of Slade draughtsmanship at the Tate. Spencer talked a great deal, and well. Rothenstein defended the selection of the pictures for the New York Fair on the grounds that it was a light and gay occasion, and the more weighty aspects of art would have been inappropriate. Still, they have John, Sickert and Steer...Rothenstein was amused at Wyndham Lewis's jeers at Herbert Read. He thinks very highly of Lewis.

Friday 16
Went to the Tate Gallery to see a show of photographs of mural painting, including John's *Mumpers*, Duncan Grant, Mahoney, Bawden, Ravilious, E. Dunbar, Monnington, Spencer – in fact, everyone I ever heard of, and many that I don't know...

Saturday 17
Maxwell Ayrton hired a car and drove me to Ware, where he and I did some drawing by the side of the river. I concentrated on a group of the gazebos overhanging the water. The sun went, and we could not properly finish what we set out to do...

Saturday 24
Worked at the Slade all day. I have been there every day this week...Went to Roches, and a news film, mostly about the King and Queen in America. We were in Shaftesbury Avenue, and must have left the cinema shortly after there was an I.R.A. bomb explosion in Piccadilly Circus, about 150 yards away, and we saw fire-engines turning out; but we knew nothing of it till we saw the newspaper on Sunday morning...

Monday 26
Mark Gertler is dead – the news is in the papers today. Daphne told us on Saturday, of his suicide, but we were inclined to doubt it then, though she had it on the authority of John Howard, who knew G. very well. Gertler was expected at a party on Friday, where his doctor was, and the doctor was telephoned to with the information about what had happened. I am sorry that any man should be so miserable as one must be to put one's head in a gas oven. Gertler was an egomaniac: he felt the failure of his last show at Lefevre's (which nevertheless got good notices in the Press). He was bothered about tuberculosis: and his wife had left him. I think his work had been getting worse. Altogether a pitiable end for man of a real objective representational talent. I always thought there was a streak of stupidity in his other stuff. In our personal relations we got on well, I'm glad to say. Maxwell Ayrton has a different story; he thinks Gertler

disliked him, because he, Max, was a friend of Gertler's wife's father, who resented the marriage. Slade...hanging and judging paintings...Peggy Rose[3] should get any prizes that are open to her, and Dodie Glass [Masterman] also; but probably the men will beat them in after years.

Thursday 29
Slade Picnic at Wraysbury...cricket – I made ten runs – bathing, dancing, etc. The chief representatives of the School this year are Dodie Glass, Peggy Rose, [William D.W.] Paynter, Treffgarne, Parratt, Dingham, [Cecil] Riley, Miss Yeldham Taylor – I wonder how many...I shall remember or hear of in a few years' time? Constance Lane and Rowland Alston came in their own cars, and she drove me back to Shepherds Bush Tube...Daphne can talk of little else but Stanley Spencer now. She appears to provide him with inspiration as well as sustenance, and he seems happy in their household. He admires her very much, she says...He is willing now to have a daily bath and to clean his teeth. Previously, he says, he had a bath once a year...

Friday 30
Slade Prizes. Glass, Rose, Innes, etc. Strawberry tea under the Portico...Reddall in O.T.C. uniform – a reminder that future peace is very dubious, and everything very uncertain just now. Daphne brought Stanley Spencer...

JULY

Friday 7
Examining at Reading University. Met Robert Gibbings...looking very much like William Morris. He says that after he has engraved round his wood-block designs, he sends them to a man who 'scorps' them for him for about 1/- an hour.

Saturday 8
...to Dover...Tom is looking for a School in Devonshire or Wales, so that Margaret can be transferred from Walmer to a school that is safe from air-raids. 'Black-out' tonight. As we came out of the Hippodrome there were decontamination squads in gas masks, with a lorry, washing away imaginary gas bombs. The proceedings lasted well into the small hours. Sirens blew, and so on – all as realistic as may be.

Monday 10
Bathed before breakfast in the harbour. Continued drawing [from Gun Wharf], and more or less finished by 3p.m....Train home...

Tuesday 11
Took two drawings to the Leicester Galleries, for their Summer show. Saw Epstein's *Adam*, and the drawings that surrounded it. Did not care much for the over-emphasized

3 Rose took drawings of Garbo, Joan Crawford and her brother to her Slade interview. Schwabe said as they 'were from life they made her an acceptable candidate' (Obituary, *Independent*, 5/02/13). She was the first student to be awarded the Ida Nettleship Scholarship, for her *Domestic Employment: A Girl Seated in a Chair Sewing* (1938), a painting of her fellow student Dodie Glass. Glass painted Rose in *Domestic Employment: A Girl Seated by a Dummy Arranging a Dress.*

.

drawing of children's heads but thought *Adam* had realized the artist's intention of great energy and monstrous power. Later, Alan Durst explained to me many technical reasons why the cutting of the stone was bad. It is said to have been sold for £7000, and is to be exhibited at places like Blackpool, where, it is supposed, its peculiar nudity and eccentricity may rake in shillings from the curious. Julian Huxley ought to have it for the Zoo...

Thursday 13
Daphne Charlton is sleeping in our house for a few nights while George is away in Yarmouth. This is to preserve the *convenances*, as Stanley Spencer is staying at 40 New End Square.

Wednesday 19
Drew Randall Davies [plate 4], at his house...he sat well for most of the morning. Lunch with Mrs. Davies. Randall lunches alone. He is getting rather eccentric.

Friday 21
The Leon Joneses drove me to Monk's Eleigh [Suffolk] for the week-end. He reached a speed of 80 m.p.h....Astrid, their Danish maid, had got the Mill House ready for them. She is a sort of family friend more than a servant, and speaks English without any discoverable accent. Her friends in Denmark think the British Empire is finished and that we should lose a war with Germany. Lutyens, whom Munnings brought over some time ago to the house, admires its little Georgian front...Leon Jones is an old friend of the Strang family, and went to school with Oliver Brown. As a young man he was for a short time on the music-hall stage, in a touring company. He then appears to have done some commercial travelling, after having a job in China. Now he is a director of Rowntree's, and works at the chocolate factory in Plaistow. He told me what their annual turnover is – I forget how many millions. They sell one fifth of all the chocolate consumed in Britain...They treat their workpeople well. Jones talked about General Ironside, whom he knows: a remarkable man: speaks German, Polish and other languages. Served in the Bavarian army, presumably as a member of our Secret Service, and keeps a diary rigourously, every day...

Sunday 23
Continued drawing, and finished what I could, but I wanted light, and there was none. Dined in Highgate with the Joneses about 9 o'c. and brought home by their chauffeur...

Saturday 29
Birdie, Alice and I left for Cerne Abbas – the Abbey Farm again. Argued with Mrs. Vincent about her charge of 1/- each for a bath, in addition to the £3-3-0 a week. As I have a cold bath she has to let me off, at least, but she was firm about the hot water, owing to the price of coal and the inconvenience of her hot water system, which Lord Digby will not alter: neither will he do much in the way of repairing the premises: the rain dripped through the ceiling of my bedroom this night.

AUGUST

Wednesday 2 – Monday 28: no diary entries

Tuesday 29
In response to a telegram from Albert R., left for Oxford to see about Slade arrangements in the event of war. Left Cerne for Dorchester on the 1.45 bus and got to Oxford by train, at 7 p.m. Leonard Huskinson and Albert met me at the station. Drinks at The Randolph. Huskinson kindly arranged to put me up for the night at his house at Stanton Harcourt. Paul and 'Bunty' Nash were staying at The Randolph, whether…taking refuge away from London in the crisis, I don't know…Dined at The George with Ian Robertson of the Ashmolean and a Professor Donner, a Swede…Robertson drove me to Stanton Harcourt. It was not light enough to see the outside of the beautiful house, but the inside at once became most interesting, with its 17th century wainscot in its original state of painting, graining and marbling: this is the work of an artist called Van Witt, known for some work at Holyrood…Huskinson's family…are concerned about the evacuated children they will have to house. Huskinson has a talent for drawing, and vitality in his work as an artist…He did some very competent decorations for the New York World's Fair, assisted by Slade students, Allan Carr and Elizabeth Stephen.

Wednesday 30
Went in to Oxford to meet Elton and Albert, and to have an interview with Veale, the University Registrar, which passed off successfully. Inspected the empty Ruskin School premises, and the Ashmolean, which is being dismantled and the treasures sent away to Wales and to Chastleton. The staff, K.T. Parker, Robertson, and others, helped by amateurs – Huskinson, Albert, [Francis Falconer] Madan (an ex-Indian judge and art collector) and three Ruskin School students, including my cousin, Margery Ermen, have been working…to get the pictures and objects of art off the walls and out of the cases… To Stanton Harcourt to dinner. Paul and Bunty Nash, Albert, and Madan to dine…Nash looks very ill, and relieves his asthma by frequent inhalations. His wife says, in her 'clever' way, which I dislike, that she always knows when he has been unfaithful, because the smell of women's face-powder prostrates him…

SEPTEMBER

Friday 1
…We heard rumours of war in the village, and positive information on the wireless at 11.30 of the bombing of Warsaw, Cracow…The balloon has gone up, as they say. Monstrous and almost incredible…

Saturday 2
Evacuation commotion continues in Cerne. Many people are behaving very badly. Some go so far as to suggest that London children are all little monsters, that some of them, like dogs, are not 'house-trained'…Finally, 150 arrived, at night, and were distributed from the Village Hall, in cars, in heavy rain. The 'brats' turn out to be decent, well-conducted girls, mostly 13-14 years old, from a Haberdasher's Aske School…We… worked all day 'blacking out' the house with curtains, black paper and other devices,

according to orders...

Sunday 3
11.15 Listened to Chamberlain's solemn wireless message. War from now.

Monday 4 – Monday 11: no diary entries

Tuesday 12
Went to London from Cerne to sit on a committee for the selection of camouflage personnel, at the request of Capt. Glasson of the Air Ministry. Train, supposed to arrive Paddington about 2 o'c., was an hour and a half overdue: consequently, I did not reach the Kingsway offices till 4...In a stuffy room found Jowett, Monnington, Ernest Jackson, Glasson and Kenneth Clark, as well as a secretary, Mallett. Masses of applications... Adjourned till tomorrow, K. Clark offering the use of the Board Room at the National Gallery, now completely cleared of pictures...Met Dick Carline, Grayson and others, working in the Kingsway offices on models...but they didn't seem to have too much to do, and there are complaints about muddled organization and waste of time. Rang up Willie Clause to ask him to put me up for the night. There is nobody, naturally, at Church Row. Grace, the maid, is evacuated to Market Harborough with her children...

Wednesday 13
Everyone carries his gas mask...You are stopped and questioned by the police if you haven't one...Vulnerable points in the streets are heavily sandbagged, and strips of paper pasted over shop and other windows to prevent splintering of glass. Camouflage committee...Lunch with the Hagedorns in Belsize Park. Nelly, who is under the Home Office at Wormwood Scrubs, has been asked by them to organize ten canteens in Hampstead... Hagedorn is working with her...Went to the Grimmonds after supper with Willie Clause. G. has lost his job – instantly on the beginning of war. Talking of sandbags, he tells me that great quantities of sand are being excavated on Hampstead Heath, and fine groups of trees have been destroyed...

Thursday 14
...Went to poor Lewis about some mounts, as the N.E.A.C. and R.W.S. are both continuing to hold exhibitions. He is on the brink of ruin. Called Max Ayrton. He and Mrs. Ayrton are sleeping in the garden studio, as being safer. His job at Mill Hill is still going on, but he has had to sack his chief assistant...He has moved his office equipment from Grosvenor St. to Church Row...Tony is hoeing roots on a friend's farm, and waiting to see the result of his application for camouflage work...

Friday 15
Committee – the same persons, except Monnington, who has gone to Avonmouth on a camouflage job...Lunch with Jowett and Ernest Jackson, at the Senior United Services Club, which is housing the Athenaeum during cleaning operations. Everyone in uniform, except the Athenaeum members...Looked into Church Row...Met Egan Mew for a moment, off to Worthing, in a taxi to Victoria. 'Better be dull than dead', he said. His Mrs. Stephenson will look into our house occasionally for us: gave her 5/- and my key...

Saturday 16
…Left Paddington for Cerne…Train…crowded…Alice and Bish [Harry] Barnes met me, in his car. He has come over for the weekend from his job at Bushey. The Haberdasher's Aske children moved from Cerne to Dorchester today. Mr. Venables, husband of one of the teachers, is still at the Abbey. He has talked, at Weymouth, with survivors of the Belgian ship that has just been sunk by the Germans in those waters.

Sunday 17
Shocking news about Russia invading Poland. Worked on a drawing, perhaps the last I shall do at Cerne, in order to forget about it…

Monday 18
Left for Oxford…Met Robin Darwin at Oxford station…He is painting a portrait of a soldier. Albert R.…reported to me that Daphne Charlton and Stanley Spencer are having 'a terrific affair' in Gloucestershire. This is on Billy (W.M.) Rothenstein's authority. He has been staying in the same place – Leonard Stanley…

Tuesday 19
Work at the School…seeing odd people and writing letters. Elton, Albert, and the Ruskin secretary Phyllis Alden(?)…Lunch at The George with Albert and the Lowinskys, who now talk of taking Garsington…It is about £300 p.a. unfurnished…

Wednesday 20
…Ormrod came over from his house near Newbury to assist Elton in the search for accommodation for students. There may…be over 60…coming…met Muirhead Bone in the street, full of a scheme to have a war-time exhibition of paintings by modern artists in the empty Ashmolean…Went to see the two rooms in George Street that Bone has been using as a studio. He pays about £100 a year for them and is now vacating them. He had a young protégé there, a lad of 15, whom he is encouraging to take up art with a view to commercial work. Oxford seems…very dear. I pay 10/- a day bed and breakfast, at The Golden Cross…The Nashs are settled in Beaumont Street for a while.

Thursday 21
…Oxford is a great place for meeting people whom one knows. Later, in a tea shop in High Street I met Mrs. Ralph Edwards, dressed in trousers, escorting her sons and a boy of Robert Austin's to Radley School, and anxious to get there in time to do the return journey to London before dark, because of the difficulty of driving a car in the black-out. Got through half *Bouvard and Pécuchet* (price 6d) which I have not read before, though I remember George Kennedy recommending it to me thirty years ago for its humour: it is cynical, disillusioned and Voltairean, and, apart from its harping too long on the same string, very good reading…

Friday 22
Worked at the School. Interviewed two prospective students…Lunch at The George. Albert, John Piper and his wife, John Betjeman (who says we met at the New Inn at Cerne last year…) and Huskinson. Betjeman had composed a facetious poem on the War, which I thought mildly funny. Huskinson passed it over to some friends of his at

another table. One of those…said it was childish and in bad taste, and tore it in half: he is in some branch of the army…Betjeman was not disturbed, so the little scene ended… took a train to Cerne, or, at least, to Dorchester. It took over 6 hours…No light in the train except the moon…

Friday 29
Left Cerne…Oxford 6.15. Elton engaged rooms for us at 12 Museum Road. He left quantities of roses and *The New Yorker* to cheer us up…

Saturday 30
At the School with Elton and Albert. Birdie and Alice went to house agents…[who] say there has been more demand in the last month than in a whole normal year…

OCTOBER

Friday 6
…Work at the School for me every morning…

Saturday 7
…Meeting with Paul Nash at his house in Holywell Street, where there was a committee convened to consider the employment of artists in war-time. Parker, Albert, Huskinson, Madan, [Philip] Morton Shand and others…Looks to me as if Nash is seeking a job out of it for himself. He proposed to raise money out of the Committee – a private affair – to keep the scheme going. £10-10-0 should keep it afloat…Trouble about the rooms we had settled on in Beaumont Street, no. 7. Landlady wants to give us up for a longer let. Sent round to say she had reconsidered it…

Wednesday 11
…The Ruskin School has now two big rooms quite ready for the students to move into.

Thursday 12
Meeting with Roy Harrod, Lord Rosse and Albert R. about making pictorial records of 18th century buildings in Oxford. Sir M. Sadler rang up Albert to say that William Roberts and his wife are in Oxford without a penny – could the Slade or Ruskin give him a teaching job? The answer is in the negative. Roberts came to see me yesterday, but said nothing of his finances, nor of having lost his job at the Central School. He wanted to come and draw short poses in the School, and took the address of a studio in St. Giles's that happened to be vacant.

Friday 13
Mrs. Brown, who lets our lodgings at 7 Beaumont Street, relates that there was an air-raid warning in the earliest days of the war, when the Paul Nash's were in this house, and that Paul and Bunty were in a great panic: Paul flying about with a wet towel wrapped round his head in case of gas attack (he cannot wear a gas mask because of his asthma). Mrs. Brown retired into another room to laugh. It was a false alarm, anyway. She did not get on well with the Nash's. Landlady's gossip!

Monday 16
Slade-Ruskin School opened. Over 100 students, men and women, new and old, were in their places and working within an hour. Not so bad, considering all the difficulties, negotiated mainly by Albert and Elton. Charlton and Ormrod came.

Tuesday 17
G.J. came, having travelled from Standon, where he is staying with Nellie Schwabe. He stays here for 2 nights in Albert's room in Vanbrugh's House (St. Michael's Street). He and Rosemary were in Provence until just before war was declared. Unexpectedly, they found Augustus John, Dorelia, and Derain staying in the same place. They all seemed to get on well together. John says Derain is 'not a good natural draughtsman.'

Friday 20
Went over to our new big design room in the unfinished Bodleian building. We have to take the greatest care that the students do not drop paint or mess up the new floor. The lavatories are not finished yet, and the girls have to use the Sheldonian: the men, the King's Arms. Huskinson has done a design for the cover of the catalogue for the Ashmolean exhibition of paintings. He is lively, inventive, quick and free from vulgarity. Penrose Tennyson today was married to Nova Pilbeam in London, quietly. He is in the R.N.V.R....Hallam says she is a nice girl, not like the ordinary film star...They were not to have been married till she was a little older (she is 19), but in war conditions they changed their minds.

Saturday 21
...This is, for the moment, a whole-time war-time job. Albert has many vexatious questions of expenditure, big and little. University authorities, though obliging in most ways, present complications in an irregular situation like ours. I carried on with teaching all morning. Met Laurence Binyon in the Ashmolean...He has developed into a rather plump elderly man, with a kindly manner, and little of the more poetic appearance that he had when younger. He spoke of Gilbert Spencer in a very friendly way. They are neighbours in the country. Binyon referred sympathetically to Spencer's retirement from the R.C.A., with only six months' pay – like all the other staff, except Jowett.

Sunday 22
Set out for London to fetch some clothes...Train, as usual now, late...Called on Max Ayrton. Tony, who is very pessimistic about this war and future wars, has some hope of work in camouflage. He feels that the interruption may be fatal to his chances of development as an artist...

Monday 23
Dined in Hall, Keble, as [Leonard] Rice-Oxley's[4] guest...Saw a portrait by Henry Lamb, good: it was taken off the walls for security, but not yet stored. There are also portrait drawings and an engraving of the chapel by Dodd, and a drawing by Will R.

Tuesday 24
Spent sometime with students in the new Bodleian, still in an awful mess, with workmen

4 Tutor in English (1921-60).

all over the place. Introduced five students as readers to the Bodleian Library, and met Hassall there. He is a helpful young man. Albert R. started a small theatre class in the same room. Charlton and Gwynne-Jones came. Charlton, Daphne and Stanley Spencer are still at the White Hart, Leonard Stanley. Stan has sent two pictures from Tooth's to the Ashmolean show, one a big Pre-Raphaelite sort of landscape, the other a grotesque *Man & Wife*. The latter is not my line of country. Devas has sent a poor portrait. Coxon, Pasmore, Hitchens and Duncan Grant some very slight things. Slightness seems to be considered a virtue, and no clear line is drawn between slightness and emptiness. Kenneth Rowntree seems affected by the same creed.

Wednesday 25
G.J. and I dined at New College as Albert's guests. We took a taxi from Beaumont Street (which seemed rather unnecessary, as it is only 250 yards) and picked up Paul and Mrs. Nash from The Randolph, who had asked to be given a lift to the corner of Holywell Street...The Hall was adequately lighted with candles, but there is some trouble over it, and the lighting may have to be reduced or more 'blacking-out' done...

Thursday 26
Frankie Harrod describes George Moore as a hideous young man. He came to see her, when she, as a young woman, was living in a convent, at the time he was writing *Evelyn Innes* [1898]. He extracted some information about convent life from her, and gave it, she says, a nasty turn in the book, quite against the spirit of what she had told him. He chased her round the table of the room where they met, trying unsuccessfully to kiss her. She knew Will R. well, and doesn't like him now. She says that, not having seen him for years, she met him with a mutual friend in Campden Hill, and was re-introduced as 'Forbes-Robertson's[5] sister'. Will said: 'Who is Forbes-Robertson? Do I know him?' and this annoyed Frankie very much, particularly as she remembered the young Rothenstein pestering her, years before, to use her influence to get her famous brother to sit for him. It sounds...unlike Will to be guilty of a deliberate piece of rudeness...

Saturday 28
Tried to adjust the awkwardness, which has arisen between Muirhead and Stephen Bone on the one hand and Albert and Parker on the other, over framing the pictures at the Ashmolean. Albert, Parker and I understood that all the frames were to be painted a uniform grey. Stephen volunteered to do this...and Bobby Roberts was engaged as his assistant. The frames are now all the colours of the rainbow, especially those done by Roberts...Stephen does the job with taste, Roberts does not...Some of the worst examples will be repainted, and more uniformity achieved. I can foresee the fury of painters like Lowinsky and G.J. when they see (if they do) the high-handed treatment of the frames round their works...

Sunday 29 – Saturday 4 November: no diary entries

5 Actor and theatre manager.

NOVEMBER

Sunday 5
Lunch at Garsington. The President of Trinity, Weaver, drove me out at Lowinsky's request…the Lowinskys have given over a part of the servants' quarters to evacuated mothers and children…Lovely house and garden: Lady Ottoline did a great deal to the latter. I think she bought and placed the statuary round the pool.

Friday 10
Barnett Freedman came to the School to do his day's teaching…After tea, met Muirhead Bone in Broad Street looking for a figure to put in the foreground of his drawing of Beaumont Street. He wanted a girl in a scholar's gown: seeing one coming, he hastened across the street, following her closely, memorizing the gown…till she turned into Balliol gate. I thought she noticed him and seemed suspicious of his intentions. Later, after a walk round St. Ebbe's and the Castle, met Francis Dodd in Beaumont Street. He is in Oxford to draw a portrait of a year-old child…He does not like our Exhibition of Younger Painters at the Ashmolean very much; was just in the act of abusing Lowinsky's portrait, when Lowinsky, Ruth and Lawrence Haward[6] appeared on our doorstep…Eric Newton… Marriott and Jan Gordon have all come to Oxford to see our show. Haward is here for that purpose too. Muirhead Bone is touchingly proud of Stephen's new book on England from an artist's point of view.[7] He seems to carry it with him always, and showed me a review of it in *The Times Literary Supplement*…Dodd told us of his binding up Charles Gere's weekly letters to him and his intention to leave them to the British Museum.

Saturday 11
The Private View of our show of Young Painters was very well attended… W.M. Rothenstein and Duffy[8] apparently had an open row with Stan. Spencer and the Charltons in the pub. at Leonard Stanley, and they packed up their bags the same day and left the place…The ostensible cause was an ill-timed remark of Stanley's about W.M. reading the newspaper at breakfast, but I suspect deeper reasons, between Duffy and Daphne. Charlton says Spencer spends a great deal of time writing a book of some sort, presumably about himself.

Sunday 12
Lunch with the Vice Chancellor and Mrs. Gordon, Magdalen. Present: the Bishop of Truro, Miss Stocks (Head of Westfield College), an American Professor, and two or three other people, including the pretty Miss Gordon, who used to be at the Ruskin School. Bill Coldstream, whom Kenneth Clark thinks such a lot of (and deservedly in some respects), is painting a portrait of her father: he has a good head, like one of David Octavius Hill's photographs, a resemblance helped by his white official band round his neck…

Monday 13
…About 8.30a.m. Dodd came in, having finished today his drawing of the baby…Stories of the taxidermist who set up Briton Riviere's[9] lions to paint from, and birds for other

6 Curator Manchester Art Gallery (1914-45).
7 *Albion: An Artist's Britain* was illustrated with his landscapes.
8 Michael Rothenstein's first wife, the artist, Betty Fitzgerald's nickname was 'Duffy'. She later married designer and teacher Eric Ayers.
9 *Daniel in the Lion's Den* (1872).

Academy artists: stories of Manzi the model and [Frederic] Leighton (*Married Love*) – how that picture was a failure, and would hardly sell, and then, finally, the Fine Arts Society stopped the picture on its way to Australia, paid Leighton £250 for the reproduction rights, and netted £10,000 from the Goupil photogravures. Abuse of Stanley Spencer, for his monstrous behaviour in Muirhead Bone's house [Note in margin see Monday, Nov. 20], for which he was quietly but firmly sent away from Petersfield. Epstein, we were told, has had thousands from Bone. Theories that Frith, having learned something about composition from Sass, based his *Derby Day* [1856-58] on *The School of Athens*. Dodd liked my drawing of Randall Davies at the N.E.A.C., and said, looking at a drawing of Cerne over the fireplace here, 'How like an ash tree that is – it couldn't be anything but an ash tree'. Compliments from Dodd are fairly rare, so I remembered these.

Tuesday 14
G.J. to tea. Pleased at the references to himself in Will R.'s new book. Tommy Lowinsky said to him – 'You and I come out far the best'...

Wednesday 15
Lunch at The Randolph, with Alic Smith of New College, a Ruskin Trustee, and with Albert R., to discuss the finance of the School. The University of Oxford is charging a capitation fee of £4-0-0 per student per term, which we think too much for what we get (about £600 a year might go to Oxford University). Met Mrs. Robin Darwin and John Nash visiting the Younger Painters exhibition (separately). John Nash is an anti-aircraft observer, 30/- a week. He has observed one German plane over England, at 20,000 ft. When the R.C.A. re-opens, the 30/- will be deducted from his normal salary. Trouble with Paul Nash, who is to do an article on the show in *The Listener*, and wants, for foolish reasons not unconnected with propaganda for Sur-Réalisme and Paul Nash, to reproduce Ithell Colquhoun's *Anchor*, a sur-réalist 'machine', as the feature of the show. We nearly threw it out when hanging. Albert squashed this plan and got Nash to agree to reproduce Fitton's *Eve* instead.

Thursday 16
H. M. Bateman came to see me, from Curridge, near Newbury, to ask advice about his painting. He might have developed into a good painter instead of a caricaturist, and does some pleasant things now, but does not seem able to carry them very far. When young, he had lessons from an Antwerp painter, who seems to have taught him little about tone and values. I suggested some private coaching from G.J., who teaches at Reading now one day a week...I took him into no. 7 Beaumont Street afterwards to show him some drawings of my own, and to compare notes, as we had been drawing similar subjects during the summer – barns, farm wagons...He is an able draughtsman, apart from carica-ture. Birdie was very favourably impressed by his personality and manners; not knowing that he was the celebrated Bateman...

Friday 17
Left Oxford for Birmingham, to make a drawing, commissioned by the Cadbury firm, of Arthur Hackett, lately, before his retirement, their chief engineer. They have other drawings of retired members of their staff. Henry Payne has hitherto been their artist...

Saturday 18
Went over to Bournville in the car, to see the Henry Payne drawings, so that mine might range with them in size and style. They are hung in the Staff dining room…The huge chocolate industry seems to be doing very well in war-time. Plenty of captive balloons about − A.R.P.…In the afternoon, a football match, the first I ever saw on a big scale (Birmingham v. W. Bromwich Albion, played at the Hawthorns)…There were about 10,000 people present. In normal times there might be 60,000…

Sunday 19
Did a second drawing of Arthur Hackett…A short walk with Hackett before lunch… Camouflaged 'Triplex' factory, very effectively done…

Monday 20
Charlton to supper. He had been puzzled and concerned last week by Dodd's denunciation of Stanley Spencer. His own experience, over a considerable time including close relations for some months at Leonard Stanley, leads him to think that Spencer is upright, honest and well behaved (by the way, how does this square with the Rothenstein theory of a carnal 'affair' with Daphne? − if Charlton is so much in Spencer's favour). On his return to Gloucestershire he told Spencer what Dodd had said. Stanley took it calmly, said he had heard these stories before, and that there was nothing in them. He was not indigent when he went to Petersfield, but was selling his pictures steadily; he was previously staying with his friend, Schlesser (now Lord Schlesser) and left merely because Muirhead B. asked him to give Stephen drawing lessons for £25 a term, and held out hopes of a decorative commission for £250, which subsequently fell through because Bone failed to raise the money: these were ordinary business arrangements, and he does not feel that he owes Bone any special gratitude for them. The only colour for the story of his reading Mrs. Bone's letters was that he did casually see a postcard turned face up on the place where letters were usually put, and read it, thinking it might be for himself: it was from the Sturge Moores, asking Mr. & Mrs. Bone to lunch, and asking them to bring Stanley with them. The Bones went, but did not take Stanley. Later, when S. Moore asked Stanley why he hadn't come, he said he wasn't asked: then he told Bone he had seen the postcard, and that started the row. Anyhow, Bone and he didn't get on. Bone, Stanley says, was too 'bossy'. So here we have two entirely different versions of a scandal. Dodd, of course, speaks in perfect good faith.

Tuesday 21
Bone asked Albert and me if we could suggest anyone for the job of official war artist: he is going up to London for a committee meeting on this matter, to which Kenneth Clark and Jowett are also going. Albert suggested Freedman and Rowntree. I suggested Norman Janes. Kennington is already in Bone's mind, and Bone himself is booked by the Admiralty…Huskinson…says that, as a result of Paul Nash's activities, the Government may employ 1500 artists…Met Enid Marx, who asked me to go into her rooms, 98 Holywell Street, tomorrow night, but I couldn't. Albert says she is a Lesbian. I neither know nor care if there is any truth in this.

Sunday 26
…Sherry with 'Colonel' Kolkhorst[10] the Professor of Spanish Literature and Squire of Yarnton: an Elizabethan manor-house with a long gallery, but much remodeled in parts…'The Colonel' is a specialist in roses and erotic literature. An amusing man.

Monday 27
H.A.L. Fisher called in at the Ashmolean to see Albert, having visited the exhibition of Younger Painters…

Wednesday 29
Lunch with Albert and Miss Burrill at The George. She is of Dutch extraction. Her mother suffered the horrors of the Boer women's concentration camps when young, for a year. G.J. to supper. He credits himself with the idea of getting a Civil List pension for Walter Bayes, but actually Betts spoke to me of this months ago…Betts is going to try the necessary advances to the P.M.'s Secretary, backed, he hopes, by Will Rothenstein.

DECEMBER

Friday 1
Cadbury paid me for two drawings of Mr. Hackett, at the rate of £16-16-0 each.

Sunday 3
First meeting with Nova Pilbeam. We all three went to tea to meet her, in Hallam's rooms. Charles T. was there too, and a Balliol don named Roger Mynors, who has just bought Stanley Spencer's *Man and Wife* from the Ashmolean exhibition for 60 gns: he is a special friend of Pen's. His reasons for buying that particular Spencer seemed to me obscure, or at least to have little to do with true appreciation of painting. However, I am quite glad that anyone can be found just now to pay so much for a living artist's picture…

Tuesday 5
Went up to Headington Hill, Pullen's Lane, by taxi, in the sleet, to begin a portrait drawing of old Mr. [William] Hume-Rothery.[11] Albert got me this commission. I am to get £12-12-0. Progress slow, as he did not sit very well, and I had to wait for longish intervals to see the sort of view of him that I wanted to see…Birdie and I went next door to the Playhouse to see Nova Pilbeam in *Twelfth Night*. She is the star, but it was not a remarkable performance. Rosalie Crutchley as Olivia was the better actress.

Wednesday 6
Paid K.T. Parker £1-10-0, my subscription to the purchase of Gilbert Spencer's picture [*Cottage Garden at Compton Abbas*] for the Ashmolean collection. The Contemp. Art Society are giving 25 gns., and we have asked him to reduce his price of 60 gns. to 45, which…he agreed to do. He will thereby get about as much as if he sold the picture through a dealer and paid commission. Parker has to raise the balance of 25 gns. Albert R., Thomas Lowinsky, Bone and others will make it up…

10 George Alfred Kolkhorst was a Member Exeter College, University of Oxford, known as 'the Colonel' because, according to John Betjeman, he was so little like one.
11 Chemist and founder of scientific metallurgy.

Thursday 7
Went to London for a committee at the Athenaeum, at MacColl's insistent request. Travelled up with Mrs. Douie. Douie is now in the Ministry of Information…At the Club…The mirrors in the drawing room have been boarded over…I signed for David Low, who is up for election. His sheet has more signatures than any I have ever seen…

Sunday 10
…G.A.E. Schwabe sent me Mrs. Strang's book on the South of France, with Ian's drawings, for a Christmas present. I wish I liked the drawings more than I do. I look hard at them and they do evoke the country successfully, and I respect their hard-working honesty and craftsmanship; but I see faults – some rather mechanical quality, and a black uniformity in the shadows. This is not professional jealousy.

Monday 11
…finished the drawing of Hume-Rothery…They seem genuinely pleased with the likeness, and even the little girl of five…recognized her grandfather…

Tuesday 12
Charlton says that Stanley Spencer has painted an interior of a village wool-shop, with a figure in it that is based on Daphne. Stanley also continues his mysterious writings… Birdie and I went to *Arms & The Man* at The Playhouse, with Ena Burrill in it, who looked very well and acted well. Nevertheless she has been given a week's notice in a curt letter which said that the public liked to see new faces…

Wednesday 13
Went with [Edward] Scott-Snell to see his work, in his room at Radley College…I think I was very wrong in my judgment…when he was a student at the Slade…his drawings in the Beardsley style struck me as poor. He seems, on better acquaintance, to have a good deal of an artist in him, and is not…totally unfitted for the job of art-master in a public school. He is certainly a little precious, but I find myself in sympathy with many of his ideas, and I admire the way he goes on persistently developing his sense of rhythmic design. He is soaked in William Morris, Walter Crane, Kate Greenaway and the artists and poets of that period…also he really has something that he is trying to express. He could illustrate a book well, if it appealed to his rather special taste…

Thursday 14
…Dance at The Randolph…178 people…Among the company, a Lowinsky party, the Michael Holroyds, Ena Burrill and Enid Marx. Also Polunin of New College, and his wife, Grace Lovat Fraser's daughter. Some very good fancy dresses…

Friday 15
…Everyone is pleased about the naval affair of the *Graf von Spee.*[12]

Saturday 16
…train to Birmingham, to draw Miss Catnach for Cadbury's. Crowds of R.E's and A.T.S.'s going on leave.…

12 In the Battle of the River Plate she was hit by seventeen shells, shortly after scuttled by her Captain Langsdorff, who three days later shot himself.

Monday 18
Miss Catnach…Drew her more full-face. She is the first woman to be thus immortalized for the Cadbury firm…Train to Oxford.

Friday 22
Left the house in Beaumont Street…Trains all late. Arrived Peasenhall…

Saturday 23
Pen and Nova joined the party, and Charles Harold came the following day. The house being full, I slept at The Swan on the other side of the village street. Julian is away in the army…Harold has a job too, with some ministry. Pen is concocting a semi-official film, and is to go to sea on a cruiser in a week or two to get 'atmosphere' with a convoy.

Thursday 28
Travelled to Cerne Abbas from Peasenhall.

1940

A bitterly cold winter with blizzards; the year is also marked by gloomy war news including the fall of Antwerp in May. In the same month Slade students Paul Feiler and Pringsheim are interned. The summer brings some good news with former Slade student Harry 'Bish' Barnes announcing his engagement to Schwabe's daughter Alice, and Bill, his brother, returns from China. The art market is suffering and some commercial galleries have closed. Troops 'muddy and bloody' are evacuated from Dunkirk. Italy declares war on Britain and France, the Blitz begins on 7 September and London is subject to 57 days of relentless bombing. Coventry also suffers and John Piper and Schwabe are sent by the W.A.A.C. to record the Cathedral ruins.

JANUARY

Starts Monday 8
Returned to Oxford from Cerne...

Tuesday 9
Looked in at the School and answered letters...Albert in London for Humbert Wolfe's funeral...After lunch...start[ed] a drawing in St. Helen's Passage...

Wednesday 10
Elton at the School. He has put his name down for some sort of military service. Gerrard has got a job...in the R.E.s, after lying about his age and making himself out to be younger than he is. He goes to France next week...After lunch Bysshe Barnes drove us to Minster Lovell and Burford...The 50th Division is in and around Burford, and leaves for France shortly; 3000 army lorries are said to be on the road, passing through.

Saturday 13
...Saw the new cast of Eric Kennington's Lawrence tomb in the Ashmolean. I think it is the best piece of sculpture that I have seen of Kennington's, and it has fine qualities...

Sunday 14
...Skating in Worcester garden, on Port Meadow and at Blenheim...

Monday 15 – Friday 26: no diary entries

Sunday 28
Bysshe Barnes showed me A.J. Munnings's cheerful *Garrick Club* – pothouse letter in the *New Statesman*, about Clive Bell. I enjoyed his high spirits, and think that Clive Bell deserves that someone should be rude to him. He has been rude enough to a number of artists. Anyhow, Munnings can paint a good landscape, a fact of which C.B. is probably not aware. His (C.B.'s) superior attitude to certain forms of painting (of which matter, I think, he has little real knowledge) resembles that of H. Walpole sneering at Hogarth.

Monday 29
Charlton arrived in Oxford at 4 o'c. having left Gloucestershire early in the morning. His train took two hours to cover 18 miles, because of the snow and frost. Signalling was done verbally and by hand. Albert was unable to drive his own car in from Combe, and gave up the idea of taking up his quarters to-day with the Huskinsons, because of the difficulties of the roads. Instead he got a carrier to bring him in a heavy lorry, and took up his quarters at The Randolph. The heating system has broken down there. Charlton describes a curious blizzard in Glos. on Saturday, blades of grass being converted into spikes of ice. There are more students in the Slade than there were last term. I spend the short-pose hour from 3-4, if I have the time free, in drawing from the model. There are two fine figure models, Miss Duval, who has the head of a Watteau on the torso of a Greek Venus, and Miss Yeaxley, the Don's daughter. Charlton had supper with us, and Albert came in after dining in New College; very cheerful, in spite of a depressing conversation with a Polish gentleman about the horrors of his country and the ruthless extermination of its most valuable inhabitants by the Nazis.

FEBRUARY

Tuesday 6
G.J. described the difficulties besetting the copying of Gerald Kelly's royal portraits. He and Rosie [Rosemary] have started the copies, according to instructions, before the originals are actually finished, and as the temperamental Kelly changes his pictures so the copies have to be changed too. The work is most minute. Details of ornament are introduced on a scale, and in a fashion that could not possibly be seen at the distance necessary to see a whole-length figure. Kelly takes a pair of calipers, and if he finds that one minute high-light is a thirty-second of an inch nearer or farther from its context on a piece of jewellery than it should be, it must be corrected. No chalk-marks or visible measurements must be made on his canvas, but threads may be stretched across. He contradicts himself, also, from one day to the next, and needs a good deal of management generally. He has an assistant who sets out the architecture for him, most accurately.

Thursday 8
Letter to Prime Minister, in reply to enquiry from secretary about Walter Bayes & his proposed Civil List pension. Gave grounds for his having it. Kenneth Clark is backing this, too.

Friday 9
Went to London. Collected some pictures for a show in Newcastle from 20 Church Row...Met Albert R. for tea at the Athenaeum, and went on to Huskinson's show at the Calmann Gallery in St. James's Place. Calmann is a German Jew. Met Basil Fielding, Violet Bonham Carter, [John] Bryson, Athene Seyler, Nich. [Nicholas] Hannen, Madan, Freedman, Patricia Koring the model, and others. Albert has organized a subscription to buy one of H.'s drawings, a nude for the Ashmolean...The drawing is £7-7-0. Train home, 7.40-9.45: full of soldiers, back from France on leave, and sailors. One of the latter was going out to join the *Ark Royal.* The troops came home on the *St. Helier* to Southampton.

Saturday 10
Began a drawing in Pembroke Street…It has begun to freeze again…

Monday 12
Charlton says that Stanley Spencer is very enpeptic and requires no exercise; consequently, in the winter, he practically never goes out, and hardly stirs from the fire. He has been for short walks once or twice with Daphne and George, but seems little interested in winter landscape. Renewed accounts of the great blizzard. Even pine trees have perished under the weight of ice, cracked off close to the ground…Stories of robins sheathed in ice, dead, on a branch.

Friday 16
…Met Bloomfield, the cosmopolitan artist. He seems to be living with the Beazleys. He knew Vollard very well in Paris round about 1906, and saw a great deal of Cézanne's paintings then, as they passed through Vollard's hands, who was careful to have them all re-lined. Eric Kennington came in to see me, with a young Canadian artist named Slade, who has little if any money, and wants to come to the School. He has been serving as a gunner on a trawler. He is 18 years of age, and a fine-looking fellow. I told K. that I liked his Lawrence tomb. When I related an anecdote out of László's life – his surprising energy and vitality in rushing off to Buckingham Palace, on a sudden call, and painting a successful portrait of one of the Princesses, after a most exhausting morning showing King Ed. VII and everybody in London round his Private View – Kennington said he was not a bit surprised at that, as he could have done it himself: he said he should have printed on his visiting card that he was guaranteed to do portraits of anybody under any conditions whatever. He told me again of the Canadian General (not Currie) who went for him with the boxing gloves after a dispute about his portrait, which he wanted K. to alter. K. firmly refused, and, I suppose, got a licking. Met Paul and Bunty Nash in Alden's shop. Took occasion to congratulate Paul on the election of his brother John to the ranks of the R.A. It was in the papers this morning, with the news of Augustus John's return to the fold, and Arnold Mason's Associateship. Paul had not heard of all this, and seemed doubtful whether it was a good thing in John Nash's case.

Saturday 17
Visits from Albert and Huskinson. H.'s show has not been a flat failure – about 8 drawings are sold…one to the Contemporary Art Society…Barnett Freedman, Huskinson reports, made some unfavourable comments on the nudes – 'Like dirty picture-postcards, only worse, because they were rather well drawn.' I don't see the justice of this. Kapp, the caricaturist, seems to have been abusive too. Tommy Lowinsky told me the other day that a young friend of his and Ruth's, Rebecca West's daughter, who was staying with them, was equally uncomplimentary about Albert's drawings at Garsington, which she said were 'vulgar'. I thought that was decidedly the wrong adjective to apply to Albert.…

Wednesday 21
7p.m. Gwynne-Jones and Albert went to hear Lord David Cecil talk to the Slade Society. He and his wife stayed and danced with the students afterwards…

Thursday 22
Visited the Union Library for the first time with Albert and saw the wall paintings by Rossetti, Burne-Jones…made visible to some extent by Tristram's restorations…Went, also with Albert, to see Celia Dennis, the model, in her little bed-sitting room off Walton Street, to discuss compensating her for her broken arm that she is suffering from after a fall in the School. The School will pay her £12 beyond her pay for 3 weeks. She was Mark Gertler's model, and…was mixed up in some way with the inquest after his death. A pretty, affected creature…

Friday 23
7.30 Meeting at The Randolph with Parker, Madan and Albert to discuss another show at the Ashmolean in May of draughtsmen. Albert and I had produced a tentative list of people to be invited. We shall show our own work this time…[Parker's] idea for his own show is to make money out of the sale of catalogues and use this to buy drawings for the Ashmolean, thus benefiting the artists as well as the Museum. 1500 catalogues have been sold in the recent exhibition. Albert will do a drawing to decorate the catalogue cover…Miss Cadbury paid for the two drawings of Miss Catnach – 32 gns.

Saturday 24
School till 1 o'c.…Met Stephen and Gavin Bone. Stephen is doing some form of camouflage job. Muirhead B., Stephen says, was busy yesterday doing an official drawing of the men of *Exeter* and *Ajax* marching to Guildhall, in London.

Sunday 25
…Read Ld. Alfred Douglas's latest book on Oscar Wilde, easy to get through in an hour or two. I was amused at the description of O.W. throwing men out of his rooms when they tried to rag him at Magdalen. Douglas thinks Wilde better than Yeats as a poet. I recall that Yeats told me that Wilde was not, in Yeats's young days, taken very seriously as a writer, but admired as a talker.

Monday 26
Alice did her first day of her week's Red Cross work in the Radcliffe Infirmary: 9 hours of it, including casualty ward work…

Tuesday 28
G.J. has now met the King at Windsor. He likes H.M.'s easy manners, and above all his healthy, well-conditioned appearance. No trace of a stammer in his conversation. Madan took Patricia Koring, the model (whom he met at Huskinson's show), out to the theatre and supper. Rather a sporting venture for an ex-Indian judge. I think Albert was a little jealous. Not that there is anything in it, really. She is going down to Stanton Harcourt on Saturday and Sunday to sit for Albert and Huskinson…

Friday 29
Freedman, at the School…He is awaiting his instructions, Albert says, to go to France with Bawden and Ardizzone as an official artist. Albert took two students over to The Playhouse to do a little practical work with Anthony Holland, the scenic artist.

MARCH

Friday 1
Anthony Betts came to see me at the School, about a Reading University Exam. Paper.
Left him with Albert in The Randolph, in order to lunch with Miss Grier[1] at Lady
Margaret. Mrs. Behrend, Louis B. and their son were there, and some Viennese refugees...
Mrs. Behrend thinks Patricia Preece a poisonous woman: she had her to stay in her house,
thinking it better to be unprejudiced about Stanley's affairs. She doesn't like Hilda much
either, and, when I said that Dick Carline was a bore, she said 'Yes, and a bounder too!'
She and Jean Inglis were art students together. They drove me back to St. Giles'...Miss
Grier has a fine drawing of Stanley Spencer's, in pencil, of one of his nieces: a masterly
and most sympathetic study. Her two Christopher Woods gave me a better opinion of
that artist...She has things by Morland Lewis...and others. She says Kenneth Clark
remarked that M. Lewis 'has no more brains than a hammer'. She has an early small
landscape by Stanley, of which Gil. said to her 'Well, he must have been a cuckoo when
he painted that'...

Sunday 3
Finished drawing in Pembroke Street – some 4½-5 hours, morning and afternoon...

Monday 4
...Priestley is putting on a new play, a 'world premiere' tonight at The Playhouse. Mrs.
Priestley is working in the School...

Tuesday 5
G.J. criticized the few Slade summer pictures that have reached us. We could not give a
first prize, as the consignment was so incomplete, but Angela Baynes, Tony Baynes and
Bartlett got £10 apiece, and Trice Martin and Irene Williams £5...

Wednesday 6
Gwynne-Jones gave his lecture on 'Realism and Naturalism in Modern Art', to the Slade
students and a few others, in the Ashmolean. He told me that he had had a commission
to illustrate Dickens' *Christmas Books*, but that it came to nothing. I suspect that the
publisher didn't like the drawings that G.J. did, though he says the contrary. I cannot
see him as an illustrator, particularly of Dickens. He has little pictorial imagination, and
little, if any, of the Dickensian humour, and his drawing, out of his head, is far from
satisfactory. Which reminds me that Miss Aronson, a Slade student, presented me with
a miniature edition of Menzel's [1877] *Zerbrochene Krug* [*The Broken Jug*]. This is real
illustration. Even the reduced reproductions show how masterly the drawings are. They
should take the conceit out of anybody.

Friday 8
Went to London...In the street, quite by chance, met, first, Charlton Bradshaw, then
Pevsner, then MacColl. Pevsner was working with Gordon Russell, but the business seems
to have gone down very much since the war began. He tried to let his house through
Potters in Hampstead, but Potters said they had a hundred houses on their hands and

1 Ruskin Trustee.

only three inquiries. Charlton Bradshaw[2] is living with his wife in a desolate house without servants. MacColl has a wild scheme for amalgamating the N.E.A.C. and the R.B.A.. Lunch at the Club, after calling on Mrs. Beaumont. She and her husband have given up their flat and are living in an hotel. They could not stand the deserted streets where they lived, enlivened only by notices – 'To the Trenches'. They shut the shop, too…[as] there is no business now. With MacColl, before lunch, met the young artist Scarfe, who has done the decorations based on a Greek vase-painting, for the drawing-room of the Club: a good workman, and intelligent. Met…Haward…[who] is a great admirer of the set of illustrations to *Wuthering Heights* by Edna Clarke Hall, presented to his [Manchester] Gallery by Michel Salaman…New English Meeting (Executive). Fully attended – Jowett (Chair), Ronald Gray, Wilkie, Shepherd, Clause, Cundall, Maresco Pearce, Ethelbert White, Chisman.

Saturday 9
…Wrote to Priestley, asking him to come to the Slade Dinner and make a speech…Alick Schepeler came to lunch…from Hunton Bridge, where *The Illustrated London News* is evacuated…[she] says…[they] may move back to St. Bride St. shortly. She is sorry – she likes the country, and the change, and the communal life with the staff in the quarters, where they are all housed, seems to have given her a new lease of life. She must be about 60. I saw a drawing of her by John at Agnew's yesterday, done about 1905…Birdie is reading Gen. Spear's *Prelude to Victory*,[3] and I read a bit…disillusioning and by no means exhilarating stuff, but just what one should be told (and usually isn't) about War.

Wednesday 13
…Richard Naish, a good-looking young man, who is going to do some teaching in the School next term in place of Freedman, came in…

Thursday 14
Leeds, of the Ashmolean, got in a violent passion with Bennison, one of our men, for whistling in the galleries, and ordered him out of the building for the day. Later, I observed that Bennison was still there. The hall porter is used to these explosions, and is very philosophic about them, taking little notice…

Friday 15
George and Daphne Charlton, and Evan Charlton and his wife, came to tea. They have all come to Oxford especially for the Slade Dinner…at New College…Very good speeches from Albert, Priestley, Huskinson and Smith…

Saturday 16
Mrs. Priestley says that they have sold out some investments and are using the money to buy drawings. She offered to help good students of the necessitous kind in that way…

Monday 18
…Examiner's Meeting at…the Imperial Institute at S. Kensington…Lunch at Roche's

2 Architect, recipient the first Rome scholarship in Architecture (1913), first Secretary of The Royal Fine Art Commission.
3 Published 1939 on the Nivelle Offensive of 1917 on the Western Front.

with Birdie and Alice, who had been doing some shopping, and Donald Towner, who looks very well on his country life at S. Harting. He is staying in Church Row for a few days. Train 3.15 to Dover.

Tuesday 19
Applied for permit to 'sketch', Dover town being a restricted military and naval area...

Saturday 23
...Minesweepers lying in Granville Dock, with depth charges all along the gunwale, inscribed 'Kiss me, Adolf' – 'An Easter Egg for Addie'...Each ship has a gun mounted forward...Rosalind Ord came to lunch. She is doing canteen work at Marlborough. Her crew sometimes serve 3000 cups of tea in a four-hour shift. The troops steal a good deal if precautions are not taken...Rosalind's tile business is still going on, and she is busy with that, too.

Thursday 28 – Wednesday 3 April: no diary entries

APRIL

Thursday 4
To Ringwould, meaning to do a distant prospect, but the north-east wind howled round the corner of the hedge by which I sat, so that...my portfolio blew about: so I gave it up, found a sheltered corner of the village and drew that instead...

Friday 5 – Thursday 11: no diary entries

Friday 12
Left Dover. Attended a New English meeting (Executive), chiefly about Kenneth Clark's show of pictures at the National Gallery, which has occasioned a lot of talk. Ethelbert White wrote to Clark to know why he was left out, and got a reply from Gibson to say that the omission was 'not unintentional'. Will Rothenstein isn't in it either, except for a small old drawing that was lent by Steer. Dodd is omitted and a lot of us. I don't see the use of making a fuss about it, but the Executive decided to write a mild protest to K. Clark. It is said that a woman called Miss [Lillian] Browse, who works in some Gallery, was responsible for choosing most of the pictures, from private collections such as Eddie Marsh's and Louis Behrend's. This has given rise to a supposition that Clark is in league with the dealers...He was doing his best to stimulate an interest in art in war-time, and, being called away to the Ministry of Information, had to leave the arrangements to Gibson, who does not know much about such things. At least that is how I look at it... Spent the night with Willie and Lucy Clause in Hampstead. I grew rather worried when Willie told me the state of his finances...The Bank has taken the house as security for a £900 overdraft...and now he has lost his job at Blackheath, as part-time art teachers have nearly all been axed by the L.C.C.

Saturday 13
Went with Clause to see the show at the Nat. Gallery...It is a very interesting collection... Lots of artists such as Gwen John, Gilman, Gore and Innes could have been better repre-

sented…met Will Rothenstein there…He is very sore about his own treatment. After-wards we all three went on to a show of Claude Rogers's painting at the Leicester Galleries – good, and a great advance…

Sunday 14
Francis Dodd came down from London and lunched with us. He brought with him a large parcel of his excellent domestic scenes in charcoal, for selection – three are wanted for the show of drawings at the Ashmolean…Dodd talked most interestingly about his experiences with the Navy in the last War. He is doing the inside of an arms factory at Enfield, as official artist, now. He went off to see his sister at Ferry Hinksey, and I walked with him as far as Hinksey Church, along the road that Ruskin made…

Monday 22
Slade began…K.T. Parker is a little annoyed by Duncan Grant's behaviour – he…has now sent two trifling and indifferent drawings to the Ashmolean show, one with a hole in the middle, unmounted and untidy…It is as if D.G. thought anything he does is good enough to us or for the public…

Saturday 27
Huskinson came into the School with [Feliks] Topolski, the Polish draughtsman, and the lady who shares his life, a very prettily made-up tall girl, half Irish, in corduroy trousers, with a blue cotton handkerchief on her head. They are staying at Stanton…6.00 Met the Lowinskys, with Victor Stiebel, the well-known dress designer, who is staying with them. A very pleasant fellow, educated at Cambridge. They all came in to no. 7 Beaumont Street…He has lent some of his best drawings to an exhibition in aid of the Finns…at the Michael Holroyds…

Sunday 28
…Charles Kennedy unexpectedly came in to see us. He is up at Balliol…George [Kennedy] has given up architecture for the time being, as there is nothing to do. He has taken on a schoolmaster's job in Scotland.

Monday 29
Tea with Walter Douglas and young [Lawrence] Toynbee…Saw Toynbee's work, very hopeful for a schoolboy, and a picture of Douglas's, an Annunciation, imaginative and sensitive, but not well drawn. Albert had come too, and he and I sat down and made scribbles of how the drawing ought to go…

MAY

Wednesday 1
…Tommy Lowinsky unreasonably ratty with Albert about not being included in the present show of drawings at the Ashmolean. After all, he has never exhibited a drawing in his life, and there are none of the book-illustration kind included in the present collec-tion, except perhaps [David] Low's and [Felix] Topolski's, and they are not in any way different from drawings not done for reproduction…

Thursday 2
Lunch at The Randolph, with Albert R., [George] Nuttall-Smith, the architect, and a Mrs. Arnold, a clever American interior decorator, very much a woman of business, who wanted to do something in connection with the Slade-Ruskin School; lecturing, on a sort of profit-sharing basis. I don't know whether anything will come of it. Certainly she could not be officially appointed. Borenius came and did his Exam. in the Hist. of Art...

Saturday 4
Left Oxford 3.30 for London...Dinner with the Ayrtons. Tony is in France, with his camouflage unit. He has his picture of Donald Towner hung in the R.A.. Clause has two paintings there, and Hagedorn is in too.

Monday 6
...R.W.S. Jury for the outsiders' show at Conduit St....MacColl, Clausen, Russell, Flint, Eth. White, Jowett, Moira, Laura Knight, Cecil Hunt...D.S.M. went off to rest, but the rest of us, including Clausen (aged 88 or 89) went on judging the 1700 pictures sent in, and finished before 5 o'c.. Train to Oxford...

Tuesday 7
After School, went with Charlton to a show of the students' work, got up by themselves, in a shed, up a wooden ladder, in New Inn Yard off St. Aldates. Some good work. How many of these people, I wonder, will one ever hear of after they leave the School? Vera Leslie, Miss Fisher, [Cecil] Riley, [Paul] Feiler, Tony Baynes, Brayshaw and the rest. Installed a wireless for the first time in our lives, at no. 7 Beaumont Street, on the hire system. Chamberlain's speech on the Norway situation, at 6p.m. It is apparently quite true that Bobby Roberts, having been commissioned to draw generals in France, got as far as Dover and turned tail at the quayside. Funk, I suppose. It is the second time he has done something of the sort. Jowett, yesterday, was very annoyed about it.

Wednesday 8
Lowinsky has made his peace with Albert...The Private View was to-day...Paul Nash was there in Air Force uniform as official artist. He had so many badges on him that people supposed he had designed his uniform himself. Parker has bought one of my drawings (*Sisteron, Provence*) and one of Albert's for the Museum...

Thursday 9
...Eric telegraphed from London that he is arriving in Oxford tomorrow. Did not know he was in England – he has not written from China for about a year.

Friday 10
Eric arrived...[he] came by Cunard, unconvoyed, from New York to Liverpool.

Tuesday 14
In The Randolph, with Albert, saw General Carton de Wiart, a distinguished-looking man with a patch over one eye and a great many ribbons on his tunic, being introduced, apparently, to a new Staff. He is recently home from the Norway campaign. 'Uncle Bill' went up to London to meet Fairbairn, and to go with him to the War Office to be inter-

viewed…something more serious than the volunteer anti-parachute defence force which is now being formed…

Friday 17
Went to the Playhouse. *The Two Bouquets*, by Eleanor and Herbert Farjeon. Scenery good, by Anthony Holland. We can still be amused, in spite of war news, which is most depressing...

Sunday 19
Antwerp has gone now. Bish Barnes came, and drove Bill and Alice and me to Abingdon…Saw the town hall, the church and the almshouses. A very fine day…bathing and boating on the river, and everything looking as happy as if the aeroplanes overhead were peaceful civilian instruments, and all was well with the world. Winston Churchill's speech on the wireless at 9p.m. was sufficient to destroy any ideas of that kind…

Tuesday 21
Hallam [Tennyson] going about, according to Lowinsky, saying 'We ought to capitulate'…The undergraduates, he says, have been told by the Master to dig trenches in Balliol. Meanwhile, University College, London, decides in principle to return to London in October – without the Slade School. Uncle Bill went up to the War Office again. They apparently offered him and Fairbairn some job which they did not see fit to take; but it is under a veil of secrecy.

Saturday 25
Alice and Miss [Maud] Manners went off to see the Eights.[4] It seems…rather a poor show in war-time. Board of Education Examination Papers fill my time – 119…

Monday 27
Will Rothenstein came as visitor to the Ruskin-Slade School…went round the show of drawings in the Museum…W.R. bought, for the Carlisle Museum, a drawing by Willie Clause (cheap, £4-4-0) and my drawing of *Pembroke Street*, at the reduced price of £10-10-0. He had a story which is current about Augustus John painting the Queen: she saying to him – 'Now, Mr. John, I always have a whiskey and soda at this time in the morning, and I hope that you will join me'. This, of course, is an apocryphal example of supreme royal tact. Further story about John's portrait of the Queen, colporté by Bill Adams on Wednesday – Some indiscreet person asking John how long he would be engaged on the portrait, John replies gruffly, 'Oh, for the duration'. Plain-clothes policemen came to the School in the afternoon and took away Pringsheim and Paul Feiler to be interned.[5] The police were very civil, but it was unpleasant, and I was very sorry for the two men. It has to be done, I suppose…

Wednesday 29
…Went to London to see about the Diploma students in sculpture, whose work is still at the Slade. Met Ledward and Meldrum…at the Slade…Kensington Gardens was still fairly full of children, and air-raid shelters are still being built at Lancaster Gate and

4 Eights Week, University of Oxford's annual intercollegiate rowing competition on the Isis.
5 They were interned in various camps in Canada.

elsewhere. Ledward, after examining the students' work, took me to the Chelsea Arts Club...Took Bill Adams to the Athenaeum for a drink. Dined there. Met Lloyd of *Punch*. Listened in to the 9 o'c. news, in hopes that Gort's army might have made a get-away... Everyone is intensely worried about the War. The little success at Narvik comes as a small consolation for events in Flanders.

Friday 31
...7.40 train from Paddington, where I saw a number of B.E.F. returned from Dunkirk, in very good trim and spirits – perhaps they had been issued with new uniforms – it seems that Uncle Bill and Fairbairn have been found a job by the War Office...I don't know yet what the work is to be...

JUNE

Saturday 1
Albert has been faced with trouble in the School yesterday. There was a party at which one of the models was made drunk (on Thursday night) and was too ill to sit on Friday; also, Huskinson told me, a student broke his arm. Elton is calm about it, being...more interested in joining the anti-parachute volunteers. Bawden is back from France or Belgium, and Ravilious from Norway; so I hear from John Rothenstein, who came to the Ashmolean this morning. I walked round the show of drawings with him, and pointed out the merits of some artists such as Willie Clause, [Charles J.] Bathurst and [E.] Heber Thompson, with whom he was not familiar. He likes Horton's work, and not Epstein's [Les] *Fleurs du Mal*, nor the waste-paper basket scribbles of Duncan Grant...

Monday 3
Diploma examination in the New Bodley building. Charlton had arranged the work. Present, Ledward, Corfiato, Bayes, Ormrod: Borenius arrived when it was all over, and concurred in passing the lot...Took Bayes to tea, and subsequently travelled up to London with him by bus. It takes about 2½ hours, and costs 4/9d single. We had supper together at the Windsor Castle at Victoria, where the old waiters, Leonard, George and another were pleased to greet us after perhaps ten years' interval. Bayes is cheerful enough about his getting the sack from University College on the age limit question...The Pilgrim Trust is employing Bayes to make drawings of Essex.[6] He does 2 a week and earns about £6...Characteristically, instead of doing only the 'picturesque', he has chosen as one subject a tattooist's parlour in Colchester, where the soldiers go [plate 19].

Tuesday 4
...After supper at 59B Belsize Park Gardens with Hagedorn (who has done a lot of paintings and one or two textile designs for the Schwabe firm in Manchester), walked in Primrose Hill and Regent's Park and saw a captive A.R.P. balloon wound down to earth.

Wednesday 5
Again the Board's Exam. – 500 drawings to judge. Bus home to Oxford...

6 Part of the 'Recording Britain' scheme.

Thursday 6
Huskinson's brother is back in England, wounded in the leg. He found himself in command of a detachment of the Guards at or near Dunkirk, all their own officers having been killed.

Friday 7
Warned a girl student, Maybury-Lewis, of the danger of selling Communist literature, and told her not to do it in the School, as she was doing. Anthony Betts came, to look at the show of drawings in the Museum, and to collect ideas that might assist the Curator at Reading in selecting a few for purchase (which he never did). He praised, to me, my little head of Randall Davies [1939, £10. 10s.], and Horton's head of Mahoney [1926, £8. 8s.] I praised, to him, Willie Clause's cow [1939, £7. 7s.], which is still unsold. He tells me that Sickert, having received a small civil list pension, has taken a fine old manor-house near Bath (Bathampton), the sort of place that ought to have peacocks strutting on the lawn...

Sunday 9
Supper with the Tennysons...Pen has joined up with the R.N.V.R...Gerrard, I hear, is safe home...

Wednesday 12
[Bd. of Ed.] Exams.. Dickey...is now in the Ministry of Information, apparently liking the actual work, but not the information, which is very bad today. Luard continues his flood of reminiscences and ideas. He is in command of an A.R.P. district in St. John's Wood. He was responsible for digging out Lecoq de Boisbaudran's[7] book, which he translated into English, and got published over here...

Friday 14
The Provost and Lady Mawer visited...Mawer has not seen us at work in Oxford until now.

Saturday 15
Tea, 358 Woodstock Road, with the family of Dale, the architect...We sat in the garden and after tea played an amateurish, amusing game of croquet on the lawn...Dora writes from Dover that the scenes there during the Dunkirk evacuation were 'unforgettable'. Tom was up three nights operating on the wounded. Mary Fletcher, Alice's friend, reports in much the same strain from Plymouth, describing the arrival of troops, 'muddy and bloody'.

Monday 17
1 o'c. in The Randolph with Albert, Charlton, Polunin and Ensor Holliday, heard of the French laying down their arms. 5 – 7 drawing in St. Michael's Street. One might as well do that as anything else...Margery Rutherston, I hear, would like to take her children to Canada. Later, I heard...They decided...against sending the children abroad. Things look at their worst to Jews, of course. They may be worse off in the future than the rest of us. There are, of course, Government schemes on foot for taking children to America and the Dominions.

7 *L'Éducation de la mémoire pittoresque et la formation de l'artiste*, publié par L.D. Luard, Paris, Laurens, 1920.

Thursday 20
The Slade Picnic should have been today…but Parratt and Knaggs, for the Slade Society, very rightly called it off, as the War leaves few people in a mind to be festive. A good many men are leaving us for the Army: Heath, Treffgarne, Parratt, Emery…

Friday 21
Lowinsky came, in much better spirits than before. He is very active in command of the Local Defence Volunteers [L.D.V.] at Garsington. They practice their duties most realistically, and L. has typed out instructions, short and clear, to every man. He says the villagers and farmers are very keen on the work, in spite of haymaking…and some of them say…they would rather be killed than put up with German victory in England… The Huskinsons, uncle and nephew, are doing L.D.V. work too at Stanton Harcourt. They use Pope's Tower as a look-out…

Saturday 22
Last day of the Slade…Met Gerald Hopkins and old Mrs. Lowinsky…went to see a show of drawings of Oxford and Winchester by Gotch, which was being held in someone's rooms in Peckwater Quad. Met Gotch. His drawings have some delicacy. He had sold perhaps 8 at about £10-10-0 each…Saw a horrible film with Birdie of which she thoroughly disapproved. It was *Pastor Hall*, based on the life of Niemöller, and featuring the brutality of Nazi concentration camps. Nova Pilbeam was in it.

Monday 24
…had new nozzles fitted to our gas masks…at St. Giles' Parish Room…1a.m. Air raid warning sounded; we all got up, put on some clothes, and sat together in our dining-room, with Mrs. Brown and the maid. The maid was frightened, but controlled. At 1.45 the all-clear sounded…Alice did what she had been told to do, and reported for duty at the Radcliffe Hospital as soon as possible after the 'all-clear' sounded, but of course she was not wanted. Only her commandant turned up…the alarm lasted till 3.45 in London. They say that some 13 people were killed in different places during the raid.

Tuesday 25
Drove up to Esher with Albert, who took Patricia the model as well. Canadian troops in lorries on the road…Went…to MacColl's Private View of drawings and paintings at the Leicester Galleries…Mrs. MacColl says that René barely escaped from Boulogne. Among other things, a bomb fell on R.A.F. headquarters, and a close friend of René's sitting at a desk, had his arm torn off. Gerrard seems to have had a hard time too. Went on to Willie Clause's show of very good drawings at Colnaghi's (now where Knoedler's used to be)… Back to the Club…Met R.A. Walker. His son was four days on the beach at Dunkirk, bombed and shelled. His men occupied a chateau and fed themselves on a pig or two and some poultry. He was up to his neck in water when a boat took him off. Walker was in Boulogne himself as a stretcher bearer or canteen worker for the Church Army…

Wednesday 26
Bd. of Education Exams…Went to the Club…saw John Rothenstein, and asked him if he was still considering my doing a drawing of the Tate Gallery: he is, apparently…He tells me the Tate has just bought a portrait of Daphne Charlton by Stanley Spencer…

Thursday 27
Final meeting of Examiners…My fee for the job comes to £119, but the Income Tax makes a large hole in that. Back to Oxford…

Saturday 29
Drew the Hume-Rothery child, Jenepher, at Sandfield Road, Headington. This went off well, and they were pleased. Mrs. H-R is going to Canada, too, so I am to start a drawing of her tomorrow…Bysshe Barnes came, and meeting Riley in the street, brought him in. R. is a conscientious objector to military service. Hallam and his friend, Roddie Fenwick-Owen, appear to have the same ideas, but are going to do some form of war-service.

Sunday 30
10 o'c. At Sandfield Road again. Made a drawing which I consider like her (Mrs. H-R), but her husband can't see it – said if he had seen it in an exhibition it would hardly have occurred to him that it was a portrait of his wife – so I shall have to start again on Wednesday. He is a talented amateur water-colour artist. He worked under Carline at the Ruskin School. His wife is being very brave about leaving England, but she minds very much…

JULY

Monday 1
Spent the afternoon drawing in St. Michael's Street (Vanbrugh House). The railings round the Martyrs' Memorial are being removed as scrap-iron for munitions…

Wednesday 3
At Headington, drawing Mrs. Hume-Rothery…She was pleased enough, but when her husband came into no. 7 Beaumont Street at 2 o'c. he was…far from enthusiastic, though he thought the drawing much better and more like than the first one, and agreed, finally, to accept it. Sherry – Alice and I, with Maud Manners and her brother, who escaped with difficulty from Biarritz, just before the Germans came. He came away in company with the *Arandora Star*, which has just been sunk, to-day, with enemy aliens on board, bound for Canada. He left from St. Jean de Luz. There were German submarines waiting outside, of which one was sunk; but a Canadian destroyer collided with one of ours and was sunk. Manners and the other passengers knew nothing of these events till afterwards.

Saturday 6
About 5.30 Yve and Dooley came in. She is in Oxford for the weekend. Dooley is leaving Cowley Barracks [with the Oxford & Bucks Light Infantry] shortly for Nantwich…Pen's film, *Convoy*, has very good notices in the papers. Ivy is very much wrapped up in a scheme for running two canteens for the soldiers. Leo Myers and the Petos (Sir George) are putting up some of the money.

Sunday 7
Finished the drawing of Vanbrugh House at home.

Tuesday 9
...Made a beginning of the Tate Gallery drawing for John Rothenstein. Met Lowinsky coming back from London with Justin and his younger daughter. He has been making arrangements to get them off to America. Augustus John has made a drawing of Justin, which L. is very pleased with, and says it is very like. John took about 1½ hours over it.

Wednesday 10
...Got in nearly 5 hours drawing at the Tate. Met K.T. Parker. His children have arrived safely in America. He is full of appreciation for the kindness of their voluntary hosts overseas. They have to receive the children without money, and to sign an undertaking to be responsible for them for the duration of the War. The Tate exterior has several bad architectural defects. The balusters are an ugly design, too.

Thursday 11
At the Tate again. Ginger came on a bicycle from the Grove Hospital to look me up. I was very pleased to see him, though he wasted an hour of my drawing time...He has been dealing with over 150 wounded, English and French, from the Flanders evacuation. They were not very serious cases for the most part, and have been sent elsewhere now. Ginger's brother, the Commander, sunk a German submarine while escorting a convoy with his sloop in the Channel. Five depth charges were dropped, and the submarine sprung a leak and came to the surface. Most of the crew – 42...were taken off, and the submarine sunk by gun-fire. July 14 – Commander Ellison gets D.S.O. for this action.

Saturday 13
...Tommy Lowinsky called...to get me to spray his John drawing of Justin with fixative. It is rubbed and smudged rather awkwardly by the great man. We did a little faking with India rubber and chalk, which improved it and made the damage less noticeable. It is very like the boy...and it is seen in a big way, and carries admirably across a room; but there is a defect of looseness, and a rather careless scribbling in the non-essential parts. John seemed pleased with it himself, and said it was 'as good as he could do'...

Monday 15
To London. Drew for half-an-hour: rain. Saw the show of war drawings at the National Gallery. Met Muirhead Bone, Gleadowe, Dickey, and Vincent Lines there. At the Athenaeum, met Darcy Braddyll, who has been engaged with A.P. Herbert[8] and the *Water Gypsy* and other craft in the Thames. Braddyll's companion on his boat was hit on his tin-hat by a splinter of a German bomb which fell a few yards from them.

Friday 19
4a.m. We were awakened by explosions. Did not know whether they were bombs or gun-fire. It seemed later that neither was the case. There was a fire at a mineral-water factory near the station and some cylinders exploded. Tate – a good day this time – over 5 hours drawing.

8 Sir Alan Herbert novelist, playwright, law reform activist and Independent M.P. Oxford University constituency. Member R.N. Auxiliary Patrol, his own motor launch was named after one of his early novels.

Monday 22
Drew during the morning. Two soldiers came down and asked me, politely enough, for my card of identity, which satisfied them, but not the police to whom they reported. A policeman drove back with the soldiers in a car and asked more questions, again very civilly. Having a permit now from the Ministry of Information and a Passport as well, there was no real difficulty...

Sunday 28
In the afternoon Bish drove us to Haddenham, to look at a cottage. Supper at the Black Horse in Thame. We did not go to The Spread Eagle, fearing it might be too expensive, though Fothergill is no longer there and the man who sold the business to him (and did him in the eye) has it again...

Monday 29
Tate, for the last time. Weather held out...and the sun came as I wished at 4.30. (Ginger's brother said to the German submarine commander whom he captured:- 'You see that little ship over there? – That's the *Ajax*, that had a hand in defeating the *Graf von Spee*'. 'Unmoglich', said the German, 'the *Ajax* was sunk: Goebbels has said so.' 'Well, you'll hear more about it from your submarine comrades who are interned where you are going to.' 'Impossible, again; mine is the first German submarine to be sunk or captured during this War'.

Tuesday 30
Finished the Tate drawing at home. I have to put colour onto it, as the Gallery cannot buy anything that is not in colour, unless from some private fund...Elton is taking steps to get a job in the army. Gerrard (who is a great success as a camouflage officer) may do something to help him...

Wednesday 31 – Wednesday 14 August: no diary entries

AUGUST

Thursday 15
Bish Barnes announced to me his engagement to Alice.

Monday 19
...Alice started work in the Radcliffe today, after an experimental day yesterday. She works for eight hours on the sterilizing plant for which she is to be responsible...Birdie making rolls...for Ivy Tennyson's canteen, (the canteen went out for the first time yesterday, and was sold out)...

Thursday 22
Lunch with the Lowinskys at Garsington. Ruth L. very busy conducting the operation of canning plums in the village. There has been a record crop and a ton of sugar has been rationed to the villagers for preserving fruit. Claire and Justin have arrived safely in America. Ruth L. is very down on Hallam Tennyson for being a conscientious objector...We planned to visit Sir Charles Peers at Chiselhampton House. Martin could not

drive us, having to drive the cook to the doctor, and Lowinsky cannot drive any more than I can, so we walked. It isn't far...At the entrance to the park, Sir Charles' grand-children burying each other merrily in a heap of hay, which struck a different note from the heap of smashed aeroplanes, German and English, in a dump outside Cowley... Drawings of Peers by Gilbert Spencer and Monnington, the Spencer very good and alive; he worked on it for several days while staying in the house, awaiting the arrival of his wife's baby. Sad news that F.H.S. Shepherd, Peer's brother-in-law, has gone out of his mind, or had a very bad nervous breakdown, from strain caused by the War. He thought we were going to be defeated, and the French disaster finished him. He is in a mental hospital at Headington, takes no interest in anybody, not even his wife, and imagines he is in a German concentration camp...

Friday 23
News of Dover being shelled across the Straits. Poor Tom!...Bill is still in hush-hush work in Inverness-shire...Kate Syrett writes that the wreck of a German 'plane lies on the Downs just near her house...

Tuesday 27
Birdie and I took a bus to Henley...where the Wellingtons met us and drove us to North End, where they have bought an 11 years' lease of the Kauffers' house...Marion Dorn and Kauffer have done the small old house up extremely well, and at great expense, with furniture as if from Fortnum & Mason. All this the Wellingtons have taken over for about £600, the rent for the first 4 years is only £30 per annum, afterwards £50. The Aga cooker alone cost £60. Dorn and Kauffer found their business declining with the War, and Americans were advised to leave England anyhow, so they have gone to the U.S.A...

Wednesday 28
...Demonstration to collect money to buy a Spitfire – a march through the streets: Navy, Army, R.A.F., various auxiliaries, Fire Brigade, Home Guard, Boy Scots...I believe Elton was in it.

Friday 30
Met the Huskinsons...Margaret H. told me about the air-raid the other day at Stanton Harcourt: 20 casualties, some bad as a foot blown off, and seven...dead. They tried to bomb the landing ground of the neighbouring aerodrome, but the bombs fell in fields, wide of the mark: after that they machine-gunned the place...

Saturday 31
Bill turned up unexpectedly on ten days leave from Lochailort. He has not got his commission yet, nor any pay, but has been promised both. Met Fat [George] Marston,[9] of the South Pole and Rural Industries [Bureau]. He and his daughter (I believe it was the daughter we knew as a little girl in Petersfield), talked about bombs at Horton-cum-Studley where they were last night...

9 He was recruited by Shackleton as artist on the *Endurance*. Following the expedition he taught at Bedales (1918-22).

SEPTEMBER

Monday 2
…The Dodds came to tea…Dodd has been drawing at Chorley near Manchester, in a factory where they make chemicals for high explosives. Forty persons were injured in an accident there the other day, but they have not so far suffered from German bombing, though attacks have been made. Bone is working so hard at his official drawings that he tires himself out and will have to take a rest presently. Kennington and John Nash have decided not to be official artists any longer, preferring to do something more helpful in the war. Dodd says that Orpen, in the last War, painted Gen. Birdwood, full length, in two days, beginning at six in the morning.

Friday 13
Sisam, of the Clarendon Press, wrote me about a drawing for the 1941 *Oxford Almanack*. He wants Oxford in the Blackout, with moonlight. Started making notes in the afternoon and studied the moonlight (which was very clear) in the evening, after the 9 o'c. radio. I think I shall decide on Magdalen Tower. It must be something at once recognizable as Oxford…

Saturday 14
…Seven thousand people, who have evacuated themselves from London, mostly with children, are said to be in Oxford. I met Robin Guthrie with his parents. His father and mother have had to leave Bognor, and now have left London to be away from the raids. Guthrie is going back to London on Monday, where he is still painting portraits, but he says that under existing conditions they are apt not to materialize. Playhouse in the evening – a comedy by Ivor Novello, amusing. Veale, the University Registrar was in the seat in front of me. He sees no reason why the University term should not begin as usual, short of an invasion, which may come, of course. Churchill said so the other day, but spoke hopefully in the main.

Monday 16
…Met William Roberts. He is no longer teaching in Oxford, but thinks the Central School may re-open and employ him.

Thursday 19
Went up to London for a New English meeting. Could not get near the office in Burlington Gardens, as there were time bombs unexploded in both Cork Street and Sackville Street, and the premises were evacuated by order of the police…Saw the damage done to University College, in Gordon Place, and Maple's shop fronts in Gower Street…Heard about 5 explosions, fairly distant, but arrived home without other incident.

Wednesday 25
…Bayes writes that Parkhill Studios has little but the walls left. His place was opposite the explosion, and he and his wife had improvised a shelter to sleep under by the garden window. The blast of a 1000lb. bomb passed 2ft. over their heads, but they crawled out of the wreckage unhurt…

Thursday 26
Went up to London…Air raid warning outside Westbourne Park…Got out of train in order to take the underground, on advice of porter at Westbourne Park…All clear while waiting…Contrary to what I was told trains ran as far as King's Cross, so got out at Euston Square. Gerrard was misinformed about the damage to the Slade. It still stands, with most of the glass gone…There was a fire from an incendiary bomb in the adjoining building at the N.E. corner of the quad yesterday or the day before…The adjoining building and the library have suffered heavily; the Great Hall was hit by a large bomb on Wednesday of last week. I was shown the remains – a 20ft. high heap of debris: not a thing standing…Physics Dept. is gone and the Tuck Library. I saw, for a moment, the Provost, Prof. Chambers and Tanner. Fellow of the Works staff came with me to investigate the Slade basement. It was dripping with water from the firemen's hoses yesterday, but the pictures have been carefully stacked and are pretty dry. Charles Darwin's house is down in Gower Street. There is a hole in the road opposite University College Hospital and Gordon Place has got it…Houses down in Tottenham Court Road opposite Central Y.M.C.A., Peter Robinsons, Oxford Circus, burnt with large slabs of masonry in the street. Hits in Maddox Street and Mill Street, Conduit Street (a heap of ruins). Bomb crater in Burlington Gardens and the N. end of Burlington Arcade demolished: a gap through into Bond Street. The North side of Berkeley Square hit and houses in ruins. Notices in French from General de Gaulle in public lavatories. Attended meeting of N.E.A.C. in Chisman's office, with the windows out. Only Clause and Chisman present, Jowett was at a meeting at the National Gallery. Got through to him on the telephone. He agreed to the holding of an exhibition – on Chisman's facts, that the circularizing was already done, and we were likely to lose more money by not having a show owing to loss of hanging fees, etc. Philp of the R.W.S. thinks they may not have a show there, but other societies are carrying on. The R.C.A. is closing in South Kensington. 2nd air raid warning 4.15-4.35. Advice from loudspeaker on Paddington platform to take cover because of the risk of the glass roof splintering. Difficult to carry out this instruction if you want to catch a train. Paddington signal boxes have been hit, which disorganizes things a bit…

Saturday 28
I am told that one of the bombs we heard last night fell on Boar's Hill. Bish, who came in the evening with Edgar Holloway by car, has more stories of the peppering of Bushey. Another School is wrecked near his: a big printing works was burned in Watford, and the ground for miles is covered with burnt paper. Met old Hugh Fisher, drawing casts in the Ashmolean; he had stories of his youth at the Lambeth School under Llewellyn, Ricketts and Shannon…

OCTOBER

Wednesday 2
Bayes came to tea. He and his wife are staying with Prof. Betts at Reading. Bombs were too frequent and too close in London to be pleasant, so he got her away, accepting a standing invitation from the Betts family. She won't let him go back to work in London alone, so he is trying to get the Pilgrim Trust to allow him to draw Oxford instead.

Thursday 3

Finished drawing of the backs of Ship Street houses from the yard off Broad Street. Saw Dr. John Johnson and his collotype expert at the Clarendon Press about the reproduction of the Magdalen College drawing for the *Oxford Calendar.* Meninsky called. He is staying at Hampton Poyle with friends, his job at the Central School having lapsed. All the part-time teachers are cut off: there are so few students. Both his sons are in the Army, one R.A.F... He talked about Kitson's collection of Cotmans, which he admires enormously, and which he wants me to see. It is at Kidlington. Also about Matthew Smith and Sickert. He had a room in the same house as Smith in Fitzroy Street, and persuaded him to send to the London Group for the first time. No one had heard of Smith before that. He asked Meninsky whether he thought his (Smith's) work was too influenced by Matisse. M. used to breakfast with Walter Sickert, also, in Fitzroy Street. Sickert is an excellent cook and used to put on a chef's cap to do his cooking. He gave Meninsky a bed as a wedding present. It was a good bed, and was given to Sickert by Walter Taylor. It figures in S.'s pictures.

Monday 14

Slade began, with over 60 students...

Wednesday 16

News that the Athenaeum has lost its windows, the Union Club in Carlton House Terrace has gone, and St. James's Piccadilly, is a ruin. Other news from London over this week-end – the Carlton is wrecked. Over 100 members, including Cabinet ministers, were dining, and not one was hurt. The R.A.C. is hit. *The Studio* offices in Leicester Square are also hit, and the firm has to move out. Tommy Lowinsky's house in Kensington Square has the back blown away. The R.W.S., to which I sent two pictures on Monday, has decided not to hold its show after all. Conduit Street has got it again, and the gallery roof is damaged...Prof. Beazley concerned for the safety of his casts, some of them irreplaceable: students are careless...

Sunday 20

Albert drove me over to Stowe to see the boys, and the School, which was new to me... Met Roxburgh [the Headmaster], whom I liked. He showed us his Strawberry-Hill Gothic room. Apparently, every boy in the School comes under his tuition...The roads are very completely furnished with block-houses, machine-gun emplacements and obstacles of all kinds, ranging from milk-cans to obsolete vehicles. Some of these features of Home Guard activity are disguised as petrol stations, ancient sheds and the like...

Tuesday 22

...Albert reports that Lord Berners promised to become quite a serious student of life-drawing. He started on Monday, never having done it before he came to our School. He is working for the Blood Transfusion service part of his time.

Friday 25

...University College is in an awful state...Another bomb has fallen on or near it, the Provost said. Pictures suffering more and more from damp. The big Veronese is a total ruin, and was left behind. Tonks's decoration from the dome was put out to go first, but it got overlooked, to my annoyance, till it was too late to get it in the van. Meanwhile,

two large pictures of mine and some rubbishy portraits from the College were taking up the space it ought to have had. The Tonks is cut by glass splinters. We must make another journey to retrieve it and other things...

Saturday 26
Elton and I drove to Chastleton in Scott's van with the Slade pictures...Mrs. Whitmore Jones kind and helpful, and not fussy. Scott's two men and two men of the house carried all the stuff up to a room on the same floor as the ballroom, a long way up. Some of Sargent's pictures are already stored in the same room by Mrs. Ormond(?), Sargent's sister. The John *Serpent* [1898] and the smaller of our two Veroneses are badly mildewed, and some of the small things are damp, but the room being central-heated they may dry out...

Sunday 27
It is extraordinary how closely many of Wordsworth's poems (I bought a complete Wordsworth for 3/-, and have actually, for the first time, got right through *The Prelude* and *The Excursion*, not to mention minor poems, fine and otherwise) seem to fit with the circumstances of our war with Hitler. I find one parallel after another...

Monday 28
...Tate Gallery paid me £20.

Thursday 31
Stuart-Hill turned up. He is staying with Col Kolkhorst at Yarnton. His hair is a wonderful gold, his face as made up as always, but he is practically living on charity now. Ivan Philipowski helps him – he is making £900 a year playing the piano at Lyons's Corner House. The place suffered in the raids. The windows went, but an army of Lyons' men blocked them out next day and business was carried on as usual. Ph. is dreading that any day his job may come to an end. He sleeps on a table in the café in his clothes. The Catholic church in Cheyne Row is gone. It was an air-raid shelter. People were killed there. Stuart-Hill's charwoman, Salisbury, carries on in his absence. She has been with him for 21 years. Her house is demolished and she sleeps in an air-raid shelter, washing in the studio. She cannot sleep there, as it is roofed with glass. The Boltons, with Orpen's old studio, is destroyed. Church Row was hit, but not our part – the part between the Church and Frognal. A house next to Carnegie's vicarage was destroyed. Bombs have fallen from Chesterfield Gardens to Benham's Place, hitting Oak Hill Park lodge and a house in Frognal Gardens. Denis Mathews gave this information in a letter to Alice...

NOVEMBER

Friday 1
...London with Elton to rescue more Slade property, including the Tonks decoration from the dome in the College...The N.E.A.C. exhibition has suffered damage (but not to the pictures) and it is carrying on...

Sunday 3
Met Nuttall-Smith, the sculptor, who described the wholesale effects of a land mine

which fell on Aylesbury. The oil bomb which fell in Ferry Hinksey Road, the only one Oxford has had, was ineffective. Victor Pasmore goes on painting in London…

Tuesday 5
Albert talked about his affair with Aminta Dyne. It happened when he was living in Fitzroy Street, and he first met her one night in a crowd which had formed to watch a fire in Howland Street. She lived with him, and there was some talk of marriage, but Will and Alice came and talked Aminta out of that. A good thing for Albert – she ruined Dyne, and Gregory at the Foreign Office, and another F.O. man, a friend of Albert's, whose name I forget: he had to resign on account of speculations with which she was concerned. Capt. Peter Wright started her off on those. Dyne knew all about Albert's affair, but generously married Aminta and educated her. She came from Liverpool, whence she had run away when Albert picked her up. Father Walker, S.J., Dean of Campion Hall, told me that Father D'Arcy was the only man in their house who liked Stanley Spencer's work. His designs, if he did any, were turned down, and the Campion Chapel is still undecorated. D'Arcy and Walker went to Burghclere to look at the Spencer Chapel, and they disagreed about it. D'Arcy could not push his preference in the teeth of all the others…

Thursday 7
Polunin came to tea. He is living in Wellington Square, uncomfortably, among a large collection of dusty Spanish books left behind by a defunct Professor… Mrs. Vladimir Polunin is at Petersfield, Chiswick being too uncomfortable.

Thursday 14
…Barnett Freedman's roof in London has been damaged, but he is getting it repaired. Some granite paving-stones found their way in his bedroom. He wasn't there at the time. He looks very fat and well in his Captain's uniform, and is drawing air-raid shelters and their occupants. He taught at the School on Friday.

Friday 15
Albert dined with me at Keble…[it] is full up with women of some Government depart-ment…about 200 of them are living in, either from the War Office or the Office of Works…The Warden was present, and half-a-dozen other men, including Rice-Oxley and his old father, Sir Alfred, who is living in the guest-chamber…Back to Beaumont St. about 11.15. A pleasant evening. There is still claret in the cellars, and port too…

Saturday 16
John Rothenstein is trying to get Worcester, his old College, to buy some of my drawings of the place…In the afternoon, as I was drawing a cast for my private satisfaction in the Ashmolean, Alice brought over a telegram from Dickey at the Ministry of Information suggesting that I might draw the ruins of Coventry Cathedral, which was demolished in the great raid on Thursday night.

Friday 22
Will R. went round the Ruskin-Slade, for which he gets the modest fee of £3-3-0. 11.28 train to Coventry. Arrived there by bus from Leamington about 2.30, as the train

connection was very bad. Called at Ministry of Information, in the Council House, besieged by all sorts of applicants for all sorts of social services & help. Mr. Morris was helpful, and took me to the Chief of Police for an extra permit. Got into the Cathedral ruins, which have been to some extent tidied up: but I couldn't have worked while the tidying was going on...Gangs of sappers pulling down a building fronting the W. end of Cathedral, using steel ropes and having a tug-of-war with it. Could not start work this afternoon. A man from the Ministry drove me to Birmingham at 5 p.m., where I put up at the Imperial Hotel, the same place I was at when doing portraits for Cadbury. Others of the Ministry people are living there and going over to Coventry daily – Councillor Flaherty, with one leg, from Leeds, Aytoun Ellis & others. A party of neutral journalists, too, – Swiss, Finnish, Hungarian, Danish, Swedish. I joined them after dinner. Air raid began about dinner-time and lasted till 5.50 (11 hours). Very heavy indeed – comparable, I am assured, to the worst of the London raids. Incendiary bombs dropped in Temple Street, outside the hotel...Later there were heavy explosions and the hotel shook...Aytoun Ellis doesn't think much of these foreign press men. With the exception of the Finn, he thought they might be fifth columnists. Ford's Hospital still stands, battered and shaky, but timber buildings don't collapse in the way that bricks and mortar do. People were killed there by a direct hit. The Guild Hall is fairly untouched.

Saturday 23
400 people were killed; 500 at Coventry last Thursday. Damage in Birmingham last night was serious. I saw a lot of it because I was driven to Coventry by a Mechanised Transport Corps woman named Mrs. Daly, and, as many roads were blocked, we drove by a very circuitous route, losing our way several times. Whole rows of cottages are gone, factories, warehouses and commercial buildings knocked down or burnt out. The Cathedral still stands. New Street Station was hit. We had no water in the hotel this morning except what was left in the bedroom water pipes – no tea for breakfast, but food and fruit juice. Queues of people in the streets fetching pails of water from available sources. Arrived late in Coventry, after a 2 hour drive. Called on the Chief Engineer, to get the Cathedral key, as the place is locked up now. Was sent on to the Provost, the Very Rev. Mr. Howard, who was at a funeral...Waited in the Provost's house from 12.15 to 1.15. He was most kind, and asked me to stay to lunch, but having got my key, I went off to work till 4.20, when I had to leave on account of the return journey to Birmingham...Mrs. Daly anxious to get home before the black-out. These M.T.C. women buy their own uniforms, pay a small sum to enter the corps, and get no pay...

Sunday 24
Coffee and tea are again procurable in the hotel, but no hot water for washing: Had a cold bath in the water left for fire emergencies. 10.15 to Coventry with Mrs. Daly and Aytoun Ellis. Worked without interruption from about 11.45 to 3.45. Luckily a fine day. Saw the Provost in the Cathedral. He says that as long as he lives the spire (which he admires greatly) will stand, and the church rebuilding will begin as soon as feasible. Arrived at the hotel in time for tea – hadn't had any lunch. Production stopped dead in Coventry for some days after the big raid. About 10% of the people in the factories are back at work now, and the percentage is rising: perhaps it may reach 50%. The old Alvis works are gutted, and there is a bad hole in the road near there. Water has been laid on

again to-day in parts of the town. People, on the whole, don't look as miserable as one expects. Coventry Art School is said to be re-opening tomorrow; and, of a row of 15 or 20 wrecked shops that was pointed out to me, the only one re-opened was one for the supply of artists' materials!

Monday 25
Driven to Coventry again in the same company. Started work at 10.45 and went on till 4. Aytoun Ellis is a good companion, a good talker, who, by his own account, has been a medical student, a lecturer on syphilis in the U.S., a company promoter, A.P.M. in Cairo, a soldier, an airman, a race-horse owner and rider, and a B.B.C. announcer. He says he knows from censored letters that bodies of German soldiers were washed up in Ireland after Sept. 15: over 20 in one place, smaller numbers elsewhere. These soldiers must, I suppose, have been on the barges that were bombed by the R.A.F. at places like Cherbourg, and the point is that there was a serious attempt being made to get troops from France over to England, contrary to what many people say.

Tuesday 26
…Some confusion about getting a car to Coventry: Mrs. Daly's was filled with persons on more urgent business than mine: however, the Ministry of Information in Lombard House found one…to take me and a girl typist. Started work at 11 o'c.: finished by 4 [plate 18]. Returned my key and a volume of marriage registers that I had picked up in the ruins to the Diocesan Registry…Notices on shops in Coventry-'We are blasted well open.' 'More open than usual'. 'You should see our Berlin branch.'

Wednesday 27
Train to Oxford 10.58a.m. Hendy's last lecture on Rubens.

Friday 29
Clarendon Press paid me £35. Barnett Freedman had several stories of Dunkirk: one about a respectable grey-bearded man at Dover, who was setting out for Flanders in a sort of canoe with an outboard motor: 'What d'you think you are going to do in that craft?' asked an officer: 'I can save one', was the reply – and he is said to have done this and more. Another story about a ship taking off soldiers up to their chests in water, who had been waiting in the sea about seven hours – the ship crammed on every man it could, till there was positively no place for another: 'Wait a bit, son, they won't be long' said the captain to a lad of nineteen, who should have been the next to go: "Urry up, then, guv'nor – my feet are getting cold', said the lad. And on landing at Dover, with feet swollen from long marching and exposure to salt water, some men encountered an elderly regular officer, who thought it good to make some effort at discipline – 'Form up there', he was saying: but a young lieutenant, who had been through it all, intervened: 'Let them go where they bloody well please', he said acidly to his superior…

Saturday 30
…Kempton has been bombed, but the bombs missed the German prisoners camped in the race-course. In London I noticed damage to the Admiralty, Hampton's in Pall Mall East and the east end of the Nat. Gallery & N.P.G…Train back to Oxford, 4¼ hours…

DECEMBER

Sunday 1
Finished the Coventry drawing. Marmalade is now unprocurable. Bramley seedlings of good quality are 6d per lb. H.M. Carr has been bombed out of his house and studio at Beckenham.

Saturday 7
Albert R. is trying to get New College to buy my drawing of their gateway. John R. talks of buying another of my drawings for the Tate. Will R. has failed to impress the Provost of Worcester with the desirability of buying my drawings of that College, though John R., too, added his persuasions. The Provost said he didn't like the figures I had introduced. He appears to think them comic, or at least undignified. This Will countered by saying I could easily alter them for him; but it was no use...

Sunday 8
...Dinner with the Tennysons...Pen, I hear, is now doing film work for the Admiralty, no longer being sea-sick on ordinary naval service...Hallam has experienced some difficulty as a C.O. in uniform. One officer declines to have meals in his company in the mess. Hallam takes up the attitude that it is a pity anyone should be so narrow-minded.

Monday 9
Tanner came down from University College, of which the administration is now settled at Stanstead Bury in Hertfordshire...Short discussion of financial arrangements and their possible simplification as far as the combination of the Ruskin and Slade is concerned. Our combined numbers are now about 138. John Rothenstein bought my drawing of the arcade under Worcester, not for the Tate, but for the National Gallery of Wales. Price to be £12-12-0...Corfiato writes from Cambridge asking me to go there and do a portrait drawing of the Master of Cat's: so things are looking up. Visit from the Air Raid Warden, who recommends Mrs. Brown's household to buy a stirrup pump as a precaution against incendiary bombs...

Saturday 15
...Tea with Ethel Hatch. She wanted me to look at the pictures she has brought away from Chelsea...Ethel H. was at the Slade with Augustus John and Albert R. She talked about Mrs. Everett (whom Orpen painted) and her son the artist, and the parties they used to give in Fitzroy St. I believe Augustus John had one of his earliest shows of drawings in her rooms. Fred Brown must think well of her pictures, because he bought one. She is a very skillful water-colourist. She uses all sorts of colours that I never do – Cobalt violet, Naples yellow, Madder Pink and so on (but not Prussian blue). She draws almost, or quite, directly with the brush and attains great freshness, decorative quality in her flowers and tone in her landscapes...

Monday 16
Ratcliffe, Bursar of New College, rang me up and suggested that he should drive me to Stanton St. John to look at a very good subject, as he thought, for a drawing. Albert explained to me later that New College would not buy a drawing of mine of College

(having the one of their gateway given to them), because it was not their own college, but they *might* consider buying one of Stanton because the village is New College property...The Bursar is right – it is an excellent subject. We pottered round the manor farm, which has traces of 14th century work...and the church...Albert and I went to tea with Father D'Arcy and Father Walker at Campion Hall. D'Arcy is a distinguished-looking priest, ascetic and aesthetic, who must look entirely right in the wonderful vestments of which he has such a fine collection. He showed us these with pride...He also took us all over the building, showing us Lutyens's work and the fine collection of pictures by masters ancient and modern – Palma, Bellini, Bosch, Murillo...down to Georges Rouault; as well as sculpture from the French 14th century to Eric Gill. I was interested in the Brangwyns. I have always disliked and abused Brangwyn's work, but here at least one must give him credit for something – ingenious space filling and a certain passion. Father D'Arcy has collected all these things in about five years – rather a feat.

Tuesday 17
10.30 Left for Cambridge. Arrived 2.25. Called on Dr. Sidney Smith (he has a Monet in his rooms, borrowed from Stuart Stanley of the Bartlett School) at St. Catharine's College, who was expecting me, and showed me to the guest room in the new buildings. Called on the Master [Rev. H.J. Chaytor], who was digging his garden. We will commence operations tomorrow at 10 a.m. Tea with Smith; crumpets and chocolate biscuits, both rarities now. The gates of Christ's College and of St. John's look extremely clean: the stone work has been done up lately...

Wednesday 18
Bed-maker called me about 8. Breakfast in my room at 9. Bacon and eggs and marmalade...and coffee in a Cona machine. Began on Chaytor in his study at 10 o'clock. Met Mrs. [Mary] Chaytor [née Rashleigh], who is a wood carver and has worked on church screens in Devon...Chaytor...is a Fellow of All Souls. Mrs. Chaytor not displeased with the portrait, so I thought I had better leave it...

Monday 23
Bought Christmas presents...symbols rather than gifts, for the Tennysons, Mrs. Brown, the two maids....

Tuesday 24
Lowinsky brought K.T. Parker into no. 7 Beaumont Street to look at my drawings of Oxford. Parker thinks he might get one...bought by the Ashmolean. Ruth Lowinsky came in too. They have had the John drawing of Justin photographed as a Christmas card...

Wednesday 25
Went out with Birdie to take a little Christmas present to Frankie Harrod at 91 St. Aldates. Met Roy Harrod and his wife pushing a perambulator...The house belongs to Christ Church...[10] Walking home...met Meninsky, searching for a place where he could get a cup of tea...Took him to The Randolph...(He teaches 1 afternoon and 1 evening at the local art school). He says Matthew Smith and Arnold Foster are both in Oxford, Smith

10 Frankie (Frances) had much influence on her son Roy, an economist who taught at Christ Church until retirement 1967 and who wrote *The Life of John Maynard Keynes* (1951), his mentor and friend.

in the Acland Nursing Home…Christmas dinner with the Tennysons…Turkey, mince pies, plum pudding, claret and port…Charles admired Winston's speech to the Italians which was broadcast yesterday.

Thursday 26
Arnold Foster called…His wife is in the Acland Home, having been operated on for cancer. He is as enthusiastic about drawing as ever, and has a great regard for Tonks. His opinions on, and disagreements with, Roger Fry's *Vision and Design* coincided with mine, with curious exactness.

Saturday 28
Lunch at Garsington…T.L. was very cross with Paul Nash, who, he said, asked himself to lunch and then went round the premises with a camera (without asking permission) collecting material for future paintings. Such photographs are apparently all the material Nash now requires for his pictures…Nash has got the sack from his post as official artist. The official mind didn't think his proceedings were good enough. He took a few photographs of aeroplanes and painted from them, introducing fantastic backgrounds. Sir M. Sadler telephoned Lowinsky asking him to subscribe to a fund for Nash's support. Lowinsky refused. Tom [Lowinsky] is a slow worker. He doesn't do much more than 2 hours a day on his painting at the best of times. He has not yet got far with the view from his window towards Wittenham Clumps. It is still only drawn in, but promises well. (He has been working hard, of course, on his Home Guard duties).

Monday 30
…4.30 at the Emergency Blood Transfusion Service in the New Bodleian. Operation takes about ten minutes, is painless, and with the prescribed rest and a cup of tea, takes half an hour in all. I felt no ill-effects…

Tuesday 31
Slade…letters, with Elton back from a week-end with Ormrod…A.R. Thomson, the deaf and dumb R.A., called to ask for models' addresses. He is living at Long Handborough. He communicated by writing on a tablet and does not seem to lip-read: one has to write replies…

1941

London is again subject to heavy bombing; Schwabe is commissioned by the W.A.A.C. to record the Guildhall ruins and later in the year to undertake portraits of Home Front heroes. He is invited to serve on the Committee and accepts albeit reluctantly. In May Schwabe records the great satisfaction that is felt on news of the sinking of the Bismarck *given the heavy losses of British sailors and shipping. Former Slade student Paul Feiler visits Oxford to thank him for his part in securing his release from internment in Canada. In June Germany invaded Russia and in the same month clothes rationing came into force and increasingly there is a shortage of materials for artists.*

JANUARY

Thursday 2
Went on with the drawing of Wadham for about 2 hours.[1] Telegram from Dickey of the Ministry of Information asking me to go up to London and make another drawing, possibly of the ruins of the Guildhall...Riley came in too, about some badges or emblems that Mrs. Priestley wants for a home for evacuated children – things that little children who can't read can easily recognize, and by which they can identify their own property.

Friday 3
It was so cold that I did not go out to draw, but amused myself drawing in the Ashmolean Museum instead.

Saturday 4
...Went to Home Office in Whitehall, to the Ministry of Home Security, and interviewed Mr. J.T.A. Burke, who gave me a letter of authority in addition to the permit from the Ministry of Information which I already have, and sent me on to Mr. Alston, at the Govt. dept. in the Geological Museum, S.Ken., who will get me in touch with Capt. Daw, the A.R.P. Controller of the City. Lunch at the Athenaeum...Met Oppé, and discussed the show of John drawings at the National Gallery...There are some of great beauty...Oppé was more critical of them than I was inclined to be; I know that almost any drawing of John's has a vitality & meaning unattainable by anybody else; but I must say that I cling for choice to the greater precision and earnestness of the earlier ones. The full-face portrait of Alick Schepeler is there, and a study of Ida for one of the big decorations. These represent the kind I mean. By the way, someone reported to me that *The Mumpers* has been burned with other pictures in the Pantechnicon. But reports are tricky things just now. Mr. Burke, for instance, put a different complexion on the incident of P. Nash getting the sack from the Air Force. It was not on account of his work (which Burke, at any rate, likes – he used to be in the V.&A. Museum, and knows something about pictures; I saw some of them myself, too, at the N.G. and they seem quite unobjectionable) but on account of personal differences. So, too, with the stories about Roberts. It

1 Exhibited Oxford Art Society 1943, priced 12gns.

seems that 'Bobby' was on his way to France to draw Gort,[2] but took offence at Dover because nobody met him, and there was some hitch about the boat or train so that he had to sleep the night on the floor of some hotel: this he resented, though others were obliged to do the same, so he took the next train home. Pitchforth is a valiant war-artist, but, being almost completely deaf, he has to be accompanied sometimes to keep him out of danger – to the great relief of his wife – as he cannot hear explosions or the challenges of sentries...

Sunday 5
After an air-raid warning in the night and distant gun-fire or explosions which seemed to come to nothing, got up and walked out to look at the City. Most of the familiar landmarks are still there: St. Mary le Strand damaged & St. Bride's gutted, but the steeples of both standing. The church by the Guildhall gone, and the one in Coleman St....many warehouses in St. Paul's Churchyard burnt out, but St. Paul's unscathed as far as one can see...Looked round to try and find a window from which I could draw the Guildhall, but there was none. Decided to make the best of it & draw in the open, inside the roofless building but under cover. It snowed a little and turned to slight drizzle. Many sightseers in the streets. Buses running. I began work about 1.15 & went on till after 4. Monuments inside Guildhall smashed & cracked with the heat of the flames. The Library, I am told is mostly saved. Dynamiting of unsafe buildings going on.

Monday 6
After 11.30 last night, when the 'all clear' went, had a good night. I stayed downstairs till that time: the writing room is a 'shelter'. This hotel [Strand Palace] is full of Czecho-Slovaks, Poles and Jews...Some of the foreigners are in khaki. Drew from 10.30...Still inclined to snow a little, and the ice on the water-tanks (an A.R.P. precaution) in the streets still unthawed...Going out of the buildings for lunch met Bruno Kohn – to our mutual surprise...Bruno's office and all his papers have been burned. He has to write to his customers to ask how much they owe him. His house at Kingston is badly damaged, but is being slowly repaired. They have been out of it now for four months. A time-bomb fell just outside, making a hole thirty feet deep, and went off after they had cleared off to safety. His air-raid shelter, which cost £50 was ruined...A kindly functionary (cashier) named Crowe, took me into his office after I had finished drawing for the day at 4.20 (light very bad), to get thoroughly warm by his cozy fire. We walked through the police court to get to the office – it was all very old-fashioned and Dickens-like: so was Mr. Crowe...

Tuesday 7
At my pitch in the City by 10.30...Snow lying in patches – it did not go from the dome of St. Paul's all day. Explosions – bombs? – and air-raid warnings...To my surprise, after a quick lunch at Pimm's, where there is still excellent cold roast beef, I finished my drawing, as far as I could on the spot, by about 3.30. Back at the hotel, tried to telephone to Oxford, but was told there was a three hours' delay...Wired instead, with about as much hope. Rang up Dickey and made an appointment for lunch. He is expecting a visit to-morrow from P. Nash, whom he regards as a bore – talks too long...General impres-

2 Commander-in Chief British Expeditionary Force Western Europe in the months that led up to the evacuation at Dunkirk.

sion of air-raid damage – pretty bad, but a vast deal of London is still standing. Broadly the effect of air attack seems to have been exaggerated, as a 'win-the-war' concern…

Wednesday 8
To Church Row. Saw Max A. & Mrs. A.….Tony still in Kenya, busy & not unhappy. Max had an amusing account of a visit from Norman Evill, whose nephew is in a special 'secret' corps of desperadoes who raid the French coast in motor boats and do other dangerous service. They have a special training – they are marched up and down with machine-guns firing as close as possible on their flanks, and if anyone bats an eyelid or shrugs a shoulder he is fired out of the corps. Each man carries a Tommy gun about with him. 'But' said Evill, 'the chief toughs are a couple of instructors who were in the Shanghai police (these, of course, are Bill [Schwabe's brother] & Fairbairn). "Now", they say to the man being instructed, 'take your revolver and fire at my stomach'. The man does so, but the pistol is knocked from his hand before any damage is done. Very clever & neat.' Lunch with Dickey in the cafeteria in the Ministry of Information (Univ. of London)…Saw a new drawing by Frank Dobson, of a fire in Bristol, very lurid & dramatic. Met several people I knew from the University or the V.&A. Museum, and John Betjeman. Home by the 4.45. Noticed a large hole in Charing Cross Road opposite the St. Martin's School of Art. Buses are carried past it on a temporary wooden staging…

Saturday 11
Albert telephoned the news of Frederick Brown's death…I wrote to MacColl, asking him to write a notice of F.B.. It appeared he had already done so, for *The Times*…

Sunday 12
Ivy…called to Portsmouth with her canteen, to help in the feeding of the bombed out people after the recent severe raid there…

Tuesday 14
…Charlton sent me a copy of a most abusive letter he had written to R.O. Dunlop about that gentleman's article referring to the Slade in *Picture Post*[3] – 'ignorance', 'downright dishonesty', 'inaccuracy', & 'bloody cheek'.

Wednesday 15
Ironside, of the Tate Gallery, is in Oxford, getting up a show of paintings & drawings for the Contemporary Art Society in the Ashmolean. He is going to show three of my Oxford drawings. Parker is buying the one of Vanbrugh House for the Museum, for the reduced price of £8-8-0.

Thursday 16
…Bob Wellington came to see us…He is running picture exhibitions up and down the country, officially.

Saturday 18
…Started reading Charles T.'s typescript of *Alfred Tennyson 1809-1833*. He says it will have to be recast, or approached from a different angle, as in its present form it duplicates

3 'The Life of An Art Student', *Picture Post*, 11 January, 1941.

too much of the work of Harold Nicholson & others; but there is plenty of new infor-
mation in it from the Tennyson & Eyncourt papers.

Monday 20
People talk about the shortage of meat. In Oxford Market the butchers' shops are quite
empty except for sausage-meat, and queues are waiting for that. Fish, game and poultry
are expensive. There was a notice on one shop-front – 'Positively no rabbits whatever'…

Wednesday 22
Many artists are ruined in this war. Many write…for advice or information about jobs.
Anthony Devas, who is going about the country painting portraits (which is at least
something, while it lasts), would like some settled teaching work. Cheston, who is in
Bristol, would like something other than the mechanical copying of plans on which he
is engaged. [Cecil] Brown, the Prix de Rome sculptor, sends a conceited, illogical, consci-
entious objector's letter asking about teaching work: he has given up some work in the
potteries on account of the 'stupidity' of business men…I remember the phallus labelled
Christ which Brown once sent to the National Society, from which it was removed before
the opening of the exhibition…

Thursday 23
Invited by the Minister of Information to serve on the Artists' Advisory Committee. I
would rather not do it, but it is a not a thing one can refuse.

Saturday 25
Trouble about finding a figure model for the School…Engaged a German refugee, a Dr.
Berkowitz, poor devil: he is being kicked out again, to America, in a week or two.
N.B. – He wasn't. We recommended him as model to Muirhead Bone in June (see June
25) and I believe he got a respectable job in an Oxford Hospital. Bone wanted someone
to wear the black oilskins with which he had asked the Admiralty to supply him for his
painting of mine-layers.

Wednesday 29
…to London, for my first sitting on the Artists' Advisory Committee of the Ministry of
Information…The Committee at the N.G. was Russell, Gleadowe, Dickey, Muirhead
Bone, Peake of the Air Force and Crowe of the War Office. Clark was absent with 'flu.
Looked at a lot of pictures and drawings submitted for purchase, and some that were
commissioned. Trouble about the Royal Academy, some members of which feel hurt at
the actions of Clark's committee – want to know why there should be a such a commit-
tee, in fact, when there is an Academy – and the King has intervened. Storm in a tea-cup.
Russell is unmoved, and as a matter of fact about 10 members of the Academy are
employed through the Committee. If they want to paint the War, there is nothing to
stop them. Special facilities could be arranged through Lamb. But still, there is a feeling
of awkwardness about Clark…

Thursday 30
…to St. Giles' Parish Room to hear John R. speak to the Slade Society on *The Tate Gallery
in War Time* – which he did well, and was not too long…the Fellows [St. Catherine's]

want me to do a second drawing of Chaytor, as they don't approve of the first, [this] is rather disappointing...

Friday 31
Mrs. Durst – Clare – ill in her boarding house in Holywell. She is a Christian Scientist... Birdie has been much bothered about her and after much trouble has discovered a Christn. Sc. practitioner in Oxford...The Slade students have been asked by Albert to volunteer as fire watchers in the Ashmolean in case of raids. I shall have to go over too if anything happens at night. It probably means spending the night in the lecture room...

FEBRUARY

Saturday 1
Ernest Jackson visited us at the School. I congratulated him on his portrait drawings which are now being shown by the Ministry of Information at the National Gallery. He said some of them were done under rather trying circumstances, with a big gun going off at close quarters and other war-like things happening. He is on his way to Leamington, to join the camouflage organization there. He will be in good company: Monnington, Burn, Schilsky, Carline, [G.] Grayston...

Monday 3
Will R. came to Oxford...to see about the reproduction of his drawings of airmen, by the University Press. He was in R.A.F. uniform. He showed me a number of photographs of the drawings, some of which, as Charlton said, are excellent and a variation on his previous manner. I borrowed the photographs, as I wanted to stick up some reproductions of portrait drawings, mostly by old masters, for the students to look at. It was Albert's suggestion to put Will's up with them...

Sunday 9
...Durst looks very well in his Major's uniform. He has been carcering about England on his Admiralty job, and goes to Falmouth to-morrow. He described the amount of destruction in Portsmouth High St., & in Southampton...Bish telephoned to Alice – he wants to take a flat in Bushey, & get married. He says other people in the School get married on the same income that he has, and don't seem too up against it...

Monday 10
[Robin] Ironside hanging his Contemporary Art Society show in the Ashmolean...Lowinsky is upset...by being outshone by numerous Paul Nash paintings, higher than his in key. He complains that his picture is killed by them. I said 'What *does* it matter?' One's pictures usually get some recognition if they deserve it, and exhibitions are usually trying – one expects it: pictures seldom look their best in more or less accidental company. Tommy said to Ironside, looking at the Nash's, of eggs or molehills or some such odd shapes – 'I wonder what people will say of these in fifty years'+ time?' 'Ah', said Ironside, 'they will understand them then.' I wonder if Ironside does now? There are things by Geoffrey Tibble, too, which Ironside & Tommy disagree about...

Tuesday 11
I don't know whether I have noted this before, and forgotten that I did: but there is a painting by Augustus John, reproduced in a book which I saw in a shop window in the Turl, and called 'Old Ledanois' – a study of a French peasant. Now, I knew the subject of this picture: he was the proprietor of the inn at Siouville in Normandy; he was painted by Lamb, as well, I believe, when he, too, stayed in the pub; and later, about 1911-12 I stayed there, when I spent 3 weeks in Siouville with Kate Syrett & Helen Anrep. (They stayed in rooms in a cottage belonging to a Mme. Polidor). I drew him more or less from memory in an amateurish, Daumier inspired sketch. His name was not Ledanois, but Hamel. Ledanois was the verger, who sang amusing songs...I carried, or helped to carry, Hamel up to his bed when he died of alcoholic poisoning, and I went to his funeral in the village church. They used to tell stories of how John opened a bottle of wine by cracking the neck against a stone.

Wednesday 12
...[W.A.A.] Committee at National Gallery...Barnett Freedman's big picture of camouflage has just been added to the collection. Discussion, among other matters, about the desirability of making pictorial records of the changes in military uniform: no enthusiasm for this. I said *sotto voce* to Gleadowe that I wouldn't be very keen to do the job myself, though I had done diagrams for two books on costume. He said he knew I had, and that *Kelly & Schwabe* was one of the most thumbed works in Winchester School Library, where there were two copies, both in tatters...P. Nash's expensiveness as an official artist was also debated. He wants a special allowance for long-distance telephone calls, to which he is much addicted. Both Clark & Peake agreed that though they had received dozens of such calls from Nash, they were never about anything that couldn't have been dealt with equally well by a two penny-halfpenny letter...[Bone] has been coming up from Oxford on the 8.40 train after a 2-mile walk from Hinksey, works all day on his pitch, and catches the 6.5 back with a 2-mile walk again at the other end...He described his method of working on small sheets of paper for a big drawing, and sticking them together afterwards; the practical reason for this is that if the drawing is over a certain size it obscures his view when held infront of him. He uses a grey chalk sometimes, a device which had not occurred to me. It might be useful for separating a distance from a black chalk foreground. He agrees with me in liking Wolff's 'Academy Chalk Pencils', especially no. 3. We travelled home together & dined on the 6.5 train. He is a tee-totaller...and described jokingly his efforts to convert the ward-room of the ship he was recently on to his way of thinking...

Saturday 15
John Rothenstein, introduced by Alic Smith, opened the Contemporary Art Society's exhibition in the Ashmolean...

Thursday 20
G.J., & Tommy L. have both sold paintings at the Ashmolean show; and Will R. has bought 4 of Albert's book illustrations for Carlisle.

Friday 21
Will R. taught in the School in the morning and went back by the 1.50 bus to Gloucestershire...John's first *Fragment of an Autobiography* is out in *Horizon*. Most people think

it very good and hope for more.

Wednesday 26
London, Artists' Advisory Committee. Kenneth Clark in the chair. The Committee would only buy one of Willie Clause's numerous drawings of the interior of the air-raid shelter of which he is Warden. I must say they were not his best work. He is so good when he is entirely distinctive & spontaneous, and these drawings were not of that kind. Kennington is extraordinarily variable too, and weak in self-criticism. Some of his big pastel portraits are downright bad, but here and there he produces one which might be by a good artist of the Holbein school. Travelled home with M. Bone. It...was due to him that I got the commission for the *Oxford Almanack* drawing...He told me of a humourous scene when he met John Quinn, the American collector, in New York for the first time. They had not met, but Quinn invited Bone to dinner. He went up in the elevator to Quinn's flat. Quinn received him in the hall, and took his coat. 'Put your hat there', he said, and Bone automatically did what he was told; finding to his amusement that he had put it on Epstein's bronze bust of himself, which had been planted for the purpose...I don't know what happened to John's full-length portrait of Birdie that Quinn had, and for which he paid £800. Quinn sold it, I believe.

MARCH

Saturday 8
Birdie & I went to The Playhouse – a play by Gertrude Jennings. In the middle of it the actors gave notice of an air-raid warning. When the play was over I went over to the Ashmolean, to see whether the Slade-Ruskin fire-fighting party had turned up. There were a dozen of them there – about eight women. As there was nothing happening, Gardner put the 'History of Art' slides on the screen in the lecture room, to entertain the students until the 'all clear' went, which it did about 10.15.

Tuesday 11
A moon-lit night, and an air-raid warning. Went over to the Ashmolean. The students' fire-fighting party turned up and stayed till about 11 o'c. I believe it was to-night that Miss Felicity Sutton decorated the statue over the centre of the Ashmolean pediment with bits of drapery. She must have gone to some risk to do so, as Gardner had some difficulty in reaching the drapery to pull it down...

Wednesday 12
Went to London for a Ministry of Information committee...Met Dodd. His method of doing a portrait drawing is to make a preliminary careful but possibly untidy study to get the construction & proportions and then trace it off for the final work...

Friday 14
Yet another alert about 8.45. Looked in at the Museum. The students' party there, most dutifully...I have told Gardner I shall not appear every night...[he] was a sergeant-major in the artillery in the last War. He is now in the Home Guard (so is Parker) as well as looking after the Museum...

Tuesday 18
Evan Charlton, at Cardiff, managed, with the students' help, to save his Art School from being burned. They extinguished a quantity of incendiary bombs. Ceri Richards was injured in the face…

Thursday 20
Borenius, who came down to conduct his History of Art Examination, described his experiences when carrying despatches recently for the Finnish Government to Berne. He flew to Lisbon, on a course which took him some 300 miles out west into the Atlantic, from an unknown aerodrome. He started from the Bristol plane works, but changed planes before leaving England. From Lisbon by train to Madrid, and thence by plane to Barcelona…Spain is in a miserable state with starvation and discontent, but Portugal is comfortable & normal. German agents everywhere, some even in uniform. His impression of Free France, which he passed through on his next stage, was that the people were curiously light-hearted & out of touch with the tragedy of the war. Switzerland is not doing too badly, though there is some decline from the previous high standard of living. He thinks the Swiss will fight if attacked, and the Finns again, too, if need be.

Friday 21
…Cumberlege, of the University Press, has bought my drawing of *Worcester* (his old College) from Beaumont St.

Saturday 22
Last day of Slade term. Lunch with Albert in Common Room at New College, the Water-fields [Mr & Mrs. Aubrey W.] being his other guests. They, of course, have had to abandon their villa in Italy, and came home with great difficulties, via Spain. The other Waterfields, Humphrey's parents, who lived comfortably & happily on the Riviera before this War, could not face the miseries of being uprooted and the general horror that they foresaw ahead of them, so, being elderly, they decided on suicide. She drugged herself with veronal[4] he then shot her, and shot himself afterwards. When Waterfield was at the Slade with John & Orpen, Maxwell Balfour was looked upon as one of the most prominent and promising students, in the second rank. He used to say 'John is a peril to the Slade', distrusting John's great facility in *pastiche* and the adaptation of old masters. Mrs. Aubrey W., about the beginning of last War, bought a drawing of mine – I believe from the Friday Club. This they still possess. It is in ink & wash, originally blue ink, but the Italian light has turned it, so they say, an old masterish brown. I remember at that time I used Field's writing ink, 1d a bottle because I liked the colour…

Monday 24
Pursued the Vicar of St. Mary Magdalene, the Rev. B. Hack, from Broad St., where he lives, into his Church (sitting through a service in that interesting building) in order to get Alice's banns published there…

Wednesday 26
London…At the Redfern Gallery in Cork St. saw an exhibition of Eurich's paintings, including a big one of the embarkation of troops from Dunkirk. He has improved very

4 Also called barbitone, the first commercially-marketed barbiturate, used as a sleeping aid 1903-50s.

much and is now a very interesting, personal & meritorious painter...Dodd...met me
to give me a drawing of myself done in 1915, now a wedding present for Alice...

APRIL

Wednesday 2
Went to London to start a pastel head of Miss Colles, daughter of Paymaster Commander
Colles, R.N. He has a house in Ambassador's Court, St. James's Palace, but his work just
now seems to be at Windsor Castle. I owe the commission to Gwynne-Jones, who meets
the Commdr. at Windsor and recommended me...I started operations at 3p.m., after
lunch at the Athenaeum, where I met Dodd & Lutyens, engaged to-day on the R.A.
hanging. Gere was also there. Lutyens says he has been a member of the Athenaeum for
fifty years. Met Darcy Braddyll too, now engaged on building a hospital. He looks upon
his work on county houses as gone, both now and after the War. He related that when
he did up Lord Melchett's house (Harry Mond's)[5] in Smith Square [Westminster] he
collaborated with [Charles Sargeant] Jagger the sculptor and Glyn Philpot [murals]: when
he told Paul Nash this, Nash said – 'Good God, Braddyll, how can you work with such
a pair of charlatans?' the house has been bombed since.

Thursday 3
Reports in the papers about Virginia Woolf's death, supposed to be suicide. Not much is
said about it. With Jugo.Slavia, the battle off Cape Matapan and the campaign in Abyssinia
and elsewhere (100 miles to Addis Ababa now) there are other things to talk about...

Sunday 6
Attended a very high Church service in St. Mary Magdalene to hear Alice's banns
published a second time. Bish came to Oxford...

Monday 7
We all left for Sheffield. Drove to the Barnes's house in Witham Road, and had sherry
with Professor and Mrs. Barnes while waiting for a car to take us to Baslow and Grislow
Fields Farm. The Barnes's house has the windows stopped (many of them) with water-
proof paper, and the plasterers are putting up the ceilings again...

Wednesday 9
To Baslow and thence by bus to Bakewell to get our ration tickets and our bacon supply.
Cigarettes are now unprocurable in this district...

Saturday 12
...Letter from Elton – 'London looks like Paris did after 1918 plus all sorts of vast smashes
round the White Stone pond. Jack Straw has the middle part standing but I doubt if
they'll keep it: five small Union Jacks had been fixed to the balcony, what was left of it.
The whole of North End village had gone in a puff of smoke...Hampstead is really begin-
ning to show signs: to make one think of Wells's early novels about Martians and gigantic

5 The commission by Henry and Gwen Mond (née Wilson, a Slade student under Tonks) was one of Jagger's
most important; *Scandal* (now in the V.&A.) was a satirical reference to the Mond's *ménage à trois* with
writer Gilbert Cannan.

explosions. But people take no notice of daylight sirens at all now, and seem mostly to sleep in their beds at night. So it looks as if we really did win the battle there. Anyway the first part of it.'

Sunday 13
To church at Baslow. A well conducted service…full congregation – the last factor unusual in these days…Went on with the drawing of Grislow Fields farm…

Thursday 17
…Uncle Bill arrived…He has a week's leave from Lochailort. It is the first time we have seen him in uniform….Fairbairn & he don't get on so well together as they used to. Fairbairn hates this country, and grumbles and is miserable: Bill likes his job and thrives on it. The Hythe Gunnery School, after sending a representative to inspect the doings at Lochailort, has adopted a good part of the method of shooting taught by Fairbairn and Bill. Their design for a lethal knife has been taken up and manufactured in thousands by the Wilkinson Sword Company: it is stamped F. & S.: Fairbairn & Sykes.

Saturday 19
…2.45 Alice's wedding in Baslow Church. To-day is also the anniversary of Birdie's wedding & mine in 1913. The Rev. Mr. Drew could not officiate having a cold, but his friend Canon Hewson took the service, and performed the duties very pleasantly & well. He is 80 years of age. Mrs. Drew played the organ. A large contingent about 35 or 40 of the Barnes's friends came to the Church and to the little reception at The Rutland Arms afterwards, where a reasonably plentiful collation was eaten and five bottles of champagne drunk: three were supplied by the pub and were expensive without being good, the other two came from Professor Barnes, Epernay 1928, and were well worth the 17/6d I paid for each of them. The hotel bill was just under £10. The bride looked very pretty – everybody said so – and the sun shone as she came out of church. John Barnes, as best man, proposed the health of the bride and groom, and Bysshe replied. Everything seemed…to go off well…No one had the temerity to put on a tall hat or tail coat, and the informality seemed suitable for a war wedding. Alice & Bysshe drove off to The Peacock at Rowsley, and Birdie, Ann Bassett, Maud Manners, Dora, Bill & I went back to the farm.

Sunday 20
Left Grislow Fields at 11 o'c.…We reached Oxford about 5.45.

Wednesday 23
In London for my Committee. Fresh ruins after the heavy 'blitz' on Wednesday & Saturday…A land mine has fallen in the centre of Willie Clause's studio in New End, but has not, so far, gone off. Muirhead Bone, who had tea with me after the Committee and with whom I travelled home, described the progress of his vast drawing, 6ft. x 4ft.: it is now finished and in the hands of Colnaghi's man to be stuck together & framed. As the paper was not used always the same way of grain, it has stretched unevenly and does not always fit. Bone has had a lot of trouble scraping out the misfits and re-drawing them to make them join up. Two frightful portraits by James Gunn & Birley were submitted to our Committee through Air-Commodore Peake, & rejected. Very interesting

drawings of shelters by Henry Moore. Clark dislikes W. Roberts's paintings…

Thursday 24
To London for another sitting from Miss Colles. The house in Ambassador's Court has a good many windows smashed…Miss Colles was working at her First-aid post last Wednesday. A parachute mine fell just beyond the Palace (St. James's) on the edge of Green Park. Bridgewater House is gutted. A leg of one of Landseer's lions in Trafalgar Square was blown over the Admiralty Arch into the Mall…It is said that 1100 civilians alone were killed in last week's strafing, besides about 150 Canadian soldiers…

Friday 25
A.M. Hind sometimes doses in one of the rooms in the vaulted basement of the B.M., where he does most of his work now. An oil bomb came through the dome of the Reading Room, but only one book was destroyed. There is a large bomb crater full of water in the Museum forecourt…Steer still goes on living in his house in Cheyne Walk, with his house-keeper, but Russell has gone to Bourne End. Final sitting from Miss Colles…Met Dodd at the Athenaeum, suffering he admits, from war nerves and depression. He does not sleep well now. His studio windows have been smashed again and a large firebomb fell in his garden…

MAY

Wednesday 7
Ruth Lowinsky drove me up to London, in company with Prince [Matila] Ghyka…delivered my portrait to Mrs. Colles, in St. James's, and went on to John Parkinson, 12 o'c., to be over hauled about my heart, which Tom Cobbe says is behaving oddly. Parkinson put me through it most thoroughly for an hour and a half, with X Rays and electric tests…says I must accept the fact that my wind has gone, and that I should behave accordingly. Strenuous exercise is not encouraged too much. I am to see Hobson in Oxford, to see whether a treatment can affect my short-windedness…

Friday 9
Huskinson called at the School. So did Ghyka, bringing another volume of his works on a system of rhythm & proportion (*Le Nombre d'Or*)[6] for my inspection…

Saturday 10
…Most of the tobacconists in Oxford have notices saying 'no tobacco; no cigarettes'…In the afternoon, Albert was drawing Lord David Cecil…

Monday 12
Slade Scholarship judging, with Charlton.

6 *Le Nombre d'or: Rites et rythmes pythagoriciens dans le developpement de la civilisation occidentale* (Paris: Gallimard, 1931, trans. *The Number of Gold: Rites and Rhythms Pythagoreans in the Development of Western Civilization*). Prefaced by his friend and admirer Paul Valéry, it ran into many editions and translations. Ghyka published his memoirs *The World Mine Oyster*, 1961.

Tuesday 13
Met Fairlie Harmar, who is living in Oxford with her husband. Apparently they have only succeeded in getting a bed sitting room…their house in Cheyne Walk was damaged in a raid. They escaped in their night-clothes. At The Randolph, 10 o'c. Albert, Johnny Bryson, Ensor Holliday. Talked of the blitz on Westminster & Waterloo (very bad) and of [Rudolph] Hess's[7] aeroplane descent on Glasgow, which amuses everybody…saw Dr. Hobson in St. Giles's at 5p.m. he is a friend of Parkinson…The result is that I am to take digitalis pills, and report to him in a month…He says, too, I am not to do any more fire-watching…

Thursday 15
New English Executive meeting in the Ashmolean…We decided to hold the show as usual in the autumn, and to send it round the provinces…

Friday 16
Charlton wrote me a very indignant letter about the Contemp. Art Soc. holding a show of the Euston Road School in the Ashmolean, over the head of the Slade and Ruskin Schools. This he regards as not merely a piece of tactlessness on the part of Ironside, but as a deliberate attack upon us. He has a morbid suspicion of Messrs. Pasmore, Coldstream & co., who he says hate the Slade and would do anything that would serve their own interests to damage it. They say that I should never have been Slade Professor, but that Duncan Grant ought to have been appointed. They abuse Charlton, 'Nazi blackguards' he calls them. He is afraid that they might open their school in Oxford: but with Coldstream in the Army, Pasmore likely to be called up, and other circumstances that Elton tells me of, such as the difficulty of finding premises, or accommodation of any kind for students, this seems unlikely. Albert, Elton & Freedman (who knows the Group well, and does not like or trust them) all think that Charlton has a complex on this subject, and exaggerates. Charlton is rather addicted to writing wild and abusive letters…

Saturday 17
Kenneth Clark opened the Euston Road exhibition in the Ashmolean at 3p.m. a completely harmless speech, making no extravagant claims and saying nothing that could possibly be construed as hostile…Met Helen Anrep, Pasmore (with beard now), Rogers, Fairlie Harmar, the Lowinskys and many more – a big crowd…

Monday 19
Left by the 10.20 train for Bournemouth, via Reading & Basingstoke, to do the Board of Education Exams…Imperial Hotel. At tea, Mrs. Travis. Walked with her afterwards on the cliff towards Boscombe. At dinner Travis, Mrs. T., Woolway. Southampton School of Art has been badly bombed, and over 20 of the students killed. There was a curious effect of plaster dust on this occasion, which impregnated peoples' skins. Though it could be got off the hands, with some difficulty, it took three weeks to wear off the face. The Head of the School was puzzled to see what he thought at first were bits and pieces of casts from statues, far from the part of the building where they were kept. These were in reality heads, arms, legs, etc. of dead students. Travis is seeing about its evacuation to Winchester, which has escaped so far. Endsor, of the Board staff, has been blown up in

7 Hitler's Deputy flew to Britain in an attempt to broker a peace deal.

Bournemouth losing his clothes, his teeth and his glasses. It cost him £21 to replace his clothes, in order to appear in public at all. Woolworth's here is burnt out. Woolway's furniture has been destroyed in a repository, and Travis's house is damaged. He fell three stories to the ground. He was in bed when the bomb fell. He describes turning over in the air, and slithering down over the rubbish. His wife, and another man from the Board, were in the same lodgings, and shared the same fate. All…were cut and bruised. The other fellow has a piece of glass in his back still, which can't be got out, and he showed me a piece that was removed from his eye. Seven or eight persons were killed in the adjoining house.

Thursday 22
Ceased to work at 5 and went by bus to see Christchurch, through the uninteresting suburbs which connect it with Bournemouth. A very fine church, but we could not get into it – it was too late. A few pleasant old houses, an old bridge and parts of a Norman castle are left in the centre of the town, and there are flats by the side of the Avon which might be reasonably pleasant to walk about in, apart from the gasworks and some untidy waste land covered with rubbish…The Municipal College & Art School is a hideous, silly and expensive building, reminding me of the one I worked in in Camberwell. Baker, whom I met, is the head of it.

Friday 23
Finished the Drawing Exam about 3 o'c. and all of us – Luard, Travis, Mrs. T. and I – took the 5.15 train to London…Mrs. Travis wanted to show me some of the Bournemouth art students' work which was being shown in a waiting room at the railway station; but she was told the room was engaged by the military; they said 'that was the reason' indicating a German airman prisoner in grey uniform, with a gash on his face, who was being given a cup of tea by one of our own soldiers, and smiling amicably. Luard is Deputy Chief Air Warden of the Marylebone district. Travis & Mrs. Travis are Air Raid Wardens in Richmond.

Saturday 24
Slade. Albert is at home this week-end. Miss Yexley, our former figure model called. She is now stage managing a repertory company at Landindrod Wells, and has altered and smartened her appearance…I hear old Voysey is dead. He used to be in the Dover St. Arts Club a good deal, a lonely, rather depressed figure, feeling his age…

Tuesday 27
News of the sinking of the *Bismarck*. Great satisfaction at this offset to our heavy losses at sea. Paul Feiler came to see me, having arrived back in Oxford after about a year's internment in Canada and elsewhere. He thanked me warmly for the efforts I had made to get him out. It was a long business. He looks very fit, and is not resentful, knowing the conditions, and having come in contact with internees who really have Nazi sympathies. G.J. reports that Connard roundly abused John Rothenstein for having a hand in the purchase of the Duncan Grant through the Chantrey Bequest. He said he would devote the rest of his life to getting J.R. sacked from the Tate: to which J.R. replied that no one would come to the R.A. to learn anything about painting, but the next time he wanted a lesson in malice, venom and intrigue he would come to the R.A. Soirée…

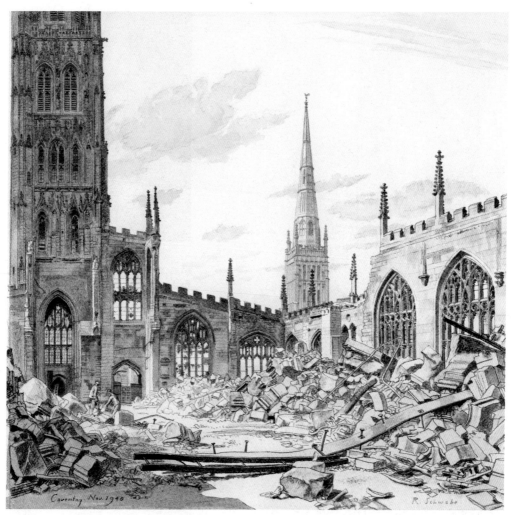

PLATE 18

RANDOLPH SCHWABE
Coventry Cathedral
1940 • pencil, conte crayon, wash on paper • 38 × 39.6 cm

PLATE 19

WALTER BAYES
Tattooist's Parlour, Colchester
1940 • pen and ink and watercolour • 32.4 × 39.4 cm

PLATE 20

EDGAR HOLLOWAY
Harry Jefferson Barnes
1941 • etching • 17.7 x 12.7 cm

© THE ARTIST'S ESTATE.
COURTESY JANET AND DI BARNES

PLATE 21

AUGUSTUS JOHN
Father Martin D'Arcy, 6th Master
mid-1940s • oil on canvas • 58.4 x 48.3 cm

© THE ARTIST'S ESTATE.
COURTESY CAMPION HALL, UNIVERSITY OF OXFORD

PLATE 22

MUIRHEAD BONE
Winter Mine-Laying off Iceland
c.1942 • oil on canvas • 127.9 x 160.6 cm

© IMPERIAL WAR MUSEUMS

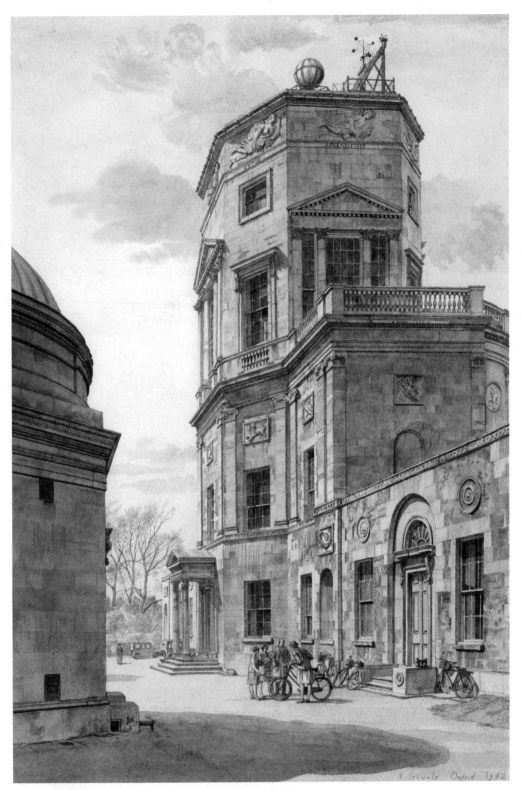

PLATE 23

RANDOLPH SCHWABE
The Radcliffe Observatory, Oxford
1942 • watercolour on paper • 56.5 × 38.7 cm

PLATE 24

CHARLES MAHONEY
The Death of the Virgin
oil on board • 29.3 x 28 cm

© THE ARTIST'S ESTATE.
COURTESY CAMPION HALL, UNIVERSITY OF OXFORD

PLATE 25

RANDOLPH SCHWABE
Janet Barnes
1944 • pencil on terracotta coloured paper
17.6 x 13.4 cm

© THE ARTIST'S ESTATE.
COURTESY JANET AND DI BARNES

PLATE 26

PAUL FEILER
Boats and Sea
oil on canvas • 87.5 x 90.8 cm

© THE ARTIST'S ESTATE.
COURTESY BISHOP OTTER TRUST,
UNIVERSITY OF CHICHESTER

PLATE 27

RAYMOND MASON
Ginette Neveu
1945 • oil on canvas • 39 x 31.5 cm
© ADAGP, PARIS AND DACS, LONDON 2012.
ALL RIGHTS RESERVED. SWINDON MUSEUM AND ART GALLERY

PLATE 28

BEN ENWONWU
Monotony
1948 • oil on canvas • 91 x 71 cm
COURTESY THE BEN ENWONWU FOUNDATION
AND BISHOP OTTER TRUST, UNIVERSITY OF CHICHESTER

PLATE 29

IVON HITCHENS
Autumn Stream
mid-1940s • oil on canvas • 59 × 108.5 cm
© JONATHAN CLARK FINE ART, REPRESENTATIVES OF THE ARTIST'S ESTATE.
COURTESY BISHOP OTTER TRUST, UNIVERSITY OF CHICHESTER

PLATE 30

RANDOLPH SCHWABE
The Square, Swindon
1947 • pen and wash on paper • 35.5 × 50 cm
© THE ARTIST'S ESTATE. COURTESY SWINDON MUSEUM AND ART GALLERY

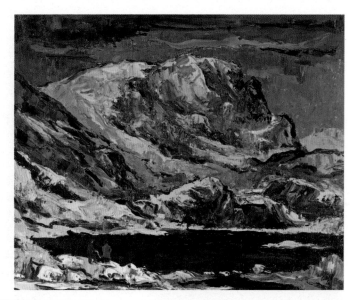

PLATE 31

KYFFIN WILLIAMS
The Dark Lake
1951 • oil on canvas • 44.5 x 54.5 cm

© LLYFRGELL GENEDLAETHOL CYMRU/THE NATIONAL LIBRARY OF WALES.
SWINDON MUSEUM AND ART GALLERY

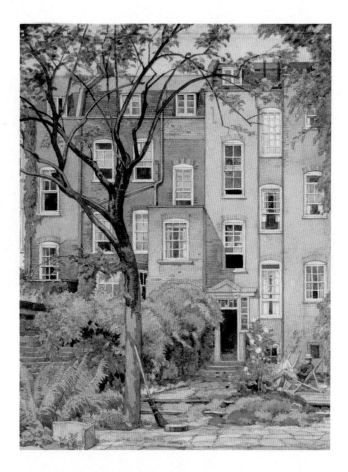

PLATE 32

WILLIAM GRIMMOND
A Hampstead Garden
1929 • watercolour on board
37 x 27 cm

© THE ARTIST'S ESTATE.
COURTESY JANET AND DI BARNES

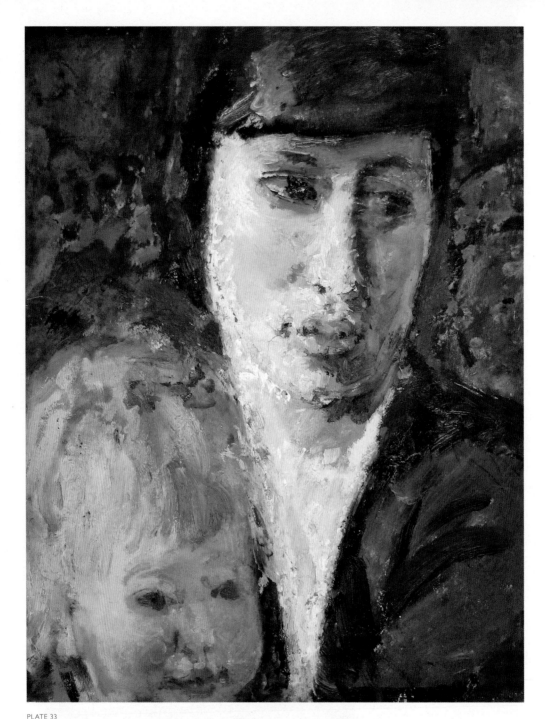

PLATE 33

ETHEL WALKER
Mrs Randolph Schwabe and Child
1916 • oil on board • 36 x 28 cm
© THE ARTIST'S ESTATE / BRIDGEMAN IMAGES. COURTESY JANET AND DI BARNES

Wednesday 28

Eric Newton, who is rather an ass, has a notice in *The Sunday Times* of a memorial exhibition dedicated to Mark Gertler's work. After talking of 'the brilliant early promise', he has, in another paragraph, this statement:- 'The exhibition shows how he made one false start, influenced by the prim domesticities of the Slade School (see *The Artist's Family*, painted in 1911), but soon had the courage to shake off the influence and establish himself on firmer soil. Then came a period of experimental but quite consistent growth that culminated in the lovely *Servant Girl* in which he pays a personal but by no means a slavish homage to Renoir. And then he plunged into those essays in hectic colour and deliberate design that are so reminiscent of the somewhat tasteless exuberances of mid. Victorian needlework.' Agreed as to the latter part; but what if the essential Gertler were precisely in the 'prim domesticities' of family life and Jewry, or at least in a naturalism which followed on, through, as Newton says, a personal homage to Renoir (a phase which the Slade would by no means have discouraged)? So much of Gertler's later work was second-hand, what he conceived to be the gospel according to Cézanne or Picasso. He may have been working up to something, as Newton begins by suggesting, but even Newton agrees that he hadn't got there. I have been reading *Horizon*, a high-brow monthly: it gives some indirect support to my own theories on Gertler, in a chat on Proust & James Joyce. Here are views which the ordinary person like myself held some time ago, when they were no means high brow. The commentator says he has been taking up Joyce & Proust again 'with considerable disappointment: they both seem to me very sick men, giant invalids who, in spite of enormous talent, were crippled by the same disease, elephantiasis of the ego......both failed for lack of that dull but healthy quality without which no masterpiece can be contrived, a sense of proportion.' Charlton recalls his impression that Gertler attained fame – that is, he was 'news' in the press; before John did. Charlton remembers going to a rehearsal at The Cambridge Theatre when Fay Compton sang a musical ditty about him. He, Gertler, must have been very young at this time, and it was before John had also been sung about on the stage, as I remember during the last War at the Chelsea Matinée, when a female dressed in the sort of clothes Dorelia wore chanted –

'John, John,
How he's got on!
He owes it, he knows it, to me.' etc.

Friday 30

The three RAF men who crashed and were killed in Linton Road, off the Banbury Road, recently, were, we are told by John Barnes, in the habit of joy riding, flying low, and waving to their friends in a particular house. On this occasion they over did it, and took the roof off the house. The occupants were either killed or terribly disfigured...

Saturday 31

Elton busy removing the last of the Slade property to Chastleton, with Ward, a student, helping him. I went to London, on the 10.20 train, to 'alter' Jane Colles's mouth, according to instructions from that dragon her mother, also, as she politely put it in a letter, to 'make her body look less sloppy'; but the dragon is not a bad sort really...and, if she knows how to be rude, knows how to have good manners too... Before going to them,

I went to the Athenaeum and met Andrade, who invited me to lunch at the Savage, where he said…that the food was better. I had not been there before. The house is Curzon's old house: it has a grand staircase and the dining room is a fine apartment, with good decoration, mantel-piece etc. most of the rest of the club is shut off, having been damaged by 'enemy action'. Noticed a flashy, clever painting by Hal Hurst, a typical Savage of not so long ago. When I was a boy there was a lot of his illustration about, smart, superficial stuff which I never liked. There was a painting or two by James Pryde, another artist who devoted too much of his time to this sort of club, and to being a buffoon. But when, late in the afternoon, when I went into the R.A. (where I met the genial deaf Pitchforth and H.M. Carr) I saw a good picture of his, bought by the Chantrey: John's early *Yeats* too, very good: the *Athlone* has a deceptive vigorous look, and the evidences, or ruins of them, of John's vitality, but obvious faults. Noticed Duncan Grant's interior, good, Ethel Walker's portraits, Kelly's of the Queen, unatmospheric and not good colour…a bad Dodd of Nellie Tanner and a huge Grace Wheatley (didn't know she could do it)…

JUNE

Monday 2
The students having a holiday, I worked in the School for a while on my painting of Cerne, making some alterations to the sky, on Will R.'s suggestion (when he was last in Oxford). Elton has now got away all the artists' materials that were left in the Slade: they may be useful in view of possible – indeed, probable – shortage. Some things are difficult to get already. The students – chiefly, I think, James Bailey & a dreadful youth named Richardson (from Stowe) have got up a show of some drawings & paintings in Castle Street. I went, late, to the Private View. Riley has improved a good deal in his work. (Sudden) Announcement of the rationing of clothes with margarine coupons causes a lot of talk, but little real complaint…

Tuesday 3
Left for Bournemouth…We were unable to book rooms…for Monday night, on account of the holiday crowd, or we should have started work at 10 this morning…Travis, Luard & Woolway had arrived in Bournemouth shortly ahead of me. I got to the hotel about 2.30, being greeted at New Milton by the sirens. Travis says that in Canterbury, where he has been, there was usually only an hour in the twenty-four that was 'all-clear'…

Wednesday 4
Exams…with intervals for excellent meals at the hotel. Sirens in the night, and a loud 'crump' which rocked the hotel slightly…Travis and Woolway are very loyal to the memory of Augustus Spencer, who, they think, did far more for the College of Art than Will Rothenstein did, and left him an organization without which he could have done nothing. They think Will R. should and could have done more for the industrial side-typography, for instance. I pointed out the lack of space: they said it was his business to get other buildings, and that he was chary of running counter to the board, wanting his knighthood…But when I consider his staff and compare it with Spencer's men – Hayward & B.A. Spencer positively futile, and both relations of Gussie's – and Anning Bell whose influence was not of the best – I am inclined to see another side to the case. Travis and Woolway don't like Barnett Freedman either. I suspect a prejudice has grown up.

Friday 6
Left Bournemouth, 11.12. got to Oxford in time for tea…

Monday 9
Charlton helped me to arrange the Diploma work for the Examiners to see to-morrow. He is very good at this sort of thing. He spent the evening with me, discussing the ignorance of Herbert Read, the poetic theories (they can be adapted to one's own art) of Matthew Arnold (whom I have for the first time in my life begun to read) and the War.

Tuesday 10
Diploma Exam. Russell, Ledward, Borenius, Ormrod, Bayes. Borenius and I lunched at Anderson's in George St., 3/6d each…All the candidates passed, much to my relief, as I had been bothered about little Miss Northend in particular, who is weak, but such a deserving girl, who would make a good teacher, and to whom the diploma is so important. Russell & Borenius, indeed, congratulated us on an improved standard. Students like Tony Bayes and John Turner of Belfast show up well.

Wednesday 11
Hendy's last lecture on Velásquez. A real pleasure to have one's memory so pleasantly jolted and one's old impressions so persuasively reinforced. I have always deeply admired Velásquez, and vividly remember my introduction to that astonishing work, the *Innocent X* [1650] in Rome. What a man Velásquez! So humane, so urbane: what a *draughtsman* – we all know he was a painter. 'Bon dieu, quel oeil!'…Albert busy drawing Patricia. Talking of Humbert Wolfe's [autobiography] *Upward Anguish* [1938], he told me that Wolfe's engagement to Jessie was a youthful affair, as that he afterwards fell in love with Essil Elmslie: he told Jessie all about this, but she, being still in love, wouldn't let him go, not taking the greater breadth of view that it might be more generous and wiser to set him free. Even in his Bradford days, Wolfe thought people disliked him because he was a Jew, whereas nobody in Bradford cared a damn whether he was a Jew or not. His brother was disliked, but not on that account.

Friday 13
Will R., in air-force uniform, teaching in the Ruskin-Slade school. An air-raid warning for about an hour at lunch-time, so that according to instructions from the Keeper, the students suspended work for that time…

Saturday 14
Ivy and Charles came to the Ashmolean and bought a water-colour of Bosham, with boats in the foreground for £5-5-0, as a wedding-present for Hugh de Paula who is a yachtsman, and therefore is presumed to prefer pictures of shipping, especially if coloured, because most people would rather have them coloured than plain. I hope this estimate is correct, and that he will like it. Any how, Ivy wants to do me a good turn by spending the £5 she has earmarked for a present in this way and I appreciate that £5 is better than no sale at all. Did two nude studies of Jane Henderson, the actress-dancer-model befriended by Gerald Kelly (to whom she is duly grateful), in the afternoon. She has been drawn by Matisse…at Perpignan…She talked about Juan Gris and other artists in Paris. Gris, she says, had not a penny, and more or less starved in Monmartre, though he became famous.

Tuesday 17
Fuss with the police about a light which had been left on in the models' dressing-room at the Ruskin School, and became visible in black-out hours. Leeds & the policeman at loggerheads: Leeds telling the man not to be an ass...hectors & bullies & loses his temper, but nobody seems to mind much – except this policeman, who was on his dignity. Gardner & I pacified him. 3.30 Left for Bournemouth...

Wednesday 18
Rokeling, one of the Board's secretaries, is in attendance at the Examinations. He has a perfect board-room manner-the stage type of the Circumlocution Office. I'm sure it is a mistake, and out of date, to cultivate this convention.

Thursday 19
The French chef at the Imperial Hotel naturally gets on very well with Luard. It was at my suggestion that Luard paid special attention to him, as I knew that with Luard's easy, fluent French and good manners it would give the old man pleasure. As a result, we had a perfect little lunch...cooked specially for us: escallope de veau...washed down with a Bottle of Beaujolais...and reminded us all of pleasant times in France: for myself, of Dijon and Max Ayrton, in 1938. Finished work about 4 and caught the 5.15 train...to Oxford...

Friday 20
I do not altogether like Augustus John's literary style. It seems to me a little 1890ish and precious and the wit a little strained. Why can't he sometimes call a thing by its proper name – an eyeglass an eyeglass, not a 'disc', and a collar a collar, not 'a Spencerian cylinder of muted white'; a dirty collar would do.

Saturday 21
Albert & I lunched with David Low and his daughter Prudence (now no longer at the Slade) at The Mitre. Low has shaved off his beard and looks better for it. He is writing something about caricaturists & cartoonists: admires Gillray [c.1756-1815] greatly...

Sunday 22
Heard the wireless announce Hitler's attack on Russia...

Monday 23
Low and his daughter lunched with Albert and me...Low talked about politics and politicians, his great interest, and was interesting about them...especially about Beaverbrook & Duff Cooper...Began judging work for Slade prizes, with Charlton, who also came in to us in the evening, shall not award a figure drawing prize, the standard not exceeding a fair average. Stanley Spencer has left Leonard Stanley and is now at Epsom...Norman Janes can't come to Oxford to teach, as I wanted him to. He is joining the R.A.F....

Tuesday 24
Judging again – G.J., Charlton, Albert & Polunin. Fruitless hunt for cigarettes and tobacco. Only cigars to-day. And beer is getting short...It is not that less is made, but that more people drink it.

Wednesday 25
Polunin & Charlton said goodbye, their work at the Slade being finished for this session. Albert & I gave a farewell lunch to Harold Jones…because he is being called up for the Army, being still under 40. He has had two books to illustrate this year, and thinks himself a lucky man in many ways, matrimony being evidently one of them, from the way he speaks of his wife & child: another child is on the way. I always look at his clear-cut features with interest. He is very grateful to Albert. Muirhead Bone called at the School to ask Albert & me to come to tea in Gavin's rooms in St. John's, to look at the progress of his picture of the mine-layer…Saw the big drawings of the men laying the mines from the stern of the special ship which does this work, also other drawings of such ships' activities, some of them very secret and unpublishable at present, which I ought not to have seen: all done at sea, under very difficult conditions, with obstacles that only Bone could surmount. The main work, from which he is going to do a painting, is huge as a drawing, and very interesting as it comes in the cartoon that he is now doing. We had some friendly dispute about the exact placing of it on a canvas that is to be. I inducted Bone into the mysteries of the 'Section d'Or', of which he had never heard. Luckily my demonstration confirmed my judgment that the principal figure should be about 1½ ins. further to the right, and as Gavin had also made a similar criticism Bone was suitably impressed. He showed me the two volumes of his great book on Spain of which he is rightly proud. I must say it made me envious that he has accomplished so much. What have I done to compare with it? Gavin came in. I thought he wasn't pleased to see me – perhaps because his father, in entertaining me, had made the rooms too untidy… Muirhead takes a naif pleasure in all that Stephen, Gavin, Mary & Gertrude do, and becomes quite uncritical. It is quite pleasant to see him purring around the rooms, showing off the family genius, including Gavin's schoolboy achievements. There is a bust of Gavin by Městrović, & Epstein's *Conrad*.

Saturday 28
Last day of the Slade…A long session after supper with Egan Mew. He says he was born in '62. He has just bought a drawing by his relative Tom Mew, a hunting scene, about 1860-70…in a shop in Oxford – 15/-.

Sunday 29
At the request of Dickey & K. Clark, I went over to Appleford to see a man named [James] Kenward, who had written to the Min. of Information asking for a job as a war artist. He is an author principally, having written a novel or so, and a book called *The Roof-Tree* (Ox. Univ. Press) illustrated by himself, besides articles in *The Architect* and *The London Mercury*. His drawings are almost untrained – he had only three months' study at Lausanne – but he has a natural bent that way, and the work is lucid, meticulous and competent: even his figures are well seen, and he bases himself on reproductions of drawings by good masters…Kenward is, of course, a Home Guard, but being only 33, is due for military service. He was trained for a business career, but his father's death left him independent…

JULY

Wednesday 2
Went to London for a Ministry of Information meeting, train late owing to a smash on the line near Slough in which five people were killed...

Friday 4
Examining at Reading University with Betts.

Wednesday 9
Finished drawing of Wadham. Tea with Paul & Bunty Nash in their garden flat, 106 Banbury Road. I went on what the Min. of Inf. committee supposed to be the delicate mission of asking Nash to submit some sort of design or project for his next big picture that he proposes to do for them. They turned down two others that he submitted, which was rather a shock to him, but as he almost immediately sold them to someone else no great practical harm was done. The Ministry propose to spend £200 on the new picture, a 6 x 4 canvas. Nash has proposed two themes, to be treated, I suppose, more on the imaginative basis than as mere records: one, the Air Battle of Britain; two, the Air War over Germany. It seems that Nash is practically dependent on what he makes. Bunty had some capital, but it is locked up (like mine) in a Hampstead freehold. He seemed pretty ill this afternoon with his asthma, and inhaled something about every quarter of an hour...He tells me that he is writing his autobiography. Alice Rothenstein said to him, when he told her – 'Oh yes, everyone is doing that since Will started!' his notions of autobiography as far as I can make out, are somewhat like those in his pictures. Objective truth is not his intention. He wanted confirmation from me about details of some of Horace Cole's famous hoaxes, but I knew nothing about the particular ones, which he proposes to describe as an eye-witness, though he never saw them. One case, that of Cole persuading persons to hold a rope in the street till he had a continuous line all round some important building, Nash proposed to write about as if he were personally concerned in it, though he did not know whether St. Paul's or the National Gallery was the building in question. He said one, Bunty the other. Thus is history made. Well, I hope it may be more credible than a sunrise water-colour that he showed me, with a blue sun in the sky. Yet some of the work he has just brought home after a fortnight in Gloucestershire is very interesting...I liked one drawing of the Forest of Dean very much. Bunty has been very far-sighted about provisioning herself when there was plenty: she gave me some of Wilkins' Tiptree jam for tea, stuff I haven't seen these 2 years. I gave her a packet of 10 Woodbines. After writing this, the news came from Ivy on the telephone of Penrose's death, Birdie went off to Norham Gardens.

Thursday 10
As Birdie thought it her duty to stand by Ivy and the canteen in the upheaval caused by Penrose's death...I took her place as a promised visitor to Alice & Bysshe in Bushey... Amusing to me, coming along in the bus by Boxmoor, to see how the long line of chestnuts, opposite the Swan, where you turn up to Bovingdon, has grown in 45 years. It is a bit more than that since I walked under them as a little boy with Eric & Mother. Started a train of reflection about her. How non-complaining, she was in the unhappinesses of her life, and how little a boy understands or sympathises with such things...

Wednesday 16
To London, for M.o.I. committee...After the Committee, Bone, Russell & I went to the Leicester Galleries to inspect a picture by Topolski, of an operation in a shelter, with a view to a possible purchase by the M.o.I.. Having seen it – it struck me as quite good, and Kenneth Clark had previously said he liked it...

Thursday 24
...Penrose T.'s memorial service at St. Martin's in the Fields. Met Alice by chance in the Tube, on her way to the Church. Having 20 min. to spare, went into the Nat. Gall. basement to see the show of drawings done for the Pilgrim Trust; some very good ones. Saw a lot by Walter Bayes & W.M. Rothenstein. Met David Rolt there. The service lasted about 20 minutes. The church more than half full. An actor read a poem by Rupert Brooke...and the choir sang *Crossing the Bar*.[8] Shook hands afterwards with Charles, Ivy, Yve, and other members of the family...Called on Beaumont, still busy in Charing Cross Road. The area just behind his shop is laid waste...

Friday 25
Did a headpiece for Bill's book *Shooting to Live*, getting my material from a copy of Meyrick[9] & Skelton in the Ruskin School.

Wednesday 30
To London, M.o.I...A longish meeting...Peake, of the Air Ministry, turned up again... Coote away ill with neuritis. I gather he is on *The Times*, and broadcasts for the B.B.C. also. Clark suggested me for one of the portrait drawings of women war heroes...

Thursday 31
Finished my twelfth diagram for Bill's book. Scorer, from Repton, called, worried about his plans. Is he to be artist, scientist to do with radio, or Fleet Air Arm? Advised the first alternative, till called up. He is about 17½ . Note added *Sept.* (He gave up his Slade scholarship, and got a Govt. bursary which enabled him to study science at Cambridge, with a view to work on radio location and similar matters. I was disappointed, as he seemed to have unusual talent, but, economically considered, he may have been wise).

AUGUST

Friday 1 – Friday 8: no diary entries

Sunday 10
...Called on the Dursts, Alan & Clare, who are staying with Mrs. Austin Durst in a charming small house in Wendover High St.: they have given Alice & Bysshe one of his marble groups, of fox-cubs...A generous wedding present, as Alan Durst is attached to his works and values them.

Wednesday 13
In London for M.o.I. committee...Lunch alone at Athenaeum. Tea there too; met Oppé,

8 Alfred Tennyson's poem in which he contemplates his own impending death. *Crossing the Bar* (1889) appears (at his request) as the final poem in collections of his work.
9 (1783-1848), founding 'father' of systematic study of arms and armour.

in the throes of a smashing review of a new book on Bonington, which he says is a bad book & very inaccurate. Dined with Cumberlege on the train. His firm is publishing the book. He told me a rumour that Winston Churchill was in America with Roosevelt; and much about the difficulties of the Oxford University Press in war-time, over the paper shortage and other matters. *Inserted* This was borne out by Attlee's broadcast at 3p.m. on Thursday.

Thursday 14
Finished the 27th & last diagram for Bill's book...Some glowing personal tributes to Penrose have appeared in *The Times*.

Wednesday 20
Working again in New Coll. Lane. Many people accost one there...young Toynbee, doing a drawing of the Quad...and Sir Charles Peers now working on the carved figures and grotesques in the cloister at Magdalen. He says some are very bad, and thinks they may have been intended for another place originally, being of unsuitable sizes, which entails their being mounted on 'footstools'...Peers showed me exactly what his restorations amounted to on N. Coll. gate, in the figures. The Virgin had no face before he took her in hand: she has now, but he did not think it necessary to give her hands. The uppermost corbel heads are entirely fashioned to Peer's instruction. William of Wykeham's head was lying in a corner of the niche before he was taken in hand. Some form of plastic stone had been used in parts.

Monday 25
Will Rothenstein came to tea. He was in Oxford about his book that Lord David Cecil is writing an introduction for. He talked about John's *Autobiography* with admiration, and does not seem upset at a somewhat ambiguous reference to himself, 'turning wine into water'. There seems to have been a printer's error about this, and John has made some sort of apology. John R. came in too, and the three of us went off to see Father D'Arcy at Campion Hall. Will wants my support for Mahoney's lunette designs for the Chapel. I gave it honestly, and Will was pleased, because Father D. had seemed a little doubtful, seeing faint resemblances to [A.R.] Mowbray's *Ecclesiastical Furnishing*. Aug. John has just painted Father D., but has not handed over the picture yet. Saw some new vestments, and looked again at Jacovleff's[10] drawings, highly skilled but tasteless.

Wednesday 27
Went to London on M.o.I. business – to inspect the exhibition of fireman artists at Burlington House...Selected a few pictures as suitable for purchase. It was a good show, with interesting work by artists new to me – Dessau, Rosoman, Uden, Hepple, Hailstone & others...

Thursday 28
London again. Travelled up with Muirhead Bone. He was on his way to the M.o.I. committee, postponed by K. Clark till to-day...Gave Bone lunch at The Athenaeum... Andrade came over to our table in the dining room and renewed an acquaintance with Bone made during the last War, at Arras...Left them together, and went to the N.G.,

10 Russian painter (1887-1938).

Miss Hollyer had already arrived, with her mama, and they had been shown by the attendant through the halls of darkness to the 'studio'. I liked my sitter, quite straightforward & frank, easy to talk to, though a little nervous, rather dowdy in appearance, and at first sight a plain, rather red-haired, freckled girl of about 30, though after a study of her features they appear to have some distinction. I do not think I made a very good beginning, but may pull it round on Saturday...Met Bone again on the 6.5. We dined together. He had a curious story of Mrs. Watts-Dunton[11] whom he met somewhere in Norfolk... She told him that when Swinburne died [1909] at The Pines a Mrs. Rothenstein called at the house, and though she was told that neither W.D. nor Mrs. W.D. could see her, persisted till an interview was granted. She (Alice R.) had with her a young man whom she introduced as Mr. Epstein, a sculptor, who was anxious to make a death mask, and from it a bust, of the dead poet. This request was refused, the clinching reason being that Watts D. had already asked a sculptor living in Putney (Bone forgets his name) to make a mask; and this sculptor did actually make one, but in some subsequent crisis or removal the mask was lost or destroyed, so there is none extant. If Epstein had done the job, we might have had something very interesting.

Saturday 30
Finished drawing of Wendy Pauline Hollyer [G.M.] at the National Gallery...

SEPTEMBER

Monday 1
...Albert asked us round to drink sherry in his rooms in New Coll. ...Inge of U.C.L. was there, and talked about the future of scientific research, which he holds should be as free of practical politics as possible, and indulged in as much for the love of it as possible. He instanced Henry Cavendish[12] who never published anything, but did valuable work, which was made available to others.

Tuesday 2
Went to see a picture Parker has bought, unidentified, but presumably of the French School. Albert has suggested that it is an early Delacroix or Géricault...Parker also showed me half-a-dozen Samuel Palmer drawings, new acquisitions...They are very good – finely designed & very poetic, with the Blake influence very strong. The Copleys, John and Ethel, called on us at no. 7. Their house in Hampstead is only slightly damaged – a bomb dropped nearby, on the Hospital in New End. Ann Kay Robertson, of the U.C.L. staff, who was a friend of the Copleys, has been killed with all her family. Their bodies were never recovered from the wreckage of the house where she lived. John Copley, who is ten years older than I am, knew Ford Madox Brown. He describes him [as]...flat-faced, bright eyed & very intelligent, and admires him greatly. Stuart-Hill also called...[he] is staying again with Kolkhorst at Yarnton...

Monday 15
...Went over to the School...found enough to keep me busy, with Elton...letters and interviews. The School may be too full when term begins.

11 Theodore Watts-Dunton (1832-1914), literary critic.
12 (1731-1810), scientist noted for discovery of hydrogen.

Sunday 21
…Met Paul & Bunty Nash at The George. P.N.'s face is getting heavily lined, much in the same way as Disraeli's did. I think Nash is a little like Disraeli, and, like him, too, was rather good-looking when young. He is now at work on his big picture of the R.A.F. battle subject.

Monday 22
Went round to 65 Holywell to see Ernest Jackson, about his taking on the job of art master at Shrewsbury School…I saw some of his paintings…and a good architectural study in pencil & water-colour of the Norman church-door at Loches. I think Jackson deserves more reputation as an artist than he possesses…

Wednesday 24
…M.o.I. Committee, which went on a long time, 2.30-5 o'c. Dinner at The Mitre with Arthur Norris. He had many reminiscences of his time at the Slade, fairly near to my own – the period of Fothergill, Clause, Lees, Ihlee, Elliott Seabrooke (who loathed Fothergill), Donald Maclaren and Stuart Boyd.

Thursday 25
We lunched with Ivy in Norham Gdns.…She is rather pathetic now in her indecisions, she who was always so positive & decided. Pen's death has changed her. Nova will get a hundred or so down from the Govt. and a widow's pension of £100 p.a. Pen left about £2000, and the film industry – Micky Balcon[13] and the rest of them – are putting up £500 out of the profits of *Convoy*…

Friday 26
…Met Ernest Jackson, back from doing some portrait drawings for the M.o.I. at Bristol. He is not sure about taking the Shrewsbury School job…Met 'Fritz' (F.H.S.) Shepherd, and tried to dissuade him from taking a cottage which has been offered gratis to him & his wife in the depths of the country. They would be dependent on oil as fuel during the winter, and might not be able to get any. He might suffer from loneliness & depression, possibly have another breakdown…and then she [Charlotte] would be in a great difficulty…

Tuesday 30
Russell came by bus to Oxford from Chipping Norton, where she is staying with her doctor brother…She was given notice – 12 hours – to fly to England from Lisbon, after being in Portugal for 3 months. The food in Portugal is excellent, and she was well set up after the meagre diet of Cotignac.[14] She told me of an old shoemaker and his wife who died of cold and hunger last winter, at Hyères…and they were not the only cases. She left her woollen underclothes & stockings behind in Cotignac, knowing the hardships of the winter to come, and that such things as clothes are unprocurable by the people there, who would gladly use what she gave them…They told her to 'tell Winston Churchill' to come and bomb their factories, as they are working for the Germans. Russ

13 Film producer.
14 Following escape from France Russell travelled to Sintra, near Lisbon, eventually securing a passage to England in late September. By chance she landed in Bristol where her friend Joyce 'Tommie' Emery lived.

had an extraordinary second-hand story of a German officer in a prisoners' camp in Germany helping a Frenchman to escape (at the price, almost certainly, of his own life) on condition that the Frenchman took the German officer's only remaining son, aged 13, away from Germany. His wife had been killed in our bombing of Berlin, his other sons were dead, and he did not value his own life any longer. The French soldiers who returned from the campaign leading up to Dunkirk & the armistice speak well of the English. Russell used to listen in to the B.B.C. and give news to the village. There was a good deal of espionage. She and the village people are very loyal to each other, and she likes the French and is very sorry for them. The rot came from the top, not from the bottom. Gamelin, she says, is still respected. He wanted to 'go over the top' and to extend the Maginot line to the coast.

OCTOBER

Saturday 4
Took bus to Bushey…Bysshe on duty at the School. Saw him in the evening, and [Edgar] Holloway came in, and showed me proofs of some recent portrait etchings [plate 20]. I thought them very good, particularly one of a woman, a large head. H. is leaving the Masonic School, thereby entailing more work and trouble for Bysshe, who thinks he has throughout acted selfishly, without regard for other people…or for any war-time sacrifice.

Sunday 5
Reunion – Ginger & Russell both came to lunch. Ginger told us something about the bombing of Tooting, and the bravery of the nurses in his Hospital, who carry on as if nothing was happening.

Monday 6
Visited Aldenham in the afternoon…a pretty little place, still countrified, with very large elms, and agricultural land, much as it used to be when I was a boy at Hemel Hempstead. It used to be almost inaccessible for me then, and I never rubbed the brasses in the church, having no chance. I did the St. Alban's ones.

Tuesday 7
Birdie, Alice & I went to a Disney film in Watford *The Reluctant Dragon*. Saw also a propaganda film, *A Day in Soviet Russia*.

Wednesday 8
…M.o.I. Committee. Looked in at Cooling's, to see the Civil Defence Artists' Exhibition, where I met Denis Mathews, the organiser, and Vera Cunningham…My drawing of Wendy Pauline Hollyer came up and was passed…

Monday 13
Slade began. Charlton came. I interviewed new students…

Tuesday 14
…British Council Committee at National Gallery…K. Clark, Clive Bell, Herbert Read, Longden and Mrs. Somerville (Miss Tillard, of the Slade school, now Longden's secretary).

We discussed pictures to be shown in America. Naturally there was a strong bias, from Read & Bell, towards abstractionists, sur-réalists and 'movements'. I acted as a drag on the wheel, saying something in favour of artists such as Munnings, Russell & Connard (with Clark's mild approval). Read mentioned some abstract artists new to me – one Morton, son of Morton 'Sundour', a disciple of Ben Nicholson and some others John Tunnard, John Armstrong & Rowland Suddaby were, as far as I remember, turned down. Clark said to me afterwards that Clive Bell was not as helpful as he might have been, and made too many 'catty' remarks about the artists…

Thursday 16
Had a drink before lunch with Albert R., Athene Seyler and Nicholas Hannen (both old friends of Albert's, and Hannen of mine). 'Beau' Hannen and I talked about Unwin and S.H. Evans at 59 Gt. Ormond St. in 1907, and about Aleister Crowley[15] who took rooms in the house later on, and conducted mysterious and unpleasant Black magic rites there, so Evans said. In the evening Dora, Birdie and I went to the New Theatre and saw an Old Vic production of *The Cherry Orchard*, with Hannen & Athene S. in it…it is a bad house for sound…Athene Seyler much prefers the little old theatre in Exeter, whence she has recently come. It is one of the few that still has a genuine 'Green Room' [waiting room].

Saturday 18
Contemp. Art Society's show of recent acquisitions; Private View at the Ashmolean… Pictures by John, Claude Rogers, the Spencers, Max Ernst, Paul Klee, Sutherland, Ben Nicholson, Graham Bell, Gwynne-Jones (a clock on a mantel-piece, which everybody likes) – drawings by Dobson, Henry Moore, David Jones, an early one of a theatre by Innes, others by Gilman, Frances Hodgkins, Steer, Segonzac…

Sunday 19
In Worcester Coll. Gdn. for about 5 hours. Two little boys, the gardener's children… were picking up walnuts…I asked them if they had found many, and they said 'yes – would you like some?' and shortly afterwards brought me a few. I produced a penny (I had only one) and pressed them to take it…Soon they brought more walnuts, saying 'Now you shall have these without a penny'…

Tuesday 21
Met Edna Clarke Hall with Albert. She strikes me as a somewhat inhuman, remote person…I remember her at Albert's parties in Fitzrovia St. nearly forty years ago. She was rather a beauty then, and is distinguished-looking now, but I should not have recognized her. She talked of a shower of land-mines that fell somewhere where she lives, on Upminster Common…

Tuesday 28
Went up to London with Albert…to attend what was for me a first meeting of the British Institution Scholarship Committee at the R.A. We only awarded one to an engraver, a girl, as the paintings were not thought up to standard. I was a little sorry afterwards when I found that Ursula McCannell was one of the competitors. I saw a painting of hers in the N.E.A.C. in the course of the afternoon, unmistakeably by the same hand, but

15 (1875-1947), influential English occultist, astrologer, mystic and ceremonial magician.

better than the things she sent up for the School: and she is a talented girl, badly taught about printing at Farnham, and she might have learnt a lot if she had been given a scholarship to go somewhere else like the Slade, which she can't afford. Lutyens was in the chair, they say he has had a stroke. He seemed vague and old, and Walter Lamb seemed to be doing all the business for him. Other members of the Comtee. Russell, Reid Dick & a stranger. Met Gerald Kelly in the building, who is very angry with G.J. and the way he behaved at Windsor. He says that Rosie is a dear, but used a short, opprobrious word to characterise G.J., who, he insists went behind him to the Castle people and said that he Gerald Kelly, was spinning out the Royal portraits because it suited him to stay on in the Castle, and that he would never get the job finished. This is Kelly's side of the case. G.J. has it differently…to the N.E.A.C. in Suffolk St. Two good rooms full of drawings… Bysshe's painting – *The Garden* – hung over the mantelpiece in one of the far-rooms. It looked well…

NOVEMBER

Wednesday 5
M.o.I. meeting at Nat. Gall. Neither Clark nor Bone was there. I expect Bone is kept away by Gavin's illness. At the Club, Salisbury and John Squire. Squire is collecting material for a Red Cross Album – one of those books in which artists & authors scribble for the supposed benefit of a good cause. He has got drawings from John & Epstein, and is very desirous of one from Muirhead Bone…He said rather half-heartedly that he would like one from me too…Squire had persuaded Curtis Green to do a small architectural drawing in the book, and I noticed poems from Binyon…

Thursday 6
…Slade Society's party in Taphouse's rooms…in Mary Magdalene Street…Barnett Freedman sent me ½ doz. packets of superior French cigarette papers, which he brought back from Boulogne and has saved ever since.

Tuesday 11
Albert criticized the Summer compositions, his oration, a good one, in the only available lecture room at the Ashmolean (the other being occupied by the military) lasting an hour & a half. Moya Cozens was given first prize, and there were seconds and thirds, £60 in all…

Wednesday 12
M.o.I. meeting. Looked at Civil Defence Artists' Exhibition, 2nd edition (Cooling's)… Athenaeum…Tea, Bone & Dodd. Dodd painting his Bishop, and making notes of the Athenaeum furniture as a suitable background. He makes a ground-plan for the introduction of such things, and sets them & his figure out in perspective…

Monday 17
Father Walker called about the boy Wilner's affairs – an Austrian refugee whose mother was a de Rohan & his father, I suppose Jew converted to Roman Catholicism. He is at the Slade, for which his fees are paid by the Jesuits. F. Walker is a great admirer of Lutyens, but considers him very unpractical. They had great expense in the building because Lutyens forgot the lift shaft, and it had to be hacked out of the concrete. Also in

the wing that he proposes to build at Campion he has not allowed for any corridor, and will not consider the inconvenience of cutting off the sun from the garden by a high building on the south side, at present more or less open, with only low buildings. F. Walker has done a good deal of planning himself, he says, or more would have been sacrificed to symmetry. I tried to reassure him about Mahoney, whose designs he thinks are wanting in originality. He doesn't like Spencer, whom he considers unspiritual & ugly. Brangwyn is his admiration…

Tuesday 18
Batsford called to ask me to do a book jacket for *London Churches*, bringing with him a large volume of *Kip*. Poor Neil Cook, his nephew, who started so well at the Slade, has been killed flying over Germany. He was a brilliant air-man…'Peter' Huskinson, once Editor of *The Tatler*, Leonard H.'s uncle, has been killed in an accident…Stepping out of a train in the black-out. As he was inclined to drink occasionally, those who know him are inclined to suspect that may have been a contributory cause; but it is only suspicion…

Saturday 22
…Supper with Charles & Ivy in Norham Gdns.. He says there is a plan now to build boats for the Atlantic crossing which draw only four feet of water, so that they shall be more or less immune from torpedo attack. Listened in to the 9 o'c. news of the battle in Libya, which we are all so hopeful about…

Wednesday 26
M.o.I. Committee…Tea with Oppé and two German or Austrian refugees, one a picture restorer and expert on Rembrandt…both had been interned in Canada. They said…that the application of Freudian theories to education had never been so extreme or so widespread in Germany or Austria as in England…Was complimented on the drawing of Wendy Hollyer by Burke of the Ministry of Home Security (and the V.&A. Mus.)… Went into the basement of the Nat. Gall. to see Miss Lillian Browse about a John drawing for Melbourne…The price for a good one seems to be round about 60 gns.…

Thursday 27
Ivy gave me dinner at The Mitre – farewell to Oxford…Pen's death has altered and softened her. Dinner – in war-time – excellent. If you pay for things, they still are…

Saturday 29
Finished book-jacket for *Shooting to Live*. In the morning, ordered James Bailey, Richardson, his fiancée Diane Bulteel, and an undergraduate out of the School. Richardson & Bulteel do no work, though he, in particular, has promised to do some, after a warning: and they have no business to introduce strangers into the life-rooms, without permission…

Sunday 30
11 o'c. Longden called, in a car from South Leigh…We went up to Old Headington to see Sir Michael Sadler[16]…a sick man, in the hands of doctor and nurse, but he saw us in his dressing gown, and showed us many of his treasures. He said he remembered my calling on him in Leeds with Charles Rutherston, and had put out a painting & a

16 Educationist, reformer and patron arts, from 1923 master University College, Oxford.

drawing of mine which he bought about 1913. He is extremely alert mentally and has a very wide range of interests…He is lending the British Council a Vanessa Bell and a Ginner: this was the purpose of our visit…He produced for us a handsome volume of wood-engravings, plain & coloured, after Rouault, illustrating French poems, chiefly religious…The prints enhanced my opinion of Rouault, whom I have frequently been disposed to dislike. I risked a reference to Gustave Doré, which was taken as I meant it. Sadler alluded to *The Prison Yard* which Van Gogh imitated: and I told him I had been the first to point out, in *The Burlington*, where Van Gogh had got his material. We were given sherry and cheroots, and sent round the garden to look at Henry Moore's sculptures and one by Leon Underwood, all weathering and mellowing pleasantly. Leon U. wanted Sadler to put a canopy over his, to prevent it weathering too much, but this has not been done…

DECEMBER

Wednesday 3
M.o.I Committee. Met Manson in the street. His studio and its contents have been destroyed by fire in the air raid, and he is now living in Hounslow, in some extraordinary household of foreign refugees. I had M. Bone's company at tea and in the train home. He was full of stories and reminiscences…Bone took Mĕstrović[17] to Westminster Cathedral to show him Gill's *Stations of the Cross*.[18]…Bone thinks the *Stations* 'pretty' and lacking in dramatic feeling or religious expression. Mĕstrović thought much the same…

Thursday 4
…Started tracing Kip's[19] view of London for Batsford's *London Churches* book jacket.

Saturday 6
Dodd looked in at the Slade. He has been made Vice President of the R.W.S., and has been asked to follow Russell as Keeper of the R.A.. Albert has been made a full member of the R.W.S.…he has alluded to it sometime as a thing he would like. I missed it by one vote. I am glad I wasn't elected ahead of Albert, who is senior to me in years and as an Associate.

Monday 8
Elton went up to London to see Tanner about giving up his Slade job and going to the War Office. Ralph Nuttall-Smith is to take his place with us…

Wednesday 10
M.o.I. Bone was not there: work and worry have got him down and he is away for a time, with leave from the Admiralty, at Bournemouth…News of the sinking of *Repulse* & *Prince of Wales*.[20] A hard blow, but people seem determined to take it stoically. Barnett Freedman was on *Repulse* for some time as official artist, and got on famously with every one on board. Noticed workmen working with blowlamps, cutting away all the railings round Hyde Park.

17 Bone had been a supporter of Mĕstrović since the First World War.
18 Gill's first major commission (1914-18), the panels, each 5ft 8in square, were carved in low relief in Hopton Wood limestone for £765.
19 Johannes Kip (1653-1722) Dutch draughtsman, engraver and print dealer.
20 Sunk north of Singapore by land-based and torpedo bombers of the Imperial Japanese Navy 10 Dec. 1941.

Thursday 11
2nd meeting at National Gallery of Kenneth Clark's British Council Committee, about the show of pictures in America...Gertler's absurd picture, *The Mill*[21] (with a man & dog in the foreground) was presented, but rejected without dispute. Clark said, among other things, that it 'dated' so terribly.

Saturday 13
Slade ended. I had a farewell drink with Elton, who goes to London on Monday; and Albert stood drinks to the models, Sallé & Patricia Koring...Sallé has a new fur coat, civet cat...given her by the kind Edward Le Bas...

Tuesday 16
...Saw some of the Italian prisoners of war who are camped in tin huts on the Oxford Road about a mile out of Aylesbury. They work on the land and wear a costume of ginger brown with large roundels of bright colour sewn on.

Saturday 20
Letters, and a little work on the *London Churches* drawing...Bill sent £20 in payment for the drawings in *Shooting to Live*. I had refused any money, but he is insistent, and, as Fairbairn pays half, and, as Birdie suggests, I can give the other half to Alice & Bysshe to do some 'doing-up' of the flat...Fears for Hong Kong, after listening to the news. I wonder what has happened to Trevor Powell, Bill's step-son, who was on the Council of the International Settlement in Shanghai.

Sunday 21
...George & Mary Kennedy & Charles Kennedy, the younger boy at Balliol, and Mme. Vandervelde, wife of a former Belgian Prime Minster, called on us after tea. George is teaching Art and other subjects at Gordonstoun School[22]...

Tuesday 23
...to Ivy Tennyson, for Christmas. She has 2 flats made into one on the fifth floor of 'Brae Court' [London], and she pays £260 p.a....with her own furniture installed. This is a saving on the furnished-house rent of 8 Norham Gardens...

Wednesday 24
Shopping, and getting ration cards, in Kingston...

Thursday 25
Christmas Dinner – ourselves, Ivy, Charles, Nova & the Kohns, at the Wilderness. An excellent dinner – no suspicion in it of war-time privation or rationin – and some excellent wine from Bruno's cellar...The hock was 20 years old.

Sunday 28
Connard came to lunch at Brae Court, having walked across the Park from Richmond...

21 The actual title is *Gilbert Cannan and his Mill* (1916), the Ashmolean acquired it in 1968.
22 Evacuated from Scotland to Wales.

He says he has no work, and is hard up…Anyhow he sold all three of his water-colours at the N.E.A.C.. I believe he gets £30 a piece for them. He keeps two maids in his house… Connard described his early days as a British Institution Scholar in Paris, with £50 in his pocket to last him a year. He drew in the schools, but did not paint. Like most of us, he spent his afternoons in the Louvre. He got £20 for repainting a decorated ceiling in the V.&A. Mus.…The £20 helped him out in Paris. Being a skilled house-painter, he did the job in the Museum quickly & well, deceiving the keeper into the belief that he had matched the damaged parts only, whereas he had wiped out the whole thing and done it over again.

MEMORANDA
Models of the old Italian breed, now almost extinct. Some of them are in the eighties:

Reitzo (*Speak! Speak!* [Millais 1895] & *The Forerunner*
 [Eleanor Fortescue-Brickdale 1920])
Manzi (Will R.'s portrait of a priest) stood for Millais's *Gladstone* [1879] & sat
 for B-J's [Burne-Jones] *King Cophetua* [c.1883]
Pasquale Tullio (Michelangesque)
Another Tullio, probably dead.
Giovanni Marcantonio sat in my Slade Days, & appeared in Oxford in 1941
Another Marcantonio
The Mancini family – Domenico, Luigi, Achille, and a girl Luigi di Luca
Reia
The Avicos. One, Marietta, was known as the Venus of Milo in her youth.
 She was as near that type as could be, in head & figure.

1942

One of the coldest winters on record. Schwabe joins the Council for the Encouragement of Music and the Arts. In February Singapore surrenders to the Japanese. Schwabe undertakes further portraits of Home Front heroes. In April a show of wartime acquisitions by the Tate opened at the National Gallery. The Leicester Galleries continued to show London Group artists; the Fourth War-Time Exhibition of the Group was held at the Leger Galleries. Walter Sickert, founder of the Group died. The British Council's cargo of pictures was sunk on its way to South America.

JANUARY

Friday 2
…to Windsor, at Longden's invitation, to view the British Council's exhibit of Arts & Crafts before it is sent off to America. In the train, Eric Maclagan, Fennemore, an architect named Hughes, and a metal-worker…The exhibits, books, textiles, metal-work, pottery, toys…were arranged in the library of the Castle. John Farleigh, Longden, Mrs. Somerville, Campbell Dodgson and others, including Morshead the librarian…Had to leave, with Read & Farleigh, half-way through lunch, in order to get a train back to London; we all three had other meetings to go to. Mine was at 2.30 at the National Gallery – the Council for the Encouragement of Music & the Arts (C.E.M.A.): my first appearance on their Committee. The business was to arrange for the spending of £750 allowed by the Treasury for pictures. Clark in the Chair. Philip James Secretary: other members, Russell, Jowett, Miss Cazalet, John Rothenstein. Had tea afterwards with Jowett at the Club, and talked to Oppé. Jowett talked a lot about William Nicholson, whom he knows well and likes very much: described his endless interest in painting and his undying boyishness. I must go and see the collection of his pictures now being shown at the National Gallery…he shares the honours with Jack Yeats, whose work I have not seen for a long time. It is said to be very colourful & thickly painted now. Oppé calls it vulgar, and compares it with paintings by Louis Corinth,[1] Maclagan, when he spoke of it, seemed rather to like it.

Wednesday 7
To London. United Artists' Exhibition at R.A.. Nicholson & Jack Yeats show…Nicholson's paintings are sometimes very near to posters. He has a pleasant, discreet colour sense, but no true sense of colour relations. Did not see much in Yeats…

Thursday 8
British Council Ctee. at Nat. Gall.…My two drawings chosen by Longden came up – *Romney's House* on Windmill Hill and *Queen's Lane*. The Committee tactfully, decided to include both…in the U.S.A. show. Clive Bell said that the former was 'so English', and appeared to like it. I wonder what he says when I am not there. Ithell Colquhoun sent up 2 paintings & some photographs. One of the latter was a very morbid piece of

1 German painter and printmaker (1858-1925).

sur-réalism, rather like a specimen in a bottle at the College of Surgeons' Museum. A small abstract ptg. was approved, but not an over-life sized flower-piece, very skilfully handled...Went to the Leicester Galleries to look at some Pissarros. Saw an interesting thing by Sérusier[2] and a good John drawing of a head, £40, which I shall suggest to Russell as a purchase for Australia...

Saturday 10
...G. Kennedy came in again. He stayed till 11.15 having to go by a midnight train to Wales, to rejoin the school in which he teaches...

Tuesday 13
...Tommy L. came in to tea. He admires the John portrait of Father D'Arcy [plate 21], which has just come to Campion Hall, and praised it to the holy fathers, who are none too sure about it. They say it hasn't got his 'puckish' expression. Tommy doesn't think much of Wm. Nicholson as a painter, and less of Jack Yeats, whom he compares with Kokoschka,[3] another of his bêtes noirs ('Continental vulgarity').

Wednesday 14
M.o.I. meeting...Lord Willoughby de Broke made his first appearance instead of Air Commodore Peake.

Thursday 15
British Council Committee at National Gallery. Travelled up with Russell Knowles, and a stranger in whom I was interested on account of his distinguished profile and his rather dilapidated fur-lined black overcoat. He joined in our conversation, and it appeared from his references to young [Lawrence] Toynbee, his grandson, that he was Gilbert Murray[4]... Knowles went to the R.A.C., Murray to the National Liberal Club & I to the Athenaeum. Here I met [Michel] Salaman[5] (lamenting the loss of money on his London property since the War: he has made settlements on his children which are now worthless)...

Saturday 17
Reddall, ex-Slade student...called upon me with a few drawings he had been able to do while in the Army. He described his difficulties...and the lack of comprehension of anything to do with an artist's life, among his fellow soldiers...Irene Aronson[6] another ex-Slade student, sent from New York a case of 2lbs. of tea & 2lbs. of coffee...

Monday 19
Slade began...Albert has managed to get models for the School – two for the figure and one for the head. The College of Art is having difficulty over models at Ambleside. Leonora, the Polish girl, is sitting there...

2 French painter, pioneer of abstract art (1864-1927).
3 Expressionist painter, draughtsman and lithographer, born Austria, became a British subject in 1947.
4 Professor of Greek, Glasgow University aged 23,1908-36 Oxford, founded the League of Nations Union.
5 Michel and Chattie Salaman had 6 children, every weekday he went to London to manage his properties and investments and lunched Athenaeum. Attended Slade from 1905. Chattie was an actress and sat for the Charleston artists for the Berwick Church decorations Sussex.
6 Painter, designer and printmaker, born Germany 1918, active in Rego Park/Forest Hills, New York.

Wednesday 21
10.20 train to London left at 11.30, and arrived at 1.40, owing to snow disorganization…Meeting…at the Nat. Gall.. Tea at the Club with Dodd, who had been to a luncheon given to celebrate Lutyens's O.M.. Dodd says there are two men who would give almost anything to be P.R.A. – Dugdale & Lawrence. He dislikes them both. He was not very favourable in his reports of Bone's painting, still going on in St. John's.

Friday 23
Tea with Sir Charles & Lady Harper, their son and her sisters, at 112 Banbury Road. He was Governor of St. Helena for some seven years [1925-32]…I was amused to see that…art does not come within their view. They have, for example, a picture by J.D. Harding[7] and were quite ignorant of the artist's name. Jack Townend is doing a book-plate for Sir C.

Saturday 24
…Have been reading an excellent book, *The Lost Peace* [1941] by Harold Butler.[8] It came into the house as a present to Dora Rowe, who lent it to Birdie. Dora is the Butlers' valued servant, who was with them in Geneva for 17 years, when the League of Nations business was going on…The Butlers want her back. The domestic problem is acute everywhere…

Wednesday 28
London, taking a parcel of Albert's drawings to select from for the Felton Trustees, with Russell, at the R.A. At the R.A. two other parcels, one from Connard, one from Ginner. We selected one of each, and took the three drawings to the solicitors who act for the Felton Bequest, in College St. Westminster…To the Club…Other people I met, either in the club or elsewhere – Hind, Oppé, Le Bas, T. Bodkin, Ithell Colquhoun. M.o.I. meeting, a small one: Clark, Willoughby de Broke (who is shrewd & capable), Miss Oppé, Bone & Dickey…There is talk about the Government refusing to allow any more paint to be put up in tin tubes, all tin and lead being wanted for munitions. The R.A. and the colour manufacturers are protesting. Nothing has been said about tubes for tooth-paste… Kenneth Clark says that Kelly, Dugdale & A.K. Lawrence are very angry about the neglect of the Academy by the British Council Committee which chose the pictures for exhibition in America. He asked me if I had heard anything of these protests, which I had not. Having to follow up this with some opinion on the matter, I said that I was a late comer on the Committee and had little or nothing to do with its policy, which was settled before I joined; and I had always taken it as a matter of course that the Americans wanted to see, not the work typical of 30-40 years back, but of our young and 'advanced' talent, Clark said this was definitely so. In any case, I shouldn't think they would appreciate Dugdale & A.K. Lawrence v. highly. Clark put it to them that the R.A. should arrange an American show of its own if it wished to be seen in America.

Thursday 29
Albert got his cheque for his water-colours (£12-12-0) from the Felton Bequest people… Connard's price was £16-16-0. Ginner's £14-14-0.

7 James Duffield Harding (1798-1863), landscape painter.
8 Civil servant, Deputy Director International Labour Office, Director 1932.

Friday 30
…Depressing news on the wireless of Benghazi & Singapore, and 800 men of the *Barham*[9] lost.

Saturday 31
…H. Batsford called, to see the book jacket, now done, as far as the buildings are concerned, except the dome of St. Paul's. He likes it, and will not only pay the £12-12-0 fee, but will try to sell the drawing for me. After supper he brought in Charles Fry… Batsford showed me a design for a book jacket, in poster-colour by Paul Nash, for a book by Massingham. Neither Batsford nor Fry liked it, and they were not going to use it. It was hasty, untidy, Batsford didn't like the colour, and the lettering was bad. Fry said Nash was an old friend of his, but he thought him conceited, and that he had too high an idea of the monetary value of his work. Rex Whistler acts differently – he has an excellent agent who gets good prices for him, and he does not deal with the money side at all…

FEBRUARY

Monday 2
Another blood-transfusion at the New Bodleian…they have been sending a lot of the stuff abroad, and there is a big drive for more just now.

Tuesday 3
Wilson, R.S.A., an Edinburgh artist, called upon me in the morning at the suggestion of Hubert Wellington. He is to do a commissioned drawing of New Coll.. He could not start to-day on account of the damp weather – nearly snowing – and returns to Edinburgh about Friday…He says that a fashionable pastime in Edinburgh is splitting matches into two – on account of the scarcity. Albert & I noticed an advertisement in the School of Cecil Riley's evening life-class, announcing that Lilian Kenton, would be the model for to-night. Miss Kenton being one of our students, we had to explain to her that, harmless and self-sacrificing as the act was, it would not be looked upon, in such a public way, with anything but disfavour by either of our Universities. Parents, too, might disapprove, besides Provosts & Proctors…Albert & I followed up this interview by calling on Riley in…Wadham Place, and explaining the situation to him. The inconvenience of possible objections and scandal had not occurred to him, but he took our attack very sensibly. Wilson, to go back to him, said that James Wilkie, whom he met painting abroad, introduced him to the drawings of Claude Lorrain. I thought they were a part of every art student's education…

Wednesday 4
…London. Talked to an A.T.S. corporal in the train, going on a week's leave to Yarmouth, which, as well as Lowestoft, has been badly blitzed. She was in the fish trade but all her fishing boats but one are being used by the Government. Her husband a prisoner of war in Germany, taken in Crete. She joined up 5 months ago…M.o.I. Committee…Burke put it forward that I might do some more portrait drawings for his Ministry…

9 Sunk 25 November 1941.

Friday 6
Lunch at The George with Peter Copley and his wife Pamela Brown. They are leaving Oxford for a while. I gather there are disagreements among the company at The Playhouse...She has been drawn by Gregoria Prieto. They – she & Peter – are making Hampstead Square their headquarters. There is plenty of room now in the elder Copley's house. An excellent story, an example of how we can all help in the war effort:- Mrs John Copley, having finished an officially commissioned lithograph, took it to the prescribed firm to have it printed. The government department concerned, in furtherance of the campaign for saving paper, issued orders that clean paper was not to be used for this edition – only soiled sheets; so the printers spent five days passing clean new paper through the press, and soiling it on the back, to comply with the regulation.

Sunday 8
...Went on to see Egan Mew, and talked with him about the theatre – mostly – of bygone days: Irving, Ellen Terry, 'Queen of My Heart' Hayden Coffin (who sang in Granville Barker's production of *Twelfth Night* that Albert designed costumes & scenery for) Lillah MacCarthy[10] (whom I remember at Albert's parties in Lincoln's Inn)...In the afternoon... finished *The Old Churches of London* for Batsford, working in the Ashmolean, with Griselda Allan slogging away at the lithographic press in the next room...Mrs. Brown says soap is to be rationed, but not shaving soap.

Wednesday 11
Tea with Mrs Vandervelde, in her bed-sitting room over the tea shop in High Street (106)...The house is a warren of other apartments, 18th cent. in the main. She has known the George Kennedys well for about 8 years, and was with them in France or Spain when Sandy K. died. Dined with Albert at New College. After dinner...went over to his rooms in the Warden's lodgings. He asked Mrs. Fisher upstairs: a lady of distin-guished appearance, once a don. She & H.A.L. must have been an impressive sight together. Drank a good deal of Albert's weekly ration of port (one decanter). He is always extremely hospitable...Only one guest is allowed...

Friday 13
Ballet at New Theatre...*Giselle*, with Margot Fonteyn; *Comus*, with Margaret F. again and Oliver Messel's scenery & costumes. There was very much to enjoy...Uncomfortable depressed feeling, though, I am sure in everybody's minds, about the war news: Singa-pore seems doomed, and the German battle-cruisers have got away, after the action in the Channel. The Lowinskys and a lot of people one knew...made part of a crowded house: Slade students, Ben Nicholson, young Toynbee, Lord David Cecil & his wife: it is a very popular show...

Sunday 15
...Glanced at Hendy's article in *Horizon*, on Henry Moore's sculpture. I regret that I cannot always follow Moore with any satisfaction or pleasure. Sometimes I see a certain impressive idea in his arrangement of semi-human masses; but I think the same degree of impressiveness can be attained in other ways, in combination with the qualities that Moore disregards.

10 Popular dramatic actress, married Granville Barker.

Monday 16
News from Hubert of Charlotte Wellington's (to us totally unexpected) death at Hawick, in a convent nursing home. She had become a Catholic, in the end, which makes Hubert very much happier; his being one…But though he will find some consolations in his old age, they were pretty well inseparable, and he is sure to miss her terribly…

Tuesday 17
Went to London for a C.E.M.A. Committee, but it was a mistake …at the Club…Talked to Dodd and Reginald Blomfield, who were up for an Academy election (they elected Pitchforth & Frank Dobson Associates, and Eurich nearly got in); also to Michel Salaman who stood me a glass of brandy after lunch. Salaman mentioned John's biography in *Horizon*. He had met John recently, and said to him –'Why don't you tell the truth?' John said it was 'too dangerous'. Salaman says there was a period, just after Aug. J.[ohn] was at the Slade, when Tonks & Brown and everybody just gave him up – thought he had gone to the devil completely, that he would never do anything, and that Orpen was the coming man. John was drinking heavily, living with prostitutes somewhere in the region of the Euston Road and generally ruining himself. Salaman took him away to Le Puy. Gwen John came out there too, and between them they set him up again. Salaman was humorous about Albert in his early days – his assurance, his precocious 'decadent' culture of the 90s, his buttering up of William, Will's buttering up of him (this was a family habit, in which Charles was concerned too, and which was not always understood by outsiders: David has something of it now). But Salaman does justice to Albert's many-sided activities, and the influence he has had in directions such as illustration and the theatre; and, of course, they are good friends. There is little harm in poking fun at one's friends occasionally; provided it is done good-naturedly.

Wednesday 18
Meeting of the A.A.C. Clark is leaving for a month in Sweden, so we shall not meet so frequently in his absence. Saw the Artists' International show at the R.B.A.. Some good minor pictures. Liked one of an Essex farm by Geoffrey Rhoades, and some oil studies of people by Patricia Preece. There was a poor painting by H. Lamb, of some soldiers queuing up for the mess, at the Nat. Gallery meeting; and a, possibly, worse one by Duncan Grant, of St. Paul's after the Blitz. Even K. Clark is against it, & very disappointed. Muirhead Bone, after looking at it, congratulated himself on being a 'competent trades-man'…on the train home…Story of the late Walter Sickert: he was a rebellious youngster, and when his father gave him two guineas to buy a tall hat and an umbrella, he decided disobediently, to lay out the whole sum on a very superior hat from Lincoln & Bennett…He wore it on the way home, and it rained, and, having no umbrella, the hat was ruined. One of his brothers always did exactly what he was told, and was a complete failure. Walter went on the stage as a rebellious gesture.

Thursday 19
…Batsford says of *London Churches* book jacket – 'We think, of course, that it is perfectly adorable, and we are proud to put it round our book. If the author carps at positions and proportions, he can go boil his head!'

Saturday 21
...Urged by Nutthall-Smith, went to a show of portraits, plaster, by a Jugo-Slav sculptor named [Oscar] Nemon, in the School of Slavonic Studies...A seated figure of Freud is good: excellent poise & movement...

Sunday 22
Steer said to John Rothenstein, apropos of Hone's *Life of Tonks*: 'Tonks was a great man, and had great faults' – and went on to suggest that their friendship might not have lasted in fact if Tonks had lived many more years.

Wednesday 25
...We are trying to get our models, Duval, Sallé and Patricia Koring registered as in a permanent recognized employment. Otherwise they may be called up for some more obvious national service; but they, or others like them, are essential to the working of the Schools. *Note added:* Patricia K. was called up in July, subject to passing a special medical exam. They thought she did not seem fit.

Saturday 28
Birdie & I...to Brae Court. Charles & Ivy gave us the news that Simon, Yve's & Dooley's twin child, is now positively pronounced a mental defective of the Mongol type. This is...another great blow to them, but not unexpected. The boy will have to be kept in a private home for such cases...The flat...for us who endure a good deal of cold in our Oxford rooms, is too hot, with its central heating & electric fires, even though the windows are open. This is one of the coldest and longest spells of winter since 1895.

MARCH

Sunday 1
Went over to see the Kohns...and walked in the Park again. Bruno's lake has been frozen over for more than five weeks. Two herons fought each other over the garden recently. One was killed, and made into a pie after it was picked up. The body weighed under 6lbs. Bruno's sister-in-law is now acting as his cook. Another of his nephews committed suicide lately.

Tuesday 3
Scenes in the School. Leeds is in a great state of mind about the students not regarding the dignity of his museum, making a mess [and] whistling...Albert & I think that some part of his irritation, which has now boiled over, is due to his not being consulted by Veale about our taking over two rooms in the new Ashmolean block, in exchange for the one we have in the new Bodley. The Slade Society held a meeting, and Albert addressed the students. We shall have to be firmer...on points of order. Tunstall, head of the Slade Society agrees...

Wednesday 4
...Royal Academy with Russell to select drawings for the Felton Bequest: one each by Gere & Harry Morley, whose names were on the list supplied to us by the Trustees. We now discontinue purchases, owing to the war situation [in the Far East]...M.o.I. Committee...

In the train, afterwards, over dinner, asked [Bone's] advice about accepting Dodd's offer to put me on the list for election, Associates, of the R.A., as a draughtsman, not as a painter. Am doubtful. Asked Bone why he didn't belong to the R.A. Everyone knows they'd be glad to have him, and he exhibits there, which is more than I do. I gathered that one reason may be that he feels it a little undignified for one of his age & position to put up as a junior. If he could be a full R.A. at once it might be different. He seemed on the whole in favour of my putting up, but withheld any positive advice.

Thursday 5
Slade Society's dance in the lecture room used by the men fire watchers...About 150 people...Nothing but lemonade to drink... Bernard Dunstan did some clever decorations in distemper on long strips of wall paper...

Friday 6
...Freedman was in the School to-day, and spoke to the Slade students in Taphouse's room in the evening – amusingly & successfully, I hear.

Sunday 8
Worked on the Penrose Tennyson Film Library Book-Plate...

Wednesday 11
[Peter] Greenham, a graduate of Magdalen, who is an occasional student in the Ruskin School, being caught whistling in the Randolph Gallery, was dragged into the Office in the School by the Keeper, to be made an example, and in order that in future students of Oxford University who work with us should be made acquainted with the rule about this important matter...

Saturday 14
Bill arrived for lunch, in battle dress. He had been driven from Northampton, during the morning, and is to do an inspection at Thame on Monday. He moves about England a great deal now, Fairbairn has gone to Canada, unregretted by Bill...

Monday 16
Saw Bill off on his bus to Thame. He had the luck he tells me, to sell his sole remaining asset in China, a house in Peterhof, for £200 a few weeks before the balloon went up. Trevor is out of Shanghai, but Bill is afraid Marshall must still be in Hong Kong – if so, there is little hope for him...

Wednesday 18
M.o.I.. Travelled some part of the way, on the 10.20, with L. Binyon...[he] had been to see Will Rothenstein. In London, went to Bourlet's to inspect some of the British Council's pictures for America – James Pryde, Gwynne-Jones, Graham Sutherland, Robert Buhler & Alastair Morton (abstract). Missed the committee, who had left before my late arrival. Went on to the Leicester Galleries, and looked at W.R.'s drawings of the R.A.F. To me, they are not so dull as so many people find them, though some are failures and there are insensitive passages: there are compensating qualities...

Saturday 21
Slade term ended. Steer died. The news was on the wireless…

Monday 23
Bought *The Times*, instead of my usual *Telegraph*, thinking to get a better obituary of Steer…Albert thinks W.R. wrote it (he didn't)…Lowinsky called at the Ashmolean to present a pencil scribble by Steer to the Museum collection, in his memory. I know very few drawings of his, and it is therefore interesting to see what he did when he had a pencil in his hand. Evidently, in this case, an interior with a figure, the tone was his chief preoccupation…Sent off a parcel of Slade & Ruskin students' drawings to a show in Cheltenham, and my design for the Penrose book-plate to Charles Tennyson…

Tuesday 24
Took Mme. Vandervelde to see Aug. John's recent portrait of Father D'Arcy at Campion Hall…in the refectory. It is very like, though elongated in the face & neck…3.20: bus to Boar's Hill, to see Will R. & Alice. Boar's Hill is like another North Oxford built at the height of the Edwardian Arts & Crafts movement. Mrs. [Hilda] Harrison the Rothensteins' hostess, is vaguely reported to be Asquith's mistress.[11]…She has done a good portrait drawing of Stanley Spencer, and copies 18th century pictures skilfully. There is a good G. Spencer landscape on her walls. Will R. was sitting in the sunny garden in a fur-coat – the first time he has been out, indeed the first fine day we have had for a long time. He spoke of Steer with high regard, but rather acrimoniously of Tonks. He said T. was jealous when Will was appointed to S.K. Alice would dearly like to see William succeed to Steer's place in the Order of Merit. She said so to me privately, enumerating all he has done for Art & other artists. He took much trouble to get the order for Steer. But I believe the idea originated with Collins Baker.

Wednesday 25
'Warships Week' in Trafalgar Square. A sort of model of a battleship, loud speakers, military music & crowds of people to see the show. 10.20 to London…ran into Rushbury, anxious to draw the new bomb-proof buildings being erected by the admiralty & the B.B.C.. Clause called for me at the Club, to talk about an Aid for Russia exhibition…

Saturday 28
…drew Mr. Giblett, G.M. of the Post Office service in Bristol. A youngish fellow, with some sort of good looks and good bony structure; quiet and refined, unselfconscious when sitting, easy and modest in manner. He sat in the life-room in the Ruskin School, where the light is excellent.

Sunday 29
…finished pastel of Giblett. He was very civil about it, and apparently pleased.

Monday 30
…Meeting of C.E.M.A. at National Gallery…Selecting pictures for purchase at cheap rates, which it is an act of patriotism to accept, on the part of artists.

11 See *Letters to a Friend* by Asquith.

APRIL

Wednesday 1
M.o.I. Committee…Our meeting was interrupted for a brief visit to the opening ceremony, in the ground floor rooms of the N.G., of the new show of recent Tate purchases; a great crowd of people, so that the pictures could not be seen…

Friday 3
Started out to draw the Radcliffe Observatory. Professor Gunn, of Osler House, kindly provided me with a cushion, and offered any assistance…I had barely begun, when M. Bone, whom I had arranged to see in Gavin's rooms at 4, came to tell me he had bad news of Gavin and could not see me in the afternoon…he sat beside me on the edge of the tank of 'static water' and gave me good advice about turning up the collar of my inner coat as well as the outer one, in the cold wind. Went to see his picture as promised. I had not anticipated, somehow, that he would have brought it off so well: he has not painted anything to speak of for thirty years. It is…entirely unlike anybody else's picture, and the result of what must have been, for an artist, an unusual experience…

Saturday 4
My Tennyson book-plate, over which I took a long-time, particularly as I am not an expert letterer, is now going to be lettered all over again by Percy Smith.[12] The film people have promised Smith the job, and Charles did not know this…Smith will do it more expertly, but probably out of character with my design…
Note in margin: No – he did it very well.

Sunday 5
…Lunch & tea at Garsington. Bus to the Swan at Cowley, and was picked up by the Lowinskys on the Garsington road, beyond the aeroplane dump. Raymond Mortimer and Stenhouse at the Manor. Tommy's landscape is still only half covered, and after two years. It must be one of the slowest and most laborious pictures ever painted; but it is going well. Will R. rang up T. while I was there, to ask him to write a letter of protest to *The Sunday Times* because Eric Newton has completely ignored Will's show at the Leicester Galleries (though he mentions Hitchens and the old master drawings in adjoining rooms)…Will had said that he had never made a similar request to any other artists. I did not give him away, as he was sufficiently unpopular; but he asked me to write to *The Times* once when Marriott said he was a bad draughtsman – and I did so…

Monday 6
…1.45-4 (when my set square blew into the water tank – there was a stiff south-westerly gale) at the Observatory…

Tuesday 7
Arthur Norris took me to lunch…he has Millais's old drawing-room in S. Kensington as a studio. It has a room off, a bathroom, and a housekeeper, and he has it on a wartime monthly tenancy. He has sent pictures to the Royal Academy. His position at Repton is

12 Artist and calligrapher.

very much a part-time job. He says Roy Morris, of the Derby School of Art, was an exceptionally brilliant student at the Slade, but as far as he is aware, seems to have been submerged by provincial art teaching; which he thinks is a great pity...

Wednesday 8
Observatory, or Nuffield Institute, as it now is...

Thursday 9
Lunch at The Mitre with Haward of the Manchester Gallery. He was in Oxf'd to see the Czecho-Slovak show at the Ashmolean, in case it might be sent on to Manchester. He talked about the Blake drawings at Manchester, portraits of various historical characters, done for [William] Hayley.[13] When he was in the neighbourhood of Felpham...he took the trouble to go over Hayley's house, to try to find the room for which he supposed the drawings to have been done; but there seemed to be no such room, library or drawing room, which would have been at all suitable. Is going to confer with Blake scholars such as Figgis...

Saturday 11
Received copy of *Shooting to Live*. Drew Mr. Pople, G.M. of Bristol, an ex-soldier once in Tientsin, now a telephonist. Says the Germans were not more than 300 feet away at times in the Bristol raids; also that he didn't deserve a medal any more than anyone else, certainly not more than his wife, who had to stay at home all alone. She came with him. She looked at the portrait and said – 'That's you, Frank' and expressed herself as satisfied...They did not want to stay in Oxford another night, so I hurried the drawing over in the day...

Monday 13
...Observatory, 2-5.30. Alice writes that she & Bysshe called on Daphne [Charlton] in New End when they were in London, and that Stanley Spencer came in, 'and looked so dirty, chewing a handkerchief all the time, like some child of about 12 years old'... Bysshe (who also writes) says, 'he showed his strange self even in that short time by a delightful and shrewd observation that woodland wild daffodils hang their heads in a different way to cultivated daffodils'.

Wednesday 15
...M.o.I....Delivered drg. of Giblett. Russell said he liked it. Gavin Bone is dead. Made unfortunate inquiry after him, to Muirhead Bone, and upset him...Gavin probably wouldn't have died if he hadn't got pleurisy 'digging for victory' in an allotment.

Thursday 16
...Met Roger Pettiward and his wife Diana. He said he was in the Army and had trained for Commando work in Scotland. I asked if he had met Capt. Fairbairn & Capt. Sykes: he had-Sykes had even given him some private tuition. I told Pettiward that Sykes was my brother. 'Tough guy,' he said. I presented him with a copy of *Shooting to Live*.

13 Also a noted writer, invited Blake to Felpham. 1790 Hayley was offered position of Poet Laureate, but turned it down.

Wednesday 22
[Entry written on Julian Marks's headed note paper.]
Arrived here…[Snoxhall, Cranleigh, Surrey] after a day in London, where I saw a show
of New Movements in Art…Drew Susan Marks all Thursday…On Saturday drew Nancy
Joan Marks…The Marks family is partly American. Mrs. Marks is of the Philadelphia
Quakers, and he was born…in N. York, where his father published an art journal…until
it failed. He is a…well set-up man of about 54.

Thursday 23/Friday 24
…There are a lot of horses about the place…all the family are expert riders, especially
the two girls, who hunt and show up well at point-to-point meetings…One son who
was at Univ. Coll Ox. has a commission in the Navy, and is on convoy service, the other,
Henry, is about 17…He, like his father, is in the Home Guard. Susan is joining the
W.R.N.S. and Nancy Joan drives a car for one of the services…The Marks's are very
hospitable. You never know who will be at dinner, or staying the night, English officers,
Canadian officers, a curate, or women friends. Rationing must be difficult, but food
seems plentiful. Mrs. Marks spent an entire evening mixing sausage-meat, the farm
manager having killed a pig; and she helped him to put it through a new sausage machine
they have…The orchard is being planted with potatoes, and a good deal of land is
ploughed up and sown with oats….Marks who is something in the City with an address
in Old Jewry, still has the best part of a pipe of port, laid down years before the War…
He, in the intervals between government office work, from which he is having a month's
respite, is a managing [financial] director of the Hungaria Restaurant [in Lower Regent
Street]…The central heating is of course cut off, so the house is rather cold; but there is
a fire in the drawing room in the evenings, & I had an electric heater for my sitters.

Saturday 25
A great friend of Marks's is Cooie Lane.[14] They know the Gaddesen & Water-End district
[Hertfordshire] well. Other friends are: Iolo Williams, Geoffrey Webb, Lady Allen
(Clifford Allen's wife) and Mrs. Reggie Hunt, wife of Reggie whom I used to know as
Secretary of the R.W.S. and R.B.A. He formed a link between the Marks's and the art
world, hence, partly…the presence of various pictures by Connard, Harry Morley and
Walter Bayes…

Sunday 26
Left Snoxhall, with £40 in my pocket being driven to Guildford station by Mrs. Marks…
Arrived in Oxford at 9.30…No taxis, of course, and my bag and easel & portfolio as
much as I can manage…

Monday 27
Slade began…

14 Constance 'Cooie' Lane was the daughter of Rev. Charlton George Lane who served as rector Little
Gaddesen until his death in 1892. He and his family would likely have been known to the Schwabes as
they lived nearby. She trained Slade similar time to Schwabe and was a friend of Dora Carrington.

Tuesday 28
Letter from Daryl Lindsay, in Melbourne, with news of Basil Burdett's[15] death in Malaya. He was Deputy [Assistant] Commr. of Red X there...

Wednesday 29
M.o.I. Committee. Travelled up in the train with David Rolt, the portrait painter, Arthur Norris's nephew...Bone's big picture of the mine-layers [plate 22] came up before the Committee. Russell admired it. Bone has had one of his drawings thrown out by the R.A., and one of Gavin's was chucked too; so was Norris's portrait, though he got a water-colour hung. Kelly seems to have been mainly responsible for the hanging, and has tried to keep a single line of pictures in most of the rooms, and this, where the pictures are small, makes a very thin show...

Thursday 30
C.E.M.A. meeting at National Gallery. Travelled up with Eric Ravilious (in uniform of the R. Marines) who had been taking his small son to school at Burford. He says John Nash is known as a 'Wax-work' in his officers' mess. Of Freedman, on board ship, being taken up, or down, an awkward companion-way by members of the R.N. – 'Here, I'm not a bloody sailor!' He is popular with the Navy...*Note in margin:* Ravilious wanted to go as official artist to Russia, but they could not arrange it for him.

MAY

Saturday 2
...studied the lighting of the Observatory...Paul Nash rang up, rather fussed about his new picture at the National Gallery. Clark has written him about the proportions of his bombers, making it clear that they are too 'imaginative' for general consumption, though he – Clark – likes the picture. Nash defends one point the size of the wings, which he says he had authority for in the shape of a photograph. A difficult business, this compromise, between a certain degree of recognizable realism and the Nash conventions. At the other end scale is Charles Pears.

Tuesday 5
Wilenski came and talked to the Slade Society in the Ashmolean extension, where the School now has two rooms: one for Polunin and one for Ormrod. (Delia Cooker, Tunstall & Griselda Allan seem to be the mainstays of the Society.) Talked of the current theories of the duty of artists to the state, which he traced to Dr. Goebbels and entirely set his face against. Albert R. & I were both dragged into the discussion...Albert mentioned how the idea of having official war artists, in the last war, was first mooted in his rooms in Lincoln's Inn, with Lady Cunard, Will R....and M. Bone present. Judged Slade entrance scholarship work with Charlton. No doubt that Bysshe's candidate Bowerman & Miss Gruby are the best. Luckily there are two scholarships this year, the Rich & the Slade.

Wednesday 6
London. At the Club...Richmond...talked of Burne-Jones and Holman Hunt and his personal impressions of them. Apparently one had to be a good listener to enjoy the

15 Killed Sourabaya, Java, 1 February 1942, when the aircraft he was a passenger in crashed on landing.

conversation of Hunt. Once he began to talk he never stopped. Burne-Jones's humour was characteristic…M.o.I – a small gathering…Willoughby de Broke now replaced by another man, and Burke taken off onto some other job. Afterwards, with Bone, went to a show of Eileen Agar & W.M. Rothenstein. W.M.R. has changed his style and become more divorced from the actual appearance of objects, like some of the performers now admired, such as Nash & Sutherland. 'Imaginative' art is the development of Sur-Réalism, I suppose. Back to Oxford with Bone…Reminiscences of Arthur Studd, and the house in Cheyne Walk which was afterwards Hugh Lane's, where Bone stayed as Studd's guest for a time.

Friday 8
With Albert hanging pictures for the forthcoming Slade Society show in the Ashmolean. Conversation: myself, to A.R. & Griselda Allan, 'I suppose it's a good thing to have a few of these abstract, or semi-abstract designs'; Griselda: 'yes, it shows we keep in touch with the past.' Tea with Muirhead Bone…I had visited him in St. John's, where he is clearing up Gavin's affairs, distributing books to members of the College and other-friends…and disposing of his furniture (some of it by [Edward] Barnsley[16])…I was allowed to select one as a souvenir. I chose a little Georgian anthology, abridged from *Elegant Extracts*…Looked over G.'s early diaries of travel, written in a careful schoolboy Bedalian script, one dedicated 'To my father, whom I love'; and his drawings of orchids, and other treasures, of which poor Bone never tires. Gavin was certainly a good son, and one to be proud of…

Tuesday 12
Opening of Slade Society Show…Opinions (at least, as expressed to me) favourable…

Wednesday 13
London. Saw a show of pictures by members of the Balloon Barrage corps at the National Portrait Gallery. M.o.I. Committee. Stephen Bone's memorandum on choice of subjects for war-record pictures discussed. Some lively Piper drawings presented, of the bomb-damage at Bath…

Sunday 17
Marked 20 Exam. papers for the Board of Ed. Exams. There are 118 to do this year. Luard will help.

Monday 18
…Train…to Yeovil via Reading & Basingstoke, on Board of Ed. Exam. business…Yeovil has been heavily bombed…

Tuesday 19
9.30 Reginald Green, H.M.I. for the Board of Ed.'s S.W. district, called in a car to take us to Montacute. The House is now full of the objects from the V.&A. museum – furniture, carpets, tapestries…We work in a long gallery on the top floor…

Wednesday 20
Talking of [bomb] damage, Green (he & his wife are both painters…who came under

16 Furniture maker, key figure Arts and Crafts Movement, had considerable influence on design.

Sickert's influence at the Westminster School), described the way Bath and Exeter have suffered. The Art School at Bath has been destroyed, and the students are carrying on in the house & studios belonging to Thérèse Lessore Sickert. Rosemary and Clifford Ellis, of the Art School, were great friends of Sickert. Clifford Ellis attended on the old man daily in his last few months, when he was troublesome and ordinary professional nurses wouldn't do it. He, Ellis, would bring a student up to help…Now Thérèse has lent the house to help Ellis. There are 14 bombed out students living at present with the Ellises. Green spoke of Exeter also, where students are in similar difficulties. One was trapped in a fire in the Close near Southernhay, but got out and went on with her Painting Examination, in temporary premises, the School having perished. The model continued to sit…and many students, working for Examination, must have been pretty well worn out with fire-fighting.

Friday 22
Returned to Oxford…

Saturday 23
To London, to hang pictures from the War Records collection for the Ministry of Supply in a newly to be opened canteen in the basement of Adelphi House…We hung some forty or fifty works by Kennington, Lamb, Pitchforth, Bone, Rushbury, Jackson, Piper…

Tuesday 26
The Provost came to visit the Slade…Ridiculous scene in the Broad – one of my coat buttons flew off, and as buttons are precious these days…I stopped to look for it…Birdie went to tea with Faith Henderson[17] and left on my hands Mme. Vandervelde, with her foot in plaster…She is extremely brave, humorous and uncomplaining; considering her age, over 70…

Wednesday 27
…M.o.I. Committee…New Henry Moores, of coal mines, to my mind like the best of Gustave Doré (Cézanne & V. Gogh both liked Doré, as I do); and a parcel of things by Bawden, of the Middle East, just arrived and brought by Coote from the War Office. A disappointing Connard head…

Friday 29
Mme. Vandervelde whom I went to see after dinner…(Madan was there too) described [Augustus] John in Paris at the time of the Peace Conference[18] as reeling drunk at an official luncheon, but everybody, apparently, quite used to it. At that time the Marchesa Casati[19] used to go about, in her own house, perfectly naked, and received her guests in that condition. John painted a nude of her, which was shown in Paris between two of his portraits of members of the Conference. Mme V. also told us how [W.B.] Yeats came to her in Paris for advice about whether he should propose marriage to Maud Gonne. He admitted that he didn't really want to marry her, but he thought that as a man of honour he should offer to do so. It was settled, after he had deliberated again for a day

17 Married the economist Sir Hubert Douglas Henderson.
18 1919, Orpen also attended.
19 Heiress, socialite, artists' muse.

or so that the offer was to be made, and Mme. V. accompanied him in a taxi to Maud Gonne's residence. She stayed in the taxi while Yeats, pale with emotion, went upstairs. Presently he came back radiant, and bounding downstairs like a youngster – she had refused him.

JUNE

Monday 1
Slade till 10 o'c. Train…for Yeovil…

Tuesday 2
Montacute…Marked 118 still-life paintings, passing about 70 pc. Some say…we are too generous in our marking, but the standard is…better than it used to be…The Germans have seriously damaged Canterbury now, in revenge for the big raid on Cologne.

Friday 5
Left…at 9.45 with Luard, Travis & Woolway…

Saturday 6
Private View of P. Wilson Steer in the top room of the Ashmolean. Helped Mme. Vandervelde across the road and up in the lift to see it, and, what I suppose she is really more interested in, to see the few people who came: Madan, John Rothenstein, Mavrogordato, Mackeson, Denis Sutton and a very few more. The *Yachts* of 1880 something, in spite of its black frame, looks very well, as well as a Monet, whose inspiration one recognizes. Other oils have a fine Turner feeling, without being positive derivations: and there are beautiful water-colours, magical to artists like me & Mackeson, who can't achieve anything in that apparently unlaborious way. Knowledge & feeling – inimitable things. It's no good trying to imitate Steer. 8.30 Party at the Sydney Shepherds'. Birdie didn't go…It was really rather like an old-time (pre-war) Chelsea party, very informal and not very highbrow…Tables laid in the back yard of the small house in Walton Street, for about eight or ten people with the washing hanging out in the garden behind…

Tuesday 9
Diploma Examination. One failure. Borenius, Ormrod, Russell examiners. Russell drove over from Bourne End, with Lydia [née Burton][20]…whom I quarrelled with about 30 yrs. ago in Chelsea because she spread scandalous untruths about Birdie and Norah Summers[21] and who has cut me ever since till now, was most affable and engaging both to me and her old friend Albert…This year I was worried about the excellent Charlotte Stone[22] whose work is decidedly on the weak side, but who has so many qualities that go to make a teacher, and who was warmly approved when interviewed by the representatives of the London Institute of Education. It went well with her, however, and the work in general praised by Russell. He liked [Bernard] Dunstan and Miss Cartwright, and Norah Godfrey.

20 Married 1900.
21 Lesbian photographer and painter, lover of Dylan Thomas' mother-in-law Yvonne Macnamara.
22 *Beacon Writing: A Course in Italic* (1957-59) by C. Stone & A. Fairbank; *Teachers' Book for Books 1 & 2* (1957) by C. Stone & *First & 2nd supplements to Books 1 & 2* (1961) by A. Fairbank & C. Stone.

Wednesday 10
M.o.I. Committee. At the Club...Dodd...told me of an instance of how far a scent will travel over the sea...when he was on a submarine it surfaced fifteen miles from the English coast: the commander said 'Would you like to smell the hay-fields of England?', and Dodd noted that the scent of new-mown hay was very clearly perceptible.

Thursday 11
C.E.M.A. at the National Gallery...Bought more pictures, by Kirkland Jamieson, Tunnard, Keith Baynes...and made lists for further purchases...John's O.M. [Order of Merit] was announced in the papers this morning. *The Daily Herald* alone made no mention of it... though it mentioned all the tuppenny ha'penny labour men who had received honours. Every one seems very pleased...

Monday 15
...Lowinsky called at the School...we visited Codrington Library, where I had never been, having always looked upon All Souls as entirely inaccessible during the War; and we proceeded to Queen's, bluffing the porter who wanted to know our business (as permits are supposed to be necessary) by saying we were going to the Library which we did...Met Dr. Berkowicz, mild & resigned as always, but now a figure model no longer. He has a Government job suited to his talents, being employed as a surgeon at the Wingfield for the duration of the war. Oddly enough, he was operating the other day on the same North Oxford lady who employed him some time ago to scrub her floors; an indignity he suffered with the resignation and fortitude that carried him through several German concentration camps, with all their horrors...

Tuesday 16
Recollections of Charlton's gossip yesterday – Bernard Shaw opened the Tate Gallery Restaurant decorated by Rex Whistler. Charlton went...It was not a crowded affair, and a few young artists were conspicuous in the audience. Shaw at one moment addressed himself particularly to them, giving them advice based as he said, on his own experience, and quite seriously, without a suspicion of the tongue in his cheek: 'Never' he said, 'if you want to succeed, never behave like gentlemen'. The exact opposite of Augustus Spencer's – 'Be gentlemen – it pays.' Steer spent one of his summer vacations at Fothergill's Spread Eagle in Thame, which accounts for his painting of *Brill* [*Buckinghamshire* 1923], now being shown at the Ashmolean. Charlton had hoped that Steer would join him, in another vacation, at Long Melford, but it came to nothing. Steer came, with David Muirhead, and Charlton met them and showed them around. He says that Steer completely dropped his indolent, heavy, sleepy Chelsea manner, leapt out of the car, and bustled about most actively to see what was to be seen, from a painter's point of view. Eventually, since Muirhead complained that there were 'too many willow trees', Steer and he went off to Harwich, a familiar haunt of artists, where, I suppose, they found stock subjects more to Muirhead's liking. I don't think Steer cared much either way-he could find subjects anywhere...Left Oxford for Yeovil...

Thursday 18
...Meeting in Montacute House conducted by Rokeling... [a] very typical superior civil-servant...

Friday 19
Train back to Oxford. Luard…as far as Frome, where he changed to go to Chester, being engaged on some drawings for Bomber Command…

Tuesday 23
Judging for Prizes at the Slade.

Wednesday 24
London. Lunch at Athenaeum, with Gere, Walter Lamb…Coffee with Gere & Oppé: discussed Nicholas Pocock, and John's moral character. Oppé is the only man I have heard maintaining that John shouldn't have had the O.M., on grounds of character. I alluded to this (a little later, when we our M.o.I meeting) in conversation with Miss Oppé, which Kenneth Clark overheard, and was good-naturedly combative about it. I suppose he must have backed John's name with the K^g & Q^n. Oppé has a reputation for his bitter tongue. Tea with Gere & Bone. Bone, when working on his drawing of the Painted Hall at Greenwich, where there is a portrait of Thornhill among the mural decoration, was accosted by a descendant of Sir James, and an illustrator of children's books in civil life. Bone is putting a little portrait of the Lieutenant in the foreground of his picture. He says that if he had two lives to live he would devote the second to the study of perspective. He does not set his drawings out, but does them by eye. He is working at present in some discomfort, perched up with a large drawing-board on top of a kitchen table…

Thursday 25
Awarding the rest of the Slade prizes with Albert & Ormrod & Miss Allan (for lithography). The students are a little puzzled, it seems, about our previous decisions. They can't see Miss Godfrey's claims to prizes for drawing & painting. There is, I suppose, more brilliant and showy work, and her sterling qualities are not sufficiently appreciated. However, the staff are unanimous about her. Whether she will become an artist there is no telling, but she has much of an artist in her…

Friday 26
To Reading, to judge the work of a single candidate for B.A. Hons. in Fine Art. Betts showed me some of his paintings. There is a strong Sickert influence in them, and a good deal of talent. They have a certain oddity, a dislike for the conventional beauty or prettiness carried sometimes rather far. I saw, too, some good wood-engravings of his, well-designed to go with type.

Saturday 27
Last day of Slade term. Albert gave a tea-party to 30 or 40 Slade students in S.C.R. at New College.

Monday 29
Birdie's birthday…Father Richard Kehoe (of Blackfriars) came in in the evening. He is a man of great intelligence and knowledge, with charming manners…

Tuesday 30
Bernard Gotch is holding his annual exhibition of water-colours, of Winchester and

Oxford, in 9 Peckwater [Christ Church]. His trees and buildings are very carefully &
pleasantly drawn...Before this...visited another little private exhibition of Cecil Riley's
paintings & drawings...One or two quite good works...

JULY

Wednesday 1
London...P.V. of the Artists Aid Russia exhibition, where Bysshe has a picture...M.o.I.
Committee...Took a taxi to Hertford House: crowded with pictures and people. Mme.
Maisky,[23] the Mayor of Marylebone & Charles Tennyson had all made good speeches, it
seems, at 3p.m. Met Alice, Bysshe & Lady Mellanby[24] and a number of others...Escaped,
and had a quiet tea at Lady Mellanby's club in Cavendish Square...it has something to
do with nursing...

Friday 3
...went to London to attend the dinner given by Kenneth Clark to mark the retirement
of Dickey from the post of Secretary to the Artists' Advisory Committee. It took place at
The White Tower, once The Eifel Tower run by the late [Rudolph] Stulik[25]...now run
by Greeks, with wall paintings by a Greek artist in a neo-modern French style. There
were present Sir K. & Lady Clark, Dickey & Mrs. Dickey, Miss Oppé, Ld· Willoughby de
Broke, Bone, Russell, Gleadowe, Henry Moore, Eurich, John Piper, Freedman, Ravilious
& Graham Sutherland...Clark...spoke for about ten minutes after dinner in praise of
Dickey, who replied suitably. Freedman also spoke briefly and in a comic vein...

Saturday 4
Began to draw [Police Constable] Dart, B.E.M.[26] of Swansea, who arrived in a very smart
full dress uniform with silver buttons, modelled on the Guards'. He began life, as a boy,
in a coal mine, his father having been a miner too. His father's advice was to chuck that
career, as there was nothing in it, so he joined the Constabulary, in spite of being offered
a Scholarship which might have taken him to a Welsh University. He was well treated in
the coal-mining firm, and went on with his education, while with it, so that he might be
qualified as a possible overseer or manager. An intelligent man, of fine physique. His medal
was for conspicuous courage in air-raids. Got a good way with the drawing, in pastel...

Sunday 5
I see in *The Observer* a review of the book about the late E[dward] Powys Mathers...I
did not know that he was 'Torquemada',[27] and I did not know he was dead [1939]; but
I remember him very well in his rooms on the top floor of the big old early Georgian
house on the south side of Lincoln's Inn Fields, which subsequently became the College
of Estate Management, and from which the lowest stage of the huge spiral staircase was
removed to the V.&A. museum. Mathers & his wife used to haul up their coal and parcels

23 Wife Soviet Ambassador to Britain.
24 May Tweedy married Edward Mellanby 1914, collaborated in his research on nutrition, as well as
working independently.
25 Stulik's restaurant was popular with the likes of Augustus John, Wyndham Lewis, Nancy Cunard.
26 See the supplement to the *London Gazette* 25 April, 1941.
27 Mathers composed crosswords for *The Observer* under the pseudonym 'Torquemada' – a grand
inquisitor of the Spanish Inquisition.

by means of a rope and tackle fixed on the top landing of the staircase well. This was…not long after the last War. I remember, too, when we went to Worth Matravers one summer [c.1920] with C.R. & Margaret Mackintosh, that we found Mathers staying there. I met him unexpectedly in the village street, and after exchanging greetings I took him to the village pub. I asked him 'what he would have?' 'Well' he said, 'I will start with a quart'. He used to drink a good deal, a habit formed…during his war service as a secret agent in Norway, where it was his business to sit in cafés and talk to the sailors. Finished P.C. Dart's portrait in the morning, and worked on the Radcliffe Square drawing in the afternoon…

Monday 6
To London, for a New English meeting. Travelled up with Griselda Allan, who was setting out on an expedition to draw railway engines…Decided that the [N.E.A.] Club would not hold a large exhibition of Steer, as had been proposed. In the first place, K. Clark wants one at the National Gallery. In the second place, R. Gray has ascertained that neither Blackwell nor Daniel would lend, and without their collections a show would be too incomplete. Also there is the financial risk…At the R.B.A. Galleries W.L.C. took me downstairs to the rooms now used by the Artists' Society for drawing from the model, a pursuit in which he takes part with enthusiasm. The Society is that founded by Etty in 1830, once in Fitzroy Street, then at Langham Place rooms. There is an Etty oil on the walls…I took one of the Charles Keenes down and had a good look at it: a good painting – good in tone, as is all his work is-of the club interior and dining table.

Wednesday 8
With Norrington, of the [Oxford University] Press, to London, to examine Amen House [Warwick Square] with a view to making a drawing of it for the *Oxford Almanack*. The house and a few of its neighbours stand as a small group amid the partially cleared ruins of others. There is an excellent view of St. Paul's from the roof…M.o.I Arnold Palmer [secretary] came for the first time.

Friday 10
Left Oxford for Liverpool…Fare £1.11….Hanover Hotel…A hundred yards away the Bluecoat School (1717) is a mere shell. One cannot walk a hundred yards without seeing similar traces of bomb and fire damage…The Cathedral has grown greatly since I last came to Liverpool to make drawings for *The Manchester Guardian*, 15-18 years ago…

Saturday 11
At the Art School, in Hope Street, where Huggill, the Principal…put a studio at my disposal…10a.m. Chief Supt. Nichols [G.E.M.] of Liverpool, & Sergt. Alker, of the Manchester Police Force came. I started to draw Alker, a fine fellow, once a coal miner. He gave up that career because he wanted, if he stayed in it, to become a mine-manager, and there were too few mine-managers wanted in the slump; so he joined the police. Much the same story as P.C. Dart…Drew him from 10.15-12.45, and again from 2-4.30, by which time I decided that his portrait was finished. It was a fine day…and the light was good, which helped.

Sunday 12
Drew…Nichols…An excellent man, he has risen from an ill-educated (since then self-

educated) youngster to a rank equivalent to Lieut. Col. His attitude to me was genial yet respectful − he addressed me always as 'sir', rather to my surprise. A brave fellow (as they all must be, to get their distinctions), religious, simple and fond of gardening… Some torpedoed Norwegians are in the hotel. I am told that Liverpool's worst 'blitz', for nine days or nights, on end, was in May 1941. Since then it has been fairly quiet. There are still a few shawled women, like the mill hands of my childhood, to be seen in the streets; and numbers of Chinamen…

Monday 13
…Trouble at no. 7 because Mrs. Brown can no longer cook our mid-day meal…We shall have to go out three days a week, which may add to our expenses and is a bother with all the Oxford restaurants so full…Bought Birdie a 'utility' lighter − 5/9d…on account of the match shortage.

Wednesday 15
London…Lunch at Club. Talked to…Dodd, who had Stephen Bone with him…[Bone] has got leave from Camouflage to paint some pictures for the Artists' Advisory Committee…Ran into Reid & Lefevre's shop…to glance at an exhibition of paintings by Matthew Smith, some of which I disliked very much, though an occasional flower-piece or still-life was…good…M.o.I. Committee…At Paddington, met Mrs. Norman Janes. Janes is in the Middle East, in the Libyan Desert: all well so far…I am not quite clear what his duties…are…

Thursday 16
Saw Griselda Allan's drawings of engines and engine-sheds on the Southern (?) Ry. Interesting subjects, and the engines themselves are fine things. Very little pictorial use has been made of them: I myself have never drawn them in my life, though I have tackled threshing machines & tractors: in fact, I remember Clausen, one day in the studio I shared with Monnington at S.K. protesting against my making use of such 'ugly' material…

Saturday 18
To London, to see the Artists Aid Russia exhibition…and to meet Ginger there. Ivy & Charles very busy running the show. Edward Le Bas bought the £600 John oil of a negress. The sales are nearing £3000…

Sunday 19
Went to London. Began my drawing for the *Oxford Almanack* of Amen House.

Thursday 23
Got up at 6.45 (really 4.45) to go from Bushey to Oxford to meet Tanner and discuss Slade business with him and Albert R.. When I reached the Ashmolean, at 11.40, Albert gave me the news of the Provost's [U.C.L.] sudden death. Naturally, Tanner gave up his Oxford visit…I am very sorry indeed about [Sir Allen] Mawer. He was a good friend to me and to the Slade, a good scholar and a fine character. He was a very energetic man − it was the effort of running to catch a train, and carrying a heavy bag at the same time, that killed him. Something similar happened to Matthew Arnold. The Tate Gallery has bought my drawing of the Observatory [plate 23].

Saturday 25
...Ivy [Tennyson] has sold Epstein's *Young Communist* bronze for £300 to a business man, Mr. Hill of Muswell Hill...who has never in his life bought a work of art before, and is interested in the bust partly as a study of a communist, partly as a means of subscribing something to Russia. The taxi driver who took us to Kingston subscribed £3 in notes to help Russia...and didn't want a picture for his money.

Friday 31
Amen House. In the morning Madan called me to look at a painting that he has bought, a figure of *Literature*, on a canvas about 4 ft. sq., by Laurent de la Hire (1650)...and is going to house it, with K. Clark's permission, in the National Gallery. It is a good picture. Italianate, with a trace of something like Poussin's classicism...Mme. Vandervelde was in Madan's rooms, her foot in plaster for the second time...Madan's notion, as a liberal-minded Indian magistrate of experience, is that the Hindus tend more to bad character than good; and that they are as yet far from being constructive politicians.

AUGUST

Wednesday 5
M.o.I. Committee. Delivered my drawing of P.C. Dart... ...Return train journey with Bone. He is still working on his Greenwich interior – finds the business of minute portraiture difficult & troublesome. He lunches at 11 o'c., so as to be free when the staff has its lunch. Dodd has finished painting Baldwin. He complains that Baldwin's face is seldom still – his tongue is constantly moving about and his facial muscles alter.

Thursday 6
Memorial service for the Provost, at Christ Church in Woburn Sq....Returned after lunch with Corfiato to U.C.L....for the Professorial Board convened to consider the question of the Provost's successor. Committee of 5 appointed...This was the first Prof. Board I have attended since the beginning of the War...Butler took the chair. Hitherto the Boards, since the U.C.L. was evacuated, have been held at Leatherhead...Bob Lyon – a bad teacher – is appointed to Edinburgh instead of either Rodney Burn or Allan Walter. Wellington's own preference in the choice of his successor was Burn, but he had nothing to do with the final decision...

Sunday 9
...Got in over 7 hours work on the Radcliffe Camera. Talked to an Indian about Gandhi, who has just been interned. The Indian gentleman said he would like to know what Sir W. Rothenstein – always a friend to India – thought about it. Churchill he did not regard as a friend to India. There was nothing in the great Atlantic Roosevelt-Churchill Charter about India. I put in a word about Stafford Cripps, and he let that pass...One reason, he said, for Gandhi's civil disobedience is that G. does not believe in the ultimate victory of the Allies...

Tuesday 11
Amen House. The Irish and cockney workmen are still engaged in the apparently futile job of picking up the chipped curb and putting down a new set of stones, all along Warwick Lane...

Friday 14
Amen House for the last time.

Wednesday 19
M.o.I.

Thursday 20
...Took my drawing of *Amen House* to be censored by the Ministry of Information, which was done in a moment when I reached the right department...C.E.M.A. Committee at the National Gallery, for purchase of water-colours. A good unaffected one...by Geoffrey Rhoades...

Saturday 22
Bill on a week-end leave, came to Oxford and he & Alice, Bysshe & I dined at The George, 5/- dinner, very good...

Sunday 23
In the morning made some studies of Bill, over in the Ashmolean, for some more diagrams of shooting attitudes that he wants for his teaching courses...

Monday 24
...Took a bus to Cumnor Hill, at the invitation of Healey, late of Knoedlers. Cathleen Mann (the Marchioness) was there, at the small house overlooking Oxford (though you can not see much of Oxford owing to the growth of Hinksey & Botley), and her handsome & well-mannered little boy, Lord Drumlaurig, who has returned from an evacuation to Canada...Cathleen Mann, who was at the Slade for about a year in 1914, confused me, I believe with Derwent Lees, who was teaching in her time. She found Tonks alarming, but said that the girls used to fall in love with him and – this is on the authority of Ronald Gray – used to write him real love-letters...

Thursday 27
My last day of work...in Radcliffe Square...The University Press, to whom I delivered the drawing of Amen House yesterday, write to say that they will send me a cheque for £40 – £10 more than they originally suggested – and expenses. As they are behaving so handsomely, I shall not charge expenses.

SEPTEMBER

Wednesday 2
M.o.I. Committee. One cargo of pictures on its way to S. America has been sunk. It included works by Muirhead Bone, Cundall, Kennington, Eurich...

Friday 4
Left...for Cranleigh to do another portrait of Hank (i.e. Henry) Marks...Nancy Joan M. met me with car at station. She joins the W.R.N.S. in a fortnight...It is a small world. Mrs. Wordsworth, who is staying in the house, is a cousin of George Kennedy, and

Henry Marks goes to school at Gordonstoun…where Kennedy is teaching. At 8.20p.m. J. Marks & I walked out to talk to Sparks, the farm manager, who was still ploughing with the tractor in the fading light…

Saturday 5
Julian Marks informed me that Susan M. wanted him to sit for his portrait too: so, as he has only the week-end at home, I started on him in the afternoon, after drawing Henry, up to a certain point…Plenty of cream and butter and blackberries and mushrooms to eat here, but no jam. There has been a plague of wasps this year, and much of the fruit has been devoured; yet the pears seem to be doing well, though each windfall has about 20 wasps on it…

Sunday 6
Henry M. on parade with the Home Guard…Drew his father, and finished the drawing. Mrs. Marks, is, I feel, satisfied. When she is not, her comments are pointed. At one stage of her husband's portrait, she said it was pink & smooth, 'like a baby's bottom'. That was yesterday. To-day things are better. He is a fine looking man…Went on with Henry in the afternoon. Saw the last cart load of the Snoxhall harvest carried to the rick…Sparks said to his employer that he hoped he didn't mind the ricks being thatched with the straw finials usual in Sussex, as Snoxhall is in Surrey; though Sussex is only a mile or two away. Sparks is a most intelligent, hard-working, experienced man on the farm, though he left school at 13 and has little education of the ordinary kind…

Monday 7
Finished Henry's portrait, apparently to Mrs. Marks's satisfaction. Her interim complaint that I had made him look like a criminal is now withdrawn…

Wednesday 9
M.o.I. News that Ravilious is missing, after his first operational flight in Iceland…

Friday 11
…Camilla Doyle came over from Bampton Vicarage, with some most interesting accounts of her fire-fighting experiences in the Close at Norwich. She always sleeps in her clothes now, and is a member of a workman-like team which did a good job of work in one of the big Norwich raids, preventing, by an hour's strenuous pumping & carrying water, the fire from spreading from one house to its neighbours. Her own house is much shattered and she lives almost in the dark behind boarded windows: all the glass has gone. Her eccentricity is less marked now than when we saw her last. She was always intelligent, and I think occasionally her verses have the genuine thing in them.

Tuesday 15
Interview with Veale, about the Food Office requisitioning the Slade Design Room in the Ashmolean extension…

Wednesday 16
M.o.I. meeting was…for the first time, not a quorum…

Thursday 17
Hallam Tennyson in Oxford…preparing for a psychiatrist's career, trying to get a degree as an external student in his spare time; meanwhile acting as a male nurse. He has toughened and improved his appearance since his early undergraduate days…

Friday 18
Went to London for a meeting with Tanner, Albert & Nutthall-Smith about Slade business. We met at University College, in one of the rooms which are still usable and visited the ruins when we had finished our discussion…Travelled up in the train with Hallam Tennyson and [Lawrence] Dale the architect. Nova Pilbeam has been done out of the part in *Claudia* for which she had a contract, and Pamela Brown is playing it, and getting very good notices too.

Sunday 20
I see in *The Observer* that Roger Pettiward[28] was killed in the recent raid on Dieppe. Osbert Lancaster, who knew him at the Slade, writes a sympathetic notice of him and Ravilious. It was not so long since I met him in Oxford. He might have developed well as a painter, having great talent. Though he had a good income, he wished to be a really professional artist and to sell his work, not to remain a dilettante amateur. I believe he sold his house at Stowmarket and gave up the life of a country gentleman for this reason, and ultimately did the humorous drawings which he signed 'Paul Crum'. He went on some adventurous expedition up the Amazon, soon after he left the Slade: adventure appealed to him, and no doubt that was why he joined the Commandos, being a man of great spirit and courage.

Wednesday 23
M.o.I. a better gathering than last week, and a long meeting…Arnold Palmer is giving up the Secretaryship…MacColl has had an accident – fainted, cut his head, and has had it stitched up. They are without service again. It is all very hard for two old people, who have been used to reasonable comfort throughout their long lives. Dodd is in a state of nervous irritability – is disturbed by a fly on the window, and cannot bear to work out of doors in the streets because of the interruptions. He was harassed by his portrait of Baldwin, and is going to take a fortnight's holiday at Seaton in Devon before starting a new picture of Sir Henry Dale. However, he was pleased by Lady Baldwin's comment that he had succeeded in giving her husband the best of his many expressions – an unusual tribute from a wife to a painter.

Wednesday 30
Train to London. Travelled with Muirhead Bone. Met Haward of Manchester in Regent St., and went with him to the Leger Galls. to see a show of an artist now boomed by Clive Bell, one William Scott. Quite new to me, though it seems he had pictures in Ivy's Artists Aid Russia exhibition. Pleasant quality of paint and feeling for colour: form, tone, recession disregarded as is now the accepted fashion. To National Gallery, 12 o'c., for a small committee of Lady Clark's, about John Piper's designs for wall decoration in a restaurant at Merton Abbey…M.o.I. Committee…Another spate of Kennington nerves, the last of them…as has resigned from his job as a war-artist to the R.A.F.. Coote hates

28 19 August 1942.

Kennington's work, so does Russell, and Clark thinks it will, in its Totalitarian way, have a corrupting influence.

OCTOBER

Tuesday 6
Tea with Paul Feiler at Radley College, where he is now art master. He showed me Newton's science building, which I am commissioned to draw, and showed me much bogus Gothic building, unsympathetic to my eyes. Some of this I did not see on my previous visit to Scott-Snell. Feiler has a room in the old mansion. His humorous drawings would have found an immediate market in the days of Seymour and Crowquill [1804-72]. His painting has pleasant colour and a sense of character in figures, but the form is not closely studied. He would make a good scenic artist...

Thursday 8
Continued with drawing at Radley...The Radley College boys are quite civil & respectful about my drawing. They ask a lot of questions....

Sunday 11
To see F.H.S. Shepherd in the Acland Home. Prostate operation, successfully performed. But he is really miserable...All his old terrors have come back on him. He is frightened of Germans, afraid for his own sanity, and depressed beyond measure about life in general: wishes he was dead, says he is killing his poor wife by being such a terrible dead weight of uselessness, dreads the monotony of their life in Oxford...I couldn't find much to say that would console him, but perhaps it may do him good to pour out these complaints...To find a once cheerful, humorous old friend, of over forty years' standing, in such a condition, is painful in the extreme...

Monday 12
Slade began...Will Rothenstein is in the Acland Home to be examined and overhauled... Went to see him at 4...very cheerful & in good shape, talking of Robert Bridges, Gerard Hopkins, Everard Hopkins[29] (whom he knew well) & H.G. Wells, whom he used to like and admire, but doesn't admire Wells' latest work *Phoenix*. Tommy [L.] is all against Wells, who came to lunch at Garsington and annoyed him & Ruth very much: was inconsiderate about the lunch, said he was on a special diet and couldn't eat what Ruth had prepared...if he had told her beforehand...she would have procured something he could eat. He talked without stopping and finally assured Ruth that she and women like her would commit suicide because they wouldn't be able to stand post-war conditions...

Tuesday 13
...Clark was very good in the B.B.C. Brains Trust. When I said something of this kind to him on a previous occasion he said he was really so embarrassed by the ordeal that he forbade his children to listen...

Wednesday 14
To London (13/2 – no cheap fares now), M.o.I. Athenaeum: talked with Richmond

29 (1860-1928), watercolourist and illustrator.

about Fritz Shepherd's case…Richmond knew William Morris and admires him greatly, but, as he was young when they met and Will^m. M. didn't like little boys, he has no very intimate revelations to make…Mrs. Ravilious seems to have no private means, and under the government scheme of compensation will be entitled to only 22/6d a week, Coote says. She has three children, and was contributing 8/- a week to the support of Ravilious's father. Ravilious commonly made about £350 p.a. – not much. Hennell is dead keen to take on Ravilious's work in Iceland…

Thursday 15
Albert R. put me up as a member of the [Oxford] Union,[30] in order that Birdie (whom I can take as a guest) and I may have lunch in peace instead of the scramble and noise at the Kemp Hall cafeteria. The food costs about the same or a little more, and the subscription is £4-10-0 p.a., but I think the saving in wear and tear is worth it. We at once availed ourselves of the privilege, and had a good meal, well served…

Saturday 17
Lowinsky rang up…to tell me that Albert's little nude of Patricia Koring has been chucked by New English…I never thought it probable…Tommy is so concerned at this insult to A.R. that he says he is going to resign…Radley, 1.30-6.0. Feiler introduced me to the Warden, a very suitable figure for the head of a big school. A marvellous sunset, orange crimson, turquoise – every colour possible. Reminded me of a saying of Ernest Jackson's to his students – 'If you are bored, you've only got to look at the sky.'

Monday 19
Albert has resigned from the N.E.A.C. – after some forty years' membership. He is quite dignified and restrained about it all. He asked K. Clark to tell him frankly whether he, Albert, was really 'gaga' and deserved to have his picture rejected. Clark, who knows the picture, said far more in its favour than he need have done if he had merely been making a polite and sympathetic speech…I have written a letter of protest…Kelly lectured in the evening to a youthful gathering of the O.U. Archaeological Society…on Shakespearian costume, pouring it all out easily in his pleasant voice…He is a fine scholar – one of the finest I have known.

Tuesday 20
Said good-bye to Kelly, who called…on his way to catch the…train to London. He and I came to the Slade for the first time on the same day in 1899 – or was it 1900? and sat side-by-side in the antique room. He was the first man who spoke to me there. I was 14, and he had come down from Balliol. He had not enough money to stay up for his degree. We discovered very early that we had tastes in common, in the direction of armour and costume.

Wednesday 21
To London. Bone was on the train, and we went to the N.E.A.C.. Clause was there, full of the Albert R. business. He says there is an anti-Jew feeling in certain quarters. Even Steer seems to have had a touch of it; made allusions to 'Jews in Oxford' (including me, with A.R. & Tommy). This was when Willie Clause saw the old gentleman about a fortnight before his death. Willie told him I wasn't a Jew, and went into my family

30 The Oxford Union was founded in 1825 as a debating society.

history. Nevinson has written an extremely stupid and abusive letter to Bone, begin-ning-'Sir Bonehead Muir', and going on on a note of triumph about the Air Ministry having bought his big view from an aeroplane that was in the R.A. – a purchase made in spite of the evil machinations of the Artists' Advisory Committee. There was some reference to 'Germans', probably meaning me. I find it rather gloomy that there is so much ill – will and pettiness about. 11.45 saw John Piper at the National Gallery with regard to getting a design of his – for a mural decoration in a 'British Restaurant', executed by Polunin's students. Saw K. Clark, who expressed himself warmly in favour of A.R.'s picture. Meeting with him, Lady C., Russell & Eric Newton. Turned down a poor design by Kenneth Rowntree for another British Rest. decoration…M.o.I meeting…Clark told me that R.O. Dunlop had written to him asking him to 'open' the N.E.A.C. Clark refused. I can't understand Dunlop's action. The Club is never 'opened' by anybody, and Dunlop, as far as I know, isn't even on the Executive, which would have to deal with such a matter.

Thursday 22
Gave Stuart-Hill lunch at the Union. He is staying as before with Colonel Kolkhorst at Yarnton. Ivan Philipowski, who still sleeps at the studio in Glebe Place, is continuing his recitals of Schumann, Bach, Rachmaninoff…for which Lyons & Co. pay him £1000 p.a.. He has managed to interest the Corner House public in good music, doing, thus, something of what C.E.M.A. sets out to do. Adrian Boult took the trouble to congratulate him specially on his efforts, which sent up Philipowski's stock with his employers… Kolkhorst is spending hundreds forming a collection of carpets…

Friday 23
Lunch with Borenius at The Randolph. He broached to me, as he had broached to Albert R. yesterday, a scheme for articles in *The Burlington*, on the lines of MacColl's *Modern Vasari* in *Artwork*. Albert is to do something on the Camden Town Group. John has done his 'Gwen John'…Tea with Ivan McNair, [Trollope's]…brother, and June Miles at 18 Beaumont Street…it is civil of them to ask me to tea. We disagree about many art matters, but they are polite about those, too. He admires Cadogan Cowper and Brockhurst but also John & Raphael. Making money as a portrait painter seems to be his ambition…

Friday 30
Barnett Freedman…at the School. He presented me with some bound-up proofs of his Jane Eyre lithographs…When he was at Boulogne in 1940, he was nearly captured by the Germans. He and an Australian officer, of the 'tough guy' type, were in hiding as the Germans passed about 200 yards away. Barnett kept on peeping out, and the Australian kept on dragging him back into shelter. Barnett says, of course, that he was terri-fied…The Australian said – 'Well, you may be a bloody war artist, but you've got guts'…

NOVEMBER

Monday 2
Dined with Albert R. in New College. Father D'Arcy was his other guest…D'Arcy afraid that the old love of the land may go, with post-War re-planning and the extinction of the landlord class…Charlton tells me that Hilda Carline, Stanley Spencer's wife, is now

completely broken down in mind. It is a sort of mental degeneracy affecting the control of her bodily functions. There is a portrait of Stanley by Daphne in the N.E.A.C., and portrait of Daphne by Stanley in the Ashmolean exhibition (Tate Gallery Purchases).

Tuesday 3
Tea with Mary Dudley Short[31] now Mrs. [Broke] Freeman, in a minute flat in a big block called Woodstock Close. Her husband was once a master at Stowe and is a friend of Roxburgh since his Cambridge days. Later he was a master at Loreto, that Spartan School where they have no fires whatever, and two cold baths a day. The Freemans have pictures by Paul Nash & Meninsky, one a portrait of her, which Freeman does not think like her, but it has some resemblance. She is a skilled wood-engraver and does water-colours also...

Thursday 5
To London with Albert for a British Institution Scholarship Committee at R.A....Awarded scholarships, one without knowing till afterwards, to Reid Dick's daughter. He did not attend. Lutyens in the chair, not very useful...even about the architectural scholarship. I think he is past it...Later went to see Curtis Green's show of water-colours at Walker's. He is quite a good performer, mildly in the tradition of Cotman. News of the 8th Army's success in Libya, Australian's advancing in New Guinea, and the Germans and Japanese doing no good anywhere...

Friday 6
Took Arthur Tunstall & Anthony Kerr to lunch at the Union, and afterwards to look at the Pre-Raphaelite [Mural] decorations on the roof of the Library there.[32] As they are writing an article[33] on a decorated room, probably by Morris and Burne-Jones, in a house belonging to Queen's, it is useful to them to see these paintings also...Borenius put them on to doing the article...

Monday 9
Albert said what a good thing it was that wives such as Birdie & Margery took no part in the politics of art, and did not make any attempt to push their husband's artistic interests socially: that much harm had been done to Will in that way by Alice, who was too ambitious for him...

Tuesday 10
Albert criticized the Summer Compositions. We gave prizes – 2nd not 1st – to Kerr, Tunstall, Dunstan & Ethelreda Clark...Dined in New College with A.R.. Talked with Lord David Cecil[34]...went to a small party at Griselda Allan's studio...Zimmern[35] at New Coll. thinks our armies will be in Rome in three weeks.

Wednesday 11
To London (not on M.o.I. business, but for the N.E.A.C. Executive). Fog. The 10.20 train

31 (1895-1986), known as Molly, moved Oxford 1941, member Oxford Arts Society, left 'the pick' of her collection to the Ashmolean.
32 Begun August 1857 - Spring 1858.
33 See *The Burlington*, February1943.
34 Oxford don and literary biographer.
35 Inaugural Montague Burton Professor of International Relations, Oxford University 1930-44.

arrived at 1 o'c. Travelled with Polunin and Bone. Polunin told me his life's history. He had an official position in the Forestry department in Russia, but gave it up to be an artist. He married an Englishwoman and arrived in England with her and about £10. All his boys paid for their University education with scholarships, I think from St. Paul's School...Saw the R.W.S. show, rather good. Many people do good water-colours – Russell, Dodd, Charles Knight, Squirrell; even, sometimes, people whom one does not think able to rise above the common, such as Lamorna Birch, Oliver Hall, & Russell Flint. This makes one feel properly humble. Met E.T. Holding, a sincere lover of Sussex landscape, and an able performer. N.E.A.C. meeting at R.B.A. Galleries...Discussed the resignations (Will R. has *not* resigned his Hon. Membership) and future elections...

Saturday 14
Dr. Pye, our new Provost, called upon me in the Ruskin School, without notice. He seems a very agreeable man...He asked me to dine with him to-morrow in New Coll...of which he is an ex-Fellow...Madame Vandervelde called at the School and asked me to lunch with her...Among other gossip she said that Roger Fry wanted to have an affair with her (after having one with Vanessa Bell) but that she did not wish to do so. She and Fry, however, remained great friends. Later Fry developed his passion for Helen Anrep, whom Mme. Vandervelde describes, at their first meeting, as grey-haired and untidy looking. Madame says, too that it was her late husband, the Minister, who got [Edgar] de Bergen, Nina Hamnett's husband, deported from this country. De Bergen was a Belgian. He beat Nina, took her money, and threatened to kill her. Madame's account of Poppet John in the South of France was not flattering...Received an unexpected cheque from Batsford for my half of royalties on 159 copies of the 2nd edition of *Historic Costume* – £12-8-5: also a notification from Chisman that not only a landscape of Cerne has sold at the N.E.A.C. (£10-10-0), but that the drawing of *Radcliffe Square* has sold for the full price of £20...

Sunday 15
Egan Mew came in the morning...He talked about H.G. Wells and an abortive romance with R. Le Gallienne's[36] sister, when Wells stubbed his toe in the moonlight on the end of an iron bedstead, and walked out of the lady's room swearing. George Kennedy called in the afternoon. Conversation about Helen Anrep. He liked her and her mother, but, like me, always thought she was rather a stupid girl. He likes Lamb's war-pictures, and 'Cookham's'...

Monday 16
Charlton says that Stanley Spencer has sold £600 worth of pictures in his present show at the Leicester Galleries. He is now fairly clear of outstanding debt, but his running expenses, with his wives & children, are high – at least £9 a week, and with taxation, he has very little left for himself. He has never been extravagant...As Charlton says of him, 'he looks like a tramp and lives like one.' Nevinson is a sick man. Charlton met him at the N.E.A.C. and thinks he must have had a stroke. His speech is affected, and his right arm...

Wednesday 18
...M.o.I. meeting at 3 p.m....filled in the time by looking at Stanley Spencer's pictures

36 Richard Le Gallienne (1866-1947), English author and poet.

at the Leicester Galleries. Admired a landscape of Leonard Stanley very much. Some of the subject pictures are too grotesque for my real liking. I sometimes have the same feeling about J. Bosch. On the other hand *The Avenue at Middelharnis* [1689],[37] now on show at the National Gallery fills me with pleasure. There can be few pictures I like more. Met Yockney, who told me that he had sold my *Radcliffe Sq.* to K. Clark…

Saturday 21
…2.30 Encaenia[38] in the Sheldonian. Max Beerbohm made Hon. Litt. D. A very good scene. The Vice-Chancellor pronounces Latin one way, and the Public Orator another: the former in the very English way in which I was taught at School. I could follow enough of the speech to realize how flowery it was…Many of the men and women who were being given degrees had their gowns on over khaki and other uniforms. 3.15 – got away to a Private View in the Ashmolean, of the Leamington artists: Stephen Bone, Rodney Burn, Barry Craig, Carline, Darwin & others…Met Jacoby, who took me into another exhibition he is getting up in the Museum, of part of his wonderful collection of textiles.

Wednesday 25
M.o.I. Committee…lunch at the Athenaeum. Met Gleadowe there, who discussed a project of Alan Durst's…for carving emblematic figures of a sailor and a marine, rather in the figure-head style, for the Artists' Advisory Committee. Gleadowe was very unconvinced about the devisability of these, but dutifully brought the matter up later before the Committee. Dickey urged that at least Durst's models in plasticine should be examined, and K. Clark agreed to that.

Thursday 26
Lunch with Mme. Vandervelde and Birdie at Kemp's. Mme. is very indignant with her rich sister & brother-in-law, with whom she has been staying, near Banbury…on account of their complete idleness…and lack of interest in the War: interest, on the other hand, in food, wine, silk stockings, cross-word puzzles, cheap detective stories, flowers in the garden (they have two lady gardeners) and all the comfortable trifles of peace-time. The sister wears silk stockings even when she goes out to feed the ducks, and never offers to give any to Mme., who patiently mends her cotton ones. The brother-in-law dresses for dinner, still has a butler, and leaves the management of his farm entirely to a bailiff.

Friday 27
…to The International Ballet at the New Theatre, where they did *Carnaval* and *Twelfth Night* to Grieg's music. Idzikowski was maitre-de-ballet, and Harold Turner did Idzi's old part of Harlequin – well enough, but so inferior to what Idzikowski used to be (still more so to Nijinski) that it was hardly exhilarating to an old-timer. And the lady who did Lopokova's and Karsavina's rôle! Leslie French sang the songs, but, again, not so well as he did them at The Playhouse. The New Theatre is too big for him.

Monday 30
Albert telephoned from London that I have just been elected a member of the R.W.S..

37 By Meindert Hobbema.
38 Annual celebration Oxford University in memory of founders and benefactors.

After supper, Charlton…and Father Conrad of Blackfriars, an agreeable young man with a vein of facetiousness, whose mother was at the Slade in Brown's time, and who lived in the Ditchling circle of Brangwyn, Gill, Johnston…

DECEMBER

Wednesday 2
To London…to see Chisman and sign cheques in my capacity as Trustee of the N.E.A.C.. Found him in the R.A. Library, which he is permitted to use as an office. To Lechertier Barbe to buy materials. Paint-boxes don't exist now. I was trying to buy one for a girl in the School who has had hers stolen…M.o.I. meeting…Tea afterwards with Dickey at the Charing Cross Hotel. He wanted to discuss Board of Education arrangements for deferring call-up of women art students who were going to be teachers.

Friday 4
Robert Gibbings came to the School from Reading to lecture to the Slade Society on his under-the-sea drawings, of which he showed slides. A ready talker, and interesting. He was at the Slade before the last War. Kerr and I took him to tea at The Randolph. Questioned about Gauguin, he had little new light. I recall that he told us that Gauguin carved his lavatory seat with reliefs, that his master piece was bought by some woman and that it was destroyed by her on account of some indecency discovered in it – whether in the actual fact of its being done at all, or in the treatment I don't know. 8 p.m. Study Circle at Blackfriars, Father Conrad presiding, and interpreting St. Thomas Aquinas. I went with Birdie…A new experience for me. I was somewhat bewildered, but took that to be my fault. An atmosphere of discussion, free enough.

Saturday 5
Hubert Wellington in Oxford. Birdie, he and I lunched at The Union, and looked at the frescoes in the Library: also visited Blackfriars, seeing the Chapel – Gill's figure, the alabaster group…

Wednesday 9
To London, for M.o.I. meeting – a full one, every member…present. At the Club…Dodd has just presented…his study in pastel for the oil portrait of Baldwin. I saw it in Udal's room. I thought it had been done some years ago, as Baldwin's hair is brown in the drawing, and I expected it to be grey; but Dodd says it is not so, and the drawing was done recently…

Saturday 12
Left Oxford by the 1.20 train to Didcot to stay the night with H.M. Bateman, who had renewed an old invitation after buying my drawing of *The Mill Inn, Withington* from the R.W.S.. G.W.R. bus to Curridge (from Didcot station, after an hour's wait) where Bateman lives…Bateman met me at the hermitage station, and we walked to his house, about 20-25 minutes away across country. He has an allowance of about a gallon and a half of petrol a month, so that his car (he ran two cars before the War) cannot be often used. His house is pleasant and comfortable, with good elm-trees and acacias round it, of which he makes numerous drawings and paintings; but it is not one that I should

have chosen to live in myself, and Birdie would certainly jib at the Ruskinian ecclesiastical style of architecture, like parts of North Oxford...At Bateman's suggestion, I had brought over a parcel of three landscape drawings. He is specially interested in drawings of trees. We retired to his corrugated – iron, coke-stove heated studio in a field across the high road, to discuss these and other art matters, and I looked at many of his drawings, paintings and caricatures...Among other things there was a caricature – but so like it was practically a portrait – of my old friend Cecil King, who, Bateman says, has very recently died: a queer man, not a very good artist, whose horizon was bounded by the Savage & the Chelsea Arts Clubs. I am sorry he his gone. We were together at Julian's about 1906-7.

Sunday 13

More of Bateman's pictures. He has many that just want a final revision to be good. He likes farms...and such like scenes: also Spanish views. Some of his notes made on a journey round the world before this war are interesting and good as drawings...Bateman is not on very good terms with *Punch*. He thinks Owen Seaman was a good editor [1906-32], but that Knox[39] though a good contributor, is not good otherwise. He thinks that the change that *Punch* has undergone is becoming more like the *New Yorker* (without the talents of the *New Yorker* draughtsmen) and in sacrificing its special English character, is regrettable. He says that during the War he is not likely to do much caricature himself, or at any rate only spasmodically, and is becoming more and more keen to work from nature...

Tuesday 15

Layard called at the Slade...He brought with him for my inspection his father's own copy of *The Life & Letters of Charles Keene*, interleaved with a number of original Keene drawings. But what he really came about was the case of Fritz Shepherd. When F.H.S. and his wife called on us recently I took the opportunity of suggesting that it might be a nuisance for him to continue being secretary of the N.E.A.C., and that Willie Clause, who really does all the work and is on the spot in London, might be Hon. Sec. in name as well as in fact, Layard does not want me to go on with this, as he is trying to psycho-analyse Shepherd & cure him, and anything that might destroy Shepherd's self-confidence might be bad...so I won't even go on with my suggestion...Layard revealed that Shepherd's father committed suicide, his mother died when he was four years old, and he was brought up by a narrow, tyrannical Victorian aunt, who disliked his father and did her best to destroy everything that might preserve his memory. Layard has been treating Lady Peers at Chiselhampton, and, since F.H.S. left the Acland to stay with his sister, has had a go at him too. Mrs. F.H.S. was hostile & jealous at first, but is now acquiescent...

Wednesday 16

To London, with M. Bone...12 o'c. Lady Clark's little committee at Nat. Gall.. Eric Newton attended, and afterwards I went for a short time to the show of French Painting with him. We met Wellington & Henry Moore, briefly: both enthusiastic...M.o.I meeting...Home by 6.5.

39 Edmund (better known as 'Evoe') Knox, was editor *Punch*, a prolific writer of light verse, published several volumes of his journalism and poetry.

Saturday 19
Left Oxford…Arrived Brae Court…Charles, Ivy, Hallam.

Thursday 24
Shopping in Kingston…Bought 1 doz. chrysanthemums (15/-) for Ivy, a frightful waste: and gave her a cheque for £2-2-0 for her Artists Aid China fund.

Friday 25
A party of people to tea, and the Kohns, from among them, stayed on to Christmas Dinner. Turkey, Christmas pudding, and everything as in peace-time.

Monday 28
Arrived in Oxford…Travelling not so bad, as so many people have stayed at home (as they were told to do, if possible…) that the ordinary trains can just about cope with passengers…

Tuesday 29
Made a small beginning of a drawing, in the Turl…

Wednesday 30
M.o.I. Committee.…Udal says the Club Committee is contemplating having several wine-less days in the week, as some members order wine every day in the week, which is considered unpatriotic. [Sir] Reginald Blomfield[40] is dead…

40 Architect, garden designer and author.

1943

Schwabe regularly attends W.A.A.C. meetings in London, but still manages to complete a few private commissions and to undertake drawings for his own pleasure in Oxford. Extensive air raids on Berlin by British and American bombers. A 'Wings for Victory' week is enthusiastically supported in March. Winston Churchill broadcasts from America in May. In the summer Mussolini is arrested in Rome. Sign-posts and the names of railway stations, removed in the invasion scare, are replaced. The London Group, Fifth War-Time Exhibition is held at the R.A., Schwabe serves on the N.E.A.C. jury for the first time since the outbreak of War. His son-in-law Harry Jefferson Barnes is appointed to the Glasgow School of Art. In December there is talk of the new German 'secret weapon' or rocket gun. News of the sinking of the Scharnhorst is received with some excitement.

JANUARY

Saturday 2
Showers…but put in about 2½ hrs. in the Turl…Read Auden's introduction to his anthology, *The Poet's Tongue* [1935] (given to Birdie by Hallam as a Christmas present): and Matthew Arnold's[1] theory of poetry, in the introduction to his poems, as a contrast.

Sunday 3
Drew in the Turl for about 4½ hours…The ice on the 'static water' tanks had not thawed by the afternoon…

Monday 4
Drew for about 4 hours…At 12, had a drink with Col. __ [sic] (brother-in-law of Col. Jarvis), who is still active with the Home Guard, in spite of his age, and gets a little rough shooting now and then. He described his career as a Mosleyite. He used to be a street orator for the British Fascists, and declared his motives (and he said, those of most of his fellows) to be patriotic – stirred up by Baldwin's disarmament and other signs of the times. Finally he disapproved of Mosley, and wrote him a disagreeable letter. This stood him in good stead, as he was able to show a copy of it to the police when they interviewed him on the suppression of the Fascist movement, and he was consequently cleared of suspicion. A tough old gentleman.

Tuesday 5
…H.M. Bateman came to Oxford to discuss with me his coming to work, possibly for a term, at the Slade-Ruskin School. The difficulty is to find suitable quarters…He may have to face some boring evenings…We lunched at The Randolph, and walked about Oxford for a while afterwards. He has a quick, artist's eye and a lively interest in what he sees…

1 (1822-88), poet, cultural critic and inspector of schools.

Wednesday 6
To London for my Committee…At the Club, Jack Squire, who has not yet finished the filling of his Album for the Red Cross: the Queen of Holland kept it nine weeks. Bone went off to Chatham to start a dockyard drawing…tea with Oppé,…said he liked what he called my 'Newgate Calendar' – the article on Innes and others in *The Burlington*.[2] Bawden has come back from Libya via America. He was torpedoed, and 70 of his drawings went down with the ship. He was rescued by some Americans…

Sunday 10
Bill came to Oxford. He is for the moment stationed at Water Eaton Manor…Bill has a story about a (Col.?) Churchill, who took part in a commando raid on the Norwegian coast. As this man's boat approached the shore he started playing the bag-pipes in the dark, thereby giving the alarm to the Germans, and drawing their fire. He, apparently, plays the bag-pipes, and also wears a sword, on most occasions, suitable and unsuitable. His men were angry at this incident, not unnaturally, and, as they got away again in the boat after the raid, put Churchill in the icy water. Talk about gypsies and about the 'Methylated MacPhees' – Scottish nomads who have a mysterious influence over horses, so that wild ponies on the moors will come with them.

Monday 11
Tom left Oxford. Has to be in Dover in the afternoon for a V.D. clinic. He gets girls of 16-17 sometimes as patients. 2½ hrs. in the Turl. I sit just outside Lincoln gate. The College is full of Red X nurses, who are very friendly and talkative. An Indian lady said (among the odd things people say to an artist) she 'would give ten years of her life to be able to do that.' Leila Faithfull came in. She is working in a hospital (not in Oxford) on drawings for plastic surgery, under a successor to Gillies, the friend of Tonks. He wants outline drawings of sinews, faces, hands…He enjoys his work, and whistles cheerfully as he sticks on an eyebrow, eyelid or lip on the shapeless, faceless heads he has to deal with. She says she finds she can bear the horror of the work. Doris Zinkeisen is working with the same man. Mrs. Faithfull is paying the Slade fees for a young soldier whom she taught at the Wingfield when she was doing occupational therapy. His drawing seems very promising.

Wednesday 13
No M.o.I. Committee: went up to town in mistake…Looked at the French pictures at the Nat. Gallery, with Nuttall-Smith. Very full…Snow-pieces by Monet and Pissarro, miracles of feeling and observation. Some slight things by Manet: a Berthe Morisot in the Corot style, and others more developed. Sisley well represented, and Renoir, Cézanne's *Choquet* [c.1877]…good: a Provençal landscape, beautiful colour and quality, but flat. An excellent Van Gogh of orchards.

Saturday 16
…H.M. Bateman arrived in Oxford, staying at 7 Beaumont Street. He is to move to Phyllis Alden's in the Banbury Road tomorrow.

2 *Reminiscences of Fellow Students*, January 1943, pp.6-9.

Monday 18
Slade term began. A pretty full house…Some new students. Bateman started a painting, and enjoyed himself. Charlton & Polunin came. Polunin has executed (with his assistants, Celia Venning, [Rosalind] Mackertich and others) the big decoration designed by John Piper for the British restaurant at Merton. The job was done at Uni Coll. London. Albert Trollope helping much to his satisfaction. After over three years' divorce from his real job at the Slade, he was delighted: an excellent fellow. Bombs on London again, in retaliation for ours on Berlin…

Wednesday 20
…to London…M.o.I. meeting…Bone presented to the Comm^tee his great drawing of *The Painted Hall*, with personages. Everyone was very pleased with this…Clark discussed Benno Elkan[3] who wants a job. Clark dislikes him as much as I do, but we did not let prejudice affect our aesthetic judgments. Elkan showed some medallions…There was an air-raid alert at mid-day, the first day-light one on London for months. Not for long. Some school-children were machine – gunned in the suburbs, and 11 German planes… brought down.

Saturday 23
8.40 to London, for an Examiners' meeting (London University, General Schools) at the Imperial Institute…

Sunday 24
…finished what I wanted to do in the Turl…such a drawing takes 34½ hours to do, or about 5 days' work in good conditions, but I have had to go to the pitch 13 times… Egan Mew came. His reminiscences included a party at Fitzgerald Molloy's[4] sixty years ago, when he, Mew, was 20. Four, if not five, members of the party, including himself, survive at over 80 years of age, among them Bernard Shaw. Oscar Wilde was also there. Mew quarrelled with Shaw over Molloy, whom he liked. Molloy, about this time, had written a bad novel, which Shaw cut to pieces mercilessly in a review. Molloy was very hurt at this, as coming from a friend, who owed something to him. Meeting Mew at a Pinero play shortly after the publication of the review, Shaw said he was sorry to hear that the author took it like that. Shaw did not think he should be aggrieved, as it was a bad novel and an honest review. Mew, in reply, accused Shaw of ungentlemanly behaviour (he says he might not take the same attitude to-day, but his youthful prejudices were strong, and he was championing his friend: anyway, if Shaw felt the novel to be bad, he might have declined to review it). They had a row, and never spoke to each other afterwards. I lent Mew Binstead's [1903] *Pitcher in Paradise* [*:Some Random Reminiscences, Sporting and Otherwise*].

Wednesday 27
M.o.I. meeting. Clark absent, Russell recovering from an operation. Bone unwell – Dodd says he has been putting too much strain on himself in the course of doing his big Green-

3 1933, the sculptor Elkan (1877-1960) joined the exodus of Jewish artists from Nazi Germany, settled London, lived Oxford during the War.
4 Novelist and historian, (1858-1908).

wich drawing. Elmslie Owen asked me to take the chair...

Friday 29
...A third bloodletting at the Emergency Blood Transfusion Service...They are sending
the stuff out to N. Africa. John Hope-Johnstone called at the School, being in Oxford for
a few days. He says he may be going to Persia. (Last time he went there he walked from
Constantinople – or at least, Asia Minor – pushing a perambulator containing his posses-
sions.) He got away from Pekin [sic], where he seems to have been doing some teaching
work. He has no personal grievance against the Japanese, though he dislikes them. They
do not appear to have interfered with him and he came back from Shanghai on the same
ship as Lady Maze.

Saturday 30
2-6 'Battle of Oxford'. All shops shut, and people asked to keep within doors. Aeroplanes,
dive-bombers, flying low over the house-tops, 'casualties' being dealt with by N.F.S. in
Beaumont Street, moderately loud explosions.

Sunday 31
9-3p.m.'Battle of Oxford' continued. Albert R. very busy...fire-watching in New College.
Kyffin Williams, with the Home Guard, never saw the enemy till 2.45 on Sunday, when
to his delight, they appeared, and there was a real scrap. Windows were broken in the
Indian Institute by a bomb on the pavement. A 'fire' was staged in Cornmarket, and a
mob of 'refugees' poured down the Cowley Road towards the city...the police dealt
with them firmly. I saw nothing of all this, unfortunately.

FEBRUARY

Tuesday 2
Donald Towner came to Oxford. He is having a week's holiday, his only holiday in the
year, from his labours on the farm at Compton, above Uppark and Harting. He gets
practically no time at all for painting now – only a few odd Sundays...

Wednesday 3
Decided, on account of Towner's visit, to cut my usual Wednesday meeting. Took him
over to the Ashmolean, and looked at a few things there, including the exhibition of
paintings by living Frenchmen – Friesz, Lhote,[5] Lurçat[6]...Some pleasant pictures, some
bad...Towner is very appreciative and full of perception, a very good companion on
such a holiday...He has a phrase collected from the men on his Sussex farm, who, when
they fell specially idle or slack, say they 'have got the Londoners'.

Thursday 4
...Towner says that at Harting there is a youth named Garman, now working on a farm,
who appears to have great talent as an artist, though conceited and unteachable. He does
water-colours on tissue paper, with vision, colour and design: is about 18, and is the

5 Sculptor and painter.
6 Painter and influential tapestry designer.

son of Epstein. His mother, who calls herself Mrs. Garman, has two little girls, also Epstein's children. She is an intelligent woman, with some resources. The boy goes up to London to see his father. Gunning King, another Harting artist, is now dead. He made his reputation by a picture of a woman lying dead in the bottom of a quarry, where she was supposed to have fallen from her horse on the cliff above. King was very dependent on the model, and his wife sat, or lay, for the figure of the dead woman. He dragged his large canvas daily to the actual background, and daily killed a chicken, the blood of which was used to dabble his wife's hair – she being supposed to have cracked her skull in her smash…

Wednesday 10
…Luard at the Athenaeum to concoct examination papers for the Bd. of Education Exams. He lunched with me. Wednesday is a wineless day but sherry, beer and cider are procurable…Luard is still doing A.R.P. work…Ethel Gabain is very ill and is faced with a serious operation…

Thursday 11
Birdie and I gave H.M. Bateman lunch at the Union. He is still painting away at the Slade. He displayed, without in the least forcing it, his freakish sense of humour, his usual serious demeanour breaking down at intervals…Birdie and I went to Walt Disney's film *Bambi* – about the life of a deer – and thought it was the best thing of his we had ever seen. The Caldecott of the films – in a totally different, modern American way, of course.

Saturday 13
Letter from Conch Andrews to say that Millicent Russell died in Taunton Hospital on Wednesday. She had been staying with Conch in Exeter, and then for a night or two with the Lucien Pissarros at Chard, where she was taken seriously ill last week. Joyce Emery (Tommie)* wrote also. The cremation was at Bristol today. There had been difficulties about getting wood fuel while Russell was at Little Barn through the winter. These may have helped to make her ill…

Sunday 14
Worked for about 5 hrs on a drawing of All Saints from the High. Was interrupted by the Cambridge Boat Race crew, who were defeated by Oxford at Radley yesterday: rather drunk and noisy, shouting their war-cry, but harmless…

Tuesday 16
Towner writes of bombs and machine-gun fire in Sussex…he believes the glass in Chichester Cathedral is gone…

Wednesday 17
To London…delivered pictures at [The Wallace Collection] Hertford House for Ivy's Aid China show…

Thursday 18
Albert and I went to tea at the Layards, no. 1, Northmoor Road, where there were a lot of people who came on from a lecture and discussion on children's art. Mrs. Broke

Freeman (Molly Dudley Short)[7] spoke, and was at the Layards. Miss Douie, the Librarian was there. Paul and Bunty Nash came to tea. Marion Richardson's sister had been another speaker: so had Layard. After an hour's talk and an excellent tea, I left with Albert, who was entertaining Barnett Freedman to dinner in New College. I was rather glad to get away. The discussion of Art from a psycho-analytical standpoint is not very much in my line…

Friday 19
H.M. Bateman came to tea after the School. He leaves Oxford tomorrow. He seems to have enjoyed his five weeks of painting from the model, and takes all our criticism and professional tips in good part; but says he now sees he wants two years of that sort of thing. The caricature he has done of me with the students, including the robust Miss Buckingham and Kyffin Williams, is very funny and like everybody. It was done for *Phoenix*, the College magazine.

Saturday 20
Lunch with Melville Foster at the Union…who is an old acquaintance of the Carlines and Stanley Spencer, was describing the early married life of Hilda and Stanley: he said there was a heap of paper in the corner of the studio, and that was where the baby slept: also he related that Mrs. Melville Foster once came to him and said that Stanley was at the door and had nowhere to sleep, and could he spend the night? M-F replied, 'Only if he has had a bath.' His wife promised to see to that, and it was arranged.

Sunday 21
…Did a few hours drawing in the High. Was interrupted by a long procession of uniformed persons (and a crowd of spectators)…which took over half an hour to defile, and betokened sympathy with and admiration for Russia…

Monday 22
…attended a meeting of a literary society – mostly undergraduates, in the upper part of the Congregation House adjoining St. Mary's Church…Father D'Arcy read Gerard Manley Hopkins with real understanding, in a beautiful voice, as well as it could be done. It was an interesting experience…

Thursday 25
Dora, Birdie and I went to Noel Coward's film, *In Which we Serve*. A very good production. Coward, in other ways, has not gone down very well in Oxford lately. His plays have been performed to not very enthusiastic houses, and he himself is said to have talked all about himself when he took part in a Union debate.

Saturday 27
Prof. A.E. Richardson called…He is working, he told Birdie, on the reconstruction of Bath, and was motoring there from Cambridge, having sufficient allowance of petrol.

7 She had trained under Marion Richardson.

MARCH

Monday 1
...Charlton and Albert came in in the evening. Albert had been giving a public criticism of a Photographic Society's exhibition.

Tuesday 2
Visit from [Alban] Atkins, of Sheep St., Burford. He brought some drawings to show me. He has a good artistic intelligence, is fond of the country, and...has been doing some work for the Pilgrim Trust. He is beginning to feel, at his age, the strain of his physical culture teaching...he thinks he will have to give it up in a few years; though, at the moment, the combination of it with his art classes is needful for his bread and butter...

Wednesday 3
London...Committee...Afterwards, with Bone to the Leicester Galleries to see a Private View of Stephen Bone and Roger Pettiward. Stephen's small paintings were better than I had expected...He went up in my estimation. He was there, and Mary, and James Bone, and Mrs. Pettiward and Daphne Charlton. Pettiward's more serious paintings were hardly represented. The Gallery included, with one or two exceptions, only those which more or less follow on the humorous intention of his 'Paul Crum' drawings...

Saturday 6
Polunin's Aid to Russia exhibition was opened by Gilbert Murray in the absence of A.P. Herbert, who was ill. Charles Parker also spoke, and Polunin himself, in his bad English...I escaped, and got on with my drawing in the High (there are some good things in the show – a charming head by Ethel Walker, John's old drawing of Slade, a good Gwynne-Jones landscape; also a 2nd quality Duncan Grant, a good drawing by Jackson, and a slick portrait head by him in oil). Coming away from my pitch about 5.40 I was accosted by Jacob Kramer[8] whom I did not at first recognize. I have not seen him for many years. He is staying in Oxford with his brother-in-law, Bobby [William] Roberts (Roberts married his sister [Sarah]). He has been teaching drawing to soldiers and the A.T.S....

Monday 8
Went with Bone to inspect Dodd's portrait [of Baldwin]. The arm seems too short, and the hands unsatisfactory in colour: yet, compared with James Gunn's two paintings in the same room it has something so much less commonplace, so much more reality, and so many more qualities of a considered work of art, that I respect it in spite of its faults. Was Dodd thinking of Ingres, I wonder? Something in the background suggests this... Scott-Snell lectured to the Slade Society on William Morris. His mother was there, a handsome woman (as her son is handsome) and with some of the intensity of manner, which strikes so many people – among them many of our students, I'm afraid – as affected and ridiculous. She talks about beauty as 'heart-breaking', for instance, and has an emotional note in her voice. Still, it is good for the students to know something of Morris from a person of knowledge and enthusiasm...

8 Slade (1912-14), friend Epstein and Gertler.

Wednesday 10

Train to London. Lunch in company with Cecil Hunt. He doesn't like the work of Paul Nash, Henry Moore and Stanley Spencer, but he does like Clausen's – thinks it better than Steer's…Meeting A.A. Committee. Trafalgar Square crowded: 'Wings for Victory' week: a bomber on show in the open space: millions, I suppose, being subscribed. I understand Pitchforth is doing a drawing of the scene…Saw a portrait of K. Clark lying about the passage to the N.G. Board Room by Henry Lamb: very like…and true of a certain mood and expression: but Dickey says Clark doesn't like it. It is difficult to satisfy sitters. I wonder what Freedman's 32 aircraft factory people think of his excellent drawings – character studies – of them.

Sunday 14

…I took Wellington to tea with the Manners', taking my own piece of cake as a war-time contribution…Wellington has the whole story, which is not quite as I had heard, of Victor Pasmore's being court-martialled. Wellington lunched with Pasmore's Colonel, a decent fellow, to discuss the situation. Pasmore was always a conscientious objector, but his first appeal was rejected by a tribunal. He would have made a good soldier – did his work well – and his officers had him in mind for a commission. But he really objects to having to kill people, though he wouldn't have minded camouflage. When he saw that he was heading for a thoroughly military career, he deserted. I suppose that in fact he cares for nothing but painting. He was not disliked at all by the officers, but they could do nothing, naturally, but court-martial him…

Friday 19

…Went to lunch with Nuttall-Smith at the Municipal Restaurant in St. Giles' Parish Room. Queue for tickets. My meal cost 1/-2d – mince, and 2 veg., roll and butter and a small piece of cheese, tart and a cup of tea. The people lunching ranged from parsons and ladies in fur coats, to shop girls and working women…Borenius came for his Exam. He suggested my doing another article for *The Burlington* – this time on my teachers.

Sunday 21

Elton came to see me, on leave from London. He said Brooker is now in Nigeria, and that Gerrard has had a serious injury to his spine, which may take a year to mend… B.B.C. Winston Churchill spoke well for ¾ of an hour, on the post-war world.

Monday 22

Muirhead Bone lectured to the Slade Society…discursive, ranging from the Altamira caves to Stanley Spencer and to himself on a minesweeper, or as a boy in Glasgow. He told how he had been engaged to be married for four years, but had not enough money to marry on. One day Mayer of Obach's offered him £60 in advance for some prints, which he took and telegraphed to his fiancée – 'have £60; let's get married.' He has great natural simplicity and directness…and this goes down well…He never had a day in an Art School…only evening classes in Glasgow, when he was a boy in an architect's office.

Tuesday 23

Someone has bought a drawing of mine – the one of Everitt's shop and the Portico house at Cerne Abbas – from Polunin's Aid Russia exhibition. As the price was £8-8-0, I feel I

have presented £4-4-0 to Comrade Stalin, or, at least, to Mrs. Churchill's fund. Polunin has now put just on £100 in the bank to that end.

Wednesday 24
To London for the Artists' Advisory Committee...A lot of the Sheffield pictures were damaged in the raids, and the Government has paid about £700 in compensation. A picture by Gotch, for which £1000 was paid when it was acquired for the Gallery, was valued at £20. Some drawings...by Dodd and Bone, were valued at more than the original purchase prices...Bone...has finished his work on the spot at Chatham.

Monday 29
8p.m. Sydney Sheppard called to tell me that if I liked to come over and join the Life Class at 27 Beaumont St., I was cordially invited...The class is run by Greenham of Magdalen, who teaches in Magdalen College School. Mr. and Mrs. Sheppard were there, and Dunstan, and Wynter and Daphne Dennison and another girl who was at Somerville. Diana Yeldham Taylor was the model, and a very good one too, better than most professional models in the beauty of her figure and in the way she poses. She does scene-painting at The Playhouse. Nuttall-Smith says that Greenham is a very good draughtsman, a friend of Ernest Jackson's. He is rather secretive about his work, and does not show it to many people. The room where we work is underground, and warmed by a fire and an oil stove, with a good electric light on the model, but not so good a light on one's paper.

Wednesday 31
Artists' Advisory Committee...Went to a show, after the meeting of the Artists' International Association, in the basement of what is left of the burnt-out building of John Lewis in Oxford Street. Saw John's *Fisherman's Return*. He has evidently made use of early drawings and studies. There are beautiful things in it...though I doubt if it will appeal to the public of today as much as it would have done to us when this sort of picture was new...Patricia Preece and Beryl Sinclair are two good painters: Percy Horton a genuine, unpretentious artist.

APRIL

Friday 2
Letter from Walter Russell resigning the Examinership for Slade Diploma. He finds it difficult to get here from Bourne End, and is not fit after his operation...Pottered round Oxford in the afternoon...One always discovers something new, or something one has forgotten...

Wednesday 7
...to London...Met Gilbert Murray on the platform at Oxford: he talked about Xenophon, and the system of telegraphy in use in Waterloo days...Tube to Morden, to be present at the opening of John Piper's decoration in the British Restaurant[9] there (Lady Clark's idea, and her invitation). Polunin and his three girl assistants, who executed the job, were there – Yenny Sniders, [Rosalind] Mackertich, and Celia Venning...'Madame Chairwoman', a

9 Morden Road, Merton, the murals depict the remaining chapel of Merton Abbey.

councillor or Mayoress, made many glowing references to the 'murials', and introduced Vincent Massey, the High Commissioner for Canada, who was followed by Kenneth Clark and the Town Clerk of Morden. Piper...got up just to make a reference, factful enough, to one of his girl assistants who had been overlooked by the other orators. I was driven back to London with the Clarks in Vincent Massey's car...Others present at the function, Barnett Freedman, Mrs. Osbert Lancaster, Myfanwy Evans, Brill & Birch (of the Kingston and Epsom Art Schools...)

Thursday 8
...I am getting on with a drawing of the back yard behind Savory & Moore's [chemists] in the High Street. Quite undisturbed there. Only one person interrupted me. He said he had been down the yard hundreds of times, and it had never occurred to him that there was anything to look at there – now he realized that there was.

Friday 9
Muirhead Bone came in in the evening...He is working on a drawing for some book of Gavin's...He was very amusing about the late Walter Berry, cousin of my friend, Francis Berry [wine & spirit merchant]. W.B. seems to have been a somewhat eccentric gentle-man. He was an observer in the Balloon Corps in the last War, and developed a passion for balloons and ballooning, competing for the Schneider Trophy [a seaplane race] and collecting pictures and prints dealing with the subject. He was fished up out of the sea – the Baltic or the North Sea – when his balloon came to grief. He also complained about the arrangement of the *D.N.B.*, saying it was impossible to find anything in it if one started from the local interest point of view: so he engaged a typist and rearranged the entire Dictionary in the order he desired. This took scores of volumes of type-script, of course – sustained and monumental effort. Another of his doings was to write a book to prove that no royal personage...ever died of drink. This was a semi-comic effort.

Monday 12
...Paul Nash's show of Applied Art opened in the Ashmolean...Dined at Somerville, at Mrs. Broke Freeman's invitation, to hear a Mr. Barton speak to a Conference of Art Teach-ers on School education in Art. Herbert Read and Philip James were present, and I met Elsie McNaught, Essil Rutherston, and a number of former Slade and R.C.A. students...

Wednesday 14
To London. Travelled with the Lowinskys. He was going up for a meeting of the Contem-porary Art Society. I went to Ivy's show...[she] has taken over £2000 so far, for the Chinese fund. She introduced me to Lady Peto, who is running the Chinese section. A little depressing to think how many good and competent artists there are – takes the conceit out of one. Followed up this by seeing Will Rothenstein's *Drawings of the Nineties* at the Nicholson Gallery. He has sold a number. They aren't all of the 'nineties'...

Thursday 15
...Finished work on the spot at Tackley's Inn...The sun shone at the right moment...

Friday 16
Birdie returned from her visit to Joyce Emery at St. Anne's Park, Bristol. The Emerys are

Baptists – the father was a Minister – and the family now consists of a brother, Joyce (or 'Tommie') and a sister who is a B.A. They run a farm. The house is looked after by old Mrs. Emery, aged 78. Occasionally they drive forth in an old Victoria, with an old horse aged 23. They also have an old buggy with yellow wheels…The Emerys are very kind and live in Christian amity with each other, cherishing the memory of the father, about whom a little paperbound volume has been published [1937].[10] Their reading is wide, the father having left an excellent library; and Trollope is one of their favourite authors. They seem to be somewhat like a Trollope novel themselves.

Saturday 17
Bus to Watlington, where I was met by Hubert & Bob Wellington. We walked round the little town…Drove up to North End…Bob cooked a huge cauliflower, with an excellent sauce…My pleasure in everything mixed with other feelings caused by the news of Tony Ayrton's death in Libya. He was a Major, R.E.[11] and had been mentioned in dispatches. The announcement was in *The Times.*

Sunday 18
Hubert to Mass early, in Watlington. Bob made breakfast. I had a fresh egg, quite a rarity…It is interesting, perhaps to remember these war-time details. Many aeroplanes, some flying very low. The crops, they say, are doing exceptionally well. A great field of kale, a mass of yellow eight feet high, grown for seed…Harold Curwen, the former printer, is making a successful venture of the village shop and post-office at North End.

Wednesday 21
Went to London…My main business was to decide whether…University College should buy Will Rothenstein's portrait drawing of Tonks for £16-16-0. It was done so long ago that I have forgotten if Tonks ever looked like that…There was a note waiting for me at the Nicholson Gallery from the Provost, who was obviously more than half prepared to have the drawing, and only wanted my approval; so I decided to back him up…

Saturday 24
Started to draw the small Cumberlege boy, aged 20 months, in the garden at 351 Woodstock Road. Did a head which they – Mr. & Mrs. C. – thought was like. A difficult job with a small and restless child. It's true he was strapped in a pram, but his capacity for movement…was almost unrestricted…His play of expression was quite wide…and usually he had his thumb or his foot, in his mouth…

Sunday 25
No buses on Sunday morning, so postponed my second operation on the Cumberlege child till the afternoon…After about an hour and a half, succeeded in getting a full-face drawing of the boy, which Mrs. Cumberlege seemed to like better than the first one. I naturally said they had better have both, Cumberlege having given me a cheque for £10-10-0…

Monday 26
Most of our usual luncheon restaurants were closed. Went to Lyons's. A queue of sixty

10 *His Day of Life. A Memoir.* William Walter Burch Emery 1862-1937. Arranged by his daughter D.M.E.
11 Royal Engineers, died meningitis 4 April.

or so…a number constantly replenished – helping themselves patiently and good-naturedly on the cafeteria system…

Tuesday 27
…Saw the film *Desert Victory*, about El Alamein, with Birdie, Dora and Margaret.

Wednesday 28
London…Artists' Advisory Committee…Some food at Paddington in company with Bone, and travelled home with him…Stephen Bone has had notice of discharge from the Civil Camouflage organization at Leamington…the staff is being reduced because little more is left for them to do.

Thursday 29
Charles Hobson, of Hobson's Advertising Agency, came to see me at the Slade. He wants, for commercial purposes, two oil paintings of interiors. He has already employed Cundall and Campbell Taylor for these, and has paid them 50gns. each for what they did, which he does not like at all (nor did I…). I encouraged him in an idea he had of trying Stephen Bone, and suggested also Gwynne-Jones…

Friday 30
To London with Bone, to hang the pictures of the Middle East campaign (mostly by S. African artists) at the Nat. Portrait Gall. Bought two oz. of sanguine from Lechertier on the way…Lunch with M.B. at The Garrick Restaurant, for which he paid, but not for my drinks, that being against his principles. Went, when we had revisited the N.P.G. to the Private View of the R.A. Lady Alexander there, as always, in all her war-paint, but most people have given up looking smart. Met…a great many people, many of whom I had not seen for a long time…Ian Strang, the Nevinsons (Nevinson undoubtedly has had a stroke)…the Rushburys…My two drawings for W.G. Newton are being shown, but skied, in the Architecture room. Rushbury said the drawings were liked, but not the architecture.

MAY

Saturday 1
Tom Cobbe in Oxford for the weekend. All fairly quiet in Dover – a little shelling, but nothing much. He anticipates trouble there when our invasion of the Continent begins… In the evening we all played cards at 9 Observatory St. Kyffin Williams joined us, fresh from a holiday at home in Wales, fishing and painting. He will be busy with the School and the Home Guard now.

Monday 3
Slade term began. A few new students. Charlton came, and we looked through the work sent in for the Entrance Scholarship…

Wednesday 5
To London…Advisory Committee M.o.I. It was over before 4 o'c. Looked in at Private View of Aug. John & Gil. Spencer, Leicester Galleries. Augustus is a little more white-

haired, but seemed fit and in a very good mood. I congratulated him quite sincerely on his drawings. They may have all sorts of defects, but the particular vision is something no one else can approach. It is really vital. In a lesser way, Gilb. Sp. has put up a good show too. He has worked hard and got much done since the War…Some seem a little toneless.

Friday 7
Albert got Chief Commander Gower of the A.T.S. to…address the students on the work of the Topographical draughtswomen – work which will suitably employ some of our girls…Talked to her audience even about the official issue of underclothing…A.R. and I went with her to inspect the map-making dept. in New College, where were several ex-Slade girls and two men, besides other girls…

Wednesday 12
To London for Artists' Advisory Committee…Tea with Bone, Dodd & Gleadowe. Gleadowe has taught English & Greek & Latin, as well as Art, at Winchester, for years. Bone is taking six months rest from the Admiralty work. He is very interested in the publication of Gavin's book on *Anglo-Saxon Poetry*: as a side-line of course…

Friday 14
…8 o'c. Father Richard Keogh lectured at Blackfriars. Interesting spectacle, of a convinced, enthusiastic and dramatic preacher expounding mystical views. His audience, except myself, was entirely composed of women, with whom he seems very popular. He left off at 8.45 to give his hearers a chance of listening to Winston Churchill broadcasting from America.

Saturday 15
Bus to Burford to visit Alban Atkins, who lives in a pleasant cottage…opposite The Lamb Hotel…Burford is now full of rich persons who buy and sell the houses and raise the cost of living for the more natural and normal inhabitants. The R.A.F., too, which includes some gay dogs, as might be expected in war-time, contribute something to the demoralisation of the little town. The Atkins were very hospitable and kind. Whatever hardships the War and teaching may entail, they have at least the advantage of surroundings which they appreciate…He is very hard-worked as a physical training expert at the School. His father or grandfather was an artist. I saw a goodish Victorian painting by him, of a stable interior with figures.

Tuesday 18
To London. Bd. of Education Drawing Exam in V.&A. Museum (East Court). 507 Entrants…

Thursday 20
Bd's. Exams….The garden court at the V.&A. Museum is used now for growing vegetables. There are a large number of children about South Kensington who have been evacuated from Malta and Gibraltar…

Sunday 23
...Was interviewed by Stanley Parker for *The Oxford Mail.*

Monday 24
London. Saw Rogerson of the I.C.I. (a friend of Charles Tennyson's) at his Club, the United University in Suffolk Street, about doing a drawing for an advertisement; the fee to be £30 or £40. I was recommended to him by Geoffrey Webb...3.0-5.0 – At the Imperial Institute. Took the chair at a sub-committee to consider the University syllabus for General School Certificate in Art. Noel Rooke and Bellin-Carter very sensible and helpful. Three art teachers and Jenkins of the University, were the rest of the gathering. Nothing acrimonious: some improvement made, I hope...

Tuesday 25
Gave Stanley Parker a sitting for his drawing to accompany his interview article in *The Oxford Mail.* Parker is a self-taught artist: a Melbourne man; he started his career on one of Keith Murdoch's papers. He knew Basil Burdett, and...knows the Lindsays. He has a gift of likeness, and his drawings have to be rather heavy and coarse to make half-tone blacks for newspaper work. His series of Oxford characters include many proletarian ones, such as the Scotch hall-porter at The Randolph and the man in charge of the bicycle park...

Wednesday 26
London for Artists' Advisory Committee. Lunch with Prof. Salisbury. Met Keith Baynes, one of the fortunate artists who is able to go on working...Saw MacColl...He had come up from Hampstead for Geoffrey Blackwell's memorial service...Griselda Allan's home in Sunderland has been damaged in an air-raid. She is going home for the weekend to see her mother. An unexploded bomb was removed from the garden.

Friday 28
Cocktails with Russell Knowles, 38 St. Margaret's Road. Egan Mew was there, and a Russian man, a friend of Pasternak, the octogenarian Russian artist and friend of Tolstoy, who illustrated *Resurrection* and has recently painted Knowles. Knowles wants me to give him some lessons in the vacation – for a fee. 6.55 at Blackfriars, with Father Conrad. Dined in the Refectory, with about 20 of the Order. A silent meal, except for one of the Fathers who read to us in a foreign accent...Drew Father Conrad in the Library...

JUNE

Saturday 5
Bus to Radley, at Paul Feiler's invitation, to have tea with him, Dodie Glass (now Mrs. Masterman), and her husband, a former U.C.L. student. She is lecturing tonight to the Radley College boys on Abstract Art...

Sunday 6
Wrote a report on the Bd. of Education Exams in the morning...Birdie and I went to Mme. Vandervelde's room in the evening, and looked at picture books of the Phaidon Press – Greco, Michelangelo and Etruscan sculpture. She has also taken up Aubrey Beardsley as a new discovery – not new to us, who studied him when we were students at the Slade. I

dare say some of the present students have never seen his work…I had not realized before that her rooms are in the old house built on top of the wall of what Melville Foster calls Tackley's Inn, in the back yard where I was drawing some time ago. The drawing [£20] is now sent to the exhibition of the Oxford Arts Club in the Ashmolean.

Monday 7
…Albert said in the course of the evening that one of the secrets of his work was that only about six times in his life has he been so excited and moved by a person (I presume he was speaking of women) that he really *wanted* to draw her. Birdie was one of these persons. Otherwise, he sees a model like Dorothy Duval, he admires her, but doesn't passionately want to draw her. This characteristic of his, he thinks, accounts for his best drawings, and for the relatively less degree of interest in others. But on thinking it over, not all his drawings even of these special people, have the special quality we recognize. Perhaps he deceives himself a little.

Tuesday 8
…Albert says that the drawing by Aug. John, of a whippet, bought by the National Art Collections Fund in 1933, dates from the period when he (Albert) and Fothergill lived in Fitzroy Street, and Fothergill, who was editing *The Slade*, kept whippets which John used to come and draw.

Wednesday 9
Provost Pye visited the Slade…He was very interested in the lithography class, and spent most of the day in it, pulling a proof himself with the help of Griselda Allan and Jack Townend. Allan Walton[12] called on me. He is living near Ipswich, but also has rooms in Paulton's Square…He came down from London to talk over with me the conduct of an Art School, prior to taking over the Glasgow School in the autumn from Bill Hutchison… Walton is now over 50, but little changed from the days when we all lived in Cheyne Walk, nearly 30 years ago. He is a shrewd fellow, and should be able to hold down the Glasgow job.

Thursday 10
Train to Cambridge, to judge the work of a Diploma candidate in Architecture…Richardson and Corfiato and Stanley received me very cordially. After the examining and my interview with the student, an exceptional, good sort of girl… Richardson, Stanley and I called on Louis Clarke [Director] at the Fitzwilliam. He showed us various treasures among his recent acquisitions, and took us off to tea at his large house, full of excellent drawings and objets d'art. I identified for him his John portraits of Alick Schepeler. It was a great pleasure to see so many fine drawings, from Claude to Poussin and Rembrandt and Ingres to John's beautiful studies of Ida, Dorelia and Euphemia…

Saturday 12
I showed old Furini (who dusts the sculpture in the Ashmolean) the bronze cast of a Pisanello medal that was given me by Legros's son, the engineer. Furini came to the conclusion that it was one he had made himself for Alphonse Legros. He talked about a big laughing mask, too, that he had made – grinning ferociously to show me what it

12 Textile designer, founder member Council of Industrial Design.

was like. When I told him that this bronze of his casting was now in the Slade he was very pleased. He did other medals for Legros, and described the *cire perdue* process [lost-wax casting] by which he did them. He made the castings for Benno Elkan's candelabra. He is full of reminiscences of [Edouard] Lanteri, George Walker, Derwent Wood and everyone who ever did any modeling. He knew about the [Jules] Dalou bronze of Legros at University College.

Sunday 13
To London…took the 9.40 (1st sleeper) to Glasgow. The railways were not crowded, in spite of it being holiday time. The official notices about not travelling unless your journey is really necessary seem to have had effect…

Monday 14
…reached the Art School at 10 o'clock. I was naturally interested to see Toshie's celebrated building. It is much admired by the Glasgow people, and has an impressive appearance from most aspects. Did my examining in company with Hutcheson, Crawford and other members of the Staff and talked a little to the Diploma students, about fourteen…afterwards…Hutchie, Walton and I went…to an excellent loan exhibition of French Impressionists and Post-Impressionists at the Kelvin Grove Gallery…

Tuesday 15
Arrived at the Edinburgh College of Art at 10a.m. Bob Lyon, Allison and others…They draw better in Edinburgh than in Glasgow. Went on to Dundee in the afternoon. The job I am now doing has been done in the past by Allan Walton, Laura Knight and Henry Lamb. The fee is £7-7-0 a day plus ex's. At Dundee found my way to Mr. Donald's house at Broughty Ferry, overlooking the Tay. Very beautiful, with intermittent sun and storm. Dined and slept here. Donald's daughter and son-in-law (a deaf artist named Kinneir) were at dinner: he himself is over 70, a textile manufacturer (Glamis Fabrics, now working almost entirely on Government orders), and has many interesting examples of weaving and embroidery collected in India, Sweden and elsewhere. An enlightened man, a keen gardener, and a good host. Dundee has not been bombed…

Wednesday 16
Got to the Art School with Donald, hitch-hiking in a private car instead of waiting for a bus. Cooper is the head of the School, a capable man, absorbed in his administrative work and keenly interested in the students, but not, I gather, much of an artist himself. (He was a Royal Exhibitioner once at the R.C.A.) Purvis seems to do most of the teaching. There were only two candidates, both hardworking, earnest girls. The School work is fairly lively, particularly on the craft side, and though there are, as is to be expected, some provincialisms in the painting school, the pervading ideas are sound and good. Was soon off to the station…Arrived in Aberdeen…6.30, and enjoyed a walk along the quay side…though the harbour, being fenced off, mostly, with barbed wire, did not reveal itself to any great extent.

Thursday 17
Spent the morning with Sutherland and Sivell, looking at students' work. Sutherland is quiet; Sivell, who is said to be of Irish extraction…talks almost unceasingly. He is an

enthusiast for his particular principles, and his work is coloured by the Italian Renais-sance...took me to see Old Aberdeen...we looked...at Sivell's big half-finished decorations in the students' Union hall. They are interesting and vigorous work, like a very superior A.K. Lawrence...Recently, there was a raid on Aberdeen...about 200 people were killed. Low-level attack. Some glass is gone from St. Machar's [Cathedral] and there are bomb craters nearby...

Friday 18
Oxford about 11.30a.m...7.45 Blackfriars. Father Richard Keogh lecturing. Very obscure to me, but the matter, the manner, and the circumstances still keep one interested. He would be an excellent figure to draw in his habit, and he is a fine type of intellectual religious enthusiast...

Saturday 19
Slade business, and Exam. papers for Reading University. Leila Faithfull came into the School, with some of her drawings of plastic surgery. She speaks of Tonks's man, Gillies, as rather superseded now, and admires the daring work of her own employer. She has some good paintings in the Oxford Art Society's show...

Wednesday 23
...Meetings of the Artists' Committee...Had time to go round the Steer exhibition in the National Gallery, and saw some beautiful oils...Train to Oxford 4.45 with Muirhead Bone, who had been buying canvas paper for Stephen, who has a commission to make sketches for War records at Greenock: panels are unprocurable now. In my absence last week, I was put in the minutes to do two more portrait drawings of heroes, and Coote this time suggested me for yet another, of a scientist, Stapleton...who has done much to help the War effort...

Thursday 24
To Reading to examine with Betts for B.A. Hons....5 candidates. Travelled with G.J., who was doing his day's teaching there...Betts has done some interesting heavy landscape drawings of trees – dense, tunnel-like lanes and open country – mostly as backgrounds for his *Wuthering Heights* drawings. He was concerned in the raid on Reading. A bomb fell 20 yards from the place where he was on duty, prone on his belly looking after some children – he was in fear that the wall they were sheltering under would fall on them. He escaped with a contusion, not a cut, from a lump of flying glass. What upset him most was having to dig out dismembered bodies afterwards. He says the situation was saved for him and some of the others, who might otherwise have been sick, by a navvy who actually joked about the horrors...Over 20 people were killed.

Tuesday 29
Dined with Mrs. Michael Hope to meet Gordon Russell[13]...a grave, quiet man, now inter-ested in the making of 'Utility' Furniture. His son is at Blundell's School, and has won a 5-year scholarship to the Edinburgh College of Art...

13 Furniture designer/maker, calligrapher, entrepreneur, educator and champion of well-crafted design.

JULY

Thursday 1
Boards' Exams again, last day. Final revisions, awards, and committee. Finished by 3.30…

Friday 2
At the School…to the river picnic organized by the Slade Society…We, Nuttall-Smith, Kyffin Williams, Delia Cooker and Ursula Cartledge rowed up after the others (there were over forty…) to a point a mile above the The Trout at Godstow. Most people bathed…and played childish games like 'rounders' with great gusto, in a pleasant setting, on a perfect afternoon…

Wednesday 7
To London for Artists' Advisory Committee, 11 a.m…Willow herb is now flowering thickly in the space at the corner of Brook Street where the houses were destroyed by bombs.

Saturday 10
Slade finished.

Monday 12
…Saw an Aid to China exhibition…at Somerville, got up by a German Jew dealer, E.[Erich] Cassirer[14]…

Wednesday 14
To London…Artists' Advisory Committee…postponed. There is a new Secretary, Eric Gregory, once of Percy Lund, Humphries & Co., the Bradford printers, for whom I once did a Christmas card…Lunch at the Club…Sir Charles Peers…has been having his portrait painted by Lawrence Gowing[15] whom he likes; and the Peers family like the portrait. Gowing has a frightful stammer, but doesn't appear to be self-conscious about it: he has always made an income by painting, seldom less than £400 p.a.…K. Clark's influence has helped him.

Thursday 15
Batsford and Charles Fry came in the evening…They are staying at The Ashmole Hotel, where there are notices saying that there are no towels, and guests staying more than one night must make their own beds.

Friday 16
Batsford gave me a commission for a frontispiece. Looked up material for this and another illustration for the I.C.I. [Imperial Chemical Industries] in the Hope Collection…

Saturday 17
By train to London – *en route* for Leatherhead and the Professorial Board…

14 First a philosopher, then art dealer, expert ancient Chinese art. Later started a small gallery in London.
15 Professor of Fine Art, University of Durham (1948-58); Principal Chelsea School of Art from 1959.

Sunday 18
A good many people stayed over the week-end, including J.B.S. Haldane – at least for Sunday morning – bearish as usual...I don't think he means any harm by his odd manners...Richardson, the scientist, showed a most interesting film made by himself of the movements of the arm and hand. This is the way to teach anatomy – I hope more may be done on these lines in the Slade after the War.

Tuesday 20
Walking in the Broad with Albert, met Merula Salaman, Michel's daughter, a charming woman, authoress of the very amusing and clever *A.B.C.* published last Christmas. It was sold out and has now been reprinted. She is doing another book.

Wednesday 21
Artists' Advisory Committee...Bawden has made himself disliked by the Army in the Middle East. He hates soldiers – prefers Arabs...Saw a show at the Leicester Galleries, Artists of Fame and Promise. Moynihan and Devas are among them, and younger men I know little or nothing of: Michael Ayrton for instance, whose work I saw again at the Redfern Gallery, with Basil Jonzen's (not very good)...

Saturday 24
Went on the invitation of Robin Watt of Stowe School to award prizes to the students of his art class...Lunch at the High Table, sitting next to Roxburgh...The list of Stoics who have been given decorations in this War is a long one, a V.C., many M.C.s, D.F.C.s... and a good many are killed, too. It is clear that the public schools act up to their ideals...

Monday 26
...visited the Steer show again, with increased enjoyment...The N.G. luncheon café had 'Mussolini hash' on the menu, this being the day of the Duce's resignation...

Wednesday 28
...Tea with the Sydney Sheppards in Walton Street. Albert R. and R. Nuttall-Smith came too. We looked at the garage which has been fitted up as a sculpture studio. A few students have begun work.

AUGUST

Sunday 1
In the morning, finished Batsford's frontispiece[16] of the shop in Holborn, the place where I had my first dealings with the firm, when old B.T. Batsford was alive. He had...quite a noticeable Cockney accent. I first became well acquainted with Piranesi through the prints in that shop. Francis Unwin bought some there, when he was living at 59 Great Ormond Street...

Thursday 5
...Batsford called and took away his frontispiece, for which he suggested giving me £20...

16 See *A Batsford Century* (1943).

Friday 6
...Started seriously to work on my drawing for Rogerson[17] of the I.C.I.. Mme. Vandervelde told me some old scandal she should not have told me. The best thing I can do is to forget it, so I have crossed out a few words above.

Wednesday 11
London for Artists' Advisory Committee. Took up some things – [including] a drawing to Sidney Rogerson for the I.C.I., which got left in a taxi...I went to the police in Lucan Place, who were exceedingly civil and spared no trouble (and the constable refused a tip), but I was left very worried about the loss of the drawing, which is worth £30... However, when I got home at night, there was a telegram from the I.C.I. to say that the taxi man had delivered the drawing there. I don't know how he traced the address. It's true Rogerson's name was on the parcel, but no address, and I don't think he is in the telephone book. Lunch at the Athenaeum...Jowett gave me details of [H.J.] Harding's[18] death at Ambleside. Harding had some unexpected – to me, unknown – facets. He wrote poems, did some good portrait drawings, and, I am told, did some excellent architecture for Lady D'Abernon. He died quickly, of cancer...3.30 with Max Ayrton in Church Row, who is being kind and helpful about the repairing of no. 20 now that the dry rot may be assumed to be dead...Max is resigned about Tony's death. He does not curse the War, thinking that it has brought out the best that was in a lot of people, Tony among them. He is busy with work on Mill Hill and Bedford College. He works almost alone now – only a woman secretary with him...

Wednesday 18
Artists' Advisory Committee. Photographs being taken of the proceedings for *Picture Post* or some such paper...

Wednesday 25
Artists' Advisory Committee. Clark absent. Russell in the chair: he says he hates being a Chairman...Gregory, the Secretary, is quite efficient. Lunch at the Club...Talked to Provost Pye...There is now some doubt as to the position of Wilkie and White on the Slade staff. Neither has done any War work (except, presumably, that White may have grown a lot of vegetables); both, in spite of there being no means of employing them in Oxford, have received their full salaries. Tried to find out what a lady's sable coat looks like, as Rogerson doesn't approve of the one I have drawn. Went to a fur shop in Oxford Street, and to Jay's. Apparently, there is no such thing as a sable coat to be found in London shops now. However, I got a lot of kind counsel, and bought a fashion magazine devoted to furs...

Saturday 28
Father D'Arcy, who had come up and spoken to me the other day when I was drawing the Clarendon building, asked me to dinner to meet Wellington and Mahoney, and see the progress of Mahoney's painting [plate 24] in the Chapel at Campion Hall. The figures of angels are about half finished, and they and the decorative foliage are executed with great care, under considerable difficulties from the way they are situated, in the dark,

17 Head of advertising in the 1940s.
18 R.C.A. teacher of architecture from 1926.

and with corners awkward to reach. Dinner, with beer and port for guests only...and both H.W. and I thought that Mahoney came out very well in the conversation in Common Room afterwards. He was thoughtful, sensible and well informed...

SEPTEMBER

Thursday 2
Made a quick, slight drawing of Egan Mew...I always regret that I never drew Charles Mackintosh, for whom we had the same sort of friendship as for Mew...

Friday 3
Long visit from Leighton Woollatt of Exeter, who married the daughter of Morris (Shrimpton & Morris) the boot-maker in the Broad. Woollatt is an artist and teacher, trained at the R.A. Schools. He has done a very interesting record, in water-colour drawings of merit, of the air-raid damage in Exeter. He is an A.R.P. warden. These works ought to be kept together (he showed me several, and many photographs of others) and bought for the city records...

Saturday 4
...Sent back W.W. Cave's *Epistle of Joad*, with some comments on his involved style and a confession of my inability to follow his thought completely. It seems to me that Cave's ideas are good, but his method of expression is against him. I hope he won't resent my remarks. He is a very sensitive soul...

Sunday 5
...The sign-posts and the names of railway stations, removed in the invasion scare, have been put back...

Monday 6
Alban Atkins in Oxford...The show at Foyle's has done well: total sales about £120, of which the gallery takes $33\frac{1}{3}$%. Notices in *The Times* and *Time & Tide*...Spent some time writing to Lieut. Walton (whom I don't know), a prisoner of war in Germany, where he has done a large number of interesting portrait drawings of his fellow prisoners. A parcel of them, released by the Germans, was sent to me by his mother in Lyme Regis, for criticism and comment. Others have been published in the *Illustrated London News*. 8 o'c. [Peter] Greenham's life class in Cornmarket.

Tuesday 7
To London for a meeting of the British Institution Scholarship Trustees at the R.A....

Wednesday 8
London, for Artists' Advisory Committee...Stephen Bone has worked hard during the last three months and has produced a mass of stuff, some of it very good. [William] Dring, too, has been very active. Henry Carr and [Harold] Hailstone disappointing. Henry Lamb and Leslie Cole not so. An interesting set of things from Sapper [Albert] Richards.[19]...Walked with Dodd to Cornelissen's in Great Queen Street, in search of

19 In 1944 he became an official war artist with the rank of captain, killed crossing a minefield 5 March 1945.

artists' materials. Could not get any black and sanguine chalk, but got ½ doz. sheets of Ingres paper, unprocurable elsewhere...In Oxford, met Meninsky, who told me the news of Italy going out of the War, just heard on the 6 o'c. wireless.

Friday 10
To London...visited the Pilgrim Trust show...Admired Phyllis Ginger, an artist hitherto unknown to me.

Wednesday 15
London, with Muirhead Bone, for Artists' Advisory Committee. His two big drawings of submarines at Chatham were presented and generally admired and praised. The bigger one is one of his best – the sort of thing that only he can do...

Wednesday 22
To London for Artists' Advisory Committee. Lunch with Albert and the Provost, to discuss the Slade's hopes of opening up again in London. Decided that we cannot go before Oct.'44...

Thursday 23
Started a drawing of the Merchant Taylors' School, for W.G. Newton.

Wednesday 29
London for Artists' Advisory Committee...Work sent from Sicily by air, from Lieut. Worsley, interesting Outside the Athenaeum...met Durst on his way to the Admiralty. We...walked round St. James's Park, looking at...the lake...the pelicans and anything else that offered itself, including the great new cement block of building by the Admiralty Arch. There are only two pelicans now: one died a natural death, and the fourth was killed in an air-raid.

OCTOBER

Wednesday 6
London for Artists' Committee...Some good Pitchforths and Ardizzones...

Monday 11
Slade began. Many new students. We are as full as we can reasonably be. Charlton and Polunin came.

Tuesday 12
London with Bone for N.E.A.C. After the mess they made of things last year, we both of us felt that we should do our best to help. I haven't served on the jury since the War began...the other members were Connard, Ethel Walker, Millie Fisher, Dunlop, Clause, Cundall, Devas, Fairlie H., Beatrice Bland, Robin Guthrie & Willie Clause. Lunch at the Comedy restaurant...Finished the selection, and rectified some injustices, including the rejection of a MacColl, a Stephen Bone...Ethel Walker showed me two very kind letters from Augustus John, written at the time of her unsuccessful show at Lefevre's. John got her a commission to do a portrait of Captain Brinsley Ford (?) who also wrote to her –

she showed me this too – about her being made a Dame.

Wednesday 13
New English again...Poor old Ethel Walker (with her dog Peer Gynt) is quite useless...
I managed to persuade her to go home after lunch, giving her a valedictory kiss on the
cheek. Other Hangers – Dunlop, Connard and Cundall...Dunlop has his good side, and
works hard. Though his judgment is not always good, I cannot always accuse him of
prejudice. Cundall is very level-headed and valuable. Connard does his best too. Again,
he shows, often enough, a surprisingly open mind.

Friday 15
Albert and I lunched with Borenius at The Randolph...Borenius talked about John, who
has written something for him on Holbein: he is impressed by John's reading and literary
memory...Lowinsky has been black-balled from the St. James' Club. I believe he was
put up by Osbert Sitwell and Perowne, and supported by Osbert Lancaster, Brinsley Ford
and many others. T.L. says B. Ford told him it was because some member declared he
would not have a Jew in the Club, but Borenius does not agree about this – he thinks it
is not an anti-Semitic move, but a case of personal unpopularity. Tommy has a bitter
tongue and gossips indiscreetly. Something similar happened, Albert says, over Humbert
Wolfe and the Savile Club. A.R. put Wolfe up, but was warned of his unpopularity and
withdrew his name, resigning himself six months later. T.L. is naturally very upset.

Monday 18
Heard that Bysshe's appointment to the Glasgow School of Art is confirmed by a second
Committee. We have been on tenterhooks about this for some time past, and are now,
naturally, very pleased. The new appointment gets Bysshe out of the slough of teaching
in a boys' school, and more closely in touch again with real drawing and painting: also,
we hope, he will have more opportunity for doing his own work...

Wednesday 20
To London...Bysshe and I had tea at the Club. His appointment has still to be ratified by
the Scottish Education Committee...The salary, as stated in the official announcement
from Glasgow, is £575...Charlton Bradshaw died suddenly in his office a few days ago.
There was a memorial service.

Wednesday 27
Artists' Advisory Committee...After lunch, with Dodd in a taxi to St. Paul's to attend the
unveiling of the memorial to Steer. The Committee of the Steer Fund had had a good
lunch at Simpson's and all seemed very cheerful...The stone tablet was carved by E.R.
Bevan, whom I met. It is much better than the adjoining carving of Constable...The Steer
Memorial Fund amounted to £1503.

Saturday 30
...Tea at the Charter Club in the Broad – in one of the tall old ramshackle houses which
will...be pulled down after the War. The invitation came from the Vice-Chancellor, Sir
David Ross, who addressed the assembly on the objects of the Club, an international
association for those interested in the Arts. Griselda Allan was there, and Miss Hands,

the library attendant in the Ashmolean. Paul and Bunty Nash arrived late...

NOVEMBER

Monday 1
Albert R. criticized the Slade Summer Compositions. First Prize divided between two women. Roberts and [Wyn] Casbolt...

Tuesday 2
Anthony Blunt talked to the Slade Society on modern French painting.

Wednesday 3
London – Artists' Advisory Committee. Discussion, during which Bone left the room, as to the choice of Stephen Bone or Pitchforth as Admiralty artist: decided in favour of Pitchforth...

Thursday 4
Awarding British Institution Scholarships at the R.A....Lunch at Club. Adm. Sir Andrew Cunningham[20] was also lunching...He looks a fine fellow, without any pomp: obviously intelligent. There was a Private View of the Portrait Painters going on at Burlington House, which has opened its doors to the London Group and the Fireman Artists...I don't think the R.A. would have considered such a proposition during the last War. Looked at a few pictures in each show (bad paintings by Seabrooke, a John head, Moynihan, Rogers...some very good, and less of the extreme Left than I had expected)...I haven't sent to the London Group for years, though I am still a member of it. Rosoman, the fireman, does some interesting work.

Friday 5
Officials visited the house and inspected our gas-masks, which we have almost forgotten about. Ours were passed as still in working order...Worked with Kyffin Williams and William Cole on the hanging of the students' show in the Ashmolean. Dunstan has a large composition of nudes, some clearly based on June Miles and Daphne Dennison. It is a good effort.

Sunday 7
A fine day, with a cold north wind. Encouraged by the loan of Bob Bassenden's New College scarf, lent by Mrs. Brown (I have not one of my own), I worked for 5½ hours in St. Giles. Davis Richter, the painter...looked at my drawing and asked if I was an architect. He gave me his card and I told him my name, which he knew from my having taught at Camberwell when he was lecturing there. We have not met before. We talked of Jesse Cast, the Camberwell student who went to the Slade, and had instruction from both of us...

Monday 8
I notice in *William Nicholson*, by Marguerite Steen, that he lived, when in Paris, as a Julian's student, in the Hotel de L'Univers et du Portugal. So did I. It is described, quite untruthfully in the light of my experience, as a small (it isn't so small), incredibly dirty

20 Commander-in-Chief, Mediterranean Fleet.

(Benoit, the garcon, used to do my room beautifully every day), and shady (why shady? – there was plenty of sun; or if its moral character is meant, it was quite respectable) little (sic) place that stank of bad drainage (not so) and unaired rooms (the windows were usually open). The picture of Julian's too, in this book, though it has little more truth, is very overdrawn.

Tuesday 9
...2.30 N.E.A.C. General Meeting...Elected Devas, Ruskin Spear, and Thomas Carr...

Wednesday 10
To London...Artists' Advisory Committee...Rodney Burn has done some work that was not much liked...(We heard Churchill on the wireless last night, speaking at the Lord Mayor's banquet. A rousing speech, as usual. One or two people said to me that it sounded as if he were well primed with drink.)

Friday 12
...7.45 Father Conrad at Blackfriars. He gets deeper and deeper and more involved, and Birdie and I can make little of it. We realize more and more our own ignorance, and the enviable state of those who hold the Catholic faith without question. Perhaps we ought to give up going to the meetings. The audience consists of a dozen or fifteen ladies. Several times I have been the only man present.

Monday 15
Opening of a propaganda exhibition, The Spirit of France, in the Ashmolean Museum. It is mostly photographs, with a series of puppets in regional costumes. Masefield, introduced by the Pro-Vice Chancellor, made the opening speech, followed by Mme. Rosay, cinema star, and a French Commandant. The last two spoke in their own language. Masefield and Mme. Rosay spoke very well, sufficiently above the commonplace, completely in command of themselves, and not over dramatic. I first met Masefield about forty years ago in William Strang's St. John's Wood studio, on one of his Sunday evenings at home. Albert R. introduced me to Edmund Blunden...He is not as striking a figure as Masefield. We talked about Yalding and my drawings of that village for *A Summer's Fantasy*. Blunden presented the drawings to the Ashmolean Museum. I was sorry to hear that the High Houses in Yalding have been pulled down, because no one would put up £500 to save them from destruction: and the old bridge has been damaged by a tank...

Wednesday 17
To London, Artists' Advisory Committee...Went to see the R.W.S. Met...Rushbury, who...told me of the sad case of Blair Hughes-Stanton, who was taken prisoner by the Germans in Crete. As he was being marched under escort along a street, he tendered a coin to a girl who was selling oranges. The guard immediately shot him through the head with a revolver, breaking his jaw. Now he is back in this country. Fortunately, he is not much disfigured.

Friday 19
Opening of show of work by Slade and Ruskin Students...I had to introduce Alic Smith (who made the inaugural speech)...This I did in very few words, and with less prelim-

inary agony than I used to have...He likes the Ruskin School, of which he is a Trustee. Kyffin Williams returned thanks for the Slade Society...

Sunday 21
Did some 'moderating' on an Exam. paper of Bellin-Carter's...

Friday 26
Albert R. came back to the School after a very worrying absence in London. Margery has had a complete mental breakdown, and he has had to take her to a home near Sevenoaks. It was sudden and very distressing...

DECEMBER

Wednesday 1
Artists' Advisory Committee at National Gallery...To Lechertier Barbe to discuss the suggested possibility of a paper shortage which might seriously affect the students at the Slade...

Friday 3
The Slade Society gave me tea in The Randolph Hotel. Kyffin Williams, William Cole, Derek Chittock, Bernice Evans, Ann Todd...They had had a lecture the previous evening on the place of the artist in society, which seems to have given rise to fruitful discussion. Chittock is a socialist...

Monday 6
...3p.m. Father Gervase Mathew lectured, with slides, to the Slade Society on recent discoveries by himself...and others, of Byzantine art in S. Sophia and elsewhere...

Tuesday 7
Bill came in to tea – he is at Water Eaton...He has been a Major now for some months and is kept very busy travelling about inspecting schools of small-arm shooting. He is pessimistic about our future brotherhood with the Chinese, and about the remote outcome of the Japanese problem...7.00 Dined with Albert R. in New College...Some general talk is going round about the new German 'secret weapon', or rocket gun. Elton writes that it would be unwise to move the Slade back to London till the effects of this weapon are seen...

Wednesday 15
By 8.40 train to London with Muirhead Bone. Artists' Advisory Committee...At 4.15 Clifford Hall called and had tea. He desired information for a book he has in progress on Walter Greaves. I told him what I could, which was not much...I encouraged him to write on one, whom I consider an interesting and memorable artist; though Jimmy Laver had taken an opposite view, and thought Greaves not worth writing about.

Saturday 18
Last day of the Slade term...

Sunday 19
Wrote out the dedication to Marchant, Principal of the Royal Academy of Music, in a book containing the signatures to an address to be presented to him. This was done at the request of Dodd and Carnegie, to replace the script already in the book. They did not like the handwriting of this previous effort, which was done at some Art School...

Tuesday 21
Left Oxford for our Christmas visit to the Tennysons at Kingston...Ivy is full of talk about the exhibition she is going to run in America. She leaves in January...

Thursday 23
Birdie and I went down to Kingston shopping for Ivy. Returned with a 22lb. turkey from Sainsbury's which Birdie carried slung over her shoulder, in the bus and up to the flats.

Monday 27
Walked with Charles by the golf course on Kingston Hill. Saw the recent bomb damage... it happened the same night some hundred people were killed in a dance-hall at Putney.

Wednesday 29
Artists' Committee. Travelled...with Muirhead Bone...Gavin's book on Anglo-Saxon poetry is well reviewed...in the *New Statesman*...We are all excited about the sinking of the *Scharnhorst*.

Friday 31
To London, for meeting of The Arts Inquiry committee at the National Gallery. In chair, Julian Huxley: others, Elmhirst, C. Martin, Brill, Kenneth Holmes, Jowett, Pullee (of Dover), Tennyson, Dickey, K. Clark, Freedman, Hendy, Philip James, Misha Black, Audrey Martin, Henry Moore, John Rothenstein...a formidable collection. They have been working on their report...for fourteen months...At 2.30 met Luard, and discussed Board's Exam. papers...Poor man, his grandson, aged 4, has been burnt to death during the holidays. The child's clothes were set alight by an electric fire.

1944

Schwabe completes a number of private portrait commissions and continues his involvement with various committees and in particular the N.E.A.C. jury. Rome is liberated by the Allies and there is relief that the city is not in ruins. June 6 D-Day-landings and invasion of France, a few days later the first V1 flying bomb ('doodlebug') attacks launched from France. Street lamps were put back in preparation for the relaxation of the black-out. Aerial bombardment continued with V2 rockets. Talk of the Slade returning to London next year.

JANUARY

Sunday 2
To Snoxhall, to draw John Marks, home on leave. He is a submariner. His submarine brought a reindeer home from Norway and sent it to Whipsnade. Nancy Joan Marks at home, invalided out of the W.R.N.S. with a patch on her lung…

Monday 3
Drew John Marks. Henry M., now a seaman, R.N., came home on leave. Susan got compassionate leave too from her W.R.N.S. unit, so the family was united for the first time in 2 years.

Tuesday 4
Finished drawing of John Marks, and made some adjustments desired by the family to the one of Julian D.M. They said he looked 'too soft'. As he certainly doesn't look soft, I looked at it and honestly felt there was something in the criticism; so I strengthened it somewhat – an improvement…

Wednesday 5
Met Paul and John Nash in Oxford; they were having lunch together at The Randolph. John is a Major, and is stationed at Portsmouth.

Wednesday 12
Artists' Advisory Committee…Went to an exhibition, at the Leicester Galleries, of the late Sir Michael Sadler's collection of paintings and drawings. Gertler's old portrait of his mother was there – very good – and a drawing of mine was in the gallery, but not on the wall. There was some confusion about it, as the frame had [Rudolph] Ihlee's name on the back.

Friday 14
London. Two Examiners' meetings at the University (Imperial Institute). At the first, General Schools, Charlton, Potter, Erik Sthyr and Jenkins. After lunch in the basement (2/6d – very like a British Restaurant, copious & rough) a second meeting, Higher Schools: only Bellin-Carter, Jenkins & myself…

Wednesday 19

London for A.A. Committee. Met Bone at Paddington...A good deal of Stephen's work – drawings on an air-craft carrier – was shown at the Committee: well-chosen...very thoroughly studied. He is a most industrious man, like his father, who went off afterwards to get a little publicity for Stephen with the *Illustrated London News*...

Thursday 27

Garsington Manor is advertised for sale...£22,000, which is thought to be too high...

Friday 28

Huskinson entertained Albert and myself to dinner at The Randolph: two brother officers of his, a Major and Capt. Lynton Lamb, the painter, were present. ...Lamb says he worked at Camberwell as an evening student when I was teaching there. Afterwards he was at the Central School. On getting home, heard the news that Tom Falcon had died suddenly in Braunton, aged about 70. We were very old friends and I liked and respected him very much.

Monday 31

...Trouble in the School about a few of the students who are fire-watchers and save money on lodgings by sleeping every night in the Museum, being otherwise homeless...We cannot allow this...

FEBRUARY

Tuesday 1

Professor C.A.W. Manning of Chatham House in London, called at the School because he wanted a drawing done of his dead father, now lying in St. John's House. Albert... suggested me...I did the drawing in the course of the afternoon. A handsome old man – I understand the son's feeling in wanting his appearance commemorated...

Wednesday 2

...Lydia Russell is dead. We have known her a long time, but quarrelled with her years ago in Chelsea. She had a habit at that time of spreading mischievous gossip, mostly untrue. This is ancient history and had been forgotten, to all appearance, when we met in Oxford. She had a long illness.

Thursday 3

...Am trying to get a book-plate done for Andrade by Bernard Dunstan in Oxford...

Friday 4

...Dr. Aitken lectured on anatomy at the Slade...7.45 Father Conrad's study circle. Doctrine of Papal Infallibility. I asked one or two questions of an historical nature...

Saturday 5

...I went, on Hesketh Hubbard's invitation, to hear him read a paper on *Early Victorian Draughtsmen* at the Art Workers' Guild (Ansell, the Architect, is Master), 6 Queen Square. Luard also spoke. Both did their job well. Met some old acquaintances – Hanslip

Fletcher, Hamilton Smith, Clifford Bax, Frank Emanuel, Percy Smith…

Sunday 6
…1.45-3.15, drawing Black Hall – the last of the work on the spot…Julian Marks writes expressing the family's pleasure at the last portrait, and enclosing a cheque for £21. He says he would like to have the drawing I did of Snoxhall…Found much of interest in Hallam Tennyson's *Life of A.T.*, a book I was inclined to gibe at on skimming through it.

Monday 7
Lord David Cecil gave a talk to the Slade Society on *Book Illustrators & Book Illustration*. As it was very good-natured of him to come and do this, it seemed only polite for Albert, myself, and Nuttall-Smith to go and listen. Cecil acquitted himself well, and the students were pleased…

Wednesday 9
To London with Albert, Muirhead Bone, and Woodward of All Souls. Albert always goes 1st class, so Bone and I went 1st class…A.R. also has a taxi to the station, in which he gave me a lift. I took a taxi from Paddington to the National Gallery as I had promised Gregory to get there early to select some of [Robert] Austin's drawings of hospital scenes (10 out of 19). This I did with the help of Bone and Coote. Ardizzone is ill in Italy, and has been in hospital…He has been doing his job manfully, under arduous conditions at the front…4:45 to Oxford. Travelled in the same compartment…as Lord Berners, who gave me a lift in his car from the station to Beaumont Street. He has been working on some music for a film.

Thursday 10
K.T. Parker, who is working on a book about Holbein for the Phaidon Press, is developing a theory, which seems to have occurred to no-one else as yet…that Holbein was a left-handed artist, like Leonardo: also that in his later period in England he used a drawing machine for the portraits of his busier and more important sitters. The drawing machine theory has been brought out by a German, to the great indignation of Ganz,[1] who didn't think of it first, and is sure to be equally annoyed with Parker about the left-handed drawings.

Friday 11
Met Ithell Colquhoun and her husband.[2] He seems to have had something to do with the Ballets Russes de Monte Carlo[3] before the War. I asked if she were still being a Sur-Réaliste…She says she is more so than ever, and exclusively so. I said I liked her earlier things. 'One cannot stand still', she replied…

Saturday 12
Received from Mrs. Brown an allowance of four oranges. Haven't seen one for months. This is the official ration for Oxford, per person. Elizabeth [Longstaff] came in, with a parcel of slight drawings by her father [Falcon]. He did some good things in his time,

1 See Diary entries November 1933 and February 1934 re Ganz & Holbein.
2 Married Toni del Renzio 1943, divorced 1948.
3 Founded Monte Carlo 1932 under the direction of Colonel W. de Basil.

and had great knowledge of some type of country. I like a water-colour dated August 1921, of the estuary near Barnstaple...I wish he had studied his artistic business more earnestly when young...It is very difficult for a painter to develop at his best in complete isolation. He was entirely self-taught...and did not devote himself to art till he was 26. I was wrong in supposing that he never sold anything.

Tuesday 15
Towner came to Oxford...having a few days holiday from his Harting farm...Physically, farm work seems to suit him...but mentally and artistically it is a desert. He thought of taking a job in the Norwich Art School...but that seemed pretty well a desert too...what finally decided him against it was the air raids and the danger for his mother.

Thursday 17
...Ormrod has been to Coventry on behalf of the School, in response to an inquiry from a big firm about design for motor-cars.

Friday 18
Dr. Aitken lectured on anatomy...He is in favour of a state-controlled medical service.

Tuesday 22
In the night, anti-aircraft guns in action for about twenty minutes. An airman told me they (the German planes) come in this way now to attack London. The Treasury has been hit, the Horse Guards Parade too, and the Athenaeum has had the dining-room windows blown in...and other parts of London have suffered recently.

Wednesday 23
...meeting at National Gallery. Sir Geoffrey Burton gave me a glass of sherry afterwards at the United Universities Club. Met Geoffrey Webb there, and thanked him for introducing me to Julian D. Marks...Saw Fennemore afterwards at the National Gallery, and Lillian Browse, whom I tried to help in her researches into the study of J.D. Innes...Tea at the Athenaeum with Dodd, Bone, Stephen Bone, Leonard Huskinson and his cousin Air-Commodore Patrick Huskinson, a much be-ribboned man, once something to do with the Armament Factory at Woolwich (Chairman?), now blinded by a land-mine. He took L.H. and me in his car to Paddington. Walter Lamb described to me the sad state of Walter Russell (who has written asking me to be his artistic executor), now that his efficient, managing wife is dead...

Thursday 24
7.45 Class in George Street. O'Brian French, one of the supporters, was a pupil of André Lhote in Paris: thinks Lhote dynamic and intelligent, but too theoretical and too inclined to reduce pictures to geometry. Nuttall-Smith agrees about Lhote's great intelligence. Unlike the average French painter, L. has made some study of Turner.

Friday 25
Visited Egan Mew...He talked about Alice Rothenstein's acting with Laurence Toole in an early play of Barrie's. She appeared under the name of Kingsley.

Tuesday 29
The Scottish model last night at Greenham's class, Miss Wilkinson, told how when she lived in Glasgow in hard times, she had a room in a court inhabited by gangsters – six or seven hundred paid tribute of a shilling a week to the King and Queen of the gang. The Queen was the daughter of a doctor of medicine. She had gone to the bad. Four members of the gang were hanged during the year Miss Wilkinson saw something of them. She herself was threatened with a pistol to her chest, with demands for money… She complained to the police, who escorted her home...

MARCH

Wednesday 1
No meeting of the Artists' Advisory Committee…went to London for another meeting, of which Charles Tennyson is Chairman and Fennemore, Secretary, to arrange about a competition for religious pictures for publication, inaugurated by Messrs. Mowbray, who are willing to give £1000 gns. in prizes…Ivy Tennyson is now in New York, organizing an exhibition of British pictures.

Friday 3
Martin Lowinsky is killed in Italy. I saw Tommy literally for a moment, and shook his hand…He and Ruth have been dreading this…The Major at dinner last night was saying how the Guards are always put in the worst and most dangerous places. Tea with Prof. Powicke[4] of Oriel, at his house…to discuss a portrait of him for the College…

Saturday 4
Called on Mew again. He mentioned the recent bombing…and how the occupants of his Church Row house now spend every night in the Hampstead Heath Tube Station shelter, crowded, uncomfortable and miserable, but safe. It is well organized, but they can't get much sleep – trains part of the time, children crying...

Sunday 5
Went to Oriel to draw…Powicke. Was a little discouraged by my lack of success. He sat well…a distinguished man…[but] I came perilously near making him unlike a scholar and more like an old farmer…

Wednesday 8
Meetings of Artists' Advisory Committee and Mowbray Committee. Met Sydney Maiden, out of the Army, and back in advertising; Knapp Fisher, also out of the Army…Oppé says a thousand people are homeless in the World's End part of Chelsea as a result of recent raids.

Friday 10
Freedman visited the School. He joins in the general praise of Clark – with whom he does not always agree – as a generous-minded, sincere devotee of art. He stood an expensive round of drinks at The Randolph, about ten shillings' worth to five persons…He is a superior person, with a great deal of kindliness in him: shrewd, and very good at earning money: perhaps too business-like, if one can be so….

4 A medieval historian.

Sunday 12
Called on Mrs. Powicke...to show her the drawing. Reception of it civil, but frigid...
Had a drink at The King's Arms...it was, like all the other pubs, full of American sol-
diers...9.00 Claude Rogers came to see me. He is staying with Lady Henderson. As he
wanted nothing from me, I may take his visit in some measure as a compliment. We
discussed various pictures in the National Gallery, agreeing in our praise of the Tintoretto
portrait. Morland Lewis and Graham Bell [d. Transvaal 1943], whom we both knew, are
among the painters who have died in the Army or Air Force. Rogers is discharged from
the Army. His experience of soldiering was nothing but fatigues.

Monday 13
Charlton and I went to Greenham's drawing group. Charlton says this has been a very
dry winter in the country...Spring vegetables are perished.

Wednesday 15
...Meeting of Art Committee at Athenaeum. Maclagan, MacColl, Curtis Green, Hind,
Dodd. Discussed MacColl's proposal to cut down the bookcases in the drawing room
and hang pictures there...Walter Lamb satisfied with Munnings' election as P.R.A. Albert
R., Nuttall-Smith and our students in Oxford ridicule it, and think the Academy has once
more declared itself as retrograde...

Thursday 16
7.20p.m. Alice's daughter [Janet] born in Shearwood House Nursing Home, Sheffield...

Wednesday 22
To London for A.A. Committee. Travelled with Bone, who could not come to the Com-
mittee because he is heavily engaged with a huge drawing of the big concrete landing
craft now being built in the London Docks. This drawing he is doing against time and
under great difficulties from physical inconvenience and the changing nature of the
scene, though the Dock staff have done well in supplying him promptly with a special
shelter and a special large drawing board. The chief man of this staff comes from Paisley
and got on well with K. Clark when Bone and he were taken by Sir Geoffrey Burton to
view the scene. Being fellow townsmen and Scots is a great bond. All this Bone told me
in the train, and much else. (Discovered that M.B. does not like Gwynne-Jones, and feels
he could never get on with him...) 11-12.30 Meeting. Russell was there – he has not
been for some time. Walking away along Pall Mall E. we discussed the purchase of more
drawings for the [revived] Felton Bequest...also my appointment as Russell's artistic
executor. At the Club, a long talk with Oppé, who depreciates Iolo Williams' articles in
The Times, but to some extent defends Douglas Cooper's article on Steer in *The Burling-
ton*, because he likes Cooper personally...

Friday 24
Father Richard lectured at Blackfriars on the Gospel of John, with a wealth of cross-ref-
erence to Old & New Testament texts. We are very ignorant of such matters, not having
thought much about them since we were school-children (I remember the School, under
Mr. Dowling, attending services in the fine parish church); and Birdie with the nuns in
Cavendish Square, who, by the way, never made any effort to make her a Papist.

Saturday 25
Last day of Slade...

Sunday 26
...Drew in the afternoon, in a sketch book, at Osney Mill...Met Nemon[5] the sculptor with Nuttall-Smith. Albert and Margery came in in the evening...They gave us good advice about how to feed ourselves now that Mrs. Brown refuses to give us any meal but breakfast. Bed and breakfast 50/- each per week.

Monday 27
Went, at Peter Greenham's invitation, to see *St. Joan* performed by scholars of Magdalen College School. The scenery and costumes were mainly of his designing...We lunched to-day at the new City Restaurant...We had two courses (hot) each, and tea, for a total cost of 2/6...

Wednesday 29
London for A.A. Committee...Took pictures to R.W.S. in taxi from Paddington, waiting in queue and sharing taxi with 2 women, one an American who said the taxi situation was much worse in Washington. After the meeting, Russell and I went to the Nicholson Gallery and bought W.R.'s drawing of Steer. It is very like him...I hope to get some drawings from Salaman for the Felton Bequest...

Thursday 30
Alic Smith opened the Sculpture Show in the Ashmolean Exhibitors: Elkan, Nemon, Nuttall-Smith, Miss Fletcher (all present) & [Annesley] Tittensor ...Nuttall-Smith comes out well. He is a better sculptor than most of us knew. Nemon is very able, and so is Elkan, though I don't like his overdramatic and exaggerated tendencies...

APRIL

Sunday 2
Double summertime.

Tuesday 4
London, for Westminster drawing. Worked till 6.15 (from 10 o'c.) when I discovered I was locked in. The Fire Guard fortunately let me out after about twenty minutes, and after I had made unavailing efforts to get out through the Churchill Club (Ashburnham House). I was just preparing a scaffold of furniture to climb over the wall...

Wednesday 12
No Committee, but went to London. Met Michel Salaman, and, with Russell, looked at a number of drawings & sketchbooks by John, Orpen & Edna Clarke Hall (at the Athenaeum). Bought one of the *Wuthering Heights* series for Melbourne...

5 Born Croatia 1906, moved England 1938, worked studio outside Oxford for 40 years, Winston Churchill and Elizabeth II, were amongst his sitters.

Thursday 13
R.W.S. Election. Elected Lord Methuen and MacCulloch. Wheatley looked very sour because his wife got only one vote...Alban Atkins had no better luck...

Saturday 15
London...Met Brian Cook, who was in the Churchill Club and, prompted by him, to the R.A.F. exhibition at the N.P.G. where he has some pictures...

Sunday 16
At Garsington... Augustus John has given the Lowinskys a drawing of Martin. It is not very like...Tommy's picture is still going on, unfinished in the foreground: a marvel of minute study.

Monday 17
London. Hanging R.W.S. with Ronald Gray and Vincent Lines...Lines an intelligent, sensible man...

Wednesday 19
Artists' Advisory Committee....Went on with Russell to the Leicester Galleries: saw some more John's – one might do for the Felton Bequest...Went on to R.W.S. and bought a Cundall and a [Robert] Purvis Flint for Melbourne...

Friday 21
London. Finished work in Westminster...Talked to two pleasant nuns who came to look at the ruins while I was working...self-assured, well-informed women...

Saturday 22
Carnegie called for me at the School and I went with him to meet his son in Oriel, to fix on a viewpoint for a drawing of the College. Chose the obvious one of the Front Quad, with the stairs up to Hall and Merton Tower over the sky-line...

Monday 24
Slade began. Rushbury brought his 16 year-old daughter Janet to the School and Albert and I gave them lunch at The Randolph. Rushbury was one of those who wanted John to be P.R.A. He got G. Kelly to come round to this point of view, pointing out to him that he hadn't an earthly chance of being elected himself. But the architects didn't think John would do. Something like what happened in the case of J.M.W. Turner, who was not considered quite respectable. Rushbury knows Munnings well – they were near neighbours in Suffolk – and considers him rather a cad, limited in his views on painting, and with a strong vein of snobbery; but not a bad painter in his day. Rushbury says Kelly is bad as Chairman of a Committee: talks too much and cannot keep to the point. As he (Kelly) is a bit of a bully, Rushbury takes the line of bullying him instead.

Tuesday 25
Daphne Charlton now has a job in the drawing office of the Southern Railway. Stanley Casson[6] has been killed in an aeroplane accident.

6 Lt. Col. Intelligence Corps; former student & Asst. Director British School at Athens; from 1927 Reader in Classical Archaeology, New College, Oxford. 1920s directed British Academy excavations in Constantinople.

MAY

Monday 1
...Called on the Powickes, taking them my first drawing for comparison with the second...I said that Albert had described John's portrait of Craster as having great vitality. Powicke replied with a twinkle that it was the one thing [Edmund] Craster[7] hadn't got.

Wednesday 3
...A.A. Committee...lunched with Russell at the Arts Club in Dover Street. Only half of the fine old house, which used to belong to Lord Stanley of Alderley, is left after the bombing...Russell and I went on to the R.A. and bought a Monnington drawing which he had noticed, for Melbourne. Saw John's paintings and drawings, all portraits...the 'Montgomery' I did not care for much: saw a fine drawing of a girl's head, in his recent manner...

Thursday 4
Tea with Ormrod and Nuttall-Smith in N-S's studio, in the mews between Beaumont Street and Gloucester Green. The Slade Society has subscribed (£8 or 9...) to buy a cast of one of N-S's works in the exhibition in the Ashmolean...

Wednesday 10
Artists' Advisory Committee...The Committee settled the awkward question of Gwynne-Jones, who had been given an impossible commission to paint two distinguished airmen at their station in Lincolnshire (two men, who, with the best will in the world, never had time to sit), by buying all the slight drawings of ground crews that he had made to pass the time. He was paid £40...Had some food at The Welsh Pony in Oxford, where I met Griselda Allan and Leo Steinberg[8] now a journalist on *Picture Post*.

Saturday 13
Went to the Playhouse – Nicholas Polunin paid for a seat for me...He had a Mrs. Neild with him, whose daughter Julie[9] was at the Ruskin School and does good wood-engravings. The play was *Thunder Rock*[10]...

Sunday 14
...Dined at Oriel, to hear what the Fellows say about the drawings of Powicke. The long and short of it is that they want me to try again. I did not dress for dinner, which was wrong...They don't dress at New College...

Monday 15
Bd. of Education Exams. at the V.&A. Mus.. Luard, Woolway (now retired from St. Martin's), Dickey and Travis...Woolway was one of a deputation of three – himself, Connard and another man – which waited on Clausen at Derrick's house, with a tribute of admiration and congratulation from Clausen's numerous friends and admirers on his

7 Bodleian Librarian.
8 Born Moscow, studied Slade (1936-40), later naturalized American citizen and eminent art historian.
9 Best known for illustrating *Lark Rise to Candleford*, a trilogy by Flora Thompson (1945).
10 By Robert Ardrey, more successful in the UK than New York (1939). Made into a film 1942.

92nd birthday. Connard did the talking...The old man received them in bed – it was thought better so, to avoid strain...It all went off well. Birdie and I were among the signatories to the address.

Wednesday 17
...Board's Exams. There are over 500 candidates in the Drawing Exam – about 70 more than last year.

Thursday 18
Board's Exams. Stayed with the Luards. She was doing her Warden's duty in the evening at the Fire-watching post, dressed in her uniform – dark blue tunic and trousers...Spent the evening in Luard's studio (which used to belong to Waterhouse, R.A.) looking at masses of his work and reproductions of masters. He has wide knowledge and a good deal of artistry – more than I gave him credit for.

Friday 19
Finished the Drawing Exam...caught the 4:45 train to Oxford. Met Henry Moore in the saloon bar of The Hoop and Toy, where we have our 2/6d lunch. Some talk of a statue of the Virgin which he has recently done. Dickey has seen it and likes it. Letter at home from the Fellows of Oriel enclosing a cheque, £21, for the drawing of Powicke. I am to do another all the same, to give them a choice. Batsford's royalties on *Historic Costume*, 2nd edition, are up this year: £10-9-5 on 134 copies.

Saturday 20
...drew Professor Hely Hutchinson of Birmingham University, a commission I owe to Thos. Bodkin. H.H. is a son of the former Governor of S. Africa, and Nuttall-Smith, whose father had a living near Cape Town, exchanged reminiscences of that country...He had come to Oxford for the day for the sitting...He is taking over the musical Directorship of the B.B.C....A very pleasant man in the early forties: Eton and Oxford: knows a lot of people I know...

Sunday 21
Met Charlton in St. Michael's Street, who presented me with a lettuce – as Barbara Lloyd-Jones presents me with eggs. He is something of a market gardener...

Tuesday 23
There is an interesting show of Narrative Pictures, from the Tate, in the Ashmolean. It includes Potter, G. Lewis, Tonks, McEvoy, Conder, Frith and E.M. Ward. The unfinished *Garrick* by the last-named is very well done. Someone came along to the Museum the other day, and, with a razor, neatly cut out and removed a tapestry panel from the back of one of the Boucher chairs in the Cooper collection.

Wednesday 24
...A.A. Committee 11 o'c. Afterwards went with Russell to Burlington House to select drawings for the Felton Bequest from...Ethelbert White and Franklin White. The latter's work is a bit thin...

Thursday 25
London for N.E.A.C. meeting. Lunch at Athenaeum, where I picked up the eighty-five year old MacColl. He is very unfavourable in his comments on Robin Ironside's introduction to the Phaidon book on *Steer*...

Saturday 27
Went to Private View of Gavin Bone's drawings in the Ashmolean. Met Muirhead, Stephen and Mary Bone, F.H.S. Shepherd and his wife, Dr. Armstrong the musician (the original of Nemon's bust)...The bust of Gavin [Bone] by Městrović is placed in the exhibition. Went on to visit Will Rothenstein in the Acland Home. He is having a rest cure...[and] recalled with some slight feeling of hostility the closeness of the inner corporation of the Slade and N.E.A.C. in Tonks's time, with Daniel, George Moore, and MacColl as supporters...

Sunday 28
...Egan Mew and I repeated our former experience of sitting in the sun by the river at the Cherwell inn, and talking about books and people (like Robin de la Condamine, the actor, and J.B. Yeats), and watching Renoir- and Monet-like groups of people and boats forming themselves and breaking up again: all very quiet and enjoyable, the chief noises being aeroplanes overhead. Last night a great many planes went over about midnight, whether on their way out to the Continent or not I do not know. This happens so often that one's curiosity is dulled.

Wednesday 31
London – Board's Exams. (Painting, 106 candidates)...

JUNE

Thursday 1
Exams. again at the V.&A....bus to Lower Feltham, having been invited to spend the night at The Hermitage by the Hagedorns. The house...is of various periods from about 1720 onwards, mostly Victorianized. It is enclosed in a garden wall...[with] pleasant views of the Georgian church...Most of Feltham is disagreeable, a recent housing estate, but there are a few pleasant old corners of the village left.

Friday 2
Left The Hermitage with Nelly, on her way to Wormwood Scrubs. Hagedorn is very busy keeping the house and garden going, (being a Fire Guard, too)...keeping hens... but he finds some time for painting and has made himself a good studio. They paid £1000 for the house, freehold...They have had their windows smashed by bombs, but the damage has been repaired. Their nephew Johnny Stiebel was killed on Commando...Coming away, met F.M. Kelly in the street. Poor man, his serious illness (cancer?) has affected his mouth so that it is difficult to follow what he says. However, he seemed in tolerably good spirits. He was always philosophically insensitive to illness, though, of course, he must feel his present condition.

Saturday 3
After supper at Kemp's, met Meninsky...He is a good talker, well informed about art.

He likes Derain, Cézanne, Turner, Millais's *Lorenzo and Isabella*[11] which he knew well as a young man (I developed to him my theory that Millais could not draw easily, and drew well only by intense concentration in front of an object motionless for a long time), Leonardo, and lots of other seemingly disparate things, as we all do. He has been reading Tolstoy's *What is Art?* [trans. 1904], and, with natural and sensible reservations, approves a great deal of it. Yesterday he was in London and was disappointed at the new Epstein show. There is a big bronze nude there. He thinks Manson dull, and got some fun out of John Craxton.

Sunday 4
To Worcester at Cumberlege's invitation, to dine...I put on a dinner jacket...[He] has given my drawing of Beaumont Street to the College.

Monday 5
Wrote 200 words on Gavin Bone, at Bone's request, for the *Oxford Magazine*...but the Editor, Kingdon, Chaplain at Exeter, wanted it cut. 7.45 Class in Beaumont Street: a good man model. Sydney Sheppard, Charlton, Greenham, O'Brian French and Bryan Wynter attended. Rome captured by the Allies. Everyone very pleased that the city is not in ruins, and with the general honour and glory of the event.

Tuesday 6
...Met Albert R. in...New College, and dined with him...After dinner, 7.45, brief service of prayer in Chapel for the Allied Forces who have just landed in France...

Wednesday 7
...Before the Artists' Advisory meeting called on Arnold Palmer and Kenneth Clark, who want me to do something for a Recording Britain scheme [The Londoners' England] that is being paid for by the London Home Counties brewers, Barclay's and others. Bone was asked to do a drawing of a brewery, but, being a teetotaler, felt it his duty to decline... To Bone's show of drawings at Colnaghi's (about half sold). Left him heavily engaged with the Duke of Alba, and went on to the Royal Academy. Jimmy [James] Grant sometimes does a brilliant drawing. I am told by Jackson that he has taken to the bottle. Patrick Hall is an able man in the Rushbury style.

Thursday 8
Slade Diplomas. Two failed: standard not low: some good work...

Friday 9
...O'Brian French gave me a suit of clothes, which belonged to an uncle of his, and which fits me but not him. In these days when 18 coupons and about as many guineas are needed for a suit, this is worth having. French has rooms in St. John Street. He has just illustrated a book on cats – rather a change from what were...among his former occupations – soldiering, Canadian Mounted Police duty, and being M.F.H. [Master of the Fox Hounds].

11 Millais's first Pre-Raphaelite painting (1848), he was 19. The subject is taken from Keats's poem *Isabella* or *The Pot of Basil.*

Saturday 10
Reading…for Betts's examinations…Four candidates for B.A. Hons. Scrutinized the practical work – painting, sculpture, engraving…Our marks were in very close agreement. Betts worked with Sickert for a time when young. He has painted some landscapes which pleased me. Train to London. Made sure of my sleeper reservation on the 9.30 train from St. Pancras to Glasgow, and then to dine at the Club.

Sunday 11
Bysshe met me at St. Enoch's and we took tram to Kelvin Bridge, and so to 20 Hamilton Drive, where I had my first sight of my granddaughter Janet, now aged about 3 months [plate 25]. A pleasing sight, but I felt a momentary inclination to cry, for unaccountable reasons…An idle day, but not dull. So much that is new to see and think of.

Monday 12
…at the Glasgow School with Bysshe, Allan Walton, Cranford, other members of the staff and governing body. Diploma work, seven candidates. Chairman at lunch, at the Arts Club – Innes, an engineer…Tea with Birdie in the shop which has now incorporated the Mackintosh Cranston Tea Rooms.[12] There is a good deal of Mackintosh left, but not the furniture. Walton came to supper…He had to leave early to meet Frank Dobson, who was coming to assess the sculpture…

Tuesday 13
Left Glasgow for Edinburgh. Started work about 10. Bob [Robert] Lyon, Lumsden (a difficult man, with grievances again Will Rothenstein and others in the art world, but a great friend of John Copley), Allison, and others…Finished work after lunch. Spent some time with Lyon in his studio, looking at some portraits he has been doing, and at the pictures of the Durham coal miners whom he helped and sponsored.[13] His account of the way they live is rather shattering. We generally preserve a beautiful ignorance of such things. Train to Dundee…

Thursday 15
At Gordon's College [Aberdeen]. A new director of the Technical School, D.M. Sutherland, Sivell and some women staff. A very lively show of work. Strong influence of Sivell, a genuine enthusiast for his job…A C.E.M.A. show of theatre designs, including Piper, Hurry, Graham Sutherland (who sticks in Sivell's throat – he thinks he gets too much publicity), Albert R., Whistler….

Friday 16
…arrived Kings Cross. Breakfast at St. Pancras. There had been an air-raid warning at 11 p.m., and some of the waitresses had been up all night fire-watching. The 'All-Clear' had not yet gone. (This was the first of the raids by 'robot' planes, supposed to be radio-controlled). In the School at Oxford about 12 p.m.…

12 Miss Catherine (Kate) Cranston was a patron of Mackintosh, he designed/restyled rooms all her four Glasgow tea rooms.
13 Ashington Group of miners who took up painting made an impresson in the art world, from their beginnings in 1934 through to the nationalisation of the mines.

Monday 19
Conversation runs much on the new German pilot-less bombing...Paul Feiler narrowly missed one in the neighbourhood of Tottenham Court Road, seeing the houses rock as it burst...People estimate that the flying bombs come over London about every twenty minutes...

Wednesday 21
Artists' Advisory Committee...Lunch at the Athenaeum...Air raids in progress...Went to...Lewis for some mounts. Lewis says that if you hear ten or twelve explosions in a night it is about the utmost; but it is very tiring, and nerve-racking...However, everyone seems resolved to carry on as usual. Goya's *Don Andrés del Peral* [c.1798] on show at the N.G., as always now, without glass. Inspected it with Bone. We were both impressed. I thought I saw similarities to Gainsborough. Bone maintained that it was on a higher plane.

Thursday 22
Slade Picnic in the pasture by the river above Godstow...over fifty... a good many bathers, a well-organized supply of food and drink...Albert and Kyffin Williams, Nuttall-Smith, Barbara Lloyd-Jones and I rowed home along Port Meadow...

Sunday 25
Tea with Lawrence Dale and his wife at their house in Woodstock Road. He is an amateur water-colourist of taste and ability. His mother was a mezzotint engraver of great skill, who went to Bushey in Herkomer's time, and also modeled a bust of him. He does not care much about being an architect...though here again his taste is good...

Monday 26
Worked with Charlton & Ormrod sorting out work for Slade prizes. Charlton thinks it is a good standard of drawing...He wrote me a most indignant letter from Leonard Stanley because I started doing this work of selection...He pointed out that he had been employed on it since 1920...He is an enthusiast for the School, and I had no intention of doing without his services, which are valuable...

Wednesday 28
Board's Exams. at S. Kensington. Several air-raid warnings and the noise of P-planes overhead. Rokeling and Woolway got under the furniture when the latter occurred, very sensible with the glass roof of the Museum over us, but Dickey, who is experienced, was able to tell us that the planes were not for us...

JULY

Saturday 1
Last day of the Slade...Kyffin Williams came in...He was to have had a fortnight's teaching experience at Whitgift School with Potter, but Potter now writes...to say that, owing to the bombs, his classes are not going on...

Sunday 2
...Supper at The Welsh Pony. Dr. Newman was there. Queue waiting. A girl whose face

seemed familiar sat by chance at my table: she was Felicity Sutton, daughter of Eric S.; she is working at Camouflage in Leamington.

Monday 3
...Drew Powicke a third time. I felt rather gloomy about the drawing at one stage, but, contrary to my expectation, he seemed rather pleased with it...

Wednesday 5
To London for Artists' Advisory Committee. Met Arnold Palmer at the National Gallery, who told me that the selecting committee of The Londoner's England scheme were going to buy six out of the parcel of topographical drawings that I delivered to them. This, at £15 each, is very useful. Lunch...Athenaeum. Alerts, and P-planes overhead. Several members in the drawing room, including myself, lay on the floor (a comic sight) and Philip James took cover from possible blast on a sofa...Some women with children seem to spend their day sheltering in the Tube stations...

Thursday 6
Started on some lettering for a book-jacket [*Peace Treaty*] for Douie...At the Union, at tea-time, met...Ernest Jackson, who criticized the Slade Sketch Club the other day. He liked Kyffin Williams's work.

Friday 7
...Oxford is over-full again, with London refugees.

Monday 10
Began on drawing of Oriel for Carnegie. Couldn't get much done – heavy showers. It will be a long job...

Tuesday 11
...bus to Radley. Tea & supper with Paul Feiler [plate 26]. He has something in the current show at the Leicester Galleries, and drawings at The Redfern. Discussed with him many artistic problems, theoretical and practical: also the position of Goethe as a world genius on the Shakespeare plane, as to which I have doubts, though, not knowing German well enough to read him in the original, I am not in a strong position to judge...

Wednesday 12
To London; went round the R.A. with K. Clark, Coote, Gleadowe and Dickey, looking for pictures to add to War Records. Afterwards, discussed with Dickey the affairs of our student, the ex-sailor R.[aymond] Mason [plate 27], hoping to get a grant for him from the Govt....Lucien Pissarro is dead. He was a very likable old man and a good artist. I looked at his Chantrey picture in the R.A. today. He had some good paintings of his father's in the house at Brook Green...Latterly, being hard up, he and his wife let the house and lived in the studio; but they seemed able to afford a cottage in the S. of France. His English was a little difficult to understand – indistinctly spoken, with a strong French accent.

Thursday 13
...Jess sent on a letter from Eric, who has been ill since April. He must have thoroughly overstrained himself, and developed heart trouble. I am frightfully sorry – I thought he was the strong member of our family...I wrote him at once...

Wednesday 19
London – Artists' Advisory Committee. Raids going on. Two bombs or doodle-bugs fell within ear-shot...At 4p.m. sat to Willie Clause for an hour in the Club. He is making a composition of a New English Jury, and has got Bone to sit too – rather like him...

Saturday 22
Met Meninsky...lunch at The Municipal Restaurant in St. Giles...2.20 Bus – crowded – to Burford, to see Alban Atkins. His father was the vicar of Marsworth near Tring. We discovered many memories in common, of Ivinghoe, Albury, Eddlesborough, and that corner of Herts. + Bucks. + Bedfordshire, where much of our upbringing took place. Burford Bridge is passable again, after an American tank went off it into the river, breaking down the parapet and making an arch unsafe. They are carefully putting back the old stones...

Sunday 23
...In the Sunday paper, obituary of Sturge Moore, a familiar figure for years in Hampstead. Though he had a fine, venerable appearance, I had little respect or regard for him... He seemed to demand respect...and to be too cosseted in self-admiration by his immediate circle. I first met him when I went for the *Burlington Magazine*, about some Rodin drawings, to [Charles] Ricketts's & [Charles] Shannon's flat in Ladbroke Grove. He had a thin, bleating voice.

Monday 31
Went to see the decorations Bysshe is doing in the Children's Restaurant near the [Glasgow] Cathedral. He has one assistant, a first-year student, Lindsay. The job is being very efficiently done...It will have taken about six weeks to do...

AUGUST

Sunday 6
Charles and Ivy Tennyson came to Glasgow from Edinburgh, where she is running a picture exhibition and he is taking a holiday...

Tuesday 8
Mrs. Sally Pritchard [née McLellan], the young stained-glass artist who teaches in the Art School, came in in the evening. I think she is ambitious to get a commission from Maufe for a window in Guildford Cathedral. She thinks well of Hendry (with reservations) and thoroughly despises Burne-Jones. Chartres Cathedral is her chief admiration.

Thursday 10
Called on Miller at Mount Florida, and looked at a lot of his paintings and water-colours. He has an artist's eye...and...has great appreciation, both for pictures and scenes to paint.

His self-portraits are like, but the drawing is not always sound from the academic stand-point. He took me to see a wall-decoration by [Maurice] Greiffenhagen[14] in the Battlefield Public Library – capable and poster-like; and the Museum at Camp Hill, in a fine Adam house: pictures by Sam Bough, David Roberts, William Strang, Leslie Hunter, J.D. Fergusson and others, of which I liked a few...

Friday 11
To Edinburgh with Bysshe, for the opening of the C.I.A.D. American exhibition...At 12 went into the National Gallery. Met Ivy and Charles. Speeches by Darling (Lord Provost), Lord Linlithgow, Charles T., an Air Marshal and the American Consul. The pictures most interesting to me when most national and unlike what we see in Europe. The prices very high: one picture, by R. Philpp £2,500. Met Cursiter and MacTaggart at the S.N.G... Looked at Sally Pritchard's windows in the new Bank in St. Andrew's Square...

Monday 14
Margaret Morris and J.D. Fergusson came in in the evening. They have rooms nearby, across the Kelvin. 'Fergus' is a Highlander. His father spoke Gaelic as his native tongue and learned English as a foreigner: consequently, he would reprove his children for saying, for example 'can't', as he said it was incorrect, and should be 'cannot'. F. started life not as an artist but as a medical student. His furniture is still stored in Paris...

Wednesday 16
Saw an exhibition of the early Glasgow School – W.Y. Macgregor, George Henry (*Galloway Landscape*, good, and another early landscape: his work influenced by Hornel I did not like), Alexander Roche, Lavery...including some bad things by Hornel and Melville. Interesting on the whole, and Macgregor certainly worth seeing.

Thursday 17
Went to visit the Mackays (Campbell Mackay...teaches design at the School of Art) at Milngavey. He is an intelligent, cultured man, a very keen gardener (with half an acre of garden, growing some rare plants, but ill cared for now in war-time). His daughter is an art student. Saw one pleasant semi-decorative landscape of his, done near Dunfanaghy in Donegal...

Friday 18
Sally Pritchard gave Birdie and me lunch at a Swiss restaurant, Ferrari's, in Sauchiehall Street. It must have cost her quite a lot. Three gins, as an aperitif, cost me 8/6d After-wards we went to the Art School and looked at some windows she is doing for a church in Milngavey, and at her cartoons for some of the windows in the Edinburgh bank: also at photographs of her husband's work – Walter Pritchard, now in the Navy – mural decorations, bronze and glass. He is a considerable artist, with a special feeling which comes, perhaps, from his strong Catholic bias. He was trained at Dundee, but seems to have developed very individually. She worked for a year in Copenhagen. Things were so cheap for an art student then in Denmark that £100 was enough for all her expenses, allowing her even to go to the Opera occasionally.

14 *Battle of Langside* (1919).

Monday 21
Thomas Howarth and his wife, and Fergusson and Margaret Morris, came in in the evening and we all discussed Mackintosh while Howarth made notes…It will be the first book on Toshie. He is doing it as a thesis for his doctorate, and it may be published afterwards. When Birdie saw Margaret Mackintosh after Toshie died, Margaret told her not to take his loss hardly – she herself thought it a relief: 'Fancy – Toshie free from pain!' But it broke Margaret. The constant attention and strain were too much for her. Birdie remembers – thinking of another aspect of Mackintosh before his illness – that she once spent an evening with Margaret in Chelsea and stayed late: when she got up to go, Margaret begged her not to: she was obviously in a state of mind, dreading Toshie's return. He was out with Augustus John, and would come back…the worse for liquor. But she presently changed her mind, and Birdie came home before Toshie appeared. Margaret must have had to face many such situations; though I never saw Toshie drunk. Probably their choice of the south of France to live in was influenced by this question of drinking. At least the wine was harmless.

Friday 25
To London, and on to Hertford to see Bill in the County Hospital there. He is in the Nursing Home, and cannot walk yet, though he has great hopes of ultimate recovery. Still, he will never be able to sail a boat, so all his schemes of living on one after the War have come to nothing…I am relieved to find him in relatively good spirits. He is writing a book on his special subject of unarmed combat, or on shooting…a book to 'debunk' other people's views. He was at Peterborough when he overworked and got 'flu, in charge of some 300 men…

SEPTEMBER

Friday 8
In the afternoon, started drawing at Abingdon, for Kenneth Clark.

Tuesday 12
…to Abingdon…3 hours drawing. Men are going about with lorries putting up the street lamps again, in preparation for the relaxation of the black-out. The Americans are now just over the German frontier and it looks as if the doodle-bugs have been stopped…

Wednesday 13
London Artists' Committee. Met Anthony Gross, who was showing the Committee some excellent sketches and drawings done since D-Day in France…

Friday 15
5 hours work at Abingdon…Street lamps alight again, after 5 years, in the main streets of Oxford.

Saturday 16
…Went to a film, a rubbishy American thing. I know the name neither of it nor the actors; but it was an attempt to find entertainment for Birdie to go to it, and it was a diversion for both of us.

Sunday 17
...worked out the placing of my Abingdon Town Hall within it margins, according to my usual crude working of the golden section...

Monday 18
...Abingdon. As once or twice previously, someone said to me quite seriously: 'how much better that looks in your drawing than it is in reality.' It is curious and interesting to try and work out the reasons that make people say the things they do about pictures, and the motives underlying popular appreciation of art. Certainly, exact imitation (if there can be such a thing in drawing and painting) is appreciated.

Thursday 21
A final 2½ hours – about 40 in all.

Saturday 23
...Lawrence Dale brought in a copy of his book, *Towards a Plan for Oxford City*, with a magniloquent inscription to myself because the book reproduces my drawing of Radcliffe Observatory.

Wednesday 27
Artists' Advisory Committee. Travelled with Muirhead Bone, who...talked about Gavin's *Beowulf*, his brother David, who brought his ship home to-day, the big drawing he is working on at Coventry....Went to Philpot's exhibition at Leicester Galleries to buy a drawing which Walter Russell had earmarked for Melbourne...

Thursday 28
Had tea with Bernard Dunstan at no. 1 Saunders Passage, the rickety old building in the Broad.

Saturday 30
Went to Cumnor by bus, with a sketch-book. Italians working on the land there...

OCTOBER

Sunday 1
To Manchester, to see about the drawing I am to make at Haward's instigation. Dodd and Hagedorn are to make drawing of the same series – we are all connected with Manchester...

Monday 2
Met Haward at the Art Gallery, where I saw, among other things, a collection of C.J. Holmes's landscapes, and then to the Ferranti factory at Hollinwood in a Corporation car. Inspected the radio-location gadgets that Haward wants me to draw...Manchester has very many traces of bomb damage. Squalid depressing districts where the 'workers' live.

Tuesday 3
...to Ferranti's...Lunch with members of the firm – Vincent Ferranti and another of the

family – and the superior members of the staff. 2-5p.m. drawing. Everybody very atten-
tive and civil. A Miss Ferranti was at the Slade in Oxford for a short time, the daughter
of the gentleman with a loud laugh, who has been painted by Cathleen Mann.[15] The Fer-
rantis have several factories in different places, and employ 12000 people in all. The
ones I saw seem cheerful, clean and contented...

Wednesday 4
Work 9.30 ... 12.30. Lunch with the firm again. Back to work 2.30 ... 4.30...Haward
came to inspect my progress...

Thursday 5
Left Manchester...

Saturday 7
Luard died about a fortnight ago of jaundice...I should not be surprised to hear that he
was worn out by the bombing and his A.R.P. work.

Monday 9
Slade began. A full house. Derek Chittock, as head of the Slade Society, addressed new-
comers in the Randolph Lecture Theatre...

Tuesday 10
To London, for N.E.A.C. Jury...Over 1000 pictures. There was a bit of a scene at the
end, when I recalled one of Cheston's works which had been, I thought, unjustly rejected
– one of Malcolm Milne's too: in fact, the whole question of the rejection of members'
work came up, and the recalling of it. Devas became very heated, his point being that
we were reducing the rejection of members, one of the fundamental points in the Club's
constitution, to a farce.

Wednesday 11
Hanging N.E.A.C., D.S.M., Spear, Cheston, Clause, White. MacColl reminiscent about
Whistler, whom he seems to have snubbed on one or two occasions such as the Sir
William Eden[16] affair. However, he and Whistler appear to have got on fairly well...

Thursday 12
Finished hanging the N.E.A.C....Cheston, Clause and I disagreed rather violently; but we
parted good friends, after having made some much desired emendations to his arrange-
ment. Ethelbert White is very sensitive and fussy about the hanging of his pictures. He was
quite in a rage yesterday, because, at D.S.M.'s suggestion, one of his drawings was hung
below the so-called line. So was one of mine, and, I believe, looked the better for it.

Saturday 14
Letter from Bill, from which it is clear that he will be an invalid for the rest of his time.
This is a great blow. At present he cannot walk more than 50 yards...

15 Also known as the Marchioness of Queensberry until her divorce in 1946.
16 Refers to the judgment of the Court of Appeal in Paris (Dec.1897), the action between Sir William Eden
and 'Jimmy' McNeil Whistler. The significance of the judgment is that a painting belongs to the artist
until it is delivered, but the client who does not get the picture may sue for damages, not the picture.

Sunday 15
Finished my drawing of Ferrantis…

Monday 16
Rodney Burn called. He told me how MacColl took him up when he was young, and helped him. Then he described with a twinkle in his eye how D.S.M. (of whom he was very much in awe) decided that his education had been neglected, and read Blake's poems aloud to him in the evening; then gave the book to Burn to take home and study. Burn wrapped the book up in paper, but looked upon it as so precious that he did not dare to open it; MacColl, by a process of cross-examination, discovered that B. hadn't read a word, and there was some awkwardness.

Tuesday 17
In the evening…Burn…We discovered a common enthusiasm for Turner, and talked of his pictures, his character and his habits. Burn is engaged on a drawing for our War Artists' Committee – something to do with air photography. He said that Robin Guthrie acted as assistant to Fred Brown on his last self-portrait. He was paid at the rate of £1 per visit. Burn was genial and amusing about other mutual friends, MacColl and Gertler (whose Sunday evening receptions, when Gertler, in a flowered waistcoat, did almost all the talking) among them.

Thursday 19
Had to go to London about pictures…Delivered the portrait of a judge which I have very slightly touched up and washed (it is probably by Jonathan Richardson [c.1665-1745]) to John Colombos at 4 Pump Court. I am charging him £5-5-0…At the Leicester Galleries, where I went to collect the drawing of Philpot that Russell and I bought, found W. Michael Rothenstein and his wife hanging an exhibition of his water-colours. They are now all in the Christopher Wood neo-naif manner, and he professes a great enthusiasm for modern bungalows and the new forms that they give him, and the coal dust of Stoke-on-Trent. He says that the coal, all over the ground, gives him a beautiful blue colour, which sets off the warm colours: all this is much more interesting than the old-fashioned picturesque of old cottages and barns…

Tuesday 24
…memorial service for Gleadowe at the Savoy Chapel…Durst and others were going; but I could not go…because of the urgency of hanging the R.W.S.…with Ronald Gray and Vincent Lines. Lines is a useful hanger and an intelligent, rational, well-informed man. Gray talks a great deal, but gives little practical help…he is in his 77th year…

Wednesday 25
R.W.S. again. Travelled up with Muirhead Bone. He has not yet finished his huge Coventry drawing…Russell Flint was at lunch, and went round the hanging, making a few changes with his usual sense and generosity. He was cured of his serious illness last year by being given penicillin.

Monday 30
…H.M. Carr called at the School. His studio in London – Parkhill Road – was completely

destroyed by a bomb…His experiences of War, particularly in Italy, where the devastation and its effect on the civilian population…have rather got him down. Other war artists, such as Ardizzone, react differently, and keep up their spirits.

Tuesday 31
Albert R. criticized the Summer Compositions. We had decided to give no 1st prize, but Gruby, Pam Morgan and Barr-Dawkin did well and got lesser prizes. I was glad about Gruby, as we had given her an Entrance Scholarship, and her recent performance has now justified that award…The Phaidon Press book on *Augustus John* is in the shops and is selling out rapidly. Jack Townend bought a copy for me with some difficulty.

NOVEMBER

Wednesday 1
Albert's friend, Alic Smith is to be elected Warden of New College to-day. Unfortunately, another friend of his, the Dean, David Boult…who was recently married, died this morning. His death will cast a gloom over the proceedings…Rodrigo Moynihan and his wife, Elinor Bellingham-Smith, called at the School…Rosemary Gwynne-Jones, née Allan, also called: all old students. Moynihan, who, of course, knew Gleadowe, by a curious accident saw his naval funeral from the coast of Cornwall before he had heard of Gleadowe's death. Seeing the pinnace with the body on board, he inquired about it, and learned that the scene taking place was the funeral of 'a Mr. Gleadowe'.

Thursday 2
In London for British Institution Scholarship Committee. Lunch with Margery and Albert at the Strangers' Club in St. James's Place. Met Sir William Nicholson in this little club: always dandified, he had on an eccentric flat black hat and a stiff standing collar with points turned down…He looks very old. Munnings, later on at our meeting, where he was in the Presidential chair, made a very poor display…He arrived 20 minutes late, took his place from Sydney Lee (who was acting as Chairman) without any apology, greeted nobody, said nothing useful and made poor jokes…

Friday 3
Yesterday, young Mrs. David Boult, the late Dean's wife, committed suicide in the Warden's Lodging at New College, by putting her head in a gas oven during the night.

Saturday 4
In the afternoon, worked on the drawing of Abingdon Town Hall, adjusting tones and values…

Wednesday 8
Artists' Advisory Committee. Took my Ferranti drawing for censorship to the Min. of Information. They declined to pass it, as the A.U.K. radio-location instrument is still on the secret list. Met…Bob Wellington in Regent Street. Bob tells me that Hubert is getting married again this week, to a Miss [Irene] Bass, who used to be a student (and later, I think, on the staff as a letterer) at the Edinburgh College of Art…

Thursday 9
Russell said yesterday that the reason Norman Wilkinson has given his naval pictures to the nation is that he wants a Knighthood – probably thinking of Orpen in the last War, though Orpen cared, apparently, so little for the honour that the Lord Chamberlain had some difficulty in getting him to Buckingham Palace to be dubbed. Russell disclaims any great interest in his own Knighthood…and he is not in sympathy with anyone else touting for one.

Saturday 11
Alic Smith, introduced by Derek Chittock, spoke very well at the opening of the show of Slade and Ruskin students' pictures. He drew a parallel between the problems of teaching in philosophy, his own subject, and those in Fine Art…Parker was busy acting as interpreter with German prisoners who were being interrogated somewhere.

Friday 17
…Muirhead Bone came to tea with me at the Union…Proud as ever of his family; he was pleased to be able to show me a drawing of Stephen's in the *Illustrated London News*, of a German rocket bomb being fired from the island of Walcheren. This Stephen actually saw from one of H.M. ships, and as there has been so much mystery about the rockets, it is a journalistic 'scoop'…

Saturday 18
Alfred Wolmark came to the School…I never knew him very well, and don't quite know why he comes to see me now, except that perhaps he had a hope of doing some teaching at the Slade – a hope which I discouraged…We met Meninsky, who is going to talk about Mark Gertler (with whom he was intimate) at the exhibition of Gertler's pictures now going on in London. Late in the evening I met Meninsky again, with his wife, and asked them in. M. was in a reminiscent mood, and talked about his meeting with Augustus John in the Old Sandon Studio days in Liverpool: also of a party which John once gave in Chelsea in honour of Meum Stewart,[17] the guest of the evening never came, because Epstein wouldn't let her, and locked her up in her room. Meninsky did not stay many months at the Slade, though Tonks liked his work, and Meninsky learnt much from Brown. He got some sketch-club prizes, too. William Roberts was then the star draughtsman, drawing with the meticulousness and certainty of an early German master and able to draw in the style of any master. Bomberg was a leading spirit in the School, and from him, Meninsky thinks, emanated an unpleasant atmosphere of personal competition which M. did not like. Bomberg and Roberts fought with each other – a hand-to-hand fight. Meninsky, of course, did not get the Rome Prize, as is said in Hone's *Life of Tonks*.

Wednesday 22
In London for a Professorial Board in Gower Street…Gwynne-Jones is still engrossed with his picture of the Princess and the pony carriage at Windsor…He has a curious lack of appreciation for much of Augustus John's work.

17 Actress, who after giving birth to Epstein's first daughter, allowed her to be raised by Epstein and his wife Margaret.

Thursday 23
Lunch with Borenius and Albert R....Borenius seems very relieved by his re-appointment as Professor – like mine, for a further period of 5 years...Bone...took me to tea at The Racket tea-rooms, in the 17 cent. house adjoining Christ Church. He showed me the announcement, in the evening paper, of Clausen's death at the age of 92...

Saturday 25
...Reduced the tone of Merton Tower in the Oriel drawing that Dodd criticized. I did this with rubber and an eraser. They leave no trace.

Tuesday 28
...Our conscientious objector friend, Humphrey Waterfield,[18] who distinguished himself with the Red Cross at Narvik, is now taken prisoner by the Germans. He was driving an ambulance full of German wounded. Before that he was offered the Croix de Guerre, which he declined, as he is not a soldier...

DECEMBER

Saturday 2
The Provost came to the Slade and talked to the students in the Ruskin Life Room about the move back to London next year...In the afternoon helped Parker to select pictures for an exhibition of the Glasgow School – the same collection which Bysshe and I saw in Glasgow...

Sunday 3
...Went to see Egan Mew. He says that Max Beerbohm several times caricatured him in each case stressing his insignificance: as with Albert R., whom he represented in the N.E.A.C. drawing as a tiny figure under a table. Further, he says that Will R. in his young days discouraged the idea of Max learning to draw academically; and he remembers how pleased Max was when starting his career, at having his drawings reproduced in *Pick-me-Up*. I used to buy that journal when I was a boy.

Monday 4
Albert R. was called to London by a telephone message announcing that Margery had attempted suicide. She has broken her leg in three places and is in St. George's Hospital. She threw herself out of a window at Burton Court, in a state of insanity.

Wednesday 6
Artists' Advisory Committee...Visited Epstein's show of water-colours – flower pieces and views of Epping Forest: rather monotonous in the mass, when the first vivid impression has been made. I believe every one...is sold...Humphrey Waterfield is out of German hands.

Thursday 7
...Slade-Ruskin Dance...It went well...It is essential, of course, to get outside men, as we wouldn't have enough of our own. Leo Davy did some good wall decorations painted

18 Studied history at Oxford and art at Ruskin and Slade, achieved recognition as an amateur garden designer.

on newspaper...

Sunday 10
George and Daphne Charlton came in...She is here for a brief holiday with him, staying
in Vanbrugh House in St. Michael's Street. She looks as handsome as ever...

Monday 11
Drawing class in Beaumont St....A negro model. Ferranti's paid for the Hollinwood
drawing – 50gns. and 5gns. expenses.

Tuesday 12
2-3.30p.m. Made a drawing, commissioned by Birmingham University, of Mr. Camm,
solicitor of Dudley, and until recently lecturer at Birmingham. Albert R. praised the draw-
ing when he saw Mr. Camm and it, and it was agreed by G.J. and R.N-S that it would
be better not to do any more to it....

Wednesday 13
To London for a Whitechapel Trustee meeting, the first I have attended during the War.
Lord Bearstead away...Another trustee, Councillor Davis, ex-Mayor of Stepney is in gaol
for forging identity cards...The roof of the Gallery has been damaged at the time of the
Petticoat Lane bomb, and the upper rooms are unusable...

Tuesday 19
...Potters have an offer from Mrs. Kitchin of Church Row of £4000 – which is what I
asked – for no.20. I have put the matter in the hands of Messrs. Marshall & Eldridge of
Vanbrugh House, St. Michael's Street, to get the sale legally carried through. When I have
paid off the Tennyson mortgage and the expenses there should be roughly £2000 left...

Wednesday 20
...Artists' Advisory Committee. Fog: the train arrived at 12 noon, and the meeting was
over. Saw K. Clark, who paid for the Abingdon drawing (£18-18-0)...At the Club...
Lessore quoted my limerick on [Adolf] Menzel[19] to Iolo Williams who published it
to-day in *The Times*.

Thursday 21
Birdie and I left Oxford for Drayton Court to spend Christmas with Charles and Ivy
Tennyson...

Saturday 23
...read Charles' memoir of his grandfather in typescript – the second part, most inter-
esting. The publishers think the early part about Somersby...is too long, and Charles will
cut it. Went to see F.M. Kelly...He was in bed: a dying man...His speech almost unin-
telligible, and he can eat nothing. I was glad I went. I may not see him again, and I think
he was pleased to see me...Pantomime in the afternoon, at the St. James's Theatre: *The
Glass Slipper* by Herbert & Eleanor Farjeon...Donat produced the piece, and the Ballet
Rambert did well...

19 German painter (1815-1905).

Sunday 24
...I hear Farringford is being sold...Birdie and I are very sorry, remembering the place as we do. A pity the National Trust could not have it. Charles no doubt regrets it bitterly, but is uncomplaining...

Monday 25
19 degrees of frost reported at Kew...At 4 o'c., a party and Christmas tree, with distribution of presents...

Friday 29
Albert at the Ashmolean. He has had to leave the Warden's Lodgings, and quarters have been found for him by the College in New College Lane – in a house used by undergrads., at the corner of Hell's Passage...He and Mickey stayed at Garsington over Christmas. Tommy L. has nearly (or quite?) finished the landscape he has been working on for nearly five years – surely a record. Lowinsky is pleased at being put on a Committee of the V.&A. Mus.. He is also to be a buyer for the Contemporary Art Society next year.

Saturday 30
...Devas said the other day that John disapproves strongly of John Rothenstein's selection of photographs in the Phaidon Press book. J.R. told me some time ago that Augustus made a lot of difficulties. Darsie Japp, Juanita said, is now in Mexico, hoping to sell his pictures...

1945

In January Schwabe is asked by the W.A.A.C. to record the V2 bomb damage at Chelsea Pensioners' Hospital in London. Shortly after he returns to Manchester to make his second drawing of the industrial efforts of the city. April 23 sees a lifting of the black-out; on 28 Mussolini is shot and killed and two days later Hitler commits suicide. Victory in Europe is celebrated on May 8. A few days later Schwabe is much moved by the death of his brother, Eric. In August the Americans drop atomic bombs on Hiroshima and Nagaski. July sees the end of the Slade in Oxford and in early September to great regret the Schwabes return to London. Having nowhere to live they stay with good friends Charles and Ivy Tennyson. The Slade reopens in Gower Street in October amid conditions of austerity. Two important exhibitions open in December – Matisse and Picasso at the V.&A. and Paul Klee at the Tate.

JANUARY

Monday 1
...Bryan Wynter[1] called...asking for a reference. He is an admirer of drawing by [Cecil] Collins, who was featured in *Horizon*,[2] and is now in the new Oxford magazine devoted to the Arts. Wynter also figures in the latter.

Tuesday 2
...Gordon Faudrée is painting a portrait of his negro friend, Cameron Tudor.[3]

Wednesday 3
Artists' Advisory Committee. As a bomb had fallen at 9a.m. on the Royal Hospital, Chelsea (reported by Sir Geoffrey Burton, whose flat in Turk's Row had its windows blasted), I was asked to go and make notes for a drawing of the scene. Mrs. Murdoch took me to the Home Office to get a pass signed by the Inspector General of the Ministry of Home Security. Worked on the site for about 1½ hours on some minute paper supplied by the Ministry....

Thursday 4
To London to draw the Royal Hospital. Much colder than yesterday – puddles still frozen at 10a.m....

Saturday 6
2½ hours drawing in Chelsea. A slight fog, and my paper was thoroughly damp, but I got all the information I wanted...

Sunday 7
Called on Egan Mew...[he] went to Bonn University when he was young, but attended

1 Wynter was a conscientious objector.
2 Spender, S. (1944) 'The Work and Opinions of Cecil Collins', *Horizon*, 9, 50.
3 Studied Oxford University, 1942 first black president Oxford Union debating society. Later Deputy Prime Minister Barbados.

no lectures and mostly wasted his time with English friends. He was paid for by his guardians. His father had died £30,000 in debt. He spent some unsuccessful years in London trying to be a black and white artist, then he discovered that he could make a living by writing...

Wednesday 10
London for R.W.S. Council Meeting. Lunch at the Club — Prof. Hill (the engineer) of University College, London. He has been to Hollywood about aeroplanes. 'Council' consisted of Russell Flint, Charles Knight and Dorothy Coke, (both of whom travelled from Brighton), Lee Hankey (who travelled from Leamington), Holding (from Sussex), Cecil Hunt and Philp. Voted £100 to Oliver Hall, whose studio, uninsured, has been burned, with the notes and sketches of a lifetime, and his pictures for this year's R.A., where he always sells.

Thursday 11
A black student from Nigeria presented himself, backed by The British Council. The first real negro I remember at the Slade: a cultivated, well-spoken man (Enwonwu).

Friday 12
To London for an Examiners' Meeting with Bellin-Carter[4] at the Imperial Institute. Lunch at the Athenaeum beforehand: MacColl...is full of energy, and active about the N.E.A.C. show at the R.A. He asked Bodkin to open it, he being in the public eye now owing to the correspondence in *The Times* about C.E.M.A., in which he fell foul of Kenneth Clark. D.S.M. – had asked Munnings to make the opening speech, but, though the President was pleased, he was too busy to do it. MacColl's book on Steer being now in the printer's hands, he has turned to painting, with enthusiasm...

Monday 15
L.M.S. to Manchester...to execute the second of Haward's factory drawings. It is Adamson's of Dukinfield, this time. Clause and Cundall have been up doing similar drawings...

Tuesday 16
...Adamsons are boiler-makers and employ about 500 people, nearly all men. The factories are spacious and thinly peopled...They handle mostly heavy stuff, at which not many workmen can work at a time. The boys handling molten rivets look very young – I should have guessed, under 14.

Wednesday 17
Dukinfield again. Mr. Parkin and a Mr. Shaw, a Cambridge scientist, at lunch, full of interesting conversation; full of ideals...which is good to find in an industrial world. Parkin was educated under Professor C.E. Inglis of Cambridge, a believer in the value of classics as a basis for education for the professions, himself an engineer. Shaw is shortly going to the U.S.A....for the Ministry of Air-Craft production. I was shown some remarkable wooden drums, weighing not more than 10lbs. (about 2ft. high) which contain shells and withstand a pressure of something like 10,000 lbs.

4 *Principles of Drawing* by Leslie Bellin-Carter, 1916, sub-title: *Student's Notebook.*

Thursday 18
Completed all of my drawing that I could do on the spot. Parkin…says that practically all boiler-makers go deaf…and he invariably shouted at the men in the workshop. He described the special shells – globular – used for sinking the *Tirpitz* [Nov. 1944], and a vast experimental tank of translucent water, on Clydeside, used to try out devices for submarine warfare…

Saturday 20
Nuttall-Smith, Albert, Griselda Allan; preparations for Hilary Term… Albert R.'s co-examiner for the Oxf. & Cambridge Schools Board, Fyfe,[5] is drowned through falling through a hole in the ice at Cambridge.

Thursday 25
…(K.T. Parker came across to no. 7 and selected one of Falcon's small water-colours for inclusion in the Ashmolean collection. He likes it.)

Saturday 27
Young [Lawrence] Toynbee came into the Ruskin School, invalided out of the Army [Coldstream Guards] with shell-shock. He has carved another crucifix. I'm afraid he will never be anything but an amateur – doesn't know the beginnings of anything.[6] Nuttall-Smith was going to talk to him about his carving…9 degrees of frost, according to the wireless. Mrs. Brown is now making trouble about the difficulty of heating the bath-water in the house. Hot baths are important to Birdie, with her rheumatism.

Monday 29
…Class in Beaumont St.….Model bicycled from Noke, seven miles. Of course, she could not sit for figure – too cold.

Wednesday 31
London for Artists' Advisory Committee…Lunch at Arts Club in Dover Street, with Maxwell Ayrton (still profitably employed) and Brian Robb, in Army uniform, who was with Tony Ayrton in close companionship in the Middle East…

FEBRUARY

Friday 2
London. Long Examiners' Meeting at Imperial Institute – Jenkins, Charlton, Sthyr, Potter. General Schools Art papers. 4p.m. Charlton and I met the Provost and Tanner at U.C., and inspected the Slade wing, with a view to arrangements for the School's return in October. The rooms are now used principally as students' common rooms. The repairs have been very thoroughly done in those parts.

Sunday 4
Went to see Egan Mew. He talked about Mrs. Sutro, whom he knew well, and Sutro with whom he came in contact…when he was a dramatic critic. He liked Mrs. Sutro, who

5 David Theodore Fyfe, architect and archaeologist, drowned in a skating accident at his home on 1 January.
6 Later art master St. Edward's, Oxford.

was a sister of Lord Reading. Sutro was also Jewish, one of a firm of fruit-brokers in Covent Garden. He made enough money by fruit-broking to retire on before he ventured on play-writing as his chief concern. Charlton in the evening. Bombs still fall in or near London, whence he has just come.

Monday 5
...7.45p.m. Greenham's class in Beaumont Street. He is saving money as hard as he can to try to escape from teaching...and to devote time to painting. At present, he says, he can neither teach nor paint properly.

Tuesday 6
Went on to tea in New College with K.T. Parker, in Wickham Legg's rooms. Legg wished to consult us on lists of artists who are to be included...in the *D.N.B [Dictionary of National Biography]*...The lists had...previously gone through a committee, and were carefully compiled. I take it that Parker and I were a sort of appeal court, possibly of some use in classifying or grading the various names submitted, ranging from Tonks and Orpen to Cecil Aldin and Louis Wain. Some...were totally rejected. Parker and I would have rejected Louis Wain, but Legg wouldn't have that.

Friday 9
News that Francis Kelly died on the 7th – 'a merciful release' Mrs. Kelly says...I was very glad that I saw Kelly twice at Christmas time. Once, some time ago, I passed him in the street in London, and, as he did not see me, and it was so painful to talk to him, I did not stop...Dined with members of the 'French Society' and their lecturer for the evening, M. Poisson, at The Eastgate Hotel. A very good lecture afterwards at Rhodes House. Picasso, we are told, is now a War Artist. Poisson particularly likes *Guernica* [1937], which still does not move me; but it is interesting to know what other people find in it...

Sunday 11
Called on the Fritz Shepherds at 9 Marston Ferry Road. They have rooms at the top. He is employed on book-binding at the New Bodleian, and plays in a Bach orchestra at the Sheldonian. He seems much better, but does little painting. They will not return to Paulton's Square till the bombs have ceased...

Monday 12
Fairlie Harmar, who died a little time back, caught a severe chill, which developed fatally into pneumonia, from sleeping in her empty blitzed house in Cheyne Walk.

Tuesday 13
N.E.A.C. judging at Burlington House. Jury – D.S.M., Clause, Dugdale, Cheston, Fisher Prout, Stephen Bone, Guthrie, Devas, Ruskin Spear, Eurich. Lunch at Martinez Spanish Restaurant in Swallow Street. I walked there from the R.A. with MacColl, who is very shaky and rheumatic on his feet...

Wednesday 14
...On the wireless, in the evening, the death of Will Rothenstein was announced.

Thursday 15
London...Lunch and practically finished hanging in the afternoon. Some of the retro-spective section of the show is very interesting: people like L.A. Harrison and Buxton Knight, whom one rarely sees: Connard has some very good work: Muirhead Bone has his great Coventry drawing: John some recent portrait drawings and at least one small early painting: there is a self-portrait of Brown: some Tonks's...

Friday 16
Albert went off to Oakridge for Will's funeral. The Slade-Ruskin students subscribed £2.10.0 for a wreath...

Monday 19
7.45p.m. Greenham's class in Beaumont Street. Miss Scott's room, where it is held, is a ramshackle, untidy place...A slight disadvantage is that many times the model is too near.

Wednesday 21
London, to draw Lord Porter, for Prof. Smalley-Baker's Birmingham lawyers' club... lunch at the House of Lords...drew Porter afterwards in a well-lighted committee-room...Noticed with curiosity the Gibson statue of Q. Victoria, with figures of Justice and Mercy. I don't believe anyone ever looks at it – they just pass it by. I had not been in the House of Lords before.

Wednesday 28
Artists' Advisory Committee...Went to...[the] Ministry of Information to get my drawing of Daniel Adamson's censored, then to Bourlet's and so home.

MARCH

Thursday 1
W.M.[Michael] Rothenstein in Oxford, to give a talk to the Slade Society. Took him to tea at the Union, and he dined with Albert at New College. A.R. wanted Chittock, as President of the Slade Society, to dine too, but he is only allowed one guest in Hall. Met Eric Newton, also due to give a talk, at Balliol. W.M.R. spoke on *Landscape and Reassem-blage*...Enwonwu, the Nigerian, took part in the discussion, as did Evans, the talented commercial artist with a heavy stammer, and Griffiths...

Saturday 3
Long visit from Muirhead Bone...He consulted me about...the typography of Gavin's *Beowulf*, now being printed by Mowbray's for Blackwell. Bone's *Coventry* was drawn on one large sheet of paper, larger than any drawing board he could get, so that the paper had to be rolled up at the edge and constantly shifted and pinned in different places.

Sunday 4
...Dinner (evening dress) at Worcester, as Cumberlege's guest. He wants me to do a drawing, and to write a book on British Painting. The Dean wants me to draw his rooms.

Monday 5
...Ernest Jackson has been knocked down by a motor-car in the Plain. He is in the Radcliffe [Hospital]...

Tuesday 6
To London with Albert for Will R.'s memorial service at St. Martin in the Fields. It was pretty well attended and Max Beerbohm gave an address...Sat in a pew with Gwynne-Jones and Oliver Brown: in front, Dodd and Daphne Charlton: behind, William Grimmond. A lot of old friends...Dickey, Lionel Pearson, Barnett Freedman, Grace English...Alice R. and Albert's two boys, John R., William M.R., their wives – in fact the whole Rothenstein family, except Essil Rutherston, who seems to be quarrelling with John. Spoke with most...I have mentioned...

Wednesday 7
Dodd told me yesterday that his studio windows had been blown out for the sixth time last Friday, when a bomb fell at the end of his road, killing some people.

Thursday 8
...Met Paul and Bunty Nash, he with his customary asthma box on his chest. Like me, they have sold their London house...

Saturday 10
6 o'clock at Worcester, where I went with Cumberlege to the Buttery to draw Drake, one of the head College servants. He sat very well. Drew till 7.00, the head only. Cumberlege says that Leonard Squirrell's *Oxford Almanack* drawing of the view from Wytham was done entirely from notes on a postcard done in about a quarter of an hour on a wet afternoon: the completed thing was done in the studio and delivered some two months later. Reminds one of Turner getting material in a thunderstorm at Farnley, for *Hannibal Crossing the Alps* [1812]. Nuttall-Smith bicycled up to the Radcliffe this morning to inquire after Ernest Jackson. He does not know anyone. A clot of blood has been removed from his brain: now the bleeding cannot be stopped.

Sunday 11
Greenham left a note to say that Jackson died last night...Went on with Drake's portrait. He has been 64 years in service at Worcester, first in S.C.R., then in the Buttery.

Monday 12
Had a drink with Polunin before lunch. His wife is busy painting portraits...Jackson was an old neighbour of his in London, and he liked him very much. Charlton, too, knew him, and had six lessons in lithography from him – very good lessons, apparently. 7.45 – 8.45 finished my drawing of Drake...He wished his head had not been so much on one side, but otherwise seemed satisfied, and is pleased at being commemorated in College. He showed me some 17th- and 18th-century silver...and explained the phrase 'wet your whistle' as derived from wet and whistle, pointing out the whistles in the handles of the tankards.

Tuesday 13
...London. Took some drawings by Chittock to Gregory at the Nat. Gall., to be shown to the Committee tomorrow...Lunch at Club, with Corfiato and William Newton, the latter back from Khartoum and Uganda, where he is building universities. To Leicester Gall. to see work by T. Carr, Gowing and Buhler, good tonal painters...

Wednesday 14
Provost Pye in Oxford...Discussed the allocation of rooms at the Slade in London...

Thursday 15
Borenius came to Oxford to conduct his History of Art Examination...

Friday 16
Freedman at the School...still in uniform as Captain R.M., came to tea with Birdie. He talked shrewdly and kindly, but frankly, about Albert and Margery: describes Albert (whom he likes) in his home-life as a 'fuss-pot': has some hope that Margery may recover her balance in time. A.R. is thinking now of bringing her...to the Radcliffe...

Saturday 17
Ivy wired that Julian is killed in Burma...She thinks it was instantaneous. He was always confident that he would come back...

Monday 19
London, for R.W.S. election. Holden and Grace Wheatley got in. Alban Atkins had no vote except one from me. Holden has been up about ten times. Russell Flint, I believe, had six attempts before he was elected...

Wednesday 21
Called, at her request, on Mrs. Ernest Jackson whom I did not previously know...Glasson (used to teach at the Byam Shaw School) and others have formed themselves into a little committee to deal with the drawings, paintings...Jackson has left behind. The things are scattered...and must be collected together to be valued for probate; also, perhaps for a posthumous show...Jackson was a friend of Ricketts & Shannon. She has two houses in Chiswick to let or sell, and a car of his which is valued at £350...I did something on the War Artists' Committee to recommend Jackson for portrait drawing commissions. He was hard up when he first came to Oxford, but was full up with work recently. He tried to live in London, but the bombs were too much for him – he could not concentrate – so he came to Oxford again. The Byam Shaw School[7] is finished. It was the most successful of its type.

Friday 23
Albert R. was entertaining at lunch Brig. Gen. Hackett, an old New College man, and Ruskin student. He led the paratroops at Arnhem, and has been treated for wounds in Oxford: an unassuming man, with no 'side' whatever: one of Montgomery's trusted staff...Peter Greenham has now arranged his affairs so that he will in future teach only part-time at Magdalen College School.

7 Founded 1910 as a school of drawing and painting by John Byam Shaw and Rex Vicat Cole.

Saturday 24
Albert R. brought in Brig. Gen. Hackett after supper. He has been having electric treatment at the Radcliffe. He was wounded and taken prisoner in the Near East, but escaped...from a German hospital where he was well treated.

Sunday 25
At The Randolph with Albert, met Hector Whistler, ex-Slade student, and Diana Yeldham-Taylor, now married to young Veale, who was also there: and saw Hugh Mellor, the C.O., who has been left £3000 by his father, on condition that he gets the Slade Diploma, which he will never do. Whistler came round...in the afternoon, while I was having a nap, and asked me to have drinks with him at a small party in Dorchester (where he lives) between 6-7; but I went to Egan Mew instead, who discoursed on Mrs. Langtry and Louise Jopling.[8]

Wednesday 28
A.A.C....Was glad to hear...Chittock has made a successful start on his Admiralty portrait[s]...

Thursday 29
Slade term ended.

APRIL

Wednesday 4
...Met Adrian Kent, who was staying at The Randolph. He teaches at Christ's Hospital at Horsham, with Towner teaching under him...for the duration of the War. Kent is rather envious of him now, because Towner takes more time off for painting than he himself does, and is doing some good landscapes at Amberley. Began my drawing of the Dean's room in Worcester. Coll. Wilkinson is the Dean...

Friday 6
...After tea, Hubert Wellington and his new wife, née Irene Bass, called. We celebrated...by going to The Randolph...and drinking two gins apiece...

Sunday 8
Continued my drawing, 4½ hours. Had to come away at 3.30 to see Major [Kenneth] Armitage[9] ex-student of the Slade sculpture school in London...I could not make out who he was for some time, but concealed my forgetfulness...

Tuesday 10
...To London, for New English Executive, having been co-opted, although not elected at the General Meeting...

Thursday 12
Worked at Worcester Coll., putting in the figure of Hollis, the Dean's servant. He was at Omdurman, with the Grenadier Guards, and has been over forty years at Worcester...

8 Respectively actress (1853-1929) and painter (1843-1933).
9 From 1946-56 Head of Sculpture, Bath Academy of Art, Corsham.

Friday 13
Worcester again, finishing the drawing in chalk, but leaving the wash stage to be done...

Tuesday 17
...finished the tone stage of Wilkinson's drawing. Nuttall-Smith says the figure is out of tone. Albert R. says it isn't, and I think with Albert...

Thursday 19
Meldrum came to Oxford to see me about the position of the Sculpture School at the Slade...

Friday 20
To Bexhill, via London. Found Bill evidently better than when I last saw him in Hertford, but still having to take the greatest care of himself. He has a lodging in Egerton Road, near the sea, and can walk slowly up and down the ugly promenade. He seems to be well looked after for his £3-3-0 a week...After supper, discussed Bill's new book...He showed me a number of letters from his army chiefs and companions testifying warmly to the value of his work with the forces. He has been advised to appeal against a decision to give him no pension, his disability being directly the result of his service.

Saturday 21
Looked at the bomb damage to the hotel on the front and at the De La Warr pavilion, much talked about in its time as an example of modern architecture. It seems commonplace now. There is nothing else to look at except the sea, and perhaps the old village and church have something to show. Did a little work on diagrams of shooting for Bill's book. He cannot pose for the more difficult positions...

Sunday 22
Returned to Oxford.

Monday 23
...In the afternoon, a long-promised educational visit for the benefit of Enwonwu [plate 28]...to Dorchester, as a typical English village, with features of past ages. Nuttall-Smith came...and we talked a lot about Norman and Gothic carving, the Picturesque...Looked at the Georgian bridge, the George Hotel, the landscape, thatch, tiles, half-timber and brickwork. St. George's flag flying on the Abbey. To-day is the first day of the complete lifting of the black-out (except for a stretch of the coast) in England...

Wednesday 25
To London...Fetched my drawing of Drake from Lewis and left two others to be mounted, and called on Lady Gaselee about doing a posthumous drawing of her husband from photographs for Magdalen College, Cambridge. She lives in Gilston Road, S. Kensington...

Thursday 26
...Started on a diagram of a bayonet for Bill's new book...

Friday 27
...Greenham's life class...He went to the memorial service for Jackson on Tuesday, at St. James's Piccadilly (a portion of the church is used in spite of the roofless condition of the nave). The Bishop of Chichester spoke well, Greenham says, and quoted many of Jackson's sayings.

Saturday 28
Interviews at Slade. Started on one of Bill's diagrams of daggers...

Monday 30
Slade began...7.45 Model in Beaumont St., at Miss Scott's. Charlton came. When I got home there was news that Mew had died, within about a quarter of an hour of Birdie's leaving him. Miss Bradford, the owner of the house in Apsley Road, was with him. He reached out for an orange, had an apparently painful seizure...and collapsed in three or four minutes. It was angina. The nurse and doctor came promptly, but it was all over. Mew was 83...He was a very good friend. We had never a moment's disagreement with him. He was an excellent talker and an excellent listener, and never lost these social qualities, or the clearness of his intelligence...

MAY

Wednesday 2
London, Artists' Committee...Afterwards, Bodkin, who is writing a book on art; very antagonistic to the moderns...Went to see the Hugh Walpole collection...at the Leicester Galleries. There were many good things. Met Henry Lamb there...We have not met for years. He never fulfilled my great expectations of him as a young man in Paris and Fitzroy Street, though he has done good work. When he was young he seemed so brilliant and exceptional: now more ordinary.

Friday 4
...The War news is wonderfully satisfactory, as far as the approaching end of hostilities with Germany is concerned. The deaths of Mussolini and Hitler within a few days of each other make this time memorable.

Saturday 5
...A young N. Zealander corporal, a prisoner of war just returned from the horrors of a march across Germany, and from the beatings of a prison camp ('you can't down a Britisher', he said) applied for admission to the Slade. He was a commercial artist. Nuttall-Smith and I thought him a fine fellow. He had a curious pallor, the result...of his privations.

Monday 7
Anticipation of VE day. Everything is going to close – the Museum, the School, the Restaurants – all workers will have a day or two off...About 8.15p.m. Victory Days were announced for tomorrow and Wednesday. I was then with Charlton, Greenham, Hector Whistler, June Miles, Dunstan and Bryan Wynter, engaged in drawing. Miss Butler the model. The announcement was reported to us by someone in the house. Flags appeared in the streets. I heard little 'joy and uproar'.

Tuesday 8
...I waited ¾ of an hour in a bread queue in Friars Entry. The bakers did not shut...Joined Albert R., Jack Townend, Griselda Allan and Barbara Lloyd-Jones in The Randolph. Albert had shared in a bottle of champagne at K.T. Parker's house. The hotel was full, but there was no disorder either there or in the streets. Winston Churchill and a short service of thanksgiving on the wireless in the afternoon...There was rather more noise in the streets at night, and I am told of bonfires (one in front of Queen's in the High, one in Christ Church Meadow) flood-lighting, and dancing in the streets, but nothing resembling a riot.

Wednesday 9
Victory Day no. 2. Spent it quietly. In The Randolph, Albert, Barbara Ll-J., young Toynbee and Athene Seyler. 10.15p.m. Birdie and I went out to look at the crowds. St. John's was flood-lit. There were dense, well-behaved crowds at Carfax, some groups carrying an effigy; others, one of their own number. A bonfire on top of the air-raid shelter in the Broad. By the Martyrs' Memorial, the base of which was piled with tiers of people, some St. John's men were burning the A.R.P. ladders from the College, together with the props which had supported the arcade in Canterbury Quad against possible blast all through the War. A good blaze: the faces of the people lighted up by it, the sky black, the cold flood-lighting on St. John's contrasting with the warm firelight. Trees silhouetted like stage scenery, lights – unaccustomed – in the windows of Balliol – a fine scene. Not much singing – everything good-tempered and well under control. I imagine there was no drink left in Oxford, which may partially account for the sobriety. I am told that Lincoln, Magdalen and other places were flood-lit.

Thursday 10
Work began again. Birdie...went to the New Theatre to see Athene Seyler in *The Last of Mrs. Cheyney.*

Friday 11
Daryl Lindsay came to Oxford...He is about to buy a large early standing figure of Dorelia by John for Melbourne, and asked if I approved (he showed photographs of it); which I did. He bought a small water-colour of mine, of *Fetcham Church*, for the Gallery...

Saturday 12
Clarence Whaite, from the London Inst. of Education, called to discuss the teaching training of our Diploma students who take the Art Teachers' Diploma. Nuttall-Smith had a good deal to say on this. Miss Josephine Davis, a good ex-Slade girl who went on to study at the Institute, came in by chance in the middle of our conversation. She is a good advertisement for the system, intelligent, lively and apparently well content. Mrs. Lipson Ward, Eric's old friend from China days, telephoned from Bexhill to say that he had died suddenly to-day – in his sleep.

Sunday 13
7:35 train to Bexhill, via London. Arrived 1:30. Saw Mrs. Lipson Ward, who will kindly undertake all the necessary arrangements and clear up Eric's affairs. Went to his room... Saw Mrs. King, who runs the house, and Florence the maid; both spoke very highly of 'Bill', or 'The Major' as they call him. His batman had been, who admired and liked him

– they all do. Mrs. King uncovered his face: it was peaceful, but I broke down at that. Everyone was kind and made tea for me in each house. I got away at 4 and back to Oxford about 9.30.

Monday 14
London for Ministry of Ed. Exams…Dickey, Travis, Woolway, and Cooper from the Wimbledon School of Art, who, as Woolway now fills Luard's place as Examiner, takes the place of Teacher-Assessor. 700 candidates. We drank to the memory of Luard at lunch. They say he died of cancer – a sudden and violent kind. There is a good deal about death in these notes lately. Father Conrad, who did not know Bill, wrote me a charming note of sympathy.

Wednesday 16
Ministry's Exams again. Travelled up with Muirhead Bone, who was going to an Artists' Advisory Committee which I could not attend. He talked a good deal of his new drawing of the King at St. Paul's…the drawing…may take him three months, working some seven hours a day when on the job. He has a special private shelter that has been erected for him near the present high altar (the choir and one transept are boarded up), and he can see without being seen, though he cannot use very large sheets of paper, since he is rather cramped for space.

Thursday 17
Ministry Examinations still. Bill was cremated at Charing. Birdie wanted very much to go, but was dissuaded from trying to…there was a representative of Bill's army unit (more than one. Six sergeants…were sent, and an officer attended). I did not see that I could give up my job for the day – it would not be fair to the others…though, no doubt, they could do without me; it would mean harder work for them.

Monday 21
Slade. Parker has been chosen as the new head of the Ashmolean. Congratulated him. He is not overjoyed at the prospect of increased administrative duties…

Wednesday 23
Artists' Advisory Committee. Travelled to London with Muirhead Bone. Arriving early at the Nat. Gallery, looked at his big Coventry drawing which is exhibited there (an extraordinary feat…) and at the…old masters which are now back on the walls…still without glass…Athenaeum…Meeting of the Art Committee…Walter Lamb in the Chair…My last appearance, as I retire by rotation…Went to Wilkinson Small Arms Co., to see if I could trace 2 sporting guns stored…in London by Eric. The[y]…were very helpful in giving me names and addresses of gun-makers. They spoke very highly of Eric…Met Cora Gordon in Bond Street. She and her late husband were friends of mine in Paris about 1908, and before that I knew her at the Slade…

Thursday 24
Dined at Hertford, at Major Gresswell's invitation. Dinner jackets are worn…I owe my introduction to Gresswell to K.T. Parker. Its motive was Gresswell's desire to give the College a portrait drawing of the chief Butler, 'Henry', and that the butler and I should

have a preliminary meeting. He has nearly completed 50 years' service, is 70 years of age...

Saturday 26
Drew 'Henry' [Spencer] Bligh at Hertford, in S.C.R., where we were quite undisturbed. He volunteered to stand and did so manfully. His figure is characteristic, and I thought it an advantage to draw him full length...

JUNE

Saturday 2
Wilkinson came to the School to see the drawing of his room in Worcester: he was pleased and gave me a cheque for £20, the agreed price...Crowds of men and women, including soldiers, English and American, drinking beer as usual in the yard of the Lamb & Flag...

Monday 11
Examinations at Reading. Betts showed me a lot of his drawings – some very good. He exhibits very little, and is hardly known as an artist. Met Ormrod, and McCance (Agnes Miller Parker's husband) whom I had not seen since the days when we both used to teach at Westminster – he taking McKnight Kauffer's place. Now he has grown a well-trimmed beard, in the Thomas Bodkin or Hubert Wellington style, and makes a handsome elderly man. McCance is a man full of theories; interested, for instance, in Sava Popovitch's exposition of the Golden Section. Gibbings is said to have made as much as £8000 out of one of his recent books – a best seller. He does not start on a commission without 300 guineas down, being a shrewd business man. His *Othello* was a failure. He leaves shortly for the South Seas, on behalf of the New Zealand government.

Monday 18
To Edinburgh...Assessed the work before lunch. A rather remarkable Scholarship student, landscape painter, named [Jeffery] Camp[10] very prolific and very straightforward. He ought to be heard of in future. After lunch, dropped into the R.S.A...I have sold two of the half-dozen or so drawings that were invited – one of *Abbey Street, Cerne*, and one of *Black Hall, Oxford*. Back to Glasgow. Howarth and his wife came in in the evening and talked about Mackintosh...

Tuesday 19
Assessing at the Glasgow School. Cranford and Walton took me round. A touch of megalomania about some of the work. Talked to the Diploma students. Lunch. Speeches. Chairman, Sir John Richmond, proposed my health. I got through a reply. Walton spoke, and Cranford, and Hutchison. Talked to Alison, who has bought a drawing of mine from a C.E.M.A. London Group show...

Wednesday 20
Assessing at Dundee. Donald, Cooper, Purvis, Gray...Saw the decorations done on a stair-case of the City Hall by two of the present students. There is some good modern glass in the building, also done by students of the College of Art: this glass makes a series of Burne-Jones (called, I notice, Burns-Jones by my Scottish friends) windows elsewhere in the

10 Camp (b.1923) taught Chelsea School of Art (1960-61); Slade (1963-88), elected R.A. 1984.

building look very old-fashioned, gloomy and pseudo-pictorial. 3:40 train to Aberdeen...

Thursday 21
Assessing...till lunch: D.M. Sutherland, Sivell (who did most of the work and the talking)...saw me to the train (5:25). He has bought a drawing of mine from the R.S.A. for the gallery...

Sunday 24
Train to Cardiff, on scholarship adjudication business...

Monday 25
...I had not been to Cardiff before. The civic centre is in many ways admirable, if not always so in detail.

Tuesday 26
London for Min. of Ed. Exams. Revision of Drawing group. Lunch at the Athenaeum... Lunched with Sir C. Peers: coffee in the drawing room with Gere, who is remarkably young for 76. Rostrevor Hamilton told me he had bought in a shop my old painting of *The Grave-Diggers* that used to be in Sir M. Sadler's collection: he remembered it being reproduced in the defunct art magazine, *Colour.*

Wednesday 27
Ministry of Education Exams again. Finished the job. Some effort was made to raise the standard by having a higher pass mark. Passed about 75%.

Friday 29
Diploma Exam at Slade. Wellington the external examiner, Borenius absent, ill: Albert took his place. Failed one girl. Again one's conscience was wracked about the standard – there was some weak painting and design, and cases like that of the eccentric but talented Leo Davy. The drawing mostly sound – the students naturally give a lot of time to it. Even Ormrod was tired at the end of the day. There were 22 candidates. Slept for half an hour, as usual, between 5.30-6...

JULY

Tuesday 3
Sorting out Slade painting for prizes and certificates, with G.J. The head paintings are considered...to be of a standard fully equal to those of the years just before the War. The life studies are less satisfactory: conditions have been difficult. The light, with the east sun pouring in in the summer, and the crowding of the rooms, are unfavourable.

Wednesday 4
A tiring day, judging Slade Prizes... At 3p.m. set off in a taxi with Albert, John Evans and Barbara Lloyd-Jones to Port Meadow, and proceeded by boat to The Trout for the Slade picnic...

Thursday 5
Slade judging again. Voted for Quintin Hogg [Conservative] in the General Election –
because I want to see Winston Churchill continued in office...

Friday 6
Albert's Slade-Ruskin tea-party in New College. Miss Tracey made an excellent speech
of thanks from the Slade students to the Ruskin staff – A.R. and Griselda Allan were given
book-tokens and pieces of pewter (for G.A.) as souvenirs. Albert spoke in reply...There
is no question that the association of the two Schools has been a happy and harmonious
one; and we do owe a great deal to Albert, and Miss Allan has done her job well...

Saturday 7
Last day of the Slade in Oxford. For the students the episode is closed. Albert and I
received parting tokens of cigarettes from Maria Shirley and her mother. Griselda Allan
and I exchanged drawings; and I had another from B. Lloyd-Jones. Several other students
came in to say farewell to Albert, to whom we all owe so much.

Thursday 12
Started a drawing of New College barn. Dinner with the Douies...Douie says that Gregory
Foster, though many people speak ill of him, had the students at U.C.L. much more
under control than Allen Mawer had. Mawer was rather frightened of them. Foster was
on top of his job all the time.

Wednesday 18
Artists' Advisory Committee...Lunch at the Club, where my little drawing of Gleadowe
is hung up. Coffee with Codrington, who has been lecturing to the College of Art
students at Ambleside. Daryl Lindsay...called...He discussed future plans for the
Melbourne Gallery. He would like me to be a sort of official representative of the Gallery,
holding a watching brief for likely pictures on the market...The Wallace Collection re-
opens this afternoon.

Sunday 22
At New Coll., J.B.S. Haldane,[11] a very pleasant American Naval Commander, Lord David
Cecil, N. Polunin, the Bursar...The Warden told an extraordinary story of his experiences
as a Clerk in the Scottish Office before and during the last War – of official system and
convention without the smallest degree of efficiency: papers marked 'urgent' or 'To-
day' filing up in the Secretary's room for weeks; and shameless procrastination as bad as
anything Dickens described in the 'Circumlocution Office'.

Monday 23
About 4½hrs. at New College. I now have enough material to go on with the drawing
at home...

Thursday 26
B. and I went to tea with the Muirhead Bones at Hinksey. We had not met Lady Bone
before, nor seen her house, which is a pleasant one designed by Lionel Pearson, with over

11 Biochemist and geneticist.

three acres of ground and fine views over Oxford…rather a white elephant in these days, with no car, almost no service, and so far from the shops and station…Both…were extremely kind – he even insisted on paying for our taxis – and we spent about two hours there, looking at numerous works by Mary and Gavin and Stephen…Bone's new drawing of the *Brighton Viaduct* (a tremendous undertaking)…Father Conrad Pepler came to see us at 8.30…We admire him and enjoy his society. A distinguished man, but simple and unpretentious. We talked of Edward Johnston, the Macnamaras and other dwellers in Hammersmith Terrace in the old days: of David Jones, and the Eric Gill settlement.

Saturday 28
The Bursar came to the Ruskin School to see his drawing of the Barn. He was pleased.

Monday 30
After a morning on Slade letters (helped by Mrs. Denver) began on a posthumous portrait (squaring up from a photograph) of Sir Stephen Gaselee.

Tuesday 31
Tea with the young Toynbee at 9 Canterbury Road, where they have a single furnished room. He is painting a fair-sized Crucifixion in it…

AUGUST

Wednesday 1
Artists' Advisory Committee. Gave Willie Clause lunch at the Athenaeum. He had something he wanted to discuss, about the N.E.A.C. on its representation on a Committee for a St. Luke's Day Service…

Thursday 2
Dealt with 27 letters at the Slade…Paid £20 by Jesus Coll. Camb. for portrait of Mills. An encomiastic letter with the cheque.

Tuesday 7
Tea with the Hume-Rotherys – a gesture of farewell. She wrote me, speaking of my 'beautiful' drawing of her daughter, done in 1940, before they left for Canada…On the other hand, I find that she cannot bear the drawing I did of her, and won't have it on the wall, though she says her husband did, all the time she was away…

Wednesday 8
Was it today? Atomic bomb on Japan? Russia declares war in the East.

Thursday 9
B. and I left Oxford 12.35, arrived at Sheffield 4.40. Professor Barnes and Bysshe met us. We had tea at Westbourne House, and were driven to Curbar afterwards. Alice and Janet awaited us in the cottage they have taken for the summer…

Friday 10
News of Japan accepting the Potsdam peace terms…

Saturday 11
…Went via Tideswell, (Tidzer in the local dialect) and Miller's Dale to Buxton, haunt of my childhood and home of grandparents and aunts and uncles…

Wednesday 15
Victory Day…

Thursday 23
Left Curbar…The Slade furniture was removed by Scott's on VJ day…

Saturday 25
…Met young Dale, Lawrence Dale's son, back from service with the Army in the Far East…

Monday 27
Finished posthumous portrait of Gaselee. Bone is now making a beginning of his next drawing for the *Almanack* of the Fair in St. Giles, which is to take place in September, after being discontinued during the War. He sits on the steps of the Martyrs' Memorial, making…notes of the scene as it is without the Fair…

Wednesday 29
Artists' Advisory Committee…Took Russell to the Athenaeum…At our meeting, he was asked to do a portrait for the War Records, but declined, on the grounds that he has lost his nerve for portrait-painting. He told me afterwards that he has never liked doing commissioned portraits – a model, yes…Visited Nuttall-Smith at the Slade. He has a bed there and is gradually getting straight…

SEPTEMBER

Saturday 1
Nuttall-Smith in Oxford. Went through a number of letters with him. There is a great shortage of cigarettes now…Started a drawing in New College Lane…

Monday 3
St. Giles' Fair. A very pleasant sight – all the stalls, roundabouts, shows and crowds of people…in such fine surroundings. Birdie and I visited 'The twin Race Horses' – miserable little creatures – 'The largest St. Bernard on earth' – a fine dog – and the mummy, if it was a mummy and not a fake, of a fakir – 'The shrivelled man, 150 years old'…

Wednesday 5
Scott's, the carriers, removed most of our things, books pictures, the gramophone, a little china…to store in London. We are both sorry our stay in Oxford has come so nearly to an end…

Sunday 9
Left Oxford, to our great regret, and arrived at Drayton Court about 4 o'c….Charles and Ivy at home…Ivy has a daily maid, who comes at 8a.m. and leaves about 3. Her services

cost 45/- a week. Peasenhall has been sold for £5000 – a considerable profit...

Tuesday 11
At the Slade, with Nuttall-Smith, Connell and Trollope. A great deal to be done, and a very small number of workers. Tidied up my room so that it is possible to work in it...

Wednesday 12
Artists' Advisory Committee at National Gallery...Went on to the Slade. Peter Brooker came in and was very helpful. I was glad to see him after his long absence in the Army, in Africa and India...

Thursday 13
Dodd, at the Club, told me he had been asked to do a portrait of Winston Churchill, but on thinking it over – the difficulty of getting such a sitter to give his time, the probability of having to use photographs, the certainty of adverse criticism and unfavourable public-ity, and all the resultant worry and dissatisfaction – he determined to give it up, and suggested James Gunn instead.

Monday 17
At the Slade. Brooker and Meldrum were helping to straighten out the chaos. Nuttall-Smith and I interviewed a number of callers...Birdie has been trying without success to buy a hat, being invited to a reading of Tennyson by Charles at the Dorchester on Wednesday. A hat seems to cost from £7 to £11...

Tuesday 18
Slade business. Lunch at Club with Iolo Williams. Discussed such different artists as W. Greaves, the Douanier Rousseau, E.M. Ward and Collins of Dartington. Began a piece of hack-work for Batsford – drawing of a monument from a photograph. I would prefer to get someone else to do it, but cannot think of the right person...

Friday 21
...R.A. – started the hanging of the 'War Artists' pictures, with Russell, Jowett, Kenneth Clark, Dickey and Gregory...

Saturday 22
Went with Birdie by train to Christ's Hospital to discuss with Towner the possibility of living in no. 8 Church Row. Lunch in the Hall, before the boys came in, and then, from outside, watched them troop in by squads to the music of their own band: very well managed ceremonial. Not all the boys were wearing the habit. The stuff is not easily procurable now; but I suppose conditions will improve. Towner has a fine studio...with his own furniture. He has painted some good pictures, some of them richer in colour than they used to be...

Sunday 23
...Great state of uncertainty about future housing problem – whether to fall in with Towner's plan or to join with the Tennysons, as they seem to wish. At lunch, Connard, Jan Juta (whom we have not seen for perhaps 20 years, since we were all in Chelsea)...

Monday 24
A busy morning at the Slade…getting something in order for next week…

Friday 28
Slade. Took a drawing of *Charing* to Fennemore at the National Gallery, at Charles'
suggestion, to supplement the others of Kent and Sussex that I took there yesterday. The
Brewers' Committee [The Londoners' England] might be interested…went to N.E.A.C.
Executive meeting at R.B.A., 11 o'c…

Sunday 30
Finished a set of four line drawings from photographs, for one of Batsford's books on
sculpture. Very exacting work, but not disagreeable, as it has interest for me…

OCTOBER

Monday 1
Slade began. The staff did a good job of work – Charlton, Brooker, Wilkie, Gerrard,
Meldrum and Polunin: also, of course, Nuttall-Smith…

Tuesday 2
A good deal of confusion at the Slade. About fifty girls met me on the stairs, unable to
find places to paint or draw…Brought the Provost over to see the state of affairs. Franklin
White turned up, with a beard. Lunch with the Weavers' Company, 1 o'c. at the Savoy.
The Upper Bailiff, Lord Gorell (himself an Hon. R.W.S.) presented my drawing of New
Coll. Barn to the Warden of the College, Smith, on the occasion of the return of the
Weavers' records and muniments to London after safe custody in Oxford during the War.

Friday 5
Lunched at Athenaeum, because I wanted to cash a cheque (members can cash cheques
up to not more than £10 on any one day). I enjoyed the comparative good service and
comfort after the scramble and waiting about at the Staff Refectory at U.C.L. where I
have been having lunch during the rest of the week…Margaret Alexander taught her
crowded class at the Slade for the first time in 6 years.

Saturday 6
Slade morning. Nuttall-Smith in Oxford. I hope with some opportunity for carving that
he longs do…

Sunday 7
Hallam sat for about an hour and a half, for a portrait drawing in the 'battle-dress' of
the Friends' Ambulance Unit…Went with Charles & Ivy to a film produced by Michael
Balcon, at a cinema in the Haymarket. Hallam and Margot were there too – five reserved
seats at 9/6d each, for which the Tennysons paid. Production and acting were good…

Monday 8
Slade from 10 onwards…

Tuesday 9
New English jury in Suffolk Street…There were about 1500 pictures, including the members'…Ethel Walker is back in her old rooms at 127 Cheyne Walk. She looks old and tired and limps a little. She is really little use on the jury, but gets elected out of respect for her distinction as an artist…

Wednesday 10
Hanging N.E.A.C.: Clause, Connard, Cheston, Devas, White, Ethel Walker…The memorial group of five paintings by Will Rothenstein make a dignified impression at the N.E.A.C. Fairlie Harmar's look well also.

Note added: See additional note at end of Diary.
Philip Connard has a grudge, amounting to positive hatred, against Collins Baker, who is now in England again. Connard says that, if he meets him, he will tell him what he thinks. He has apparently written about his feelings already. It is all on account C-B's responsibility for getting Kennedy North to furbish up the Mantegna cartoons at Hampton Court, for which Connard has an intense admiration. He considers them ruined, particularly as regards the colour, which had a light, matt distemper quality and is now dark. Connard used to make special journeys from Chelsea to Hampton Court to look at these works, and knows them intimately. He dislikes Gerald Kelly too, and is fearful that Kelly is about to allow destruction to be wrought on the Dulwich pictures in the same manner. Connard admires the Dulwich paintings greatly too, and being very outspoken and quarrelsome, is making violent protests now in the R.A. about the threat-ened cleaning and restoration. Connard was very poor at one time in his youth…[and] used to sell drawings to John Lane for £1 a piece.…

Thursday 11
New English hanging again…Met Sivell and his wife, who had come up from Aberdeen for the Private View of the War Artists at the R.A. I am afraid he will be disappointed with the hanging of the one and only picture of his which is shown.

Saturday 13
Went to the Slade. Busy. Batsford and Fry came about the wrapper for Mrs. Esdaile's book on *English Church Monuments*…

Sunday 14
Lady Gaselee called to see the posthumous portrait of her husband, and made various suggestions…as to how the likeness may be improved…She is an old friend of Charles and Ivy. Charles was at Eton with her husband.

Tuesday 16
5.30…Reception at Drayton Court in celebration of the wedding of Hallam and Margot, which took place at a Registry Office – Birdie and Yve went…

Thursday 18
Slade. Ormrod, self-reliant, as usual, coping with difficulties of his crowded class…2.15 at St. Paul's Cathedral for the St. Luke's Festival service. Sat next to Reid Dick. Could hear

only about half of Archbishop Lang's address…Met Rushbury, and, with him, looked at the Kitchener Memorial, which is not, we thought, wholly satisfactory, though Reid Dick has done a highly skillful piece of work. We agreed that it is absurd to take the Cathedral for granted and not to be impressed by it. It is one of the finest buildings in the world…

Tuesday 23
Lunch at the Savoy on the occasion of the opening of The Londoners' England exhibition. Expenses were paid by four London firms of brewers, Courage, Whitbread, Barclay [Perkins] and another [Watney]. Mr. Courage in the chair. Herbert Morrison made a rather long speech (he had the nerve to refer to Waterloo Bridge, after talking of his love for London's beauty-spots) and Charles Tennyson made a shorter one, very well delivered. I sat between Oppé and Barnes of the Academy of Dramatic Art. Met Rushbury, Clause, Tomlinson of the L.C.C. Central School, John Rothenstein and others, including Allan Walton, who praised Bysshe's work at the Glasgow School, and told me in strict confidence that B. had even been considered for the post of Director there.

Wednesday 24
Artists' Advisory Committee…After it, K. Clark took me to see the new room-full of pictures which he has just hung. I ventured to say that I had always thought the Veronese *St. Helena* [c.1570] was not by Veronese – I was about to add that I had guessed it to be by Tintoretto – when he said I was quite right: it wasn't Veronese, it was Zeloti (of whom I was quite ignorant)…

Wednesday 31
Darsie Japp called on me at the Slade…He is thinking of leaving England again and going to France or Spain.

NOVEMBER

Friday 2
…meeting at the R.A. to award British Institution Scholarships. Albert R., Corfiato, Reid Dick, Norman Wilkinson and others were on the Committee, under the Chairmanship of Munnings, who was as grossly rude as last year, and shows himself as bad a judge of the work…

Saturday 3
Slade – and necessary too, with letters and callers to see to…3.00 Birdie and I went to the V.&A. Museum to see the Royal effigies and other sculpture from Westminster Abbey. These beautiful things are now to be seen as they have never been seen before…We both enjoyed the exhibition. There was also a show of the late Edward Johnston's calligraphy, and in it was Will R.'s drawing of Johnston, exactly like…I liked Johnston, with his odd ways, his humour and his great voice, of unusual carrying power. He was a valuable influence and an excellent performer. His textbook is one of the best I know…

Monday 5
Met Alan Sorrell, who *apropos de bottes*, was most complimentary about my drawings.
I had no idea he would like them so much...

Wednesday 7
Artists' Committee. Further meetings with Towner...we have decided to abandon the
Church Row plan and stick to the Tennysons...

Thursday 8
Charles Tennyson's birthday – age 66...I gave Charles a drawing of the garden at Peasen-
hall, done out of the window at Christmas when snow was on the ground.

Sunday 11
...Lunch and tea with the Kohns...He has a copy of the horrible, clever anti-Jewish
brochure published in Nuremberg for children by Julius Streicher before the War. One
of Bruno's German-Jewish nieces hanged herself not long ago: the effect of war condi-
tions, no doubt. Finished the monochrome stage of Batsford's book jacket.

Monday 12
Lunched at the Trocadero with Miss Burke, who is employed by J. Lyons & Co., and met
the author [H.E. Bates] of a pamphlet about Lyons's bomb-factory at Elstow,[12] which I
have been asked to illustrate. They asked Muirhead Bone in the first instance, but he
passed the work on to me...

Tuesday 13
...to the Slade to meet Miss Burke of Lyons, and went with her to Russell Square to select
from official photographs some which show activities at Elstow – filling 4,000lb. bombs.

Wednesday 14
...Council meeting of R.W.S. The excellent Flint in the chair...Tea at the Club. A fire in
the Drawing Room – the first I have seen there this winter.

Friday 16
...Executive meeting of the New English...D.S.M. was co-opted, and had many proposals
to offer, as well as information about the borrowing of Steer's pictures from Daniel and
others for a N.E.A.C. show at the R.A. next year, and about Steer's father's paintings in
the possession of the Steer family in St. John's Wood. MacColl says Philip Steer the first
was a good artist. No one at the meeting knew of his work. I was in the chair at this
meeting...Signed all the cheques for sales in the recent show – over £1000...Connard
sold over £100 worth of water-colours.

Saturday 17
Delightful day with Harry Batsford and his Mr. Wells. Car left North Audley Street about
10.45. Inspected Harefield Church, still in its setting of fields and trees...Batsford is very
good on these occasions, having great knowledge. Went on to Little Marlow Church.
Lunch...at Marlow – the Anglers' Retreat, overlooking the river and church. Did what I

12 *The Tinkers of Elstow: The Story of the Royal Ordnance Factory.*

came out to do – made colour notes of the Hoby tombs for Mrs. Esdaile's book jacket. Bisham is just as it used to be 30 years ago, when Alice was small, and we walked there from Marlow…

Friday 23
Took time off with Nuttall-Smith to see the show of portrait-painting arranged by Gwynne-Jones at Wildenstein's for Philip James. Some fine interesting things…including Steer, Tonks, Brown, John, Gwen John, Sickert, Coldstream, Lamb, Moynihan, Ethel Walker and Gilman: also some notable omissions of Academicians. Met Arnold Palmer, Eddie Marsh and Maresco Pearce. Went on to see Epstein's *Lucifer* at the Leicester Galleries. Nuttall-Smith finds the head, hands and wrists questionable, and the whole thing decidedly not in the Donatello class, though there is something to admire. All the… water-colours which cover the walls of two rooms were sold on the first day. Brown says there is no difficulty about finding someone to pay the £6000 that Epstein asks for the *Lucifer*, but they want to choose the right person…

Wednesday 28
Artists' Advisory Committee…News that Hennell is reported missing, probably killed, in Java, in an insurrection of the Indonese at Surabaya. He seized a Sten gun and fought them. The rest of his party retired into an hotel…A bothering time at the School. Raymond Mason and Leo Davy have been misconducting themselves, defacing the work of a student named Fletcher, and Davy, it seems, going so far as to burn one of Fletcher's paintings, for which, I think, he will have to be sacked. He does no work in the School anyhow. He did not turn up to-day. I sent Mason over to the Provost, who did not expel him; but he had to make a written apology to Fletcher.

Friday 30
General meeting of the R.W.S. Elected Vincent Lines and Fleetwood Walker full members. Dodd told me that he made £6000 a year when he was doing etchings…

DECEMBER

Sunday 2
Delivered the portrait…to Lady Gaselee. I asked her 20 gns. for it, which is 10 gns. less than I had meant to ask, but I relented at the last. Dejeuner à la fourchette (present, besides others, the Reid Dicks, the Fennemores, the Kohns and Mrs. Curle), preparatory to a Poetry Matinée at the Comedy Theatre, at which Charles takes the chair, and Dame Sybil Thorndike read from Shelley's *Cenci*, and about four of Browning's poems, including *A Toccata of Galuppi's*: also from the American poet Millais.

Monday 3
Had to interview Leo Davy at the Slade and ask him to discontinue his attendance. After he left me Fletcher set upon him in the corridor, hit him in the face – Davy offered no defence – and then, after Connell had intervened, shook hands and declared that honour was satisfied. Davy was concerned in a perfectly decent way when he talked to me that his friend Mason should not be blamed for any act of his.

Wednesday 5
Private View of a big show of Matisse and Picasso organized by the British Council at the V.&A. Museum. Opened by the French Ambassador…

Saturday 8
Batsford called at the Slade about the Hoby drawing. He wants it extended so that there is a 'turnover' to the jacket…Birdie and I had Ginger to dinner at Roche's, as in old times, and went to a much-changed Café Royal afterwards…Ginger, still Medical Officer at the Grove Hospital, has endured much bombing…

Sunday 9
Sherry party at Guy Brown's, 5 Willow Road. Met a niece of Darcy Braddyll, a young girl who has just written a book on Ballet in the U.S.S.R. during the War. Collins are publishing it and have given her £1000 in advance of royalties. A good fee, it seems… publishers can sell anything now. Met also Noel Carrington and his still beautiful wife, and the still handsome Daphne Charlton. After dinner, at Drayton Court, Charles and Hallam read poems aloud, both doing it excellently…

Wednesday 12
Alice's baby was born safely. It is to be called Diana Katherine.

Thursday 13
Slade Dance…Janet Rushbury did one of the big decorations in Room 1, and the man Fletcher did another. Among guests and visitors were Corfiato, Stanley, Nova Tennyson, the Marquise de Rouvigny, Barbara Janes (née Greg) and Daphne Charlton…

Monday 17
Lunch at the Athenaeum…Munnings and Bodkin were in conclave in the Drawing-room, damning Picasso and Matisse, and the V.&A. Museum for showing their work, as well as the dealers; and here I agree – for forcing up the prices of these artists to a preposterous height…

Thursday 20
National Gallery with Kenneth Clark, Dickey and Gregory – sub-committee to allocate War Record pictures to various collections. A tedious job, but the clerical staff had done their work well, making an efficient card-index…Alice wrote that Bysshe Barnes has been made Deputy Director of the Glasgow School of Art…

Tuesday 25
…Ida, the Kohn's lonely and dismal German cook, who came to help Ivy with the Christmas dinner…was invited into the sitting-room to play silly games with Hallam, Yve, Birdie and me, while Charles, Ivy, Bruno and Nelly played bridge after dinner in the drawing-room…

Wednesday 26
10.30a.m. Walking in the Fulham Road with Willow, Yve's dog, met Frank Dobson, who is staying in one of the Avenue Studios which belongs to a pupil of his. He is made uncomfortable by the pessimism of Picasso, and hates post-War conditions – starting

life again…He is teaching drawing one day a week at the Central School…Charles read the [Richard] Crashaw [1612-49] *Nativity* to us late in the evening.

Thursday 27
…Saw the exhibition of Paul Klee arranged by the Tate as well as the unfinished Turners, which are being shown. Met Eric Newton, who admires Turner greatly, and likes most of the Klees. I find it difficult to think of the latter as important works. They are, mostly, extremely tasteful and ingenious. 8.50 train to Glasgow. First-class sleepers for Birdie and me. Very comfortable. Arrived at Great Western Hotel, Botanic Crescent, about 9a.m. Friday, and met Professor and Mrs. Barnes, who are also staying there.

Saturday 29
Prof. Barnes recalls that at the time of the disturbance over Epstein's sculptures for the British Medical Association, when King Edward VII refused to open the building…this refusal was a great disappointment to the then head of the B.M.A., whom Barnes was working with; because, had the King done what was expected, there would in the usual course of events have been a knighthood for this man.

1946

The Slade School is still adjusting to the impact of the war on facilities and buildings. Working conditions remain difficult and there is a shortage of canvas, although Schwabe believes pictures are selling better than usual. He is busy outside of the usual demands of running the Slade selecting paintings for Melbourne via the Felton Bequest and is involved with the dispersal of the war art collection. In November P. Wyndham Lewis returned from his exile in North America and begins writing art criticism for The Listener.

MEMORANDA
Art Criticisms from Kilvert's Diary 1874.[1]
(He goes to see Miss Thompson's [later Lady Butler] *Roll Call*[2] at the R.A.)
'It is a striking picture, but I had heard so much about it that I was a little disappointed. Another fine picture was Millais' *North West Passage*. But there was one which I would rather have had than either, a half length picture of a child painted by [Henry] Le Jeune and as the crimson star showed already, 'Sold'. I do not wonder. It was the face of a lovely child who had been unjustly blamed and punished for a fault of which she was Innocent, innocent. Her little hands were clasped and her flushed cheek laid against them. Indignant tears were brimming in the sad imploring eyes which told their own tale. 'Innocent, innocent, oh indeed, indeed I am innocent.'

2 days later June 27....stood a long time before my lovely *Innocence* watching to hear the child sob audibly and to see the big indignant tears brim over and roll down her cheek.

Rev. Francis Kilvert cont'd same day – 'I regret to say that against good advice and wise warning I went to see Holman Hunt's picture of the *Shadow of Death*. It was a waste of a good shilling. I thought the picture theatrical and detestable and wished I had never seen it.'

Jan. 31. 1879 Bought 2 oleographs and a Kidderminster bed-room carpet.

JANUARY

Entries for 1–3 January are written in Schwabe's 1945 Diary

Thursday 3
...Birdie & I had tea at The Saltire Club [Wellington Street, Glasgow] where there was a show of J. Pringle's pictures.[3]...Pringle is an interesting case of a natural almost untutored painter. Frequently he has a delightful sense of things. I don't think it would have harmed

1 See *Kilvert's Diary*, vol. 3. Selections from the Diary of Rev. Francis Kilvert 14 May 1874-13 March 1879.
2 *Calling the Roll after the Battle of Inkerman.*
3 John Quinton Pringle (1864-1925). Barnes was Convenor of the Exhibitions Committee.

his vision…if he could have been made more certain of his drawing. In the evening the Howarths came in…More discussions about Charles Mackintosh & Margaret, with reference to Howarth's book…

Saturday 5
Returned from Glasgow…by night train…

Monday 7
Slade began.

Tuesday 8
Trouble with Polunin and his class about getting rid of the students O.T.C. from the rooms which the theatrical scene-painting class should be using. Polunin in a highly emotional state, and the students on the verge of a riot, wanting to break the doors down and sack the two rooms. Got onto the Provost about it…persuaded the students to hold their hands for a week…

Wednesday 9
…Lunch at the Trocadero, to discuss the Elstow book and the drawings with Miss Burke of Lyon's Publicity Dept. and a certain Major, ex-soldier in Burma, of the same office…

Thursday 10
…After the School (lunch at U.C. with A.E. Richardson, very amusing about his experiences in Belfast where he made, as usual, many notes of architecture in his sketch-book; and with A.V. Hill, now President of the Royal Society), to De Beer's office in Piccadilly, to see the Whistler *Symphony in White* that he is offering to Melbourne for £1200. Met Bruno Kohn there. He helps to finance De Beer.

Friday 11
Examiners' meeting (Higher Schools) with Bellin-Carter at the Imperial Institute, to approve Exam. papers in Art. Bellin-Carter was a friend of John & Orpen at the Slade. He says that John & he used to go off after school hours to get a little exercise at the Exeter Hall gymnasium, using the horizontal bar & so forth. He liked both men & found Orpen very amusing; but he has not seen John since his Slade days.

Thursday 17
Lunch with Kenneth Clark…to discuss Felton Bequest business. Went on with him to the Leicester Galleries to see a show of Lucien Pissarro's work which is admirable… Arthur Norris dined with me at the Athenaeum. We had a long conversation about Dr. Munro's albums of sketches that Norris possesses. We also talked of *Punch* and its transformation from its traditional style to that of *The New Yorker*, with some loss in humour, Norris considers. He thinks it was a mistake to get rid of Lewis Baumer. Anthony Devas was sent to the Slade by Norris from Repton. Devas's prices are going up and he has plenty of employment for portraits. His manner & appearance help to make him popular with sitters.

Monday 21
Committee – K. Clark, Dickey & I – at Bedlam, about the disposal of War pictures. Two oil stoves mitigated the chill of the building: windows are still boarded up in the Board Room, and the ceiling is half down: there were about 20 bombing incidents, and it is lucky that the building survives…6 degrees of frost last night. Gas is very reduced…

Tuesday 22
Lunch at the Club with Sir Alexander Gibb and his son Jocelyn, (Jock) to talk over the conversation piece that MacColl suggested. I must try to do it…but it is full of difficulties. Jocelyn Gibb works in the Horse Guards (he is a publisher in civil life), and knew Bill there: he also met him at Lochailort, and knew his little book, *Shooting to Live*: he considered it hard that Bill got so little of the limelight for the work he was doing. But Bill did not care about limelight.

Thursday 24
Wellington lunched with me at the Club…[he] was once up for election to the Ath., but withdrew when he left the R.C.A. for Edinburgh. He speaks well of Will Rothenstein, both as an artist and as a friend; but admits that many people disliked him. Martin Hardie, a good-tempered man, had a scene with Wellington about Will: he came into Welling-ton's room at the College in a rage and swore 'he would never speak to that little man again.' Will had a way of going on writing his letters, when people called and talked to him, which some found irritating. Wellington has written the notice of Orpen for the *D.N.B.*. They were at the Slade together.

Tuesday 29
Judging work for N.E.A.C. at the Royal Academy. Clause, Connard (who has just begun his functions as Keeper of the Schools), Cheston, Devas, Dunlop (who was noisy and tiresome after lunch, after a few drinks), Methuen, Ethel Walker, Jowett, Cundall, Ethel-bert White, Millie Fisher. Ethel Walker has poisoned her leg…She has had shingles. She has sacked her daily servant because she says the woman stole…the masseuse whom she has for her rheumatism may get some other maid for her…

Thursday 31
W.L. Clause is annoyed because the Tate will not accept a painting by Fairlie Harmar. He says Henry Moore & Graham Sutherland were responsible for this decision.

FEBRUARY

Friday 1
…Dinner with Arthur Norris [who] lives in Millais House, 7 Cromwell Place. Millais lived there before he built his more palatial residence, and Norris works in what used to be Millais's drawing-room. There used to be a big stained-glass window by Burne-Jones…but, to Norris's satisfaction (since no proper light came through the window) it was destroyed by a German bomb, Millais' initials figured largely in the design.

Sunday 3
Yesterday Charlton called at the Slade to tell me that if Gwynne-Jones's suggestion that

Moynihan should be appointed to the Slade staff is carried out he will resign: partly because he does not like Moynihan nor his connection with portrait-painting & the R.A., partly because he thinks any money that can be found for additional salaries should go to raising the pay of the present teachers. There is a good deal in what he says. Charlton thinks G.J. a most tactless person, but a good teacher of painting…

Monday 4
Charlton & I went through the sixty or so paintings by Fairlie Harmar which have been sent to the Slade by her sister for the students to paint over, (they being very short of canvas, and stretchers being almost unprocurable)…a good many of the pictures are much too good to be painted over…

Tuesday 5 – Friday 15: no diary entries

Saturday 16
Leonard Elton…is still very busy with the British Council. There is some talk of Augustus John, who is going to Rome, giving some lectures in Athens, but he is looked upon as so undependable that this is not likely to be arranged…

Monday 18
Pictures seem to be selling better than usual. Bysshe has sold a landscape at the New English, and two of my drawings have gone: one a study of June Miles done at one of the Oxford evenings, and a pen drawing of three nudes done from the same model and making a group. I finished the 11th & last drawing of the Elstow works…

Thursday 21
Went de Beer's office in Piccadilly to see the early Velásquez male portrait which he is offering to Melbourne. It is solid & well drawn, but a bit dry. I don't know what K. Clark will think of it…Tea at the Club…Spoke to Bodkin about his recent Broadcast dispute with Freedman & Herbert Read. He says that Barnett lost his temper, but that he himself has received about 100 congratulatory letters…The Press notices were very varied, so he does not know what to think…

Friday 22
…Story of Barnett Freedman, related by himself to Albert R.. F. takes a taxi. 'Where to?' says the driver. 'The Athenaeum' says Barnett. 'What, you?' says the driver. Barnett: 'Certainly – why not?' Driver: 'Well, I can't imagine you among those bloody bishops.'

Sunday 24
Worked at colouring Batsford's jacket for *English Church Monuments*. Lucilia Japp came to tea. Darsie was in bed with a chill. He did some office work for the British Council at Puerto Rico during the War, and was Acting Consul for a time. Lucilia's sympathies are divided about the parties in the Spanish War, but she is not a supporter of France. The Spaniards hate Duff-Cooper, who is said to have declared that the whole Spanish race was not worth the life of one British sailor…

Monday 25
Professorial salaries at U.C.L. have been raised to £1500 a year. How that compares with £1000 before the War I don't know, but I doubt if we are as well off now as we were then...

Wednesday 27
Meeting at the Imperial War Museum...It was reported that all efforts to find out about the fate of Thomas Hennell in Indonesia have been fruitless...

MARCH

Friday 1
...Luncheon with the C.I.A.D. and the deputation of commercial designers who have been having a kind of metropolitan refresher course, visiting Art Schools, etc. to improve their provincial outlook...Charles Tennyson in the chair...I sat between Tomlinson and a lady who designs things for Yardley, with Laver opposite. Laver says he uses the dicta-phone to compose his books, and they give him little trouble. With Jowett to the Leicester Galleries to look again at the Utrillo of *The Eiffel Tower* [1913], which Clark and I are buying for Melbourne for £1000.

Saturday 2
Slade, as now usual...Several callers. Two testimonials to write...

Monday 4
After the Slade, tea at the Club. Dodd tells me he is painting a biscuit manufacturer in Sheffield, but has put off the twelfth and possibly last sitting because the light is so poor and so unnatural with snow on the ground. Dodd gets about £400 for a head & shoulders.

Friday 8
Went with the Provost, Nuttall-Smith & Talbot of the Slade Society to inspect the houses in Cartwright Gardens which have been taken over as a sort of hostel for the Slade students. There have been adverse reports on the running of them, but they seem to be unfounded. But the houses still need repair & attention...Wellington came to the Slade and...we went out to lunch at his expense...His wife Irene now teaching lettering, part-time, at the R.C.A., as assistant to Johnston's successor...

Sunday 10
After tea: walked to 43 Oakley St. to see George Kennedy. He is working during the week in Cambridge on a large portable model theatre for the Arts Council, to show Civic Centres what can be done. Mary was packing to go to Cornwall for the birthday of her mother, aged 90. Her two boys in the R.A.F. have now been demobilized...A third is still in the Navy. Saw in the house the two paintings by Robert Gregory[4] which I know so well.

Tuesday 12
12.15. By appointment at the Leicester Gall. to meet K. Clark in order to see if one of the

4 Son Lady Gregory, studied at Slade from 1903 and in Paris. Shot down Italian front January 1918, Yeats wrote four elegies in his honour, including *An Irish Airman Foresees his Death*.

Drury collection of Alfred Stevens's drawings might be bought for Melbourne. By the time we got there – and it was only Private View – all but a very few of the roomful of drawings were sold…ranging…from £100-£200 each. And I remember when poor W.W. [William Wyatt] Bagshawe,[5] before the first Great War, was trying hard to get 30/- a piece for the collection that his father bought after Stevens's death from the studio in Sheffield. There was also an exhibition of Moynihan, and one of Kenneth Martin…4.0. Meeting of Rome School Faculty of Painting, Lowther Gardens. Only the Monningtons and myself, of the members, attended. First meeting in 7 yrs. Five have died since last we met. Colin Gill, Charlton Bradshaw, Ernest Jackson, D.Y. Cameron & Dermod O'Brien. MEMORANDA

(Evelyn Shaw recalls an early meeting of the School at Rome Faculty of Painting at which Sir Edward Poynter was in the Chair. Poynter asked privately 'who is that very intelligent-looking man at the other end of the table?' It was Tonks. And at the end of the meeting Tonks told Shaw he thought Poynter made a very good chairman.)

Wednesday 13
…Imperial War Museum Committee, Bone in the Chair. He told me afterwards he took a month, working from about 10-5, to get the big drawing of a balloon factory, in Manchester, done…With Jowett to the R.W.S. Council meeting (2.30) where Russell Flint told us that, as the result of a letter of his to Lord Macmillan, the Pilgrim Trust had given £4000 to help the declining funds of the Society…

Saturday 16
…Looked in at the James Ensor show again…The early paintings, done when he was about 20, are very remarkable. To Golders Green to see D.S. MacColl. He has passed his 87th birthday…He told me of certain book covers that he designed in the nineties, anticipating some modern forms of design. His sister, apparently, was a book-binder, and they worked together. I suggested that he was one of the Mackintosh 'Art Nouveau' group in Glasgow, but, as far as he knows, he never met Mackintosh. However, he seems to have known the MacNairs.

Sunday 17
10 a.m. bus to Richmond to draw Eunice Dickey…It was a commission. Dickey showed me a lot of his sensitive and sincere work, mostly studies of trees done at Tom Balston's or in Richmond Park. He was evidently pleased to have another artist with whom to discuss them. I suspect that he feels that he is too much an official…and is not able to devote enough time to his own creative work…I drew Eunice in her W.V.S. uniform…

Tuesday 19
Covent Garden in the evening – Sadler's Wells Ballet: *Rake's Progress*. Delius *Nocturne* and *Miracle in the Gorbals*…Met in the interval Gregory of U.C.L, his wife and daughter, and Ensor Holliday. Gregory thought with some reason that the story of Gorbals was in bad taste. It is rather obscure to me anyhow. The *Rake* was well done. It had some excellent scenic work by Oliver Messel, the proscenium designed 'as a tribute to Rex Whistler'.

5 1915 exhibited N.E.A.C., address c/o E. Schwabe, 43 Cheyne Walk. 1914 enlisted as a volunteer Sheffield City Battalion, July 1 1916 killed Somme by a German sniper on leaving the trenches to attack the village of Serre.

Burra's set for Gorbals was good too, and Robert Helpmann & Margot Fonteyn, among others, gave very creditable performances.

Wednesday 20
Ralph Edwards came to the Slade and bought a drawing of *Cerne Abbas* for the Contemp. Art Soc. of Wales (£12.12.0)…Recommended Kyffin Williams to his notice…

Friday 22
Slade Dinner…Cabaret show by the students (Miss Macksey, Trevor Makinson, Alan Barlow…) All went well, and the building was clear by about 11.30…

Sunday 24
V.&A. Museum to see the Constables…it all came as a fresh experience with the re-framing and the re-hanging. My reverence for Constable increases. His love for natural objects has surely never been exceeded. So many people say they prefer the sketches to the finished pictures: I like both equally: *Flatford Mill* [1816-17], *The Hay Wain* [1821], the *Cottage in a Cornfield* [1817]…have extraordinary interest for me…

Monday 25
Last Artists' Advisory Committee at Bedlam. Muirhead Bone (who got up at 6a.m. to get there from Oxford), [Sir Frederic] Kenyon, Lady Norman, [Oliver] Warner [Admiralty], Dickey, [A.] Blackborow [Air Ministry], [E.C.] Gregory, Blaikley, [L.R.] Bradley [Director] & Mrs. Oxford-Coxall [clerk]…Michel Salaman told me that Fred Brown's two brothers were architects, who did a lot of building (good workmanship, but bad Victorian design) for the Salaman Estates in London. Through their connection with his father Michel was sent to the Slade. Bone said that when he was in Rome he met Ernest Cole the sculptor, then a young man. Cole, when he went to look at Michelangelo's paintings in the Sistine, had an extraordinary trick of fumbling a piece of new bread in his pocket, trying to model the figures that he saw, to increase his plastic sense of them.

Tuesday 26
Slade. Lunch at Athenaeum…Great complaints among the architects about shortage of bricks. Braddyll is starting a job which should use up 500,000…he is told that only 2000 a week can be supplied, and that not for six weeks…

Wednesday 27
…Birdie came back from Bristol. They have started the restaurant service on the trains again.

Thursday 28
…Met Henry Moore. I told him I had seen Ernest Cole, his old Professor of Sculpture at the R.C.A. Moore said that Cole and his wife had to leave Kingston in Kent during the War by reason of their Fascist tendencies: she sent a ring to Mussolini. He thought that Cole was always erratic and ill-grounded in his art: his drawing showed little or no constructional knowledge, and quite missed the real spirit of Michelangelo. As Professor, he had a new theory every week: one time it would be all negro sculpture, and then something entirely different.

Friday 29
...Heard that Randall Davies is dead – about last December. He was a very old Chelsea friend of ours, and we have many pleasant & kindly memories of him.

Saturday 30
Got to Ralph Edwards's, Suffolk House, Chiswick Mall, about 10.30, for the Boat Race. Leigh Ashton, Thorpe, Noel Carrington...Crowds, but not as great as in the old days. Oxford was ahead as they came past the eyot, and won...by 3 lengths...went on to the 'Touching-up Day' cold luncheon at the R.W.S....

APRIL

Wednesday 3
Busy morning at the Slade, seeing people and overhauling the College pictures...which are stored in the Works Department...Found the Miereveld [*William Harvey* 1630], the Jeremy Bentham portrait, portraits by John, Orpen, Steer...the big David Cox, the De Wints...

Thursday 4
With Slade affairs and the last meeting of the sub-committee...of the Artists' Advisory Committee, I had only some ¾ of an hour to...finish drawing in the Green Park. Wyndham Lewis has at last submitted his unfinished picture, of a factory subject, to the Committee. We liked it. [John] Worsley, bearded & in naval uniform, came along in a taxi to Bedlam to show his new portrait of Montgomery – quite unlike the conventional notion of 'Monty', but obviously a very faithful piece of study.

Monday 8
Went to Sunbury with H.[Hagedorn] and drew there with him, on the eyot, looking towards the church, which has been so barbarously added to in Victorian days...

Friday 12
...2.30 Meeting of Whitechapel Trustees, Bearstead in the chair. When the business on the agenda was settled, Duddington was asked to leave the room, and the possibility, or desirability, of his being retired and succeeded by someone more efficient was discussed...The truth is he has let the Gallery go downhill since Aitken's time...he seems muddled and ineffectual about financial & other arrangements.

Sunday 14
...Charles T. had been to hear Osbert & Edith Sitwell read their own poems, which he says they did very badly, particularly Osbert, who has no sense of rhythm...Edith was costumed oddly as usual, a long tight black dress, a black mantle and a red turban wound round her head. There was a good audience...

Tuesday 16
Left for Dover...

Wednesday 17
Looked at the ruins of our old Dover that we liked so much. It was one of the best and

most complete survivals of the 1830s & 40s (not to mention the older buildings) in England...Began a small corner of a drawing in the afternoon, among the debris of St. James's Church...

Wednesday 24
Finished drawing St. James's Church in situ: over 5 hrs.

Thursday 25
...driven up to London by Tom...I went to the Club and wrote letters, making a fair copy of my brief introduction to the catalogue of L.D. Luard's coming exhibition...

Monday 29
Slade began – not too well, as three models failed to turn up...

MAY

Wednesday 1
Charlton has fears that models will be unprocurable at the Slade, and that man students will have to be asked to volunteer. They will be paid...

Friday 3
Lunch with the Douies at the Café Royal. They have now got into their house at Bosham again (it is not in very perfect condition, having suffered from bombs and by the Women's Land Army's period of occupation)...

Sunday 5
Worked on a drawing of Lower Feltham. Charles went to see the Tate Gallery show – Rouault, Braque and the Vincent Massey collection.

Monday 6
Entrance Schol. decision, with Charlton...Lunch with Major Martin of Lyons's, and Mr Bemrose, the printer, at the Trocadero, in order to sign 300 copies of *The Tinkers of Elstow*...Unfortunately the drawings do not reproduce...well, and two have been cut... as there were objections from the workers that some of the figures were not wearing the correct costumes.

Thursday 9
Dinner at Drayton Court: Lady Peto (Sir Geoffrey[6] couldn't come) Mrs. Arthur Chamberlain & Elsie Robertson. Lady Peto gave us an instance of Winston Churchill's imperturbability: at some house where they dined together there was a tame monkey, which amused itself, at dinner by pulling down Lady Peto's hair, to her annoyance. It then transferred its attention to Churchill, sitting on his shoulders with its tail wrapped round his throat and playing about for an hour or so with Churchill's parting, combing it backwards & forwards. Churchill was discoursing eloquently on his Marlborough book which he was then writing: he never gave the faintest sign that he was conscious of the monkey. He can drink a good deal, but remains perfectly well-balanced...

6 Conservative MP, retired 1935.

Friday 12 – Monday 27: no diary entries

Friday 31
Went to Dover…

JUNE

Saturday 1
Marked Min. of Education Exam scripts. In the afternoon, an enjoyable drive…Tea at Wye. Visited Hastingleigh Church & Brook, where the 13th century wall paintings are…

Sunday 2
…Back to Drayton Court…

Monday 3
Saw some pictures at Tooth's, on behalf of Melbourne. The big Crome sea-piece, the Hogarth *Thornhill Family* and a nameless landscape by Constable. Tooth is very well-read & well informed. Clark is in favour of the Crome, though it seems to have suffered somewhat from cleaning & restoration.

Tuesday 4
Saw Turner's *Red Rigi* [1842] water-colour at Spink's, with a view to the needs of the Felton Trustees. Kenneth Clark is in favour of it. The price is £2000. It has…fetched £8000 at some abnormal time. It seems dear enough to me at the present price.

Thursday 6
Slade Diploma Examination. Examiners – Reid Dick, Albert R., Wellington, Corfiato, Ormrod…There were…several failures in the Exam…Am nearing my 400th Exam paper. Forgot to bring any more home with me to-night, or I shouldn't have had time to make these notes.

Friday 7 – Wednesday 19: no diary entries

Thursday 20
Finished marking over 640 scripts for the Min. of Education…

Friday 21
We have now instructions from the Government that, of any new admissions to the Slade School or other branches of the University, 90p.c. must be ex-service people. We are full anyhow till 1948.

Saturday 22
Drew the model in no. 6 room at the Slade for about an hour. Lunch at Athenaeum. Told Salisbury of my strong objection to his proposed cutting down of the lime-trees in front of the Slade. Ashmole supported me. To the Tate, to see the American paintings. Met Charles T. there. We both liked many of them. Copley, Stuart, Eakins, Bellows, Cassatt, Inness, & Winslow Homer are all interesting. More modern – Niles Spencer, but many

not so good. I had no idea Copley & Stuart could rise so high. *The Skater* [1782], though rather static, is a good Stuart...

Tuesday 25
Judging Slade work for Prizes...perhaps back to pre-War standards, but...the figure drawing was not quite worth a first Prize...

Wednesday 26
Work again to do with the Slade Prizes. Brooker, Charlton, Ormrod, Gerrard, Wilkie – and of course Nuttall-Smith. Susan Palmer is developing as an artist. I wonder what will happen to Fish, [Peter] Startup and other men of talent?...

Thursday 27
Slade Picnic...over 80 people. Lunch at Chessington Zoo. Tea at the Inn at Shere...

Friday 28
Slade Prize giving. Chief honours to Sue Palmer. Strawberry Tea on the lawn in the Quad...

JULY

Tuesday 2
Slade...12.45 Claridge's, at the invitation of Sir Keith Murdoch. Other guests – Leigh Ashton, Pevsner, Osbert Lancaster, and Burke of the V.&A. who is going out to Melbourne as a lecturer. A good luncheon in Murdoch's private room...We are buying the Veronese for Melbourne. Back to the School. Tea at the Club...Max [Beerbohm] very bright and interesting. He does not like H.G. Wells: thinks he was a good imaginative novelist, but disapproves of his excursions into sociology.

Friday 5
Left for Curbar...Prof. Barnes met us with the car at Sheffield...

Saturday 13
Diana's christening in Baslow Church. The Rev. Mr. Drew officiated...Diana made a certain amount of noise in church. Both children looked very pretty.

Sunday 14 – Saturday 20: no diary entries

Sunday 21
Called on John & Grace Wheatley, at Toll Bar Cottage, Froggatt Edge...Saw some of Wheatley's[7] landscapes in Chinese ink. His studio is in Sheffield, where he has been doing a portrait of Dr. Abercrombie. He has specimens of Chiang Yee's calligraphy on the walls. Munnings has been attacking him rather absurdly in the Press for having a show of Paul Klee in the Sheffield Gallery. Mrs. Wheatley is a good potter in the Staffordshire tradition...She is doing paintings of industrial subjects, but they were not visible...

7 Director Sheffield City Art Galleries (1938-47).

AUGUST

Friday 2
Spent the day between the Slade and the Club. Signed 118 Slade Certificates…

Monday 5
…Birdie & I looked at the Fair on the Heath…There were scenes of great beauty – the crowds…the booths, swings and roundabouts, half in artificial light, half in declining day-light with strong contrasts of shadow. Birdie has a great feeling for such things. To amuse ourselves, we entered the 'Den of Death' and watched three placid and beautiful lionesses go through their tricks…

Friday 9
To Lavenham from Liverpool Street, to do my drawing for Charles and Ivy. On the platform at Long Melford station met Reginald Brill – a fortunate meeting…as he knows Lavenham well, and stays at The Swan, as I am doing. There is a portrait drawing of Robbins, the proprietor, by Brill, in the bar. Brill is an entertaining companion. Being a friend of his put me on favourable terms with Robbins and his wife. He is also an old friend of Col. Gayer Anderson, of The Little Hall, with whom I have corresponded from the Slade about his proposed hostel for art students, and about other matters to do with the School. Called on the Colonel with Brill after dinner. We were well received. He knows Edna Clarke Hall and has a picture of hers. He is an artist himself…He used to live in The Great House, but that is now occupied by Stephen Spender & his brother Humphrey.

Saturday 10
A showery morning, no use for drawing. Hired a car, and, with Brill, drove over to Chelsworth to see if it would produce an alternative or possibly an additional subject… Brill is taking a weekend off, with only a small haversack, to get away from the cares of administration at Kingston Art School.

Sunday 11
Went on with drawing. At 11 o'c. had about 40 minutes break, and, at the Colonel's invitation, Brill and I drank cider at The Little Hall, being joined by Humphrey Spender (Stephen is away) and a lady, an ex-student of my time at the R.C.A….In the evening… at The Great House, being shown over by Spender, who has done it up. He got £500… from the Govt., as the house was badly knocked about by the Army during the War. H.S. is of the high-brow type, horn-rimmed spectacles, longish hair, thin features, corduroys, and bare feet in sandals. He is intelligent, and a very accomplished and tasteful textile designer and decorator…In the house are paintings by advanced moderns – Spender himself, Scott, Bridie, Collins…I do not care much for those. They strengthen my opinion that most of these people, including Spender, are better in the applied arts.

Friday 16
6¼ hours work. Practically finished the linear phase of my drawing – a solid week's work…Saw three German prisoners who are…employed on local farms…

Sunday 18
Colonel Anderson showed me some of his fine collection of Indian and Persian drawings. The two Spenders…were there…Stephen is a tall, good-looking man with a good voice and a modest manner. He has some job he is going to in Geneva, but wants to get on with his own work…

Thursday 22
Farewell visit to The Little Hall…Train to London…

Monday 26
Left Drayton Court for no. 8 Church Row [Towner's]. I am sleeping, as before, at no. 12, the Geoffrey Hutchinson's.

Wednesday 28
…Slade…Met Mr. Gardiner, who wants a drawing of Tattersall's, at Knightsbridge Green, where we discussed the most suitable point of view. Bought a pair of sheets, of which there is a shortage – everybody's are wearing out – £4.1.4.: Indian linen. Mostly linen sheets are now £16 or £18 a pair. Why these were cheap, and why I was allowed to buy them without a 'docket' or any coupons, I don't know.

Thursday 29
…G.J. is working at the Slade on his replica of the Princess in her pony carriage. The mystery of how G.J. manages to write so clearly & well (he never used to) is explained – Eddie Marsh revises his MS. Apparently Marsh is in the habit of doing this for Somerset Maugham also – e.g. *Don Fernando*.

SEPTEMBER

Friday 6
Dined & slept at Jesus Coll. Oxford. Met the Senior Tutor, Goss, John Griffiths & Chapman. There is practically no one in College…

Saturday 7
Drew Chapman…The Principal, Ogilvie, called on us. I was installed in the rooms of the Dean, Woodward, who is away…It was favourably received by the Principal, Griffiths & Chapman himself. The last is a chemist, and F.R.S.: a very pleasant elderly man, who, though he has a variable face, sits well…

Tuesday 10
News of Willie Clause's death on Sunday, midnight, in hospital, at Tunbridge Wells… We were shocked…The cause was connected with his old gall-stone operation – an adhesion internally. He was operated on…& seemed well afterwards. He had been in pain for some days before. I have known him for about forty years, since our Slade student days. It was through me and my Uncle Edward's family that he was sent to the Slade. The Clauses & my uncle's family were neighbours in Cow Dale, Buxton. They thought of the Slade…because I was there.

Thursday 12
...Clause's cremation service at Golders Green...Met Hagedorn in the Tube going there, and then Yockney and Bradshaw of the N.E.A.C., Hereford, G.J., Robin Guthrie, the Grimmonds, Percy Smith...the chapel was so full that I and several others had to stand. There is no question that Willie was liked. I am told there was a good obituary notice in *The Times* to-day...

Friday 13
...Michel Salaman, at the Club, told me that Ida John, Gwen John, Gwen Salmon (Mrs. Matthew Smith) and himself (at a different time) all studied painting, on leaving the Slade, in Whistler's studio. He thought highly of Whistler's system of instruction, having learnt little of the technique of painting under Brown...

Tuesday 17
...Maxwell Ayrton, now aged 72, has had what looks like a heart attack and is in bed. He is very cheerful and an excellent patient. He is in some pain from gout as well.

Friday 20
...Slade. Went with Wellington to the Gwen John Memorial Exhibition at the Matthiessen Gallery. Met P. Wyndham Lewis, who neither of us had seen since before the War. He made some very shrewd and appreciative comments on the pictures...He does not seem to have liked America much: had to make money, and as fast as he sold his pictures to satiety in one town, had to move to another, always staying in expensive hotels (about 15 dollars a day) for the sake of appearances...2 o'c. emergency meeting of the N.E.A.C. executive, occasioned by Clause's death. I took the Chair. Methuen consented to act as temp. Hon. Sec. Present, Jowett, Cundall, Guthrie, Cheston, Fisher Prout, Yockney, Methuen.

Thursday 26
Worked on drawing of Tattersall's...at the Slade...'Dr.' Norman Dawson came to see me. He wants to be head of the L.C.C. Central School, and asked for my support. He told me he makes £6000 a year; so I asked him why he wanted to go to the Central? To this he had no good reply. Lunch with Salaman at the Club. He says Gwen John was Rodin's mistress: also that her father, who lived carefully in an ordinary small house in a row, left £80,000. Went to the Gwen John show again, with Salaman (I had the Felton Bequest in mind). Met Augustus there, who was cordial and sent messages to Birdie. He said that not a single newspaper has noticed the exhibition. Wyndham Lewis...is going to do something about it. I suggested that he and Augustus should together write a book on Gwen – Lewis the critical part, John the biographical. Salaman says Whistler taught them to paint on absorbent grounds, putting on a touch at a time, mixing up masses of the required tones and keeping the mixture under water for future use.

Saturday 28
At Slade, finished drawing of Tattersall's & took it to Lewis.

Sunday 29
Visited MacColl. He was in bed having had a slight heart attack yesterday...Willie Clause is a loss to him. He spoke of him with affection, and of his many friends now dead...

Monday 30
…went to the Matthiessen Gallery and after a good deal of thought, asked them to reserve for Melbourne the painting, of those which remain unsold, by Gwen John, which I consider the best. K. Clark has agreed in principle and left the choice to me. The price is £475…

OCTOBER

Tuesday 1
Albert R. at the Athenaeum, on his return from America. He travelled about a good deal – there was a strike, and he had to board the *Queen Mary* on his return at Halifax instead of New York – inspected some Art Schools (from which he considered we had nothing to learn), and admired the Frick collection, as well as American architecture & hospitality. Life is expensive there. A servant costs £50 a month, all found: a nurse £60. No good news of Margery.

Thursday 3
R.B.A. Galleries, hung a show annexed to the N.E.A.C. rooms, of pictures done for the I.C.I. by Wheatley, Kennington, Dring, Zinkeisen, Rupert Shepherd, Ernest Jackson…By a miracle, they exactly fitted the wall space, a fact from which I derived undeserved credit, and was given a double pink gin at the Carlton bar.

Friday 4
Went to 34 Well Walk with Birdie & Towner to select some of Willie Clause's work for the New English and the Hampstead Artists. There were some good paintings, of the kind he liked least and seldom showed (Lucy has quite strong views about the big overworked ones which he thought more of, and thinks some should be destroyed) and many excellent drawings…

Saturday 5
…News of Toddy Heal's death: one of the old Slade set of about 1900. I suspect she wore herself out with the care of a fairly large house and little or no help.

Monday 7
Slade began. C.R.W. Nevinson died. I was not surprised, he had been in a bad way, and out of action, for some time.

Thursday 10
…Guy Brown has lent me a volume of Freud's works, because he wants my opinion of a paper on Michelangelo's *Moses*. I think Freud reads an intention into the figure that is not there. Michelangelo, as I see it, was concerned with executing an heroic figure of a lawgiver for a Medici tomb and chose a pose which was rhythmic, impressive & novel: he was not concerned with whether Moses had seen the Golden Calf round the corner.

Friday 11
Towner has been telling me of his visit, when at Harting, to Miss Constable (the descendant of George Constable), who lives near Rogate. The family is not connected with the painter (see Leslie) though George & John were friends: it is the same as the Sussex

brewing firm. Miss Constable has many good pictures, collected by her ancestors. She is not particularly interested in them...she sold one of John Constable's oil sketches not long ago for £2. She has several of these, and some of George's which were worked on by John. There is a distant view of Arundel Castle of which one corner shows the professional hand, as distinct from the amateur look of the rest of the picture. George's painting was amateurish and the difference is clearly perceptible...

Sunday 13
...In the afternoon went to Lucy Clause, who presented me, at my request, with four good drawings by Willie, for the Slade School, which has nothing of his.

Wednesday 16
Arthur Norris dined with me at the Club...He met his old school-master, Costley-White, once the head of Westminster, now Dean of Gloucester, with whom I once dined at U.C.L. in the presence of Jeremy Bentham.

Thursday 17
...N.E.A.C. Private View. Willie Clause's panel of paintings looks well. George Fletcher, the Slade student, was there, pleased to have a drawing well hung. Met an embarrassing number of friends and acquaintances – the Rushburys, Sydney Maiden, the Gilbert Spencers, Grace English, Millie Fisher, the F.H. Shepherds...Tea with Cecil Hunt at the Club. He says he had no art school training.

Thursday 24
Lunch at the Club, with Jowett & J.G. Mann (who spoke warmly, once more, of F.M. Kelly as a scholar). To the New English Executive meeting, followed by General meeting. Rodney Burn was elected secretary in place of Willie Clause. New members – Dunstan, Lines, Craig, Cosmo Clark. I was made Chairman at both, a function which I do not like, particularly at the more public gathering...

Friday 25
Saw the Julius Wernher collection of paintings, including Constable's *Harnham Bridge* [c.1820] at Wildenstein's...Afterwards, a great revelation at the Royal Academy – the King's pictures, which completely fill Burlington House, and include so many masterpieces that so few people have hitherto seen...

Saturday 26
Slade. Left at 12, to inspect the volumes of Holbein reproductions that Zwemmer has. Charlton wanted me to do this, with a view to buying them for the School – £75. They were £100 before the War...

NOVEMBER

Friday 1
...Burlington House for a British Institution Scholarship meeting. It being proposed that one of the Seasons should be the subject for next year's painting. Munnings suggested that Crabbe's *Seasons* should be recommended to the candidates, as inspiration, and I

pleased him by quoting Crabbe – 'Cold grew the foggy morn'…But it occurred to me afterwards that Munnings must have meant Thompson's *Seasons*. The meeting went off without incident or excessive dispute. Present A.R., Munnings, Lamb (Sir W.), A.E. Richardson, Corfiato, another architect & Jowett.

Sunday 3
…MacColl's. He thinks L. da Vinci's studies of the movement of water were a failure and said he once consulted Sir William Bragg about this, who was of the same opinion. We talked of the correspondence in *The Times*, started by Gerald Kelly, about the ruination of pictures in the National Gallery by cleaning…

Friday 8
Henry Carr, the painter, came see me about sending his son to the Slade when the boy has finished his military service…Carr said he had known Henry Moore all his life – they shared a studio when students at the R.C.A. – and he is convinced that the exaggerated and eccentric forms of Moore's art are 'phoney' or bogus: that Moore has a keen eye to the main chance and knows how to court public attention…3p.m. G.J. criticized the Slade Summer Composition, very well. Prizes to Anthony Baynes, Startup, Fish, G.S. Fletcher, Bartlett, Walton & 2 girls – Blakeley & Trotman. Quite an interesting and varied show. *Inserted* See later, Feb. 23 '47

Sunday 10
Armistice celebrations. Coming back from pottering on the Heath, found Church Row packed with people after the Church service, with various military bands, soldiers, boy scouts, women in uniform, aldermen & Mrs. Carnegie the Mayor in robes…At the 1st floor of no. 9, Maxwell Ayrton, Elsa and Longden. I joined them…Norman Janes came in at 9p.m. to take away some old Japanese paper which I have hoarded for over 30 years, since I was an etcher: he is a printer and can use it.

Monday 11
Difficulties at the Slade about finding enough room for the men to paint from the model. Tea at the Club, in company with Lord Porter. Conversation turned on old Waterloo Bridge, which reminds me that Janes, yesterday, gave me evidence of the danger to navigation caused by the narrow arches: he knew the master of a tug who told him that when his tug had a string of barges behind…he shut his eyes and prayed for safety every time the tug entered the arch. I have always been obstinate about the desirability of preserving Rennie's beautiful bridge, but this shook me.

Tuesday 12
Tea in company with Munnings at the Club. He introduced me to a parson friend of his…I have always thought…when in company with parsons that it is better to restrain one's impulses to curse and swear, but Munnings goes on cheerfully & loudly blaspheming without any thought as to whether his companion may like it or not…

Friday 15
The (Indian) head of Lahore Art School, Lockwood Kipling's old School, visited the Slade. Charlton & I showed him round.

Friday 22
…4o'c. met Sally Pritchard at Oxford Circus…[she] was buying glass from a firm in London. The colours are difficult to come by now. She is doing a window 30ft. high…

Sunday 24
…6p.m. at Ayrton's. Longden came too. He is not very fond of John Rothenstein. They travelled together in Holland. Longden complains that J.R. parades his Catholicism too much: also J.R. wrote an article in *Time & Tide* describing the trip…all in the first person and saying nothing of his companions…Longden could not resist writing to Rothenstein, congratulating him on the article, saying what an excellent official report of the tour it would make if only the 39 'I's in the course of it were replaced by 'we'.

Monday 25
Charlton & I, at the Slade, looked through some parcels of drawings & prints by the two Richard Coopers, father & son, which were sent over for our examination by Wilkes, the Librarian of U.C.L., to whom they have been offered. We were interested in some of the monochrome landscapes, pen & wash, and the early lithographs (1806) and soft-ground etchings by Cooper the younger, the Eton drawing-master. Codrington, K. de B., told me at the Club, a good deal about his relations with Freud in Vienna, whom he admires, and who, he says, did him a lot of good, physically & mentally…he had an interesting story of Freud's own early struggles, and how his desperate state of mind was helped by the study of some tender weed holding its own in a strong current of water.

Tuesday 26
…Croft Murray and Iolo Williams at the Club, were very interested when I told them of the discovery of work by Richard Cooper…Called at the Institute of Boys' Clubs…to see the Secretary about a show of the boys' work at the Slade during the Christmas vacation…

Wednesday 27
Birdie & I went to Mary Hill's flat in Stanfield House after supper. Jean Inglis was there too. Mary Hill has lived in Hampstead since 1878, and showed me a drawing of hers of the High Street done before I was born. She must be over 80 now, but still working busily.

Thursday 28
After a very busy day at the Slade – seeing people and discussing diverse problems (including an address from the students to the Rt. Hon. Winston Churchill about the cleaning of the National pictures), meeting Eric Newton, who had come to talk to the Slade Society…sherry party at Guy Brown's flat in Willow Road. He and various friends… are going to Zermatt for Christmas…

Friday 29
…Council meeting of the R.W.S.…I retire from the Council after this. Russell Flint, Hunt, Hartrick (getting very old), Millie Fisher, Jowett, Cheston, Muncaster, Lines, Lee Hankey…Went to Memorial show of paintings & drawings by Ernest Jackson at the Beaux Arts Gallery. What a very able draughtsman he was!...

DECEMBER

Monday 2...
Very busy seeing Diploma students...Went to Radcliffes in Little College Street to identify the Gwen John *The Nun* [1915-20] for the Felton Bequest...

Wednesday 4
...In the evening went to see Lucy Clause about her lettering. I have it in mind to get her a job at the Slade. She was on the teaching staff at Edinburgh College of Art, worked with Ed. Johnston, knew Graily Hewitt, wrote the roll of honour of the Edinburgh students, carved inscriptions for Eric Kennington, notably on his monument in Battersea Park...

Thursday 5
Lunch at the Club – Bodkin & Richmond: a new controversy now about the proposed Roosevelt statue, whether it should be standing or seated...Vincent Lines came to talk to the Slade students on early English water-colours...

Thursday 19
Slade Dance...cabaret, with a Royal Box in which I sat. A very good can-can a little spoiled by one of the girls, who had had too much to drink, falling over every time she attempted a cart-wheel. Trevor Makinson was excellent as a ballet dancer. There was a slight brawl between Aelred Bartlett & John Evans, and Olga Lehmann was drunk, but no really serious incidents of an unpleasant kind.

Saturday 21
Last day of Slade term. Lunch at Athenaeum. Met Albert R...Margery is no better. Some doctors want to operate on her brain, but A. won't have it.

Sunday 22
...6p.m. at Kenneth Clark's, Upper Terrace House, to discuss buying the Claude, the Rubens and the Degas drawing. The pictures in the house are very fine – Gainsborough, Claude, G. Bellini, Tintoretto, Reynolds, Delacroix, Cézanne, Renoir...Orchardson and Sims (and incidentally my drawing of the Radcliffe Camera). There are so many objects... that 30 have recently been removed from the drawing-room because the house-maid said she could no longer dust them...

Monday 23
...to the Tennysons...His book is now in the hands of Secker and Warburg...

Wednesday 25
Christmas Day at no. 8 Church Row...It was Mrs. Towner's birthday. Birdie had supplied an iced cake with 84 wax candles.

Friday 27
Margaret Cobbe came from Dover...Alice met her and took her to the 'Britain can Make it' Exhibition at the V.&A....Towner & I went in the Hutchinson's car to Epping, via Waltham. Looked at the Abbey Church with its tombs & mural painting. Was sorry to

see that the old market square of which I once made a drawing had been destroyed by a land-mine. To the Wake Arms...Drove on to Chigwell. Lunch at the King's Head... Looked at the mansion alongside the Inn, at the Church, with the Harsnett brass, at the old School founded by Harsnett, and at rest of the yet unspoiled village...

Tuesday 31
Slade...Lunch, Athenaeum, with Dodd. He is going to Glasgow to open an exhibition, and possibly to lecture...He spoke of Reid Dick, who was very poor when a boy there: he did a milk round at one time. [Francis] Newbery gave him a scholarship, on the same conditions that Dodd was given one – that he never knew who paid for it; but Reid Dick gave it up after a year, as it meant that his mother had to go out and do a charwoman's work to maintain him...So he went and learnt how to carve in a stone-mason's yard.

1947

A bitterly cold winter alongside which is a fuel crisis from February to April. Coal and other industries are nationalized. Controversy rages about the cleaning of the pictures in the National Gallery. At the Slade there is contention over visiting teachers. The Schwabe's housing problems continue. The Royal Wedding of Princess Elizabeth and the Duke of Edinburgh takes place in November.

MEMORANDA
Montgomery, looking at his picture by Aug. John, said he would rather be under canvas than on canvas…

JANUARY

Friday 3
Went to Ampthill to do the presentation drawing of A.E. [Albert Edward] Richardson. Train 9:20 to Bedford, where I was met by A.E.R. and his daughter with his 12 yr. old car, now worth hundreds more than he gave for it, in spite of its age…After lunch A.E.R. showed me his new blocks of council houses. Nearly all his other work, including some very big jobs, is hung up by difficulties of licences, labour and materials. Richardson was first employed in the office of Verity, but was not well treated by that architect. A.E. says that Verity became jealous of him. He got a job at the Birkbeck College, and then one (lecturing in both cases) at the Regent Street Polytechnic. For the latter he was paid £250 a year; it was part-time. Thus he became independent of Verity. He started an independent practice with [Charles Lovett] Gill. They nearly had to give it up, but jobs came in time to carry them over. The connection was to last over 30 years. Richardson thinks Gill a dull dog. Though G.'s name appears as part author of several of R.'s books he had almost nothing to do with them. The two have parted company now and there is some ill feeling between them. Richardson's present London office is in Old Burlington Street. His son-in-law (Houfe) is also working for him in the Bartlett School, so that with his own house Ampthill, he has three places to carry on. He has big work to carry on, but it is nearly all in the drawing-office stage…[and] work is mostly suspended under the present difficult conditions. The Ampthill house designed by Holland, is very cold. There is no electric light in it. Candles are used, or gas. A.E.R. paid either £1900 or £2900 for it…The property would probably sell for £10,000 now. He has done much to preserve the amenities of Ampthill, getting rid of advertisements and hoardings in the street, preserving good old frontages…While I was with him a woman came up to him in the street and consulted him on the colour of the paint on the timber market-house, which she owns, together with the butcher's business in it. I looked at a few books in Richardson's library, among them a work, with fine illustrations (by Marmottan and someone else?[sic]) in the French Empire style. I had not noticed before the connection between French architecture and men like Nash & Burton. Richardson agreed about this. He visited Nantes, where there are very good examples of the Empire style…

Saturday 4
After about an hour and a quarter's work yesterday, in Richardson's little study, warmed by an oil-stove (we both sat in our over-coats to-day), resumed drawing ...He sat very well, unexpectedly, for such an energetic, ebullient man, and I finished it. He was pleased, seeing a touch of 18th century character in my presentment of him; and Mrs. R....expressed her approbation. Lunch with A.E.R. and his son-in-law...afterwards, with them and some members of the Council, made an official inspection of the Council cottages. They seem to me excellently planned and proportioned, and well carried out... The rent is to be 15/- a week...

Monday 6
...Slade...Bought some more old paper from Ridgill Trout[1]...G.J. told me the grave news of Lowinsky. He has cancer, though he does not know it: also some sort of paralysis of the right hand...Set up a still-life group for the London Federation of Boys' Clubs in the Slade, for their annual competition...

Tuesday 7
Marked the exercises, fifty or so...done last night in the drawing competition...Met... R.A. Walker (who is hot upon his scheme for providing a memorial tablet for Aubrey Beardsley in Cambridge Street – I promised him half a guinea) and Walter Lamb, whom I pleased by saying I thought Poynter had been a good Slade Professor in his day (he knew Poynter). Controversy still raging about cleaning the nation's pictures...

Wednesday 8
At lunch, Haward, Wheatley, Jowett. Wheatley is going to lecture to a Chinese society, introduced, I suppose, by Chiang Yee. He says Chiang sells a piece of his calligraphy for £10-10-0. Jowett reminded me of Augustus Spencer's celebrated advice to students at the R.C.A. – 'Be gentlemen: it pays. It has paid me, and it will pay you.' Jowett was guilty of a mild piece of disorderly conduct when a student – introducing a barrel organ into the College, or something of the kind, and was called before 'Gussy' for reproof. 'Jowett', said Spencer, 'I thought you were a gentleman.'

Thursday 9
[Sebastian] Isepp[2] brought back to the Slade my picture that he had cleaned – most successfully: he refused to take any payment – 'Not from an artist'– and went away with a slight drawing. He refused a more elaborate one...Miss Rowland, ex-Slade student, was with him. She is learning the trade...

Friday 10
...U.C. 6.30 Complimentary dinner to A.E. Richardson on his retirement. Provost in Chair; my portrait was presented, and 3 vols. of Pyne's *Royal Residences*, worth £100. Corfiato and an ex-student made good speeches. I said a few words of compliment. A.E.R. replied very amusingly...

1 Antiquarian bookseller and author.
2 Artist and picture restorer, interned 1940-42, settled Hampstead 1945, took British citizenship 1947.

Saturday 11
Slade for a short time…and to Covent Garden…Ballet, Ninette de Valois' Sadlers Wells Company. James Bailey[3] who was a Slade student in Oxford, is now designing costumes and scenery for them. Saw *Giselle* well done; and *Les Sirenes*, Lord Berners' music and Cecil Beaton's decoration; an amusing production. Saw the stocks of vegetables held up in the market by the strike…

Monday 13
Slade term began.

Tuesday 14
After the School…went to the Mayor Gallery in Brook St. to Private View of work by our Italian student, Paolozzi, who worked with us in Oxford. The drawings… (there is a 'construction') are of a type in fashion – an idol with feet of Klee. Bought a pyjama suit, of flannel, and a pair of woollen pants, at Beale & Inman's in Bond Street: 14 coupons: £5-0-6, i.e., £3-12-6 the pyjamas, £1-8-0 the pants. They would have been about a third of that price before the War…The soldiers are handling the food-stuff in the docks and markets.

Wednesday 15
Lunch at the Club, after a succession of visitors at the Slade. Met Pitt-Rivers who was argumentative and amusing about Basic English. His Malacca cane…is a finer one than mine, and belonged to a member of his family in the 17th century. Went on to The Building Centre for a Private View of hand-wrought building materials. Aneurin Bevan, introduced by Lord Hampden and followed by Professor Reilly, did the speech-making. He spoke well and sympathetically, and has…a pleasant personality, quite different from Morrison's: he also seems to know something of his subject, how pleasant-looking houses may be built…He said he lived for years in a thatched cottage with satisfaction, and is trying to revive the art of thatching…

Thursday 16
Whitechapel Art Gallery for Board of Trustees, Bearsted, Duddington…Much trouble about getting repairs…done…the place will [not] be fit to use for at least six months… The lorry drivers' and dockers' strike is coming to an end. Towner tells me that Pitt-Rivers, whom he met at Salisbury, was a Mosley Fascist.

Saturday 18
…Tate Gallery to see the show of Alexander Cozens [1717-86] that Wheatley had at Sheffield, and that Oppé had a hand in. Very interesting. A strong suspicion that A.C. must have seen Chinese landscape work.

Wednesday 22
At Lord Bearsted's flat, or rather two flats…to interview 2 candidates for the post of assistant at the Whitechapel Art Gallery. The man chosen will probably become Curator…

3 *Giselle* was his first commission, influenced by Oliver Messel, Bailey was a much sought-after designer for opera and Ballet. From 1960 concentrated on painting due to ill health.

Friday 24
Spent the day selecting students' pictures from the 500 sent in for the Slade show at Walker's. Charlton and the 2 Slade Scholars ([Anthony] Bowerman and Pritchard) helped…7.30 Walked down to the rooms occupied by the Hampstead Art Society and drew a model for 2 hours. Met Derek Clarke[4] doing the same (there were 6 of us in all). He was in the Army, and was wounded, nearly killed, by a shot in the back…

Friday 31
Lunch with Ambrose Heal, in his newly opened restaurant at the top of his Tottenham Court Rd. premises…

FEBRUARY

Sunday 2
…Snowing hard. Many people tobogganing and skating on the Heath…

Tuesday 4
Dickey called at the Slade and persuaded me to take on again the written examinations in Art (History and Methods of Painting) for the Ministry. I agreed…if Charlton would halve the work with me, which he will…

Wednesday 5
Walker's [Gallery] again with Charlton, to finish arranging the students' pictures. Bowerman and Pritchard got on with the catalogue, and Gerrard was coming…to see to the sculpture…

Thursday 6
…Clark has written me proposing to give up his position as buyer for Melbourne…he feels it is a cumbersome arrangement for the two of us…He points out to me that if he retires and leaves me as sole buyer, they should double my fee – a generous thought.

Saturday 8
Slade in the morning…I was ordered to spend the week-end in bed…it seems I have a small temperature…

Monday 10
It is still insisted that I should stay in bed, so I got Birdie to ring up Miss Sachs and say I would not come to the School. Charlton will be there and will cope with any situations caused by the electric power and light cuts which take place from to-day…9-12 and 2-4. And, though there were some signs of a thaw this morning, the frosts are on us again tonight. It is a hard time for many people…

Tuesday 11
…Slade…News of 'Jane' Monnington's death. It happened fairly suddenly, in the Chelsea studio: thrombosis. As Winifred Knights, she was one of the most beautiful and distinguished Slade girls of her time.

4 Slade (1931-35), Clarke served Durham Light Infantry, from 1947 taught Edinburgh College of Art.

Wednesday 12
Lunch at the Provost's invitation at 6 Carlton Gardens, with Mrs. Pye, Miss Pye, a Slade student of John's time, Capt. Talbot and Miss Blakely (both of the Slade Society). Went on to Walker's for the opening of the Slade Exhibition. I introduced the Provost very briefly and he made a good speech. The function was well attended and showed a certain liveliness, in spite of the cold…and the dark (fuel economies)…Camilla Doyle[5] is dead. Miss Pye told me.

Thursday 13
Slade…then (2.30) Jane Monnington's funeral at St. Lukes', Chelsea. Saw Gerrard, a neighbour at Groombridge, Arnold Mason, an old admirer in Rome, Rodney Burn & his wife, Ledward & others…

Friday 14
The Slade, so far, has been allowed to use the electric heaters for the models, without which the life classes could not be carried on. Albert's electricity has been cut off at the Ashmolean.

Saturday 15
From the Slade to the show at India House, of Indian paintings and drawings, including some by one of our ex-students, Chavda [Shiavax]. I went on the invitation of the organizer, Chakravorty, introduced to me by his friend, Muirhead Bone. After that to the newly-opened Spanish exhibition at the National Gallery. A number of important Velásquez' and Goyas – the Duke of Wellington's among others – lent and hung side by side with the N.G. examples. The N.G. *Philip – Old* has been cleaned and looks disagreeably chalky compared with its previous state…

Thursday 20
Function at R.I.B.A., Portland Place. Opening of Danish Exhibition of Arts & Crafts. Speech by Danish Minister. Good metal work – rustless steel – china, and utility furniture, but, on the whole, we do these things as well in England…

Sunday 23
Snow, but the first gleams of sun for many days…I called on K. Clark about Felton business…It is true that his audiences in Oxford are large. He says the greatest number was 750…We talked about Henry Moore. Both he and Lady Clark (corroborated later by Towner) said it was most unjust to say, as H. Carr did (see Nov. 8, '46), [sic] that Henry Moore was bogus, opportunist or insincere in his art. On the contrary, he is still simple and genuine: so is his wife [Irina], whom I knew in her student days at the R.C.A. Moore has never extracted money from K.C. He is a miner's son, and was very poor, so I suppose he had to think a little about ways and means. The other day he was having lunch with Lady Clark and she was about to pay for it, as usual, when he stepped in and did so, saying that he was glad to do so, as in the old days he never could afford to pay for such luncheons. Towner was a fellow-student of both Moore and H. Carr.

5 Doyle took her own life in 1944.

Monday 24
...Received a tin of food stuffs from Australia...I suppose sent by Keith Murdoch. A kind thought...

Tuesday 25
Tea in Committee Room, U.C. before lecture in Anatomy Theatre, on Museum administration, by Dr. Allen of Edinburgh, who spoke well, as Scots do...

Wednesday 26
Mr. Mories interviewed me at the Slade, to get material for an article on me in *The Artist*...

Friday 28
Wellington (who was lecturing at the Slade) and I discussed our recollections of Wyndham Lewis when a student – the poems and other things he used to write, among them, it seems, a pantomime. I remember Lewis producing a sheaf of poems for Robert Gregory to read; and the solemn way in which he handed the MS. one by one (I did not actually see this, but Gregory must have reported it to me. F. M. Kelly was amused by a similar experience). W. Lewis had the reputation of not paying his models: this was unusual and, naturally, considered rather 'low'...

MARCH

Saturday 1
Lunch, Athenaeum. Philip James. Coffee and brandy...with Barnett Freedman. Later Oppé joined us. F. recollects, when he was a student, Norman Dawson telling Herbert Read of the existence of Picasso, who had never heard of him before. 'What's the man's name – Piqu—?' 3.30 Tried to get into the N. Gallery but...The queue too long for my patience. Art is certainly being popularized (or is it that the Nat. Gallery is a nice warm place? There is still a bitter wind...)...

Sunday 2
MacColl's. Later, Jan Hutchinson...He [MacColl] was reminiscent about Ruskin and his lectures in the Museum at Oxford. Ruskin was not pompous, but friendly, and suggested coming to see D.S.M. in his rooms; but this did not come to pass...

Monday 10
...Wellington, who was snowbound last Friday, when he should have lectured at the Slade, was able to come to-day. Bought one of Tunnicliffe's excellent Bird books for Janet's birthday. She will like the pictures, and, with Bysshe's help, like to know something of the text, when she is older. Tunnicliffe was a farmer's son from Macclesfield. He always had an interest in animals and birds. Tunnicliffe, Towner, Ravilious and another man shared 'digs' when students at the R.C.A. The rooms at Walham Green, were kept by a butler's wife and were very comfortable...

Wednesday 12
3p.m. At the opening of a show at the Leicester Galleries: paintings and drawings by Methuen, some very fresh and full of feeling for the country; other paintings by Ivon

Hitchens [plate 29], pleasant colour and pattern…4p.m. Meeting of Editorial Committee O.W.C. Society's Club. Russell Flint, Cecil Hunt, Jowett, Philp and Bury. Costs of printing for the annual volume are now about doubled, and the Club's financial position is serious.

Thursday 13
Staff Meeting in my room to discuss making additions in some form to the teachers already employed. Proposals originated from Gwynne-Jones – strongly opposed by Charlton and Wilkie, who think the drawing side – the Slade's fundamental thing – is in danger, if painting is too much emphasized; but most of those present were in favour of some sort of *liason* [sic] with teachers like Coldstream, Pasmore, Moynihan, Gowing…Charlton wants young draughtsmen; but whom? He might resign himself, which would be a serious loss. A worrying business…

Friday 14
…Took six drawings to the R.W.S. for the forthcoming show…Charlton met me at Hampstead and discussed a possible compromise in the Staff situation…

Sunday 16
Went to MacColl's. Warmer and more spring-like to-day…Talked about Sickert in Dieppe, picking the lice from the hair of his mistress's child: also about Will R.'s inaccurate account of the Tweed-Alfred Stevens affair of the Wellington-Memorial.[6] Will claims that he and Legros had more to do with this than they really had. D.S.M. was the prime mover.

Monday 17
R.W.S. Election. New Associates Carr and J. Milner. Went to the Club for tea with Dodd, picking up Sydney Lee in Piccadilly on the way. Lee is getting to look very old. He is a man of dignified appearance, though, and good manners…

Tuesday 18
2.30-3.45 Staff meeting to discuss visiting teachers. Settled this amicably in principle. Gerrard told me something of his early history afterwards at tea. He comes from near Northwich in Cheshire. When a boy, 13-15, he used to attend an evening technical institute – he couldn't get to a proper art School – and he walked six miles to it every evening and six home…He used to bring birds, chickens and the like to the Institute to draw. The drawings were noticed. Sir Alfred Mond helped to get the boy to Manchester Art School. In the 1914-18 War Gerrard was in the R.F.C.….He had several crashes…After the War, he came to the Slade with a Govt. grant.

Thursday 20
12 o'c. at the Building Centre, Conduit Street, a beautiful house defaced by modern utility gadgets and advertisements. Met Aslin, Keith Murray, Mercer of *The Studio*, Yerbury and Lynch, with Max Ayrton, and looked at the models of the projected Tilbury Stadium: an interesting demonstration…

6 John Tweed was commissioned in 1901 to complete the Memorial in St. Paul's. He was considered by some insufficiently known for such a project, MacColl was among the critics; but the completed monument was well received.

Friday 21
Trouble in the Slade Society. Capt. Talbot resigned, and a group, with G.[Geoffrey] Scowcroft Fletcher[7] as chief spokesman, and Walton and Sue Palmer in support, came to the fore. Ruth Lowinsky telephoned that Tommy was in the Woolavington Ward of the Middlesex. He still does not know how dangerously ill he is, being free from actual pain...At four o'clock I went to see him...

Saturday 22
At R.W.S. 'Touching-up Day'...Russell Flint, Mrs. R.F. Rushbury, Hartrick, Holding, Holden, Ethelbert White and Betty, the Lee Hankeys, Harold Knight...Rushbury told me that he...congratulated Muirhead Bone in very high terms on his drawing of the *Painted Hall, Greenwich*, saying...something to the effect...that no one else, living or dead, could have done it. Muirhead Bone burst into tears.

Tuesday 25
...After the Slade, on my way home, called at 35 Flask Walk to inquire about Connell, the Beadle, who was absent from the School, ill for the first time that I remember. An excellent fellow, who does a great deal for me...

Wednesday 26
Charlton and I had an interview with the Provost about the proposition to invite teacher-visitors to the School. The Provost approved...Went to Zwemmer, and bought the big charcoal drawing of a nude by Degas. It has been cleaned and reframed. The price was £300...I think this was reasonable. K. Clark liked the drawing...but it did not fit in with his conception of a Gallery piece. However, he left it to me...

Monday 31
4.00 to Little College Street, to verify the big Degas drawing. Went on to Bruno Kohn's office in Finsbury Pavement to get a new thermos flask for Birdie. They are almost impossible to buy now, and yet Bruno (who started a factory to help his ruined German Jewish relatives) thinks he will have to give up making them, the obstacles to production are so many, and he is losing so much money...

APRIL

Wednesday 2
Started a drawing of [Sydney Taverner] Shovelton, Secretary of King's College, in his big room looking on to the quad. He is a pleasant gentleman, coming from Manchester, and familiar with persons and things there that I remember in my childhood, such as the building of the Ship Canal, the presence of the De Traffords in Trafford Park, the fine old trees there and the farms at Barton, where my father and my grandfather Ermen lived...

Thursday 3
A second drawing of Shovelton...We both preferred it to the first one...

7 Artist and critic, best known for *The London Nobody Knows* (1962).

Friday 4
Visited Tommy Lowinsky in the Middlesex. The paralysis of his left hand is not cured...

Tuesday 8
Lunch at the Club...Freedman took me in a taxi to 59 Cornwall Gardens to see his big
war picture of the landing at Arromanches;[8] an excellent record and a piece of fine crafts-
manship. He has the drawing-room in the house from a friend, and pays 30/- a week
for it – a big, light room, looking north.

Friday 11
Slade...Went to the Redfern Gallery...Some of Lee's work keeps an interest for me.
[Michael] Rothenstein has taste, but less interest (he has sold half a dozen drawings)...

Saturday 12
Saw MacColl...He told me that during the War, Steer, being like so many others, obliged
to go and do his own shopping...aroused considerable sympathy among younger artists
in Chelsea, who talked about raising a subscription for the 'poor old man'. 4.30 Started a
drawing of Fenton House [Hampstead Grove], but did not more than 2 hours work. It is
now double summer time, so that when one gets out of bed at 7.30 a.m. it is really 5.30...

Wednesday 16
...Slade, saw some new work by G.S. Fletcher. Looked at Stevens's drawings & bronzes,
Leicester Galleries, mostly left over from Drury Coll. Lunch at Club...Went on with Shaw
in a taxi to School at Rome judging, Imperial Institute. Awarded an Abbey Scholarship,
after some doubts, to Peter Barry, who was certainly the best. The judges were Burn,
Monnington, Moynihan, Minoprio & myself. (4 Slade men)...I am Chairman of the
Faculty of Painting meetings this year. There was a Sculpture Faculty meeting at the same
time. Met Durst, Dobson, Hardiman.

Thursday 17
...Mrs. Pissarro's, Stamford Brook Green, to see pictures by Camille and Lucien; some
delightful ones, others disappointing (perhaps being shown without frames accounts
for some of that). Orovida was with her mother. There were a small panel of Havre, a
fan (of a group of girls) a large woodland subject, a snow scene in a farm yard and some
others in the pointilliste technique that I specially liked (these by Camille, including the
pointilliste ones, I am almost sure). She would accept about £1500 or £2000 for some
of them. Some she would not sell. A sheet of 2 drawings, studies of peasant women, by
Camille, she has been told to ask £250 for...

Saturday 19
...Another hour's drawing at Fenton House after tea. Tea with Ivy and Charles at no. 10
Drayton Gardens. They moved in a month ago...

Monday 21
Slade term. Lunch with Albert R. to discuss Oxford Exams...

8 *The Landing in Normandy; Arromanches, D-Day plus 20, 26th June 1944*

Tuesday 22
After the Slade, Charlton and I visited the Derwent Lees show at the Redfern Gallery (see Fri. Ap. 11). [sic] I bought a sanguine self-portrait of Lees, with a beard, for £20, for Australia, supposing that they may be interested in him as Australian-born. The drawing is like, though Lees did not usually wear a beard...

Wednesday 23
Train to Swindon, to examine the scene for a topographical drawing. Tommy Lowinsky had put me in touch with the local organizers of such things. Was met at Swindon station by Mr. Diamint and Mr. Joliffe (the Librarian), both young, energetic people...Managed to see the few beauties of Swindon; also the Charles Rutherston collection of paintings, on loan; the beginnings of the Swindon collection of modern art – quite lively and interesting if not all good – including Graham Sutherland, Moore, Ben Nicholson, Francis Bacon, Steer and Gwen John – and some things in the Library. Was introduced to a local artist, talented, named [Walter] Poole. Home 7.15p.m.

Thursday 24
...In the evening I rang up the Lowinskys, to report on Swindon. Ruth told me Tommy died to-day...Fortunately, no pain, and to the end Tommy remained in ignorance of his desperate condition. He is to be buried at Aldbourne.

Friday 25
Party given by the O.W. Society's Club in the Gallery at Conduit Street...Claude Muncaster sang sea shanties...He has a beautiful voice, and was a sailor before the mast on a trip round the Horn...At my suggestion, the Ethelbert Whites, too, brought a guitar and sang – Spanish and Cockney songs – very well...

Saturday 26
Started on a drawing for Hubert Worthington, of his old School, Sedbergh...I am doing it in pen for reproduction by line block, and making use of photographs and drawings. Worked about 5 hours on this. My fee is to be about £7-7-0: the size 12 x 8.

Sunday 27
...Had a drink with Ayrton. Daphne Charlton came unexpectedly to supper... She described to us her lodger, a young musician from Cardiff. Stanley Spencer is meditating divorcing Patricia, re-marrying Hilda and living a respectable family life. He keeps an intimate journal in which these changes are noted.

MAY

Friday 2
Fetched my drawings of Shovelton from Lewis, and took them to the Club. Met Halliday of King's there and showed them to him. He approved. He said he meant it, and wasn't saying so to be polite: and he took them to the College in a taxi...

Monday 5
Professor Wu's[9] exhibition in Gordon Square. Met Chiang Yee, Stanley Spencer and the

9 Schwabe records that Wu came from Peiping University under the auspices of the British Council.

Chinese Ambassador. Some good drawings and interesting copies of cave paintings in China.

Tuesday 6
…Was paid for the Shovelton drawings, £20 each. Also, Richardson has got me £20 for my old drawing of the Jockey Club.

Wednesday 7
Coldstream came to the Slade as a visitor, for the first time, and went round some of the painting rooms. He seemed to get on well with the students. A warm summer day…so that the ban on electric heating did not affect one.

Friday 9
…Corfiato's Inaugural Lecture (on the Evolution of Architecture) in the Bartlett School. The Provost introduced him. It went down well. There is no question of Corfiato's popularity…

Monday 12
…Towner returned from Tenby, with six paintings, a month's work…He says that Augustus John is the great local figure – everybody is interested in him and talks of him – evidently not a case of a prophet without honour in his own country…

Tuesday 13
At Tooth's in Bruton Street, to see the *Gas Works* [1886][10] by Signac an early picture which K. Clark considers one of Signac's best. K.C. thinks Australia ought to buy it. I agree. I talked to one of the partners, who was in Australia and knew Burdett and Young and McDonnell. This partner has a drawing of mine, which he bought out there. He bought another at the same time, but appears to have it no longer. One was a nude, the other a study of Mrs. Edwards the well-known Chelsea model, who sat for many of us, including Sickert.

Wednesday 14
Moynihan taught at the Slade for the first time…Tea in the C.R., before Professor Wilde, of Vienna, delivered his lecture on Michelangelo and Sebastian del Piombo [c.1485-1547]. His Chairman was [Thomas] Boase, who is to be next President of Magdalen…

Saturday 17
Corrected examination scripts in the History & Methods of Painting…for the Ministry of Education. Was paid £10-10-0 by Sedbergh School for Worthington's drawing.

Wednesday 21
Train to Bristol, with Jowett, for the opening of the N.E.A.C. Exhibition in the Municipal Galleries…Jowett and the Lord Mayor spoke. The show looked well…The city, of course, looks very dilapidated.

Thursday 22 – Wednesday 28: no diary entries

10 *Gasometers at Clichy* (National Gallery of Victoria, Melbourne).

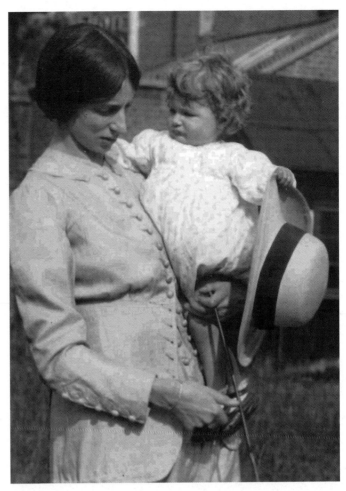

PLATE 34
Birdie and Alice Schwabe, c.1914–15
COURTESY JANET AND DI BARNES

PLATE 35
Willie Clause, Alice and Randolph Schwabe, Cashelnagore, Co. Donegal, 1926
COURTESY JANET AND DI BARNES

PLATE 36
Photograph used to announce Randolph Schwabe's appointment as
Professor and Principal of the Slade School of Art, 1930
COURTESY JANET AND DI BARNES

PLATE 37
Randolph Schwabe at the fair, 1932
COURTESY JANET AND DI BARNES

PLATE 38
Slade Picnic, 1932: (left to right) Ormrod, Charlton, Daphne Charlton, Schwabe and Wilkie
COURTESY JANET AND DI BARNES

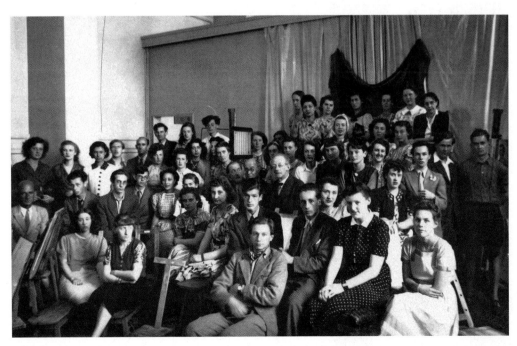

PLATE 39
Slade & Ruskin Schools, Oxford, 1941: Schwabe is seated in the third row from the front next to Rutherston on his right; Polunin is seated beside Rutherston
COURTESY JANET AND DI BARNES

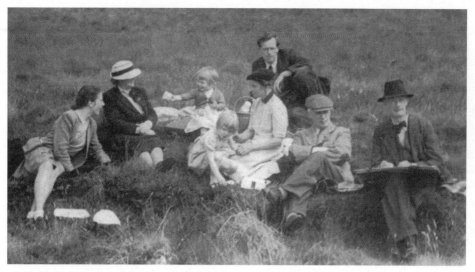

PLATE 40
The last photograph of Schwabe, August 1948: a family picnic, Glen Fruin, near Helensburgh:
(left to right) Margaret Cobbe (niece), Granny Barnes, Diana Barnes (aged 2½), Janet Barnes (aged 4),
Dora Cobbe, Harry Barnes, Grandfather Barnes and Schwabe
COURTESY JANET AND DI BARNES

PLATE 41
Model by Alan Durst for a memorial
to Randolph Schwabe, 1950
COURTESY JANET AND DI BARNES

Thursday 29
London Group party, Elliott Seabrooke and his wife acting as host and hostess. It was in the R.B.A. Galleries, where the members' works are now shown. Buffet supper. The Dursts were there, and many people I had not seen for years, including Nina Hamnett and Mrs. Karlowska Bevan. Nina is now a formidable-looking person, and seems full of life.

JUNE

Thursday 5
Slade Diploma judging. Albert R., Wellington, Reid Dick, Corfiato, Ormrod, Gerrard, Charlton. Of these, the first 5 and myself are the Examiners: the others give valuable help. It is a big job now: some 48 candidates' work to examine. There were 8 failures. The work was shown in 2 of the new cement huts in the quad, which, when a hot sun shines, as it has been doing recently, with temperatures of 93, drip pitch continuously from the ceilings. Luckily, it was cooler to-day and we were not bespattered. We had provided the Examiners with overalls as a precaution...

Friday 6
With Jowett to R.B.A. (where the London Group show is still on) for an Executive meeting of the N.E.A.C. I was in the Chair. Others, Burn, Gilbert Spencer, Guthrie, Ronald Gray, Cheston, Fisher Prout, Devas, Cundall, Chisman, Yockney. At 3.30 General Meeting, Jowett in the Chair: Vincent Lines, Barry Craig, Rupert Shephard, Lady Patricia, Evelyn Dunbar, Eth. White, and perhaps a few others.

Monday 9
Committee at R.I.B.A. First stage of award of medal. Present: Goodhart Rendal,[11] James and others. Unanimous condemnation of Giles Gilbert Scott's Waterloo Bridge [1942].

Tuesday 10 – Wednesday 18: no diary entries

Sunday 22
...Went on marking scripts. They have kept me too busy to allow my going on regularly with this Diary. Charlton and I, between us, have now marked nearly 700.

Monday 23
Slade – judging of drawings for Prizes...they are of a reasonably good standard – no decline...A man named Saxton, and G.S. Fletcher, are among those who will get prizes.

Tuesday 24
A perfect day for the Slade Picnic. By boat from Westminster Bridge to Hampton Court... accommodated about 50...Nuttall-Smith, Charlton and Daphne, Brooker, Wilkie, Janes, Connell and Mrs. C. all came. There was a bar on board...A puppet show after lunch *Maria Martin, or the Murder in the Red Barn* with cleverly made puppets, in the semblances of Nuttall-Smith (the villain), Marie Chant (the heroine), Gwynne-Jones, Charlton, myself and others...

11 Architect, writer and musician.

Thursday 26
Slade Prize-giving...Saxton, Baynes, Bartlett, Fereday, among the winners...

Friday 27
The Provost presided over a second performance of the *Judgment of Paris* by Peele...
acted by the Slade students in the Gymnasium: produced by Horace Somerville, who
wrote the music and conducted the orchestra: scenery and costumes by Sue Palmer and
Bartlett. Corinne Lloyd very fine as Juno. Gwynne-Jones organized this affair. It was quite
a distinguished production, and there were distinguished persons among the audience.
I noticed Edith and Osbert Sitwell, who liked the show...

Sunday 29
Left for Cardiff...

Monday 30
Judging entrants for Scholarship. Met Dr. Stevens, Director of Education, and Evan Charl-
ton...Charlton took me off to tea at Llandaff. He has a house near the Cathedral...A bomb
fell close to it in the war, and the roof is off: Looked at pictures by Charlton and his wife,
and then he drove me to the station...

JULY

Tuesday 8
Charlton and I have finished marking the 959 scripts of the 240 candidates in for the
Ministry of Education's Art Examination.

Thursday 10
Executive meeting of the School at Rome...I am now on this committee ex-officio,
having become Chairman of the Painting Faculty. Present – Sir F. Kenyon (Chair), Sir G.
Hill, Sir Evelyn Shaw, Sir H. Pelham, Sturch, Ashmole, Ledward, Monnington, Osborne
& the Director...

Friday 11
...Lunch at Athenaeum, with Leonard Huskinson and his guest, Lynton Lamb. After-
wards, Huskinson (who is now doing illustrations for Trollope) went with me to the
V.&A. Mus. and saw the Hilliards and Olivers, and the Duke of Wellington's treasures.
Huskinson, by the way, is a descendant of Huskinson of the Railways, and also a great
nephew of John Leech.

Sunday 13
...Called on the Ayrtons...Looked at Max's drawings for the new Bedford College in
Regent's Park. Talking of George Sheringham, Max told us that when S. was dying of
cancer of the lung and was doped to lessen the pain...he [later] refused...the dope...
during the day-time...as, though the pain was lessened, he was prevented from sitting
up in bed and drawing.

Tuesday 15
Lunch at the Club, with B. Freedman and Walter Lamb. Lamb was full of reminiscences of yachting off Cornwall and the East Coast. Freedman was busy seeing to the hanging of modern artists' lithographs – on loan – in Lyons's tea-shops – a new scheme. His boy Vincent, who seems exceptionally brilliant and precocious in some directions, has just passed his entrance for Westminster School. Freedman's favourite reading is Burton's *Anatomy of Melanchole* [1621]...

Wednesday 16
Lunch again in Freedman's company. He was continuing with the hanging of the lithographs...These...will be for sale at 15/- each. The Government purchase tax on that is about 6/-. Freedman was abusive about Anthony Betts, whom he seems to regard as an impostor, who never did any work of his own (incidentally, I have seen masses of work by Betts); and he alleges that Betts, when a student, used to pass off work by Horton, Freedman, [Gerald Judah] Ososki and others as his own...

Thursday 17
Charles Tennyson had lunch with me at the Athenaeum...Hallam is giving up his Indian job at Christmas, and retiring into some sort of monastery to study Indian philosophy till April, when he and Margot come home...Started drafting certificates of merit at the Slade – a long and complicated job...

Friday 18
R.I.B.A. The Committee for the London Architecture Bronze Medal met and drove first to 65 Ladbroke Grove (Maxwell Fry), then to Westminster Hospital (Holden), then to the Hostel for Girls, Univ. of London, in Gower Street, then the National Hospital, Queen Square (where Kenneth Clark stood me half a pint at the corner pub, that I knew in Francis Unwin's time); next, to the Water Board's building at Sadler's Wells: finally to the Blackheath Road Police Station, which was recommended for the Medal...

Sunday 20
Train to Swindon, to stay at Aldbourne with Ruth Lowinsky, who is putting me up while I do the commissioned drawing of the Square in Swindon Old Town [plate 30]. ...Brinsley Ford and his wife were staying for the weekend. Ford and I visited the fine church with its 2 big tombs.

Tuesday 22
...I made a routine of getting to Swindon about 10.35 by bus and leaving about 6.35, also by bus; working about 6 hours each day. The Lowinskys paid £6000 for The Old Rectory with 14 acres...There are at least 3 servants, a cook, a housemaid and a man, besides gardeners. A workman who was doing up a room in the house, whom I talked to, was one of the original Aldbourne Village Players organized by Charles McEvoy.[12] Birdie and I remember them in London, and what good shows they gave.

Thursday 24
...The wine merchants in the Square at Swindon, whose premises figure in my drawing,

12 Author and playwright, lived Aldbourne early twentieth century, built the Village Theatre 1910.

were very pressing that I should do another portrait of their building (once the Corn Exchange), but I declined...I had a glass of excellent sherry with them.

Saturday 26
...Left Swindon...

Monday 28
A week's accumulation of letters at the Slade – a day's work...

Wednesday 30
...committee at the University to decide on the conferment of the title of Professor on Gerrard. This went through. I was there in place of the Provost, who is on holiday...

AUGUST

Sunday 3
Left London for Dover, to Churchill House [Cobbe's house, 61 Salisbury Road]...

Tuesday 5 – Tuesday 12: no diary entries

Wednesday 13
Finished all I could do to the drawing of Waterloo Basin and made notes of the lighting...

Sunday 17 – Monday 25: no diary entries

Tuesday 26
Went up to London for the day – Slade. Took 3 drawings to Lewis to be mounted and framed.

Wednesday 27 – Friday 5 September: no diary entries

SEPTEMBER

Saturday 6
To Glasgow. Left Dover about 4.40 by train. Left Euston 1st class sleeper, 9.05.

Sunday 14
Bysshe took us to see the newly arranged C.R. Mackintosh room in the Art School: it is used as Bysshe's office: he appreciates it highly.

Wednesday 17
Went to have coffee with D.P. [Percy] Bliss...His old mother, with MacCrum and a painter named Laurie, who does portraits, were there.

Friday 19
Walter and Sally Pritchard came in for coffee...He has done a great figure of St. Andrew

in sheet aluminium for the Edinburgh Scotland can make it Exhibition: it is much discussed: Bliss thinks well of it.

Sunday 21
Back in London...

Tuesday 23
Gave lunch to John McDonnell,[13] our Australian friend of about 15 years ago: now an ex-colonel, and buyer for the Felton Bequest...

Wednesday 24
Birdie and I dined with Arthur Norris...in Millais House. He talked of many things – of Gotch, in Oxford, whom he likes, and respects for the honesty of his work. Gotch has an honorary degree from the University. He built himself a house on Cumnor Hill, commanding a very fine view. He was a friend of our old friend Francis Unwin...

Monday 29
...After lunch, to Lewis to collect three beautifully mounted and framed drawings. He knows his own value. He has been framing some drawings of Lytton Strachey by Henry Lamb: when Lamb made some suggestions about the wash-lines and the quality of the glass, Lewis said he thought he would rather not do the job: so Lamb gave way. Lewis criticized one or two points in my works, and then said 'Fancy me talking like this to the Slade Professor!'...

Tuesday 30
Lunch at the Club. C.K. Ogden talked about his meeting with Picasso at Antibes, where J.D. Ferguson also was at the time. Ferguson appeared to get a great deal out of Picasso's conversation on art...

OCTOBER

Wednesday 1
...Anne Newland, the Abbey Scholar, came to see me at the Slade. She leaves for Rome tomorrow. She has wasted the War years, as far as her development as an artist is concerned, by her service in camouflage at Leamington. I tried to give her good advice about the study of Tintoretto, in whom she is interested. I hope she will be able to get to Venice.

Thursday 2
Slade...Went with Albert to the Tate, where they have re-hung Hogarth, Blake, Turner and Constable: an impressive show. Even I (and I am always told I have no imagination) had my imagination stirred. I have the warmest admiration for these men of the British School. Queen Mary was going round the pictures unofficially with John Rothenstein...

Friday 3
...8-9.30 Hampstead Artists' Drawing class. Two models posed together, man and

13 London adviser Felton Bequest (1947-64).

woman. All very proper – that is, the man wore a slip. The class is mixed...

Saturday 4
From the Slade to the B.M. with Nuttall-Smith, to look at the drawings again. Van Dyck is one of the finest of water-colourists. The early Turner water-colours have something of his quality.

Monday 6
Slade term began. Nuttall-Smith, Gwynne-Jones, Wilkie, Charlton, Gerrard (now Professor) Bartlett and Polunin all present. Lunch in the new Staff Refectory, an overcrowded concrete hut...

Tuesday 7
R.B.A....to judge N.E.A.C. pictures – 1500...Present Jowett, Gilbert Spencer, Devas, Ethel Walker, Vincent Lines, Milly Fisher Prout (whom Ethel dislikes), Buhler, Middleton, Todd, Dunlop, Gross, Rodney Burn, Chisman and Yockney...Towner's Private View at the Beaux Arts...

Wednesday 8
Hanging N.E.A.C.. Jowett and I tackled the drawings, Burn, Spencer and Guthrie the oils...Left the Gallery about 4.30, after a bit of a scene with Clara Klinghoffer, who had sent her drawings unframed and expected the hangers to hold the show up while she got frames for them. Two of her oils had been rejected by the jury yesterday, in spite of her being a member...

Thursday 9
N.E.A.C.. Finished what I could do, and went to see Towner's show. He was there, but no one else, and there are no sales yet. Proceeded to Zwemmer's Gallery, to see Jas. Wood's exhibition. A pencil drawing of C.K. Ogden very like. Most of the other works rather highly stylized. Met Wood and Zwemmer, otherwise the place was deserted...

Friday 10
Rather a heavy day at the School, settling about some bursaries among other things...

Saturday 11
Slade. Made some researches into the facts about Degas, in connection with Robinson's proposed book (he called yesterday)....

Sunday 12
...Was asked to tea in the Hutchinson's garden...There is a reference to him in *The Sunday Express* to-day. He is described as tall, gaunt and of Mephistophelian appearance. His work for the Conservative party is beginning to be much appreciated. The H.'s are very satisfied with their new chauffeur, who does a lot of work in the house, cleaning brass, doing fires (when there is any coal)...It is increasingly difficult again to get women for private domestic work. The paper says 5½ million of them are engaged in work of national importance.

Monday 13
An unlucky day at the Slade. Pronounced disagreement between Charlton, Gwynne-Jones, and myself about the principle of having visiting teachers. At 4 o'c. took a taxi with Wilkie to Whistler's House, 96 Cheyne Walk, to see a show of early English drawings and water-colours belonging to Paul Oppé...The big drawing room floor is... where Whistler painted his *Thomas Carlyle* [1872-3].

Tuesday 14
Tea in Common Room before a lecture on *The Profession of an Archivist* (a diploma in that profession has been founded) by Mr. Hilary Jenkinson of the Record Office, introduced by the Provost and the Master of the Rolls. Gerrard came with me to the Theatre. We agreed that the lecturer was quite exceptional, and made his matter interesting, though off our beat...

Wednesday 15
Moynihan teaching at the Slade. Tea at the Club with Francis Dodd. ...Gere has been going through a bad time financially. The R.A. has been helping him. His private income is under £300p.a. He has been selling pictures occasionally at £5 each, which does him little good.

Thursday 16
Visited Victor Pasmore, with John McDonnell. We travelled down to Blackheath by train...McDonnell's object was to buy one of Pasmore's pictures for Melbourne...They have only recently moved into the house in St. German's Place...the bombed Paragon and rows of 'pre-fabs' on the common don't improve the view. Pasmore had not many pictures in the studio: some nocturnes of distinction and beauty, 2 nudes, a portrait of a strange old man and some minor things...McDonnell would have liked to buy one of the nudes, but it belongs to the Contemporary Art Society. He thinks he may decide on one of the nocturnes of Chiswick. The price is 400gns....

Friday 17
...Private View of N.E.A.C....Muirhead Bone has sold all his drawings...and the total sales, Chisman says, are about £300...

Saturday 18
Lunch with John Wheatley at the Club...He had been painting Bertrand Russell during the morning at Russell's house. He thinks of resigning from the Sheffield Gallery, having, I presume, a fair run of commissions: yet he says he never knows whether he is not overdrawn at the Bank...

Tuesday 21
Gerrard is enthusiastic about the quality and number of the Slade Summer Paintings, and the spirit behind them...He says that Monnington, his neighbour at Groombridge, is doing a good deal of painting again. There was a time when he appeared to have lost interest in his job, a rare thing for an artist. Jane and he, Gerrard says, were an ill-assorted couple, who got on each other's nerves. She used to criticize his pictures very severely.

Wednesday 22
Gave Birdie and Hagedorn lunch at the Athenaeum Annexe. Nelly H. was in bed with
bronchitis. She still works at the prison and has a long and tiring daily journey with three
changes and waits for buses: finishing up by cooking the dinner at home. Hagedorn and
Nelly went to the Royal Garden Party this year, he in his morning coat and tall hat that
he had not worn for years. He was much impressed by the affability of every member
of the Royal party, and the hard work they put into these social occasions. He was invited
as Treasurer of the R.B.A. (D.M.S. Watson, who is a Trustee of the British Museum – no
sinecure, as they hold meetings there once a fortnight – tells me that King George V was
a regular attendant at the Museum Trustees Meetings)...

Thursday 23
The difficulties of house-sharing are becoming very marked at no. 8 Church Row, with
Birdie still sleeping in the bath-room, and maid Isabel giving notice, and the bother and
worry of buying food. There have been no onions in the shops, for instance, for over a
week. Leeks are very dear. A head of garlic costs 1/-; ordinary cake, with a few currants
in it, is 2/6d a pound. Lettuces are 8d each.

Saturday 25
...Feltham, to the Hagedorns – an excellent lunch, tea and supper. Nelly is a first-rate
cook. Saw a great many recent paintings and water-colours by Karl...He teaches 2 days
a week now, at a co-ed. school in Epsom...

Sunday 26
D.S.M. lent me a copy of his *Poems*...They were published at MacColl's own expense
by Blackwell of Oxford two or three years ago. The edition is sold out...

Tuesday 28
Augustus Daniel came on my invitation to see the Slade Summer Compositions. He was
impressed...by the size, number and quality...So were Claude Rogers and Nancy Higgins
(a student of a few years before the War), who came later...Daniel has been carefully
re-reading [Sir Joshua] Reynolds' *Discourses* [1769-90], which he greatly admires. He
contrasts the intellectual range of Reynolds with the far smaller powers of Constable, as
shown in [Charles] Leslie's *Life*.[14] Daniel shows his age now rather markedly. He is over
80. When he had gone, Charlton, Gwynne-Jones and I got down seriously to the business
of Prize awards and commendations. [Anthony] Bowerman, Barnes' old pupil from
Bushey, and G.S. Fletcher are to share the 1st prize...

Wednesday 29
Tea at the Club with Francis Dodd...[He] says that Manzi the model fell downstairs,
fractured his hip and died a short time ago [aged] 90. There is a good pastel or chalk
(sanguine & white) head of him by Tonks in my room at the Slade...

Friday 31
...Executive meeting N.E.A.C. at the R.B.A. Galleries: Chisman, Burn, Cheston, Devas,
G. Spencer, Methuen, Jowett (Chair). Went on to Private View of R.W.S.. Some good

14 *Memoirs of the Life of John Constable* (1843).

work by Albert R., Rushbury (*Brantôme*)…I apologized to Flint for not writing to congratulate him on his knighthood. He said he was glad I didn't. As it was, it had taken him a month to answer all the letters…Gilbert Spencer is pretty well as dirty as Stanley – unshaven, with dirty hands and finger-nails. Towner's nails are always rimmed with black too.

NOVEMBER

Sunday 2
MacColl was full of his recent meeting with Steer's model, Rose Pettigrew (now Mrs. Warner), now aged about 70. She was engaged to Steer when she was about 14-16, but broke it off. The sight of Steer with a cold, with his head over a steaming basin of medicament, helped to make her realize her mistake. Steer was a good deal older than she. She has left several paintings of herself at MacColl's house, which she wants D.S.M. to authenticate as being painted by Steer…I thought them good…

Monday 3
3-4.15 Slade Summer Compositions criticized: 84 in number. Combined effort by Gwynne-Jones and Charlton, who held the students' attention. Tea at the Club. Met Jas. Wood. He sold about £500 worth of pictures at Zwemmer's…

Tuesday 4
…Ethel Walker's Private View at Agnew's…Prices range from £200 down to £15-15-0 for some of the drawings. About £200 worth had been sold. A very distinguished exhibition, in spite of faults. Memorable – *The Hon Mrs Adams: A Family Group* (early work): *The Land of Ecstasy* [1933-5], *Lucien Pissarro* [c.1938-9](very like)…

Wednesday 5
…Board of Studies in Architecture. Chairman, Rev. Mortlock of St. Vedast, Foster Lane, a Cambridge Don, who used, according to Darcy Braddyll (also present at the meeting) to write dramatic criticisms for the *Daily Telegraph*. Efficient, clear-headed; but what he knows about architecture, or why he is chairman, I don't know…

Thursday 6
Fog. The students tried the new fluorescent lighting. Met A.E. Richardson…He had been lecturing on Renaissance architecture in the Bartlett School. Some of our Slade people, the two Fletchers among them, take great interest in his lectures, and this pleases him.

Saturday 8
…R.A. Walker, still working on Aubrey Beardsley, and full of information about Charles II's escape after Worcester. Coffee: Oppé, discussing Hogarth's drawings and methods of work…A Hungarian lady, displaced, came from a Registry Office to see about undertaking the cooking at no. 8, but the interview came to nothing. Birdie gave her 2/6d to help with her expenses of a wasted day. A very hard life these emigres have.

Sunday 9
At MacColl's…Found him listening reverently to the Remembrance Day service on the

wireless. He pulled himself out of his chair and stood to attention for the 2 minutes silence. Returned his volume of poems. I cannot say I got much out of them, though he has great control of language…

Monday 10
Philip James came from the British Council to look at the Slade Summer Compositions… Gwynne-Jones took him round. Potatoes went on the ration to-day. 3lbs. a week per head.

Wednesday 12
Coldstream at the Slade. There is a National Savings campaign going on. The Bank sent round a circular urging investment. I returned their form with a request for £100 worth of Certificates. 9.15 Dalton's Budget speech on the wireless. A poor speaker. Expenses will evidently go up, but not as much as we feared.

Thursday 13
R.A. Shaw, from Melbourne, called…I gave him a drawing, as he had been kind in the matter of a food parcel, and a sponge. We first met, I think, at Ferranti's, during the War…when I was doing industrial drawings for Manchester?…Oliver Stanley made a poor speech on the wireless criticizing Dalton and the Labour Party…

Friday 14
After the afternoon's work, paid a visit to [Henry] Warren Wilson, at his invitation, at his studio in Lettice Road, Fulham, to see a window he has just finished for a church in Cambridgeshire…A well-designed thing, though I could not see the colour well: it was getting dark…Other glass workers are in the same block of studios, and the firing is done there. Anning Bell used to make use of the premises. Dalton resigned.

Sunday 16
…MacColl told me he now has a written account from Pettigrew of her relations with Millais, whom she respected and liked. When she sat for him as a model he paid a guinea a day, which she thought generous, though I have an idea that it was an understood thing that all R.A.s paid at that rate. In my time the usual pay was 2/6d an hour. It is now 4/- or 4/6d, in schools at least. D.S.M. refused a knighthood…

Thursday 20
The Royal Wedding, Princess Elizabeth & the Duke of Edinburgh. There were very few students in the School, so, about 11.45, Nuttall-Smith and I decided to go and look at the crowds. We got down to the Duke of York's Column, whereabouts there were many hundreds of people, railed off from the Mall, where there were more. Pleased, good-tempered crowds, and an unquestionably popular royal family…

Sunday 23
D.S.M. says that Tonks once refused an invitation to Will Rothenstein's house, saying to Albert, who was the messenger –'The fact is, I like you, but I don't like your brother.'…

Tuesday 25
Burn at the Slade. Tea at the Club, in company with Cecil Hunt. He finds Turner's

mountain drawings unconvincing, in spite of what Ruskin says…

Wednesday 26
…Saw the Provost with reference to the continuance of the Slade visiting teachers. (The Students have appealed for Moynihan and Coldstream to be kept going)…

Thursday 27
Nuttall-Smith, A.E. Bartlett, Betty Tucker and I went to the City Foundation School in Cowper St., Old Street, (this was George Charlton's old School, where he was taught drawing by Wilfrid Walter and Geoffrey Buckingham Pocock, both contemporaries of mine at the Slade) to interview the Head Master, who wants his dining hall to be decorated with mural paintings. We saw the room, and met the Art Master, who was at the R.C.A. in 1929: he gets some very good work out of his boys. There are some 300 boys now. They do about 1½ hrs. 'Art' in a week. The School…looks pretty grim after the blitz and needs restoring and enlivening…

Friday 28
Went to Rosenberg's in Gt. Russell St., to see Berenson's *Florentine Drawings,* 2 vols. 1903; the price is £28, 4 times what it was new; but it seems the sort of book we should have in the U.C.L. Library. I met Pevsner, who agreed…

DECEMBER

Monday 1
Dined with the Lyells and Mrs. Luard…in order to choose a drawing by Luard as a memento of him. I selected a study of deer, done at the Zoo…it is characteristic and I am glad to have it…Lyell is…a lawyer, a Scot and seems prosperous…The house used to belong to Waterhouse, R.A., who, I suppose, built the studio. Those were the days for a painter. Talk of Tudor-Hart, with whom Mrs. Lyell studied in Paris. I remember his school and studio in the Rue d'Assas about 1908.

Tuesday 2
Eric Newton criticized the Slade Sketch Club…

Wednesday 3
…Tea at the Club…Codrington (full of his India Exhibition at the R.A.)…

Thursday 4
Visited the India Exhibition…Some of the Indian Sculpture is impressive in its full, sensitive, robust, lively modeling and movement. A few examples are curiously parallel to European stuff of the middle ages. Wonderful textiles…and a large collection of paintings and drawings.

Friday 5
Professors' Dining Club, U.C.L. Butler of New College, Oxford, the Provost, Anthony Blunt and others. In W.R.'s *Men and Memories,* vol. 2, there is a mention of Fred Winter, the sculptor. In my copy I have corrected the anecdote given as I had it from Winter

himself. We were colleagues in the days of the Friday Club, he the paid Secretary, I the honorary one....Fred Winter used to have a studio in a block of studios in Robert Street, Hampstead Road. Whistler – 'Jimmy', Winter called him – had the adjoining one. Winter used to do various friendly services for 'Jimmy', such as taking in the coals for him when he wasn't there to do it himself. When Whistler left, he offered Winter a tip of 10/-. Winter, who considered that he had merely behaved as one artist would to another, was very hurt and showed it. 'Jimmy' made amends next day by sending Winter a copy of *The Gentle Art of Making Enemies*. I remember going with Winter to Heal's to discuss arrangements for a Friday Club show at the Mansard Gallery [1921]. We met Ambrose Heal and his chief of staff, Hamilton Smith. After some minutes' discussion, Winter broke in – 'The fact is, Mr. 'Eal, *we're* artists, and *you* are a beddin' shop. I remember the time when you was known for your beds: and you 'ad the finest shop-front in London too – ' 'Ah', said Heal, recovering slightly from his first shock, 'Our shop-front was designed by my cousin, Cecil Brewer' 'Oh no' said Winter; 'I don't mean that one, I mean the one you pulled down. It was by Owen Jones'...

Monday 8
Quarrels & disagreement at the Slade – Charlton & Gwynne-Jones over the question of visiting teachers. Saw the Provost twice. An unpleasant day...

Tuesday 9
More contention at the School. Luckily, we do not have a lot of this sort of thing. Went off with Nuttall-Smith to the Private View of a show in Portland Place, organized by the British Council for exhibition in Sweden: Duncan Grant, Vanessa Bell, Gillies, Gowing, Le Bas, MacBryde, Minton, Hodgkins, Moore, Sutherland, Piper, Pasmore, Matthew Smith, R. Colquhoun (pseudo-Picasso), Rogers. Did not like all, but there are good artists among them: only it is a very limited view of British art...

Wednesday 10
R.W.S. meeting. Lee Hankey becomes Vice-President, Russell Flint unanimously chosen to continue as President...

Thursday 11
Ormrod brought me a duck...one of his own killing. Committee at the Universities Bureau of the British Empire, 8 Park Street, to recommend a Michaelis Professor for Cape Town. Dr. Loveday in the Chair, the Secretary, Foster, John Mansbridge (who has connections with S. Africa) and myself. Interviewed two candidates short-listed by the University. Decided without dissent on Rupert Shephard, as against Forbes-Dalrymple. Tea at the Club. Met Wheatley, pleased at being a full R.W.S. and Munnings, who had been to Victor Pasmore's show. He found it unsatisfying, but agrees that P. is an artist.

Saturday 13
Went with Andrade to the Savage Club...before lunching...at the Ath$^{nm.}$ The Savage bar, with its geniality rather overdone, perhaps, is an entire contrast to anything at the other Club. Met Barney Seale and Strube, the cartoonist, who once owned the Wells Hotel in Hampstead...

Sunday 14

With D.S.M. in the morning. He deeply regrets the death of Sam Courtauld, whom he considers to have been a man of 'great magnanimity'...Called on Max and Elsa. He was very kind yesterday, helping a Slade girl, Yvonne Hudson[15] who is going in for the Rome Prize in Sculpture, and wants to know what stadium frontages ought to look like. She went at my suggestion.

Tuesday 16

Lunch at Brown's Hotel, as guest of the *Sunday Pictorial*. The journal is organizing a big show of children's Art, and wants advisors. The others are Philip James and Herbert Read. 6.30 Hotel Rembrandt, S. Ken.: farewell dinner to P.H. Jowett on his retirement from the R.C.A. Lord Hambledon in the chair. Rushbury and Tristram spoke in Jowett's praise. Met a great many friends...Charles and Ivy, the Dursts, the Gilbert Spencers, Dobson, Robert Austin, Malcolm Osborne, Derrick and John Nash. Jowett spoke well...I do not think he is sorry to go.

Thursday 18

Slade Dance. Some good decorations by Zelma Blakely and Mackenzie the caricaturist... some excellent and ingenious...costumes. Connell...must have been on duty about 20 hours. Tipped 5 other College Beadles £1 a piece...

Friday 19

Provost's party in the Slade rooms...Many people, including myself, put on full evening dress, but dinner jackets and lounge suits were permissible. The formalities of old days cannot be maintained now. I remember Professor F. Brown always came to his duties at the Slade in a frock coat and tall hat...

Monday 22

Glasgow...Bysshe met us...and on by train to Helensburgh, to the new house, Auchen-teil, Suffolk Street. It is actually an old house, about 1860, with the iron hand-rail of the stairs bowed out to admit of crinolines; and it has various rather grotesque neo-Gothic features...Prof. & Mrs. Barnes have moved up from Sheffield...

Thursday 25

All went off happily (except for an explosion of wrath against Towner on Bysshe's part).

Friday 26

Walter & Sally Pritchard, with their daughter Judith, aged 6, came...Later Eliz. Brown, the Secretary from the School of Art...Some conversation about [Robert] MacBride and [Robert] Colquhoun, two products of the School. They appear anxious to disclaim that they learnt anything there: in fact, when Allan Walton asked them to dinner, they affected to have forgotten the name of the artist who taught them painting (Cranford, who like everyone in the School, did everything possible to help them on).

15 Ceramic stoneware became her favourite medium; see the ceramic tile relief of Minerva in Crane Street, Chichester, West Sussex.

1948

The year opens much as usual with Slade business and student matters interwoven with Schwabe attending Private Views and exhibitions but this normality is short lived when he suffers a serious heart attack in the early hours of Monday 15 March. From then on he documents visitations from doctors, colleagues, students, friends and family until his last brief and rather scratchily written entry on Sunday 5 September.

JANUARY

Monday 5
Back from Helensburgh to Hampstead…

Tuesday 6
9.30 at the Slade. Connell had lighted my fire in anticipation of my arrival. I had to set up a still-life group for the London Federation of Boy's Clubs, who sit for their drawing competition in the School. Bartlett and his team working away on wall decorations in No. 1 room…Letters, for Miss Beer to type. There was one, also from Gondhalekar in Poona, to which I replied in my own hand. He is very loyal to the Slade and writes at least once a year.

Wednesday 7
Slade. 4.00 Meeting of the Whitechapel Art Gallery Trustees. Bearsted in the Chair (and a very good Chairman too). [Hugh] Scrutton now replaces my old friend Duddington. [Charles] Weekley, once of the V.&A. Museum, now Curator of the Bethnal Green Museum,[1] is a new Trustee…

Thursday 8
…Lunch, Eric Maclagan, who told me how, when he was 17, he went to see Ruskin at Coniston. The interview went off well, though there was some fear that if it was too prolonged R. might have one of his attacks. R. liked young people and addressed most of his conversation to Maclagan rather than to an older companion who was with him. Met other friends – Albert, Salaman and Rostrevor Hamilton among them. Salaman recalled that the caravan which is the subject of an etching and a painting by Augustus John was sold to John by Salaman, who spent his honeymoon in it: he sold it for £35. John never paid the money; but one day there arrived for Salaman a parcel of John's etchings instead, the value of which far exceeded £35…

Friday 9
Slade till lunch-time…Telephoned to Dr. John Parkinson to congratulate him on his knighthood in the New Year's Honours List. Professor Barnes says he (Parkinson) thoroughly deserves the distinction, and is the first man in his branch of the profession. Cobbe thinks highly of Parkinson too.

1 Now the Museum of Childhood.

Saturday 10
Geoffrey S. Fletcher and John L. Baker came to see me at the Slade. Fletcher is working hard for the Rome Prize and stayed up all night to do a specimen of genuine fresco. Thus he avoided making the joins which would have been necessary if he had worked only a few hours at a time. Baker is teaching at West Ham. Lunch at the Club, with Albert and a guest of his, [Father] Martin Haigh[2] the young priest who was a student at the Ruskin School (though a priest when there) during my time in Oxford. Now he teaches at Ampleforth...

Monday 12
Slade began again...tea at the Club, that oasis of peace, where one is not always obliged to speak to anyone...What a miserably poor book *Line & Form* by Walter Crane (1900), was. I have just picked it up: the text is poor, and so are the drawings, which have lost all the spirit and charm of his early work – *Beauty & the Beast*, *The Hind in the Wood*, *The Yellow Dwarf*...There is a legend that Mrs. Crane would not allow him to use models, but that would not account for such deterioration.

Wednesday 14
4.15 At 28 Cartwright Gardens to see the work...Fletcher has been doing for the Rome Scholarship competition. It is very varied, able and energetic...

Friday 16
Alan and Clare Durst came to dinner with Birdie and me at 6 Carlton Gardens. They are among the best of our old friends...Clare has written a novel...Publishers say it is too long. Durst reports a conversation with Percy Horton, who has been in Cambridge, drawing dons. He met Trevelyan, the Master of Trinity, who exploded to him about modern decadence in thought...Once Trevelyan went with Roger Fry to the British Museum, and as they went up the flight of stairs, to the portico, Fry pointed out the big carving from Easter Island and said 'There – you will see nothing as fine as that inside the building'...

Sunday 18
To D.S.M. He was full of reminiscences, some about the Beardsleys, whom he knew in London and at Varengeville. Beardsley's London house was painted yellow (hence the *Yellow Book*) and his yellow room, in disregard of his mother and sister, with whom he lived, was hung with obscene Japanese prints. 'What a beastly mind you have!' MacColl said to him once. 'Didn't you know?' Beardsley replied. M. Ayrton showed me photographs of the farm buildings he designed for the Hon. N. Howard near Steyning. They cost £130,000, about 1930. He also told me a story of Winston Churchill: of someone saying 'Attlee is a very modest man' and Winston replying – 'He has every right to be.'

Wednesday 21
Ian Fleming from the Glasgow School of Art, with about 17 students, came to inspect the Slade...Barnett Freedman came as Visitor...He spoke well of Jowett (in fact, one great reason he left the teaching staff of the R.C.A., besides some trivial matter about a

2 An accomplished artist and member of the Benedictine order.

short supply of easels, was that he knew Jowett was going, and he did not wish to work under another man); and of Henry Moore, whom he knew in his student days. At that time F. was very poor, and used to have to walk all the way home from the College to the East End every night. He was setting out to do so one night when a young man stopped him and said – 'Beest thou Barnett Freedman?' 'Yes' said Barnett. 'Would thou like the loan of five pounds?' The young man was Moore: the loan was accepted, until Freedman's L.C.C. Scholarship fell in. F. considers that Will Rothenstein made the College what it was…2.00 Committee to discuss the Durning-Lawrence Chair. Present – the Provost, Anthony Blunt, D.M.S. Watson, Corfiato, Ashmole, Clark. Things seem to point to Talbot Rice, who is at present in Edinburgh. Letter from the Provost to say I have been nominated by the Fellows' Committee for a Fellowship of U.C.L.

Friday 23
Luigi Innes Meo called at the Slade. He and Yvonne are hard up. He has little more than £1 a week retiring allowance, and supplements this by teaching at an evening school. He is the same age as myself and came to the Slade about the same time. We discussed Tonks, agreeing as to his generosity (he sent Gigi an unsolicited £5 when he (G.) was in difficulties at Oundle, where G. started his teaching career) 'Artists help each other, don't they?' said Tonks. We also agreed about his occasional cruelty. We went down and looked at the Life Room, where we worked nearly 50 years ago, with Albert Rothenstein, Wyndham Lewis, Wilfrid Walter, Michael Carr, Cuthbert Hamilton…all brilliant in their ways…

Saturday 24
Bysshe called at the Slade (where I was drawing one of the models), and we went off together to the Courtauld Institute to see the Poussin – *The Arming of Achilles*, which Blunt showed us in the basement: it has been carefully cleaned by Buttery. Bysshe would take £6000. Toronto might buy it. McDonnell looked at it for Melbourne, but has switched off onto the Longford Castle (Radnor) Poussin, which is £14,000…

Monday 26
Albert R. came as Visitor to the Slade, and gave instruction to some forty separate painting students – some of them survivors from Oxford, in the War years of the Slade…

Saturday 31
Interesting conversation at lunch with John Summerson[3] about Dover and its architecture: the Round House, now bombed flat, but of which I made a drawing: of R. Elsam, the architect of the Round House, of Hardwicke, Waterloo Crescent and other matters.

FEBRUARY

Tuesday 3
…Private View of the Chagall exhibition at the Tate Gallery…Saw some virtues in Chagall-colour, emotion, rhythm, ability – and it was almost entirely new to me. I can't have seen many of his originals before, though he is fairly well known through reproductions…

3 Architectural historian and keeper Soane Museum (1945-84).

Wednesday 4
Monnington as Visitor at the Slade...

Thursday 5
After the Slade (where I saw some very good printed fabrics designed by Ormrod), visited
A.M. Hind's show of drawings at Colnaghi's, most of them rather weak, but he chooses
some good landscape subjects...

Saturday 7
Miss Beer's Saturday morning off at the Slade. N.S. was there. Made a drawing in the
Life Room, of a man model. There is a rumour that old Reitzo is dead. Also went round
some of the paintings. I find more and more that most students want criticism, and ask
for it...

Friday 13
4 o'c. Took 6 drawings, nude studies, to 1 Hampstead Hill Gardens, for an exhibition
which is being organized by the Hampstead Society of Artists...

Monday 16
Albert R. came as Visitor to the Slade...Dinner of the London Schools and Colleges Dining
Club, to which I and others at U.C.L. have recently been elected...The principal guest
was the Minister of Education...No one proposed the toast of the King, as is usual on
these occasions...people did not know whether to begin smoking...so I got up and
toasted the King...I was patted on the back afterwards by several people who like the
old convention and dread Communism...

Tuesday 17
...Miss Toplis, once assistant to Beresford, the photographer, in Yeoman's Row, called
at the Slade and left us a dozen or so interesting negatives for our records. She has
19,000...Some are going to the N.P.G.....

Saturday 21
...Drew old Poley, the model, for ¾ of an hour in no. 10 room. At the Club...The Secre-
tary of the...Committee (Sir Cecil Carr) who wrote to me some time ago asking my
opinion of Francis Hodge as a candidate for membership, now informs me that he failed
to get enough support. He was considered 'respectable' as an artist and otherwise, but
not quite the sort of man (or artist) the Athenaeum wants. I had said all I could in his
favour, reporting how agreeable he had been when he was at Sisteron, at the time I was
there with Max and Tony, and Adrian Waterlow: and how he did some 'respectable'
work there and elsewhere.

Tuesday 24
Went with Nuttall-Smith to the Private View of Kyffin Williams' pictures at Colnaghi's.
A good start for a young artist...Ralph Edwards was helpful in arranging it for him. It is
not always easy for a young artist to get taken up by the dealers. He had so far sold seven
pictures. The prices were reasonable – not higher...in any case than £40...N.S. and I
agreed that the pictures, if painted quickly and slightly, were yet products of a genuine

love for, and knowledge of, his native mountains [plate 31]. Some slight drawings reminded me of A. Cozens. Went on to the Mayor Gallery in Brook Street (there is a show of old Fred Mayor's work at Lefevre's in Bond Street) to see Eduardo Paolozzi's drawings in the style of Paul Klee. Did not care about them: they have been boosted in *Horizon...*

Wednesday 25
Meeting at the University to discuss Corfiato's proposal to form a Faculty of Fine Arts, which I seconded...the special sub-committee appointed to consider the matter did not report in favour. Norman in the Chair (he is Dean of the Faculty of Arts), Ashmole, Blunt, Saxl...Tea at the Club...Jas. Wood has been having trouble with his daughter, who is in hospital as a result of systematic under-nourishment persisted in in order to attain a special slender, sylph-like, fashionable figure. She even cut out all the linings from her clothes, for the same purpose: and lied about it when warned by her doctor.

Thursday 26
Bellin-Carter came to see me at the Slade. I showed him a lot of Tonks's work. He says that no. 10 Life Room is greatly altered since his student days. Part of the light then was supplied by a ring of gas-jets – not electric: and the area of window was much smaller, without the top-light there is now. He wrote protesting against these conditions, at the time, in the College Magazine. He was an original member of the Students' Union, and wrote the Slade notes for it...

Friday 27
Slade sub-Committee – the first since just before the War: the Provost away ill, and only Albert R. (newly appointed), Ashmole and myself with Clark, the Assistant Secretary, present. Discussed...the Visiting Teachers, and the excessive number of students in the School...Two of the Slade students, [Geoffrey] Squire and [Trevor] Mackinson, know Ethel Walker and visited her last year at Robin Hood's Bay. They found that she has a habit of throwing half-used tubes of oil paint out of her cottage window on top of the cliff on to the beach below...from which they enriched themselves – no small matter in these days of scarcity and high prices.

Saturday 28
News of Alexander Stuart-Hill's death. We knew him first after the first War, in which he served as a member of the Red Cross – I think the French branch. He was a friend of Colin Gill's, and was temporarily occupying the 2nd floor of 43A Cheyne Walk, over our heads. The Battenberg princess to whom he was engaged used to visit him there – so did her brother, Lord Louis: he came once into Birdie's room by mistake. Stuart-Hill was a courageous man, with a strong sense of humour: He would be the first to turn a joke against himself, and many jokes, naturally, were made about his appearance, as he used to make up his bald head and his face in the most obvious manner, the artificial sun-tan and pink contrasting with his blue eyes and beautiful fair beard. His portrait paintings had a good feeling for character, and he had a fair number of commissions when he moved into the big studio in Cheyne Row, which he shared with Ivan Philipowski, the pianist. I believe he had some small private means. He suffered from tuberculosis. His family came from Perth and he studied art in Edinburgh.

MARCH

Monday 1
Rostrevor Hamilton, whom I met at tea-time in the Club, has bought one of Kyffin Williams's pictures from the show at Colnaghi's. He thinks Williams has sold about £400 worth...

Tuesday 2
...Irene Wellington has been commissioned to do the Roll of Honour for the Bucks. & Oxon. Lt. Infantry. One of her first jobs, after the first War, was for Christ Church, Oxford.

Wednesday 3
Freedman came to do a day's teaching at the Slade...lunch together at the Athenaeum and afterwards Davis the architect joined us and told us funny stories. Freedman (like myself) enjoys being a member of the Athenaeum, and gets on very well there. He is on the best of terms with the servants...and calls all the men by their names, 'Mr. Gedge' the wine waiter, 'Charles' and so on. Squire, the student at the Slade who is a friend of Ethel Walker, handed over to me from her a flaring red silk necktie, of excellent quality, as a present. I shall hardly venture to use it – I, who wear my invariable black bow.

Saturday 6
...Tea with the Charltons...to see his pictures & drawings that he is getting together with a view to having a show at the Leicester Gall....a varied and interesting lot, done during the last ten years, largely at Leonard Stanley in the War – others at Brighton, and on the Essex coast...

Sunday 7
...9.15 Andrade was broadcasting about Rutherford. I remember staying with Rutherford at his house in Cambridge, when I was drawing his portrait. He took me one night to dine in College, and I met J.J. Thomson[4]...I liked Rutherford, as did most people...

Monday 8
Tea at the Club. Met Leonard Huskinson (now engaged on another scheme of mural decoration)...

Thursday 11
...3.30 Board of the Faculty of Arts at Senate House. I attended because Corfiato's forlorn motion about a Faculty of Fine Arts was on the agenda. This came up for discussion, fruitlessly...After it was dismissed, I left...

Friday 12
Committee of Management of the Courtauld Institute at 20 Portman Square. I...attended out of a sort of wish to be civil to Blunt, who has been so civil to me. Present...Ld. Crawford, K. Clark, Sir R. Wiff (who is terribly crippled now with his arthritis), Prof. Wilde, Prof. Norman, Prof. Saxl, Prof. Robbins (Chair, in place of the late Sam. Courtauld), Blunt...A few words were said about Courtauld and we stood to attention

4 1906 Nobel Prize physics.

in his honour...Slade till 4 o'c. Tried the effect of cutting my cigarettes, down from 11 a day to nil. I suppose one should cough less if one doesn't smoke.

Saturday 13
Albert R., G.J., Bannister Fletcher...at the Club. On a Saturday afternoon the top floor smoking room is practically deserted. I went there for a nap...

Sunday 14
About 3-4a.m. had a serious heart attack. No pain, but breathlessness. I thought I could not live. Got to Towner's door and asked him to fetch Dr. Plowright, who came and injected something into my arm.

Monday 15
Plowright kept me home and got Parkinson to come, who insisted on almost complete immobility, and spoke of Hospital. Everyone very sympathetic – the Hutchinsons, the Ayrtons, the Charltons. Albert telephoned, and Maureen, from MacColl. Charlton called to assure me that the Slade could carry on.

Tuesday 16
Plowright has been most kind...I must take quite a long rest...

Wednesday 17
Was taken in an ambulance to University College Hospital. Plowright has arranged for me to be under the care of Dr. Harries there. Two men carried me down from my bed at no. 8 and drove me and Birdie to the Casualty entrance – there seemed to be some irregularity about my admission, as if I was not expected, and this caused some irksome delay. I am not in a private patients' ward, Nursing Homes, Plowright says, costs £14-14-0 a week, but in a room off Ward 52 on the top floor of the U.C.H. Birdie was finally able to leave me in peace – though the noise of a room next to the Ward kitchen can hardly be called peaceful. Saw two doctors, one a lady and each went through the usual tests for blood pressure, which nurse does too, night and morning. One of the nurses who attends to me says she is not yet 20. She has been a nurse two years...They won't have them under 18 at U.C.H. They have a 'shift' system here, and don't work such long hours at a stretch as at some hospitals.

Thursday 18
Saw Dr. Harries: the usual tests. Nuttall-Smith called...I seem to have lost the desire for smoking. I actually gave it up a week ago...Doctors don't seem to think, though, that a small number of cigarettes has much effect on catarrh. Parkinson is against anyone in my condition adding salt to his meals. One is put into a grey flannel hospital bed jacket, over the pyjamas you bring with you. I find this produces very much the air of a public institution; but everything, of course, is a public institution now. There is no meaning in the term 'work-house' as used in my youth.

Friday 19
The young doctor who comes in Dr. Harries' place says it is a great thing to avoid boredom. Lying here, tied to one's bed, one is apt to get bored, though, as will be seen

from those notes, the day is not lacking in incident. I think it is a resource to keep this Diary going. I have not started a course of reading. All I have here is…*The Australian Artist* with an article on Picasso…

Sunday 21
U.C.H. Waked 6.30, after a good night. Temperature taken & blood pressure. 7 o'c. Breakfast: porridge, bread & butter, tea & my own egg. Bed-pan. 8 o'c. – Blanket bath, teeth…This takes till 8.30, with bed-making. 8.45, room is dusted. 9 o'c. Sister looks in. 9.15 maid cleans sink…Brief nap at 9.50 – maid crashes in with hoover and does the floor. Cup of coffee. Two or three distant wireless sets audible. Relatively quiet. 12 noon, tray with bread ration (you are asked how many slices you would like) is brought in preparatory to dinner 12.25 (roast beef, potatoes & cabbage, plums & custard). 2 more tablets to swallow. Sleep or doze disturbed (1.30) by 2 nurses coming to wash my backside – a special routine treatment to avoid bedsores. Sleep again till 3 o'c. At 3.30, again the question of how many pieces of bread – for tea, which includes jam & cake. 5.15, face & hands washed – one can't complain of lack of attention; and the backside treated with the spirit lotion as before. Bed made by 5.30. 5.45 Preparations for supper commence. Bread is brought, with a tray. 6 o'c. Barley broth; followed by fish pie & potatoes; rounded off by Elsa Ayrton's grapes. There was some jelly & custard…This brings us to 6.15. Then coffee (or milk, or tea, or Horlicks) & 2 more tablets, 6.50. Cleaned teeth. 8.10, last blood pressure test. Tea about 9 o'c.

Monday 22
Routine as yesterday. The U.C.H. Chaplain called…and the lady doctors. 3.30 Hubert Wellington came. Then, at 4 o'c. Connell & Wilkie. Wilkie has angina himself and will have to be careful…Tried the headphones of my wireless here for the first time…

Tuesday 23
Visit from Lady Almoner, explaining schemes of voluntary payment for treatment here. Another young doctor called to tell me that [Jewad] Selim, the Iraqi Slade student…is in U.C.H. with pneumonia…Mrs. Frisby, the Hospital Librarian, who lives in Keats Grove, and is a friend of Dr. Plowright's, called in with a trolley load of books. I selected three, including *The Golden Treasury*. 3.30 Gwynne-Jones came with some flowers and stayed for half an hour. 4.0 Birdie came for a whole hour. I have seldom been so pleased to see anybody. I feared she might not be able to get away from no. 8.

Wednesday 24
10.30 John L. Baker and Geoffrey S. Fletcher, on behalf of themselves & other students (Olga Marshall, Nancy Skillington, George F. Fletcher and Leonard Talbot) brought over a large box of daffodils. They had been to Covent Garden to get it…2.30 Nuttall-Smith called. At Sister's suggestion, some of my daffodils were sent into Selim…3.30-4.0 Margaret Cobbe, who brought me from Joy, her stable-companion, a copy of *The Anatomy of Melancholy* from U.C. Library. I have never read it…Burton's *Anatomy* –'"Vel ut lenirem animum scribendo", to ease my mind by writing.' My bed has a green coverlet in a debased William Morris manner, based on a cyclamen as a motive for the pattern: damned cleverly and professionally executed, but so lacking in any true sense of beauty or plant formation that it really annoys me to have it confronting me all the time.

Sunday 28
Charles Tennyson called…talking most interestingly, of his grandfather & Palgrave; of Hallam and his meetings with Gandhi; of Hallam's book [*The Wall of Death*], which has been well reviewed in America; of Robin Darwin and R.C.A. He says Wedgewood makes a very good Chairman of the R.C.A Board; and the Ministry has increased the grant. Darwin is a strong personality. He may make some mistakes, but he gets things done. Alfred Tennyson did not, it seems, think John Donne's verse sufficiently perfect technically for inclusion in *The Golden Treasury*. The same selection may have applied to Blake. The bard admired Walter Scott's shorter poems. Charles has not read *The Anatomy of Melancholy* but, of course, he is one of the most widely-read men, in English, that I know…

Monday 29
Geoffrey Hutchinson called: suggested, very sensibly, lending me *The Stuffed Owl* and *The Bab Ballads* as a relief from serious verse and *The Anatomy of Melancholy*. When one considers how small a proportion of fine poems avoid reflections on death it is surprising…

Tuesday 30
Dr. Harries came to see me and is very satisfied with my progress. He talks of another week in bed…Dickey came…He has…[been] doing 4 water-colours at Tom Balston's place in Berkshire: and has got the Bristol Gallery to buy a *Portrait of his Mother* by Gilman (under whom he himself studied painting)…

Wednesday 31
…This evening, in Chelsea, the dinner in honour of Charles Ginner's 70th birthday took place. I had been invited by Ed. Le Bas, and would certainly have gone…Clive Bell was in the chair, and a large number of guests, nearly everyone one knows, it would seem. Duncan Grant, Vanessa Bell, Elliott Seabrooke, Dobson, Nina Hamnett, Karlowska-Bevan, Rushbury, Dunlop, Rogers, Pasmore, Ruskin Spear…

APRIL

Thursday 1
…Mrs. Frisby brought some fresh books – Flecker's *Poems* and the Oxford Univ. Press *Longer Modern Verse* of 1926. The latter makes one think how little more than 20 years has made 'modernity' completely old-fashioned. At 9.30 the Doctor from the Ward called and asked me if I would mind being moved to another ward – the same sort of private room though – on account of an infectious T.B. patient who was dying and could not conveniently be treated among other patients. Naturally I agreed, and was taken…hurriedly, to Ward 32…A new Sister and new nurses. Albert had been to the Paul Nash Memorial Exhibition at the Tate. He feels that the abstract pictures 'date' pretty obviously.

Friday 2
Gwynne-Jones called…he…told me about Ginner's banquet. Nina Hamnett and Karlowska were both overcome with drink, and were bundled into taxis and sent home…Daphne Charlton has got chickenpox. I wrote to her.

Saturday 3
Miss Sachs, of the Fine Arts Stores, U.C.L., sent over a bunch of flowers…Dr. Cockrell
called. She is a well-read lady, of pronounced literary tastes, which she now has little
opportunity of indulging…She gave me instructions about my beginning to take
exercise. While she was with me, Sir John Parkinson came, with begonias of his own
growing. He expressed himself as satisfied with my improvement in strength, and with
what Dr. Harries has been doing to me. Prof. Barnes has written to him from Helens-
burgh suggesting than I might go to recuperate there. Parkinson thinks I could do this
if care were taken over the journey; but he leaves it to me as a domestic rather than a
medical matter. I think I shall choose Dover, although I can't go there just when I should
wish: and postpone Scotland until the summer: it is a long way.

Sunday 4
Arthur Norris came…Among other subjects of conversation he mentioned the high rate
of wages being paid to craftsmen in the potteries: as much as £800 per annum…for
producing utility goods. He has lately visited the pottery at Burton-on-Trent, with a view
to getting models fired for the boys at Repton.

Monday 5
Callers today – Wellington and Dr. Plowright. W. was going to have lunch with Father
D'Arcy, who has been to Guatemala. Plowright is trying to fix up a convalescent home
for me in Hampstead…Miss Beer came over from Slade [office] with proofs of the illus-
trations to Robinson's book on *Degas*, for which he wants me to write comments. I'm
sorry, I can't touch it just now. Had my tea sitting up in a chair, for the first time…
Birdie came – a pleasant, long visit.

Wednesday 7
Visit from the Provost. He, like me, will have to go a little slower, in future…he has
high blood pressure. He wanted to see me about one or two items of college business…
8.10p.m. Gerrard was announced…he has been working 18 hours a day…to get his
carved stone reliefs done to time…

Thursday 8
…Dr. Aitken from the Anatomy Department, U.C.L., spent quite a long time with me.
He was on the way to a serious T.B. case upstairs…

Monday 12
Monahan, the Establishments Officer at U.C.L., came and chatted…He knows some
people who own 3 or 4 of the drawings I did around Whitby and Robin Hood's Bay,
when Birdie and I spent our honeymoon summer, in these parts, in 1917…Birdie came
and discussed arrangements for my departure on Thursday…

Tuesday 13
…Had a very pleasant letter from Muirhead Bone. I hear that the letter from Maresco
Pearce & myself about the Oxford Union frescoes has been published in *The Times*.

Wednesday 14
In the morning, Charlton & Nuttall-Smith called. N.S. has been in Oxford, I hope doing some carving. Charlton has been doing drawings in Brighton. Dr. Cockrell came. She says that Selim…has gone off his head and wants to embrace all the nurses and patients. Albert R. came in the afternoon…He tells me…that Rosie Gwynne-Jones is expecting a baby soon. (See July 7) A large azalea plant arrived, inscribed 'from the students at Slade'…

Thursday 15
Gave the Almoner at U.C.H, on this my last day, £10.10.0. 3 o'c. Birdie came in the Hampstead taxi she had hired, and after the usual delays and muddles which seem insep-arable from hospital life – is it good-natured inefficiency? – because really they couldn't be kinder – we got away to 87 Redington Road, a modern sun-trap house (architect, Oliver Hill. It cost £14,000 to build. There was a divorce soon after it was built and now the wife, 'Miss Francis' runs it as a nursing home) with a long distance sea-view over South London…Plowright came to see me installed. He had been a little nervous about my climbing the long slope and stairs which lead to the door of 'Sunhouse.' There was a little package awaiting me from Becky Kendall – an anthology of verse chosen by herself, and written out in a minute hand when she was in hospital herself some time ago, with appendicitis. It seems a very good little collection, widely ranging & unprejudiced. Started to read Clare Durst's type-script of her long novel – *Shemmings*. As far as I have got (which is not far) it seems easily written, with plenty of matter, and easily read.

Friday 16
Birdie came and brought me an extensive equipment of drawing materials. Perhaps I may draw something out of the window…

Saturday 17
12p.m. Plowright paid me a long visit, and gave me an injection, after a thorough overhaul. It seems as if the move…may have tired me more than I thought. I confess I am disappointed. I had a bath in the ordinary way this morning (not a cold one, though) and P. does not want me to have another till he sees me again…

Sunday 18
…Alan & Clare Durst came to tea, bringing with them a bottle of sherry. A good deal of talk about *Shemmings*, which I have nearly finished…It has been refused by 7 publish-ers…among them John Lane (to whom it was warmly recommended by John Nash) and Secker-Warburg. As I expected, the novel is largely based on her own family history and her own theatrical experiences. Barry is her own father. 'Shemmings' is E. Finchley. Mrs. Robinson is her father's second wife, Albert her step-brother…

Monday 19
Dr. Plowright called…as I was doing a drawing out of the window. He thought I was better than on Saturday, but did not seem entirely satisfied. It is still a question of rest & going slow…Birdie came, with grapes. It is our wedding-day, and I wanted her to buy flowers for herself; but she says she has nowhere to put flowers and brought the grapes instead. Geoffrey S. Fletcher, though he failed to get the Rome Prize, was awarded the Abbey Major Schol.…

Tuesday 20
Daphne Charlton came. After she had tea & gone, Peter Brooker came, and while he was here, Birdie paid her visit. Brooker has become a Catholic...

Wednesday 21
Plowright came in the morning and was more satisfied with my condition...Birdie came, and we discussed plans for the future. I wish I was a better planner and organizer. I seem unable to arrange my own or anyone else's future: and no doubt Birdie is right about no. 8 Church Road being now thoroughly unsuitable...But what are we to do?

Thursday 22
...Had a heart collapse in the night, but not so bad as the first one. Plowright...came, and gave me an injection. A nuisance being set back on to the 'tied-to-one's-bed' regime.

Friday 23
Plowright came about 11a.m. He was pretty pleased with my reactions, but we have to be very cautious. Birdie came too, after tea. A cheerful oasis in an afternoon of torpor.

Monday 26
Plowright came...I had been feeling rather gloomy, about a bad night, with a cough. He cheered me up; but my regime is pretty rigourous [sic] as yet – still tied to bed...

Wednesday 28
O.[Olga] Marshall & John Walton from the Slade called with flowers, and the catalogue of the Slade Students' Exhibition at Walker's Galleries...A pleasant letter from Fr. Conrad, who has said a Mass for me, as he did once for Bill.

Thursday 29
John L. Baker (now teaching at the Cass Institute) and Geoffrey Scowcroft Fletcher, the Abbey Scholar, called in the morning. I was shaving at the time (against Parkinson's orders...) and had to keep the young men waiting a quarter of an hour...

Friday 30
Plowright paid me another visit and made a satisfactory report. I am still, however, tied to bed. About 12.30 I had a call from Fr. Conrad Pepler, who staid [sic] for about an hour...this visit pleased me greatly. I owe much to my acquaintance with him & Fr. Richard in Oxford – so does Birdie – and that he should give up one of his few hours in London to me is a great compliment. He talked a lot about Eric Gill, whom he respects as a craftsman, but considers shallow as a thinker. He mentioned that Brangwyn is somewhat of a recluse at Ditchling: Conrad and his father used to visit Brangwyn once a week and liked him. It irked B. to be pointed out – 'That's Brangwyn' – unlike Tennyson, I think...

MAY

Saturday 1
…Gilbert Spencer has been sacked from the R.C.A. Durst is engaged on a shield of armorial bearings for Painswick church…No more news of Clare's novel…

Tuesday 4
The Provost of U.C.L. called…mostly…shop: how the Slade is to be run in my absence. Gerrard, being an established Professor, will be nominal head. The Fellows' Dinner and Inauguration ceremony took place. I am now a Fellow, but I must sign the roll…

Friday 7
Plowright came and was pleased with my progress. I am to get up a bit now, though still confined to this room. Alice writes that the Montreal Art Gallery has offered £5500 for the Sheffield Poussin. She talks of buying a house for us with the money. They spent £25 on the picture and £60 on having it cleaned. Olga Marshall and Maria Shirley called…with flowers and chocolate – some from the Slade students in general, some from themselves. Shirley is connected with the Ditchling circle and Father Conrad in Oxford. She has written an article in *Blackfriars*.

Monday 10
Plowright came in the morning – a good report. I am to sit up more. 2p.m. Maureen Clark found her way here with a letter from MacColl, who has been thinking of the expenses of my illness (this Home costs £12-12-0 a week). He is prepared to ask Sir Alexander Gibbs and his son at the Athenaeum to spend some of £100 put aside at the Club by them for another purpose, on the purchase of drawings by me. This shows a kindly interest in one's affairs. Luckily, however, my Bank balance has not yet been exhausted. Birdie came, with a hydrangea in a pot, from herself and Alice to signalize my birthday [May 9]…

Wednesday 12
Hagedorn came in the morning. He had only just heard of my illness…He brought…½ dozen new-laid eggs. He does not like the new President of the R.B.A. (John Copley)…

Thursday 13
Plowright came in the morning. I am allowed a little more licence in my movements… Late in the evening came Zelma Blakely and her friend, the caricaturist, Mackenzie. They are working together at a scheme of mural decoration in a part of U.C.L…

Saturday 15
I read a book on the technique of painting for Heinemann's and reported adversely on it. For this I get £1-1-0 – a miserable fee. Birdie came again after supper, with some drawing materials I wanted. I have started on a water-colour out of the window.

Monday 17
Plowright came in the morning. I am to make more exertion…Albert Rutherston came in a taxi from Chelsea. He is very worried because one of his sisters and her son (born

in Germany, and a 'displaced person') are in Tel Aviv, and can't get away. The place is being bombed. Moynihan is replacing Gil. Spencer at the R.C.A. Albert wants to have Horton as his successor at the Ruskin School...

Tuesday 18
...Charles Tennyson came...He will be retiring from his post at Dunlop's shortly. Birdie came in the evening. She had been to visit Clare Durst in her Hampstead Christian Science Convalescent Home. There seems to be some professional feeling between Christian Science and Roman Catholicism. The 'Practitioner' wanted to know if Clare's proposed visitor was an R.C.

Wednesday 19
Gerrard called...He showed me some large photographs of the big reliefs he has been working on...and very good they look. 5.30 Birdie came, bringing with her a bottle of S. African hock and a book which Barnett Freedman had sent – a new one, reproducing his own work: enclosing also a letter of condolence...

Saturday 22
Durst came to tea...He went on to visit Clare. My attempt to get Warburg to give fresh consideration to Clare's novel was a failure. Birdie came after supper. She had been to see the Ayrtons and Max had generously offered, quite spontaneously, to put up £50 to help with the expenses of my illness...

Monday 24
...Spent a good part of my day reading *Siegfried's Journey*. There are so many people mentioned in it whom I knew...Lady Ottoline, Yeats, the Sitwells, Gertler, Eddie Marsh, T.E. Lawrence and Robert Ross (who was kindly instrumental in getting me employed as a War Artist in the first Great War)...

Thursday 27
Plowright overhauled me in the morning...We may not meet again for some time. 73 year old Francis Dodd took the trouble to come and see me in the afternoon...Poor man, since his wife's death he depends on a highly-paid housekeeper, and his income is very much reduced...At one time his wife had £25,000 and he earned £1000, perhaps £2000 a year. Now he has £450 a year to depend on. He spoke of the disasters which have overtaken other artists in old age – among them Hugh Thomson the illustrator, whom he knew and who ended in penury...

Saturday 29
Stayed in bed all morning as a preparation for the journey to Dover...A letter from Alice to greet me at Salisbury Road...Went to bed about 9p.m., none the worse for the drive of 75 miles or so. Tom got special petrol for the occasion.

JUNE

Tuesday 1
Schwarzschild's Life of Karl Marx (*The Red Prussian*) which Dora is reading, mentions the firm of 'Ermen & Engels' as that with which Friedrich Engels was connected in Manchester a hundred years ago. Anthony Ermen, one of the founders of it, was my maternal grand-father. The business became subsequently 'Ermen & Roby' and was finally absorbed, long after my grandfather's death, in the 1880s, by the English Sewing Cotton Company...

Wednesday 16
Finished writing captions for Degas' drawings. There are forty-four of them. A Miss Jones of Balfour Road is typing the stuff out from my MS...

Sunday 20
Started a drawing of a group of buildings behind the Maison Dieu. About an hour and a half in the morning, and perhaps as much after tea. Birdie came to fetch me about 6.15, and we walked back by the High Street (looking into St. Mary's) and round by the sea-front and Woolcomber St. home...

Tuesday 22
40 minutes drawing: rain...Had a letter from Robinson of the Rockliff Publishing Corpo-ration, about the Degas book. He says – 'Now that I see your comments on the drawings, I am all the more attracted to the idea of this series. I think they should do an excellent service for draftsmanship'...

Monday 28
Rain and thunder...Overhauled my drawing for an hour at home.

JULY

Saturday 3
...A fine, warm day. I have practically finished work on the Maison Dieu pitch – one more corroborative visit should do it.

Wednesday 7
Most of the day in bed again. Very disappointing. Another attack – very slight. The Gwynne-Jones baby girl [Emily] was born, 8½lbs. All has gone extremely well with Rosemary.

Saturday 10
[Dr.] Laird, with Tom, examined me about 10.30. About 12.15 I had another attack. Tom was out. Birdie got Laird on the telephone and he came at once. Gave me an injec-tion. When Tom came in, before 1 o'c., he gave me another, as my breathless condition had not passed...Laird and Tom conferred and agreed that my general condition was not grave – indeed much better than it has been. Laird brought the *Illustrated London News*.[5] A page of photographs is given up to Enwonwu, our Nigerian sculptor at the Slade...

5 'An "Epstein" of West Africa: A Modern Nigerian Artist's Work', July 3, p.25.

Sunday 11
Slept very well. Birdie came in at 1a.m. with my Digoxin. She has been doing everything possible to make me comfortable and to lessen my boredom…

Tuesday 20
9 o'c. Laird and Tom. Got out with Birdie for a very brief walk. C.O.G. Douie wrote asking me to do the dust cover for his new novel. *The Lost Heritage* cover, he says, 'was a great success – indeed, it was reproduced in the *Times Literary Supplement* and occupied…more space than the review of the book'…

Friday 23
Laird said good-bye…Colonel & Mrs. Lane came with their car, and at 11.20 started for London with Tom & me as passengers…4 o'c. Tea with Tom in the hotel… Slept till 5.45p.m.

Sunday 25
Arrived at Glasgow 8a.m. – 2 hours late. Bysshe met us with the car…Breakfast in Helensburgh (Auchenteil) with our large family party – Prof. and Mrs. Barnes, Alice, Janet and Diana, Bysshe, Dora, Tom, Margaret and Birdie. Mrs. Low, the cook, met me on the doorstep and shook me warmly by the hand…I am given a bed in the library on the ground floor…

Wednesday 28
Revised and completed, as far as possible, the drawing of Maison Dieu.

Thursday 29
The Cobbe family took the train to Edinburgh, which they had not previously seen… Petrol is very restricted. Our outing of Tuesday cannot be repeated. Started a drawing in the hayfield across the road at the back of Auchenteil. Birdie brought out a garden chair for me…Worked from about 5-6 o'clock…

Friday 30
With Birdie's help in carrying a chair and a portfolio, continued the drawing of Wood End Farm…Temperature 80 degrees in the shade by the house…Almost cloudless…Dr. Barnes, having visited the Royal Academy this year, notes that many of the portraits, including several of A.R. Thomson's, show a squint in the sitter's eyes. Thus the scientific, non-artistic observer (who hates the work of Paul Nash); but is it really so?…

Saturday 31
Received MS of Douie's novel *Raynard* and began to read it. Two hours on a new drawing of the farm from the cabbage field. Birdie carried my things. Heat, thunder, midges.

AUGUST

Sunday 1
2½ hrs. drawing in the afternoon…Met J. Arnold Fleming, a Governor of the Glasgow
Art School – a friend of George Henry, Mackintosh, Russell Flint and others of my own
acquaintance. Russell Flint used to live in Helensburgh. Hornell was another artist whom
Fleming knew and talked about. Alice introduced Fleming to Birdie and me in the road
at the back of Auchenteil…Finished reading Douie's novel: I found it rather an effort.
He has some gift for story-telling…yet it all strikes me as unreal…The books all sell out.

Monday 2
…Bysshe attended a meeting at the Art School. Bliss came up from Derby for it…Bysshe
had a pleasant surprise: his Board has granted him an increase of salary…another £300
p.a. on account of his increased responsibility…Bed at 11p.m. Later than usual; but woke
at 12.45 nevertheless. Cup of Allenbury's from a thermos flask at 3a.m.….Read something
of *The Torrington Diaries*:[6] how many of the same places have I visited…

Tuesday 3
Got on with the drawing of the farm from the cabbage field, from 3 o'c. onwards, but
after tea, about 6 o'c., was finally defeated by midges, which make concentration too
difficult when they are so numerous…We all rub a stuff called 'Mylol' on the exposed
places…before going out…but after a while everyone gets stung just the same as if no
precaution had been taken.

Wednesday 4
Finished drawing cabbages by 12.30. Margaret acted as porter for my chair and heavy
portfolio…

Thursday 5
Bysshe got paid for the Poussin. The cheque…has been a long time in coming. He also
heard from…Blunt that the Canadian purchasers, having seen a technicolour photograph
of the picture in the first place, were rather disappointed at the actual colour of Poussin…

Friday 6
Started on a drawing of an oak from the laundry at the back of the house. Took Janet
and Diana for a walk to the farm…The farm people very civil…Found, to my discomfi-
ture, that a hay trolley which I drew from memory has different wheels from those in
my drawing – much smaller, not rising above the floor of the vehicle…

Saturday 7
…Made a few notes of the Rossetti type, for Douie's dust-cover, out of books in Bysshe's
library. Also got Margaret to sit for a note of hands, for the same purpose…Dr. Barnes
produced the Marillier, *Life of Rossetti* which contains all the information anyone could
wish for about the Rossetti type.

6 Tours of the Hon. John Byng (later Fifth Viscount Torrington) between 1781-94.

Wednesday 11
Worked only 2½ hours. Didn't feel equal to more, and am inclined to think I have been overdoing it. In spite of that, walked to the farm with Dora and Janet – very cautiously...

Thursday 12
In bed, ill again. Very disappointing. Tom Cobbe gave me an injection...The night passed well till 5.30a.m. From then on felt really rotten.

Friday 13
Still in bed. More Digoxin tablets again 4 a day. Birdie paid 18/- to mend the electric bell so that I could summon her when wanted. Janet picked some wild flowers and gave them to me...

Saturday 14
Better to-day. Bysshe helped me by typing some of my Slade letters, among them a testimonial for Percy Horton, who is going to apply, with Albert R.'s approval, for the post of Ruskin Master.

Sunday 15
Still in bed. Put in a sky, from a chalk note, on one of the water-colours of Wood End Farm. Got up in the evening, in a dressing-gown, and sat in the drawing room...

Monday 16
Spent the day in bed. Worked again on the Wood End Farm drawing. Wrote letters... Reading *Thomas More* [1935] by R.W. Chambers (whom I used to know, and like, at U.C.L.): and Roper's *Life* together with Anne Manning's *Household of Sir Thomas More* [1852]...I write this at 2.30a.m...

Wednesday 18
...Dr. Barnes and Tom made a thorough examination of my heart...I am to take no more tablets – Digoxin, Amenophilin – for the present...Going backwards in the evening. Injection by Tom. Left bad consequences of depression next day.

Thursday 19
...One of the worst nights I ever had for sleeplessness. Birdie passed the time most uncomfortably in a chair by my bedside. Called up Dr. Barnes reluctantly. He gave me some dope and assured us that no fatal consequences could immediately follow from my symptoms.

Friday 20
The Tennysons, Charles, Ivy and Simon, arrived late for supper...I was glad to see Charles and Ivy. Simon I did not see.

Saturday 21
...Ivy came in, and presented me with a bottle of gin. She says Albert has now gone on his American visit. She had some criticism to make of Margery, who is now perfectly restored mentally, but is fat (which she can't help), overdressed and flamboyant. Charles

came into my room and we talked…of Turner, Watts and pictures in general, ending with Gwynne-Jones and Gilbert Spencer: the high place the British School takes with regard to the French, and what one owes to the other: what Monet, Renoir, Pissarro and Sisley handsomely recognized in Turner, 'the illustrious', 'a great master of the English School': a rambling conversation, which also touched on Milton, who appeals strongly to Charles.

Sunday 22
Ill, with frequent attacks of breathlessness – something to do…with stopping my 'cardiphiline'. Dr. Barnes produced an electrical apparatus and made some electro-cardio-grams. He wants to test the digoxin effects.

Monday 23
Still ill, but a better night. Back to the tablets. More electrocardiograms…Charles talked to me. He remembers Mr. Gladstone (W.E.) and was patted on the head by him. Gladstone was a friend of Alfred Tennyson. Slept into tomorrow in a drugged, halluci-natory way…

Tuesday 24
Charles and Ivy went to Edinburgh to lunch with Will MacTaggart the painter. Ivy bought one of his pictures for America, when she had her Scottish Show…

Wednesday 25
Much discussion with Charles on Raphael. The critics don't consider him much now…

Saturday 28
…Was unexpectedly taken for a motor-drive by Dr. Barnes (with Birdie and Mrs. Barnes) after tea, in my pyjamas, with an over-coat over them. Saw the Clyde estuary and Arran in the distance. Beautiful scenery, much defaced by the ship-breaking yards on Gareloch…

Sunday 29
Was introduced to Dr. Scott of Helensburgh, who may be called in to see me if Barnes is away…He will attend Alice in her next confinement.

SEPTEMBER

Sunday 5
The Tennysons left Auchenteil, early in the morning. Ivy was threatened with her old bladder trouble and wanted to see her doctor in London. *Schwabe's last Diary entry.*

Randolph Schwabe died on September 1948 without returning to the Slade. A service in his memory was held at St. Pancras Church on October 12. A small statue carved by Alan Durst stands against the wall of the churchyard of Hampstead Parish Church where his ashes are interred. Wrapped around the figure is a banner on which is carved:

Randolph Schwabe in whose life we have seen such excellence in beauty.

Biographical Notes

These notes refer to members of Schwabe's family, his friends and prominent figures mentioned in his diary. The details relate largely to the time span of the diaries and the inter-connections between the individuals (and places, particularly Chelsea, Hampstead and Manchester) and art works (plates of art works and photographs are referenced where appropriate) as featured in Schwabe's entries. Names in square brackets are nicknames.

Maxwell [Max] Ayrton (1874-1960), Scottish architect, designed British Empire Exhibition at Wembley Stadium (1924-25), pioneer in the architectural use of concrete. His son **Tony** (1909-43) was an aspiring artist and camouflage officer in the Second World War best known for his work on the large-scale deception for the second battle of El Alamein, Operation Bertram. They spent several painting holidays with Schwabe staying in Sisteron in France and Esch-sur-Sûre in Luxembourg and lived in Church Row (no. 9), Hampstead.

Harry Jefferson [Bish/Bysshe] Barnes (1915-82), as a young man was known as Bysshe (Schwabe wrote this for some time as 'Bish') from his resemblance to the poet Shelley. Born Sheffield, second son of Professor Alfred Barnes, a physician, and Jessie Morrison. His father's family were deeply rooted in Sheffield; his mother had moved there from Scotland to work as a nurse. Educated Repton and Slade where he was a student of Schwabe's; he also studied stage design under Vladimir Polunin. On leaving spent a year travelling in Europe as far as Moscow, studying art education, especially in schools. Taught in schools in London and Bushey; in 1941 he married Schwabe's daughter Alice. He took up a post in 1943 in the Glasgow School of Art; illness had prevented his joining the armed forces. He remained in the School of Art for the rest of his career, becoming Director in 1964 until he retired in 1980. From the outset he was very involved in the arts in Scotland, in particular with the Scottish Crafts Centre and the Edinburgh Tapestry Company. He was knighted in 1980 for services to the arts in Scotland.

Walter Bayes (1869-1956), art critic, founder member of the Camden Town (1911) and London Group (1913). Elder brother of the sculptor Gilbert Bayes, in 1904 he married the model **Katherine (Kitty) Telfer**. Studied Westminster School of Art, influenced by Sickert. Head of Westminster (1918-34) he was instrumental in Schwabe obtaining work there. Examiner for Drawing & Painting for the Board of Education; lecturer in Perspective at the R.A. and Slade. Contributed to *Recording Britain* including *Tattooist's Parlour, Colchester*, one of the few pictures to make explicit reference to the War rather than the changing British landscape.

Cyril Beaumont (1891-1976), pioneering writer, ballet critic, specialist book seller (75 Charing Cross Road) and publisher, ran Beaumont Press 1917-31 which specialised in fine book production of work by contemporary writers. Schwabe was associated with him in the production of more than a dozen books.

Muirhead Bone (1876-1953), born Partick, Glasgow, married the sister of his great friend Francis Dodd, **Gertrude**, a writer, settled in London. A skilled draughtsman, became first official war artist 1916. Knighted 1937, served W.A.A.C. from December 1939. Ten years earlier he bought a three-acre site at Ferry Hinksey overlooking Oxford and built a house, 'Grayflete'. Muirhead's eldest son **Stephen** (1904-58), was educated Bedales School, in 1929 he married Slade contemporary **Mary Adshead** (1904-95), he was appointed war artist attached to Royal Navy 1943. **Gavin** (1907-42) was a Fellow and Tutor of St. John's College, Oxford, he died from tuberculosis. Muirhead used Gavin's rooms as a studio to work on *Winter Mine-laying off Iceland*. He frequently travelled to W.A.A.C. meetings with Schwabe.

Tancred Borenius (1885-1948), Finnish art historian, authority on Italian art, 1914 appointed lecturer and successor to Roger Fry, and in 1922 the first Durning-Lawrence Professor of the History of Art at the Slade, retired 1947. A regular contributor to the *Burlington* from 1910, in 1925 he was involved in founding the art magazine *Apollo*.

Fred Brown (1851-1941), studied R.C.A. (1868-77), Paris (1883-84). Involved with setting up N.E.A.C. 1886. Head Westminster School of Art (1877-92), under his guidance it became one of the most progressive Schools in London. Succeeded Alphonse Legros as Slade Professor (1892-93), retired 1918. Like Legros he believed in the practice and tradition of draughtsmanship and also that all teachers should be practising artists. A far-sighted teacher, Schwabe was much in awe of him; Brown found him his first commissions and bought a drawing of his from N.E.A.C.

George Charlton (1899-1979), landscape painter and illustrator. Won a scholarship to the Slade 1914. 1917 aged 18 he served in France. Taught drawing at the Slade (1919-61), working closely alongside Schwabe. While working there met **Daphne Gribble** (1909-91), a student ten years his junior, who had enrolled in 1927, they married in 1929. Shortly after they stayed at Dora Carrington's home in Tidmarsh. George knew **Carrington** from his Slade student days, he was also friends with Mark Gertler (a near neighbour). 1932 the Charltons purchased 40 New End Square, Hampstead. The marriage was not a happy one and Daphne had a series of affairs, most notably with Stanley Spencer.

William [Willy] Clause (1887-1946), born Middleton, Lancashire, studied Slade alongside Schwabe under Tonks and Brown. 1920s holidayed with Schwabe and his family in Donegal, Ireland. Birdie sat for him in the early 1930s. Prominent member N.E.A.C.. Second World War made drawings of civil defence. Lived 34 Well Walk, Hampstead (previously 16 New End Square).

Dora Cobbe (née Jones) (1887-1965), Schwabe's sister-in-law, born Mandeville Place, London, sixth child of Herbert and Elizabeth Jones, was the closest of the siblings in age to her younger sister Birdie, born two years later, and they remained very close all their lives. After education in a convent school, spent some time in Belgium where she learned French. First World War worked as a V.A.D. nurse Westminster Hospital where she met her future husband Tom Cobbe. Following her marriage, she became a doctor's wife in Dover; their daughter **Margaret** was born in Westminster Hospital, London in 1929.

Margaret also saw a lot of Schwabe during his later years when she was at University in London; he expresses appreciation for her company in his diary. For many years, the Schwabe family spent every Easter in Dover. Second World War they were evacuated due to the bombardment, went to live in Oxford, near the Schwabes. Participated in a project to build up a pictorial map of the coast of Northern France after a broadcast appeal for postcards and photographs of the area brought millions of responses. After the War, returned to Dover.

Tom Cobbe (1884-1965), Schwabe's brother-in-law, having married Birdie's sister Dora. Born Tullamore, Co. Offaly, Ireland, into a farming family, studied medicine Trinity College, Dublin; moved to London to work at Westminster Hospital where he met his future wife, Dora Jones. After the First World War, he set up in general practice in Dover, remained there during the Second World War and worked tirelessly caring for the many wounded soldiers who passed through that port. He and Schwabe were very close friends and together explored much of Kent, either on foot or in Tom's car. He was very involved with Schwabe during his final illness and provided much support.

Francis Dodd (1874-1949), draughtsman, painter, printmaker. Studied Glasgow School of Art under Fra Newbery and Archibald Kay. 1895 lived Manchester, from 1904 London. Official War Artist First World War; Second World War specially employed by the W.A.A.C. to undertake a few specific works. Close friend of Schwabe, they did etchings of each other *c.*1916 [front cover]; Dodd suggested to Schwabe that he might apply to become a war artist in 1918 (which he did). Schwabe wrote an article on Dodd in *Print Collector's Quarterly* (1926). Dodd gassed himself in his Blackheath home.

Alan Durst (1883-1970), born Alverstoke, Hampshire. Served Royal Marines (1902-13), enrolled Central School of Art and Design, returned to the Marines in the First World War. Resumed his studies end of the War. Became Curator G.F. Watts Museum, Compton (1919-20), left to take up sculpture full-time, later taught wood carving R.C.A. (1925-40 & 1945-8). Exhibited with Seven & Five Society (1923-24). 1938 published *Wood Carving*, carved the memorial that contains Schwabe's ashes in Hampstead Churchyard.

Joyce [Tommie] Emery (*c.*1899-1976), born Harborne, just outside Birmingham, fourth child Rev. William W.B. Emery (1862-1937), a Baptist minister, and his wife. During the First World War she served in the Women's Land Army where in 1917 she met her great friend Millicent Russell who introduced her to the Schwabes. She loved animals, especially horses, and the outdoor life and trained in agriculture after the War. Spent much of her life in the outskirts of Bristol where the family had a smallholding for which Tommie and her brother were responsible. Also spent much time at Little Barn in Devon with Russell. 1954 left Bristol for the village of Tresham in the Cotswolds, driving there in her pony and trap where she remained for the rest of her life. Godmother to Schwabe's grand-daughter Janet (b.1944).

Mark Gertler (1891-1939), born Spitalfields, son of a Jewish furrier, came to live in Hampstead several years after leaving the Slade where he won a scholarship (1909) and prizes (1910), he was regarded as the best draughtsman since Augustus John. Gertler, like Schwabe would regularly walk on the Heath on Sundays; he had a studio in Rudall

Crescent 1915-32. Summer 1917 he and Schwabe took lessons from Nevinson in lithography. 1930 married **Marjorie Hodgkinson** who had also studied at the Slade. He briefly taught life drawing at Westminster. Schwabe recorded Gertler's suicide in June 1939.

William Grimmond (1884-1952), born Manchester, studied School of Art there. Landscape painter, mainly in watercolour, also designer of theatre costumes, posters and book illustrator. Member Art Workers' Guild, lived 28 Well Walk, Hampstead. His drawing *A Hampstead Garden* [plate 32] which he exhibited at the N.E.A.C. in 1929 shows Schwabe and Alice seated in the garden at the back of their home in 20 Church Row.

Allan Gwynne-Jones (1892-1982), born Richmond, educated Bedales School 1902-10, qualified as a solicitor but never practised. Circa 1912 he and his mother lived in rooms in Cheyne Walk, became friends with the Schwabes. Birdie and Schwabe lived on the ground floor of the same house and introduced him to Augustus John, J.D. Innes and Albert Rutherston. Won the DSO in 1916 during Battle of the Somme. Returned Slade post war, from 1923 taught at the R.C.A. with Schwabe, became Professor of Painting; 1930-59 taught Slade. 1937 married former Slade student **Rosemary Allan**. Their daughter Emily (b.1948) is also a gifted artist.

Karl Hagedorn (1889-1969), born Berlin, 1905 came to England, naturalized 1914, served British army First World War. Studied art Manchester, Slade and Paris. Known as Manchester's first modernist, also devoted time to cotton print designs, advertising and window display. Schwabe had a great influence on his work. Hagedorn's *The Artist's Wife and Friends on Holiday* (1932) is inscribed 'The Schwabes, Singer & Jonny & Nell [Nelly, née Stiebel] at Lanteglos' [in Cornwall]. Schwabe made several drawings in Lanteglos, including the church and its interior and *Farm Carts*, bought by the Contemporary Art Society for six guineas for the British Museum. Hagedorn's *Beach Scene: Hastings* (1933) was painted in the company of Schwabe.

Jean Inglis (1884-1959), born Kensington, studied alongside Schwabe at the Slade, gained first class certificates for figure drawing and painting, remained in contact with the Schwabes throughout her life, living nearby at 70 High Street, Hampstead before moving to Gloucestershire. In her youth she modelled for Sickert. First World War served as a V.A.D. in London. 1928 exhibited Paris Salon, received an honourable mention. Taught various schools including Frognal. A skilled portraitist, she participated in the *Recording Britain* scheme.

Augustus John (1878-1961), born Tenby, Wales, brother of the artist Gwen John. Studied Slade (1894-98), first visited Paris 1900. Taught painting University of Liverpool (1901-04). Painted many portraits of his contemporaries including *Mrs. Randolph Schwabe* (Birdie) *c.*1915-17 in his Chelsea studio and later when the Schwabes stayed at Fryern Court, near Fordingbridge. From *c.*1918 portraiture was an important source for income and his skill at portraying his many famous contemporaries enhanced his reputation. He painted **Lady Ottoline Morrell** in 1919. They first met in 1908, she would visit his studio and they became lovers. Birdie remembered Ottoline Morrell's kindness at one of her parties after Boris Anrep abandoned her for someone more important. Nearly 40 years later John undertook the portrait of Father D'Arcy, the Master of Campion Hall.

Hugh Jones (1884-1975), an older brother of Birdie and thus Schwabe's brother-in-law. He refused to conform to a conventional lifestyle. A lifelong pacifist, in the First World War he refused to bear arms but went to France to care for military mules and horses. In December 1918 he married **Ruth Slate** (1884-1953), a Quaker and early feminist, who had also joined pacifist organisations in the First World War, she trained as a social worker. They lived in Blackheath in south east London from 1921 and participated in many Quaker causes, including helping refugees and sending money to South Africa to support education for black children. She worked in the Blackheath Peace Shop during the Second World War, and was a friend of artist Edward Le Bas. Hugh always believed in living a simple life. He went everywhere by bicycle and from time to time chose to work as a brick layer and gardener. He was very close to Birdie who helped him considerably after they were both widowed.

Francis Michael Kelly (1879-1945), leading authority on costume, including armour. Studied Slade, a contemporary of Schwabe, shared many common interests and had a great regard for each other's work. They collaborated on a number of books, including *Historic Costume: A Chronicle of Fashion in Western Europe, 1490-1790* (1925), and the two volume *A Short History of Costume and Armour, Chiefly in England* (1931), both revelled in the research such practical and authoritative books necessitated, Schwabe supplying the illustrations. Kelly in a letter to Schwabe in December 1930 informed him that the 'second edition of our old K. & S. is selling…like hot cakes…We've had a topping press…'. According to Kelly in his preface to his book *Shakespearian Costume for Stage and Screen* (1938) 'the talent of my friend' Schwabe is shown by the illustrations.

Thomas Lowinsky (1892-1947), read English at Trinity College, Oxford but failed first year exams, left to study Slade 1912-14 where he met his future wife **Ruth Hirsch**. Served France 1914-19. The Lowinskys shared with Schwabe a mutual friend in Steer whom Ruth sat for, one of the results *Mrs. Thomas Lowinsky* was exhibited at the N.E.A.C. in 1924. Schwabe visited the Lowinskys during the Second World War when they rented Garsington Manor, the former home of Lady Ottoline Morrell. *Garsington* (1939-45) was Lowinsky's last painting. He was known as a painter of portraits and scenes of fantasy, book illustrator. He commissioned Schwabe on behalf of the Borough of Swindon (for 15 guineas) to draw *The Square, Swindon* (1947). Schwabe stayed with Ruth at The Old Rectory, Aldbourne (the Lowinsky's home 47 Kensington Square was destroyed by bombs) to do so, Lowinsky had by then died from cancer.

Dugald [D.S.M.] Sutherland MacColl (1859-1948), born Glasgow, studied London and Oxford Universities before studying Westminster and Slade under Legros (1884-92). Keeper Tate Gallery (1906-11), Trustee (1917-27). Editor *Architectural Review*; 1930 Schwabe succeeded him as editor of *Artwork*. Founder member Contemporary Art Society which bought several paintings by Schwabe. MacColl's last work *The Life, Work, and Setting of Philip Wilson Steer, O.M.* (1945) one of his longstanding friends (Schwabe was another), won the James Tait Black Memorial Prize. Steer painted MacColl's wife Andrée. MacColl wrote frequently to Schwabe when he was in hospital in 1948, Schwabe's diary opens in January 1930 with reference to him and a poem he wrote.

Charles Rennie Mackintosh [Toshie](1868-1928) and **Margaret Macdonald Mackintosh** (1864-1933), were close friends of the Schwabes when they lived in Chelsea from 1915-23. The friendship continued until their deaths respectively in 1928 and 1933. The Mackintoshes' studios were in Glebe Place and they had lodgings nearby. Margaret, in a letter to Schwabe in September 1930 from St. Paul, France, asked for news of the 'beloved famille Schwabe'. She says 'I expect you are on holiday – tho' that never means leisure – but just a change of work – '. Margaret, a watercolour painter and designer, provided much inspiration for Toshie's architectural work, was familiar with Schwabe's leisure practice as they had holidayed together on two occasions in Worth Matravers, Dorset in the 1920s. Schwabe loaned a number of works including *Textile Design* to the Mackintosh *Memorial Exhibition* in Glasgow in May 1933. As a mark of their friendship Margaret left in her will to Schwabe her 'three Catalan elephants and my old French oil and vinegar cruet in white', to Birdie 'any china, pottery…which she may care to have and which are not otherwise bequeathed' and to Alice her 'Catalan crocheted shawl with yellow fringe.'

Cyril [Charles] Mahoney (1903-68), studied Beckenham School of Art under Percy Jowett, won a scholarship to the R.C.A. (1922-26) under William Rothenstein. He knew Schwabe from his R.C.A. student days, their teaching careers at R.C.A. overlapped, they and Percy Horton would frequently lunch together and discuss art matters. Mahoney like Schwabe was a conscientious, sympathetic, highly informed teacher who upheld academic discipline. Schwabe had much respect for Mahoney's work including the mural scheme he oversaw at Brockley School, Lewisham (1933-36), recognising the direct experience Mahoney had gained from 1928-30 working on the large mural painting, *The Pleasures of Life* at Morley College. Schwabe also refers to the Brockley Murals and Evelyn Dunbar's contribution to the scheme. Dunbar was much influenced by Mahoney with whom she had an intense and romantic friendship for a number of years. The Lady Chapel at Campion Hall, Oxford was Mahoney's last major commission (1941); he was approached by Father D'Arcy to undertake the work (Schwabe lent his support) which continued for just over 10 years as he was only able to work on it during vacations. *The Death of the Virgin* shows the spiritual intensity of Mahoney's work and includes the Campion Hall Fathers in mourning. Mahoney married Dorothy Bishop, a calligraphy tutor from the Design School, R.C.A., in September 1941.

Bernard Meninsky (1891-1950), born Ukraine, of Jewish parents, brought to England some six weeks later, lived Liverpool, attended the School of Art from 1906, winning various scholarships before studying in the summer of 1911 at Académie Julian, Paris. He soon returned to England, studied Slade (1912-13) showing great promise, leaving to teach the drawing of stage design at Gordon Craig's newly-formed theatre school in Florence. Lifelong member London Group, he and Schwabe served together for a short period on the executive committee. 1914 taught Central School, outbreak of First World War enlisted 42nd battalion, Royal Fusiliers. 1920 succeeded Walter Sickert as teacher of life drawing at Westminster. Schwabe was much involved with Bayes and Gertler in 1932 in raising a subscription from other contemporary artists to support Meninsky when he had a nervous breakdown and was sent to the Cassel Hospital in Kent. He corresponded over the course of this with Schwabe expressing how deeply moved he was by the trouble taken on his behalf. During the Second World War Meninsky also taught in

Oxford, obtaining a post at the City Art School. 1950 died by his own hand like Gertler, Carrington and Dodd.

Egan Mew (1862-1945), a near neighbour of the Schwabes at 7 Church Row, Hampstead. Connoisseur of antiques and porcelain in particular, he wrote books on china including *Chelsea and Chelsea-Derby China* (1909) and several comedies in the 1890s. During the war he lived in Oxford where he died.

Thomas Monnington (1902-76), studied Slade (1918-23), Rome Scholar (1923-26). Married fellow Rome Scholar and the first woman recipient of the award (Jane) **Winifred Knights** (1899-1947) in 1924, a Slade student (1915-17), she returned to the Slade 1918-20, was close to George Charlton, Allan Gwynne-Jones and Arnold Mason to whom she had become engaged before she left. Monnington specialized in decorative painting, taught drawing part-time R.C.A., from 1931-39 Royal Academy Schools. Outbreak Second World War he joined Directorate of Camouflage. Post-war taught Camberwell; 1949 joined the staff of the Slade. Elected R.A. 1938. From the 1940s they lived in Groombridge, Kent. He married again in 1947 after Winifred's death.

Jean Orage (née Walker) (b.c.1875), studied R.C.A., a theosophist, she married **Alfred Richard Orage**, journal editor and advocate of social credit 1896, divorced 1927. Wove rugs and tapestries for William Morris & Co. (1905-16) and then in her own Chelsea workshop (49 Church Street). She designed rugs for exhibition in Paris 1925 and collaborated with leading designers including Edward McKnight Kauffer, Marion Dorn, Claude Flight and Ronald Grierson. Schwabe exchanged a drawing for one of Orage's hand-woven rugs in 1933, their friendship dated back to when the Schwabes lived in Chelsea. Orage was still weaving for Dorn in 1935. She later gave her loom to Alice Schwabe.

Eunice [Minkie] Pattison, a friend of the Schwabe family whom they befriended during their many holidays in Cerne Abbas, Dorset during the 1930s. She was very involved in caring for her mother and in the life of Cerne. She had a very elderly small car (an Austin 7) which she called Tubby and in which she drove Schwabe around the countryside to locations he wished to draw. Minkie visited the Schwabes in Oxford during and after the war in Hampstead. Godmother to Schwabe's grand-daughter Diana (b.1945), died 1989 at a great age.

William Rothenstein (1872-1945), born Bradford, studied Slade (1888-89) under Legros and Académie Julian, Paris. 1894 settled Chelsea. 1899 married Alice Knewstub, a former actress. Principal R.C.A. (1920-35), did much to help younger painters, appointed Schwabe drawing master in 1921. Encouraged his students to paint murals for public buildings. An official War artist First World War. Knighted 1931. Second World War was employed by W.A.A.C. for a number of specific works attached to the R.A.F. (1939-40 & 1943). Died Far Oakridge, near Bisley, Gloucestershire, having gone back to live there after his retirement from the R.C.A.

Laura Millicent Russell (1887-1943), born into a wealthy Scottish family, attended a fashionable boarding-school. A lonely child, she studied music for a year in Dresden. She bought a house in Chelsea, 131, Cheyne Walk. First World War served Women's

Land Army where she met her great friend Joyce 'Tommie' Emery who knew her as Marsland Russell; before the Armistice she joined the Police Force. Exhibited Royal Photographic Society 1920. Became good friends with the Schwabes in Chelsea and was especially close to Birdie, she also knew Egan Mew. Always known as Russell, she was eccentric and did not conform to social norms: she always wore breeches and a tunic and had her hair cropped. A great traveller, lived much of the time in Moustiers-Sainte-Marie in Provence where the Schwabes and their friends had many holidays, she left in June 1941, via Spain and Portugal. She also had a cottage, Little Barn, part of an old mill at Welcombe in North Devon, on the Hartland peninsula. Russell did not enjoy good health and was looked after tirelessly by Birdie until her death in 1943, prior to which she had been staying with Lucien and Esther Pissarro, whom she knew when she lived in Cotignac, France.

Albert Rutherston (Rothenstein) (1881-1953), born Bradford. One of Schwabe's closest friends, their association began at the Slade. Schwabe and Birdie attended his parties in Fitzroy Street where he and John Fothergill (Slade 1905-06) lived. He drew Birdie in 1910, and gave the drawing as a gift to his brother, **Charles**, in 1911. Albert like Schwabe's elder brother Eric changed his surname during the First World War to the anglicized version as did Charles. Their older brother William retained the family name of Rothenstein. Rutherston shared an interest in the theatre and ballet with Schwabe. In the 1920s Rutherston's distinctive illustrations contributed to transforming the Curwen Press. He gave Schwabe a copy of Aldous Huxley's *Holy Face and other Essays* (1929) which contained his fine and vibrantly coloured drawings, signing it in September 1935 'affectionately Albert R.', the patterned paper-covered slip case was also the result of his labours. *The Haggadah*, probably the most successful of Rutherston's illustrated books, was published in 1930. The ill health of his wife Margery (c.1898-1957) and her unsuccessful attempt to take her own life receives attention in Schwabe's diaries. Rutherston succeeded Sydney Carline as Ruskin Master of Drawing in 1929, a post he held until retirement in 1949. A Fellow of New College, Schwabe would join him for supper during his Oxford stay. Rutherston met Patricia Koring in 1938, who had been a student at Chelsea Polytechnic, Barnett Freedman suggested he drew her. Rutherston and Schwabe's friendship enabled the Ruskin and Slade to collaborate effectively in Oxford 1939-45 and the staff and students to negotiate the tribulations of wartime relatively smoothly.

Alice Schwabe (Alice, Lady Barnes) (1914-2010), born 43A Cheyne Walk, Chelsea, the only child of Randolph and Gwendolyn [Birdie] Schwabe. Her childhood was very bohemian, an only child surrounded by leading artists of the day. A favourite of Charles and Margaret Mackintosh who looked after her, often in the Blue Cockatoo restaurant (she also met Augustus John, Alick Schepeler and Alexander Stuart-Hill there), she was sent to a kindergarten run by a friend of the dancer Margaret Morris and then, as a boarder, to Bedales School where her fees were paid by her godfather, Allan Gwynne-Jones. Later she trained with Margaret Morris and became one of her teachers. In 1941 she married Harry Jefferson Barnes and in 1944 they moved to Glasgow. Alice spent the rest of her life in Scotland, bringing up her three children, caring for both sets of grandparents and involved in the life of the Glasgow School of Art. She was a skilled craftswoman, knitting stunning garments, designing and sewing patchwork quilts and working in tapestry. In old age she was much in demand to share her memories of Mackintosh and Schwabe and his circle.

Eric Anthony Schwabe [Bill Sykes] (1883-1945), sometimes referred to as Uncle Bill, was Schwabe's older brother; they remained close throughout their lives. Eric was born in Barton-upon-Irwell, Manchester, the elder son of Lawrence Schwabe and Octavia Ermen. The family was of German origin and were all involved in the cotton industry. Lawrence Schwabe was an unsuccessful business man and his wife suffered often from the debts he incurred. The family moved in 1895 to Hemel Hempstead where Lawrence set himself up as a stationer. Eric and his younger brother Randolph wrote, illustrated and produced the school magazine (*Heath Brow Chronicle*). After Eric left school he worked as a clerk. In 1907 following his mother's death he departed for China to work in a trading firm connected to the family. 1917 changed his name to Sykes (his paternal grandmother's name) due to anti-German feeling. Joined Shanghai Municipal Police (operated by the European powers) as an inspector and, along with his friend William E. Fairbairn, developed training in unarmed combat and shooting. He continued to work for various firms in Shanghai, including acting as the representative for Colt Remington. In 1934 Alice spent six months in Shanghai with him. In 1940 he and Fairbairn returned to the UK and were recruited by SOE as instructors in unarmed combat and silent killing. His book *Shooting to Kill* (1945) was illustrated by Schwabe. Died in 1945 in Bexhill-on-Sea after a period of ill-health.

Gwendolyn [Birdie] Schwabe (née Jones) (1889-1978), born Mandeville Place, West End of London. Seventh and youngest child Herbert and Elizabeth Jones. At her convent school, the nuns recognised her talent for drawing and suggested that she should go to the Slade, where she enrolled aged 14. Because of her youth and her retiring nature, she would at lunch time take her lunch basket and perch on top of lockers. It is said that Augustus John, for this reason, gave her the name Birdie. At the Slade met Schwabe and they were married in Chelsea Old Church in 1913. Birdie had been developing her own artistic career, creating fashion drawings for journals, including *Vogue*, but gave this up to support Schwabe. A talented creator of interesting interiors, dressmaker and highly skilled needlewoman. She had a great gift for friendship and looking after people in need. An avid reader and lover of literature, her retiring nature meant that she never took part in Schwabe's public life.

Walter Sickert (1860-1942), studied briefly Slade (1881-82), became Whistler's pupil and studio assistant. Met Degas in Paris and in Dieppe in 1885, the coastal town held his attention for over four decades, lived there from 1898-1905. Founder member Chelsea Arts Club and in 1907 Fitzroy Street Group and later Camden Town Group and London Group, taught part-time for several evenings a week at Westminster School (1908-12 & 1915-18). His third marriage in 1926 was to the painter Thérèse Lessore, whose work he much admired. They moved to Bathampton in 1938 where he lived until his death.

Philip Wilson Steer (1860-1942), founder member N.E.A.C. 1896, exhibited with them throughout his life, in his early career was influenced by Whistler and the French Impressionists, giving a paper on the latter at the Art Workers' Guild in 1891. 1898 moved to 109 Cheyne Walk, Chelsea where he lived for the rest of his life. Steer taught Schwabe at the Slade, having been appointed by Fred Brown in 1893, known for his kindly manner and patient approach to teaching – a sharp contrast to his lifelong friend Tonks. No lover of theory, he brought to his weekly teaching an insistence upon tone, he retired

in 1930. His domain was painting, including watercolour; Schwabe learned to appreciate his pictures.

Charles Tennyson (1879-1977), grandson of the poet Alfred Lord Tennyson, and his wife **Ivy** (née Pretious, 1880-1958), married in 1909, were perhaps the Schwabes' closest friends, spending more than 20 Christmases together. The Schwabes shared their home in Drayton Gardens after the War. An earlier indication of the depth of their friendship was the loan of several thousand pounds to enable Schwabe and Birdie to purchase their Hampstead home. They first came into contact with the Schwabes in Chelsea when they moved to 26 Cheyne Row in 1915. During these early years in Chelsea the Tennysons developed their love of the arts and made friends with many artists including Allan Gwynne-Jones, Philip Connard and the sculptor Frank Dobson. Between 1941-43 Ivy organised several exhibitions for the War effort. Tennyson was involved with industrial design and the Council for Art and Industry which was established in 1944, he was Secretary of the Dunlop Rubber Company from 1928-48. The Tennysons had three sons, their eldest **Penrose [Pen]** (1912-41), was in charge of the Admiralty's Instructional Film Unit and was killed when the naval aircraft he was a passenger in crashed when flying south from Scapa Flow. He made the propaganda film *Convoy* (1940). He married the actress **Nova Pilbeam** (1919-2015) who had starred in two films directed by Alfred Hitchcock, Pen being assistant Director, in 1939. His middle brother **Julian [Dooley]** (1915-45), was killed in action in Burma. A gifted writer about the English countryside, Schwabe's drawing of Sibton forms the book jacket for his work *Suffolk Scene* (1939); Schwabe also provided the frontispiece *Windmill, Peasenhall*. The Schwabes regularly stayed with the Tennysons in the Ancient House at Peasenhall. Dooley married **Yve [Yvonne Le Cornu]** in 1937. **Hallam** (1920-2005), the youngest sibling, was educated at Eton and Balliol College, Oxford, a conscientious objector, he served with the Friends' Ambulance Unit. He married **Margot Wallach**, a Jewish refugee from Nazi Germany in 1945, they went to India 1946-48.

Henry Tonks (1862-1937), joined the Slade staff *c.*1892 after a successful surgical career. In his free time he had studied part-time at Westminster School of Art under Brown before he moved to run the Slade. Schwabe was taught life drawing by Tonks almost from his first day at the Slade and found himself subject to his penetrating, stern gaze and withering criticism; he learnt much from him and his insistence on studying the Old Masters at the British Museum. During the First World War Tonks made pastel drawings of facial injuries of soldiers for use in plastic surgery. His knowledge of anatomy was an integral part of his own art and teaching. Appointed Slade Professor in 1918, retired in 1930, although he continued to paint. He died at his home in The Vale, Chelsea.

Donald Towner (1903-85), painted landscapes and church works, trained Eastbourne School of Art alongside Eric Ravilious (1903-42); they took the R.C.A. entrance test on the same day in 1923 and for a time shared lodgings. Towner was taught drawing by Schwabe and gained the College painting prize in 1926. In 1930 he was offered a tempo-rary teaching job by Hubert Wellington at King Edward VII School of Art, Armstrong College, Newcastle upon Tyne. 1937 moved with his mother to 8 Church Row, Hampstead meeting Stanley Spencer at the Schwabes on a number of occasions. During the Second World War the Towners stayed in South Harting, West Sussex where Gunning King (1859-1940) the *Punch* artist lived. Towner worked as farm labourer and taught a

day at week at nearby Churcher's College, Petersfield. After the war he returned to Hampstead, the Schwabes lived with them for a short period. Towner was Godfather to Schwabe's grand-daughter Janet.

Charles Vyse (1882-1971), sculptor and studio potter, in 1919/20 with his wife, **Nell**, set up a studio at Cheyne Walk, Chelsea. They produced figures based on characters seen on the streets of London. They worked together until the marriage ended *c.*1940. Vyse trained at the R.C.A. (1905-10) and taught alongside Schwabe at Camberwell School of Art, having studied there in 1912. He gave Schwabe a number of pots. His studio was damaged in an air raid resulting in his leaving London. He taught at Farnham School of Art from this date.

Ethel Walker (1861-1951), born Edinburgh, taught by Fred Brown at the Westminster and Slade who recognized her promise and followed her development as an artist. She also attended Sickert's evening painting classes having previously been a student at Putney School of Art. Schwabe knew Walker from when they lived in Cheyne Walk, Chelsea, she lived at 127 (she also had a cottage on the cliffs above Robin Hood's Bay in Yorkshire) and in 1916 she painted Birdie and the young Alice in her large studio, [plate 33] female portraits being her favourite subjects. The portrait *Mrs. Randolph Schwabe and Child* was exhibited at the N.E.A.C. in the same year. One of Britain's leading women painters, she was created a Dame in 1943.

Hubert Wellington (1879-1967), painter, teacher and writer. Studied Gloucester School of Art (1895-98), transferred to Birmingham Art School, 1899-1900 Slade. Served with the Field Survey Unit, Royal Engineers (1916-19). Lecturer National Gallery (1919-23). Registrar and lecturer R.C.A (1923-3). Principal Edinburgh College of Art (1932-42). 1947 Schwabe invited him to stand in as lecturer in art history (after Borenius). He and his first wife – **Charlotte** – who died in 1943 were longstanding friends of the Schwabes. His second wife **Irene** (née Bass, 1904-84) whom he married in 1944 was a distinguished calligrapher and former pupil of Edward Johnston at the R.C.A. She had been his assistant in the calligraphy class from 1927-30. She taught at the R.C.A. (1945-47) and Central School of Arts and Crafts (1947-59).

Selected References

Aitchison, D. (1989) The Slade School of Fine Art at the Ashmolean Museum, 1939-41, *The Ashmolean*, 15, Christmas 1988 & Spring 1989, pp.3-5

Baile de Laperriere, C. (Ed) (2002) *The New English Exhibitors 1886-2001, Volumes I-IV*, Calne: Hilmarton Manor Press

Baron, W. (1977) *Miss Ethel Sands and Her Circle*, London: Peter Owen

Baron, W. (1979) *The Camden Town Group*, London: Scolar Press

Bohm-Duchen, M. (1990) *Thomas Lowinsky*, London: Tate Gallery

Borland, M. (1995) *D.S. MacColl: Painter, Poet, Art Critic*, Harpenden: Lennard Publishing

Buckman, D. (2006) *Artists in Britain since 1945, Volumes 1 & 2*, Bristol: Art Dictionaries Ltd. (Sansom & Co)

Chamot, M. (1937) *Modern Painting in England*, London: Country Life Ltd.

Chaplin, S. (1998) A Slade School of Fine Art archive reader: a compendium of documents, 1868-1975, in University College London, contextualized with an historical and critical commentary, augmented with material from diaries and interviews, Slade School of Fine Art

Clarke, G. (2006) *Evelyn Dunbar: War and Country*, Bristol: Sansom & Co.

Clarke, G. (2012) *Randolph Schwabe*, Bristol: Sansom & Co.

Dewsbury, S. (2003) *The Story so Far: The Manchester Academy of Fine Arts from 1859 to 2003*, Manchester: The Portico Library

Forge, A. (Ed) (1976) *The Townsend Journals. An Artist's Record of his Times 1928-51*, London: Tate Gallery

Foss, B. (2007) *War Paint. Art, War, State and Identity in Britain 1939-1945*, London: Yale University Press

Freeman, J. (1979) *Made at the Slade. A Survey of Mature Works by ex-students of the Slade School of Fine Art, 1892-1960*, Brighton: Brighton Polytechnic, Faculty of Art & Design

Holroyd, M. (1974) *Augustus John, Volume 1: The Years of Innocence*, London: Heinemann

Horne, J. (1939) *The Life of Henry Tonks*, London: William Heinemann

Huxley, P. (Ed) (1988) *Exhibition Road: Painters at the Royal College of Art*, Oxford: Phaidon

Lindsay, D. (1963) *The Felton Bequest: An Historical Record 1904-1959*, London & Melbourne: Oxford University Press

MacColl, D.S. (1945) *Life Work and Setting of Philip Steer*, London: Faber & Faber

Redfern, D. (2013) *The London Group: A History 1913-2013*, London: The London Group

Rothenstein, W. (1932) *Men and Memories, Recollections of William Rothenstein 1900-1922*, London: Faber & Faber

Towner, D.C. (1979) *Recollections of a Landscape Painter and Pottery Collector, An Autobiography*, New York: Born-Hawes Publishing

Whitworth Art Gallery and Chris Beetles Ltd. (1994 & 1995) *Manchester's First Modernist Karl Hagedorn 1889-1969*, Manchester: The Whitworth Art Gallery

List of Illustrations and Credits

Plate 1: Randolph Schwabe
Edmund Bernard Fitzalan-Howard, 1st Viscount Fitzalan of Derwent
1930, collotype, 32.3 x 24.7 cm. © The artist's estate. Courtesy National Portrait Gallery

Plate 2: Randolph Schwabe
Rowland Thomas Baring, 2nd Earl of Cromer
1930, collotype, 32.1 x 25.1 cm. © The artist's estate. Courtesy National Portrait Gallery

Plate 3: Randolph Schwabe
General Sir Neville Lyttelton
1930, pencil, 35 x 25.5 cm. © The artist's estate. Courtesy Janet and Di Barnes

Plate 4: Randolph Schwabe
Randall Robert Henry Davies
1939, chalk, 35.9 x 29.2 cm. © The artist's estate. Courtesy National Portrait Gallery

Plate 5: Walter Sickert
The Mantelpiece
1907, oil on canvas, 76.2 x 50.8 cm. Courtesy Southampton City Art Gallery/Bridgeman Images

Plate 6: Dora Carrington
Iris Tree on a Horse
c.1920s, oil, ink, silver foil and mixed media on glass, 11 x 14 cm. Courtesy Ingram Collection

Plate 7: Charles Rennie Mackintosh
Textile design
c.1918, pencil and watercolour on tracing paper, 30.1 x 23.8 cm.
© Victoria and Albert Museum, London

Plate 8: Charles Rennie Mackintosh
Textile design
c.1918, watercolour on backed tracing paper, 13.3 x 13.3 cm.
© Victoria and Albert Museum, London

Plate 9: Karl Hagedorn
Beach Scene, Hastings
1933, pen and ink, and watercolour, 34.8 x 50 cm.
© Private collection. Courtesy Chris Beetles Gallery and The Hagedorn Family

Plate 10: Randolph Schwabe
Street Musicians
1934, watercolour, 41 x 47 cm. © The artist's estate. Courtesy Janet and Di Barnes

Plate 11: Randolph Schwabe
On certain afternoons in the week there were operations
(*Of Human Bondage*, Somerset Maugham)
1936, collotype, 69.5 x 48 cm. © The artist's estate. Courtesy Janet and Di Barnes

Plate 12: Jessie C. Wolfe
Professor Schwabe
1938, oil on canvas, 71.1 x 55.9 cm. © UCL Art Museum, University College London

Plate 13: Randolph Schwabe
The Round House, Dover
1938, ink and watercolour, 32.9 x 39.2 cm. © The artist's estate.
Courtesy Manchester Art Gallery

Plate 14: Henry Lamb
Portrait of Lady Ottoline Morrell
1910-11, black chalk, 29.2 x 22.9 cm. © Estate of Henry Lamb. Courtesy Ingram Collection

Plate 15: Augustus John
Mrs Randolph Schwabe
*c.*1915-17, oil on canvas, 61 x 40.6 cm. © The artist's estate.
Courtesy University of Hull Art Collection

Plate 16: Randolph Schwabe
Sir John Rose Bradford
1938, oil on canvas, 101.7 x 76.2 cm. © UCL Art Museum, University College London

Plate 17: Ithell Colquhoun
The Judgement of Paris
1930, oil on canvas, 62 x 75 cm. © The artist's estate.
Courtesy Brighton and Hove Museums and Art Galleries

Plate 18: Randolph Schwabe
Coventry Cathedral
1940, pencil, conte crayon, wash on paper, 38 x 39.6 cm. © Imperial War Museums

Plate 19: Walter Bayes
Tattooist's Parlour, Colchester
1940, pen and ink and watercolour, 32.4 x 39.4 cm. © Victoria and Albert Museum, London

Plate 20: Edgar Holloway
Harry Jefferson Barnes
1941, etching, 17.7 x 12.7 cm
© The artist's estate. Courtesy Janet and Di Barnes

Plate 21: Augustus John
Father Martin D'Arcy, 6th Master
mid-1940s, oil on canvas, 58.4 x 48.3 cm. © The artist's estate.
Courtesy Campion Hall, University of Oxford

Plate 22: Muirhead Bone
Winter Mine Laying off Iceland
*c.*1942, oil on canvas, 127.9 x 160.6 cm. © Imperial War Museums

Plate 23: Randolph Schwabe
The Radcliffe Observatory, Oxford
1942, watercolour on paper, 56.5 x 38.7 cm. © Tate 2015

Plate 24: Charles Mahoney
The Death of the Virgin
oil on board, 29.3 x 28 cm. © The artist's estate. Courtesy Campion Hall, University of Oxford

Plate 25: Randolph Schwabe
Janet Barnes
1944, pencil on terracotta coloured paper, 17.6 x 13.4 cm. © The artist's estate.
Courtesy Janet and Di Barnes

Plate 26: Paul Feiler
Boats and Sea
Oil on canvas, 87.5 x 90.8 cm. © The artist's estate.
Courtesy Bishop Otter Trust, University of Chichester

Plate 27: Raymond Mason
Ginette Neveu
1945, oil on canvas, 39 x 31.5 cm. © ADAGP, Paris and DACS, London 2012.
All rights reserved. Swindon Museum and Art Gallery

Plate 28: Ben Enwonwu
Monotony
1948, oil on canvas, 91 x 71 cm. Courtesy The Ben Enwonwu Foundation and Bishop Otter
Trust, University of Chichester

Plate 29: Ivon Hitchens
Autumn Stream
mid-1940s, oil on canvas, 59 x 108.5 cm. © Jonathan Clark Fine Art, representatives of the artist's estate. Courtesy Bishop Otter Trust, University of Chichester

Plate 30: Randolph Schwabe
The Square, Swindon
1947, pen and wash on paper, 35.5 x 50 cm. © The artist's estate.
Courtesy Swindon Museum and Art Gallery

Plate 31: Kyffin Williams
The Dark Lake
1951, oil on canvas, 44.5 x 54.5 cm. © Llyfrgell Genedlaethol Cymru/The National Library of Wales. Swindon Museum and Art Gallery

Plate 32: William Grimmond
A Hampstead Garden
1929, watercolour on board, 37 x 27 cm. © The artist's estate. Courtesy Janet and Di Barnes

Plate 33: Ethel Walker
Mrs Randolph Schwabe and Child
1916, oil on board, 36 x 28 cm. © The artist's estate/Bridgeman Images.
Courtesy Janet and Di Barnes

Plate 34: Birdie and Alice Schwabe, *c.*1914-15. Courtesy Janet and Di Barnes

Plate 35: Willie Clause, Alice and Randolph Schwabe, Cashelnagore, Co. Donegal, 1926.
Courtesy Janet and Di Barnes

Plate 36: Photograph used to announce Randolph Schwabe's appointment as Professor and Principal of the Slade School of Art, 1930.
Courtesy Janet and Di Barnes

Plate 37: Randolph Schwabe at the fair, 1932. Courtesy Janet and Di Barnes

Plate 38: Slade Picnic, 1932: (left to right) Ormrod, Charlton, Daphne Charlton, Schwabe and Wilkie. Courtesy Janet and Di Barnes

Plate 39: Slade and Ruskin Schools, Oxford, 1941: Schwabe is seated in the third row from the front next to Rutherston on his right; Polunin is seated beside Rutherston.
Courtesy Janet and Di Barnes

Plate 40: The last photograph of Schwabe, August 1948: a family picnic, Glen Fruin, near Helensburgh: (left to right) Margaret Cobbe (niece), Granny Barnes, Diana Barnes (aged 2½), Janet Barnes (aged 4), Dora Cobbe, Harry Barnes, Grandfather Barnes and Schwabe.
Courtesy Janet and Di Barnes

Plate 41: Model by Alan Durst for a memorial to Randolph Schwabe, 1950.
Courtesy Janet and Di Barnes

Index

Adam, Robert 58, 244, 288, 447
Adams, Bernard 38, 188, 289
Adams, Bill 158, 322, 323
Adeney, Noël (née Gilford) 55, 115, 148
Adeney, Bernard 55, 59, 111, 145, 148
Adshead, Mary 25, 48, 236, 546
Agar, Eileen 158, 189, 383
Ainsworth, Edgar 36, 37
Airy, Anna 26, 45
Aitken, Charles 26, 28, 37, 47, 70, 89, 121, 152, 223, 232, 489
Alexander, Margaret 47, 97, 258, 475
Alexander, Philip 28, 100, 120, 129, 175
Allan, Griselda 374, 382, 383, 387, 389, 390, 398, 417, 418, 426, 439, 459, 467, 471
Allan, Rosemary (later Gwynne-Jones) 130, 138, 144, 147, 152, 154, 168, 170, 213, 246, 452, 536, 540, 548
Alston, E. Constable 21, 40, 50, 54, 70, 163, 289
Alston, Rowland W. 32, 299
Anderson, Stanley 15, 273
Andrade, Edward 354, 360, 432, 524, 531
Anquetin, Louis 121
Anrep, Boris 29, 89, 223, 258, 272, 548
Anrep, Helen 172, 258, 293, 345, 351, 399
Ardizzone, Edward 286, 316, 425, 433, 452
Armstrong, John 102, 215, 364
Arnold, Matthew 355, 390, 404
Aronson, Irene 317, 371
Arp, Jean 145, 162
Asquith, H.H. 77, 78, 378
Atkins, Alban 410, 416, 424, 438, 446, 463
Austin, Robert Sargent 62, 250, 269, 303, 433, 525
Ayrton, Maxwell (Max)* 6, 27, 31, 44, 52, 58, 59, 68, 69, 100, 103, 104, 114, 131, 142, 154, 164, 167, 171, 173, 176, 187, 195, 196, 217, 233, 234, 250, 252, 255, 259, 264, 267, 271, 276, 280, 282, 295, 298, 302, 305, 321, 356, 423, 459, 495, 498, 499, 508, 511, 514, 527, 532, 539, 545
Ayrton, Tony 6, 58, 100, 110, 114, 134, 168, 174, 264, 271, 275, 278, 280, 302, 305, 321, 414, 423, 459, 545

Badmin, Stanley Roy 51, 86
Bagshawe, William 93, 487
Baldwin, Stanley 21, 115, 121, 167, 252, 391, 394, 401, 404, 410
Balniel, Lord 183, 203
Balston, Tom 111, 116, 125, 252, 487, 534
Barker, Margaret 14, 42, 77, 231
Barnes, Alice Lady (née Schwabe)* 7, 13, 14, 16, 21, 22, 34, 35, 45, 63, 80, 81, 83, 90, 91, 97, 100, 101, 105, 109, 110, 114, 128, 135, 141, 142, 154, 161, 163, 164, 167, 168, 169, 172, 177, 181, 183, 188, 193, 196,197, 200, 203, 209, 215, 217, 221, 227, 231, 234, 235, 241, 242, 243, 245, 249, 252, 253, 254, 256, 266, 270, 271, 278, 280, 281, 285, 287, 297, 300, 303, 304, 313, 316, 319, 322, 324, 325, 326, 328, 333, 334, 344, 347, 348, 349, 358, 359, 363, 368, 380, 388, 392, 436, 472, 479, 480, 500, 538, 539, 541, 542, 544, 545, 548, 550, 551, 552, 553, 555

Barnes, Diana (Di) Barnes 480, 492, 541, 542
Barnes, Harry (Bish/Bysshe) Jefferson* 11, 49, 201, 225, 235, 236, 295, 303, 313, 322, 326, 331, 328, 344, 348, 349, 358, 359, 363, 365, 368, 380, 382, 388, 392, 404, 426, 443, 446, 447, 454, 472, 480, 482, 485, 507, 516, 520, 525, 528, 541, 542, 543, 545, 552
Barnes, Janet 436, 443, 472, 507, 541, 542, 543, 547, 555
Bateman, H.M. 308, 401, 402, 404, 405, 406, 408, 409
Batsford, Harry 52, 54, 57, 66, 75, 84, 167, 215, 366, 367, 373, 374, 375, 399, 421, 422, 440, 474, 475, 476, 478, 480, 485
Bawden, Edward 15, 16, 21, 49, 132, 146, 245, 246, 298, 316, 323, 384, 405, 422
Bax, Clifford 59, 232, 262, 263, 433
Bayes, Walter* 14, 15, 16, 17, 24, 25, 28, 29, 32, 33, 34, 35, 38, 43, 46, 53, 56, 61, 69, 78, 80, 89, 91, 94, 95, 96, 113, 115, 138, 163, 180, 188, 189, 194, 209, 210, 211, 219, 220, 265, 275, 310, 314, 323, 330, 331, 355, 359, 381, 545, 550
Baynes, Anthony 'Tony' 317, 321, 498
Baynes, Keith 59, 110, 152, 386, 417
Bayon, Pamela de 58, 77, 82, 100, 237
Beale, Sir John 145, 147, 149
Beardsley, Aubrey 75, 81, 311, 417, 503, 521, 527
Beaumont, Cyril* 13, 21, 22, 25, 29, 31, 35, 36, 40, 44, 55, 57, 59, 60, 61, 81, 86, 88, 89, 101, 145, 268, 285, 303, 304, 318, 359, 545
Beck, Maurice 161
Beddington, Roy 194, 238, 260
Bedford, Duke of 54, 55, 87
Bedford, R.P. 82, 113, 150, 219
Beerbohm, Max 8, 51, 52, 84, 112, 126, 134, 188, 211, 214, 220, 238, 281, 282, 283, 400, 454, 462, 492
Behrend, Louis 64, 82, 89, 186, 208, 229, 295, 317, 319
Bell, Clive 276, 313, 363, 364, 370, 394, 534
Bell, Robert Anning 50, 354, 522
Bell, Vanessa 15, 39, 211, 219, 272, 367, 399, 524
Bellin-Carter, Leslie 417, 429, 431, 458, 483, 530
Bellingham-Smith, Elinor 115, 265, 452
Bellini, Giovanni 111, 338, 500
Bennett, Arnold 72, 228
Bennett, Dorothy Cheston 72, 75, 79
Bentham, Jeremy 102, 105, 107, 108, 489, 497
Beresford, George Charles 173, 251, 529
Berry, Francis 33, 66, 73, 413
Betjeman, John 303, 304, 310, 342
Betts, Anthony 45, 106, 117, 141, 168, 230, 255, 277, 310, 317, 324, 331, 358, 387, 420, 443, 469, 515
Binyon, Laurence 305, 365, 377
Bird, Henry 46, 173
Birdie (Gwendolyn Rosamund Schwabe née Jones)* 6, 11, 16, 17, 21, 23, 26, 27, 29, 30, 34, 35, 37, 39, 42, 44, 45, 49, 50, 55, 56, 58, 68, 79, 83, 89, 90, 91, 94, 95, 97, 101, 102, 104, 109, 113, 115, 119, 123, 124, 126, 128, 130, 131, 136, 137, 139, 140, 141, 142, 144, 151, 153, 161, 163, 175, 177, 181, 183, 187, 190, 194, 195, 196, 200, 201, 203, 204, 210, 211, 212, 215, 217, 219, 220, 224, 229, 230, 232, 233, 234, 236, 243, 249, 252, 253, 254, 256, 261, 271, 272, 276, 280, 281, 283, 287,

288, 291, 296, 297, 300, 304, 308, 310, 311, 318, 319, 325, 328, 329, 338, 344, 346, 349, 358, 363, 364, 368, 372, 376, 384, 385, 387, 390, 396, 398, 400, 401, 402, 404, 408, 409, 413, 415, 417, 418, 428, 430, 436, 440, 443, 447, 448, 455, 456, 459, 463, 466, 467, 468, 473, 474, 476, 477, 480, 481, 482, 488, 493, 495, 496, 499, 500, 505, 509, 515, 517, 519, 520, 521, 527, 530, 532, 533, 535, 536, 537, 538, 539, 540, 541, 542, 543, 544, 546, 547, 548, 549, 550, 552, 553, 554, 555

Birley, Oswald 111, 125, 221, 295, 349

Birrell, Augustine 30, 129

Blaikley, Ernest 159, 488

Bland, Beatrice 76, 202, 215, 272, 274, 425

Blake, William 136, 164, 361, 380, 451, 517, 534

Blakely, Zelma 506, 525, 538

Bliss, Douglas Percy 33, 48, 58, 516, 517, 542

Bloch, Frieda (Blockie) 72, 75, 87, 105, 121, 172, 178, 188, 297

Blomfield, Sir Reginald 261, 268, 269, 284, 375, 403

Blunden, Edmund 21, 22, 25, 31, 35, 37, 38, 39, 40, 46, 55, 57, 59, 60, 61, 81, 88, 428

Blunt, Anthony 427, 523, 528, 530, 531, 542

Bodkin, Thomas 372, 440, 458, 466, 469, 480, 485, 500

Bomberg, David 453

Bone, Muirhead* 6, 7, 34, 66, 76, 223, 284, 294, 303, 306, 307, 308, 309, 310, 316, 327, 330, 343, 345, 346, 349, 357, 359, 360, 365, 367, 372, 375, 377, 379, 380, 382, 383, 384, 387, 388, 391, 392, 394, 396, 397, 402, 405, 406, 410, 411, 412, 413, 415, 416, 420, 425, 427, 429, 430, 432, 433, 434, 436, 442, 444, 446, 449, 451, 453, 454, 461, 468, 471, 473, 478, 487, 488, 506, 509, 519, 535, 546

Bone, Gavin 223, 316, 357, 365, 379, 380, 382, 383, 413, 416, 430, 441, 442, 449, 461, 472, 546

Bone, Stephen 15, 21, 34, 97, 103, 107, 179, 306, 307, 316, 357, 383, 390, 400, 410, 415, 420, 424, 425, 427, 432, 434, 441, 453, 460, 472, 546

Borenius, Tancred* 46, 96, 115, 138, 156, 183, 249, 265, 268, 275, 296, 321, 323, 347, 355, 385, 397, 398, 411, 426, 454, 463, 470, 546, 555

Braden, Norah 43

Bradford, Sir John Rose 110, 275, 277, 278, 279, 282, 283

Bradshaw, Charlton 109, 187, 219, 266, 268, 317, 318, 426, 487

Bragg, Sir William Henry 113, 129, 498

Brancusi, Constantin 114, 251, 252

Brangwyn, Frank 338, 366, 401, 537

Braque, Georges 145, 157, 490

Brett, Dorothy 79, 146, 178, 258

Brinkworth, William Ian 167, 177, 206, 208, 236

Brinton, Diana 58, 70, 71, 77, 110, 149, 210, 214, 219

Brockhurst, Gerald 73, 397

Brooker, Peter 67, 68, 83, 158, 215, 246, 411, 474, 475, 492, 513, 537

Brown, Cecil Atri 95, 158, 343

Brown, Ford Madox 116, 361

Brown, Frederick* 27, 31, 33, 36, 41, 43, 44, 56, 58, 59, 71, 74, 76, 79, 82, 87, 97, 118, 120, 127, 166, 189, 193, 197, 207, 208, 211, 261, 262, 265, 268, 269, 272, 282, 283, 292, 296, 337, 342, 375, 401, 451, 453, 461, 479, 488, 495, 525, 546, 553, 554, 555

Brown, Oliver 14, 35, 44, 47, 70, 130, 135, 149, 300, 462

Browse, Lillian 319, 366, 434

Burdett, Basil 71, 137, 183, 185, 186, 187, 188, 189, 191, 192, 193, 194, 196, 206, 219, 226, 244, 260, 276, 382, 417, 512

Burn, Rodney 18, 19, 20, 21, 24, 31, 34, 47, 48, 50, 68, 83, 140, 178, 198, 208, 227, 229, 230, 247, 248, 249, 265, 291, 344, 391, 400, 428, 451, 497, 506, 510, 513, 518, 520, 522

Burne-Jones, Edward 144, 165, 226, 316, 369, 382, 383, 398, 446, 469, 484

Butterfield, David Francis 157, 158

Caldecott, Randolph 225, 279, 408

Cameron, D.Y. 33, 62, 69, 125, 218, 487

Camp, Jeffery 469

Canaletto 86, 237, 261

Carline, Hilda (Mrs. Stanley Spencer) 179, 200, 208, 230, 295, 317, 397, 409, 511

Carline, Richard (Dick) 115, 200, 231, 302, 317, 344, 400

Carline, Sydney 28, 326, 552

Carr, Allan 105, 190, 206, 208, 217, 223, 229, 236, 241, 301

Carr, Henry Marvell 337, 354, 424, 451, 498, 506

Carr, Michael 127, 528

Carrington, Dora 79, 91, 100, 106, 240, 294, 381, 546, 551

Carrington, Noel 97, 100, 134, 257, 259, 480, 489

Carrington, Mrs. Noel (Catharine Alexander) 258, 259

Cave, Wilfrid (Willie) 80, 105, 188, 198

Cecil, Lord David 121, 315, 350, 360, 374, 398, 433, 471

Cézanne, Paul 17, 47, 70, 97, 117, 231, 315, 353, 384, 405, 442, 500

Charlton, Daphne 131, 133, 139, 163, 168, 174, 179, 182, 192, 201, 211, 217, 225, 231, 233, 235, 244, 254, 258, 259, 269, 275, 281, 294, 295, 298, 300, 303, 306, 307, 309, 311, 315, 318, 325, 380, 410, 438, 455, 462, 480, 511, 513, 531, 532, 534, 537, 546

Charlton, Evan 60, 181, 276, 318, 347, 514

Charlton, George* 61, 78, 81, 84, 107, 108, 116, 121, 131, 133, 139, 149, 150, 156, 157, 158, 163, 168, 169, 174, 178, 179, 182, 184, 189, 190, 194, 201, 211, 215, 225, 227, 229, 230, 235, 244, 253, 254, 257, 262, 266, 268, 269, 280, 281, 285, 292, 293, 295, 298, 300, 305, 306, 307, 309, 311, 314, 315, 318, 321, 323, 324, 342, 344, 350, 351, 353, 355, 356, 357, 363, 382, 386, 397, 399, 401, 406, 410, 415, 425, 431, 436, 440, 442, 444, 455, 459, 460, 462, 466, 475, 484, 485, 490, 492, 497, 498, 499, 505, 508, 509, 511, 513, 514, 518519, 520, 521, 523, 524, 531, 532, 536, 546, 551

Chaytor, Rev. H.J. 338, 344

Chelmsford, Lord 41, 197, 275

Cheston, Charles 49, 56, 70, 74, 75, 97, 115, 133, 134, 138, 140, 149, 343, 450, 460, 476, 484, 495, 499, 513, 520

Cheston, Dorothy 20, 75, 79

Cheston, Evelyn (née Davy) 49, 56, 70, 74, 115

Child, Charles Koe 31, 32, 33, 34, 68, 71, 83, 114, 126, 193, 293

Chisman, C.R. 77, 80, 85, 286, 318, 331, 399, 401, 513, 518, 519, 520

Chittock, Derek 429, 450, 453, 461, 463, 464

Clark, Cosmo 46, 86, 94, 497

Clark, Kenneth 6, 17, 22, 153, 193, 251, 265, 273, 287, 296, 302, 307, 309, 314, 317, 319, 343, 345, 346, 350, 351, 357, 359, 360, 363, 368, 370, 372, 375, 382, 387, 388, 389, 391, 395, 397, 400, 406, 411, 413, 421,

423, 430, 435, 436, 442, 445, 448, 455, 458, 474, 477, 480, 483, 484, 486, 491, 496, 500, 505, 506, 509, 512, 515, 528

Clause, William (Willie)* 15, 17, 23, 24, 26, 28, 30, 31, 36, 38, 39, 42, 57, 59, 67, 71, 73, 75, 80, 82, 89, 97, 111, 125, 133, 140, 143, 145, 151, 154, 157, 167, 168, 171, 175, 176, 178, 179, 196, 202, 207, 209, 226, 236, 244, 249, 291, 294, 296, 298, 302, 318, 319, 321, 322, 323, 324, 325, 331, 346, 349, 362, 378, 396, 402, 425, 446, 450, 458, 460, 472, 476, 477, 484, 494, 495, 496, 497, 546

Clausen, George 42, 50, 61, 62, 69, 83, 91, 93, 98, 125, 134, 151, 156, 207, 262, 269, 321, 390, 411, 439, 440, 454

Cobbe, Dora* 73, 224, 253, 546, 547

Cobbe, Margaret (later Mrs. de Villiers) 5, 36, 224, 253, 415, 500, 533, 541, 546, 547

Cobbe, Tom* 34, 36, 73, 104, 217, 224, 232, 253, 294, 350, 415, 541, 543, 546, 547

Cochran, C.B. 60, 87, 174, 219

Codrington, K. de B. 21, 170, 253, 283, 523

Coldstream, William 133, 136, 138, 158, 163, 192, 225, 270, 293, 307, 351, 459, 479, 508, 512, 523

Cole, Ernest 205, 488

Cole, Horace 156, 222, 358

Cole, Leslie 424

Collins, Cecil 457, 493

Collins Baker, Charles 22, 39, 55, 56, 67, 102, 104, 110, 180, 250, 378, 476

Colquhoun, Ithell 65, 67, 92, 93, 95, 114, 115, 167, 226, 287, 297, 308, 370, 372, 433

Colquhoun, Robert 524, 525

Conrad, Father 401, 417, 428, 432, 468, 472, 537, 538

Connard, Philip 17, 27, 39, 50, 69, 71, 75, 86, 109, 117, 167, 178, 179, 236, 272, 282, 286, 287, 352, 364, 368, 369, 372, 381, 384, 425, 426, 439, 440, 461, 474, 476, 478, 484, 554

Constable, John 45, 57, 82, 92, 96, 105, 266, 289, 426, 488, 491, 497, 517, 520

Constable, W.G. 32, 49, 62, 86, 110, 115, 124, 125, 131, 139, 141, 165, 171, 178, 179, 200, 206, 209, 215, 221, 227, 249, 257, 261

Cooper, Francis 419, 469

Cooper, Gerald 141, 468

Cooper, John 150, 156

Copley, John 50, 100, 109, 116, 179, 189, 235, 236, 237, 267, 361, 374, 443, 538

Corfiato, Hector 138, 152, 183, 222, 223, 244, 249, 265, 296, 323, 337, 391, 418, 463, 477, 480, 491, 498, 503, 512, 513, 528, 530, 531

Corot, Jean-Baptiste-Camille 39, 96, 105, 149, 405

Cotman, John Sell 176, 332, 398

Courtauld, Samuel 29, 63, 195, 525, 531

Coxon, Raymond 42, 136, 180, 190, 289, 306

Cramer, Belle 69

Crane, Walter 13, 16, 234, 311, 527

Crome, John 18, 491

Crome, Lord 40, 48

Cumberlege, Geoffrey 347, 360, 414, 442, 461, 462

Cunard, Nancy 85, 382, 388

Cundall, Charles 73, 176, 194, 207, 236, 260, 318, 392, 415, 425, 426, 438, 458, 484, 495, 513

Curwen, Harold 245, 414

Dacre, Susan 'Isabel' 72, 98, 130, 166

Dale, Lawrence 324, 394, 444, 449, 473

Dali, Salvador 5, 217, 231, 257, 289

Dalton, William 67, 45, 88, 94

Daniel, Augustus 18, 29, 37, 47, 49, 87, 96, 140, 163, 170, 264, 265, 270, 389, 441, 478, 520

Darwin, Robin 127, 133, 138, 231, 260, 303, 308, 400, 534

David, Jacques Louis 58, 264, 265

Davidson, W. 132, 158

Davies, Randall 21, 58, 115, 140, 177, 300, 308, 324, 489

Davy, Leo 454, 470, 479

Dawber, Guy 166, 195, 196, 202, 218, 273

Dawson, Norman 27, 258, 495, 507

De Broke, Lord Willoughby 371, 372, 383, 388

Degas, Edgar 170, 171, 20, 269, 500, 509, 518, 535, 540, 553

Delacroix, Eugène 46, 47, 59, 61, 96, 107, 267, 290, 361, 500

Dennis, Celia 316

Dennison, Daphne 412, 427

Dent, Hugh 16, 39, 51, 54, 127, 131

Denton, Blanche 88, 189, 282

Derain, André 44, 67, 148, 149, 150, 213, 305, 442

Despiau, Charles 206, 278

Devas, Anthony 62, 133, 158, 225, 270, 306, 343, 422, 425, 428, 450, 456, 460, 476, 483, 484, 513, 518, 520

Diaghilev, Sergei 110, 212

Dick, Sir William Reid 140, 365, 398, 476, 477, 479, 491, 501, 513

Dickey, E. M. O'Rourke 13, 32, 34, 35, 49, 73, 81, 82, 106, 111, 115, 122, 130, 165, 178, 190, 201, 240, 254, 270, 276, 324, 327, 334, 340, 341, 342, 343, 357, 372, 388, 400, 401, 411, 430, 439, 440

Dicksee, Frank 30, 43, 127

Disney, Walt 225, 279, 285, 363, 408

Dobson, Frank 38, 4, 45, 62, 75, 95, 99, 103, 109, 189, 342, 364, 375, 443, 480, 510, 525, 534, 554

Dodd, Francis* 6, 15, 21, 59, 71, 72, 98, 99, 118, 119, 130, 159, 165, 166, 185, 195, 207, 226, 227, 257, 262, 264, 274, 287, 305, 307, 308, 309, 319, 320, 330, 346, 348, 350, 354, 365, 367, 372, 375, 377, 386, 390, 391, 394, 399, 401, 406, 410, 412, 416, 424, 426, 430, 434, 436, 449, 454, 462, 474, 479, 486, 501, 508, 519, 520, 539, 546, 547, 551

Dodgson, Campbell 48, 103, 104, 144, 249, 370

Doré, Gustave 58, 367, 384

Dorn, Marion 99, 105, 149, 194, 329, 551

Doubleday, Nelson 202, 207, 216, 220, 223, 224, 225, 227, 228, 235, 241, 242

Douie, Charles 49, 60, 61, 67, 140, 167, 177, 183, 198, 199, 205, 213, 241, 246, 259, 278, 286, 287, 291, 293, 311, 445, 471, 490, 541, 542

Doyle, Camilla 39, 393, 506

Drake, Mrs Tyrwhitt 180, 181, 182

Dring, William 201, 424, 496

Duddington, John N. 121, 144, 203, 211, 258, 489, 504, 526

Dunbar, Evelyn 79, 114, 120, 134, 141, 143, 155, 220, 223, 229, 270, 298, 513, 550

Dunlop, Ronald Ossory 194, 239, 342, 397, 425, 426, 484, 518, 534

Dunstan, Bernard 377, 385, 398, 412, 427, 432, 449, 466, 497

Dürer, Albert 48, 288
Durst, Alan* 15, 17, 31, 35, 37, 44, 59, 60, 66, 82, 84, 98, 100, 113, 120, 128, 135, 137, 146, 150, 156, 160, 169, 170, 180, 199, 211, 214, 218, 219, 227, 256, 264, 270, 282, 292, 300, 344, 359, 400, 425, 451, 510, 513, 525, 527, 536, 538, 539, 544, 547
Duval, Dorothy 314, 376, 418
Duveen, Sir Joseph 14, 15, 30, 39, 59, 62, 67, 157, 254
Dyne, Aminta 94, 334

Eade, Edward 131
Eden, Sir William 450
Edwards, Ralph 270, 303, 488, 489, 529
Elkan, Benno 239, 406, 419, 437
Ellis, Clifford 384
Ellis, Lionel 27, 37
Elton, Leonard 22, 26, 39, 40, 43, 45, 50, 139, 140, 143, 148, 150, 151, 155, 158, 194, 203, 213, 215, 220, 229, 266, 278, 289, 301, 303 304, 305, 313, 323, 328, 329, 333, 339, 348, 351, 353, 354, 361, 367, 368, 411, 429, 485
Elwes, Simon 249
Emery, Joyce 'Tommie'* 362, 408, 413, 414, 547, 552
Ensor, James 78, 487
Enwonwu, Benedict 'Ben' Chuka 458, 461, 465, 540
Epstein, Jacob 47, 62, 66, 67, 75, 88, 113, 127, 135, 136, 137, 143, 167, 174, 175, 193, 194, 199, 257, 299, 308, 323, 346, 357, 361, 365, 391, 408, 410, 442
Esher, Lord 20, 30
Eurich, Richard 347, 375, 388, 392, 460
Evans, Myfanwy 262, 413
Eveleigh, Henry 131, 152, 170, 177, 178
Eves, Reginald Grenville 146, 213
Evill, Norman 112, 131, 248, 342

Fairbairn, W.E. 209, 321, 322, 323, 342, 349, 368, 377, 380, 553
Faithfull, Leila 405, 420
Falcon, Thomas 'Tom' 124, 232, 280, 432, 433, 434, 459
Farleigh, John 59, 115, 122, 125, 133, 152, 166, 202, 211, 219, 370
Farjeon, Eleanor 38, 106, 201, 322, 455
Fedden, Mary 167, 208, 217
Feher, Hans 6, 181, 183, 205, 215, 221, 233, 235
Feibusch, Hans 211
Feiler, Paul 313, 321, 322, 340, 352, 395, 396, 417, 444, 445
Fergusson, J.D. 16, 33, 99, 119, 206, 447, 448
Fisher, Hervey 20, 87
Fisher, Hugh 331
Fitton, James 134, 308
Fitzalan, Lord 40, 43, 49
Flaherty, R.J. 84, 222
Fleischmann, Asphodel 247
Fletcher, Geoffrey Sowcroft 498, 509, 510, 513, 520, 521, 527
Fletcher, Hanslip 62, 102, 126, 152
Fletcher, Helen 58, 77, 82, 100
Fletcher, Morley 134, 255
Flight, Claude 69, 193, 551
Flint, Russell 58, 59, 399, 451, 458, 463, 478, 487, 499, 508, 509, 521, 524, 542
Flitcroft, Henry 87, 256

Florence, Mary Sargant 93, 145, 155, 172, 253
Foster, Arnold 209, 338, 339
Foster, George Carey 46
Foster, Gregory 15, 18, 61, 68, 471
Foster, Melville 409, 418
Fothergill, John 137, 328, 362, 386, 418, 552
'Fougasse' (Kenneth Bird) 271, 283
Freedman, Barnett 50, 51, 86, 93, 94, 106, 107, 133, 146, 180, 181, 182, 202, 204, 219, 245, 254, 283, 307, 309, 314, 315, 316, 318, 334, 336, 345, 351, 354, 367, 377, 382, 388, 397, 409, 411, 413, 430, 435, 462, 463, 485, 510, 515, 527, 528, 531, 539, 552
Freeman, Molly Broke 398, 409, 413
Friesz, Othon 44, 407
Frith, William Powell 308, 440
Fry, Roger 5, 15, 17, 26, 33, 50, 70, 78, 79, 83, 89, 121, 130, 148, 149, 164, 167, 170, 172, 175, 194, 238, 339, 399, 527, 546
Fulleylove, Joan 70, 104, 109, 161, 236

Gabain, Ethel (Mrs. John Copley) 100, 116, 117, 178, 179, 212, 226, 235, 267, 361, 374, 408
Gainsborough, Thomas 59, 82, 87, 262, 281, 444, 500
Ganz, Paul 147, 160, 433
Gardiner, Gerald 45
Gaselee, Sir Stephen 209, 465, 472, 473, 476
Gauguin, Paul 285, 401
Geddes, Andrew 288
Geddes, Patrick 97
Gere, Charles March 262, 307, 348, 376, 387, 470, 519
Gerrard, Alfred Horace 31, 46, 69, 76, 93, 129, 130, 214, 215, 244, 245, 251, 267, 269, 275, 313, 324, 325, 328, 331, 411, 475, 492, 505, 506, 508, 513, 516, 518, 519, 535, 538, 539
Gertler, Mark* 58, 59, 60, 64, 66, 79, 82, 91, 94, 96, 100, 109, 111, 115, 116, 140, 177, 178, 180, 189, 190, 234, 236, 251, 258, 287, 296, 298, 299, 316, 353, 368, 410, 431, 451, 453, 539, 546, 547, 548, 550, 551
Gibbings, Robert 71, 252, 299, 401, 469
Gibbs, Evelyn 175
Gilbert, Stephen 69, 200
Gilman, Harold 17, 157, 319, 364, 479, 534
Gill, Betty 91, 159, 170
Gill, Colin 52, 91, 98, 106, 137, 159, 170, 181, 190, 227, 241, 251, 258, 261, 274, 278, 487, 530
Gill, Eric 71, 106, 119, 134, 159, 164, 192, 262, 274, 290, 338, 472, 537
'Ginger' (Dr. Joseph Bramhall Ellison) 6, 26, 87, 100, 118, 131, 141, 181, 183, 197, 205, 215, 220, 221, 225, 233, 235, 255, 280, 295, 327, 363, 390, 480
Ginger, Phyllis 425
Ginner, Charles 18, 57, 58, 69, 82, 100, 148, 149, 161, 172, 186, 187, 190, 213, 214, 249, 268, 270, 367, 372, 534
Girtin, Thomas 72, 76
Gladney, Graves 71, 84, 103
Glass, Rhoda 'Dodie' (later Masterman) 277, 286, 299, 417
Gleadowe, Reginald Morier Yorke 62, 74, 95, 327, 343, 345, 388, 400, 416, 445, 451, 452, 471
'Gluck' (Hannah Gluckstein) 89, 118
Gondhalekar, J.D. 257, 277, 526
Gooden, Stephen 81, 137, 199, 288

Gordine, Dora 269, 283
Cordon, Cora 188, 274, 468
Gordon, Jan 131, 157, 166, 177, 201, 307
Gore, Frederick 79, 185, 206, 219, 246
Gore, Spencer 17, 26, 52, 67, 69, 79, 185, 319
Gosse, Edmund 218
Gotch, Bernard 325, 387, 412, 517
Goya, Francisco de 241, 270, 444, 506
Gowing, Lawrence 421, 463, 508, 524
Grant, Duncan 15, 18, 30, 47, 148, 170, 193, 194, 251, 260, 268, 272, 274, 298, 306, 320, 323, 351, 352, 354, 375, 410, 524, 534
Gray, Ronald 134, 162, 212, 282, 318, 389, 392, 438, 451, 513
Gray, Stuart 31, 63
Greenham, Peter 377, 412, 424, 435, 436, 437, 442, 460, 461, 462, 463, 466
Gregory, Eric 421, 433, 480, 488
Gregory, Robert 125, 126, 154, 237, 486, 507
Greiffenhagen, Maurice 127, 447
Griffiths, Rhys 27, 52, 103, 150
Griggs, F.L. 145, 276
Grimmond, William* 14, 16, 22, 23, 44, 73, 75, 99, 103, 117, 125, 128, 129, 130, 147, 148, 151, 158, 161, 163, 176, 220, 221, 253, 267, 270, 288, 293, 302, 462, 495, 548
Gross, Anthony 177, 279, 448, 518
Guthrie, John 110, 174,
Guthrie, Robin 25, 45, 68, 73, 83, 178, 235, 293, 330, 425, 451, 460, 495, 513
Gwynne-Jones, Allan* 7, 11, 15, 17, 19, 22, 23, 26, 27, 28, 31, 32, 33, 34, 35, 38, 40, 41, 42, 44, 48, 50, 54, 61, 62, 63, 67, 75, 78, 83, 84, 98, 116, 117, 133, 134, 140, 178, 189, 199, 244, 246, 276, 283, 295, 296, 305, 306, 308, 310, 314, 315, 316, 317, 345, 348, 352, 356, 364, 365, 377, 410, 415, 420, 436, 439, 453, 455, 462, 470, 479, 484, 485, 494, 495, 498, 503, 508, 513, 514, 518, 519, 520, 521, 522, 524, 532, 533, 534, 540, 544, 548

Hagedorn, Karl* 8, 14, 16, 22, 24, 27, 55, 61, 69, 97, 99, 106, 114, 115, 116, 117, 118, 126, 131, 133, 135, 136, 142, 150, 151, 155, 170, 171, 172, 174, 175, 176, 177, 178, 180, 181,1 182, 192, 205, 207, 213, 220, 221, 222, 232, 234, 237, 245, 250, 251, 256, 260, 270, 274, 281, 282, 285, 292, 293, 302, 321, 323, 441, 449, 489, 495, 520, 538, 548
Hagedorn, Nelly 114, 282, 302, 441, 520, 548
Hall, Edna Clarke 61, 147, 193, 215, 318, 364, 437, 493
Hambledon, Lord 201, 203, 525
Hamilton, Cicely 56
Hamilton, Cuthbert 528
Hamilton, Rostrevor 470, 526, 531
Hamnett, Nina 95, 100, 108, 115, 217, 399, 513, 534
Hannen, Nicholas 93, 314, 364
Hardie, Martin 22, 73, 190, 207, 295, 484
Harding, J.D. 372
Harding, H.J. 15, 17, 47, 87, 98, 146, 220, 423
Hardinge-Papillon 70, 78, 143
Hardy, Dudley 212
Hardy, Thomas 98, 204, 214
Hare, Leman 40, 41
Hare, Loftus 41, 43
Harmand, M. 288

Harmar, Fairlie 76, 151, 208, 289, 351, 460, 476, 484, 485
Harrod, Frankie 306, 338
Harrod, Roy 304, 338
Hartington, Lord 30, 32, 35, 67
Hassall, John 100, 218
Hatch, Ethel 337
Haward, Lawrence 307, 318, 380, 394, 449, 450, 458, 503
Hay, Athole 165, 220, 232, 254, 260
Heal, Ambrose 121, 139, 168, 187, 222, 293, 297, 505, 524
Heal, (Edith Florence Digby Todhunter) 'Toddy' 139, 496
Henderson, Faith 384, 436
Henderson, Jane 355
Henderson, Keith 147,149, 268
Hennell, Thomas 268, 396, 479, 486
Hepworth, Barbara (see also Skeaping) 38, 97, 98, 145, 179, 211
Herbert, Alan Patrick 59, 214, 273, 327, 410
Hill, Adrian 209, 236
Hilton, Roger 76, 92, 200
Hind, Arthur Mayger 161, 163, 169, 207, 237, 239, 266, 268, 289, 350, 372, 436, 529
Hitchens, Ivon 66, 113, 145, 149, 156, 162, 190, 306, 379, 508
Hodgkins, Frances 162, 192, 364, 524
Hogarth, William 44, 90, 164, 165, 313, 491, 517, 521
Holbein, Hans 123, 146, 147, 149, 150, 160, 259, 426, 433, 497
Holden, Charles 107, 109, 135, 139, 195, 229, 234, 265, 515
Holden, Harold 76, 77, 463, 509
Holland, Anthony 316, 322
Holland, George 49, 261
Holland, Henry 62, 502
Holliday, Ensor 324, 350, 487
Holloway, Edgar 331, 363
Holmes, Sir Charles John 15, 18, 19, 77, 80, 86, 102, 117, 130, 137, 138, 140, 145, 160, 162, 170, 179, 207, 208, 449
Hollyer, Wendy Pauline 361, 363, 366
Hone, Joseph 'Joe' 237, 238, 247, 260, 287, 295, 376, 453
Hope-Johnstone, John 26, 79, 92, 100, 156, 407
Horsnell, Jimmy 44, 89
Horton, Percy 15, 20, 23, 27, 32, 35, 37, 47, 48, 50, 94, 107, 111, 134, 135, 178, 180, 323, 324, 412, 515, 527, 539, 543, 550
Howarth, Thomas 448, 469, 483
Hughes-Stanton, Blair 85, 133, 195, 428
Hunt, Cecil Arthur 139, 321, 411, 458, 497, 508, 522
Hunt, Violet 22, 23, 24, 26, 27
Hunt, William Holman 136, 382, 383, 482
Huskinson, Leonard 301, 303, 304, 305, 309, 323, 366, 434, 514, 531
Hutchinson, Geoffrey 112, 182, 189, 224, 248, 256, 494, 500, 518, 532, 534
Hutchinson, Prof. Hely 440
Hutchison, William 'Bill' 190, 291, 418, 469

Idzikowski, Stanislas 224, 285, 400
Ihlee, Rudolph 226, 362, 431
Inglis, Jean* 17, 27, 52, 59, 63, 70, 93, 104, 109, 124, 139, 142, 146, 154, 161, 168, 169, 185, 200, 224, 236, 249, 278, 280, 283, 295, 317, 499, 548
Ingres, Jean-Auguste-Dominique 24, 32, 37, 188, 410, 418

Innes, James Dickinson 14, 99, 172, 175, 176, 222, 226, 280, 294, 319, 364, 405, 434, 548
Innes, John 257

Jackson, Ernest 93, 133, 156, 214, 219, 302, 344, 362, 384, 396, 410, 412, 442, 445, 462, 463, 466, 487, 496, 499
James, Henry 218
James, Monty 224, 266
James, Philip 370, 413, 430, 445, 479, 507, 522, 525
Jamieson, Robert Kirkland 158, 209, 236, 239, 386
Janck, Angelo 54
Janes, Norman 247, 309, 356, 390, 498
Japp, Darsie 148, 182, 208, 245, 280, 456, 477, 485
John, Augustus* 18, 26, 27, 31, 35, 46, 58, 72, 75, 87, 92, 93, 97, 99, 101, 102, 106, 127, 128, 129, 131, 132, 134, 136, 151, 152, 153, 154, 155, 162, 165, 172, 173, 178, 185, 188, 191, 192, 195, 196, 198, 199, 200, 206, 207, 208, 211, 219, 221, 223, 230, 233, 261, 272, 276, 292, 294, 296, 297, 305, 315, 318, 322, 327, 333, 337, 338, 340, 345, 346, 347, 353, 354, 356, 360, 364, 365, 366, 371, 375, 378, 384, 386, 387, 388, 390, 397, 410, 412, 415, 418, 425, 426, 427, 437, 438, 439, 448, 452, 453, 456, 461, 479, 483, 485, 489, 495, 502, 512, 526, 547, 548, 549, 552, 553
John, Gwen 97, 319, 375, 397, 479, 495, 496, 500, 511, 548
John, Poppet 27, 79, 200, 399
John, Romilly 58, 79, 92, 155, 156
John, Vivien 27, 116, 128, 191, 192, 195, 196, 200
Johnson, Amy 54, 131, 157
Johnston, Edward 47, 401, 472, 477, 486, 500, 555
Jones, David 47, 52, 149, 364, 472
Jones, Gwendolyn Rosamund (see Birdie)
Jones, Hugh* 80, 549
Jones, Inigo 110, 244, 252, 264
Jowett, Percy 24, 50, 61, 84, 85, 107, 108, 117, 162, 163, 165, 173, 178, 189, 194, 201, 202, 207, 218, 220, 223, 239, 254, 260, 276, 283, 286, 287, 302, 305, 309, 318, 321, 311, 370, 423, 430, 474, 484, 486, 487, 495, 497, 498, 499, 503, 508, 512, 513, 518, 520, 525, 527, 528, 550
Juta, Jan 247, 424

Karsavina, Tamara 224, 400
Kauffer, E. McKnight 16, 99, 110, 134, 149, 220, 329, 469, 551
Kay, Harold Isherwood 15, 110
Keene, Charles 47, 120, 133, 141, 186, 207, 389, 402
Kelly, Francis* 6, 14, 16, 29, 37, 55, 58, 66, 84, 120, 138, 260, 288, 345, 396, 441, 455, 460, 497, 507, 549
Kelly, Gerald 24, 70, 87, 98, 125, 133, 140, 146, 147, 150, 170, 197, 199, 200, 202, 207, 221, 224, 225, 226, 228, 229, 260, 275, 283, 314, 354, 355, 365, 372, 382, 438, 476, 498
Kelly, Jane 62
Kennedy, George 23, 28, 54, 59, 93, 94, 103, 154, 255, 303, 320, 368, 371, 374, 392, 393, 399, 486
Kennington, Eric 28, 37, 66, 204, 309, 313, 315, 330, 384, 392, 394, 395, 496, 500
Kent, Adrian 68, 78, 226, 464
Kerr, Anthony 398, 401
Kestelman, Morris 37, 106, 117, 132

Kilvert, Francis 9, 482
King, Cecil 402
King, Colman 'Tiger' 222
King, William Gunning 263, 408, 554
Klee, Paul 145, 148, 158, 162, 279, 364, 457, 481, 492, 504, 530
Klinghoffer, Clara 67, 97, 116, 518
Kohn, Bruno 63, 79, 122, 15, 162, 168, 183, 184, 197, 198, 203, 210, 229, 239, 242, 277, 341, 368, 376, 403, 478, 479, 480, 483, 509
Konody, Paul G. 13, 43, 87, 157, 166
Koring, Patricia 'Pat' 314, 316, 368, 376, 396, 552
Knight, Laura 38, 95, 106, 321, 419
Knights, Winifred 'Jane' (later Monnington) 15, 505, 551
Knobloch, Edward 107, 250
Knobloch, Gertrude 136, 211
Kramer, Jacob 410

La Thangue, Henry Herbert 42, 50, 127
Lamb, Euphemia 14, 56, 94, 171, 286
Lamb, Henry 96, 125, 135, 154, 186, 190, 193, 248, 305, 343, 345, 375, 384, 399, 411, 419, 424, 466, 479, 517
Lamb, Lynton 432, 514
Lamb, Walter 200, 365, 387, 434, 436, 468, 498, 503, 515
Lambert, George 127
Lambert, Maurice 38, 144, 187, 188, 219, 267, 272
Lane, Homer 112, 239
Lane, Hugh 125, 127, 383
Lanteri, Edouard 93, 419
László, Philip Alexius de 121, 125, 146, 261, 315
Laver, James 119, 183, 241, 429, 486
Lawrence, Alfred Kingsley 43, 49, 61, 91, 125, 146, 153, 187, 215, 218, 273, 278, 372, 420
Lawrence, D.H. 52, 63, 120, 146, 195
Layard, John 402, 408, 409
Le Bas, Edward 35, 54, 125, 270, 368, 390, 549
Leach, Bernard 75
Ledward, Gilbert 62, 69, 70, 85, 103, 227, 275, 296, 322, 323, 355, 506, 514
Lee, Rupert 38, 70, 77, 110, 148, 176, 183, 187, 210, 214, 218, 219
Lee, Sydney 268, 274, 287, 452, 508, 510
Lee Hankey, William 58, 180, 212, 234, 235, 268, 293, 458, 499, 509, 524
Lees, Derwent 127, 172, 175, 192, 226, 362, 392, 511
Legros, Alphonse 28, 38, 43, 101, 121, 418, 419, 508, 546, 549, 551
Legros, L.A. 101, 418
Lehmann, Olga 76, 82, 109, 137, 139, 152, 169, 183, 194, 260, 500
Leighton, Clare 199, 200, 263,
Lessore, Thérèse 211, 384, 553
Lethaby, William 103, 163
Lett-Haines, Arthur 191
Lewis, Morland 270, 317, 436
Lewis, Neville 32, 155, 230, 246
Lewis, Wyndham 16, 28, 57, 77, 89, 243, 272, 273, 282, 296, 298, 388, 482, 489, 495, 507, 528
Lhote, André 117, 407, 434
Lindsay, Daryl 137, 141, 183, 191, 260, 267, 268, 382, 417, 467, 471
Lines, Vincent 292, 327, 438, 451, 479, 500, 513, 518
Lloyd-Jones, Barbara 440, 444, 367, 470, 471

Lopokova, Lydia 110, 224, 285, 400
Low, David 295, 311, 320, 356
Lowinsky, Ruth 307, 315, 328, 338, 350, 435, 509, 511, 515, 549
Lowinsky, 'Tommy'* 59, 71, 81, 88, 119, 141, 145, 152, 207, 222, 248, 259, 277, 282, 287, 292, 294, 303, 306, 307, 308, 310, 311, 315, 320, 321, 322, 325, 327, 328, 329, 332, 338, 339, 351, 374, 378, 379, 386, 396, 413, 426, 438, 456, 503, 509, 510, 511, 549
Lowry, L.S. 156, 157
Luard, L.D. 21, 28, 324, 352, 354, 356, 383, 385, 387, 408, 430, 432, 439, 440, 50, 468, 490, 523
Lurçat, Jean 145, 407
Lutyens, Edwin 63, 104, 108, 110, 112, 133, 163, 166, 234, 248, 255, 287, 288, 300, 338, 348, 365, 372, 398
Lyttelton, Sir Neville 53, 54, 65, 67

McCance, William 85, 469
McCannell, Ursula 364, 365
McDonnell, John 129, 130, 512, 517, 519, 528
McEvoy, Ambrose 116, 172, 189, 440
McNaught, Elsie 144, 413
McNeill, Edie 58, 92, 101, 156
MacBride, Robert 525
MacColl, Dugald Sutherland* 11, 13, 15, 22, 28, 59, 65, 70, 71, 83, 127, 134, 148, 150, 166, 170, 174, 179, 195, 197, 207, 210, 245, 246, 247, 251, 260, 261, 262, 64, 265, 268, 269, 272, 274, 291, 295, 296, 311, 317, 318, 321, 325, 342, 394, 397, 417, 425, 436, 441, 450, 451, 458, 460, 478, 484, 487, 495, 498, 507, 508, 510, 520, 521, 522, 527, 532, 538, 549
MacNair, Frances 132, 487
Macdonald, Ramsay 15, 167, 222
Mackinnon, Sine 67, 284
Mackintosh, Charles Rennie 'Toshie'* 6, 26, 36, 123, 129, 130, 132, 134, 137, 158, 424, 443, 448, 469, 483, 487, 516, 542, 550, 552
Mackintosh Margaret (née Macdonald) 6, 79, 119, 122, 123, 124, 132, 389, 448, 483, 550, 552
Maclagan, Eric 15, 18, 370, 436, 526
Macnab, Iain 69, 158
Macnamara, Francis 62, 92, 101, 102, 293, 472
Macnamara, Nicolette (later Devas) 58, 62, 101, 156, 225
Macnamara, Yvonne 385
Mahoney, Charles* 15, 21, 23, 25, 26, 27, 31, 33, 35, 37, 40, 45, 47, 48, 94, 107, 120, 128, 132, 133, 134, 138, 141, 143, 180, 220, 298, 324, 360, 366, 423, 424, 550
Mancini, Luigi 278, 369
Manet, Édouard 98, 127, 279, 405
Mantegna, Andrea 14, 148, 196, 476
Mann, Cathleen 15, 392, 450
Mann, J.G. 124, 125, 138, 160, 171, 249, 270, 497
Manson, James Bolivar 14, 37, 50, 107, 145, 183, 187, 190, 194, 270, 367, 442
Marcantoni, Giovanni 36, 369
Marcantoni, Niccoli 45
Marks, Henry 'Hank' 381, 392, 393, 431, 434
Marks, John 431
Marks, Julian 381, 393, 431, 433, 434
Marks, Nancy Joan 381, 392, 431
Marks, Susan 381, 393, 431
Marriott, Charles 100, 116, 117, 177, 201, 307, 379
Marsh, Ernest (Eddie) 23, 32, 64, 66, 75, 78, 79, 82, 97,

118, 226, 228, 254, 289, 319, 479, 494, 539
Marx, Enid 102, 232, 309, 311
Masefield, John 284, 428
Mason, Arnold 192, 196, 219, 315, 506, 551
Mason, Raymond 445, 479
Mathers, E. Powys 388, 389
Matisse, Henri 44, 47, 79, 97, 141, 149, 207, 241, 332, 355, 457, 480
Maude, A.E. 154
Maufe, Edward 75, 89, 446
Maugham, W. Somerset 185, 199, 200, 202, 207, 216, 217, 224, 225, 226, 228, 238, 240, 241, 245, 258, 494
Mayer, Katherine 104, 108, 195, 250, 255
Mayo, Eileen 187
Mawer, Allen 40, 46, 138, 241, 324, 390, 471
McNeill, Dorothy 'Dorelia' 26, 27, 92, 191, 296, 305, 353, 418, 467
Medworth, Frank 31, 36, 69, 89, 94, 120, 150
Meldrum, George 168, 322, 465, 474, 475
Mellor, Hugh Lyell 364
Meninsky, Bernard* 28, 69, 91, 94, 95, 96, 98, 100, 101, 108, 123, 265, 332, 338, 398, 425, 441, 446, 453, 550, 551
Meo, Luigi Innes 21, 39, 53, 78, 88, 103, 104, 105, 528
Messel, Oliver 60, 106, 284, 285, 374, 487, 504
Meštrović, Ivan 47, 357, 367, 441
Meunier, Constantin 227, 228
Meynell, Francis 151
Mew, Egan* 52, 84, 97, 107, 112, 136, 146, 178, 188, 211, 218, 220, 222, 238, 243, 246, 250, 252, 256, 276, 277, 281, 285, 302, 357, 374, 399, 406, 417, 424, 434, 435, 441, 454, 457, 459, 461, 466, 551, 552
Michelangelo 32, 417, 488, 496, 512
Miles, June 397, 427, 466, 485
Millais, John Everett 369, 379, 442, 482, 484, 522
Miller, Guy 86, 150, 239, 260, 446
Modigliani, Amedeo 48, 189, 191, 206
Moffat, Curtis 95, 124
Moira, Gerald 50, 132, 163, 321
Monet, Claude 87, 164, 171, 338, 385, 405, 441, 544
Monnington, 'Jane' (née Winifred Knights) 15, 60, 68, 111, 195, 218, 505, 506, 519, 551
Monnington, (Walter) Thomas* 15, 19, 20, 29, 30, 32, 33, 40, 41, 42, 43, 47, 50, 60, 62, 67, 68, 70, 91, 101, 115, 125, 146, 167, 195, 214, 218, 219, 229, 230, 231, 244, 245, 298, 302, 329, 344, 390, 439, 487, 510, 514, 519, 529, 551
Moore, George 15, 66, 76, 98, 126, 127, 134, 198, 214, 237, 238, 247, 306, 441
Moore, Henry 11, 15, 17, 40, 45, 47, 52, 62, 65, 82, 100, 111, 115, 132, 135, 136, 144, 145, 148, 150, 173, 205, 211, 230, 253, 272, 289, 291, 350, 364, 367, 374, 384, 388, 402, 411, 430, 440, 484, 488, 498, 506, 511, 524, 528
Moore, Thomas Sturge 39, 59, 109, 158, 221, 266, 309, 446
Morrell, Lady Ottoline 63, 272, 548, 549
Morris, Cedric 191
Morris, Margaret 16, 80, 83, 91, 97, 99, 100, 101, 105, 110, 119, 161, 221, 254, 270, 285, 299, 447, 448
Morris, William 116, 126, 152, 299, 311, 396, 410
Mosley, Oswald 228, 404, 504
Moynihan, Rodrigo 62, 67, 115, 164, 179, 192, 211, 217, 258, 259, 265, 270, 422, 452, 479, 485, 487, 508, 510, 512, 519, 523, 539

Munnings, Alfred 191, 229, 273, 276, 300, 313, 364, 436, 438, 452, 458, 477, 480, 492, 497, 498, 524
Murdoch, Sir Keith 185, 191, 196, 230, 417, 492, 507
Murray, David 98, 233,
Murray, Gilbert 228, 371, 410, 412
Murray, William Staite 97, 130, 266
Murry, Middleton 52, 258
Mussolini, Benito 101, 102, 195, 198, 274, 404, 422, 457, 466, 488
Mynors, Roger 310

Nash, John 64, 66, 106, 181, 192, 207, 212, 220, 239, 254, 308, 315, 330, 382, 525, 536
Nash, Paul 66, 145, 148, 192, 204, 205, 207, 245, 301, 303, 304, 306, 308, 309, 315, 321, 339, 340, 341, 344, 345, 348, 358, 362, 373, 382, 383, 398, 409, 411, 413, 427, 431, 462, 534, 541
Nemon, Oscar 376, 437, 441
Nevinson, C.R.W. 18, 58, 59, 60, 85, 88, 89, 98, 138, 153, 157, 177, 179, 187, 189, 190, 194, 207, 234, 238, 247, 257, 258, 282, 283, 286, 290, 295, 296, 397, 399, 415, 496, 548
Newton, Algernon 121
Newton, Eric 195, 307, 353, 379, 397, 402, 461, 481, 499, 523
Newton, Lord 42
Newton, W.G. 15, 37, 45, 146, 395, 415, 425, 463
Nicholls, Bertram 262, 263
Nicholson, Barbara 175, 176
Nicholson, Ben 97, 98, 102, 128, 145, 148, 161, 179, 192, 211, 364, 374, 511
Nicholson, Harold 284, 343
Nicholson, William 78, 370, 371, 427, 452
Nicholson, Winifred 98, 162, 239
Nijinsky, Vaslav 224, 400
Nixon, Job 77, 98, 106, 212, 265, 279
Norris, Arthur 225, 362, 379, 382, 483, 484, 497, 517, 535
Nuttall-Smith, Ralph 11, 333, 367, 405, 411, 412, 421, 422, 433, 434, 436, 437, 439, 440 459, 462, 465, 466, 467, 473, 474, 475, 479, 486, 492, 513, 518, 522, 523, 524, 529, 532, 533, 536

Oakes, Alma 69, 81, 88, 99, 109, 124, 185, 192, 222
Oppé, Paul 82, 280, 288, 340, 359, 366, 370, 372, 387, 405, 435, 436, 477, 504, 507, 519, 521
Orage, Alfred Richard 159, 189, 222, 551
Orage, Jean* 56, 76, 88, 99, 109, 141, 150, 159, 178, 182, 192, 194, 253, 551
Ord, Rosalind 37, 186, 217, 319
Ormrod, Frank 78, 130, 138, 169, 203, 219, 229, 255, 275, 276, 296, 303, 305, 323, 339, 355, 382, 385, 387, 434, 439, 444, 469, 470, 476, 491, 492, 513, 524, 529
Orpen, William 18, 61, 62, 75, 82, 86, 104, 106, 127, 128, 147, 150, 162, 165, 173, 174, 192, 233, 234, 237, 238, 330, 333, 337, 347, 375, 384, 437, 453, 460, 483, 484, 489
Ososki, G.J. 106, 121, 144, 515

Palliser, Herbert 134, 146
Palmer, Arnold 389, 394, 442, 445, 479
Palmer, Samuel 207, 294, 361
Palmer, Susan 'Sue' 492, 509, 514
Pankhurst, Sylvia 254

Paolozzi, Eduardo 504, 530
Parker, Agnes Miller 85, 125, 133, 263, 469
Parker, Dr. K.T. 301, 304, 306, 310, 316, 320, 321, 327, 338, 342, 346, 361, 433, 453, 454, 459, 460, 467, 468
Parker, Stanley 417
Pasmore, Victor 270, 293, 306, 334, 351, 411, 508, 519, 524, 534
Pattison, Eunice 'Minkie'* 256, 280, 290, 551
Payne, Henry 269, 308, 309
Peake, Air Commodore Harald 343, 345, 349, 359, 371
Pearce, Charles Maresco 38, 53, 118, 149, 194, 213, 286, 290, 291, 318, 479, 535
Pearson, Lionel 26, 49, 91, 138, 462, 471
Peers, Sir Charles 240, 248, 328, 329, 360, 421, 470
Penrose, Roland 287, 297
Pepler, Father Conrad 472, 537
Pettiward, Roger 54, 109, 380, 394, 410
Pevsner, Nikolaus 157, 166, 229, 317, 492, 523
Philipowski, Ivan 139, 333, 397, 530
Philpot, Glyn 50, 104, 105, 348, 449, 451
Picasso, Pablo 48, 97, 145, 149, 177, 223, 251, 257, 277, 285, 353, 457, 460, 480, 507, 517, 524, 533
Pick, Frank 152, 241, 263
Pilbeam, Nova 305, 310, 312, 325, 362, 368, 394, 480, 554
Piper, John 7, 128, 162, 262, 264, 288, 303, 313, 383, 384, 388, 394, 397, 406, 412, 413, 443, 524
Piranesi, Giovanni Battista 148, 422
Pissarro, Camille 82, 171, 278, 285, 510
Pissarro, Lucien 55, 82, 83, 116, 201, 218, 277, 278, 408, 445, 483, 510, 521, 552
Pissarro, Orovida 69, 114, 278, 510
Pitchforth, Roland Vivian 204, 270, 341, 354, 375, 384, 411, 425, 427
Pite, Arthur Beresford 103
Platt, John 61, 154
Plessis, Henri E. du 133
Pocock, Geoffrey Buckingham 26, 45, 68, 104, 523
Polunin, Nicholas 311, 439, 471
Polunin, Vladimir 95, 143, 144, 152, 183, 194, 214, 247, 265, 296, 324, 334, 356, 357, 382, 397, 399, 406, 410, 411, 412, 425, 462, 475, 483, 518, 545
Porter, Frederick J. 32, 33, 110, 115, 149, 237, 274
Poussin, Nicolas 92, 173, 391, 418, 528, 538, 542
Powicke, F.M. 435, 439, 440, 445
Poynter, Sir Edward 126, 487, 503
Pratt, Muriel 55
Preece, Patricia 230, 317, 375, 412
Prior, Professor Edward 61, 74
Pritchard, Sally (née McLellan) 446, 447, 499, 516, 525
Pritchard, Walter 447, 516, 525
Prout, Margaret 'Milly' Fisher 97, 211, 268, 460, 495, 513, 518
Prout, Samuel 267
Pryde, James 14, 100, 127, 243, 354, 377
Pryse, Spencer 73, 74 267, 268
Pym, Roland 116, 294

Rabinovitch, Samuel 95, 180, 186, 278
Raeburn, Henry 153, 288
Rambert, Marie 95, 212, 269
Ravilious, Eric 15, 21, 59, 125, 180, 206, 232, 245, 251, 298, 323, 382, 388, 393, 394, 396, 507, 554
Read, Herbert 6, 86, 145, 148, 149, 175, 279, 298, 355,

363, 413, 485, 507, 525

Redon, Odilon 231, 267

Reeve, Russell 150, 239, 260

Reitzo 369, 529

Reizenstein, Franz 210, 239

Rembrandt 87, 140, 288, 366, 418

Rendel, Harry Goodhart 135, 137

Renoir, Pierre-Auguste 28, 47, 171, 241, 260, 353, 405, 441, 500, 544

Revel, John 24, 32, 50, 190

Rhoades, Geoffrey 107, 120, 134, 143, 375, 392

Rice-Oxley, Leonard 248, 305, 334

Richards, Ceri 48, 129, 163, 164, 289, 347

Richardson, A.E. 46, 54, 55, 61, 62, 63, 83, 86, 89, 90, 103, 107, 109, 112, 121, 130, 133, 139, 141, 144, 152, 155, 163, 166, 167, 171, 173, 177, 182, 186, 198, 199, 217, 223, 240, 246, 267, 287, 409, 418, 483, 498, 502, 503, 512, 521

Richardson, Jonathan 451

Richardson, Marion 409

Ricketts, Charles 33, 77, 83, 88, 89, 109, 158, 205, 266, 331, 446, 463

Riley, Cecil 299, 321, 326, 340, 354, 373, 388

Roberts, William 79, 97, 108, 110, 180, 209, 304, 306, 321, 330, 340, 341, 350, 410, 453

Rodin, Auguste 47, 188, 227, 228, 249, 278, 446, 495

Rogers, Claude 127, 136, 138, 143, 293, 320, 351, 364, 427, 436, 520, 524, 534

Rogerson, Sidney 417, 423

Romney, George 58, 290, 370

Rooke, Noel 122, 125, 139, 152, 252, 276, 417

Rose, Peggy 299

Rosenberg, Isaac 254

Rosoman, Leonard 360, 427

Ross, Robert 539

Ross, Vera 30, 60, 62

Rossetti 25, 116, 245, 316, 542

Rotha, Paul 84

Rothenstein, Albert (see Albert Rutherston)

Rothenstein, John 37, 46, 80, 172, 198, 277, 286, 289, 292, 295, 298, 323, 325, 327, 334, 337, 345, 352, 360, 370, 376, 385, 430, 456, 462, 477, 499, 517

Rothenstein, W. Michael 106, 136, 307, 451, 461, 462, 510

Rothenstein, William* 4, 8, 11, 15, 17, 21, 24, 27, 29, 53, 93, 103, 106, 110, 116, 121, 165, 170, 178, 203, 255, 266, 277, 282, 292, 293, 296, 303, 305, 306, 308, 310, 319, 320, 322, 334, 337, 344, 345, 354, 355, 358, 360, 369, 375, 377, 378, 379, 382, 383, 395, 398, 399, 413, 414, 441, 443, 454, 460, 461, 462, 476, 477, 484, 528, 550, 551, 552

Rouault, George 338, 367, 490

Rowe, Connie 24, 93, 94, 139

Rowlandson, Thomas 58, 62, 166, 171, 286, 287

Rowntree, Kenneth 163, 219, 245, 270, 306, 309, 397

Roxburgh, J.F. 332, 398, 422

Rushbury, Henry 11, 18, 38, 52, 70, 71, 73, 88, 98, 99, 109, 125, 246, 273, 276, 378, 384, 415, 428, 438, 477, 497, 509, 521, 525, 534

Rushbury, Janet 438, 480

Ruskin, John 112, 150, 210, 267, 273, 507, 523, 526

Russell, Bertrand 68, 172, 519

Russell, Gordon 187, 317, 420

Russell, Laura Millicent* 46, 55, 107, 110, 114, 201, 205,

236, 281, 362, 363, 408, 547, 551, 552

Russell, Lydia 178, 385, 432

Russell, Walter 45, 51, 87, 138, 200, 229, 262, 359, 365, 370, 412, 434, 436, 449

Rutherford, Sir Ernest 266, 531

Rutherston, Albert* 6, 11, 14, 16, 26, 28, 49, 58, 63, 71, 88, 94, 99, 100, 106, 126, 127, 139, 147, 154, 155, 162, 163, 169, 172, 173, 183, 194, 197, 212, 220, 223, 228, 232, 238, 243, 244, 246, 248, 249, 251, 260, 268, 269, 275, 280, 283, 284, 287, 292, 294, 295, 301, 303, 304, 305, 306, 308, 309, 310, 313, 314, 315, 316, 317, 318, 320, 321, 323, 324, 325, 332, 334, 337, 338, 342, 344, 345, 347, 350, 351, 352, 355, 356, 357, 361, 364, 365, 367, 368, 371, 372, 373, 374, 375, 376, 378, 382, 383, 387, 390, 394, 396, 397, 398, 400, 407, 408, 409, 410, 416, 418, 422, 425, 426, 427, 428, 429, 432, 433, 436, 437, 438, 439, 442, 443, 444, 452, 454, 455, 456, 459, 461, 462, 463, 464, 465, 467, 470, 471, 477, 485, 491, 496, 500, 506, 510, 513, 517, 521, 522, 526, 527, 528, 529, 530, 532, 534, 536, 538, 539, 543, 548, 552

Rutherston, Charles 188, 366, 375, 511, 552

Rutherston, Essil 119, 413, 462

Rutherston, Margery 14, 212, 220, 234, 398, 429, 437, 452, 454, 463, 496, 500, 543, 552

Rutter, Frank 102, 118, 136, 137, 145, 157, 164, 165, 166, 176, 179, 201, 224, 237, 246

Sadler, Sir Michael 137, 148, 157, 215, 284, 304, 339, 366, 367, 431, 470

Salaman, Michel 71, 318, 371, 375, 422 437, 488, 495, 526

Sallé, Miss 190, 191, 217, 293, 368, 376

Sands, Ethel 14, 15

Sands, Morton 14, 81, 150

Sargent, John Singer 42, 79, 127, 190, 199, 266, 333

Schepeler, Alick 26, 29, 72, 92, 119, 155, 169, 191, 318, 340, 418, 502

Schwabe, Alice (see Barnes, Alice Lady*)

Schwabe, Eric (see Sykes, Eric 'Bill'*)

Scott, Giles 176, 241, 513

Scott, William 394

Scott-Snell, Edward 311, 395, 410

Seabrooke, Elliott 20, 53, 115, 221, 362, 427, 513, 534

Seale, Barney 88, 524

Seurat, Georges 33

Seyler, Athene 93, 314, 364, 467

Shannon, Charles 83, 88, 109, 205, 227, 228, 331, 446, 463

Shaw, Evelyn 19, 20, 30, 50, 60, 62, 195, 214, 219, 230, 259, 487, 510, 514

Shaw, George Bernard 66, 79, 107, 122, 125, 158, 193, 386, 406

Shaw, Richard Norman 170

Shepherd, F.H. 170, 173, 188, 215, 292, 294, 295, 318, 329, 362, 395, 396, 402, 460

Sheppard, Sydney 412, 422, 442

Sheringham, George 101, 102, 174, 243, 244, 289, 514

Short, Sir Francis (Frank) 145

Sickert, Walter* 13, 15, 25, 27, 29, 47, 52, 58, 70, 76, 77, 79, 82, 104, 148, 149, 150, 165, 170, 199, 207, 211, 218, 219, 251, 268, 298, 324, 332, 370, 375, 384, 387, 443, 479, 508, 512, 545, 548, 550, 553, 555

Sikes, E.E. 206, 209

Simon, Oliver 97, 180, 245

Sitwell, Edith 51, 54, 254, 259, 489, 539

Sitwell, Osbert 60, 85, 259, 426, 489, 514, 539
Sitwell, Sacheverell 'Sachy' 60, 81, 213, 243, 259, 539
Skeaping, Barbara (née Hepworth) 38, 97, 98, 130, 132, 179, 192
Smart, Rowley 14, 165, 174
Smith, Alic Halford 308, 345, 428, 437, 452, 453
Smith, Matthew 108, 135, 190, 238, 332, 338, 390, 495, 524
Smith, Percy 15, 59, 157, 379, 433, 495
Smith, W. Thomas 195, 229
Sokolova, Lydia 214
Sorrell, Alan 283, 478
Southall, Joseph 77, 179
Spear, Ruskin 65, 108, 180, 428, 450
Spencer, Augustus 162, 163, 354, 386, 503
Spencer, Gilbert 21, 50, 63, 70, 79, 96, 99, 117, 123, 141, 161, 163, 180, 194, 202, 218, 229, 231, 276, 286, 290, 295, 296, 305, 310, 329, 497, 513, 518, 521, 525, 538, 539, 544
Spencer, Stanley 21, 23, 44, 64, 132, 135, 137, 166, 167, 180, 194, 197, 199, 200, 207, 208, 210, 230, 251, 286, 295, 297, 299, 300, 303, 306, 307, 308, 309, 310, 311, 315, 317, 325, 334, 356, 378, 380, 397, 399, 409, 411, 511, 521, 546, 554
Spender, Humphrey 493, 494
Spender, Stephen 457, 493, 494
Squirrell, Leonard 194, 399, 462
Stack, Prunella 270, 285
Steer, Philip Wilson* 8, 17, 27, 28, 30, 31, 32, 36, 46, 59, 60, 68, 70, 71, 72, 86, 87, 96, 97, 107, 114, 115, 127, 133, 134, 146, 165, 178, 186, 189, 207, 247, 256, 262, 269, 272, 282, 292, 298, 319, 350, 364, 376, 378, 385, 386, 389, 396, 411, 420, 422, 426, 436, 437, 441, 458, 478, 479, 489, 510, 511, 521, 549, 553, 554
Stein, Gertrude 154, 237
Stern, Ernest 106, 219, 265, 294
Stevens, Alfred 157, 173, 174, 487, 508, 510
Stokes, Adrian 30, 39, 43, 67, 103, 105, 167, 213, 234
Stuart-Hill, Alexander 27, 77, 139, 236, 241, 333, 361, 397, 530, 552
Strachey, Lytton 91, 93, 100, 186, 517
Strang, David 38, 44, 169
Strang, Ian 14, 35, 36, 59, 93, 99, 156, 157, 165, 194, 218, 222, 265, 294, 311, 415
Strang, William 93, 103, 195, 428, 447
Stratton, Fred 91
'Stripes' (Oriana) 67, 98, 99
Strudwick, John Melhuish 86
Summers, Gerald 200, 204
Summers, Norah 200, 204, 385
Sutherland, D.M. 419, 470
Sutherland, Graham 232, 364, 377, 383, 388, 443, 484, 511, 524
Sutton, Felicity 346, 445
Sykes, Eric 'Bill'* 8, 54, 154, 159, 160, 161, 162, 164, 166, 167, 168, 172, 177, 209, 231, 275, 313, 321, 322, 323, 329, 342, 349, 358, 359, 360, 368, 377, 380, 392, 405, 429, 446, 448, 450, 457, 465, 466, 467, 468, 484, 537, 553
Swynnerton, Mrs. 87
Symons, Arthur 29, 85, 96, 199
Symons, Mark 190

Tagore, Rabindranath 50
Taylor, Sir Andrew 126, 141, 144, 165, 182, 195, 262
Taylor, Diana Yeldham 299, 412, 464
Taylor, Walter 79, 175, 332
Tennyson, Alfred Lord 184, 342, 343, 359, 534, 537, 544, 554
Tennyson, Charles* 6, 20, 26, 63, 111, 119, 122, 184, 194, 204, 215, 284, 286, 324, 337, 338, 339, 342, 378, 379, 388, 417, 430, 435, 446, 455, 457, 474, 475, 477, 478, 486, 500, 515, 534, 539, 543, 544, 554
Tennyson, Hallam 204, 284, 305, 322, 328, 337, 394, 433, 475, 480, 515, 534, 555
Tennyson, Ivy 119, 184, 284, 328, 342, 359, 368, 391, 394, 430, 435, 446, 455, 457, 463, 473, 475, 476, 480, 493, 510, 543, 544, 554
Tennyson, Julian 'Dooley' 63, 204, 256, 312, 326, 376, 463, 554
Tennyson, Penrose 'Pen' 63, 128, 256, 305, 337, 358, 359, 360, 377, 378, 554
Thesiger, Ernest 115, 147
Thomas, Havard 46, 129, 134, 151
Thompson, Heber 120, 145, 289, 323
Thomson, A.R. 22, 339, 541
Thornton, Alfred 18, 57, 58, 68, 71, 77, 88, 94, 145, 207, 210, 237, 245, 246, 285, 292, 294
Thorogood, Stanley 25, 36, 37, 39, 42, 49, 89, 91, 94, 261
Thorpe, W.A. 34, 35, 43
Tibble, Geoffrey 164, 211, 344
Tintoretto 138, 196, 207, 436, 477, 500, 517
Tonks, Henry* 4, 7, 8, 13, 15, 17, 18, 21, 22, 26, 27, 28, 30, 31, 32, 33, 35, 36, 39, 41, 42, 43, 45, 46, 47, 59, 60, 66, 68, 69, 70, 71, 72, 82, 87, 97, 107, 126, 127, 134, 152, 170, 173, 175, 189, 193, 194, 197, 235, 243, 244, 245, 246, 247, 248, 249, 250, 251, 59, 260, 261, 262, 265, 266, 268, 273, 282, 287, 292, 293, 295, 296, 332, 333, 339, 348, 375, 376, 378, 392, 405, 414, 420, 440, 441, 453, 460, 461, 479, 487, 520, 522, 528, 530, 546, 553, 554
Tonks, Myles 244
Topolski, Feliks 320, 359
Toulouse-Lautrec, Henri de 29, 106
Townend, Jack 372, 418, 452, 467
Towner, Donald* 13, 16, 22, 35, 39, 40, 57, 75, 92, 94, 95, 99, 100, 105, 106, 107, 114, 117, 120, 134, 135, 136, 141, 161, 171, 186, 198, 212, 230, 231, 234, 239, 257, 261, 263, 271, 284, 285, 288, 319, 321, 407, 408, 434, 464, 474, 478, 494, 496, 500, 504, 506, 507, 512, 518, 521, 525, 532, 554, 555
Toynbee, Lawrence 320, 360, 371, 374, 459, 467, 472
Travis, Walter 43, 77, 106, 111, 201, 254, 351, 352, 354, 385, 439, 468
Tree, Iris 95, 124
Tree, Viola (Mrs. Alan Parsons) 84, 183, 233, 241
Tristram, E.W. 34, 49, 68, 89, 203, 316, 525
Tryon, Wyndham 8, 18, 22, 83, 148, 151, 159, 176, 182, 187, 188, 189, 190, 208, 235, 245, 290
Tullio, Pasquale 36, 93, 369
Turner, J.M.W. 18, 80, 82, 158, 164, 193, 282, 385, 434, 438, 442, 451, 462, 481, 491, 517, 518, 522, 544
Turner, Harold 224, 400

Underwood, Leon 50, 54, 89, 156, 189, 192, 367
Unwin, Francis 18, 93, 103, 112, 124, 130, 169, 172,

239, 364, 422, 515, 517
Unwin, Clara 107, 111, 112, 142
Utin, Archie 24, 51

Van Gogh, Vincent 44, 69, 134, 367, 384, 405
Vandervelde, Lalla 5, 368, 374, 378, 384, 385, 391, 399, 400, 417, 423
Velázquez, Diego 355, 485, 506
Voysey, Charles 31, 67, 84, 352
Vyse, Charles* 16, 17, 22, 24, 25, 29, 38, 66, 73, 75, 82, 97, 103, 120, 150, 240, 273, 555

Wadsworth, Edward 27, 102, 145, 148, 169, 265
Wadsworth, Mrs. 27, 57
Walker, Ethel* 18, 23, 74, 76, 85, 97, 104, 136, 172, 178, 187, 188, 191, 193, 194, 198, 207, 226, 236, 237, 240, 246, 293, 354, 410, 426, 476, 479, 484, 518, 521, 530, 531, 555
Walker, Rainforth Armitage (R.A.W.) 11, 17, 21, 22, 24, 26, 33, 37, 39, 40, 50, 71, 75, 78, 81, 118, 144, 175, 325, 503
Walter, Wilfrid 139, 523, 528
Walton, Allan 189, 215, 418, 419, 443, 469, 477, 525
Waterfield, Humphrey 219, 245, 260, 347, 454
Waterlow, Adrian 58, 166, 250, 529
Watson, Professor D.S.M. 105, 108, 520, 528
Watson, Harry 24, 43, 61
Watts, Arthur 18, 37, 44, 59, 85, 89, 96, 121, 178, 193, 203, 253
Watts, George Frederic 20, 286, 544
Weekley, Charles 257, 526
Wellington, Bob 62, 84, 97, 100, 102, 108, 109, 115, 136, 142, 149, 153, 157, 158, 164, 244, 262, 264, 265, 268, 272, 282, 342, 414, 452
Wellington, Charlotte 94, 99, 100, 109, 112, 134, 296, 375, 555
Wellington, Hubert* 91, 100, 109, 115, 373, 375, 401, 414, 452, 464, 469, 533, 554, 555
Whaite, Clarence 467
Wheatley, Grace 247, 354, 438, 463, 492
Wheatley, John104, 155, 246, 247, 438, 463, 492, 496, 503, 504, 519, 524
Whistler, James McNeill 24, 29, 50, 97, 151, 179, 255, 450
Whistler, Rex 25, 26, 60, 61,106, 138, 174, 373, 386, 487
White, Ethelbert 82, 118, 120, 125, 139, 150, 179, 187, 210, 212, 283, 318, 319, 321, 440, 450, 476, 484, 509, 511, 513
White, Franklin 33, 76, 155, 215, 423, 440, 475
Wilenski, R.H. 44, 113, 114, 150, 178, 382
Wilkie, James 33, 46, 69, 83, 139, 177, 244, 318, 373, 423, 475, 492, 508, 513, 518, 519, 533
Wilkinson, Norman 453, 477
Williams, Iolo 381, 436, 455, 474, 499
Williams, Kyffin 407, 409, 415, 421, 427, 429, 444, 445, 488, 529, 531
Williams, Ralph Vaughan 201
Williams-Ellis, Clough 44, 170, 290
Willis, Rosamund 34, 35, 229
Wilson, Richard 82, 108, 153
Winter, Fred 523, 524
Witt, Sir Robert 29, 172, 193, 274
Witt, Lady 28
Wolfe, Edward 'Teddy' 79, 97, 149, 152

Wolfe, Humbert 59, 71, 228, 263, 271, 313, 355, 426
Wolfe, Jessie 228, 270, 271, 275, 355
Wood, Christopher 60, 103, 317, 451
Wood, Derwent 143, 419
Wood, Jas 200, 203, 518, 521, 530
Woolf, Virginia 193, 291, 348
Wynter, Bryan 412, 442, 457, 466

Yeats, Jack B. 370, 371, 441
Yeats, W.B. 214, 316, 384, 385, 486, 539
Young, John 22, 71

Zinkeisen, Doris 60, 405, 496

Acknowledgements

There have been many people who have provided advice, encouragement and support over the past five years or so since I started working on Randolph Schwabe's diaries while I was at the same time writing his biography (published in 2012). I remain indebted first and foremost to the family of Randolph Schwabe and in particular to the late Alice, Lady Barnes for her encouragement and generosity in sharing her memories of her father and his contemporaries. I also owe a special debt of gratitude to Janet and Di Barnes, daughters of Alice and Harry Jefferson Barnes for allowing me unrestricted access to their grandfather's diaries. Their friendship and hospitality has been much valued and appreciated. Margaret de Villiers, niece of Randolph Schwabe has provided invaluable help painstakingly transcribing her uncle's diaries and providing insights into his life in London and Oxford. George MacBride has again expertly advised on textual matters for which I am most grateful.

There are many people who have assisted me throughout this research and to whom I extend my thanks. While space precludes my naming them all I am particularly grateful to those who also transcribed his diaries: Liz Lim, Matthew Perry, Caroline St. John and Sue Sherwood. David Wootton, writer and researcher at the Chris Beetles Gallery, read and commented on the diaries and associated material and provided invaluable suggestions.

The assistance from numerous archivists, curators and librarians has been much appreciated. I should like to thank staff at: Burgh House & Hampstead Museum; Christ Church College, University of Oxford; Courtauld Institute Library; Ditchling Museum; Emsworth Library; London Library; National Art Library; National Portrait Gallery; St. Barbe Museum & Art Gallery, Lymington; UCL Special Collections, University College London.

For their help with images and copyright clearance for the edited diaries, thanks are extended to: The Ben Enwonwu Foundation; Bishop Otter Trust, University of Chichester; Bridgeman Images; Brighton and Hove Museums & Art Galleries; Campion Hall, University of Oxford; Chris Beetles Gallery; DACS; Imperial War Museum; Jonathan Clark Fine Art, representatives of Ivon Hitchen's estate; Manchester Art Gallery National Portrait Gallery, London; Paul Feiler's estate; Southampton City Art Gallery; Tate Images; UCL Art Museum, University College London and the University of Hull Art Collection.

I am also grateful to Clara Hudson, John Sansom, Stephen Morris and Ian Parfitt for producing and designing this book. I gratefully acknowledge the research grant received from the Marc Fitch Fund and the support of Janet and Di Barnes.

It has been a pleasure to work once more with the Otter Gallery team at the University of Chichester on the exhibition: 'Circles of Influence: British Art 1915-50 – A Diarist's Perspective'. I am grateful to the staff for their help and especially Laura Kidner and Catharine Russell for sourcing the images and associated photography and to Julie Peachey for expediting related matters financial.

The exhibition has been generously sponsored by Chris Beetles Gallery. It would also not have been possible without the cooperation of the following lenders: Bishop Otter Trust, University of Chichester; Brighton and Hove Museums & Art Galleries; Chris Beetles Gallery; Imperial War Museum; Ingram Collection of Modern and British and Contemporary Art; Swindon Museum and Art Gallery; Victoria and Albert Museum, London; Worthing Museum and Art Gallery; Janet and Di Barnes and those private lenders who preferred to remain anonymous.

Finally, I should like to thank Sarah Gilroy who has read and commented critically and insightfully on this text. As ever I gain richly from her scholarship and partnership and most importantly her support from the outset and encouragement has enabled me to complete what has been the most challenging of my research endeavours to date.

Dr Gill Clarke MBE
Visiting Professor and Guest Curator
Otter Gallery
University of Chichester

February 2016